HISTORICAL DICTIONARY

The historical dictionaries present essential information on a broad range of subjects, including American and world history, art, business, cities, countries, cultures, customs, film, global conflicts, international relations, literature, music, philosophy, religion, sports, and theater. Written by experts, all contain highly informative introductory essays of the topic and detailed chronologies that, in some cases, cover vast historical time periods but still manage to heavily feature more recent events.

Brief A–Z entries describe the main people, events, politics, social issues, institutions, and policies that make the topic unique, and entries are cross-referenced for ease of browsing. Extensive bibliographies are divided into several general subject areas, providing excellent access points for students, researchers, and anyone wanting to know more. Additionally, maps, photographs, and appendixes of supplemental information aid high school and college students doing term papers or introductory research projects. In short, the historical dictionaries are the perfect starting point for anyone looking to research in these fields.

HISTORICAL DICTIONARIES OF ASIA, OCEANIA, AND THE MIDDLE EAST

Jon Woronoff, Series Editor

Guam and Micronesia, by William Wuerch and Dirk Ballendorf. 1994.
Palestine, by Nafez Y. Nazzal and Laila A. Nazzal. 1997.
Lebanon, by As'ad AbuKhalil. 1998.
Azerbaijan, by Tadeusz Swietochowski and Brian C. Collins. 1999.
Papua New Guinea, Second Edition, by Ann Turner. 2001.
Cambodia, by Justin Corfield and Laura Summers. 2003.
Kyrgyzstan, by Rafis Abazov. 2004.
Turkmenistan, by Rafis Abazov. 2005.
Vietnam, Third Edition, by Bruce Lockhart and William J. Duiker. 2006.
India, Second Edition, by Surjit Mansingh. 2006.
Hong Kong SAR and the Macao SAR, by Ming K. Chan and Shiu-hing Lo. 2006.
Pakistan, Third Edition, by Shahid Javed Burki. 2006.
Iran, Second Edition, by John H. Lorentz. 2007.
Gulf Arab States, Second Edition, by Malcolm C. Peck. 2008.
Laos, Third Edition, by Martin Stuart-Fox. 2008.
Brunei Darussalam, Second Edition, by Jatswan S. Sidhu. 2010.
Mongolia, Third Edition, by Alan J. K. Sanders. 2010.
Bangladesh, Fourth Edition, by Syedur Rahman. 2010.
Polynesia, Third Edition, by Robert D. Craig. 2011.
Singapore, New Edition, by Justin Corfield. 2011.
East Timor, by Geoffrey C. Gunn. 2011.
Postwar Japan, by William D. Hoover. 2011.
Afghanistan, Fourth Edition, by Ludwig W. Adamec. 2012.
Philippines, Third Edition, by Artemio R. Guillermo. 2012.
Tibet, by John Powers and David Templeman. 2012.
Kazakhstan, by Didar Kassymova, Zhanat Kundakbayeva, and Ustina Markus. 2012.
Thailand, Third Edition, by Gerald W. Fry, Gayla S. Nieminen, and Harold E. Smith. 2013.
Syria, Third Edition, by David Commins and David W. Lesch. 2014.
Science and Technology in Modern China, by Lawrence R. Sullivan and Nancy Y. Liu. 2014.
Taiwan (Republic of China), Fourth Edition, by John F. Copper. 2014.
Australia, Fourth Edition, by Norman Abjorensen and James C. Docherty. 2015.
Indonesia, Third Edition, by Audrey Kahin. 2015.
Fiji, by Brij V. Lal. 2016.
People's Republic of China, Third Edition, by Lawrence R. Sullivan. 2016.
Israel, Third Edition, by Bernard Reich and David H. Goldberg. 2016.
New Zealand, Third Edition, by Janine Hayward and Richard Shaw. 2016.
Nepal, Second Edition, by Nanda R. Shrestha and Keshav Bhattarai. 2017.
Burma (Myanmar), Second Edition, by Donald M. Seekins. 2017.
Yemen, Third Edition, by Charles Schmitz and Robert D. Burrowes. 2017.
Chinese Economy, by Lawrence R. Sullivan. 2018.
Malaysia, Second Edition, by Ooi Keat Gin. 2018.
Tajikistan, Third Edition, by Kamoludin Abdullaev. 2018.
Postwar Japan, Second Edition, by William D. Hoover. 2019.
Iraq, Third Edition, by Beth K. Dougherty. 2019.
Democratic People's Republic of Korea, Second Edition, by James E. Hoare. 2019.

Chinese Environment, by Lawrence R. Sullivan and Nancy Liu-Sullivan. 2019.
Saudi Arabia, Third Edition, by J. E. Peterson. 2019.
Republic of Korea, Fourth Edition, by James E. Hoare. 2020.
Chinese Culture, by Lawrence R. Sullivan and Nancy Liu-Sullivan. 2021.

Historical Dictionary of Chinese Culture

Lawrence R. Sullivan
Nancy Liu-Sullivan

ROWMAN & LITTLEFIELD
Lanham • Boulder • New York • London

Published by Rowman & Littlefield
An imprint of The Rowman & Littlefield Publishing Group, Inc.
4501 Forbes Boulevard, Suite 200, Lanham, Maryland 20706
www.rowman.com

6 Tinworth Street, London SE11 5AL

Copyright © 2021 by Lawrence R. Sullivan and Nancy Liu-Sullivan

All rights reserved. No part of this book may be reproduced in any form or by any electronic or mechanical means, including information storage and retrieval systems, without written permission from the publisher, except by a reviewer who may quote passages in a review.

British Library Cataloguing in Publication Information Available

Library of Congress Control Number: 2020944196

♾ The paper used in this publication meets the minimum requirements of American National Standard for Information Sciences Permanence of Paper for Printed Library Materials, ANSI/NISO Z39.48-1992.

This book is dedicated to the late Seymour Topping and Audrey Ronning Topping and to the late Professor Ezra Vogel, Harvard University, each connoisseurs of China's rich cultural heritage.

Contents

Editor's Foreword	xi
Preface	xiii
Reader's Note	xv
Acronyms and Abbreviations	xvii
Map	xix
Chronology	xxi
Introduction	1
THE DICTIONARY	5
Glossary	461
Bibliography	465
About the Authors	497

Editor's Foreword

Countries are not all alike, nor, barring international protocol, are they all equally important. So when China, brief for the longer and more formal name People's Republic of China (PRC), gets a half-dozen books in this series while most others only have one, this is perhaps a reason to apologize that the series is a bit lopsided or more likely to point out that China is a particularly important country. It is the largest in population, with 1.4 billion, and, growing albeit slowly, one of the largest countries in geographic extension. In addition, it has one of the longest and most varied histories. But quite simply, what happens in China matters—in virtually every field—although it no longer throws its weight around as it once did.

So we have no compunction about adding yet another China book to our series, this time on its culture, which is shifting again as it tries to be just another country, which is not quite as easy as it sounds. This is evident in the entries, which contain some—perhaps rather many—that could not be found in other volumes, on not only religion and philosophy, which includes Buddhism, Christianity, Confucianism, and Daoism, but also more broadly such issues as ideology and human rights, as well as art, cinema, and music, to say nothing of more faintly exotic aspects like ancestor worship and shame. Once having gone through these topics for the abstract pleasure of learning more about them and China, or to fill a gap in a comparative study or assignment, the reader will most probably not feel disappointed, but may well go back for more.

This book is written by Lawrence R. Sullivan, author of the volumes on the Chinese economy, environment, foreign affairs, and science and technology, as well as the Chinese Communist Party and especially the core People's Republic of China. For a long time, he was on the political science faculty of Adelphi University in Garden City, New York, from which he has retired, although he has since worked as research associate at the Weatherhead East Asian Institute, Columbia University. Aside from our books, he has also written numerous shorter pieces, notably a book entitled *Leadership and Authority in China, 1895–1976*, and given numerous talks and lectures. Given this track record, we should not be surprised to have him back again, with the able assistance of Dr. Nancy Liu-Sullivan.

Jon Woronoff
Series Editor

Preface

Undergoing continuous evolution and refinement during a period of 4,000 years, second in length only to India, Chinese culture has been revered, especially in the imperial era, as the core of the national spirit and basis of national pride and unity. Historically sustained by a meritocratic elite of scholar-officials trained in the state doctrine of Confucianism, elite and popular culture shared fundamental cultural precepts on the importance of family and commercial activities, along with tolerance of competing philosophical precepts, including Daoism and Buddhism. Absorbing new cultural norms throughout the centuries as the imperial empire expanded into the northeast and Inner Asia, China confronted increasingly severe internal crises during the Qing Dynasty (1644–1911), most notably the pseudo-Christian Taiping Rebellion (1850–1864), which cost an estimated 40 million lives.

At the same time, China faced the cultural challenges of the Western world rooted in advanced technology and military power, and diametrically opposed to Chinese traditions of metaphysical exploration and literati refinement. Cultural principles once propagated as the ultimate in human accomplishment in a variety of realms, including architecture, the arts, literature, painting, poetry, and the theater, were suddenly subject to withering critique, domestic and foreign, blamed for the country's existential crisis and the primary cause of China's subjugation by superior powers. Vilified by the best and brightest minds, especially during the seminal New Culture Movement/May Fourth Movement (1917–1921), and turned into a target of open political warfare and explosive mass hatred by the Chinese Communist Party (CCP) under chairman Mao Zedong (1936–1976), during the chaotic Cultural Revolution (1966–1976) China's elaborate cultural edifice was gradually dismantled, leaving a population in despair and searching for meaning beyond lofty political rhetoric and meaningless ideological nostrums.

Following the passing of Mao Zedong in 1976, and the introduction of economic reforms and social liberalization in 1978–1989, the war on culture in the People's Republic of China (PRC) came to a gradual end, with major elements of the population seeking meaning in everything from religions, domestic and foreign, to new higher cultural forms in the fine arts and music, to the lower forms of crime and pornography. Confronting a widespread moral malaise, cultural norms and practices previously derided are being revived and the likes of Confucius rehabilitated, but with strong action taken against any and all ideas and groups epitomized by the heterodox Falun Gong, which would directly challenge state power. Examining the historical

xiv • PREFACE

roots to the contemporary battleground concerning culture and its rich variety of manifestations, this book portrays the major actors and various realms of contention from the literary to the mundane, delineating the skirmish lines while delving into the inner recesses and rich depths of one of the world's great cultural traditions.

Reader's Note

The romanization used in this dictionary for Chinese-language terms is the Hanyu pinyin system, developed in the 1950s and currently used in the People's Republic of China (PRC), and officially adopted on Taiwan by the government of the Republic of China (ROC) in 2009. The older Wade–Giles system of romanization is used for a few historical names and places where appropriate. Chinese-language terms generally unknown to Western readers are italicized, while some words different in English have the same Chinese romanization, for example, *shi*, with several different meanings, including "to be," "lion," or "affair." In Chinese and East Asian culture, generally, the family name comes first, preceding the single or multisyllabic given name.

To facilitate the rapid and efficient location of information and make this book as useful a reference tool as possible, extensive cross-references have been provided in the dictionary section. Within individual entries, terms and names with their own entries are in **boldface** type the first time they appear. Related terms that do not appear in the text are indicated by *See also* references. *See* references denote other entries that deal with similar topics.

Acronyms and Abbreviations

BFA	Beijing Film Academy
CAA	China Artists Association
CAFA	Central Academy of Fine Arts
CAS	Chinese Academy of Sciences
CASS	Chinese Academy of Social Sciences
CBD	compulsive buying disorder
CCP	Chinese Communist Party
CCTV	China Central Television
CDIC	Central Discipline Inspection Commission
CDPF	China Disabled People's Federation
CETV	China Educational Television
CGTN	China Global Television Network
CNTC	China National Tobacco Company
CSR	corporate social responsibility
CYL	Communist Youth League
DINK	double income, no kids
DPRK	Democratic People's Republic of Korea
ECD	early childhood development
ECS	East China Sea
FCTC	Framework Convention for Tobacco Control
GDP	gross domestic product
GONGOS	government-organized nongovernmental organizations
GPS	global positioning system
IOC	International Olympic Committee
ISS	International Space Station
ITER	International Thermonuclear Experimental Reactor
KMT	*Kuomintang* (Nationalist Party)
ME	Ministry of Education

xviii • ACRONYMS AND ABBREVIATIONS

MFA	Ministry of Foreign Affairs
MPS	Ministry of Public Security
MRT	Ministry of Radio and Television
NGO	nongovernmental organization
NPC	National People's Congress
OBOR	One Belt, One Road Initiative
PETA	People for Ethical Treatment of Animals
PLA	People's Liberation Army
PRC	People's Republic of China
PSC	Politburo Standing Committee
ROC	Republic of China
SACH	State Administration of Cultural Heritage
SAD	social anxiety disorder
SAR	special administrative region
SARFT	State Administration of Radio, Film, and Television
SARS	severe acute respiratory disorder
SCS	social credit system; South China Sea
SOE	state-owned enterprise
TAR	Tibet Autonomous Region
TCM	traditional Chinese medicine
TVE	township–village enterprise
UNESCO	United Nations Educational, Scientific, and Cultural Organization
USSR	Union of Soviet Socialist Republics
VPN	virtual private network
WHO	World Health Organization
WTO	World Trade Organization
XUAR	Xinjiang-Uighur Autonomous Region

Map

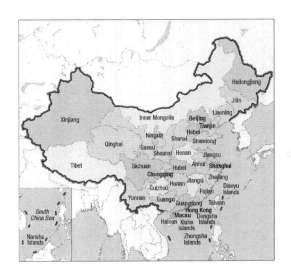

Chronology

DYNASTIES OF ANCIENT CHINA: BCE

Xia (2250?–1766?)

The era of major mythical figures, notably "Yu the Great," begins, shaping the early development of Chinese culture. Handicrafts are introduced, including lacquerware, as well as martial arts.

Shang (1600–1046)

Shamanism is introduced, along with concept of *tianxia*, "all under heaven," to describe Chinese territorial influence. The practices of traditional Chinese medicine and seal carving begin.

Zhou (1046–256)

Chinese music begins to employ the simple bamboo pipe flute. Imperial ceramics and porcelains are introduced.

950 The foot-binding of women begins.
770–476 Spring and Autumn Period: The practice of fengshui begins.
601–531 Laozi lives.
551–479 Confucius lives.
544–496 Sun Zi, author of *The Art of War*, lives.

Warring States (475–221)

372–289 Mencius lives.
340–228 Qu Yuan, poet and government minister, lives.

Qin (221–206)

China is unified and the Great Wall consolidated by the first emperor, Qin Shihuang (221–210 BCE). The Confucian classics are burned and Confucian scholars buried alive. The Terracotta Army is buried underground outside the mausoleum of Emperor Qin Shihuang. Kowtow is adopted as a method of

xxii • CHRONOLOGY

inferiors greeting their superiors, notably the emperor. The Chinese Zodiac begins. The Chinese written language is standardized with the "rule of custom," adopted toward ethnic minorities.

Han Dynasty (202 BCE–220 CE)

Historical records of individual dynasties begin to be kept, as commoners assume surnames. Puppetry becomes a major entertainment form. Human sacrifice in religious ceremonies ends as a prejudicial view of women takes hold, with gender inequality embedded in legal principles.

Western Han (202 BCE–9 CE)

Buddhism is transmitted from India to China. The flushing toilet is invented.

130 BCE The Silk Road is established as a land and maritime trading route with the outside world and would later serve as a major conduit for transmission of the bubonic plague to the Middle East, Africa, and Europe, especially in the fourteenth century CE.

112 The first music bureau in the Chinese imperial bureaucracy is established by Emperor Han Wudi (141–87 BCE).

Eastern Han (25 BCE–220 CE)

184 The Yellow Turban Rebellion takes place. The eunuchs appear at the imperial court.

PERIOD OF DISUNITY: CE

Three Kingdoms (220–280)

The era of renowned calligraphers begins.

Jin Dynasty (265–420)

The Seven Sages of the Bamboo Grove compose poetry and play musical instruments under the influence of alcohol.

CHRONOLOGY • xxiii

Northern and Southern Dynasties (386–589)

Alcohol consumption spreads to the general population. Specialized academies of learning are established as major cultural differences emerge between north and south China with elites becoming prominent promoters and connoisseurs of the arts.

REUNIFICATION AND COSMOPOLITANISM

Sui Dynasty (581–618)

592 An imperial edict calls for restoring music to its Chinese "essence" (*guocui*) as an attempt to eliminate foreign influences.

Tang Dynasty (618–907)

Buddhist religious texts are brought back from India by the monk Xuanzang. Fireworks are invented, and the practice of foot-binding is spread by imperial dance troupes. Musical forms expand, and gambling becomes profuse, as the Garden of the Majestic Clear Lake is built, along with pagodas and temples. Fine arts, including ceramics and porcelains, are perfected, along with wood-block printing, making for the publication of books. The giant Leshan Buddha is constructed at the confluence of the Min and Dadu rivers in Sichuan.

691 Buddhism is established as the state religion.
701–762 Li Bai, China's greatest poet, lives.
763 Tibetan forces capture Chang'an, the capital city of the Tang Dynasty.
835 The eunuchs are purged from the imperial court.

Period of the Northern Five Dynasties and the Southern Ten Kingdoms (907–979)

White ceramics and varied landscape paintings, with the natural world of mountains portrayed as a source of social harmony, are created.

Song Dynasty (960–1279)

Buddhist influence reaches its climax in China, with its decline beginning at the end of the dynasty. The commercial economy extends to cities and the countryside, with jade-carving becoming a major art form. Movable type is invented. Tea culture flourishes as women enter workforce.

1037–1101 Poet Su Shi lives.

xxiv • CHRONOLOGY

1130–1200 Zhu Xi, founder of Neo-Confucianism, lives.

Yuan Dynasty (1279–1368)

Zaju drama is created as a popular form of entertainment. Beijing is established as the permanent capital of the empire. The Maritime Silk Road is expanded, with long-range archery perfected.

MAGNIFICENCE AND DECLINE

Ming Dynasty (1368–1644)

The Forbidden City is constructed. The Great Wall is reconstructed. A national population registration system is established. *Kunqu* opera is introduced from the south as theatrical arts reach their peak. The "eight-legged essay" (*baguwen*) is incorporated into the civil examination system.

1369 A ban is imposed on actors taking part in civil service examinations.

1389 Officers and soldiers stationed in capital city of Beijing are forbidden to sing, with the penalty being having their tongues cut out.

1433 Admiral Zheng He dies, and Chinese sea explorations of Africa and the outside world come to a halt.

1592 A severe ban is imposed on unrestrained extravagance in the presentation of plays.

1601 Italian Matteo Ricci presents the imperial household with a clavichord.

Qing Dynasty (1644–1911)

The population hits 430 million as empires expand into the far western and southwestern regions. Women's literacy grows as suicide is outlawed.

1673 Emperor Kang Xi (1654–1722) is presented with such gifts as a small organ and harpsichord by visiting Europeans. Concubinage reaches its height in the imperial household.

1689 Pilgrimages begin to Mount Miaofeng outside Beijing.

1692 The Edict of Tolerance of Christianity is issued, as European Jesuits at imperial court emphasize serving the Chinese emperor.

1724 Emperor Yongzheng (1722–1735) issues an edict forbidding the Chinese from becoming Christians and expelling foreign missionaries.

1750 Emperor Qian Long (1735–1796) orders members of music ensembles to wear Western-style clothes and wigs, as the emperor becomes a major collector of antiquities numbering more than 1 million cultural relics.

CHRONOLOGY • xxv

1757–1842 The period of the "Canton System" of trade between China and the global economy takes place.

1791 *Dream of the Red Chamber* (Honglou meng) is published.

1793 Lord George McCartney, accompanied by five German musicians and their musical instruments, arrive at the Chinese imperial court to negotiate an increase in trade, only to be rebuffed by Emperor Qian Long, who declares China is in no need of English "manufactures."

1823 Highly potent opium from Bengal, India, is introduced into China.

1839 The First Opium War breaks out.

1842 The Treaty of Nanking, between China and Great Britain, ends the First Opium War, cedes Hong Kong island to Great Britain, and opens five ports in China to international trade.

1850 The Taiping Rebellion, led by pseudo-Christian Hong Xiuquan, breaks out, leading to an estimated 40 million deaths and continuing until 1864.

1856 The Second Opium War breaks out, continuing until 1860.

1858 Opium imports are legalized.

1870 Anti-Christian violence breaks out in the city of Tianjin.

1874 An anti-foot-binding committee is formed by British priests.

1879 The Shanghai Symphony Orchestra is established.

1888 "The Internationale" is composed in Austria.

1897 Chinese leader Zhang Zhidong organizes a military band, with Western musical groups performing for Empress Dowager Ci Xi (1861–1908).

1898 The Hundred Days of Reform is pursued by Emperor Guangxu (1875–1908), with the support of Kang Youwei and Liang Qichao, one of the measures of which involves converting temples to schools.

1902 Empress Dowager Ci Xi issues an edict banning foot-binding.

1905 The notorious "death by a thousand cuts" (*lingchi*) is abolished.

1907 Female revolutionary Qiu Jin is executed. Foreign Protestants in Shanghai celebrate the centenary of missionary arrival in China.

1908 The first sports school is established in China, specializing in gymnastics.

1909 An international conference to ban the opium trade is held in Shanghai.

REPUBLICAN CHINA AND CIVIL WAR

Republic of China (1912–1949)

1912 The Enlightenment Society, a literary organization, is established in Shanghai. Foot-binding is officially abolished.

xxvi • CHRONOLOGY

1913 Liang Qichao (1873–1929) likens the minds of the Chinese people to child psychology.

1917 The New Culture Movement is inaugurated.

1919 4 May: The May Fourth Movement, condemning the Chinese government's acceptance of the Versailles Conference, granting Chinese territory to Japan and marking the inauguration of modern Chinese nationalism, breaks out. Italian Mario Paci assumes leadership of the Shanghai Symphony Orchestra.

1920 China discards the lunar calendar and adopts the Western Gregorian calendar.

1921 The Popular Drama Society is established, favoring Western *huaju*. The Chinese Communist Party (CCP) is formed in the foreign concession of Shanghai.

1923 A debate about "science versus metaphysics" is carried out. "The Internationale" is translated into Chinese by Qu Qiubai of the CCP.

1927 November: The National Conservatory of Music is established. The warlord government in Beijing declares music harmful to moral decency.

1928 Men and women appear onstage in Peking opera.

1929 The Shanghai Art Drama Society is established and suppressed one year later by the Chinese government.

1930s The musical presence in Shanghai is enlivened by arrival of 18,000 Jewish refugees from Europe.

1930 A drama school opens in Beijing.

1931 Twenty-four writers and artists are arrested and executed by the Nationalist (*Kuomintang*) government.

1935 George Bernard Shaw visits China, sponsored by the Shanghai Pen Club. The National Drama School is set up in Nanking (Nanjing).

1936 Lu Xun (1881–1936) dies.

1937 "Great patriotic song demonstrations" are carried out following Japanese invasion and the beginning of the Second Sino–Japanese War (1937–1945).

1938 The Lu Xun Academy of Fine Arts is established in Yan'an by the CCP.

1939 The *Yellow River Cantata* is composed by Xian Xinghai (1905–1945) and performed for first time.

1941 *Bitterness in the Qing Palace*, forerunner to *Hai Rui Dismissed from Office*, by Wu Han (1909–1969), is performed.

1942 At the Yan'an Forum on Literature and Art, CCP chairman Mao Zedong calls for art to serve politics, as criticism of artists expands, with Mao denouncing "art for art's sake." "The East Is Red" is composed.

1945 The *White-Haired Girl* opera is composed. Composer Xian Xinghai dies in Moscow.

Civil War (1946–1949)

1946 May: The Yan'an Symphony Orchestra is established, as a piano is sent to the remote CCP redoubt by Red Army commander Chen Yi.

PEOPLE'S REPUBLIC OF CHINA (PRC)

Takeover and Consolidation (1949–1952)

1949 July: The First National Congress of Artists and Writers is held. **1 October:** The People's Republic of China (PRC) is formally established. Musical ties with Western Europe are severed. The Three-Self Patriotic Movement is inaugurated.

1950 The Marriage Law is enacted. Membership in secret societies numbers 18 million.

1951 *The Life of Wu Shun*, the first feature film made in the PRC, is criticized, followed by national discussion of the novel *Dream of the Red Chamber*. The policy known as "Learn from Soviet Artists" is inaugurated.

Central Economic Planning and Influence of the Soviet Union (1953–1958)

1950s Ancestral halls are shuttered and ancestral graveyards converted to farmland.

1953 Halls of culture and history are established in each province of the PRC as artists become a privileged group. The All-China Federation of Music Workers is established. Foreign tobacco sales are prohibited. **October:** The Second National Congress of Artists and Writers is held, calling for more creativity in the arts.

1954 The concept of "socialist realism" (*shehuizhuyi xianshizhuyi*), adopted from the Soviet Union, is accepted as a guiding principle by the China Artists Association (CAA), as the Beijing Dance Academy is established, also under Soviet influence.

1955 Pianist Fu Cong wins an international Chopin competition in Warsaw, Poland. Peking Dance School focuses on folk dances. A mass campaign is launched against Hu Feng (1902–1985), writer and art theorist, and thousands of artists and intellectuals.

1956 The Central Philharmonic Orchestra is established, as Guangzhou Piano Factory opens. Debate among intellectuals about "aesthetics" (*meixue*) begins, continuing until 1962. **May:** The Hundred Flowers Campaign, under

xxviii • CHRONOLOGY

Mao Zedong, grants greater freedom to intellectuals and artists, continuing until June 1957. **August:** Mao Zedong issues his "Talk to Music Workers." **September:** The first National Music Festival is held in Beijing.

1957 The Anti-Rightist Campaign targets outspoken intellectuals and artists, continuing until 1959. The National Book Coordination Act is enacted.

The Great Leap Forward and Its Aftermath (1958–1961)

China becomes self-sufficient in production of pianos as quotas for new musical scores and compositions are increased dramatically, in line with other "Great Leap" goals.

1958 Chinese pianist Liu Shikun is awarded second prize in the Tchaikovsky Competition in Moscow. *Shajiabang*, a revolutionary opera, is composed. The *Hukou* system of population registration begins, with major disparities between urban and rural residents.

1959 *Butterfly Lovers*, a composition consisting of violin concerto in three parts, is completed. Soviet experts, many of them music teachers, withdraw from the PRC in reaction to the growing Sino–Soviet conflict. An experimental ballet troupe is established with the assistance of advisers from the Soviet Union.

1960 Aesthetics as an academic discipline is introduced into university curricula.

1961 Premier Zhou Enlai gives a speech announcing the relaxation of policy on intellectuals and artists. **January:** *Hai Rui Dismissed from Office*, by Wu Han, is published.

Economic Recovery (1962–1965)

1962 "Eight Articles on Literature and Art" is issued, promising greater intellectual freedom. Television is introduced into the PRC in limited amounts. Mao Zedong declares to "never forget class struggle," ushering in a new crackdown on artistic circles.

1963 Left-wing radical Yao Wenyuan criticizes music composed by Claude Debussy. **August:** A major conference on drama is held. **December:** Mao Zedong issues "Two Instructions on Literature and Art," noting "problems in all forms of art."

1964 The demand is made that music in China become "revolutionary, national, and popular," as all Chinese are urged to "learn from the People's Liberation Army," including on cultural matters, with army musical groups to serve as national model. The Four Cleanups Campaign begins, with major attacks on rural religious practices, as young people, including musicians, are "sent down to the countryside" (*xiaxiang*). *Critique of Judgment*, by Imma-

CHRONOLOGY • xxix

nuel Kant, is translated into Chinese. The practice of Qigong is banned. **July:** The Festival of Peking Opera on Contemporary Themes is held in Beijing. **October:** The ballet *Red Detachment of Women* is performed.

1965 An article entitled "On the New Historical Opera *Hai Rui Dismissed from Office*," by Yao Wenyuan, is published in Shanghai. **January:** Mao Dun is dismissed as minister of culture.

Cultural Revolution (1966–1976)

1966 February: "Theory of the Dictatorship of the Black Line in Literature and the Arts" is issued by the radical Jiang Qing, as an arts forum is held in conjunction with the People's Liberation Army (PLA). **August:** The first mass rally of the Red Guards is held in Tiananmen Square, overseen by Mao Zedong, as an attack inaugurated on the "four olds" of old ideas, cultures, customs, and habits. **September:** Renowned music instructor Fu Lei and his wife, Zhu Meifu, commit suicide. **November:** The last of eight mass rallies of the Red Guards is held in Tiananmen Square. **December:** Wu Han and Tian Han are arrested. Novelist Lao She commits suicide.

1967 The Shanghai Conservatory of Music closed. **May:** Pianist Yin Chongzong plays piano in Tiananmen Square to stave off attacks by Red Guards on the playing of the instrument, as the piano is named the official musical instrument of the Cultural Revolution.

1968 Large numbers of Chinese youth "sent down to the countryside" (*xiaxiang*) are denied basic education, becoming known as the "lost generation."

1969 The revolutionary phase of the Cultural Revolution comes to an end with schools gradually reopening.

1970 A space satellite launched by the PRC broadcasts the song "The East Is Red" while in orbit.

1971 The U.S. table tennis team is invited to China. Marshal Lin Biao, the official successor to Mao Zedong, is killed in an airplane crash while fleeing the country.

1972 U.S. president Richard Nixon visits the PRC, beginning the reopening of the country to the international community, including in arts and music.

1973 The Shanghai Conservatory of Music reopens. **March:** The performance by a Swiss cellist in Beijing and Shanghai is the first by a foreigner in years, as works of Western composers are allowed to be performed for first time since the beginning of the Cultural Revolution. **September:** The Philadelphia Orchestra performs under Eugene Ormandy.

1974 The unearthing of the Terracotta Army begins outside the mausoleum of Emperor Qin Shihuang, near Xi'an.

xxx • CHRONOLOGY

1975 Workers-peasants-soldiers begin to enroll in Chinese universities. Vice Premier Deng Xiaoping visits France.

1976 January: Premier Zhou Enlai dies. **September:** CCP chairman Mao Zedong dies. **October:** Madame Jiang Qing, wife of Mao Zedong, and members of the Gang of Four, including Zhang Chunqiao, Yao Wenyuan, and Wang Hongwen, are arrested. The revival of Qigong begins.

1977 March: The Central Philharmonic performs the *Fifth Symphony* by Beethoven.

Economic Reforms and Social Liberalization (1978–2008)

1978 Zoos, wildlife parks, and aquariums are expanded. Accused "rightists" (*youpai*) from the Anti-Rightist Campaign (1957–1959) are rehabilitated. Regular student enrollment in the Central Conservatory is renewed as conventional music education is restored.

1979 The "Stars" art exhibit is organized by Ai Weiwei. **January:** Administrative regulations are issued on pornography. **November:** The Fourth National Congress of Artists and Writers is held. An exhibit of nude paintings is presented in the Hunan museum. Better treatment for intellectuals is announced as Qigong is recognized for its medical purposes.

1980 Romantic love becomes a major theme in Chinese films. Deng Xiaoping declares that popular music from Taiwan is not harmful to China. Victims of the 1955 anti–Hu Feng campaign are rehabilitated.

1981 Criticism of the film *Bitter Love* and writer Bai Hua leads to a general crackdown on content in movies as Deng Xiaoping warns of "problems on the ideological front."

1982 "March of the Volunteers" is reestablished as the official national anthem of the PRC, replacing "The East Is Red," which was temporarily adopted as the national anthem during the Cultural Revolution. "Art should serve the people and socialism" is adopted as the national slogan. **March:** Recognition of the legal basis for the revival of religion is issued in a major central document.

1983 The Anti-Spiritual Pollution Campaign against liberal ideas and arts is inaugurated, continuing into 1984.

1984 China participates in the Summer and Winter Olympics, and the Summer Paralympics.

1985 The "fifth-generation" film *Yellow Earth* is given international release. The Propaganda Department of the CCP announces censorship for all movies, television dramas, and plays portraying national leaders. New China Book Store loses control of book sales to private vendors. "Piano fever" strikes Chinese families.

CHRONOLOGY • xxxi

1986 The Law on Nine-Year Compulsory Education is enacted. China consents to the filming of *The Last Emperor*, directed by Bernardo Bertolucci in the Forbidden City.

1987 Conflict and violence breaks out in Lhasa, Tibet.

1988 The National Conference on Culture Work discloses more than 3,000 specialized art troupes performing in China. A nude art show opens at the Beijing art gallery.

1989 1 May: A system for rating children's movies is announced. **4 June:** The PLA crushes a prodemocracy movement in Tiananmen Square in Beijing and other cities.

1990 April: Calls are renewed for increasing sex education.

1992 The Eastern Lightning Christian church is labeled as "counterrevolutionary."

1993 Fine arts dealers are required to register with the Ministry of Culture.

1994 Online internet forums are introduced. Limitations on the construction of temples and monasteries are imposed in Tibet.

1995 The Physical Health Law is enacted. Instant messaging via the internet is introduced. The number of drug users grows to 520,000 nationwide, with a 200 percent annual increase. *Turandot* is performed by the China Central Opera Theater.

1996 The China Philharmonic Orchestra is reconstituted as the China National Symphony Orchestra. A regulation requires all internet users in China to register with the police.

1997 Same-sex relations are decriminalized.

1998 *Turandot*, directed by Zhang Yimou, is performed in the Forbidden City.

1999 The WeChat forum is established. The Falun Gong religious group is banned by the Chinese government. The Millennium Altar is built in Beijing, celebrating China's national revival.

2000 The Baidu Corporation is founded in Beijing, opening China to the international internet.

2001 The unmanned *Shenzhou* spacecraft is launched. China is awarded the 2008 Summer Olympics.

2002 The Law on the Protection of Cultural Relics is enacted.

2003 The PRC signs the World Health Organization Framework Convention for Tobacco Control.

2004 Nationwide blogging begins. The concept of "harmonious society" is introduced.

2005 The Group Licentious Law is enacted.

2006 Laws against rumor-mongering are enacted.

2007 A law is passed protecting the employment of people with disabilities.

xxxii • CHRONOLOGY

Emergence of Economic Superpower (2008–2020)

2008 May: A major earthquake hits the Wenchuan area of Sichuan, killing 69,000 people, many of them school children in poorly constructed buildings, spurring a nationwide effort at rescue and support.

2009 Weibo is established.

2010 China is struck by several mass killings in schools and markets, along with the self-immolation of monks in Tibet.

2011 CCP leaders decry moral deficiencies and the lack of basic values among the population. Jasmine revolutions strike the Arab countries.

2012 The population of the cities in the PRC surpasses that of rural areas. At a National People's Congress (NPC) meeting, Premier Wen Jiabao announces a policy to promote traditional cultural and social values like marriage. A national center for "traditional learning" (*guoxue*) is established.

2013 QQ Tencent is established.

2014 The Social Credit System is introduced. A lack of social trust is noted in a national survey. A campaign begins to remove crosses from Christian churches, continuing until 2016.

2015 The Tort Liability Law, guaranteeing the right to privacy, and the Domestic Violence Law are enacted. **July:** The State Council issues an edict on reducing the emphasis on examinations in education.

2016 The Cybersecurity Law and National Charity Law are enacted. A major conference is held to regulate religious life.

2017 The Film Industry Promotion Law bans content harming national dignity. The Craft Revitalization Plan reintroduces traditional handicraft production.

2018 The "Me Too" movement from the West, calling for gender equality, is introduced into China. **January:** A campaign is launched to clean up criminal gangs and syndicates. **April:** The slandering of national heroes and martyrs is criminalized.

2019 The middle class in China numbers 400 million. Threats from the CCP to academic freedom emerge at universities.

2020 Petitions are sent to the NPC calling for the legalization of same-sex marriage. Protests demanding greater freedom break out in Hong Kong.

Introduction

Revered throughout the imperial age of philosophical and doctrinal domination by Confucianism and a well-trained governing elite of "scholar-officials" (*rujia*), Chinese culture emerged as a major political football from the late 19th century onward. With the once-magnificent empire becoming the "sick man of Asia" (*yazhou bingfu*), pillaged by intellectuals and political leaders alike from the New Culture Movement/May Fourth Movement (1917–1921) to the chaotic Cultural Revolution (1966–1976), China's rich cultural realm of philosophy, literature, and the arts was derided, and subject to withering assaults as the primary cause of the country's economic backwardness and military weakness. Fast forward to the contemporary era beginning in the1990s and the narrative has undergone a complete reversal, as the traditional Confucian culture, with an emphasis on education and rule by a hierarchical meritocracy, is lauded as a major factor behind the country's meteoric rise as an economic superpower worthy of international emulation.

Previous vilification of the cultural core of Confucianism, especially by Chinese Communist Party (CCP) chairman Mao Zedong (1936–1949), has been all but forgotten as contemporary leaders of the People's Republic of China (PRC), led by President Xi Jinping (2013–), have rehabilitated the great philosopher, declaring his principles worthy of study and emulation, while substantial resources are channeled into everything traditional, from Peking opera to Tang Dynasty (618–907) dances and music, to the unique Chinese concepts of fengshui (wind and water) and yin-yang. Expanding cultural globalization and the wide availability of social media have also offered to the Chinese public, including youth, various forms of new entertainment, from hip hop music to the more sordid pornography and prostitution.

PERIODIZATION

A great source of national pride and unification as an imperial empire and modern nation-state, Chinese culture evolved during a period of approximately 4,000 years, with major exogenous and endogenous transformations as the civilization originating in the north China plain expanded into a giant imperial state. While any periodization is fraught with arbitrary timelines and

2 • INTRODUCTION

boundaries, the history of Chinese culture can be broken down into three rough eras: ancient, "medieval," and modern, with the last subdivided into three separate periods from the late 19th century to the present (2020).

The first "ancient" (*gushi*) period of Chinese history extended from the semimythical Xia Dynasty (2250?–1766? BCE) through the multiple states and feudatories in the Shang (1600–1046 BCE) and Zhou (1046–256 BCE) dynasties, and the contentious Warring States (475–221 BCE), to the unification under the short-lived and tyrannical Qin Dynasty (221–206 BCE), when harsh measures of burning books and burying Confucian scholars became historical hallmarks. Followed by the magnificent and long-lasting Han Dynasty (206 BCE–221 CE), a monocultural realm spread throughout the expanding empire, relying on a single, standardized written script and the propagation of Confucianism as the dominant state doctrine by an emerging elite of scholar-officials with toleration of ancillary schools of Buddhism and Daoism. With the word "Han" applied to the majority ethnicity, fine arts of bronzes, ceramics, and porcelains, as well as jade carving and painting, flourished, although both the Western (202 BCE–9 CE) and Eastern (25 BCE–220 CE) Han dynasties were subject to constant threats from invading barbarians.

The second period, labeled, for want of a better term, "medieval," began with an era of considerable internal conflict and religious influence on the arts, particularly sculpture, in the Six Dynasties (220–589), as Buddhism introduced during the Han Dynasty merged with indigenous Daoism and, backed by the state, gradually took hold, especially at the popular level, with major cultural differences emerging between northern and southern China in the realms of cuisine, literature and the arts, and language. Successive dynasties began with the Sui Dynasty (581–618), which while short-lived succeeded in reunifying the empire, as Buddhism and the Confucian monoculture were gradually restored. A series of dynasties followed: with opulence and exoticism in the cosmopolitan Tang (618–907); the commercially vibrant Song (960–1279); the Mongol-imposed Yuan (1279–1368), with introduction of *Zaju* drama; the indigenous Ming (1368–1644), with construction of the Forbidden City and a rebuilt Great Wall; and the Manchu-imposed Qing (1644–1911), as emperors the likes of Qian Long (1735–1796) became major collectors of cultural relics.

Throughout this long period, and contrary to European medievalism, religion in China diminished in importance, especially Buddhism, from the Song Dynasty onward. Christian missionaries, initially entering in small numbers in the 17th century, were succeeded by an onslaught of religious proselytizers in the mid-19th century as China suffered humiliating defeats at the hands of Western powers in two Opium Wars (1839–1842, 1856–1860). Running into a wall of general Chinese disinterest for anything religious, especially associated with the aggressive Western powers, despite considerable missionary contributions to education and music, missionaries were supplement-

ed by Western merchants and traders. Introducing commercial practices and establishing such modern economic institutions as banks, Western families, including many Jews fleeing discrimination in the Middle East, like the Sassoons and Hardoons, produced fundamental cultural changes, especially in the wide-open coastal cities of Shanghai and Guangzhou.

The third period of Chinese history, the "modern" (*xiandaihua*) period, began with the gradual decline of the Qing Dynasty from the mid-19th century onward, epitomized by the Taiping Rebellion (1850–1864), characterized by widespread territorial destruction and enormous human costs in the form of as many as 40 million deaths. Following the notoriously brutal and backward-looking rule of Empress Dowager Ci Xi (1861–1908), the Qing Dynasty collapsed not with a bang, but a whimper, replaced by the Republic of China (ROC), headed by two largely ineffective and inept presidents, Sun Yat-sen (1912–1925) and "Generalissmo" Chiang Kai-shek (1928–1949).

The first systematic attack on traditional Chinese culture occurred during the New Culture Movement/May Fourth Movements (1917–1921), with distraught intellectuals like American-trained Hu Shi (1891–1962) and CCP founder Chen Duxiu (1879–1942) calling for near-total Westernization. Advocating radical changes in Chinese literature from the "classical" (*wenyan*) to the "vernacular" (*baihua*) language, New Culture/May Fourth participants, one of them a young Mao Zedong, demanded changes in a variety of the country's many "customs and habits" (*fengsu xiguan*), especially involving the lowly status of women.

Following the ultimate triumph of Marxism–Leninism, led by the CCP, traditional social and cultural practices involving the family and the arts were subject to withering attack beginning with the "Yan'an Talks on Literature and the Arts" (1942), by Mao Zedong. With the establishment of the PRC, major cultural changes included enactment of the Marriage Law (1950) and implementation of "land reform" (*tudi gaige*), culminating in a virtual war on culture during the chaotic Cultural Revolution (1966–1976). Not until the passing of Mao Zedong in 1976, and the emergence of the pragmatic Deng Xiaoping (1978–1992), followed by the equally levelheaded Jiang Zemin (1989–2002) and Hu Jintao (2003–2012), was balance restored to cultural policies, reviving fine and decorative arts, and traditional entertainment, while backtracking on reforms involving women and education by the administration of Xi Jinping (2013–), even as economic liberalization, although sometimes halting, continues.

4 • INTRODUCTION

VERITIES

The rich cultural life of China is marked by prominence and refinement in multiple realms, including acrobatics, drama, opera, and theater, along with the decorative and fine arts, including ceramics and porcelain, seal and jade carving, and painting, all internationally renowned. With the Chinese term for "culture" (*wenhua*) literally translated as "preference for writing," literature, from novels and poetry to plays, was generally encouraged throughout Chinese history, although with some efforts at state surveillance and censorship, the latter pursued during the inward-looking Ming Dynasty and, most dramatically, by the government of the PRC. Equally important is the rich culinary traditions in China, with eight regional cuisines, most notably Cantonese, Peking, and Sichuan, as accomplished chefs have won national and international fame in recent years, while Chinese vegetarianism based on Buddhism has also gained increasing popularity both at home and abroad.

Entertainment with strong traditional cultural roots includes acrobatics, with the Shanghai Circus troupe remaining especially popular, along with dancing, made popular in the Tang Dynasty, and *Zaju* drama, from the Yuan Dynasty, as well as such Western plays as *Death of a Salesman*. As with many one-party states, the PRC is obsessed with culture, considering virtually every realm potentially subversive, especially in the performing arts and cinema and film, with constant tension between artistic luminaries the likes of Ai Weiwei, who react instinctively against any and all efforts at control or censorship, and an army of CCP-controlled bureaucratic agents devoted to endless monitoring and surveillance of the cultural scene. As Chinese audiences seemingly cannot get enough of salacious and seductive art forms, from nude paintings to sex-filled films, including pornography, traditional entertainment—for example, Peking opera—struggles to keep its artistic head afloat in an increasingly market-driven environment. At the same time, Chinese artistic creations continue to soar in popularity and market value, with a Ming Dynasty rooster cup sold at Sotheby's for $36 million in 2014.

ABACUS (*SUANPAN*). Literally meaning "counting frame" and dating back to the Han Dynasty (202 BCE–220 CE), when hunters developed early versions of the device to keep track of their slain prey, the abacus was used primarily by merchants and traders until the introduction of electronic calculators and computers. Constructed of a bamboo frame, with wooden beads separated by a horizontal beam, the Chinese, or "classical," 5:1 abacus consists of two beads in the top tray, referred to as "heaven" (*tiantang*), and five in the bottom "earth" (*diqiu*) tray, sliding on seven rods, distinguished from the simpler Japanese, or "modern," 4:1 version. Counted are the beads moved toward the beam, while those moved away are not, with calculations ranging from simple addition and multiplication to more complex derivation of square roots. A centerpiece of **education** throughout Chinese history, schools in the People's Republic of China (PRC) still teaching the abacus have shown an overall improvement in learning ability, while older shopkeepers in outlying towns and poorer areas still rely on the inexpensive device, avoiding new and more costly electronic calculators and smartphones.

ACADEMIES AND UNIVERSITIES (*SHUYUAN/DAXUE*). A type of school in ancient China for study of the Confucian classics largely by the noble and privileged social **classes**, academies were established chiefly by private sources, mainly merchants. Included were a "national university" (*taixue*) established during the Han Dynasty (202 BCE–220 CE) and an "imperial academy" (*guozijian*), both national centers of higher learning for training high-level officials, the latter following the establishment of the nine-tier system of **bureaucratic** ranks introduced during the Three Kingdoms (220–281 CE). Built away from cities and towns in generally remote and quiet areas often near **mountains** where students could engage in studies and intellectual contemplation without restrictions or worldly distractions, academies maintained substantial **libraries** and were the origin of many modern universities, for instance, internationally renowned Peking University.

6 • ACCUSATIONS (ZHIKONG/ZUIMING)

Historically, academies trace back to educational institutions established during the Shang (1600–1046 BCE) and Zhou (1045–256 BCE) dynasties, with the Jixia Academy as the first formal institution set up in the Qi State (360 BCE). Following the abolition of private schools during the tyrannical reign of Emperor Qin Shihuang (221–210 BCE) as a way to secure total control of the kingdom, educational institutions expanded under state sponsorship during the subsequent Han Dynasty, especially during the reign of Emperor Wu Di of the Western Han (202 BCE–9 CE). Becoming the dominant form of elite **education** in the Tang Dynasty (618–907), including the Hanlin Academy in **Xi'an**, academies spread throughout the empire down to the village level and flourished in the subsequent Song Dynasty (960–1279) with the emergence of the "Four Great Academies," Songyang, Yingtianfu, Yuelu, and Bailudong, the last a center of training in Neo-Confucianism by founder Zhu Xi (1126–1271).

With the number of "great" academies expanded to eight, increasing emphasis was placed on preparing students for the imperial civil service examination. Dismantled during the Mongol-controlled Yuan Dynasty (1279–1368), academies were revived and greatly expanded under the Ming (1368–1644), with creation of the Donglin Academy, dealing primarily with political and state matters. Continued during the Qing Dynasty (1644–1911), more than 7,000 academies existed throughout the empire, with many receiving imperial bestowals of calligraphic signboards and rare books. Set up were specialized academies on **history** (Northern and Southern Dynasties, 386–589 CE), **calligraphy** (Tang), law (Song), and **painting** (Ming), and a Confucian Academy (438 CE). Abolished during the Hundred Days of Reform (1898), many modern universities trace their origins to the older academies, for example, Hunan University, which developed from the Yuelu Academy in Changsha.

With the rebirth of "national learning" (*minzu xuexi*) in the People's Republic of China (PRC) since the 1990s, classical education has been made available for primary and secondary school students, although at great cost, which many wealthy families in the PRC are willing to bear. Institutions of higher learning with a heavy classical curriculum include such establishments as Chunghwa College of Traditional Culture, set up in 1992, to "strengthen cultural confidence," but they lack national accreditation.

See also YOUTH (*QINGNIAN*).

ACCUSATIONS (*ZHIKONG/ZUIMING*). In a society with a weak concept of the "rule of law" (*fazhi*) and equally poor standards of "due process" (*zhengdan chengxu*), accusation, often exaggerated or totally baseless, is common among the elite and the general population alike, including **children**, especially since the establishment of the People's Republic of China (PRC) in 1949. Exacerbated by a pervasive belief that any and every human

action is done with intent, often evil, and not by accident, accusations fly frequently particularly on matters of personal integrity, reputation, and **face**. Most evident in the many **ideologically** charged campaigns prosecuted by the Chinese Communist Party (CCP) during the rule of Chairman **Mao Zedong** (1949–1976), accusations of reputed political **crimes** and moral misbehavior were launched against various individuals casually and arbitrarily labeled as "class enemies" (*jieji diren*) and "bad elements" (*huaifenzi*) with accusations flying during intense "**struggle** sessions" (*zhengdou huiyi*). With accusations most severe and widespread in the Anti-Rightist Campaign (1957–1959) and especially the chaotic and often-violent **Cultural Revolution (1966–1976)**, accusers, including students and average peasants and workers, would subsequently admit "pulling accusations out of nowhere" with little or no understanding of charges leveled, for instance, "capitalist education" (*ziben de jiaoyu*) or "running dog of imperialism" (*diguozhuyi zougou*).

Common bases of accusations included any ideas or views with a **foreign** taint and/or a "bourgeois" life style signified by wearing nice **clothes** or **jewelry** informed by a pervasive paranoia of the accusers who subjected targets to public **humiliation**, **beatings**, **torture**, and even execution. Assuming guilt of the accused party, a rush to judgment characterized the process absent any concrete evidence or proof and often at the direction of an omnipotent leader at the local or national levels. While many, although by no means all, accusers and tormentors issued public **apology** to their victims in subsequent years, concerns that an "accusatory culture" (*zhize wenhua*) pervades Chinese society led to fears of a replay of the Cultural Revolution. Serious accusations of **sexual harassment** and assault against prominent intellectuals, journalists, and even **charity** leaders hit Chinese **social media** in 2019, with claims that police systematically ignored complaints.

ACROBATICS (*ZAJI*). Performances involving balance, agility, and motor coordination drawn from traditional **dance**, **martial arts**, **magic**, and **theater**, acrobatics is a popular form of **entertainment** in China, with troupes composed of **women** and **men**. Consisting of two types, the first involves acting out fighting scenes and performances using various weapons, for example, swords, based on famous **legends** and historical tales, and the second, similar to Western acrobatics, involves balancing, juggling, and gymnastics, often with a comedic story line. Requiring a high degree of flexibility, as well as group coordination and timing, while set to **music** often drawn from classical **opera** with brightly colored costumes, Chinese acrobatics is known throughout the world for its outstanding troupes based in **Beijing** and **Shanghai**.

Historically, acrobatics dates to the Warring States period (475–221 BCE), with further development and refinement during the Han (202 BCE–220 CE) and Tang (618–907) dynasties, remaining especially popular in the Ming

8 • ACUPUNCTURE

Dynasty (1368–1644). Based on a master–apprentice system of training begun early in life, between the ages of six and seven, acrobats required strong abdominal muscles and legs to precisely control such movements as standing on a tightrope, along with agile and fluid movement exuding power and harmony.

Traveling from cities and towns to villages as itinerants, acrobatic troupes often lived as vagrants, with performances involving little stage design and using common utensils as props, for instance, benches, chairs, jars, plates, poles, tables, and vases, with acts often mimicking the actions of **animals**. With many acrobats coming from Wuqiao county, Hebei, considered the "home of Chinese acrobatics," where even local farmers can be seen performing basic tricks in the fields, following the establishment of the People's Republic of China (PRC) troupes were moved into permanent theaters and participated in international competitions, with considerable success.

Notable acrobatic tricks and movements, many involving coordinated action by several performers, include balancing tall poles on the forehead, doing handstands on stacked chairs, jumping through hoops, cycling, doing somersaults and executing backflips in midair while twirling plates, juggling seven daggers at a time, and the dancing of lions on rolling balls. Highly specialized tricks include performing the "pagoda of bowls," involving the flipping of bowls onto the head; doing headstands on heads, with one performer resting upside down on the head of another and then rolling with ease down the latter's back while spinning plates; performing the "about-bend to pick up flowers with the mouth," in which an upright male acrobat supports a bench on his head while a female acrobat on top bends backward and slowly picks up flowers with her mouth; and doing the "peacock fanning its feathers," involving various cycling feats. Well-known acts include the Monkey King (Sun Wukong), the Legend of Kung Fu, and Splendid, with major performance venues at the Chaoyang Theater, Beijing, and Shanghai Circus World.

ACUPUNCTURE. *See* TRADITIONAL CHINESE MEDICINE (TCM, *ZHONGYAO*).

ADOLESCENCE (*QINGNIAN QI*). Defined as the period during which **children** develop into adults, from roughly 15 to 24 years of age, adolescence in the People's Republic of China (PRC) is currently characterized by intense involvement in **education** and expansion of individual identity, especially among the expanding middle class. While adolescents growing up from the 1950s through the early 1970s experienced political oppression, **chaos**, and general economic deprivation, contemporary Chinese adolescents display greater autonomy and independence in social behavior, **thinking**, and

ADOLESCENCE (QINGNIAN QI) • 9

values, along with dramatically higher living standards, which began with the introduction of economic reforms and social liberalization (1978–1979). Exposed to a globalizing "youth culture" with an emphasis on social experimentation and **peer** orientation, Chinese adolescents have also suffered from high rates of **alcohol** consumption, **obesity**, and increased **drug abuse**, the last resulting in higher rates of HIV. Growing addictions to such less destructive but still distractive activities as online **gaming** and live streaming on **social media** have also occurred, although overall rates of these and other social maladies in China rank below similar problems confronting this age group in developed countries.

Life experience of adolescents underwent major changes following the establishment of the PRC in 1949, with substantial differences and effects on generations coming of age during the period of rule by Chinese Communist Party (CCP) chairman **Mao Zedong** (1949–1976) versus the post–Mao era (1978–present). Subject, like most Chinese people, to the shifting political winds and vagaries of policy under Mao, succeeding adolescent generations dealt with the mundane tasks of economic and social survival, especially during the highly disruptive Great Leap Forward (1958–1960) and Great Famine (1959–1961). During the even more disruptive **Cultural Revolution (1966–1976)**, many adolescents joined the ranks of rampaging Red Guards, with some committing heinous crimes of **violence** and even murder. Missing out on years of education, as schools, including institutions of higher education, were shut down from 1966 to the early 1970s, many youth were also "sent down to the countryside" (*xiaxiang*), never to return to their **urban** homes, becoming the country's "lost generation" (*shiqu de yidai*), lacking the training and skills necessary in a modern society.

The shift to a more open society and internationally engaged **market** economy, inaugurated in 1978–1979, provided Chinese adolescents the benefits of greater social "stability" (*wending*), with a life revolving around school and long study hours as the goal of "quality education" (*suzhi jiaoyu*) stressed competitiveness and individual talents and creativity. Included were opportunities in vocational education and paths to private privilege and status, leaving behind the Maoist principles of egalitarianism and "class **struggle**" (*jieji douzheng*). Low divorce rates and improving living standards made Chinese adolescents less prone to storm and stress but with as many as 150 million people growing up without siblings, according to the **one-child policy** (1979–2015), which was rigidly enforced, especially in urban areas. Lavished upon as children, with many labeled spoiled "little emperors" (*xiao huangdi*) and "little princesses" (*xiao gongzhu*), these Chinese millennials have become known as the "loneliest generation" (*zui gudu de yidai*) for being generally ignorant of **family** life, exceedingly self-centered, and beset by pessimism and risk aversion with feelings of isolation and regret. Lacking

10 • AGE, AGING, AND AGEISM (NIANLING/LAOHUA/ NIANLINGZHUYI)

siblings, especially brothers, this generation is often on its own later in life in fulfilling the prime responsibility of taking care of **aging** parents, while their own children lack the company of uncles, aunts, and cousins.

Major differences among recent and current generations of adolescents exist for males versus females, urban residents versus **rural** residents, and the well-educated versus the less educated. Still considered by overly protective parents as gentle, soft, and "oriental," adolescent Chinese **women** are substantially less likely than their male counterparts to take up **smoking** and/ or excessive **alcohol** consumption but are more likely to suffer **body shaming** from peers, along with severe psychological depression and higher rates of **suicide**. Rural adolescents are also more likely to commit suicide than their urban counterparts, with the latter enjoying greater wealth and more schooling, while the former are more likely to engage in **manual labor**.

Despite high exposure to the message of personal achievement and self-expression on the internet, social media, and television, the impact of family and "patriarchal" (*jiazhang*) authority on adolescents has not faded, notably the long-held tradition of male superiority and the subordination of women, along with continuing political **loyalty** to the state. In a society described as going through a "**sexual** awakening" (*xing juexing*), Chinese adolescents are woefully lacking in adequate sex education with poor or nonexistent training for teachers, as young **men** are said to learn about such matters from Japanese **pornography** and young women from one-night stands, while desperate parents resort to sending adolescent offspring to sex education summer camps. Premarital sex among adolescents rose from 15 percent in 1989, to 71 percent in 2015, with 50 percent abjuring contraception, as sex education tends to focus on abstinence, with little attention to sexually transmitted diseases. Of the country's annual 13 million abortions, 50 percent are conducted on young women who are sometimes told by partners that pregnancy can be avoided by simply holding one's breath during intercourse.

AGE, AGING, AND AGEISM (*NIANLING/LAOHUA/ NIANLINGZHUYI*). One of the most important moral obligations in the historical culture of China, respect for the elderly and aging has eroded in the People's Republic of China (PRC) from economic and political forces unleashed during the **Cultural Revolution (1966–1976)** and in the aftermath of the introduction of economic reforms and social liberalization (1978–1979). A population with a median age of 37 (2018), the starting point of "old age" (*laonian*) in China is considered to be 45, as Chinese people have generally aged faster from tough living conditions in a less developed country, although life expectancy has recently increased to 76 years.

Historically, advancing age was believed to lead to increased **wisdom**, as people in their 50s were seen as having greater "understanding of the limitations of things" (*zhiming*), while the 60s was said to produce greater accep-

AI WEIWEI (1957–) • 11

tance of "diversity" (*ershun*). Elderly people, singled out as "class enemies" (*jieji diren*) during the Cultural Revolution, were frequently humiliated by young Red Guards and subjected to public beatings and denunciations, losing any trace of "**face**" or respect in the eyes of their juniors. Shifts in the economy in the post-Mao era to more high-technology industries demanding mastery of complex production and digital techniques has put a premium on **youth**, while the largely untrained elderly are seen as incapable of operating in a highly competitive society.

In the absence of national antiage discrimination laws in the PRC, the most aggressive high-tech firms refuse to hire anyone older than 30 to 35, making people in their 40s and 50s feel old, while higher living costs, especially in less developed **regions**, have led to frequent mistreatment of the elderly. Seen as useless and even annoying, elderly **men** and **women** are often referred to pejoratively as *laotouzi* ("old timer") and *lao taipo* ("old bag"), forbidden by their offspring to remarry after the loss of a spouse. Such publications as *Senior Daily* address outstanding issues involving age and ageism, as 20 percent of the country's total population will be 60 years or older by 2030.

AI WEIWEI (1957–). Avant-garde artist and son of the famous and often-disputatious poet Ai Qing, Ai Weiwei is most noted for his collaborative design of the Beijing National Stadium—known as the "Bird's Nest" (*Yanwo*)—for the 2008 **Beijing** Olympics. Ai Weiwei, whose full name translates as "Ai not yet, not yet," grew up in the remote Xinjiang-Uighur Autonomous Region (XUAR), where his father had been exiled after being labeled a "rightist" (*youpai*) during the Anti-Rightist Campaign (1957–1959) and where the young Ai claimed he "learned to do everything." Returning to Beijing in 1978, Ai studied at the Beijing Film Academy alongside **Chen Kaige** and **Zhang Yimou**, specializing in **animation**, while he also helped form one of China's first avant-garde groups of **artists**, known as the "Stars."

Disenchanted with the purely economic focus of the reforms promoted by Deng Xiaoping (1978–1992), Ai traveled to the United States, where he studied at the Parsons School of Design and the Arts Student League, both in New York City, while performing a myriad of odd jobs, as well as hitting the blackjack tables in Atlantic City. Befriending many American artists and poets, one of whom was the iconoclastic Allen Ginsburg, Ai was influenced in his own artistic sensibilities, especially **photography**, by Andy Warhol and Marcel Duchamp.

Returning to China in 1993, Ai founded a school for **architecture** and published several underground photo albums. During the Third Shanghai Biennale in 2000, he held his self-proclaimed "Fuck Off" photo exhibit, including images of him giving the finger in front of the **Forbidden City** in Beijing and the White House in the United States, and another in which he is

12 • AI WEIWEI (1957–)

dropping an ancient Han Dynasty (202 BCE–220 CE) vase that smashes at his feet. Ai also published a number of underground and untitled photo albums containing shocking and often erotic photos, including one of his wife, Lu Qing, flashing her underwear in front of the portrait of Chinese Communist Party (CCP) chairman **Mao Zedong** in Tiananmen Square.

Becoming involved in political matters following the devastating earthquake in Wenchuan, **Sichuan**, in 2008, Ai carried out a "citizens' investigation" of **corruption**, especially the shoddy construction of so-called "bean curd (*doufu*) dregs schools" that had collapsed, killing thousands of **children**, while more well-built structures generally remained intact. In addition to gathering the names of the children who had died—considered a "state secret" by the Chinese government—Ai designed an exhibit in his classic "installation art" style of 9,000 brightly colored backpacks representing the dead children at the Munich Haus der Kunst in Germany, a country Ai admires for first exhibiting his artwork.

Arrested in 2011, the burly and bearded Ai was incarcerated without charge for 81 days on what were apparently trumped-up tax-evasion charges, while he and some of his followers were investigated for **pornography** after they posted nude photos on Ai's blog. Ai's many artistic talents include **sculpture**, woodworking, **clothing** design, video, photography, and **music**, while one of his most famous exhibits was of 100 million porcelain sunflower seeds handcrafted by 1,600 handicraftsmen in Jingdezhen, the center of China's ancient **ceramic and porcelain** kilns, and exhibited at the Tate Modern in Turbine Hall, London. Many of Ai's works were also exhibited at Alcatraz Prison in San Francisco Bay, California, in 2014, from hangings of huge kites, some in the form of a dragon, to a piece entitled *Refraction*, a five-ton pterodactyl created out of Tibetan reflective metal panels and trapped behind the shattered glass panes of Alcatraz's "gun gallery." In the psychiatric ward of the prison hospital are also recordings of **Tibetan** and Native American chants, where in the cramped surroundings the rhythmic noises—**spiritual**, strong, and culturally significant—contrast with the shiny, mint-colored walls. Described as both haunting and aesthetically delightful, the exhibition exposes issues of freedom of speech and **human rights** by virtue of creating artistic possibility within an enclosed, broken system.

A subject of several films and documentaries, notably *Ai Weiwei: Never Sorry* and the BBC documentary entitled *Ai Weiwei: Without Fear or Favor*, Ai is under constant video surveillance at his Beijing suburb studio by Chinese authorities, where he countered by setting up his own webcams, entitled Weiweicam.com, for broadcasting his life on the internet until ordered by the government to shut it down. While his own personal blog was also closed, with his name inaccessible on Chinese websites, Ai relies heavily on the internet for maintaining contact with his fans, which he considers a crucial mechanism for the Chinese people to "exercise their personal freedom of

expression." Until recently, he was prevented from attending foreign exhibits of his work by the revocation of his passport, which was restored in 2015. Working out of his studio in Berlin in November 2015, Ai posted images on his personal Instagram account displaying prominent international and Chinese dissidents made from Lego toy blocks, two of which included Ms. Aung San Suu Kyi of Myanmar (Burma) and his imprisoned lawyer, Pu Zhiqiang.

ALCOHOL AND ALCOHOLISM (*CHUN/XUJIU*). An integral part of Chinese society dating back 4,000 years, alcohol is described as the "water of history" (*lishi shui*), used as a sacred liquor in sacrificial offerings, with libations considered an expression of reverence for forefathers, **family**, and friends. Consumed by famous musicians, poets, and writers, alcohol fueled the creative impulse most notably by the Seven Sages of the Bamboo Grove (3rd century CE), who, inspired by **Daoism**, adopted roles of alcohol-fueled pranksters and eccentrics composing **poetry** and **music** later romanticized in the *New Account of the Tales of the World* authored in the era of the Northern and Southern dynasties (386–589 CE). Following the establishment of the People's Republic of China (PRC) in 1949, alcohol consumption continued at the popular and elite level with important Chinese leaders known for their love of drink, notably Premier Zhou Enlai (1949–1976), whose liquor-quaffing ability led to his nickname, *qianbei buzui*, roughly translated as "still sober after a thousand glasses." Following the introduction of economic reforms and social liberalization (1978–1979), the general improvement in living standards and affluence led to an increase in alcohol consumption, rising to an average of 7 liters annually, 11 for **men** and 3 for **women** (2017), up by 70 percent since 1990, with increasing popularity of both domestic and imported brands, from the affordable to the costly.

Chinese alcohols include various types of hard liquors, led by *baijiu*, "white" or "clear" liquor, which is considered the country's national drink. With an alcohol content between 38 and 50 percent, and popularly known as "Chinese vodka," *baijiu* is made from grain usually distilled from sorghum. The best-selling drink in the world, total sales came to 10 billion liters in 2018, 90 percent in China, and more than whiskey, vodka, gin, rum, and tequila combined. The most famous brand is Maotai, made in the town of the same name in the southwestern province of Guizhou, along with other brands, for instance, Wuliangye, Ming River, and Luzhou, the last produced in **Sichuan**, along with the popular Red Star Erguotou in **Beijing**. Made to match regional **cuisines**, *baijiu* is served neat and is a staple at major social events, including private **banquets**, weddings, and **business** gatherings, although the drink was banned at Chinese state gatherings in 2012.

A spicy and powerful liquor, *baijiu* is popularly known for dispelling melancholy and said to have substantial **health** benefits, notably reducing blood pressure. Other hard spirits include *huangjiu*, yellow wine, fermented

14 • ALCOHOL AND ALCOHOLISM (CHUN/XUJIU)

from rice, millet, and other grains often for many years, with an alcohol content of 20 percent; *choujiu*, made from glutinous rice with a thick, milky texture and associated with the city of **Xi'an**; *mijiu*, the Chinese version of *sake*; Tiger Bone wine, sold only on the black **market** and used in both **religious** and secular ceremonies; and Snake Wine, which consists of an entire snake brewed in rice wine. Popular foreign drinks include cognac, with such luxury and expensive brands as Paradis Impérial emerging as major social status **symbols**, along with high-end whiskeys the likes of Pernod Ricard (France) and Suntory Ltd. (Japan). Also popular are martinis, with several Chinese versions, for example, the Mandarin and the Green Tea martini, sold in trendy popular night spots in Beijing, **Shanghai**, and other high-income **urban areas**.

Consumption of both domestic and imported brands of "beer" (*pijiu*) and western "wine" (*putaojiu*, literally "grape liquor") has also grown substantially in the PRC, especially since 1978–1979, with a tendency toward higher-priced premium varieties. The largest beer market in the world by volume, at 46 billion liters in 2017, of both wheat and craft varieties, per capita consumption in China is still dramatically lower than comparable European and North American markets. Led by Chinese millennials favoring beer (91 percent) over wine (51 percent) and hard liquors like *baijiu* (31 percent), beers in China consist of both pale lager and dark beers. The best seller is Snow Beer (21 percent), followed by the internationally known Tsingtao Beer (brewed in the former German colonial city now rendered as Qingdao), Yanjing, Harbin, Hangzhou, Shangri-la, and Zhujiang, many named for the city of production, with Carlsberg (Denmark) brewed in-country. Domestic craft beers include Great Leap, Panda, and Slow Boat, with Beijing and Shanghai hosting international beer festivals.

Introduced into China in the 19th century by the Portuguese through the colony of Macao and by the French, western-style wines, red, white, and sparkling, both imported and domestic, have grown increasingly popular, especially among young millennials, with China becoming the fifth-largest consumer and producer in the world. Chinese vineyards are located in areas with favorable climates, like Hebei and Shandong, and account for more than half of the country's total wine production, with many considered world-class vineyards. Second only to Spain in total hectares under cultivation, interior and poorer provinces in China, for example, Ningxia, have also emerged as major producers, with 86 wineries, primarily in the Helan Mountains **region**, with a Chinese-produced wine winning a trophy at the Decanter World Wine Awards in 2010. Noteworthy Chinese wine producers include ChangYu, the country's oldest winery and the world's fourth-ranked wine in terms of sales; Great Wall, the largest producer in China, transitioning from

offering cheap supermarket plonk to higher-quality cabernet sauvignon; Ningxia Silver Heights, producing such wines as blackberry pinot noir; and Tiansai, considered a market leader, with varietals certified as organic.

Chinese companies have also invested in foreign wineries, notably high-end vineyards in the Bordeaux region of France, while French companies are involved in the management of Chinese vineyards. Chinese wines have become big winners on the world stage, with a Marselan wine, made from China's "signature grape," winning the highest award at the Decanter Asia Wine Awards in 2017, along with several gold medals at the Decanter World Wine Awards in 2018 and 2019. Wine imports remain strong, at 687 liters in 2018, with France the largest source, followed by Australia, as "red wine" (*hongjiu*) remains popular since the **color** red symbolizes good **fortune**, joy, and fertility, as Chinese brides traditionally wore red in weddings to ward off evil.

Omnipresent in Chinese society, consumption of alcohol usually accompanies **food** and occurs in groups, as drinking alone, especially *baijiu*, is a rarity. Composed of comprehensive rules, the **drinking culture** and **etiquette** in China covers behavior, especially at formal banquets and celebrations with business associates and/or family and friends during **festivals** and on holidays. With actual drinking often occurring in toasts, examples of protocol include expectations that the honored guest(s) return toasts to the host, that the first toast be offered by an elder person, and that people of lower status place their glass slightly lower than that of the toasting partner. Following a "respectful proposal to drink" (*jingjiu*) and collective declarations of *ganbei* ("dry the glass"), cups and glasses are emptied, with individuals able to consume substantial amounts of alcohol praised for their "drinking courage" (*jiudan*), "drinking capacity" (*jiuliang*), and good "drinking manner" (*jiupin*), while refusal to drink, even a sip, including nonalcoholic beverages, is strongly frowned upon. Unlike older drinkers, who generally stick to restaurants, younger drinkers gravitate to bars and clubs, with millennials interested in discovery and novelty, choosing alcohol to express identity and their personality. Trends in drinking culture include more healthy consumption, especially by **women**, including such drinks as ginseng liquor and nonalcoholic beer.

With 60 percent of **men** and 30 percent of women classified as "binge drinkers" (*xiujiuzhe*), consuming alcohol an average of five to seven days a week, alcoholism has grown dramatically in China since the 1980s. Described in one study as reaching epidemic proportions, high-risk drinking behavior is correlated with multiple health and social problems, including traffic accidents, **crime** and child abuse, domestic **violence**, and work-related injuries. Considered vital to career advancement in many jobs, Chinese men have dramatically higher rates of alcoholism than women (9.3 percent versus 0.2 percent, totaling 50 million people), as alcohol abuse is the sixth-greatest

16 • ANCESTORS AND ANCESTOR WORSHIP (ZUXIAN CHONGBAI)

health risk for men, while the social stigma associated with female drunkenness remains strong. Socially and economically underdeveloped regions have higher instances of alcohol abuse exacerbated by local illegal alcohol production, while alcoholism increases with **age**, as middle-aged men have the highest rates, unlike in other countries, where the problem generally peaks among younger demographics. Not yet labeled as a defined disease by the Chinese government, treatment programs for confirmed alcoholics are limited and prevention policies weak, and even **children** are allowed to buy alcohol, while taxes remain low. Assistance by such private organizations as Alcoholics Anonymous is limited to five major cities, as many Chinese, out of consideration of "**face**," are reluctant to publicly discuss and admit to such problems.

ANCESTORS AND ANCESTOR WORSHIP (*ZUXIAN CHONGBAI*). Referred to as China's "patriarchal **religion**" (*jiazhang zongjiao*), ancestor worship is the **ritual** celebration of deified ancestors and tutelary deities of people sharing the same surname, with ancestors considered the embodiment of the creative order of heaven. Originating with the call by Confucius (551–479 BCE) to pay respects to one's ancestors and the general veneration of **filial piety** in the historically dominant **philosophy** of **Confucianism**, ancestor worship in traditional China was an indispensable component of **marriage** and **family** life, fostering an orientation to perpetuating the family line, with the afterlife considered a natural extension of the earthly world. Central to **spiritual** life but with no formal doctrine, the ritual involved the two major responsibilities of maintaining the family genealogy or family tree, usually on a tablet, and venerating ancestors at their gravesites, especially during the annual *Qingming*, or "Sweeping the Graves" (*Saomu*), **festival**, also known as "Pure Brightness," on 15 April, along with "Ghost Day" (*guijie*), held in mid-July with **gifts** of **food** for the deceased and readings of scripture by priests. Conducted primarily by males, who must demonstrate full sincerity in their performance of rituals, ancestors are "informed" (*tongzhi*) of major events in the family, especially marriage, while the dual souls of the departed are venerated to avoid retribution against the living. In addition to maintaining tablets listing ancestral **names** in shrines, temples, and household altars, ancestor worship also involves the burning of incense and paper money as an expression of reverence.

The history of ancestor worship in the People's Republic of China (PRC) is one of repression by political authorities and secular decline from the 1950s to the 1980s, followed by a revival from the 1990s onward, as part of a general regeneration of religious faith in the country. Labeled as a "**superstition**" and included in the "old culture" (*jiuwenhua*) targeted during the era of rule by Chinese Communist Party (CCP) chairman **Mao Zedong** (1949–1976), ancestral halls were shuttered and gravesites converted to

farmland in the 1950s, especially during the Great Leap Forward (1958–1960). This was followed by the **chaos** of the **Cultural Revolution (1966–1976)**, when rampaging Red Guards wantonly destroyed temples, along with ancestral tablets and altars, as ancestor worship largely disappeared in the cities, where the "**unit**" (*danwei*) system made ancestor worship almost impossible, with the practice managing to survive in the more loosely controlled **rural areas**.

While political assaults on the ritual generally ceased in the aftermath of the passing of Mao Zedong in 1976, economic reforms and social liberalization begun in 1978–1979, further eroded the practice, especially among the emerging consumer-oriented and well-educated middle class, who generally find the "**magical**" (*shenqi*) aspects of ancestor worship unattractive and "backward" (*luohoude*). For the less "modernized" (*xiandaide*) countryside, the practice evidently fills a "spiritual vacuum" (*jingshen zhenkong*) created by the collapse of Communist **ideology** and provides solace for the emotional breakdown and community disintegration following the **death** of a relative. Among the estimated 180 million practitioners located primarily in poorer **regions** of the south and southwest (**Yunnan**, Guangxi, Fujian, Zhejiang, and Shandong), ancestor worship is still considered a moral obligation of bloodline perpetuation, with the living and dead constituting a united family and **clan**. A reenactment of the Confucian myth of kingly governance in a modern setting, ancestor worship, by stressing political **loyalty**, plays a fundamental role in the maintenance of the one-party political regime of the PRC. An example of the CCP intermixing with local culture, continuation of ancestor worship in specific areas of the country depends heavily on whether local party cadres consider the ritual, like the outlawed Falun Gong, an immediate political threat, as pictures of former chairman Mao Zedong and current president **Xi Jinping** hang in ancestral-like fashion in many Chinese homes.

ANGER AND ANGER MANAGEMENT (*SHENGQI/QINGXU GUAN-LI*). Traditionally frowned upon in a society dominated by **Confucianism**, expressions of anger by individuals and in groups have been periodically encouraged by the government of the People's Republic of China (PRC) against both domestic and international "enemies" (*diren*). Multiple words in the Chinese **language** are used to indicate different levels of anger, from the relatively moderate *shengqi*, literally to "generate energy," to *fafeng*, "go mad," to the most severe *kuxiao bude*, "so angry as to cry and laugh." With the emphasis in Confucianism on the importance of maintaining social **harmony** and the concept of "doing nothing" (*wuwei*) in **Daoism**, Chinese society evolved as a collectivist society in which people were socialized from childhood to avoid discord with others, particularly social and political superiors. Integrated into strong, cohesive in-groups, strong emotions, like

18 • ANGER AND ANGER MANAGEMENT (SHENGQI/QINGXU GUANLI)

anger, were tempered mainly for the sake of avoiding "troubles" (*wenti*). Based on the belief that people are born to be virtuous, the "gentleman" (*junzi*), in particular, should be able to control personal emotions and maintain gravity, showing neither **hatred** nor anger in the quest for the Golden Mean of moderation. Considered a threat to personal **health**, including damage to vital human organs, anger also inhibits an individual's capacity for sympathy and, in a hierarchical culture, can wreak long-lasting damage on crucial social **relations**, which must be carefully monitored and managed.

In the history of the Chinese Communist Party (CCP) during the period of revolutionary **conflict** and civil war (1921–1949), and following the establishment of the PRC (1949–present), expressions of anger and **hatred** were frequently encouraged by party cadres against officially designated "class enemies" (*jieji diren*). This included, in the 1950s, "landlords" (*dizhu*), "rich peasants" (*funong*), and "capitalists" (*zibenjia*), along with targeted political enemies, most prominently "intellectuals" (*zhishifenzi*) and CCP members labeled as "rightists" (*youpai*) during the Anti-Rightist Campaign (1957–1959). During the chaotic **Cultural Revolution (1966–1976)**, targets of rampaging and hate-filled Red Guards, egged on by CCP chairman **Mao Zedong**, included "capitalist-roaders" (*zouzipai*) and reputed "counterrevolutionaries" (*fangeming*), suffering horrendous acts of **violence** and even murder.

Following the inauguration of economic reforms and social liberalization (1978–1979), political mobilization sanctioning expressions of anger and hatred shifted from domestic groups to **foreigners**, especially the Japanese, in major protests concerning territorial issues in 2005 and 2012, which resulted in sporadic outbreaks of violence directed against visiting Japanese nationals. With emphasis by the Chinese government on maintaining domestic "stability" (*wending*), the country generally reverted to the traditional emphasis on pursuing harmony in social relations, avoiding open expression of hostility and emotional confrontation, especially in public. In addition to the reassertion of traditional Confucian social values, major factors encouraging temperance and restraint include the prevalence of dialectical thinking, with its acceptance of contradictions and clashing viewpoints, as opposed to the pursuit of a single "right" (*dui*) or "correct" (*zhengque*) answer. Described as a low-uncertainty avoidance society, Chinese develop a greater sense of ambiguity with more tolerance of unknown situations, while viewing conflict and competition as natural, with less inclination for expressions of rage and personal antagonism. **Fortune** and misfortune are seen as just two baskets in the same well, both accepted in life with little or no need for expressions of emotional disturbance, while the logical correctness of any proposition is less important than its accordance with human nature.

Defying this general pattern of temperance is the strong undercurrent of rage that periodically surfaces in the eruption of volcanic anger, sometimes leading to violence over relatively trivial matters, for example, limited parking spaces in densely populated cities, higher food prices, and delayed airline flights, along with more serious matters, for instance, chemical explosions, as occurred in the city of Tianjin in 2015. In an increasingly pressurized and impatient society beset by intense competition in **education**, housing, and jobs, decorum and civility have often given way to fits of fury aimed at rival work colleagues and misbehaving "**corrupt**" (*fubai*) and "arrogant" (*aomen*) officials, especially when carried out by uncontrollable mobs. Also criticized are public intellectuals too often inclined to mutual cursing and **accusation** on a variety of issues with little or no reliance on "logic" (*luoji*) or a gentile exchange of views. While superficial harmony is generally pursued in public, anger is often expressed in private settings and increasingly via the internet, which has become an undercurrent of indignation and animosity. Chinese concerned with the destructive personal and social consequences of uncontrolled anger are seeking assistance through anger management programs, especially parents seeking lessons in **mediation**, mindfulness, and even hypnosis to keep in check their unwarranted outbursts, often directed at underperforming **children**.

ANIMALS AND INSECTS (*DONGWU/KUNCHONG*). A predominantly agricultural society throughout history, including the era of the People's Republic of China (PRC) (1949–present), animals, both real and **mythological**, assume important symbolic status in China. Seen as embodiments of the widespread belief in **fortune** and good luck, animals make up the Chinese **Zodiac**, while insects, particularly "ants" (*mayi*) and "bees" (*mifeng*), are admired for qualities of hard work and collective action. Five classifications exist for animals, led by a particular species and associated with a geographical direction: 1) scaled, "dragon" (*long*) and East; 2) furry, "unicorn" (*qilin*) and West; 3) humankind, no association; 4) feathered, "birds" (*niao*), "phoenix" (*fenghuan*), and South; and 5) shelled, "tortoise" (*gui*) and North. Most prominent are the 12 animals represented in the Chinese Zodiac, listed in their calendrical order with symbolic associations: "rat" (*shu*), **money**; "ox" (*niu*), strength; "tiger" (*hu*), bravery; "rabbit" (*tu*), **longevity** and **charm**; dragon, power and good luck; "snake" (*she*), **wisdom** and cunning; "horse" (*ma*), swiftness; "sheep" (*yang*), satisfaction and docility; "monkey" (*hou*), clever and mischievous; "rooster" (*ji*), longevity, fidelity, and successful; "dog" (*gou*), loyal, strong, and patient; and "pig" (*zhu*), wealth and abundance.

Featured prominently in Chinese **arts**, including **literature**, **painting**, **sculpture**, and **theater**, animals are frequently attributed human characteristics, most notably the heroic Monkey King, Sun Wukong, in the classic

20 • ANIMALS AND INSECTS (DONGWU/KUNCHONG)

Journey to the West (Xiyou Ji). Displaying an ability to maneuver between the human world and the realm of the **gods**, the Monkey King also possessed 72 earthly transformations into various animals and objects, a capacity shared by other creatures, including dogs and the "carp" (*liyü*), which at critical examination time for aspiring **scholars** transformed into a benevolent dragon. Pigs were also prized as protectors of young male **children** who, following an old Chinese **custom**, were dressed in hats and shoes in the shape of a pig to prevent any misfortune. Evil spirits, parents believed, would be fooled into thinking the child was a pig and steer clear.

Most animals are assigned symbolic characteristics many with human qualities, including species that are not native to the country, for example, the "lion" (*shi*), which is associated with **Buddhism** and in pairs symbolize **happiness** and a wish for prosperity. Stone sculptures of guardian lions, known in English as foo dogs, are erected as **architectural** ornaments, especially in front of imperial palaces, temples, and homes of prominent officials, as a protection from harmful **spiritual** influences. Foremost is the mythical dragon, which represents the Chinese nation and the emperor, and, on the popular level, is associated in weddings with the groom and the equally mythical phoenix with the bride. The equally mythical unicorn is also revered, as the appearance of the animal is said to herald great events, for example, just prior to the birth of Confucius (551–479 BCE), while the equally mythical phoenix symbolizes **virtue**, duty, and correct behavior. Real animals with great symbolic and positive appeal include the "elephant" (*xiang*), representing wisdom and strength; the "giant tortoise" (*ao*), a stabilizing creature firmly rooted in the ground, with carvings added to roof sides to protect buildings and commonly associated with academic examinations; "deer" (*lu*), symbolizing **longevity** and riches, with antlers and penises used in **traditional Chinese medicine (TCM)**; "bear" (*xiong*), representing strength and bravery, often portrayed in paintings with the renowned "panda bear" (*xiongmao*), symbolizing prosperity and abundance, while serving as China's national **symbol**; "fish" (*yü*), bringing good luck, as the word in Mandarin sounds like "plenty" (*chongyu*) and "surplus" (*shengyu*), while also revered in Buddhism, symbolizing **freedom**, fertility, and abundance; the "wolf" (*lang*), a rapacious but independent and powerful beast portrayed in the Chinese film *Wolf Totem*; the phoenix, symbolizing virtue, duty, and correct behavior, and one of China's sacred animals, along with the dragon, unicorn, and tortoise; and the "crane" (*he*), the second most important winged animal after the phoenix.

Additional animals, including birds and sea life, listed with their symbolic status, include the following: the "badger" (*huan*), great happiness; the "bat" (*bianfu*), good luck, longevity, and prosperity; the carp, strength and perseverance; the "crab" (*pangxie*), prosperous **business**; the "donkey" (*lü*), steadfastness and determination, but with a reputation for stupidity; the "duck"

ANIMALS AND INSECTS (DONGWU/KUNCHONG) • 21

(*ya*), marital bliss; the "eagle" (*ying*), strength; the "lobster" (*longxia*), regeneration; the "magpie" (*que*), stability and celebration; the "owl" (*maotouying*), harbinger of **death**; the "peacock" (*kongque*), dignity; the "pheasant" (*zhi*), **beauty** and grace; and the "shrimp" (*xia*), long life. Noxious animals roaming the earth include "centipedes" (*wugong*), "lizards" (*xiyi*), "scorpions" (*xiezi*), snakes, and "toads" (*hama*), the last also associated with money. Along with ants and bees, prime insects include "butterflies" (*hudie*), a symbol of love and beauty, and "crickets" (*xishuai*), admired for their fighting spirit and kept as **pets**, especially by elderly men. Excited Insects Day, China's Groundhog Day, occurs in early March, marking the beginning of spring, when insects supposedly awaken from winter hibernation, aroused from their slumber by the Lordly Dragon.

Dogs and other protective and utilitarian animals were also revered in Chinese history with "oracle bones" (*jiagu*) consisting of ox scapula or turtle plastron, used for pyromancy, a type of divination, in ancient China, especially during the late Shang Dynasty (1600–1046 BCE). Mistreatment and cruelty toward animals also existed, which was reinforced in the PRC during the rule of the Chinese Communist Party (CCP) by **Mao Zedong** (1949–1976), when love of animals and pet-keeping were denounced as "bourgeois," with some creatures, especially tigers, almost wiped out by widespread and state-sponsored **hunting**.

Following the introduction of economic reforms and social liberalization (1978–1979), a more humane and benevolent treatment of animals has generally reigned, with the growth of zoos, **wildlife** parks, aquariums, and **shopping** malls featuring live animal displays. Yet, examples of inhumane practices persist, including the skinning of such live animals as angora rabbits for fur and the human consumption of dogs and cats, 27 million annually, at meat **festivals**, for example, in Yulin, Guangxi, where the painful killing of the animals by blowtorch is believed to improve the taste of the cooked meat. As many Chinese people still enjoy the spectacle of animal suffering, with video postings of raccoon dogs being beaten to death with steel pipes, animal welfare and rights groups, both domestic and foreign, for instance, PETA (People for Ethical Treatment of Animals) and Humane Society International, have responded with calls for greater regulation by the Chinese government, as no nationwide law yet exists banning the mistreatment and cruel treatment of animals. The globe's largest fur producer, with the world's biggest foie gras farm, near Poyang Lake, Jiangxi, China has received a low ranking by the World Animal Protection Annual Index, although some protective measures have been taken, notably banning animal testing in the development of cosmetics.

22 • ANIMATION (DONGHUA)

ANIMATION (*DONGHUA*). Introduced into China in 1918, with domestic production of animation films beginning in the 1930s, animated films experienced a golden age in the 1960s but with quality declining after the introduction of economic reforms (1978–1979), as the **market** in the People's Republic of China (PRC) became dominated by foreign products, especially from the United States. Under the direction of Wan Laiming, considered the first Chinese animator, and Wan Guchan, together known as the Wan brothers and founders of the Shanghai Animation Studio, animation classics produced in the 1960s included *Havoc in Heaven* (Danao Tiangong), a story featuring the Monkey King, Sun Wukong, from *Journey to the West*, with background **music** from Chinese **opera**. With animation treated as an extension of Chinese **arts** and culture, from ancient folklore to Chinese **comedy** known as *manhua*, other notable films from this period included the following: *Tadpoles Searching for Mother* (Xiao Kedou Zhao Mama), based on traditional Chinese ink-wash **painting**, which won several domestic and international awards; *Feelings from Mountain and Water* (Shanshui Qing), without dialogue, allowing it to be viewed by any culture; and *The Cowboy's Flute* (Mudi), a portrayal of traditional pastoral life, which was attacked during the ensuing **Cultural Revolution (1966–1976)**.

Shut down for a decade, as many animators were forced to give up their craft and "sent down to the countryside" (*xiaxiang*) to perform **manual labor**, the animation industry was revived from the late 1970s onward. Productions included such films as *Na Zha Conquers the Dragon King* (Nazha Naohai/1979), which featured heroic acts by the traditional **god** of protection, and was screened out of competition at the 1980 Cannes Film Festival. While time-consuming and costly ink-wash productions were abandoned, new technologies were introduced, for example, computer generated (CG) footage, including three-dimensional imagery. Considered a key sector for the birth of a new national identity and cultural development, the Chinese government provided considerable financial support to the animation industry beginning in 2006, with 6,000 studios producing short and feature-long animations but with many of the films suffering from low quality and poor scripts, and being decried by critics as "childish" (*youzhi*). Two types of animation exist, conventional animation produced by large studios and corporations, and the so-called webtoons or flash animation, produced by companies and individuals, allowing for greater freedom of expression.

The largest animation box office in the world in 2019, targeted audiences in China consist primarily of young people and **children**, numbering 370 million, with more female than male viewers. Government oversight of the industry is conducted by the State Administration of Radio, Film, and Television (SARFT) but with little **censorship**, as most productions involve harmless **folktales and fairy tales**. Especially popular were made-for-television serials. These include *3,000 Whys of the Blue Cat* (Lanmao Taoqi 3,000

ANTIQUARIANISM (GUWENZHUYI) • 23

Wen), the first of the genre, aired from 1999–2001, with a focus on **science**; *The Dreaming Girl* (Mengli Ren), made in 2005, dealing with contemporary teenage problems; and *The Legend of Qin* (Qin Shi Mingyue), produced in 2007, recounting the period of China's unification during the Qin Dynasty (221–206 BCE). More recent feature film productions include *Great Bug* (Kuiba/2011), *Monkey King: Hero Is Back* (Xiyouji Zhi Da Sheng Guilai/ 2015), *Big Fish and Begonia* (Dayu Haitang/2016), the controversial *Have a Nice Day* (Dashijie, 2017), and *The King of Football* (2019), the last yielding mixed **commercial** results. With the domestic market dominated by foreign animation features from the United States, for instance, *Zootopia* by Walt Disney Studios, and Japan, especially the uniquely Japanese anime, Chinese animators are seeking to win back "patriotic" viewers by combining Disney-esque narrative with Chinese cultural and historical themes, with an example being the 3-D major box-office success *Nazha* (2019).

ANTIQUARIANISM (*GUWENZHUYI*). Defined as the study or love of antiquities, particularly works of **art** and **literature**, antiquarianism appeared relatively late in Chinese imperial **history**, beginning in the Song Dynasty (960–1279) and continuing through subsequent dynasties and into the modern era during the Republic of China (ROC) on the mainland (1912–1949) and the People's Republic of China (PRC) since 1949. Research and study of China's rich collection of antiquities since ancient times began during the Song Dynasty primarily in response to the menacing threat of nomadic raiders with sophisticated cultural systems on the shrunken borders of the empire, challenging belief in the universality of the Chinese world order. With the fundamental principle of "China" (*Zhongguo*) as the center of world culture under threat, Chinese **scholars and intellectuals** in the Song engaged in a massive retreat into their glorious past with the study of "bronze and stone" (*jinshixue*), primarily ancient bronze vessels, bells, stone stele, and ink rubbings. Expanded to **paintings** and especially **calligraphy** in subsequent dynasties, systematic investigation of ancient splendors was subsequently labeled "Chinese culturalism" (*Zhongguo wenhuazhuyi*) and became a forerunner of modern Chinese **nationalism**.

For Chinese emperors and modern Chinese leaders of the ROC and PRC, collection and preservation of China's rich array of antiquities was considered a major source of political legitimacy. Most notable was the enormous collection of antiquities by Emperor Qian Long (1735–1796) during the Qing Dynasty (1644–1911), exceeding previous emperors, along with substantial collections amassed by Nationalist Party (*Kuomintang*) leader Chiang Kai-shek (1928–1949) and moved to Taiwan following the end of the Chinese Civil War (1946–1949). Similar attempts by the Chinese Communist Party (CCP) after taking power in 1949, to rebuild an imperial collection in **Beijing**, also transpired, with private collectors "invited" (*yaoqing*) to contribute

24 • APOLOGY AND APOLOGIZING (DAOQIAN)

paintings and other valuable antiquities, while the new PRC government bought back great Chinese masterpieces on international **markets** and at auctions, often at great cost.

Despite periodic attacks on China's imperial past in the history of the PRC, most notably during the **Cultural Revolution (1966–1976)**, studies of China's "cultural heritage" (*wenhua yichan*) have continued since the 1980s, reaffirming the ancient **Confucian** adage that antiquity is the repository of all human value. Common Chinese-**language** terms employed in the antiquarian field include *guwu*, "ancient objects"; *shiji*, "historic sites"; *guji*, "ancient sites"; *mengsheng*, "famous sites"; *wenwu*, "cultural relics"; and *guobao*, "national treasure."

APOLOGY AND APOLOGIZING (*DAOQIAN*). In a society generally lacking a spirit of apology, declarations of apologies in China are a complicated matter, having great significance and, in the most serious cases, bordering on the traumatic. Varying in severity, Chinese-language terms for "apologize" or "I'm sorry" range from *yihan*, used to indicate regret for being unable to accept an invitation, to the phrase *buhao yisi*, an expression of unhappiness related to an embarrassing situation involving a relatively trivial matter, *duibuqi*, dealing with a fairly serious situation, and the more formal *daoqian*, indicating admission of guilt and seeking forgiveness concerning an important matter, with *shen baoqian* as an expression of the deepest apologies. Rarely offered and often not accepted, apologies must be made with a proper level of gravity and respect that can often involve a great loss of "**face.**" Less an acknowledgement of responsibility or fault, apologies, when offered, are goal-oriented, with an intent to solve problems and overcome difficulties by greasing the wheels of personal **relations**.

That Chinese consider themselves polite but have a problem saying "sorry" has been attributed to the country's weak litigious tradition and a legacy of the **Cultural Revolution (1966–1976),** when after years of being forced to engage in unwarranted and undeserved **criticism and self-criticism**, stopping to say sorry for virtually anything became a national trait. For individuals reluctant or unwilling to offer personal apologies, private companies can now be hired to write letters, deliver **gifts**, and make explanations to an offended party. On the political level, Chinese leaders have yet to issue an apology to the millions of victims, especially during the Cultural Revolution, while in international relations the government of the People's Republic of China (PRC) interpreted the apology expressed by U.S. president Bill Clinton, following the accidental bombing of the Chinese embassy in Belgrade in 1999, as "not really an apology at all." Dozens of multinational corporations operating in China, including Versace, Christian Dior, Delta Airlines, McDonald's, and Zara, have also found it necessary to periodically issue apologies—some would say grovel—after making statements or taking actions

ARCHAEOLOGY (KAOGU XUE) • 25

considered offensive to China and its people, including, in 2019, comments made by a member of the National Basketball Association (NBA) from the United States regarding political events in **Hong Kong**.

ARCHAEOLOGY (*KAOGU XUE*). Archaeological research in China began during the imperial era with modern archaeology introduced in the late 19th and early 20th centuries by foreign explorers, missionaries, and **scholars**, for example, Sven Anders Hedin of Sweden and Marc Aurel Stein of Great Britain, whose surveys and expeditions introduced modern archaeological concepts and techniques into the country. Along with the discovery in 1900, of **Buddhist** scripture caves at Dunhuang in Gansu, dating to the 4th through 13th centuries, major archaeological discoveries included, most notably, the excavation of human fossil sites—the 500,000-year-old "Peking Man" (*Sinanthropus pekinensis*) of Zhoukoudian—at the Yangshao settlement in Mianchi County, Henan, in 1929, by Johan G. Andersson, a Swedish geologist. Liang Siyong, a Chinese graduate of Harvard University, excavated a tomb in Manchuria in 1930, containing artifacts and human remains dating back 7,000 years, and for this discovery Liang became known as the "father of modern Chinese archaeology." Other major archaeological finds include the accidental discovery in 1899, of the "ruins of Yin" (*Yinxu*), the last capital of the ancient Shang Dynasty (1600–1046 BCE), with a rich lode of "oracle bones" (*jiagu*), located near Anyang, Henan. Concerned about the pilfering of the estimated 350,000 archaeological sites in China, especially such national treasures as the Buddhist grottos at Dunhuang and Longmen by both Chinese and **foreigners**, laws to protect artifacts were passed in 1913–1914, as well as 1930, although enforcement remained a major problem, as foreign and domestic looting remained rampant.

Following the establishment of the People's Republic of China (PRC) in 1949, an array of organizations and institutes were set up at the national, provincial, and local levels to organize and systematize archaeological research. These included the Institute of Archaeology under the Chinese Academy of Social Sciences (CASS) and other relevant organizations, for instance, the Paleo-Anthropology Office under the Institute of Vertebrate Paleontology and Paleo-Anthropology of the Chinese Academy of Sciences (CAS), and the State Bureau of Cultural Relics, later renamed the State Administration of Cultural Heritage, which supervises nationwide archaeological excavation, **museum** exhibitions, and the protection of cultural antiquities through a national ranking system of cultural relics. Many Chinese universities, including Peking University, set up archaeological departments that throughout the decades have turned out highly trained personnel. Three major publications on archaeology, *Cultural Relics*, *Archaeology*, and *Archaeology Journal*, were started and then resumed publication following the disruptions of the **Cultural Revolution (1966–1976)**, along with a plethora

26 • ARCHAEOLOGY (KAOGU XUE)

of academic studies and monographs, plus 20 specialty newspapers and periodicals put out by research institutes, universities, and publishing houses, notably the Cultural Relics Publishing House. Following the establishment of the Chinese Society of Archaeology in 1979, similar organs in the provinces and autonomous **regions** were set up, and, in conjunction with *China Cultural Relics Newspaper*, hold an annual appraisal of the top 10 greatest archaeological discoveries in the country. The State Administration of Cultural Heritage (SACH) oversees national policy on preservation of cultural antiquities in China, as embodied in several cultural relics laws, most recently the 1982 statute, amended in 2015. Major initiatives include the "China Principles of Archaeology," which enshrine conservation principles and mandate an interdisciplinary management process requiring a master plan for research. Also established are visitor capacity limits at such sensitive sites as the Buddhist grottos of Mogao at Dunhuang, where a major restoration and preservation effort of the 492 cave temples has been carried out with the assistance of the Getty Conservation Institute and the Australian Heritage Commission.

Despite the enormous upheaval that characterized the Cultural Revolution, major archaeological discoveries were achieved, for example, the unearthing of well-preserved bronzes from the 11th century BCE. But it was in the 1970s that China experienced its "golden age of archaeology" with such major discoveries as well-preserved tombs near Changsha, Hunan, and, most importantly, the Terracotta Warriors of the Qin Dynasty (221–206 BCE), which were unearthed in 1974 and 1976, in Shaanxi. Although much of the site had been looted throughout the centuries, archaeologists acted on information provided by local farmers and uncovered three separate pits, the second of which was opened in 1976, containing 1,400 individually crafted warrior figures, along with horses and 64 chariots. Surrounding the still-unexcavated tomb of Qin Shihuang, autocratic unifier of the empire, the Terracotta Warriors are undoubtedly China's most internationally recognized archaeological treasure. Others include the Buddhist Mogao Grottoes, which, since 1987, have been listed as a World Heritage Site of the United Nations Educational, Scientific, and Cultural Organization (UNESCO); the imperial tombs of the Ming (1368–1644) and Qing (1644–1911) dynasties located outside **Beijing**; such lesser-known but historically valuable finds as the ruins of the imperial palace of the Western Han Dynasty (202 BCE–9 CE), uncovered outside the western city of **Xi'an**; ruins of the ancient city of Jiaohe (Yarkhoto), capital of the Jushi Kingdom (108 BCE–450 CE) near the city of Turpan in present-day Xinjiang-Uighur Autonomous Region (XUAR); and textiles and lacquer monsters, as well as other works of **art**, from the Chu and other **minority** cultures (circa 770–221 BCE) in the southwest. These shed new light on the complex origins and development lines of a highly regionalized Chinese civilization. In addition to modern tools of

archaeological research, like carbon-14 age measurement data, China has also adopted modern modes of archaeological surveying using satellite photos from the U.S. CORONA satellite, along with studies of earthquakes, hydrology, **music**, arts, and the history of **architecture**, often in joint investigations with archaeologists from Europe, North America, and Japan, with excavations of thousands of cultural relics from ancient tombs annually.

Many archaeological discoveries in China have contributed to a significant rewriting of Chinese and human history, China's contact with the outside world, and the boundaries of Chinese culture with such neighboring states as Korea. Ever since the discovery of Peking Man, China has weighed in on the complex debate concerning human origins. Recent discoveries of fossil sites at "Renzi Cave" (*Renzidong*) in Anhui show that *Homo erectus* may have established itself in China 2.5 million years ago, more than 400,000 years earlier than previously thought, which has led some Chinese scientists to propose human evolution in China as parallel to that already observed in Africa. While most Western scholars favor an early dispersal of *Homo erectus* out of Africa into Asia, *Renzidong* and a half dozen other sites in China dating to between 1.8 million and 800,000 years ago support an "Asian hypothesis," which has energized Chinese scientists and loosened important funding from CAS and other government agencies. Other archaeological breakthroughs include a 1997 discovery in Shandong of what is believed to be the oldest Chinese-**language** characters ever written on oracle bones and the oldest inscription on stoneware. Stone carvings were also recently unearthed from the era of the Eastern Han Dynasty (25 BCE–220 CE), indicating that Christianity entered China as early as 86 CE, 550 years prior to the Tang Dynasty (618–907), when Syrian missionaries are known to have brought Christian doctrine into China. Discovery of the 3,000-year-old Cherchen Man mummies, with western, Caucasian features, in Western China, suggest that China's contact with the West occurred during the very beginnings of Chinese civilization. This opened the possibility of Western influence on the origins of Chinese culture, while the tombs and ruins of the Koguryo Kingdom (37 BCE–668 CE), unearthed in the northeastern provinces of Jilin and Liaoning, support contentions by the Chinese that the kingdom considered by Korea (North and South) as its cultural forerunner was, in fact, an "important part of Chinese culture." Such assertions led to immediate, strongly emotional reactions from both North and South Korean spokespeople, who accused China of a "serious historical distortion," which they claim was part of a hidden political agenda. Similar controversies have arisen concerning Chinese discoveries in the South China Sea, specifically relics in sunken vessels, which the Chinese assert verify the country's claim to disputed territories, in this case the Paracel Islands, for which Vietnam has counterclaims. Major archaeological organs like the Underwater Archaeolog-

28 • ARCHAEOLOGY (KAOGU XUE)

ical Heritage Center have, in fact, been set up with the specific purpose of finding "evidence" that reinforces the official history used by the PRC in making territorial claims.

Just as other nations with rich archaeological sites, for example, Egypt and Iraq, have had to deal with the effects of exogenous forces—human and natural—on their cultural relics, China was confronted with a host of serious assaults, including the rash of urbanization and destruction of old buildings and areas in the name of modernization. Following the establishment of the PRC, China cut off foreign involvement in archaeological exploration, citing the role of **foreigners** in removing relics and antiquities from their original sites to museums and private collections in the West. Frescoes taken from Dunhuang and on view in London and Paris, and at Harvard University, have been the subject of a repatriation request from Dunhuang Academy, even as China has reopened its cooperation with foreign investigators in the last two decades.

More illicit means of archaeological destruction of the country's mostly unexcavated sites include the wanton looting of many sites by grave robbers, **rural** scavengers, and professional smugglers, often with the compliance of local officials, who seek lucrative foreign buyers and whose destructive impact has reportedly exceeded the Cultural Revolution. It is estimated that 95 percent of the tombs in China have been looted primarily by local residents, who reportedly abide by the notion that "to be rich, dig up an ancient tomb; to make a fortune, open up a coffin." China's massive campaign of capital construction, especially highway and road construction, has also wrought severe damage on parts of the **Great Wall**, which spans nine provinces and 100 counties in China, and has also suffered from botched efforts at "restoration" (*huifu*) by local and largely untrained conservationists. As much as 30 percent of the wall has been lost to the effects of erosion and looting, which, in 2006, led China to establish regulations for its protection, although such restrictions are difficult to enforce in impoverished counties, where the looting is most pronounced. Significant damage has also been incurred at Zhoukoudian and largely unexplored sites of China's southern cultural heritage involving the ancient Ba culture in and around the Three Gorges Dam Project on the Yangzi River in Central China. Here, unprecedented looting has been met with a tepid government response as local authorities wrangle over which relics should receive the promised central government funding for protection.

Whereas 50 years ago, China had 300 walled cities, by 2004, as a result of China's version of **urban** renewal, only four were left: Pingyao in Shanxi, a 1997 UNESCO World Heritage Site; Xi'an in Shaanxi; Xincheng in Liaoning; and Jingzhou in Hebei. Of China's original 2,000 historic cities, a mere 100 have survived, with only about 20 preserved in anything comparable to their original state. While archaeological activists in China have won some

ARCHAEOLOGY (KAOGU XUE) • 29

notable battles, for instance, the preservation in the city of **Shanghai** of the Bund riverfront and the famous Nanjing Road shopping street, over **Hong Kong** developers, other efforts have failed, with notable examples being the belated attempt to protect Dinghai Township in Zhejiang province and the old city in Tianjin. Of 730 UNESCO World Heritage Sites worldwide, 28 are in China, but getting local officials to observe basic rules governing historical conservation has been difficult, as old **neighborhoods** in the major cities have been relentlessly destroyed, in the name of "renovation" (*zhuangxiu*). A Law on the Protection of Cultural Relics was enacted in 2002, which was subsequently strengthened by vesting ownership of all cultural relics in the state and prohibiting the sale and permanent export of newly excavated archaeological objects to stop an increase in looting and the illicit sale of antiquities.

Documentation of looting in China is carried out by the Beijing Cultural Heritage Protection Research Center, which, in 2005, asked the United States to restrict imports of archaeological materials according to the Convention on Cultural Property Implementation Act. Since 2002, millions of dollars have been spent by the Chinese government at auctions, buying back treasures looted from Beijing's Summer Palace by British and French troops 140 years ago, as the Chinese State Relics Bureau wrote letters to Sotheby's and Christie's Hong Kong protesting the sales. Both houses allowed their sales to proceed, and the China Poly Group Corporation, a Beijing-based state-owned enterprise (SOE), stepped in to win bids on three of four contested objects, including bronze animal heads that once decorated a **Zodiac** fountain at the Summer Palace. China has teamed up in such joint international archaeological digs as the Sino–American team that, since 1991, has been excavating sites in and around the city of Kaifeng in Henan, once the capital of the Song Dynasty (960–1279), in search of oracle bones from the ancient Shang Dynasty.

New discoveries from 2012 to 2015 include the following: Sunjiadong Paleolithic site, near Luoyang City in Henan, with a rich variety of **animal** fossils and stone tools; Hailongtun fortress on Longyan Mountain, dating to the 13th century, near Zunhiryi City, Guizhou; Xishanpo Buddhist Temple Ruins, in Inner Mongolia, dating to 918, in Shangjing City, one of the five imperial capitals of the Liao Dynasty (916–1125), including Buddhist clay and stone **sculptures** and **ceramic** fragments; Han Dynasty (202 BCE–220 CE) imperial tombs, severely looted, at Lingsheng Lake in Shandong; Shimao ruins of an imperial town from the Longshan period (2350–1950 BCE) to the Xia Dynasty (2205?–1766? BCE) in Shaanxi; excavations of the mausoleum yard of Qin Shihuang, which found pieces of Terracotta Warriors, bronze objects, and stone tools, along with a large building complex with rooms containing heretofore unknown murals; Wenfengta cemetery of the **burial** ground of the Zeng state from the Eastern Zhou Dynasty (770–221

30 • ARCHITECTURE (JIANZHU)

BCE), containing burial offerings of bronze *ding* tripods and two chariot pits; the tomb of Emperor Yangdi of the Sui Dynasty (581–618), consisting of a large earthen mound; and the accidental discovery of 700-year-old buried tombs from the Ming Dynasty (1368–1644), containing remains of high-ranking **women** in Taizhou, Jiangsu. Major journals in the field include *Cultural Relics* (Wenwu) and *Research Materials on Cultural Relics* (Wenwu Cankao Ziliao).

ARCHITECTURE (*JIANZHU*). China's **urban** and **rural** architecture reflects a long history from the imperial era (221 BCE–1911 CE) to the period of Western intervention and semicolonialism in the 19th to early 20th centuries. Following the establishment of the People's Republic of China (PRC) in 1949, new architecture was influenced by the Stalinist style during the era of Soviet central economic planning (1953–1978), while modernist and postmodernist patterns from domestic and foreign sources prevailed following the introduction of economic reforms and social liberalization (1978–1979) as the architecture sector in China became increasingly flamboyant, with an anything-goes environment predominating.

The imperial era left China with a rich architectural heritage that is reflected in the **pagodas and temples**, palaces, and extended-**family** homes of the wealthy, as well as the centerpiece of the imperial presence, the **Forbidden City** in central **Beijing**. Chinese traditional structures are based on the philosophical principles of balance and symmetry, with the main structure of a building serving as the axis for the entire edifice, along with curved ceilings, alluding to the infinite space of the universe. Secondary structures of residences, temples, and palaces are positioned as two wings on either side to form the main rooms and surrounding an enclosed yard. **Religious** buildings are dominated by the **Buddhist** stupa or pagoda, which takes the form of a storied tower or, more rarely, an upturned bowl. Constructed primarily out of wood, their shape may be tetragonal, octagon, or diagonal, with the number of stories different for each of the buildings.

Imperial cities, especially those that periodically served as capitals, for example, Beijing, **Xi'an** (Shaanxi), and Luoyang (Henan), were laid out in a **spiritually** favorable rectangular pattern, typically on north–south and east–west axes, and surrounded by a defensive high wall. Despite the best efforts of Liang Sicheng, considered the "father of modern Chinese architecture," who, wanting to preserve much of Old Beijing, called for preserving the city's inner and outer walls, it was unfortunately demolished soon after the Communist takeover in 1949, although Xi'an's magnificent wall remains intact. Residences of the wealthy and influential were protected by their own walls, which can also be found, although in less elegant form, in China's villages, where farmers' houses of mud bricks and roots of reed have their own individual protective walls. Roof design plays a key role in traditional

ARCHITECTURE (JIANZHU) • 31

architecture, exuding deeper spiritual meaning, as in the case of temple roofs with up-curled eaves, reflecting the Buddhist belief that such a design conferred good **fortune** by warding off evil spirits that move in straight lines, with carved ornaments of tortoises serving as additional protection.

China's traditional architectural heritage was based on certain basic rules that endured throughout the centuries, thereby producing little temporal variation, including the notion that structures along a north–south axial line must be arranged in a symmetrical fashion. This was evident in the layout of Tiananmen Square before its wholesale transformation in the 1950s, which led to the creation of one of the largest open urban spaces in the word, at 44 square hectares (100 acres). Regional differences also emerged, with the northern architectural tradition comparatively more restrained and sober, while that from the south eventually exaggerated curved ornamentation to a high degree.

In traditional and modern times, the positioning and design of buildings is highly influenced by the **cosmology** of **fengshui** ("wind and water"), prevalent in **Daoism**, a geomancy system of principles that assesses how buildings in certain areas must be positioned so as not to disturb spiritual aspects of the surrounding landscape. Whether simple farmer residences or a **Shanghai** skyscraper, ideal forms for individual structures are proposed, along with carefully arranged spaces and components within a building, according to time-honored forms that minimize upsetting the fragile balance of the cosmos.

While China's accelerated march toward modernization and industrial development beginning in the 1950s has led to the demolition of innumerable traditional temples, residences, city walls, and, in some cases, entire towns, scattered examples of old-town architecture, for instance, the highly influential "**Huizhou** style" from the 17th century, with its two-story house plan centered around a courtyard, can still be found, even in such big cities as Chengdu, **Sichuan**. Perhaps the most famous structure from imperial times is the "Temple of Heaven" (*Tiantan*) in Beijing, with its circular mound altar, which served as the site for Ming (1368–1644) and Qing (1644–1911) dynasty emperors to worship heaven. Constructed in three tiers, with the upper terrace made up of nonconcentric rings, the innermost ring of the Temple consists of nine fan-shaped slabs with each outer ring made of the slabs in increasing multiples of nine—an odd **number** considered categorically masculine and often found in traditional architectural styles.

China's modern architecture reflects its political and economic history beginning from the mid-19th century onward, when in treaty ports along the eastern coast Western colonial buildings were constructed in concessionary areas carved out in major cities like Shanghai, Tianjin, and **Guangzhou**. Foreign consulates, offices, warehouses, churches, banks, shipping firms, and residences of foreign merchants and missionaries dominated entire

32 • ARCHITECTURE (JIANZHU)

streets and neighborhoods with construction of European-inspired buildings in art deco that, like the "stone gate" (*shikumen*) style in Shanghai, blended features of East and West, surviving through the 1930s and largely left intact following the establishment of the PRC in 1949.

During the period of cooperation with the Soviet Union in the early 1950s, China adopted many of the features of the brutally functional, wedding-cake Soviet/Stalinist style in everything from factories to exhibition centers to hotels, which followed the identical drab, box-like design that is often combined, as in the gigantic Shanghai exhibition hall, with massive spires and towers. At the same time, official campaigns against traditional architectural forms were carried out, as in 1955, when big-roof design characterized by overhanging eaves was singled out for criticism as examples of Chinese "feudalism" (*fengjianzhuyi*). Emblematic of this era is the massive Great Hall of the People, located in Tiananmen Square in Beijing, which was built in near-record time during the frenzy of the Great Leap Forward (1958–1960). Along with nine other large-scale structures built during this period in Beijing, notably the Museum of the Chinese Revolution, the Museum of Chinese History, and the Military Museum, the Great Hall articulated a close affiliation between the political power of the Chinese Communist Party (CCP) and architecture, glorifying the achievements of the epoch. Traditional forms were retained in design of the Great Hall, for example, the unequal spacing between columns numbering 12, the same as the Hall of Supreme Harmony in the Forbidden City, shaped in conventional lotus petals, symbolizing purity and uprightness. Following Renaissance and neo-classical styles in colonnade formation, the massive building has an overall rectangular exterior with an emphasis on proportion and uniformity of segments. One of the largest buildings in the world, the Great Hall serves as the site for many of the major meetings and conferences convened by the CCP, with an auditorium capable of seating "10,000" (*wansui*), a number synonymous with infinity and curved ceilings, suggesting infinite space. Following the death of CCP chairman **Mao Zedong** in September 1976, a mausoleum housing his preserved corpse was also constructed in the center of Tiananmen Square, with the architecture purportedly modeled on the Lincoln Memorial in Washington, DC.

Following the introduction of economic reforms and the "opening up" (*kaifang*) to the Western world (1978–1979), China moved to a more international look in architecture, apparent in the innumerable concrete-and-glass high-rise trophy buildings that dot virtually every major Chinese city. Brighter than their Russian counterparts, these uninspiring and often unattractive structures generally reject any attempt to marry the traditional Chinese form with current needs, while putting an enormous premium on gigantic size and monumental postmodern forms, often capped with rooftop restaurants resembling flying saucers. The Pudong development zone in Shanghai sports some of the most egregious examples of this style, with three massive structures:

ARCHITECTURE (JIANZHU) • 33

Jin Mao tower (1994), with the atrium of the Hyatt Hotel starting at the 53rd floor and extending to the 87th; the 101-story World Financial Center (2007), composed of glass and metal following a simple geometric curvature form; and Shanghai Tower (2008), which at 128 floors is the tallest of the three, consisting of nine cylindrical buildings and constructed for high **energy** efficiency and sustainability. Despite a massive glut of office space in Pudong and most other major Chinese cities, construction of trophy buildings continues unabated, including the 115-story Ping An International Finance Center in Shenzhen (2017) and the planned 220-story Sky City, planned for completion in 2021, in Changsha, Hunan, making it the tallest building in the world. At the same time, the assault on traditional architecture continues in many urban areas, notably Beijing, where historically important buildings and neighborhoods, including 7,000 to 8,000 alleyways (*hutongs*), have been torn down and replaced by a glittering array of avant-garde skyscrapers and cheap concrete edifices, often with a conventional tower-on-podium design. Decried by architectural preservationists as "demolishing history in order to develop," this rush toward modernization has too often led to a reckless extermination of the country's rich architectural legacy.

Many of China's most ambitious designs—for instance, the National Theatre for the Performing Arts, near Tiananmen Square, the gravity-defying structure of China Central Television headquarters, and the monumental Galaxy Soho in central Beijing—have been done by such notable foreign architects as French designer Paul Andreu, Dutchman Rem Koolhaas, and the Iraqi-British Zaha Hadida. For China's indigenous architects, this situation has led to complaints that the country's architectural heritage is being lost in the rush toward international engagement, especially as many Chinese architectural firms, the likes of MAD Architects in Beijing, employ large numbers of foreign architects. Andreu's titanium-and-glass giant egg design for the National Theatre, with its soaring glass dome set like a floating bubble in a lake with an underwater tunnel entrance, is said to violate basic fengshui principles. In addition to Shanghai's Grand Theatre, designed by Frenchman Jean-Marie Charpentier, with its oriental-industrial architecture, there is the National Museum, designed by the Shanghai Architectural Institute in the form of a squat, round building with roof handles resembling a traditional Chinese "bronze pot" (*ding*).

Major new buildings were also constructed for international sporting events, including the 2008 Beijing Olympics, for example, the Beijing National Stadium, designed by **Ai Weiwei** and Swiss architects, and commonly referred to as the "Bird's Nest" (*Yanwo*) because of its crisscrossing steel bars, and the National Aquatic Center, known as the "water cube" (*shui lifang*), inspired by soap bubbles and constructed of lightweight Teflon materials. Somewhat more elegant designs can be found in less grandiose and neo-traditional structures, for instance, the Guardian Art Center in Beijing

34 • ARCHITECTURE (JIANZHU)

and the Construction Bank of China building in Xiamen, Fujian, which features a broad, curving glass curtain wall façade along its southwest side and main entrance, inspired with a nod to Chinese tradition by the movement of the waves and wind of the nearby ocean.

Mega-size malls and **entertainment** centers like the New Century Global Center in Chengdu, Sichuan, the world's largest building, and the South China Mall, measuring 7 million square feet, in Dongguan, Guangdong, sport a motley combination of copycat architecture, including a recreation of the Champs-Élysées and a full-size reproduction of the Arc de Triomphe, with more than 1,000 stores and shops crammed into a single, colossal five-story building. Other reproductions include the headquarters of the Chinese online gaming company NetDragon Websoft, designed as a replica of the starship *Enterprise* from the American television show *Star Trek*. Located in Changle City, Fujian, the building is six stories tall and was constructed according to the starship's design by permission of the American television network CBS.

New residential housing in cities, townships, and the wealthier parts of the countryside is dominated by villa-style homes that afford the average Chinese dweller with considerably larger per capita living space than was available in Soviet-era apartments and industrial dormitories. Innovative home and building designs include a house shaped like a grand piano and a glass violin in Huainan, Anhui; an urban cabin, microhome with a golden periscope; a so-called living **garden** absent walls with a sloped roof covered by solar panels; and an inflatable, self-contained pod providing minimum requirements for survival on Earth or other planets, known as the Mars Case Pavilion. More conventional new residential buildings are of the numbingly cookie-cutter variety, reflecting the mantra in China of "bigger, bolder, flashier," which relying on prefabricated materials reduce construction time to a few days. Other architectural innovations include a **library** covered in firewood sticks over a glazed shell located near Beijing and bamboo-framed concrete walls, known as *wapan* tiling, constructed from recycled material in the Ningbo History Museum, Zhejiang. Rediscovery and reinterpretation of traditional Chinese building practices include mimicking cracked-ice window patterns, cruciform brick arrangements, and lattice work on doors and windows.

The Beijing Institute of Architectural Design and the Beijing Design Institute are the dominant educational institutions for training Chinese architects. The first fully private architectural firm was founded by Zhang Yonghe in 1993, best known for his Split House at the Commune at the Great Wall (2002), made of tamped wood and laminated wood, consistent with local ecology. Major problems afflicting Chinese architecture include a fragmentation in authenticity with projects massive in scale, disorienting in many urban environments, socially and economically stratified, and overlaid with integrated advertising, electronic **monitoring**, and ubiquitous monitoring and

ARGUMENTATION AND RHETORIC (LUNZHENG/XIUCI) • 35

surveillance. Also plaguing the sector is the faking of construction materials resulting in buildings covered by faux concrete facades; poor quality in construction and execution of architectural designs; and shoddy school construction, contributing to high fatality rates among **children** in the earthquake in Wenchuan, Sichuan, in 2008. Professional journals in the field include *Architectural Design* (Jianzhu Sheji) and *Architectural Journal* (Jianzhu Xuebao).

ARGUMENTATION AND RHETORIC (*LUNZHENG/XIUCI*). Embedded in the philosophical traditions of both **Confucianism** and **Daoism**, argumentation and rhetoric in contemporary China are also shaped by the Western concepts of "logic" (*luoji*, a transliteration from English) and Marxist–Leninist **ideology**, the latter diminishing in importance since the passing of Chinese Communist Party (CCP) chairman **Mao Zedong** in 1976. Influenced by the prevalence of dialectical thinking in traditional folk **wisdom** commonly referred to as "naïve dialecticism" (*tianzhen bianzhengfa*), the Chinese are encouraged to see both sides of an argument. Finding flaws and validity in a holistic awareness that contradictions are omnipresent, there is less of a tendency in the Chinese approach to argumentation to find fault on both sides with solutions sought somewhere in the middle. Avoiding absolutist positions and moving away from binary **thinking**, clear-cut, right-and-wrong answers are generally not pursued, with counterarguments also less likely. Rather than working through contradictions in a rigorous and mathematical fashion, as in Western thought, reality is perceived as multilayered, unpredictable, and in a constant state of contradiction and change, with Chinese thought following a spiral pattern as opposed to the more linear Western form.

Relying heavily on metaphors, analogies, parables, and anecdotes characteristic of Confucianism and Daoism, and opposed to the syllogistic form dominant in Western philosophy since Aristotle (384–322 BCE), the Chinese are less likely to seek a single truth through aggressive argument and reasoning. Suggestive of the tightly constrained and restrictive forms of the "eight-legged essay" (*baguwen*) dominant since the Ming Dynasty (1368–1644), cultural critics in China interpret such limits on intellectual pursuits as a major cause of the country's historically weak scientific and culturally iconoclastic tradition. Similar principles also inform the purposes and practices of Chinese rhetoric, which is aimed at achieving social **harmony** and articulating the views of the groups, invoking tradition and relying on accepted patterns of expression relying on idioms, clichés, **puns**, and sayings. Assertions are frequently repeated, with proof and premises generally avoided, as an indirect strategy is pursued in both speech and written discourse, with considerable dependence on memory, creating a highly discursive **political culture**.

36 • ARTISANS

With the rise of the CCP from the 1920s onward, China's intellectual world was subject to the dictates of Marxism–Leninism, which imposed a single **ideological** truth on political and economic issues. Delivering a speech entitled "On Contradictions" (1937), CCP chairman Mao Zedong wrapped his argument in a mixture of traditional discourse and Marxist–Leninist categories, suggesting the prevalence of "contradictions" (*maodun*) throughout Chinese **history** and society, including within the CCP. While principles of mathematical logic were introduced into China in the 1920s, following the establishment of the People's Republic of China (PRC) in 1949, interaction and contact with Western circles of logicians was cut off, as most available works on formal principles of logic were translations from sources in the Soviet Union. Major debates sanctioned by Mao Zedong involving logic were carried out in a strict Marxist–Leninist framework involving such ideologically orthodox issues as the separation of "materialism" (*weiwuzhuyi*) and "dialectics" (*bianzhengfa*) from "idealism" (*lixiangzhuyi*) and "metaphysics" (*xinger shangxue*). On the popular level, repeated attempts were made to instill a more assertive and aggressive posture of argumentation under the rubric of "class **struggle**" (*jieji douzheng*), especially during the Anti-Rightist Campaign (1957–1959) and the **Cultural Revolution (1966–1976)**. With argumentation and rhetoric highly restricted by ideological boundaries, **accusations**, denunciations, and exaggerations prevailed, as Red Guards in the latter engaged in frequent and sometimes violent shouting matches concerning which faction exhibited the purist version of Maoism.

Following the introduction of economic reforms and social liberalization (1978–1979), neo-traditional patterns of thought and social behavior have been reaffirmed, with renewed emphasis on restraint and structured dialogue, along with interjections of rational and rigorous logic. With the commitment to "modernize formal logic in China" announced at the first national conference on logic, held in 1978, the field of study and research has undergone significant development with studies and research in a variety of fields, including **philosophy** of logic, the logic of induction, informal logic, critical thinking, argumentation theory, and **legal** logic. Research on logic and related fields like artificial intelligence and game theory is carried out by such organizations as the Institute on Logic and Cognition at Zhongshan University, **Guangzhou**, along with international conferences on logic and argumentation, held most recently in Hangzhou, Zhejiang (2018).

ARTISANS. *See* HANDICRAFTS (*SHOU GONGYIPIN*).

ARTS AND ARTISTS (*YISHU/YISHUJIA*). Central to cultural expression from the beginnings of Chinese civilization and revered from the ancient and semimythical Xia Dynasty (2250?–1766? BCE) to the Qing Dynasty

ARTS AND ARTISTS (YISHU/YISHUJIA) • 37

(1644–1911), art was considered a **hobby** of the cultivated "gentleman" (*junzi*) instead of a craft. Following the establishment of the People's Republic of China (PRC) in 1949, art and artists were subject to political **censorship** and periodic persecution, especially during the era of rule by Chinese Communist Party (CCP) chairman **Mao Zedong** (1949–1976). Greater toleration of the arts has prevailed since the introduction of economic reforms and social liberalization (1978–1979), but censorial controls remain in place, especially for controversial exhibits, operating under a general rule of "no politics, no nudity."

Development of modern art began during the New Culture Movement/ May Fourth Movement (1917–1921) with the importation of Western forms stressing **individuality** and creativity in contrast to the strictures and heavy political influences embedded in the reigning traditions of **Confucianism**. Maoist policy on the arts was initially articulated during the Second Sino–Japanese War (1937–1945) at the Yan'an Forum on Literature and Art (1942), where writers and artists sympathetic to the Communist movement were instructed by the CCP chairman to reflect on the lives of the common people, specifically the working class and peasantry, and serve politics and advance the interests of Chinese socialism. Institutions under CCP control included the Lu Xun Academy of Fine Arts, established in 1938, and named after the great Chinese novelist **Lu Xun** (1881–1936), where people were trained in **literature**, **music**, fine arts, and **drama**. Opponents of CCP cultural policy during this period included journalist Wang Shiwei (1906–1947), who, calling for literary and artistic **freedom**, opposed censorship and political controls, a position for which he was purged and ultimately killed, reportedly over objections by Mao Zedong.

The apparatus of state control of the arts and literature in the PRC was established with the creation of such front groups as the China Federation of Literary and Art Circles and the All-China Congress of Literary and Art Workers (1949), followed by the Central Academy of Fine Arts (CAFA/ 1950). Official publications in the arts included *People's Art* (1950), *Fine Arts* (1954), and *Literature and Art* (Wenyibao), along with establishment of the People's Fine Arts Publishing House (1951). State control of art **education** was solidified by the government takeover of the National Peking College of Arts (1949) and National Hangzhou College of Arts (1950), both subsequently subordinated to CAFA, along with the consolidated East China College of Art. Instructed to "learn from Soviet artists" (1952) with the official Soviet doctrine of "socialist realism" (*shehuizhuyi xianshizhuyi*), accepted by the China Artists Association (CAA) in 1954, artists were targeted in the first of many "rectification" (*zhengfeng*) campaigns in 1951, while during the Great Leap Forward (1958–1960), artists, like other groups in China, were sent to perform **manual labor** in the countryside, while workers and peasants were trained as new artists.

38 • ARTS AND ARTISTS (YISHU/YISHUJIA)

Official policy on the arts ranged from the strictures of socialist realism, which called for glorifying Communist values and extolling everyday life of the common people, to more conciliatory policies advocated by CCP leaders, including, for a time, Mao Zedong. Speaking in 1956, Mao, while warning against excessive Western influence on Chinese writers and artists, invited their participation in socialist construction, invoking the spirit of the "hundred flowers" (*baihua*) from ancient Chinese **history** to allow greater freedom. Art and literature were not mere instruments of politics and "class **struggle**" (*jieji douzheng*), while "idealism" (*weixinzhuyi*), the **ideological** opposite of "materialism" (*weiwuzhuyi*) and traditional whipping boy in orthodox Marxism–Leninism, was now acceptable in literary and artistic circles. Traditional forms in **paintings** by such well-established artists as Qi Baishi (1864–1957) were tolerated and even praised by CCP leaders the likes of Premier Zhou Enlai but with socialist realist forms, including in **sculpture**, gradually taking over.

Granted greater creative freedom during the short-lived Hundred Flowers Campaign (1956–1957), artists and writers were harshly attacked during the subsequent Anti-Rightist Campaign (1957–1959), labeled as "rightists" (*youpai*), including Jiang Feng, president of CAFA. The influence of socially conservative groups, notably the Chinese People's Liberation Army (PLA), expanded, while Soviet policies on arts and literature also increased dramatically with the exchange of major art exhibits and training of Chinese students in socialist realist principles and styles by Soviet instructors in China and the USSR. Subject to tighter political and ideological controls throughout the 1960s, Chinese writers and artists were singled out by the CCP Propaganda Department in two major central documents, "Ten Articles on Literature and Art" and "Eight Articles on Literature and Art," with Mao Zedong now denouncing their lack of "socialist transformation" (*shehuizhuyi zhuanxing*), while a harsher "cultural rectification" (*wenhua zhengfeng*) campaign was launched. Spearheaded by Jiang Qing, Mao's hot-blooded and radical leftist wife, writers and artists were accused of pursuing a "black bourgeois line," while Red Guards mobilized from CAFA students during the ensuing **Cultural Revolution (1966–1976)** vowed to "destroy the **four olds**," including the "old culture." Countless **pagodas and temples**, historic sites, books, and artistic works were wantonly destroyed, including paintings, **ceramics and porcelains**, and **Tibetan** thangka, while contemporary works like *The Winking Owl*, by Huang Yongyu, a proponent of socialist realism, were heavily criticized for surreptitiously violating leftist guidelines.

In the aftermath of the passing of Mao Zedong (1976), official policy on literature and the arts underwent gradual liberalization, with the first exhibit of modernist art held in Shanghai in 1979, while the avant-garde "Stars Group," including cultural iconoclast **Ai Weiwei**, conducted an unofficial, open-air exhibit in Beihai park, Beijing. Greater tolerance of the arts has

prevailed since the 1980s, with the appearance of such artist communities as the 798 Art District in Beijing and major exhibits held biennially in **Shanghai** and other cities, along with world-class **museums**, notably the National Art Museum (Beijing) and the Power Station of Art (Shanghai). Controversial shows have been subject to censorship, for example, the last-minute cancellation of an exhibit by **feminist** artists planned in Shanghai at about the time of National Day (1 October 2018) and the removal of works from the Gay Pride Art Exhibit (2019), with some artists subject to arrest. Especially provocative artists include Zhang Xiaogang, with his painting of dry-eyed families dressed in Mao suits and staring at the viewer, and Ai Weiwei, who has explored themes of destruction and culture. Art markets in China are also booming, with wealthy businessmen buying domestic and foreign paintings and sculpture at highly inflated prices as a form of investment.

ATHEISM (*WUSHENLUN***).** Officially an atheistic state, among the population of the People's Republic of China (PRC) 47 percent are convinced atheists and 30 percent irreligious (2012), with members of the ruling Chinese Communist Party (CCP) required to "accept atheism." Officially, **religion** is characterized as a **superstition**, in contrast to the reputed "scientific" nature of Marxism–Leninism, while historically imperial China was strongly influenced by the secular doctrine of **Confucianism** with humankind the only measure of good or evil. Following the establishment of the People's Republic of China (PRC) in 1949, foreign missionaries were expelled from the country and religion banned, although China did not establish such organizations as the League of Militant Atheists, which existed in the Soviet Union. During the **Cultural Revolution (1966–1976)**, attempts were made to eliminate religion altogether as houses of worship were shut down, possession of religious artifacts or sacred texts was treated as a criminal offense, and monks and nuns were persecuted and even killed. Since 1982, freedom of religion has been nominally protected by Article 36 of the state constitution, with the citizenry not forced to become atheists, while five religions are officially recognized: **Buddhism**, Catholicism, **Daoism**, Islam, and Protestantism.

AUTHORITARIANISM. *See* POLITICAL CULTURE (*ZHENGZHI WEN-HUA*).

B

BANQUETS (YANHUI). A primary venue for greeting friends, **business** colleagues, diplomats, and even enemies, banquets are held for important and trivial events, the former including **birthdays**, weddings, **festivals**, and state events during the imperial era, often involving the emperor, and in the People's Republic of China (PRC), where all-important **relations** are cultivated over **food** and drink. Coming in two types, "informal" (*hecai*) and "formal" (*jiushi*), banquets are governed by elaborate rules of etiquette and **rituals** applying to the host and guests, including proper seating arrangements, selection of dishes served, **eating** styles, and toasts, which generally reflect the collective and hierarchical nature of Chinese society.

Planned well in advance usually by a single host, the honored guest is given the best seat, facing east or away from the entrance, considered good **fengshui**, with other guests seated close or farther away in order of importance. Service is on a round table seating 10 to 15 people equal distance from the food, usually offered on a lazy Susan, with banquets generally held in a private room to avoid competition with a neighboring party concerning the quality and expense of food selection. With respect and honor for one another, the honored guest is served first and elders before the young, as all food is shared and taken in small servings cut into uniform sizes, and consumed one dish at a time. Guests are expected to eat their fill but without piling up food or fossicking for most succulent portions, while serving others, especially elders, is considered a sign of respect.

Notoriously long, as leaving early is considered rude, banquets often consist of eight courses, as the **number** "eight" (*ba*) symbolizes wealth, with as many as 20 separate dishes, cold served first, followed by cooked meats and vegetables, with soups served in the middle or near the end of a meal and a whole fish usually coming in the last course, symbolizing future abundance. The most expensive banquet dishes include abalone, Peking duck, swallow's nest pudding, shark stomach, and shark fin soup, the last falling out of style due to environmental concerns, especially in the PRC. Also served are "noodles" (*mian*), symbolizing **longevity**, with one long, continuous noodle consumed at birthdays, and red bean soup, often given as a dessert, representing

42 • BANQUETS (YANHUI)

the sweetness of life. Each entrée represents a different flavor, with the combination of dishes offering an array of different **colors** and textures, together constituting a well-balanced meal.

Considered demonstrations of abundance and prestige, especially by the wealthy, banquets offer a huge quantity of food with leftovers preferred, as a clean plate indicates the host failed to provide enough food. All servings, even those disliked, should at least be tasted and even complimented—*zhen hao chi* ("so delicious")—out of respect for the host. An example of other actions to be avoided is leaving **chopsticks** stuck upright in rice, which by resembling incense sticks stuck inside an incense pot, done when people die, could be interpreted as wishing **death** for someone at the table. While casual conversation among guests is encouraged, boasting and wild gestures are frowned upon, although wedding banquets are generally known for rambunctiousness, with guests sometimes numbering in the thousands.

Central to the celebratory nature of banquets are frequent toasts of **alcohol**, preferably *baijiu*, "white liquor," with the first offered by the host to the honored guest and everyone expected to take part, even if it means taking just a sip or preferring a nonalcoholic beverage. Etiquette demands that a guest first fill the glasses or cups of surrounding people, especially the elderly, while recipients express their thanks by tapping knuckles on the table, a traditional gesture representing the head and arms of a prostrating servant. Inebriation is tolerated and even expected at joyous occasions like weddings and birthdays, especially the all-important 70th for the elderly, but behavior should remain restrained, with any aggressive move toward **women** totally verboten.

Private banquets in the PRC are a product of the increased wealth made possible by the economic reforms introduced in 1978–1979, and are especially important in Chinese business, serving as a social lubricant but with strict prohibitions against discussing business affairs or prospects during the occasion. Official state banquets generally held for international guests and diplomats have been a feature of public life since the 1950s and are usually held in the cavernous Great Hall of the People off Tiananmen Square in **Beijing**, where as may as 5,000 people can be seated in the state banquet hall. Most notable was the dinner hosted by Premier Zhou Enlai in honor of U.S. president Richard Nixon during his February 1972 visit to the country preceding the normalization of diplomatic relations between the United States and the PRC in 1979.

Offering a rich variety of dishes from throughout the country, Chinese state banquets have been subject to criticism by current president **Xi Jinping** (2013–). Deriding "lavish" (*shechide*) and "wasteful" (*langfeide*) expenditure of public money at such events, the president, noting popular outcries via the internet regarding official extravagance and "**corruption**" (*fubai*) in the Chinese Communist Party (CCP), called for reviving China's tradition of

"frugality" (*jiejian*) and "thrift" (*jieyue*), as the serving of shark fin soup and *baijiu* have been banned. Local leaders, for example, a county CCP secretary in **Sichuan**, have even gone so far as to ban birthday banquets up to the age of 70, citing excessive financial burdens, including mandatory **gift**-giving, although popular reactions have been mixed. Human "cannibalism" (*shiren-zhuyi*), referred to as "flesh-eating banquets" (*chirou yanhui*), occurring in Guangxi during the **Cultural Revolution (1966–1976)**, has been uncovered by Chinese investigative journalism but with no official acknowledgment by the Chinese government.

BARBARIANS (*YEMANREN*). A perennial issue in relations between Han Chinese and neighboring peoples largely resident in peripheral border **regions** of the imperial empire, the Chinese–Barbarian dichotomy was primarily culturalist rather than geopolitical or **racist**. Long-standing Sinicization of non-Han groups occurred throughout imperial history, especially as the empire extended into Central and Southwestern Asia. Corresponding influence and transformation of Chinese culture transpired when non-Han groups, some formerly labeled as "barbarian," founded ruling houses of new dynasties, including the Liao (916–1125) by the "Khitan" (*Qidan*), the Great Jin (1115–1234) by the "Jurchen" (*Nüchen*), the Yuan (1279–1368) by the "Mongols" (*Menggu*), and the Qing (1644–1911) by the "Manchu" (*Manzu*). Of the 35 dynasties in the imperial era, only two were purely native in origin, the Han (202 BCE–220 CE), with its name subsequently used for the dominant Chinese ethnicity, and the Ming (1368–1644), as many dynasties were of foreign origin, for instance, the highly cosmopolitan Tang (618–907).

Founded by a part-Turkic ruler referred to as "Supreme Khan" (*Zhjzun han*), China, under the Tang, engaged in extensive trade and cultural contacts abroad, absorbing enormous cultural influences, especially in the **arts** and **religion**, from Central Asia, India, and the Near East. A major task of the imperial state involved "barbarian management" (*yemanren guanli*), which ranged from military measures, usually limited, although some groups, for example, the ancient Jie people and Dzungarians, were virtually wiped out, to more acceptable practices, for example, buying off barbarian groups, like the northern Khitan and aggressive Xio, with gratuitous tributary payments and strategic **marriages** with beautiful Chinese princesses sought after by barbarian leaders.

Terms for "barbarian" in the Chinese **language** are numerous, including *di, man, rong, ye,* and *yi,* with the number of groups labeled pejoratively as "barbarian" by the dominant Han varying throughout history with fluid and permeable definitions. While Confucius (551–479 BCE) listed "nine barbarians" (*jiuyi*) in the *Analects* referring to peoples lacking in cultural refinement, the dominant concept during the Ming and Qing dynasties was the "four barbarians" (*siyi*), a designation following the Four Cardinal Direc-

44 • BARGAINING (TAOJIAHUANJIA)

tions. "Eastern" (*Dongyi*), "Western" (*Xirong*), "Southern" (*Nanman*), and "Northern" (*Beidi*) barbarians surrounded the Han people who occupied the vulnerable "middle" (*zhong*), while the primary barbarian threat came from the north just beyond and even below the **Great Wall**. Major differences between barbarians and the Han involved language, certain **rituals**, and especially economy, with the former generally nomadic or seminomadic herders and horsemen, and the latter involved primarily in sedentary agriculture and commerce. Non-Han groups adopting elements of Chinese culture were defined as "matured or familiar barbarians" (*chengshu yemanren*), in contrast to "raw barbarians" (*sheng yesmanren*), who rejected any and all Chinese ideas, and morality, for instance, the Jurchen with their rejection of Chinese styles, norms, **clothing**, and **customs**. Ethnic groups willing to submit to Chinese rule, with examples being the **Tibetans** and the Zhuang, were no longer considered "barbarian," while Chinese displaying a lack of ritual and morality could themselves be considered barbarian. Barbarous **punishment** in Chinese history consisted of branding the **face**, cutting off the nose, and chopping off the feet.

Notions of Chinese superiority and barbarian inferiority shaped interactions between the Chinese empire and encroaching Western powers, especially in the 19th century, when pressure to buy opium and cede territories by Great Britain and others led to Chinese warnings of "barbarians at the gates" (*menkou yemanren*). Demands by the British to drop all references to Westerners as "barbarian" were included in the Treaty of Tientsin, ending the Second Opium War (1856–1860), while brutish behavior by troops of the Eight Nation Alliance during suppression of the Boxer Rebellion (1899–1901) confirmed that indeed there were "barbarians at the gates." The government of the People's Republic of China (PRC) has avoided the term "barbarian" for domestic or foreign groups, declaring non-Han ethnicities as "national **minorities**" (*shaoshu minzu*) and **foreigners** as *laowai*, literally "old outsiders." More vitriolic references, for instance, "foreign devils" (*yangguizi*) and other **xenophobic** terms, are officially condemned although can sometimes be heard on Chinese streets and in villages when confronting the rare foreigner.

BARGAINING (*TAOJIAHUANJIA*). Considered an art form in China, influencing behavior in many social realms, including **business**, **commerce**, and politics, the word for "bargaining" (*taojiahuanjia*) in Chinese literally means to "talk and change the price," with haggling an inevitable part of the **shopping** experience in the People's Republic of China (PRC), especially since the introduction of economic reforms (1978–1979). Second nature for most Chinese merchants and buyers, bargaining over prices is often a complex and tedious process with a variety of tactics adopted by both parties, with merchants establishing an anchor or base price and buyers engaging in

the classic "walk away" (*zoukai*) to engender an acceptably low price. Exaggerations occur on both sides, with merchants often seeking sympathy with painful pleas of impoverishment, while offering extensive compliments to the buyer, who is likely to feign disinterest before settling on a compromise price. Both sides to the exchange are expected to act with mutual respect, avoiding personal insults or accusations of dishonesty or fraud. Prohibited in large department stores and most restaurants, bargaining is most common between shoppers and independent small shops and businesses, which still proliferate in most Chinese cities.

Bargaining also underlies relations among government officials in the highly **bureaucratized** system of the PRC, usually involving superiors and subordinates, and shaping **negotiation** strategies both domestically and internationally. Bargaining in the Chinese government over policy issues, including the economy, existed even during the period of highly centralized authority under the rule of Chinese Communist Party (CCP) chairman **Mao Zedong** (1949–1976). Following the introduction of economic reforms and social liberalization (1978–1979), with considerable decentralization of decision-making to lower levels of the state and CCP apparatus, bargaining has become a dominant form of political and authority relationships in the PRC. Involving multiple issue areas, for example, environmental protection, adherence to **legal** and regulatory standards are subject to persistent and extensive negotiation among multiple bureaucratic layers and organizations as opposed to strict legal enforcement. Successful negotiation strategy in the Chinese view takes time, involves high-level contacts, and should avoid a gold-rush mentality, with effective negotiators formulating a second-best alternative.

BEAUTY (*MEINU*). The concept of beauty in China is addressed at both the theoretical level in the philosophical field of "aesthetics" (*meixue*) and the popular level in evolving views on female and male attractiveness. Introduced into China in the 20th century, the field of aesthetics, literally meaning "study of beauty" in Chinese, continued to flourish following the establishment of the People's Republic of China (PRC), especially in the relatively liberal period of the Hundred Flowers Campaign (1956–1957), when issues of the objectivity and subjectivity of beauty were openly debated. Also addressed were ancillary issues involving the relation between the **arts** and society, and the evaluation and criticism of works of art. Unique concepts identified in Chinese aesthetics included a well-integrated, interdisciplinary approach; avoidance of rigid dichotomies; balancing binary opposites; and grounding aesthetics in existing social and political realities. Aesthetic ideals in China stressed emotional **communication** and a refinement of natural desire, with a tendency to unite human beings with nature, as beauty constituted a free state or "way" (*dao*) of human life. For such prominent Chinese

46 • BEAUTY (MEINU)

aestheticians as Li Zehou (1930–), the aesthetic experience is fundamentally transformative, involving self-cultivation and creativity, with an ultimate goal of achieving the "art of living."

At the popular level, concepts of beauty particularly involving **women** have undergone significant transformation from the imperial to the modern era. The traditional concept of female beauty among the higher classes viewed women as fragile creatures with long finger nails, soft palms, delicate white skin, high foreheads, small ears, thin eyebrows, and small mouths with highly elaborate and stylistic **hairstyles** with flowers and hairpins made of precious materials like **jade** and **animal** bone. During the period of rule by the Republic of China (ROC) on the mainland (1912–1949), Chinese women imitated and adopted Western styles, including **clothing**, makeup, and short hairstyles, especially in the more prosperous coastal cities. Following the establishment of the PRC in 1949, women and **men** were highly constrained in their appearance, especially during the **Cultural Revolution (1966–1976)**, when any attempt by a female to accentuate personal beauty with makeup or clothing, for instance, high-heeled shoes, was met with **accusations** and public **humiliation**.

Following the introduction of economic reforms and social liberalization (1978–1979), Chinese citizens were once again allowed to generally dress and grow their hair as they pleased, with women growing long and flowing hair, and wearing makeup. Heavily influenced by Western and Chinese historical and contemporary standards, mainstream concepts of female beauty have undergone significant transformation. Ideals include white skin facilitated by heavy use of skin moisturizers and avoidance of the sun, as well as big, almond-shaped eyes accentuated by eye lashes, along with double eyelids and a V-shaped **face** not overly sculpted. A pointy nose with a high ridge, although not too big, is also important, along with small cherry lips, as cosmetic surgery is now accepted as a legitimate method of beauty treatment.

Reacting against such trends, Chinese millennials have embraced the new, so-called "noble face" (*gaojilian*) for women involving a more intangible concept of beauty based on a distant, cold attitude with eyes set wide apart and strong bone structure, with opposition to plastic surgery and other such artificial transformations. While Chinese female **social media** stars and models have played major roles in setting such standards, South Korean **celebrities** have also had a major impact, including on concepts of the handsome male with soft features and a beguiling smile. Tattoos suggestive of female loose behavior are generally avoided, while facial freckles are also considered unattractive. Cities in China are often ranked for having the most beautiful women, according to a "beauty index," which, in 2013, rated the following as the top five: Harbin (Heilongjiang), **Chongqing**, Chengdu (**Sichuan**), Mizhi (Shaanxi), and Dalian (Liaoning).

BEGGING AND BEGGARS (*QIGAI*). Dating back to imperial times, begging by vagrants and other dispossessed individuals and groups has grown as the population of China expanded from the Ming Dynasty (1368–1644) onward, with Zhu Yuanzhang transitioning from a beggar to the founder and first emperor of the Ming. Included in the "lower ninth path" of occupations in imperial society, along with "pickpockets" (*pashou*), "swindlers" (*pianzi*), "peddlers" (*xiaofan*), and **"prostitutes"** (*jinü*), the number of beggars exploded in such cities as **Shanghai** and Nanking, today's Nanjing, in the waning years of rule by the Republic of China (ROC) on the mainland (1912–1949). Following the establishment of the People's Republic of China (PRC), beggars were swept out of showcase cities in the 1950s and 1960s, with little evidence of public begging during the years of draconian rule by Chinese Communist Party (CCP) chairman **Mao Zedong**. With "public security organs" (*gong'anbu*) empowered to arrest and detain anyone lacking the proper **urban** "household registration" (*hukou*), aspiring mendicants were forcibly returned home, only to return at the right opportunity. Following the introduction of economic reforms and social liberalization (1978–1979), beggars have reappeared in major cities likes **Beijing**, **Guangzhou**, and Shanghai, along with smaller cities and towns, and composed primarily of migrants from impoverished **rural areas** often seeking money and material support for medical and other personal and **family** crises back home.

Weakening of the *hukou* system and abolition of police powers of arrest and detention following the death of a detainee in Guangzhou in 2003, has led to a resurgence of urban beggars since the early 2000s, including emergence of so-called "begging gangs" (*qitao bangpai*) with regional and national networks. Exploiting the defenseless and impoverished, **children** have become major victims, kidnapped or "rented" (*zulaide*) from poor, usually rural areas and often subjected to doping and beatings, with their new "disability" (*shineng*) and "handicap" (*zhang'ai*) put on full public display to engender sympathy and larger donations from passersby. Investigations have revealed the ill intent and fraudulent nature of such begging, with most of the donations ending up in the hands of so-called "begging chiefs" (*qitao shouling*) and "professional beggars" (*zhuanye qigai*) going on nationwide "cheating tours" (*zuobi zhi lu*), begging by day and entertaining at night. With even rich elderly ladies outed as fake beggars, popular suspicions have arisen, as beggars are now widely viewed as "cheaters" (*zuobizhe*), with Chinese children instructed not to trust them, leaving beggars in real need denied voluntary assistance.

Current government policy makes begging illegal on public transportation, with beggars driven off the streets of cities hosting major national or international events with high-profile media attention. As China moves to a cashless economy of iPhone payment apps, beggars have adjusted by obtaining QR

48 • BEIJING

cards allowing for donations via mobile devices, often with the assistance of local shop owners. Public criticism has been voiced of the harsh treatment of beggars, for example, when suspects were caged and penned up behind steel bars in Nanchang City in 2012. Following the announcement of the "Say No to Beggars on the Metro" campaign in Shanghai in 2012, undercover police were deployed to collar often-helpless and poor offenders, to maintain an image of a well-ordered and clean urban environment. Chinese-**language** terms for begging include the commonly used *qigai* and *taofan*, the latter literally meaning "beg for food"; *biesan*, translated as a "wretched-looking tramp who begs for food"; and the more acceptable *jiaohuazi*, referring to appeals for alms by wandering **Buddhist** monks engaged in teaching and spreading the faith.

BEIJING. The capital of the People's Republic of China (PRC) since 1949, *Beijing* in Chinese means "northern capital," previously rendered in English as *Peking*, with the city considered as the center of Chinese culture. Known for **handicrafts** and the performing **arts**, including **acrobatics**, ballet, **opera**, and **theater**, the city also has a rich array of **museums** and historical sites, along with a major regional **cuisine**. Serving as China's permanent capital since 1272, during the Yuan Dynasty (1279–1368), periodic interruptions included, most notably, the period of the Republic of China (ROC) on the mainland (1912–1949), when the name was changed to *Peiping*, meaning "northern peace" as the southern city of Nanjing, then rendered as *Nanking*, was established as the capital. Laid out on north–south and east–west axes, with its checkerboard streets reflecting the traditional **cosmology** of the Chinese dynastic system, Beijing is dominated in the central city by the imperial palaces of the **Forbidden City** and the giant 100-acre Tiananmen Square, built in 1651. Beijing was divided into the northern Tartar City constituting two-thirds of the territory inhabited by the ruling Manchus and the southern third Chinese city populated by the Han. Like many ancient Chinese cities, Beijing was once surrounded by high city walls, inner and outer, that following the establishment of the PRC in 1949, were systematically torn down in the 1950s and 1960s, as a **symbol** of Chinese "feudalism" (*fengjianzhuyi*). Criticized by local residents and city preservationists, for instance, architect Liang Sicheng, to no avail, destruction of the walls was followed by the dismantling of the many large gates dotting the city in the 1950s and 1960s. Other notable local **architecture** includes ornate shop facades of both Chinese and Western styles, many now preserved.

World-renowned historical sites located in and around Beijing include the Temple of Heaven (*Tiantan*), the Ming Tombs (*Ming Shisan Ling*, literally "13 tombs of the Ming Dynasty"), ruins of the Old Summer Palace (*Yuanmingyuan*, imperial gardens with marble arches, once considered a wonder of the world), and the Summer Palace (*Yiheyuan*). The last is replete with multi-

BEIJING • 49

colored, exquisitely painted buildings; lush grounds; the magnificent Seventeen Arch Bridge; and the Marble Boat, built by the notorious Empress Dowager Ci Xi (1861–1908) in the late 19th century, with the Institute of Ancient Architecture, located in the city. Important places of worship and monasteries include the Confucian Temple (*Kongmiao*) and Daoist White Cloud Temple (*Baiyunguan*), both from the 14th century; the Lama Temple (*Yonghegong*), dedicated to Tibetan **Buddhism**, from the 17th century; and many Christian churches and mosques, most notably the Niujie Mosque, built in the 10th century.

Among the city's more than 140 museums are the Palace Museum in the Forbidden City, with a rich collection of **ceramics and porcelains**, enamel works, embroidery, stone carvings, and scrolls, and the National Museum of China, one of the largest and most visited in the world. Major art galleries include the China Art Gallery and the Xu Beihong Memorial Museum, named for the famous sketch artist, with more than 1,000 of his works. Historical **libraries**, notably the National Library of China and Beijing Library, contain thousands of relics and manuscripts from the imperial and modern eras. Imperial **gardens** and parks dot the city, one of which is Beihai Park, literally "northern sea," first built in the 11th century and the location of the famous White Tower Stupa, dedicated to the Dalai Lama of **Tibet**, and the famed Nine Dragon Screens, Temple of Heaven park, and Purple Bamboo Park (*Zizhuyuan*), with a bamboo forest and numerous lakes. Other famous temples and **religious** sites scattered throughout the city include Temple of the Sleeping Buddha, Temple of the Great Perception, Temple of the Ordination Terrace, and Monastery of Clay Pools and Wild Mulberry. Beijing is also a center of **education**, with more than 90 universities, two of which are the nationally known Peking University (*Beijing Daxue*) and Tsinghua University (*Qinghua Daxue*), known as the "MIT of China."

Examples of modern architecture in the city include the new Central China Television (CCTV) headquarters, with its gravity-defying structure; the egg-like National Performing Arts Center; and Beijing National Stadium, dubbed the "Bird's Nest" (*Yanwo*), designed by **Ai Weiwei**. Undergoing an enormous construction boom during the past decades, the **urban** landscape in Beijing has been transformed, with the greatest impact on the city's maze of traditional "alleyways" (*hutong*), which, designed by the city's Mongol rulers during the Yuan Dynasty to a uniform width of 12 to 24 paces and at one time numbering more than 6,000, have been reduced to a few hundred. With their infinite variety of courtyard houses and princely palaces, of which only a few survive, the alleyways have been a victim of various spurts of construction, from the massive Great Hall of the People in Tiananmen Square to the Stalinist cinderblock apartment blocks built during the 1950s and 1960s, to the more recent and expensive modern apartment and commercial building spree. The social intimacy of the alleyways has been lost, with evictions

50 • BEIJING

numbering 1.2 million by 2007, often with very short notice, with former residents relocated to high-rise apartments built in distant suburbs away from **family** and friends. While wealth is openly flouted with expensive automobiles and luxurious housing in the eastern part of the city, well-ordered streets and dull hotels dominate the western section, home to many low-profile Chinese Communist Party (CCP) and military leaders. Site of the first **business** park built in China in 2003, replete with sufficient space for 80 large enterprises, Beijing features upscale and highly priced apartment buildings, many named after famous sites in New York City, for example, the "Upper West Side" and "Park Avenue," all to the benefit of the city's nouveau riche population. The 798 District, in an old industrial area of the city, originally built by East German advisors, has become a major exhibition center for aspiring Chinese artists, while the Yabaolu District, in the east-central area, is known as a mecca of Russian merchants.

Famous Chinese arts and handicrafts identified with Beijing include, most notably, **calligraphy**, **ceramics and porcelains**, cloisonné, **jade** and stone carving, lacquerware, paper joss, **seal carving**, and silk-making. Encouraged by the PRC government throughout the 1950s and early 1960s, production of these traditional artifacts was halted during the **Cultural Revolution (1966–1976)**, as 5,000 ancient cultural artifacts were smashed in the effort by Red Guards to destroy the "**four olds**" (*sijiu*), with private homes raided for heirlooms, while artisans were "sent down to the countryside" (*xiaxiang*) to engage in **manual labor**. Following the introduction of economic reforms and social liberalization (1978–1979), a concerted effort was undertaken to restore damaged treasures and return valuable artifacts to their rightful owners, as production of traditional arts and crafts was revived. Performing arts in the city, most notably **Peking opera**, along with acrobatics, ballet, musical revues, and shadow **puppetry**, which were all prohibited during the Cultural Revolution, have also been restored, with the addition of a symphony orchestra in 1977, as well as western opera, as Beijing reemerged as a center of Chinese cultural life.

Highlighting local culture in Beijing is the unique **language** dialect, which, while serving as the basis for the "national language" (*putonghua*), is strong in sound with city residents, relying on colloquial expressions generally not understood in other parts of the country. The city is also known as the home to "cross-talk" (*xiangsheng*), literally "**face** and face," a form of **comedy** performed as a dialogue between two performers with an array of **puns** and allusions delivered in a rapid, bantering style usually in the Beijing dialect. Other traditional performances include *kuaibanr* (literally "fast boards"), in which bamboo clappers produce a rhythmic beat, and long "shadow boxing" (*changqun*), as the city has also become a major center of **martial arts** performance and instruction.

BIRTHDAYS (SHENGRI) • 51

As the capital of China for more than 800 years, Beijing cuisine, also known as Mandarin cuisine, reflects the influence of culinary traditions from throughout the country, especially from the eastern coastal province of Shandong. A favorite of the imperial court and the epitome of Beijing cuisine is the classic Peking roast duck (*Beijing kaoya*), offered in a slew of restaurants specializing in the dish throughout the city, from glammed-out ballrooms to backstreet dives. Famous eateries include Da Dong Duck, consistently rated the best in the city; Bianyifang, one of the oldest restaurants in Beijing, dating back to the 15th century; Quanjude, with branches throughout the city and abroad; Siji Minfu, one of the most popular spots in Beijing; and Deyuan Roast Duck, a neighborhood no-frills favorite.

Other notable dishes and snacks identified with Beijing include the following: dumplings (*jiaozi*); noodles with soybean paste (*zhajiangmian*); Mongolian hot pot with lamb, vegetables, and bread (*Menggu huoguo*); donkey burger (*lürou huoshao*); dry wok potato wedges (*ganque tudoupan*); shredded pork in Peking sauce (*jiajiang rousi*); fried liver (*chao ganer*); pea flour cake (*wandou huang*); and Tuckahoe pie, herb pancake wrapped in sugar, honey, and assorted nuts. City favorites also include hot and sour soup (*suanlatang*); beggar's chicken (*fugui ji*); beef wrapped in pancake (*mending roubing*); Mooshu pork (*muxurou*); fish with five-spiced powder (*wuxiang yu*); sea cucumber with quail eggs (*wulong tuzhu*); Chinese cabbage in mustard (*jiemodun*); glazed Chinese yam (*basi shanyao*); Mooshu bean curd (*muxu doufu*); shredded potato (*tudousi*); stinky bean curd (*chou doufu*); and such deserts as sour cherries dipped in sugar (*tanghulu*).

Major **shopping** districts in Beijing include Wangfujing and Qianmen, with several areas specializing in antiques, for instance, Liulichang, Gaobeidian, and Pangjiayuan, the last offering relics from the Cultural Revolution, with examples being Mao buttons and posters. Natural scenic and historic sites located near Beijing include Mount of the Wondrous Peak (*Miaofengshan*), located west of the city, with Daoist temples and a site of frequent religious pilgrimages, along with sections of the **Great Wall**, located at Badaling and Mutianyu, northwest of the city.

BIRTHDAYS (*SHENGRI*). Traditionally a day reserved for young **children** and the elderly, birthdays, in present-day China, are celebrated each year, especially by young people, replete with cakes and **gifts**, along with the singing of "Happy Birthday" (*Sheng'er Kuaile*), with the same tune as the Western version but with different lyrics. A unique aspect of birthdays in Chinese tradition is the incorporation of three celebrations. The first is held for newborns at one month, when the child is considered a new member of the **family**, with deceased **ancestors** being informed of the new addition and relatives and friends receiving gifts from the parents of the new child. The second celebration comes at one year, considered the child's second birthday,

as by Chinese calculation a child is one year old at birth, having spent nine months in the mother's womb. Following the third celebration in the sixth year, birthday celebrations cease until age 60, when by calculations in Chinese **cosmology** the life cycle of a person has been completed, with a new cycle beginning and the next celebration coming at age 70. Separate from a person's "real age" (*shisui*) based on number of birthdays, a person also has a nominal or "fake age" (*xusui*), which increases following the new year **Spring Festival**, early in the conventional calendar year.

Among the special birthday foods are "**longevity** noodles" (*changshou mian*), served to children, with instructions to slurp the noodles instead of biting them off, as doing so will result in a life cut short. Hard-boiled eggs dyed red to symbolize **happiness** are also on the birthday menu, along with dumplings (*jiaozi*) for good **fortune** and peaches with peach-shaped dumplings, offered at the 60th birthday celebration. Birthdays generally avoided by **women** include turning 30, as it symbolizes uncertainty, leading many women to remain 29 for an extra year to avoid bad luck. The same is true for turning 33, when, following traditional **rituals**, the woman stands behind a kitchen door, chopping meat 33 times to cast away evil spirits, something also done on her 66th birthday. Chinese **men** similarly avoid their 40th birthday, dodging the bad luck of this uncertain year, remaining 39 for two years and then skipping to 41 at their next birthday.

Gift-giving is expected, but certain items seen as bringing bad luck and ill fortune should be avoided. These items include flowers and towels, generally reserved for **funerals**; sharp objects like knives that can bring bodily harm; clocks or watches, as they are associated with the passage of time, ultimately leading to **death**; and shoes, candles, handkerchiefs, mirrors, and green hats, the last associated with the phrase "wearing a green hat" (*dailü maozi*), said of a wife cheating on her husband. Historically, children were offered gifts of coins, kitchen utensils, books, and a small Buddha with the child's selection of a particular item, known as "drawing the lots" (*zhuazhou*), indicating their future profession, coins for **business** and books for **scholars**. Late celebration of birthdays is verboten, as is the wearing of white, black, or purple clothes, associated with death. Birthday celebrations for China's national leaders are a rarity, as their private lives are considered off limits, although the 26 December birthday of former Chinese Communist Party (CCP) chairman **Mao Zedong** brings out some of his ardent supporters, while retired president Jiang Zemin (1989–2002) is frequently mimicked and satirized on his 27 August birthday.

BLACK MARKETS. *See* MARKETS (*SHICHANG*).

BODY LANGUAGE AND SHAMING (*SHENTI YUYAN/SHENTI XIU-CHI*). A major form of nonverbal **communication**, body language in China involves **hand gestures** and facial expressions, with a long list of acceptable and unacceptable forms of behavior. Living in a densely populated society in both **urban** and **rural areas**, Chinese stand close together when talking, while a "hands-on" (*dongshou*) approach occurs in personal interactions, although limited to people of the same sex. **Women** will often walk arm in arm, and **men** put their arms around one another but with no suggestion of **sexual** intent. Generally lacking in outward expression of emotions, public display of affection between men and women is avoided but with changes occurring, especially among young people, although overall such behavior is still restrained by Western standards. Facial expressions, many adopted from Chinese **opera**, include the "number-two **face**" (*erhao lian*). This is characterized by squinted eyes; a tight, raised lower lip; and a lowered brow, along with an outward-pointing thumb expressing self-confidence and authority.

Postures reserved specially for women include fanning, where the lower portion of the face is covered with the hand, standing in for a fan to hide a few squeamish giggles, representing a woman's inherent timidity when meeting a potential lover. For men wanting to project power and demonstrate strength, a foot is stuck out and hands placed on the hip, with the chest barreled out. Found in both Chinese opera and posters popular from the era of rule by Chinese Communist Party (CCP) chairman **Mao Zedong** (1949–1976), both men and women can demonstrate confidence and a willingness to take on any challenge or difficult task by striking a pose with a straight posture, shoulders drawn back, giving way to an open chest and arms extended straight out into the future.

Among the social behaviors and actions considered inappropriate and even rude, to be avoided, are the following: pointing a single finger or pair of chopsticks at another person; making big, sweeping hand gestures; and engaging in excessive touching, especially of a female by a male. Sitting and leaning back in a chair with feet pointing is also considered rude, as feet are considered dirty, while excessively casual postures are also avoided, as a balanced and solid sitting position is preferred. Strong eye contact is also to be avoided, as less eye contact is considered a sign of greater respect. Touching another's head is reserved for people with intimate connections, as the head is considered sacred and a window to a person's soul, with any inadvertent touching capable of provoking **anger**. Greetings between strangers should be reserved, with a casual handshake or polite smile, with the oldest person greeted first, while back slapping and hugging are strictly verboten. **Gifts** should be accepted with two hands, while hosts and guests stand up for toasts offered at **banquets**. With the second-largest number of people in the

54 • BODY MUTILATION (ZHITI QIEGE)

world suffering from **obesity** in the People's Republic of China (PRC), body shamming remains common, although primarily directed at women more than men, with negative effects on female employment and mental **health**.

BODY MUTILATION (*ZHITI QIEGE*). While **Confucianism** imposed strict prohibitions on any voluntary physical abuse of the body, which was considered a **gift** from parents, various forms of body mutilation and modification occurred throughout Chinese history, especially during the imperial era. Most prominent were the practices of **foot-binding** of **women**, introduced in the Tang Dynasty (618–907) and prohibited since the early 20th century, and castration of **men**, especially at a young age, turning them into "eunuchs" (*taijian*) for service in the imperial court. Adopted for economic and not **religious** reasons, as occurred in Western history, becoming a eunuch in imperial China was considered a guaranteed path to power and wealth by the underclass. Recruited as sexless males into the "inner court" (*neiting*) of the imperial household, eunuchs began as slaves and trusted servants to the imperial family, especially consorts and **concubines**, insuring paternity of the imperial male family line. Gradually emerging as high-level political advisors and imperial watchdogs receiving titles of nobility and even becoming military commanders, eunuchs were often witness to the secrets, private foibles, and weaknesses of an emperor and members of the household. With the imperial court becoming increasingly lavish from the Tang Dynasty onward, eunuchs expanded, reaching an estimated 70,000 serving in the court of the Ming Dynasty (1369–1644) but with numbers dramatically reduced by the Qing Dynasty (1644–1911), which sought a greater role for well-trained Confucian **scholar**-officials.

Subject to a complete dismemberment of their **sexual** organs, preserved in dried bags for burial and rebirth as a real man, eunuchs developed distinct physical characteristics, including high-pitched, effeminate voices and the loss of body hair and muscular mass, while becoming thin and deeply wrinkled in old **age**. With the procedure performed by "knifers" (*daojiang*) located immediately outside the western walls of the **Forbidden City**, eunuchs suffered low esteem in the public mind. They were considered greedy, scheming, and power-hungry, and derided as "bob-tailed dogs" (*duanwei gou*) and "keepers of the couch" (*shafade shouhuzhe*), with a reputation of being foul-smelling, as urination was hard to control. "Stinky as a eunuch" (*taijian chou*) became a popular saying, while such prominent court Confucians as Huang Zongxi (1610–1695) condemned their "poisonous" political influence, which was often blamed for weakening imperial authority and leading to dynastic declines, as during the late Han Dynasty (206 BCE–220 CE). Subject to frequent and often arbitrary beatings by the emperor, eunuchs were banned from the Forbidden City along with the last emperor Aisin Gioro Puyi and family in 1924. The last surviving eunuch, Sun Yaoting, died

BROADCASTING AND TELEVISION (GUANGBO/DIANSHI) • 55

in 1994. Famous eunuchs include Cai Lun (50–121 CE), the inventor of papermaking; Tong Guan (1054–1126), a famous military commander in the Song Dynasty (960–1279); and Admiral Zheng He (1371–1433), captain of the famed Treasure Fleets sent to the coasts of Africa and India by Ming Dynasty emperor Yongle (1402–1424).

BROADCASTING AND TELEVISION (*GUANGBO/DIANSHI*). Long considered an essential tool for shaping and ultimately controlling popular opinion and political attitudes, radio broadcasting and television service is under strong state control and regulation in the People's Republic of China (PRC). Telecommunications were rapidly restored following the establishment of the PRC in 1949, as tight control was exercised by the Chinese Communist Party (CCP), with operations centered in **Beijing** and links to the country's largest cities. Radio broadcasting, which had begun in 1940, from the Communist redoubt of Yan'an (Shaanxi), was carried out by Central People's Broadcasting beginning in 1949. With few Chinese families owning radios, broadcasts reached the population through an elaborate system of public loudspeakers throughout the country's cities and almost 1 million villages. There are 3,000 radio stations in China, with the renamed China National Radio having eight channels and international broadcasts handled by China Radio International.

On 1 May 1958, the first television program was broadcast by Beijing TV, followed one month later by Shanghai TV, with 12 TV stations operating in China, one national station and 11 regional stations in 1965. Throughout much of the **Cultural Revolution (1966–1976)**, special film teams covered the actions of CCP chairman **Mao Zedong**, for the national media to spread the image of the charismatic leader throughout the country. Beijing TV was converted into China Central Television (CCTV) in 1978, with only 32 television stations in the entire country, while less than one person out of a hundred owned a television set, fewer than 10 million people. The Ministry of Radio and Television (MRT) was given administrative oversight of Chinese broadcasting in 1982, which included the Central People's Broadcasting Station, Radio Beijing, and CCTV. China broadcast its first TV transmission by satellite in 1986, while the number of local stations nationwide has expanded rapidly to more than 3,000. Seventy percent of **urban** families owned at least one television set in 1993, and broadcasting stations offered a wide variety of programming heavily educational in content, with English-language programs especially popular.

The State Administration of Radio, Film, and Television (SARFT) replaced the former MRT in 2001, with 30 foreign networks allowed limited broadcasting rights in China in 2003. Included are Bloomberg TV, Star TV, Eurosport, BBC World, CNBC, and the **Hong Kong** start-up Phoenix, which with such programs as *Sex and Love Classroom* became one of the most-

56 • BROADCASTING AND TELEVISION (GUANGBO/DIANSHI)

watched stations in the country. China currently has only two national-level domestic television stations—China Central Television and China Educational Television (CETV)—both of which are part of the China Broadcasting, Film, and Television Group. CCTV runs multiple channels, including an English-language channel (CGTN) and international multilingual channels, both of which are available worldwide via satellite, and, in May 2005, the network launched a 24-hour news channel. Provincial-level broadcasters throughout China have a national reach and are major outlets for international programming.

All 3,000 television channels in China are government controlled at the central and provincial levels, and most domestic programming tends toward conservative content, for example, documentaries, quiz shows, and team competitions, although in recent years more programs have emerged from private sources, particularly Phoenix. Foreign programming includes TV series, for instance, the immensely popular American show *Sex in the City*; movies; **animation**; and even programs like Nickelodeon's *Kids' Choice Awards*, the often-outrageous content of which is toned down for a Chinese **youth** audience totaling 300 million **children** younger than age 14. Government approval of foreign programming is required and bought by China International TV Corporation, which was established in 1992. Encore International is a private company and one of the largest providers of international programming to the China market, while Viacom has a 24-hour MTV channel in Guangdong. Hunan TV emerged as a major player in China's media market when, in 1997, the station introduced a satellite channel and broadcast such popular shows as *Citadel of Happiness*, *Who's the Hero*, and the enormously popular *Super Girl* contest (which reportedly brought in 400 million viewers). Shanghai Media Group started as a merger of mostly local television and radio interests, and grew to encompass pay television, TV production, home **shopping**, **music** labels, newspapers and magazines, **sports** teams and arenas, **theaters**, websites, and internet television ventures.

The Shanghai International Television Festival, founded in 1986, and held in conjunction with the Shanghai International Film Festival, is the largest international television-related event in China. As government authorities have become increasingly concerned with television content and inappropriate behavior by television personalities, notably **drug** use, an order was issued in 2012, to reduce by one-third the number of shows on **dating**, **romance and love**, and **marriage**, as well as talent contests and gaming, while remaining shows like the immensely popular *If You Are the One* were required to alter their content by returning to the work of promoting "socialist core values."

China churns out more television shows than any other country—14,000 in all—but few are purchased abroad, while China still imports enormous foreign content from more freewheeling countries like South Korea. With the

growth of broadband networks in China, estimates are that half of the Chinese population, especially people younger than age 30, no longer watch television but instead view online videos provided by such companies as Youku Tudou, China's answer to the officially blocked YouTube, with a viewership of 500 million. A hot spot of popular culture, prominent television programs, many based on famous historical dramas, include *Princess Agents*, *Nirvana in Fire*, *The Journey of Flower*, *Eternal Love*, and *The Legend of Mi Yue*, with equally appealing variety shows, including *Happy Camp*, *Super Girl*, and *Sing China*, with many of the shows available on multiple video websites.

China National Radio is the state-run broadcaster, with eight channels, while China Radio International, the successor to Radio Peking, broadcasts internationally in 38 languages to more than 60 countries. Personnel are trained at the Beijing Broadcasting Institute and other such facilities. As social controls were dramatically loosened in China from the 1980s onward, radio became one of the first outlets for personal advice hotlines, beginning with the highly popular call-in show *Midnight Whispers*. The advent of podcasting and live streaming in China—technologies that enable individuals to produce their own songs and videos, and upload them to a website, which is then downloaded by viewers—has increasingly challenged Chinese government control of broadcasting outlets, as popular sites like Tudou.com, literally "potato net," operate from Shanghai. Using free open-source software on the web that allows anyone with a webcam or iPod to create his or her own channel of video or audio content, Tudou, in 2005, operated 13,000 channels, although anything possibly **pornographic** or critical of the Chinese government is self-censored. China has enacted a Freedom of Government Information Law modeled on similar legislation in other, mainly democratic, countries, although efforts by citizens to retrieve sensitive information in China from the government still face exceeding difficulties.

BUDDHISM (*FOJIAO*). Transmitted to China from India during the Han Dynasty (202 BCE–220 CE) and the Northern Wei Dynasty (386–534), major **religious** texts brought to China by traveling Buddhist monks including Faxian (399–412) and Xuanzang in the 7th century during the Tang Dynasty (608–907), Chan (Zen), roughly translated as "meditative state" and based on Mahayana (Great Wheel), became the dominant doctrine in China with smaller sects, including Pure Land, Tiantai, Huayan, and **Tibetan** Buddhism. Merged with aspects of **Daoism** and with a belief that enlightenment could be achieved in a single lifetime, Buddhism, throughout Chinese history, was subject to a mix of support and persecution. Promoted as a state religion in 691, during the unofficial rule of Empress Wu Zetian (690–705), who authorized construction of Buddhist statues throughout the empire, the doctrine was subsequently repressed, along with Nestorian **Christianity**, as a foreign

58 • BUDDHISM (FOJIAO)

import by Emperor Wuzong (840–846), with large landowning and tax exempt monasteries shut down and thousands of monks stripped of monastic status but with the persecution quickly reversed by Emperor Xuanzong (846–859).

Major Buddhist sites, monasteries, **pagodas**, and temples were constructed where the Buddha was prayed to as a **god**, as the routes to India along the **Silk Road** and Tea Horse Road in Western and Southwestern China were accorded protection by Buddhist emperors. Educational institutions were also transmitted to China including the Buddhist college (vihāra) used largely for religious purposes only. Four major anti-Buddhist campaigns were pursued between the 5th and 10th centuries but with the number of Buddhists in the Song Dynasty (960–1279) reaching an estimated 60 percent of the population. Like **Confucianism**, Buddhist doctrine in China preached the importance of paying heed to **ancestors**, while also promoting the achievement of **happiness** and cleansing the world of **violence** by following the "four noble truths" (*sige gaoshangde zhenli*) of impermanence, suffering, rejection of self, and stillness, with the heavy-set "Laughing Buddha" (*Xiaofo*) becoming the most popular image of the Buddha in China.

In the history of the People's Republic of China (PRC) since 1949, Buddhism was once again subject to strong state control and periodic persecutions, especially during the 1950s and 1960s during the **Cultural Revolution (1966–1976)**, followed by a major revival from the late 1970s onward. Previously autonomous Buddhist monasteries were subject to government control via the Chinese Buddhist Association, established in 1953, with oversight by the State Administration of Religious Affairs. Substantial monastic lands, along with rents, were confiscated during the Land Reform and Agricultural Collectivization campaigns (1953–1959), as monasteries were integrated into the local agricultural economy according to a policy of "combining Chan [Buddhism] with agricultural work" (*nongchan bingzhong*). Labor was performed daily, primarily in agriculture, with temples becoming state organizations and monks and nuns turned into government employees. During the chaotic Cultural Revolution, Buddhist temples and artifacts, including centuries-old statues and **paintings**, were destroyed by rampaging Red Guards, with Buddhist priests and nuns forced back into secular life, including **marriage**, with some tortured. Sacred books were burned, while in **Beijing** more than 4,900 religious relics were destroyed, along with a half-million antiques, as part of an all-out assault on religious life.

Beginning with the introduction of economic reforms and social liberalization (1978–1979), Buddhism underwent a dramatic revival, as ancient temples were rebuilt and new ones constructed, with direct financial assistance of the Chinese government. Recruitment of novices, performance of religious **ceremonies**, and dissemination of sacred beliefs were renewed, as Buddhist monasteries became major **commercial** and tourist sites, benefiting local

BUDDHISM (FOJIAO) • 59

economies, with many offering stocks on the country's exchanges and purchasing trademarks. Emblematic of this transformation is the 1,500-year-old Shaolin Temple in Henan, a traditional center of Chan Buddhism that has become a **business** empire involving tourism, **martial arts** (*wushu*), **traditional Chinese medicine (TCM)**, and cultural programs, with the temple abbot known as the "CEO monk."

The number of practicing Buddhists in the PRC is estimated at 100 million out of 350 million total believers, with 380,000 clerics and 144,000 religious venues, as significant elements of the Chinese population demand a faith-based religion. Concerned with the explosion of believers in Christianity, the Chinese government, including the officially **atheistic** Chinese Communist Party (CCP), has assisted the sect, which historically has been subservient to political authorities and remains politically conservative, accommodating the one-party state. Financial support has included the construction of Buddha statues, notably the Guanyin Bodhisattva of Nanshan (108 meters [354 feet] tall) on Hainan Island and the renovation of such ancient sites as the giant Leshan Maitreya Buddha (71 meters [233 feet] tall), built during the Tang Dynasty and now a major tourist attraction near the confluence of the Min and Dadu rivers, and sacred Emei mountain (**Sichuan**). Official support has also provided for the restoration and preservation of famous Buddhist grottos and caves at Mogao in Dunhuang (Gansu), Longmen (Henan), Luoyang (Henan), and Yungang, near Datong (Shanxi), all of which are major domestic and international tourist attractions. Protected sacred mountains believed to be the holy seats of bodhisattvas include Emei (Sichuan), Jiuhua (Anhui), Putuo (Zhejiang), and Wutai (Shanxi), while the most well-known temples and monasteries, excluding Tibetan Buddhism, include the following: Shaolin (Henan), the center of Chan and the training center for Chinese martial arts; White Horse (Henan), the oldest in the country, at 1,900 years; Famen (Shaanxi), considered a wonder of the world; Hanging Temple (Shanxi), built into the side of a cliff suspended 50 meters above the ground; Wenshu (Sichuan), with a finger bone relic of the Sakyamuni Buddha enshrined; and Lingyin (Zhejiang), with numerous pagodas, grottos, and carvings.

Current problems afflicting the highly decentralized Buddhist institutions absent a single, dominant leader include accusations of **corruption**, especially involving the official Chinese Buddhist Association, whose leaders are political appointees generally lacking in religious legitimacy and not really considered masters of Buddhism. In the popular mind, particularly among the lay believers who provide much of the investment and financing of monastic duties, greatest reverence is shown for monasteries with a good reputation for purity of their "style in religious practice" (*daofeng*) led by "superior monks and great virtues" (*gaoseng dade*), especially when performing such sacred duties as the "ceremony of water and earth" (*shuilu fahui*) in honor of the deceased. The World Buddhist Forum has been held in the PRC on three

60 • BUREAUCRATISM (GUANLIAOZHUYI)

separate occasions in 2006, 2009, and 2015. The Chinese film *Xuanzang* (2016) traces the life and travels from China to India of the famous 7th-century monk in his quest to bring important Buddhist scriptures back for translation into Chinese during the early Tang Dynasty (618–907). Famous Buddhist icons such as the "four heavenly kings" (*sida tianwang*), guardians placed at the entrance to Buddhist temples are in contemporary parlance used to refer to pop singer **celebrities**.

BUREAUCRATISM (*GUANLIAOZHUYI*). Defined as an excessive reliance on an elaborate and often-inefficient system of procedures and rules and regulations by unelected officials, bureaucratism has been a major malady and political target in the history of the People's Republic of China (PRC). During the imperial era of dynastic rule (221 BCE–1911 CE), the Chinese state generally avoided excessive bureaucratic routine, relying on a meritocratic-based system of relatively few "**scholar**-officials" (*rujia*) steeped in the doctrines of **Confucianism** and the imperial "Censorate" (*Jiancha Jigou*) established as the eyes and ears of the emperor from the Yuan Dynasty (1279–1368) onward. The adoption of central economic planning and a one-party state from the Soviet Union by the PRC beginning in 1953, produced a lethargic and often-bloated administrative system ripe with multiple bureaucratic deficiencies of excessive paperwork, complex licensing requirements, and arbitrary decision-making by officials chosen not on merit, but on political and personal **loyalty**.

During the era of rule by Chinese Communist Party (CCP) chairman **Mao Zedong** (1949–1976), the term "bureaucratism" was used to characterize the insensitivity and detachment of party and state personnel from the interests of the general population. The unwillingness of "cadres" (*ganbu*) to carry out investigations of practical conditions and explain the policies of the government was a sign of being "divorced from the masses" (*tuoli qunzhong*). Bureaucratism violated the "mass line" (*zhiliang xian*) and was one of the major targets for **criticism** and "**struggle** sessions" (*douzheng huiyi*) pursued during the **Cultural Revolution (1966–1976)**, with offending cadres "sent down to the countryside" (*xiaxiang*) and factories where they spent years at May Seventh Cadre Schools undergoing "reeducation" (*zai jiaoyu*) but with little or no effect on inbred political behavior.

Following the introduction of economic reforms and social liberalization (1978–1979), three separate plans were introduced to streamline the bloated administrative apparatus and eliminate overlapping responsibilities that contributed to bureaucratic inefficiency and waste. Included were plans to create independent regulatory bodies to oversee several industries, especially those with bloated staff, for instance, banking and finance, as well as state-owned enterprises (SOEs). State companies and central government ministries would be stripped of the power to develop and carry out economic policy,

with such proposals taking years to implement. Often watered down by competing factions, these plans are often undercut by the very bureaucratic interests targeted for amelioration.

With the growth of a private sector in the Chinese economy by economic reform, expectations were for a reduction in the bureaucratic maze that so afflicted Chinese society. That central government ministries were dramatically reduced in number, from 40 to 29, with a concomitant 50 percent reduction in staff, from 8 million to 4 million in 1998, affirmed an antibureaucratic strain in central government policy, as regulatory authority was transferred to a series of much leaner national commissions. Measures were also taken to reduce or transfer to lower administrative levels the approval process for more than 300 activities, including establishing a new **business** or social organization, such as a private orphanage, that can literally take years of wrangling with petty officials more interested in protecting their organizational prerogatives than advancing the public good. Yet, even as SOEs underwent an organizational transformation, guided by such American investment banks as Goldman Sachs and J. P. Morgan into modern corporations with major staff reductions, bureaucratism did not really diminish in China, but reemerged in a new, regulatory form, especially for overseeing the private sector. With the establishment of a slew of regulatory commissions and agencies, plus the increased role of such state entities as the People's Bank of China, whose staff expanded fivefold from the 1980s onward, the official number of civil servants actually expanded from 11 million to more than 16 million from 2002 to 2012. That number grows to an even larger figure of 30 million if personnel from so-called units of official pursuit are included, taxpayer-funded personnel who are technically not civil servants. This reflects continued heavy state involvement in such key economic sectors as banking and finance, real estate, infrastructure, telecommunications, railways, health care, energy, and pharmaceuticals, as well as the growth of a regulatory regime in the private sector, which has made China a "country of licenses" (*xuke guojia*). From enormously complex documentary exchange mechanisms within government departments to a labyrinth of rules and regulations governing such vibrant new economic activities as micro-credit companies, bureaucratism in China is very much alive.

BUSINESS PRACTICES AND BUSINESS ETHICS (*SHANGYE/ SHANGDE*). Based heavily on human **relations**, business practices in the People's Republic of China (PRC) reflect the influence of traditional values and beliefs among merchants and traders, along with a major role by a strong state. While state-owned enterprises (SOEs) dominated the Chinese economy during the period of central economic planning (1953–1978), the introduction of economic reforms in 1978–1979 led to a revival of private business activity. Adopted to enhance business prospects in an intensely competitive

62 • BUSINESS PRACTICES AND BUSINESS ETHICS

environment, common practices, some bordering on illegality, include cultivating personal ties with potential clients by exchanges of **gifts** and such frequent social gatherings as **banquets** and visits to karaoke bars and clubs. Dominated by males with little separation between business and private life, and a relationship with state authority that remains unclear and ambiguous, Chinese businessmen are known to engage in bribery and other nefarious actions to win favor from officials, especially in companies where the state is a major and even majority stakeholder.

With an increasingly sophisticated customer base and greater involvement in the global economy since 1978–1979, business ethics, defined as a form of applied or professional ethics in a **commercial** environment, have taken on importance for Chinese companies, domestic and international. Afforded little or no attention throughout much of the imperial and modern eras, as both **Confucianism** and Marxism–Leninism denigrated merchants and traders, the business world of production and commerce was viewed as a life-or-death activity legitimating all forms of unethical behavior. Included were mistreatment and distrust of employees, particularly **women**; bribery of government officials; perpetuation of fraud; and, worst of all, willing production of tainted products threatening the public **heath**, notably **children**. Weak corporate governance, lack of ethical codes of conduct and an independent model of business ethics, and a generally unresponsive **legal** system led to widespread **corruption** and often illegal behavior. A vicious circle evolved in which owners distrusted managers and, in turn, managers mistreated employees, while taking actions to help themselves but doing harm to the company. Rarely punished with reports of malfeasance by socially responsible employees, leading to little or no action, with the reporting party or a compliant executive often harmed, lack of business ethics became a major concern among international multinationals, especially following the entry of the PRC into the World Trade Organization (WTO) in 2001.

Major forms of unethical business practices encouraged by the overall business environment in China, with its emphasis on short-term gains, especially turning a quick profit, include the following: fake accounting methods, failure to make timely payments to vendors, lack of adherence to rules and regulations, imprecise and vague contracts rarely enforced, excessive employee overtime, and **sexual harassment** and abuse of migrant labor. For advocates of improving the overall ethical environment in Chinese business, two major challenges exist: 1) restricting lawless activity, especially in businesses composed largely of **family** members and trusted associates based on long-term cultivation of personal "relations" and "connections" (*guanxi*), and 2) protecting and advancing the interests of employees, investors, and the public through better corporate management and governance. Major Chinese government initiatives include the "Guidelines on Independent Directors in Listed Companies" (2001) and the "Code of Corporate Governance" (2002),

along with acceptance of the international concept of corporate social responsibility (CSR) and the United Nations Global Compact, agreed to by 197 Chinese firms. Regulatory bodies include the China Securities Regulatory Commission and the China Banking Regulatory Commission, the latter overseeing the rapidly growing but tainted Chinese banking sector.

Major multinationals with operations in the PRC the likes of Walmart and Apple have also imposed strict ethical restrictions on in-country suppliers and vendors, while Chinese companies with strong commitments to abiding by ethical standards include electronics-maker Huawei. Greater ethical awareness is also enhanced by anonymous employee reporting of malfeasance, although rare, via the internet and the emergence of nongovernmental organizations (NGOs) focused on issues of corporate governance, along with customer boycotts and citizen protests. Persistent problems include lack of corporate transparency and inadequate **education** and training in ethics by the country's business schools and such universities as the Beijing University of International Business, although the concept of the "Confucian merchant" (*rushang*) is designed to infuse Chinese businessmen with a greater ethical conscience.

CALLIGRAPHY (*SHUFA*). Literally meaning "beautiful writing," calligraphy is considered the highest **art** form in China, devoted to the power of the word and more valued than both **painting** and **sculpture**. With one of the oldest continuous writing systems in the world, earliest examples of calligraphy include inscriptions on "oracle bones" (*jiagu*) and bronze vessels from the Shang Dynasty (1600–1046 BCE) excavated from the "ruins of Yin" (*Yinxu*) on the north China plain in the city of Anyang, Henan. Ranked along with **poetry** as a mode of self-expression and individual cultivation, calligraphy requires lofty personal qualities and aesthetic sensitivity revealing the character and cultivation of the writer, and judged on the vitality and expressiveness of the individual brush strokes and the harmonious rhythm of the entire composition. For the traditional "**scholar**-officials" (*rujia*) who governed the Chinese empire for more than 2,000 years, calligraphy was considered one of the four best talents, along with playing musical instruments, playing the board **game** *weiqi* (known in Japan as "Go"), and painting.

Basic materials for calligraphy, which include a brush, ink, paper, and inkstone, known as the "four treasures of the study" (*yanjiu sibao*), were developed during the Han Dynasty (202 BCE–220 CE), with "regular script" (*kaishu*) fully developed by the Tang Dynasty (618–907). Standard characters needed to be legible and concise, fit the context, and be aesthetically pleasing. Innovations included production on paintings with a poem written on the canvas by a master calligrapher, which became one of China's "three perfections" (*sange wanmei*) extending from the Song Dynasty (960–1279) to the 20th century. That how one wrote was as important as what one wrote reflected the great esteem for writing and literacy in Chinese history, with special social status conferred on those who can read and write. The most famous and revered work of calligraphy is the *Preface of the Orchid Pavilion* (Lan Ting Xu), by Wang Xizhi (307–365), considered the greatest calligrapher of all ages, with copies and reproductions engraved in stone during the Tang (618–907) and Song dynasties.

66 • CELEBRITY AND FAME (MINGREN/MINGWANG)

Throughout the history of the People's Republic of China (PRC) beginning in 1949, Chinese political leaders have proudly displayed their calligraphy, often in photographs exhibiting writing skills. Most notable was the calligraphy of Chinese Communist Party (CCP) chairman **Mao Zedong** (1949–1976), whose personal signature was close to the traditional calligraphic style. Appearing on the masthead of the official *People's Daily* (Renmin Ribao), selections of his poetry are on exhibit in the chairman's mausoleum in Tiananmen Square in **Beijing**. President Jiang Zemin (1989–2002) followed suit with public displays of his personal calligraphy, notably on a stone plinth located at the Central Party School, while current president **Xi Jinping** (2013–) has evidently modeled his own personal signature on Mao's calligraphic style. Employed as a tool of social revolution, calligraphy was promoted as a form of "people's art" (*renmin yishu*), with "model worker-peasant" (*mofan gongren nongmin*) calligraphers touted during the 1950s and 1960s, although the art form was gradually subordinated to "socialist realist" (*shehuizhuyi xianshizhuyi*) artistic principles adopted from the Soviet Union and openly attacked as "feudal" (*fengjian*) during the **Cultural Revolution (1966–1976)**.

Beginning in the late 1970s, traditional calligraphy underwent a resurgence, with classes in the **art** form taught at prominent art schools and colleges, along with the creation of calligraphy clubs and competitions among professional and amateur calligraphers, the latter using fountain pens until the 1980s. Artists committed to altering long-held rules governing calligraphy include the 85 Calligraphy Group, with works appearing more like paintings than traditional calligraphy, and the postmodernist movement dubbed "calligraphyism" (*shufazhuyi*), which aims to transform calligraphy into an art so abstract as to make the words illegible, similar to the "wild grass" (*kuangcao*) script developed by Zhang Xu and Huai Su, known as "crazy Zhang and drunk Su" (*dian Zhang zui Su*), during the Tang Dynasty. Avant-garde calligraphers display their unique and often bold exhibits, such as Square Word calligraphy by Xu Bing (1955-), at home in such major outlets as the Today Art Museum in Beijing and abroad at such locales as Brooklyn Museum in New York City. Drawing calligraphy is also a popular pastime in the country, most notably by elderly Chinese men, with long, broom-like brushes and buckets of water using pavement as their canvas at such famous sites as the Temple of Heaven. Proliferation of cell phones and computers, especially among Chinese **youth**, has raised fears that the traditional art form may not be carried on by future generations.

CELEBRITY AND FAME (*MINGREN/MINGWANG*). A major feature of public life and **entertainment** in the People's Republic of China (PRC), celebrity and fame underwent significant transformation from domination by the political arena during the rule of Chinese Communist Party (CCP) chair-

man **Mao Zedong** (1949–1976) to the emergence of actors, athletes, and pop **music** stars from the late 1970s onward. A product of the 20th century beginning with French stage actress Sarah Bernhardt (1862–1922), the cult of celebrity spread beyond entertainment to political figures including in China where Madame Chiang Kaishek demonstrated the importance of celebrity status and the media spotlight to national political prominence. Following the establishment of the People's Republic of China (PRC) and with the media under tight state control, Mao Zedong reigned supreme among the top **leadership** assuming center stage, especially at mass rallies held during the **Cultural Revolution (1966–1976)** in Tiananmen Square along with periodic appearances swimming in the Yangzi River. Carefully selected "model" (*mofan*) soldiers and worker-peasants were also the focus of media attention, most prominently the heroic Lei Feng (1940–1962), a People's Liberation Army (PLA) soldier who was hailed posthumously. Subject of a "Learn from Lei Feng" campaign (1963–1964), the soldier was portrayed as devoted to self-sacrifice and living a frugal life with his image on posters disseminated nationwide. Other model figures include the illiterate peasant Chen Yonggui (1915–1986), leader of the highly praised Dazhai Agricultural Brigade in **rural** Shanxi and proponent of socialist agriculture, which was eventually overturned by the economic reforms in agriculture introduced in 1978–1979. While historians and **scholars** in China question the veracity of the Lei Feng story line, noting the constant presence of Xinhua photographers to record the soldier's every movement, Chen Yonggui faded into obscurity as semiprivate agriculture replaced the people's communes (*renmin gongshe*), brigades, and production teams that had prevailed during the Maoist era.

Following the passing of Mao Zedong in 1976, sources of celebrity and fame in the increasingly consumer-oriented PRC shifted quickly to **sports** and entertainment, especially with the advent of **social media** over television, film, and the internet. Fawning admiration of celebrities is now a multimedia and international phenomenon, with glossy magazines offering heavy doses of gossip on mainland and Taiwanese pop stars, some of whom are **foreigners** whose appearance on Chinese television and in films became a boost to celebrity. Chinese versions of the American television show *Access Hollywood* deliver a constant barrage of news about the rich, famous, and beautiful, who translate their popularity into lucrative product endorsements of such major international luxury brands as Channel and L'Oréal. With photographs of prominent celebrities appearing on billboards and buses, and in the country's highly popular **shopping** malls and on video clips available on major blog sites the likes of WeChat and Baidu, the sector is a big **business**, with companies like Shifei Technology serving as incubators of new talent for which there seems an insatiable demand, which now includes previously unknown **chefs**.

68 • CENSORSHIP (SHENCHA)

During the buildup to and aftermath of the 2008 **Beijing** Olympics, such sport celebrities as basketball player Yao Ming and Olympic diving sensation Guo Jingjing dominated the celebrity scene, along with major film stars like Jackie Chan, Jet Li, and Gong Li. In more recent years, film and television soap opera stars and pop singers the likes of actress Fan Bingbing and 20-year-old band member Cai Xukun have established a near-monopoly of the scene, as evidenced by their appearance in the annual "Forbes China Celebrity 100." While official government propaganda has designated celebrities in highly orthodox terms like "engineers of the human soul" (*renlei linghun gongcheng shi*), urging them to "create the best **spiritual** food and truly serve the people and socialism," Chinese celebrities, with their multimillion-dollar incomes and high profiles, have become major representatives of the "bourgeois romantic lifestyle" (*zichanjieji de langman shenghuo fangshi*) so attractive to young audiences. With internet stardom a highly sought-after career, especially for **women**, celebrities focus on the latest trends and talking points about branded **clothes**, shoes, and cosmetics, with little or no regard for politics and/or mention of socialism.

Along with product promotion, celebrities have also become active in such public interest areas as **health** issues, including the frequently controversial and problematic government management of the HIV/AIDS problem. Appearing in educational movies and commercial television series, these "aid celebrities" (*yuanzhu mingren*), for example, actor Pu Cunxin, have been actively enlisted in the state policy goal of controlling HIV/AIDS, especially in the southwest, where **drug abuse** and other means spread the infection. While some celebrities have also become important pillars in the field of **charity**, appearing at annual charity-night bazaars and promoting **nationalism** and traditional values, as a group Chinese celebrities score low on indexes of "social responsibility" (*shehui ziren*), with official media decrying their negative social impact, for instance, the huge traffic jam created in **Shanghai** by the wedding of actress Yang Yang, known affectionately as "Angelababy," to actor Huang Xiaoming.

CENSORSHIP (*SHENCHA*). Control of the press, films, and other works of **literature** and the **arts** has been a central component of state policy since the establishment of the People's Republic of China (PRC) in 1949. Extending into the 2000s, especially following the ascension to the presidency by **Xi Jinping** (2013–), "thought work" (*sixiang gongzuo*) has entailed tight political control over editorials and news reports of the press, especially *People's Daily* (Renmin Ribao), the official publication of the Central Committee of the ruling Chinese Communist Party (CCP). Also targeted with varying levels of censorship are books and magazines, **cinema and film**, literature and the arts, **broadcasting and television**, and the internet. From the center to the localities, the CCP exercises strict management of the media through its

CENSORSHIP (SHENCHA) • 69

Propaganda Department, renamed the Publicity Department, and 12 other agencies, including most prominently the General Administration of Press and Publication, the State Administration of Radio, Film, and Television (SARFT), and the State Internet Information Office.

Three kinds of censorship exist in China. The first is self-censorship, representing conscious efforts by news reporters and writers to remain within the guidelines established by the CCP and express views consistent with central policies. Since policies are subject to sudden and often arbitrary change, self-censorship requires constant attention to even the most subtle shift in the basic line and policy positions of the party. The second form of censorship is the formal system of review for newspapers, books, and cinema and film scripts. Newspapers like *People's Daily* have set up an elaborate system involving review of draft editorials prior to publication by chief editors and vice editors, as well as the director of the paper. Editorials and articles by official, unnamed "commentators" (*pinglunyuan*) undergo a continuous process of revision before being sent to Party and state leaders for final review. Party leaders assigned responsibility for a certain field, for example, foreign policy, review all editorials dealing with the area under their purview. Central leaders in charge of propaganda also review virtually every editorial and commentary, while especially important pieces are sent to the CCP general secretary for final imprimatur. Revisions by the top party and state leaders become the ultimate standard that reporters must follow. Editorials, commentators, and straight news items from *People's Daily* are often republished in other central and lower-level newspapers, creating an enormous uniformity of official opinion and message.

Following the introduction of economic reforms and social liberalization (1978–1979), the censorship regime was relaxed by CCP general secretary Hu Yaobang (1980–1987), who in a 1986 speech instructed editors that 80 percent of reporting should focus on achievements in modernization and only 20 percent on shortcomings. This led some newspapers, most notably the Shanghai-based *World Economic Herald* (Shijie Jingji Daobao) and *Southern Weekend* (Nanfang Zhoubao) in **Guangzhou** to generally avoid the censorial system, although both ultimately faced shutdown and/or major alterations in article content, especially following the military crackdown on the prodemocracy movement in **Beijing** and other major cities in June 1989.

The third form of censorship is postpublication review. Authors of editorials or news items that are published and then singled out for **criticism** by top leaders will usually encounter severe repercussions. Books, magazine articles, and films that are initially approved for publication or somehow get by the censors are often subject to postpublication censorship by being banned, confiscated, and/or destroyed, with their editors and journalists subject to dismissal, as proved to be the fate of the *World Economic Herald* after 1989,

70 • CENSORSHIP (SHENCHA)

and the *Beijing News* in 2005. Publishing houses operate according to the knowledge that publication of only one "bad book" can lead to their being shut down, as occurred in 2014, in Guangdong and **Sichuan**.

Opposition to CCP censorship has been a constant theme of political protests in the PRC, from the Hundred Flowers Campaign (1956–1957) to the 1989 prodemocracy movement. In the mid-1980s, a policy of relative relaxation on censorship was announced by CCP official Hu Qili (1978–1989), who in a 1984 speech to the National Writers' Congress decried the political excesses that produce derogatory labels and decrees about what writers should and should not write. But as writers and intellectuals began to test the limits, they were reminded by Hu Qili of their "social responsibilities" (*shehui zeren*), a thinly veiled warning for them to exercise self-censorship. In 1986, on the 30th anniversary of the Hundred Flowers Campaign, the new head of the CCP Propaganda Department, Zhu Houze, called for a new Hundred Flowers in China and was backed by Wang Meng, the newly appointed minister of culture. During the 1989 prodemocracy movement, journalists and reporters joined in the street demonstrations, carrying banners reading "Don't Force Us to Lie" and, prompted once again by Hu Qili, engaged in relatively open reporting. A large group of reporters, led by veteran *People's Daily* director Hu Jiwei, also issued a statement during the movement calling for radical changes in CCP press controls. Following the military crackdown on 4 June, television news broadcasters exhibited their disgust with the violent government reaction against unarmed students by dressing in black while reporting the news. These efforts came to naught, however, as protesting newsmen were fired from their positions, and individual reporters with an outspoken reputation, for instance, writer and journalist Ms. Dai Qing, were sent to prison.

Tightly controlled censorship was reestablished throughout the 1990s, first under strict control of the People's Liberation Army (PLA) and subject to the authority of a rebuilt CCP propaganda apparatus headed by more conservative leaders, for example, Wang Renzhi and Ding Guan'gen. In the initial stages of the SARS crisis from 2002 to early 2003, China's censorship system prevented an open and transparent accounting of the extent of the epidemic until reports surfacing from on-the-scene doctors led to an open admission by the government of the earlier cover-up. But despite the replacement of the more hardline Jiang Zemin by Hu Jintao as general secretary of the CCP and state president in November 2002, the expectation of relaxed media controls did not transpire, even as a policy paper circulated in the high ranks of the CCP called on officials to be more responsive to media requests for information and interviews. Journalists who pioneered stories on SARS in early 2004 were imprisoned, while proposals for greater transparency were shelved as official prohibitions remained in place against reporting on a multiplicity of stories, with examples being the possibility of a reevaluation

CENSORSHIP (SHENCHA) • 71

of the Chinese currency, the renminbi, or the "people's currency," and poor job prospects for recent university graduates. Similar blocks were placed on the publication of books, especially those on such lurid topics as officials involved in one-night stands and extramarital affairs, while critics of the state propaganda machinery claimed that such policies shielded **corrupt** officials and whitewashed the darkest moments in the nation's history. The major press organ of the Communist Youth League (CYL), *China Youth Daily*, was similarly censored for its reporting on abuse of power by local officials in the special economic zone (SEZ) of Shenzhen, while a newspaper with a liberal slant, the *21st-Century Globe Herald*, was closed down and then banned outright in 2004.

That same year, journalist Shi Tao was arrested and subsequently sentenced to a long prison term for reportedly violating national security by using his Yahoo! account to send a summary document on CCP instructions regarding the upcoming anniversary of the crackdown on the prodemocracy movement in 1989. While Yahoo! readily complied, Google.cn, confronting similar limits, shut down its operations in China in a protest against censorship and **human rights** concerns. In 2005, China topped the list of countries with the most journalists in jail, numbering 32, the seventh year in a row in which the PRC headed the list, for alleged activities on the internet and writing articles critical of the CCP that purportedly violated national security laws. A public letter issued in February 2006, by former CCP officials and journalists, including Li Rui, Hu Jiwei, and Zhu Houze, denounced the recent closings of newspapers, fueling a growing backlash against censorship. Controls have also been tightened along the still-existing border with **Hong Kong**, which traditionally was a source of books and other material critical of the government, but these are now being seized by more sophisticated methods of search carried out by Chinese customs agents. A Bureau of Public Opinion was set up in the CCP Propaganda Department that commissioned surveys and research to measure the pulse of public opinion, although within the confines of the official political line.

The advent of **social media** and the internet has posed a major challenge to the control of CCP propaganda organs, especially during such major catastrophes as the fatal crash of two high-speed trains near the city of Wenzhou in July 2011. Both social and conventional media, including Central China Television (CCTV), challenged the official narrative on the accident, which had cited reputed technological failures, and instead focused on problems with management and other human failings at the highest levels of the Ministry of Railways. The same media phenomenon occurred in June 2015, during the sinking of the cruise ship *Oriental Star* in a nighttime storm on the Yangzi River, with the **death** toll at more than 400. While officials and shipping line authorities provided little information on the tragic accident to grieving relatives, many apparently relied on such internet websites as Weibo

72 • CERAMICS AND PORCELAIN (TAO CI/CI)

to learn whatever they could about the sinking and the prospects that their loved ones had survived. In response to such events, the Chinese government has moved to regain control of the news media, which President Xi Jinping pledged to "seize the ground of." In this vein, the government has issued new and enormously vague rules against "**rumor**-mongering," while high-profile figures associated with Weibo and other microblogging sites have been arrested on what appear to be trumped-up charges. In the name of "protecting China's culture and moral standards," crackdowns were also carried out on mobile messaging services in 2014, while 2 million people have been mobilized by the government to act as cybercops and "internet public opinion analysts." Among the sensitive topics prohibited for discussion are democracy and human rights, corruption, Falun Gong, Muslims in Xinjiang, police brutality, **pornography**, Taiwan, **Tibet**, and even **food** security, along with any detailed and personal accounts of the **Cultural Revolution (1966–1976)**.

In 2017, Reporters without Borders ranked the PRC 176 out of 180 in the world in its press freedom index, with 38 journalists and reporters incarcerated, as the OpenNet Initiative found pervasive censorship of the internet. Since 2009, the General Administration of Press and Publications has maintained a database of people who reportedly "engage in unhealthy professional conduct" on social media and the internet. With an edict from the Ministry of Education to primary and middle schools to "cleanse" (*jiejing*) local **libraries** of harmful and "unhealthy" material, pictures of dutiful students burning books in Gansu hit the internet, provoking immediate controversy, with comparisons drawn to the burning of the Confucian classics during the Qin Dynasty (221–206 BCE) and the worst days of the Cultural Revolution and even Nazi Germany. Accusations of official censorship have also been voiced during the COVID-19 pandemic, with special attention to an alleged cover-up of the virus spread in the central China city of Wuhan, the center of the original outbreak.

CERAMICS AND PORCELAIN (*TAO CI/CI*). Dating back to the Han Dynasty (202 BCE–220 CE) as an **art** form, ceramics and porcelain production in China provided exquisitely made wares to the imperial court while dominating global trade in the prized items with exports to major **markets** in Europe and North America until the 20th century. Revered in **Confucianism** as the creation of objects of ornamentation, such elegantly crafted objects as vases and goblets were considered a means to influence people, contributing to overall social peace and **harmony**. Most notable forms fired in kilns included "celadon" (*qingci*), a **jade**-like glaze developed during the Han Dynasty; "white ceramics" (*baici*) developed during the contentious Ten Kingdoms (907–979); "blue-and-white" (*qinghua*) coloring perfected during the Ming Dynasty (1368–1644); and "five color" (*wucai*) wares developed during the Qing Dynasty (1644–1911). From the 11th century onward, pro-

CHAOS (LUAN) • 73

duction was centered in Jingdezhen, Jiangxi, located near valuable kaolin clay deposits and porcelain stone used in production, along with sites in Zhejiang for the production of celadon. According to an old saying, Jingdezhen products were "white as jade, thin as paper, clear as glass, and sweet-sounding as a chime." Items produced included bowls; cups; ginger jars; incense burners; platters; and vases with smooth, crackled surfaces on which were painted important **symbols** of good **fortune**, prosperity, and **longevity** (including birds, **plant** life, sacred **animals**, and mythical creatures like the dragon and phoenix, representatives of the emperor and empress), along with such revered historical figures as the Arhats (*Luohan*) of **Buddhism**.

Suffering declines in domestic and international markets beginning in the late Qing Dynasty and afflicted by the outbreak of civil war and political conflict throughout the first half of the 20th century, ceramic and porcelain production during the rule of Chinese Communist Party (CCP) chairman **Mao Zedong** (1949–1976) consisted largely of politically acceptable items. Included were statuettes of rosy-cheeked workers and peasants, and assorted Maoist paraphernalia, with the city's workshops and local craftsmen ravaged during the **Cultural Revolution (1966–1976)**. From the late 1970s onward, with old factories renovated and large numbers of traditional craftsmen employed, production shifted to wares, combining contemporary ideas with traditional elements fulfilling popular demand by the emerging middle class of the country's most prized and internationally renowned art form. Using new technologies, most notably 3-D printing, high-pressure grouting techniques, and automated production lines, innovations included using balloons to forge fragile bowls, with more than 6,700 enterprises located throughout Jingdezhen. International auctions of premodern wares yield premium prices, with one example being a Ming Dynasty rooster cup sold at Sotheby's for $36 million in 2014.

CEREMONY. *See* RITUALS AND CEREMONIES (*LIJIE/YISHI*).

CHAOS (*LUAN*). Perennial **fear** of elite and commoners alike, the outbreak of chaos from the loss of control in society by the "patriarchal" (*jiazhang*) **family** at the local level and state authority at the macro level is a prescription for the disasters that have befallen China at key points in **history**. Long-term periods of **conflict** and disorder involving **panics and mobs** can spread like wildfire. This can lead to scarcity of basic necessities, primarily **food**; an increase in **crime**; and a general collapse of social and political order. Periods of chaos and disorder in the imperial era, usually following the collapse of dynasties, are considered low points in Chinese **historiography** resulting from inattention to the primary functions of the Chinese state, for example, flood control and famine relief, and inadequate commitment of rulers to the

74 • CHARITY (CISHAN)

governing principles and practices of **Confucianism**, with **corruption** and incompetence pervading bureaucratic ranks. Vulnerabilities to the empire included conflict and **violence** among ethnic **minorities** and/or the prospect of intrusion and invasion by foreign powers, as occurred most recently in the late Qing Dynasty (1644–1911) when the chaos wrought by the Taiping Rebellion (1850–1864) combined with the intervention of the imperialist powers of the West and Japan to bring down the Qing while weakening the succeeding Republic of China (ROC) throughout the period of rule on the mainland (1912–1949).

The establishment of the People's Republic of China (PRC) provided a period of relative calm and social order, with a single national authority imposed by the organizational capacity of the Chinese Communist Party (CCP) from the national to the **urban** and village levels. Provoked by the **utopian** visions of CCP chairman **Mao Zedong**, and his traditional belief that "in times of chaos great leaders arise" (*hunluan chansheng weida lingdaozhe*), chaos returned with the disastrous Great Leap Forward (1958–1960), impacting wide swaths of **rural** society, especially in Henan, followed by the **ideologically** driven **Cultural Revolution (1966–1976)**, with equally devastating effects on the country's cities and towns. With the emergence of **pragmatic** leaders the likes of Deng Xiaoping (1978–1992) and successors like Jiang Zemin (1989–2002), Hu Jintao (2003–2012), and **Xi Jinping** (2013–), a return to normalcy was enacted, as **harmony** and "stability" (*wending*) became the operative political imperative but with the absence of strong institutions of civil society, making renewed chaos a constant fear of leaders and the populace alike.

CHARITY (*CISHAN*). Historically a social service performed by kinship groups and Buddhist monasteries, especially in the aid of orphans but with little state action, charity has gradually evolved as a civic duty in the People's Republic of China (PRC). Drawing on the principle in **Confucianism** of "helping and caring for others," prominent Chinese in the early 20th century exhibited considerable generosity and charitable initiative, notably by the former premier of the Republic of China (ROC), Xiong Xiling (1870–1937), who helped establish educational and human service institutions to confront natural disasters and the Japanese invasion in the Second Sino–Japanese War (1937–1945). American-style philanthropy was also introduced into China by Christian missionaries and private groups, particularly the Rockefeller Foundation, with contribution to the field of medicine and the work of John Leighton Stuart at Yenching University (today Peking University).

During the era of rule by Chinese Communist Party (CCP) chairman **Mao Zedong** (1949–1976), traditional charity groups, including kinship, ancestral, and **religious** organizations, as well as **pagodas and temples**, were extinguished, as Western-style private charities were associated with anti-

government activity and virtually nonexistent. Conventional charitable agents, including "philanthropy" (*cishan shiye*), "nonprofit organizations" (*fei yinglixing*), and "nongovernmental organizations" (NGOs/*fei zhengfu zuzhi*) were also prohibited, with the Chinese government providing little to no social welfare, especially during periods of political turmoil, for instance, the **Cultural Revolution (1966–1976)**, as attacks on anything "private" (*siren*) were unrelenting.

Beginning with the introduction of economic reforms and social liberalization (1978–1979), Western concepts of charity were reintroduced, as public space was gradually provided for the expression of a voluntary charitable spirit, along with the rehabilitation of religious institutions and churches. More lenient public regulations in the 1980s and 1990s, and a general retreat by the government from social welfare functions, led to an emergence of private and faith-based charities. These included, most prominently, the China Youth Development Foundation (1989); the China Charity Federation (1994); and the antipoverty, Christian-based Amity Foundation (1985). Professional and community associations also developed, with concentrations mainly in major Chinese cities. During the period of rule by President Hu Jintao and Premier Wen Jiabo (2003–2012), government public services increased, especially following the disastrous earthquake in **Sichuan** in 2008, which also witnessed a spurt in private donations to the devastated **region**. Corporate giving also emerged as two of the country's largest private enterprises, internet giants Tencent and Alibaba, established foundations to enhance charitable contributions. The former company sponsors "99 Charity Day" (2015–2019), with individuals and corporations making donations channeled to educational, **health** care, and antipoverty groups, while the latter has earmarked 0.3 percent of corporate revenues for socially responsible initiatives, along with setting up the Alibaba Poverty Relief Fund in 2017.

Passage of the national Charity Law (2016) eased restrictions on charitable fund-raising and offered tax concessions to registered charities, numbering more than 5,500, although hindrances have been imposed on some nonprofits and philanthropic groups based on a fear by the administration of President **Xi Jinping** (2013–) that their Western ties with such groups will become agents of antigovernment "color revolutions" (*secai geming*). Increasing control of charities has also occurred, as government-organized nongovernmental organizations (GONGOs) have asserted authority over major charities like the Chinese Red Cross, following accusations of a lavish lifestyle by a top official.

Poorly developed infrastructure, training, and **legal** framework to ensure that contributions go to good use may explain why overall giving in China constitutes a mere 0.1 percent of gross domestic product (GDP), lagging far behind the United States and other countries with a long history of charity.

76 • CHARM (MEILI, MIREN)

Ranked 144 out of 145 countries listed on the World Giving Index, top charitable organizations in China, with the charity focus in parentheses, include the following: Lao Niu Foundation (**education**); Ningxia Yanbao Charity Foundation (antipoverty and sustainable development); Heren Charitable Foundation (**rural** development); Tencent Foundation; and Dunhe Foundation (cultural development). Meanwhile, such internet sites as WeChat have emerged as primary venues for individuals to raise emergency funds for critically ill **children** and relatives. National events include an annual Conference on Philanthropy and the establishment of a Chinese Philanthropy Museum in Jiangsu.

CHARM (*MEILI, MIREN*). A highly subjective characteristic with major regional and **class** differences in China, charm is associated with several personality traits that, in the case of **women**, are heavily influenced by standards of physical **beauty**. For males, the concept of a prince charming, or, literally, a "sunshine boy" (*nuan'an*), involves someone who makes others feel warm, welcomed, and helpful, and is rich in empathy and positivity, with a capacity to smile away one's troubles. National lists of the top charming **men** are largely based on characteristics of vitality, elegance, intelligence, honor, and persistence, with many involved in **music** and other fields of the **arts** and **social media**. Among the personality traits closely aligned with charm for both men and women are "elegant" (*youya*); "refined" (*jingzhi*); "graceful" (*youmei*); "glamorous" (*fuyou meili*); "intelligent" (*zhineng*); "enchanting" (*yaorao*); "gentle" (*wenhe*); and "witty" (*jizhi*). Qualities specifically limited to women include "graceful and feminine" (*fengzi chuoyao*); "glamorous and seductive" (*meili sishe*); "coquettish" (*meiyan*); "lascivious" (*jiaotai*); "spicy and soft" (*malaruan*); and the highly pejorative and culturally specific "green tea bitch" (*lüchabiao*), appearing innocent and charming but actually calculating and manipulative. Chinese cities are also ranked on a so-called charm index, which highly correlates with the so-called beauty index, both expressed in percentage terms but with the method of calculation remaining a mystery.

CHAUVINISM (*SHAWENZHUYI*). Defined as excessive or exaggerated support for one's own group or gender at the expense of others, ethnic and male chauvinism has been a primary target of political groups in modern China, including the Chinese Communist Party (CCP), from Chairman **Mao Zedong** (1949–1976) to his successors, notably President **Xi Jinping** (2013–). Included are Han and male chauvinism, the former referring to the asserted superiority of the dominant Han ethnic group, constituting 92 percent of the population, over the 55 officially recognized ethnic **minorities** in the People's Republic of China (PRC), and the latter to continuing male

CHAUVINISM (SHAWENZHUYI) • 77

discrimination and mistreatment of **women**, despite officially espoused policies and laws guaranteeing gender equality since the establishment of the PRC in 1949.

Criticism and denunciation of Han chauvinism has been a constant theme in statements by CCP leaders beginning with Mao Zedong in 1938, and repeated in 1953 and 1956, with explicit warnings to CCP cadres and government officials to avoid discriminatory treatment of minorities, especially the relatively unassimilated **Tibetans**, Uighurs, and others living in peripheral **regions** of the PRC. Embedded in **Confucianism**, with the great philosopher describing the "middle kingdom" (*zhongguo*) as surrounded by hostile "**barbarians**," Han chauvinism was strengthened by a belief in the cultural superiority of the dominant majority, including the Chinese **language**, with many ethnic minorities made virtually invisible by strong assimilationist policies.

Pursued throughout the imperial era, especially in such marginal regions as **Yunnan**, extensive "Sinicization" (*Zhongguohua*) and "Confucianization" (*Kongqiuhua*) of minority peoples led to the cultural subjugation and, in extreme cases, virtual disappearance of non-Han groups like the "Dzungarians" (*Xiongyali ren*) in Central Asia. While the PRC is officially described in the state constitution as a "unitary [multiethnic] state created by the people of all nationalities," Chinese **nationalism** has become increasingly ethnocentric since the 1990s, with Han centrism more influential in the ongoing debate concerning national identity. Statements by President Xi Jinping on his proclaimed "Chinese dream" (*Zhongguo meng*) calling for "fulfilling the great renaissance of the Chinese race" have been interpreted as a not-so-subtle endorsement of the dominant Han majority, "descendants of the dragon" (*long de houyi*), with their "black hair and yellow skin" (*heifa/huang pifu*), representing the nation.

No less important is the persistence of discriminatory comments and actions directed against women by their male counterparts, despite official policy of gender equality, most notable in the implementation of two Marriage Laws (1950 and 1981) and dramatic increases in female access to **education** and leading roles in Chinese companies, where 20 percent of CEOs are now women. Long a target of such progressive thinkers as **Lu Xun** (1881–1936), who describes Confucian-dominated China as a virtual living hell for women in the short story *Benediction* (1924), notions of inherent male superiority continue to reappear with dismissive comments by prominent **men** on the internet claiming women are only beautiful when cleaning house and feeding babies. Even more shocking is the large percentage of Chinese males who admit to beating their female partners and even raping women, at 50 and 20 percent, respectively. Relatively affluent and well-educated women sometimes share these values, describing themselves as inferior to men while noting the vital importance of marrying well. Not

78 • CHEFS (CHUSHI)

escaping **criticism**, men making disparaging comments about women are often referred to dismissively as suffering from "straight man cancer" (*zhi nan aizheng*), the popular Chinese equivalent of a male chauvinist pig.

CHEFS (*CHUSHI*). Central to the culture of Chinese **cuisine**, chefs in the People's Republic of China (PRC) are beginning to gain **celebrity** as Western notions of chef stardom from such countries as France have gradually entered the country. Considered as skilled but uneducated artisans, Chinese chefs have generally accepted their lowly status with Confucian-like humility, preferring to remain nameless figures directing the collective effort of the kitchen where rank is determined solely by seniority. During the period of rule by Chinese Communist Party (CCP) chairman **Mao Zedong** (1949–1976), chefs had little passion for their jobs, as cooking was done on a mass scale with limited access to good ingredients, especially during **food**-short years and the Great Famine (1959–1961).

Following the introduction of economic reforms and social liberalization (1978–1979), increased wealth among a growing middle class, estimated at 400 million people (2019) in China, produced demand for high-quality restaurants but with most of the credit going to the owner. Chefs endured hard work and long hours in the kitchen learning from a "master chef" (*zhuchu*), especially during their early years, while top chefs were generally uncomfortable being in the limelight. Public attention, especially to top chefs, has been brought on by greater media interest, including televised cooking shows the likes of *Celebrity Chef China* and the popularity of cooking schools, most notably the Chinese Culinary Institute (**Hong Kong**). International exposure has come via the Michelin ranking of restaurants in Hong Kong and Macau, and on the mainland, in major culinary **regions** like **Sichuan**, **Hunan**, and **Guangzhou**, the last the home of Cantonese food. Coming from areas known for turning out such quality chefs as Shunde in Guangdong and nearby international centers of Chinese culinary culture, for instance, Singapore, many chefs are also from a long **family** line, learning the craft in a hand-me-down fashion from a father and/or uncle.

Top chefs are known for selecting quality, fresh ingredients, avoiding such shortcuts as pre-prepared sauces and ready-cooked ingredients. Working in a region is considered absolutely necessary for mastering local cuisines the likes of Huaiyang (Jiangsu) and Chaozhou (eastern Guangdong), with some chefs researching old recipes from dynastic periods of China's imperial history and others developing new fusion dishes often combining Chinese and foreign ingredients. Generally dominated by males, for example, Qu Yunqiang, Huang Shifeng, and Alvin Leung, with **women** usually consigned to food preparation, limited numbers of female chefs have achieved prominence. One who has is Master Chef Tika Yi Yang. Among the major compe-

CHEN KAIGE (1952–) • 79

titions between top-notch chefs is the Chinese Cuisine World Championship, held in Dalian (Liaoning), sponsored by the Luhua Group edible oils corporation.

CHEN KAIGE (1952–). A prominent member of China's "fifth generation" (*diwudai*) of filmmakers, so named for their exposure to international cinema, Chen Kaige has produced and/or directed 19 major films, transforming filmmaking in the People's Republic of China (PRC) with visual flair and epic storytelling. The son of well-known film director Chen Huai'ai, who Chen Kaige denounced as a teenage Red Guard during the **Cultural Revolution (1966–1976)**, the future director and actor was "sent down to the countryside" (*xiaxiang*) in southwestern **Yunnan** from his **urban** home in **Beijing**, experiences that would profoundly affect his later films.

Trained at Beijing Film Academy (1978) and sent to a studio in Guangxi, Chen, in conjunction with **Zhang Yimou**, directed *Yellow Earth* (1985), which tells the story of a soldier who goes to a village in the poverty-stricken area of northern Shaanxi province in 1939, to collect folk **songs**. He describes to the local peasants how **women** have been liberated in the nearby Communist redoubt of Yan'an. A local peasant girl, married at the age of 13, to an older man to whom she had been betrothed since infancy, sets out in search of Yan'an, only to be drowned in the process. Ultimately, the local peasants continue to seek salvation from the local **gods**, rather than **Mao Zedong**, the People's Liberation Army (PLA), or themselves.

Other historical works include *The Emperor and the Assassin* (1999), which traces the driving ambition of Ying Zheng, the king of the Qin state, and China's first emperor, Qin Shihuang, to unify seven kingdoms into one magnificent empire, and *Sacrifice* (2010), set in the Spring and Autumn Period of the Zhou Dynasty (770–476 BCE). Chen has also directed films set in modern-day China, both pre-and post-1949, for example, *Temptress Moon* (1996), starring internationally acclaimed actress Gong Li, and *Caught in the Web* (2012), in which he addresses the contemporary issue of cyber-bullying. Chen has also acted in several films, including *The Last Emperor*, directed by Bernardo Bertolucci, and his own *The Emperor and the Assassin*.

A favorite theme of Chen Kaige is **Peking opera**, which is featured in *Farewell My Concubine* (1993), tracing the experiences of two singers through decades of change in China in the 20th century, including the Cultural Revolution, and for which Chen won the Palme d'Or at the Cannes Film Festival. Recounting the life and work of Mei Lanfang, perhaps China's greatest Peking opera singer, *Forever Enthralled* (2008) was screened at the Berlin Film Festival. More recent films by Chen Kaige include the highly commercial *Together*, a sentimental story about a talented young violinist, for which Chen won the Silver Seashell Award for best director, and *The Promise* (2005), a high-profile **martial arts** film, as is his more recent work,

80 • CHILDREN AND CHILDHOOD (HANZIMEN/TONGNIAN)

Monk Comes Down the Mountain (2015). Chen also directed *Killing Me Softly* (2002), his only English-language American film, which focuses heavily on the intense **sexual** relationship between the two lead characters, including several nude scenes generally a rarity in Chinese cinema.

CHILDREN AND CHILDHOOD (*HANZIMEN/TONGNIAN*). Revered throughout Chinese history and considered the centerpiece of **family** life, children experienced major benefits and hardships in the People's Republic of China (PRC), with their lives profoundly affected by state policies, especially **education** and family planning. With Confucius (551–479 BCE) declaring that "having no offspring is the worst disrespect," an intentionally childless **marriage** was deemed unimaginable as an heir, namely a son with one to spare, with the word for "children" (*zi*) often taken to mean just sons and guaranteed to preserve the family line. While generally less preferred, daughters were also the route to wealth via a healthy "bride price" (*pinli*). During the early 1950s, childhood was overall a pleasant experience with the end to invasions and domestic warfare, with many children raised by dotting grandparents, as mothers and especially fathers in **urban areas** worked away from home. The absence of divorce and generally safe **neighborhoods** in the cities made for a relatively stress-free early life with plenty of free time and many friends for childhood play and local adventures, including searching for and capturing such **insects** as cicadas and dragonflies. While **food** was in short supply and a constant family concern, public **education**, including at top-tier schools, was free, and housing, although sparse, was provided by the work **unit**. Fewer amenities were available in most **rural areas**, with children often contributing to agricultural work and offered fewer educational opportunities than their **urban** counterparts.

With a penchant for political campaigns and mass mobilization by Chinese Communist Party (CCP) chairman **Mao Zedong** (1949–1976), the relatively tranquil environment for children was periodically upset in both the countryside and cities, especially during the Great Leap Forward (1958–1960) and Great Famine (1959–1961) in the former, and the **Cultural Revolution (1966–1976)** in the latter. Children were among the estimated 15 to 30 million **deaths**, largely in the countryside, during the Great Famine, while in the cities they were frequent witnesses to the rampages of Red Guards, often against older, often elderly, members of their own family or friends, who children often were pressured to hate and treat with contempt.

Official childhood organizations include the "Young Pioneers" (*Shao Xiandui*), established in 1953, organized by school or village and mandated for children ages six to 14, with a trademark triangular "bright-red scarf" (*honglingjin*) worn around the neck. Replaced by the "Little Red Guards" (*Hong Xiaobing*) in 1967, as a recruitment base for the older "Red Guard" (*Hongwei bing*) units and dismantled in 1978, the Young Pioneers was re-

CHINOISERIES (ZHONGGUO FENG) • 81

vived and given the task of strengthening **ideological** indoctrination of the young. Penning personal letters to "Grandpa Xi" (President **Xi Jinping**), children are also the focus of national celebrations, most notably the annual "International Children's Day" (*Er Tongjie*) on 1 June, with major cities sporting "Children's Palaces" (*Shaonian Kong*), where young people engage in extracurricular activities, including **singing**, studying foreign **languages**, playing **sports**, and even partaking in military **games** in times of international tension.

The emergence of a middle class with higher levels of education and greater prosperity has led to more intense parenting of children with concentrations on a wide variety of abilities and talents ranging from education to **music** to sports. Enrolled in top-tier schools, middle-class children exhibit high levels of concentration, orderliness, and competence, both socially graceful and adept. Less well-off children, especially in poorer rural areas, often lack comparable social and intellectual stimulation, as migrant-worker parents are often away for long periods of time, leaving children in the care of grandparents with even less education and exposure to modern society. Low levels of early childhood development in rural and remote **mountain** and desert areas with poor childhood nutrition and lack of psychosocial stimulation is cited as a major factor inhibiting future economic development. Organizations and government bodies devoted to addressing issues involving children include the National Working Committee for Women and Children, under the State Council, and the National Health and Family Planning Commission, along with Early Childhood Development Conferences.

Given various nicknames early in life to ward off and trick evil spirits, children were traditionally accorded given names with the assistance of an astrologer suggesting a name based on which of the **Five Elements** (metal, wood, water, fire, and earth) is associated with the time of birth and harmonizing with the family name. Consideration is also given to the number of strokes used to draw the usual two Chinese characters constituting the given name.

CHINOISERIES (*ZHONGGUO FENG*). Derived from the French term *Chinoise*, and meaning "after the Chinese taste," Chinoiseries involved European and American interpretation and imitation of Chinese artistic traditions that began in the 17th century and continued through the 20th century. Especially alluring were the decorative **arts, architecture, ceramics and porcelains, garden** design, **literature, music,** and **theater,** with proponents led by the aristocracy. These particularly included **women**; monarchs the likes of Louis XV of France, George IV of Britain, and Frederick the Great of Prussia; and such prominent writers as Voltaire. Appearing for the first time in French literature, including Honoré de Balzac, and fueled by the enormous growth in Western trade with the Chinese empire, especially in the 18th and

82 • CHONGQING

19th centuries, the appeal of everything Chinese was based on a view, somewhat distorted by its Jesuit and other limited sources, of China as highly civilized and a harmonious, almost ideal world.

Major imitated objects produced in factories outside Paris and London included vases, bottles, clocks, folding screens, lacquerware and furniture, and just about any item associated with the consumption of **tea** in polite society, for example, caddies, sugar boxes, and caskets. Extending to larger and more elaborate creations, including gardens and buildings, most notably the Trianon de Porcelaine at Versailles, built in 1670, and torn down in 1687, other Chinese-inspired structures were constructed in Germany and Britain. Reflecting a European and American fascination with the supposedly exotic and the mystery of Chinese and all East Asian cultures, the popularity of Chinoiseries declined with the disruption in trade following the two Opium Wars (1839–1842, 1856–1860), as Western views of China gradually shifted from admiration to disdain and virtual demonization, as the semicolonial presence in such cities as **Shanghai** involved the openly contemptuous treatment of Chinese residents barred, along with dogs, from foreign concessions. Experiencing a renaissance in the 1920s and 1930s, Chinese **clothing**, including robes and dresses, became popular, with famous American movie stars like Carole Lombard and Lana Turner donning Chinese designs in major feature films.

CHONGQING. Located in Southwestern China and surrounded by **mountains** on a promontory at the confluence of the Yangzi and Jialing rivers, Chongqing, meaning "double celebration," is the third-largest **urban** area in the People's Republic of China (PRC), known as the "City of Fog" for its humid and smoggy air. Described as a "furnace" (*lu*) because of the scorching summer heat and hot, spicy **food**, Chongqing sports a rich local culture centered on popular **Sichuan opera**, along with such major historical sites as the famous Dazu caves, dating back to the Tang (618–907) and Song (960–1279) dynasties, with thousands of Buddhist stone carvings. With a landscape dominated by winding roads and rolling buildings, local **architecture** ranges from modern skyscrapers in the central city to the unique hillside construction of houses and buildings known in Chinese as *diaojiaoliu*. Traversing many city **neighborhoods** are steep staircases consisting of stone steps, which the locals describe as "climbing the road," and dotted with local street vendors offering local foods and services. Multilayered flyovers are present throughout the city, including the highest overpass in the world, along with the world's longest continuous steel-truss arch bridge in a city with more than 8,000 bridges.

Historical origins can be traced to the ancient Bayu culture, located in the upper Yangzi River valley, which, surrounded by a tough living environment, developed a tenacious personal character still evident in the modern

CHONGQING • 83

era. The temporary location of the Republic of China (ROC) government in exile during the Second Sino–Japanese War (1937–1945), Chongqing endured constant aerial bombardment, with entire neighborhoods destroyed and thousands of fatalities. During the chaotic **Cultural Revolution (1966–1976)**, Chongqing was the site of lethal battles between various Red Guard groups and the People's Liberation Army (PLA), often fought with tanks and artillery, resulting in more than 1,000 casualties.

Following the introduction of economic reforms and social liberalization (1978–1979), the city was transformed into a major industrial center of Southwest China, with iron and steel production facilities, along with the largest aluminum smelter and motorcycle plants in China, plus substantial automobile production, with the city slated by the central government to be a national center for "green energy," even as city lights in the multiple high-rise buildings burn nightly. Chongqing has also emerged as a prime center of the electronics industry, especially laptop computers, as one out of every four laptops in the world are now assembled by plants located within the municipality. Major financial and **shopping** areas include the high-rise Raffles City Center and the munificent Chaotianmin **market** with hundreds of shops, while the "old city" (*ciqikou*) retains remnants of the city's past, along with portions of the old city wall. The location of natural hot-water springs on nearby mountain cliffs, Chongqing was named a "global capital of hot springs" available for bathing in pools with micromineral elements at major tourist sites.

Residents of Chongqing are known for being straightforward, enthusiastic, humorous, and generous, but also quick-tempered, with males considered passionate and bold, and females tender and full of animated courage. The local **cuisine** is most noted for the "spicy hot pot" (*mala huoguo*), with ingredients of beef, chicken, sausage, pig's blood, duck intestines, and loads of Sichuan pepper, along with the equally spicy "little noodles" (*xiaomian*), sold in restaurants and street stalls located throughout the city. Shaped by a mindset of fraternity and brotherhood, as well as a strong code of personal **loyalty**, Chongqing has also been the site of considerable **crime** and **gang** violence, which led city leaders, including the now-disgraced Chinese Communist Party (CCP) municipal secretary Bo Xilai, to launch major anticrime crackdowns against widespread **prostitution** and **drug abuse**.

Local folk culture is most noted for Sichuan **opera**, with unique face-changing, flame-throwing, and sleeve-shaking by performers in such well-known titles as *Shades of Willow Trees* and *Tale of Madam White Snake*. Other examples include the famous dragon and hand-winding **dances**; festive lantern shows; drums and gongs of the local Tujia **minority** people; and the playing of such traditional musical instruments as the "southern fiddle" (*erhu*) and "lute" (*sanxia*), often at spontaneous street performances. Also popular are "working **songs**" (*chuangjjiang*), so named for the old river

84 • CHOPSTICKS (KUAIZI)

trackers pulling boats up the Yangzi River rapids toward the city and considered a centerpiece of Chongqing "wharf culture" (*matou wenhua*). Everyday social interaction often takes place in the city's many teahouses with their notable **tea culture** featuring the pouring of tea from long-spouted tea pots into small cups. Major **museums** include the Jiefangbei Guotai Arts Museum of modern **art**; the Natural History Museum, exhibiting rare **plants** and locally discovered fossils; and the Three Gorges Museums, one of the largest in the world, with a collection of historical relics unearthed from the nearby Three Gorges on the Yangzi River during construction of the controversial Three Gorges Dam, the largest hydropower station in the world, completed in 2012.

CHOPSTICKS (*KUAIZI*). Invented as early as the Neolithic Period in Chinese history (7,000–6,000 BCE) and universally used in China as the primary **eating** utensil, chopsticks and chopstick culture are considered a major element of Chinese civilization. Comprised of two pieces made from a variety of materials, including **animal** bone, bamboo, metal, wood, and, in the most expensive case, ivory, chopsticks are considered **hygienic**, avoiding the use of potentially dirty hands for eating. Operating on the principle of a lever, the Chinese term *kuaizi* means to "have sons soon," making fancy chopsticks a popular **gift** at **weddings**.

Taboos involving chopstick use include hitting the side of an eating bowl or plate, as **beggars** do when asking for food; stretching out the index finger or pointing a chopstick at others, which is regarded as making an **accusation**; sucking on the end of a chopstick, which is considered impolite behavior lacking in self-cultivation or **education**; using chopsticks to poke and search for food in a dish; and inserting a chopstick vertically into a bowl or dish, as this resembles the burning of sacrificial incense for the dead.

Benefits include making the fingers flexible and reducing the glycemic index of food consumed, as using chopsticks makes for slower eating and the consumption of smaller quantities of food. According to the traditional Chinese saying that "one chopstick can be broken easily but 10 together will stay as solid as iron," people are instructed to remain united, as acting individually produces weakness. **Women** unable to use chopsticks properly were also said to have trouble finding a man and getting married.

CHRISTIANITY (*JIDUJIAO*). An officially sanctioned **religion** in the People's Republic of China (PRC) divided between "Catholics" (*Tianzhujiao*) and "Protestants," the latter also translated as *Jidujiao*, Christianity dates to the Tang Dynasty (618–907), with the number of Chinese converts growing from the mid-19th century onward, especially after the introduction of economic reforms and social liberalization (1978–1979). As a religion with

CHRISTIANITY (JIDUJIAO) • 85

foreign origins and promoted by missionaries associated with the intrusion of Western imperialism, especially following the two Opium Wars (1839–1842, 1856–1860), Christianity has been a source of considerable domestic controversy, with periodic attempts by the imperial and modern state to limit and even eliminate its influence. While two modern Chinese political leaders of the Republic of China (ROC), presidents Sun Yat-sen (1912–1925) and Chiang Kai-shek (1928–1949), were practicing Christians, the threat of the religion to the power of local gentry and Confucian "**scholar**-officials" (*rujia*), and opposition by the officially **atheistic** Chinese Communist Party (CCP), produced a series of anti-Christian movements and policies, including anti-Christian riots in Tianjin (1870) and, most notably, the Boxer Rebellion (1899–1901), when foreign missionaries and Chinese converts alike were assaulted and wantonly killed with churches and church properties razed to the ground, including orphanages believed by locals to be centers of abuse and even cannibalization of the young. Banned along with all religions, during the period of rule by CCP chairman **Mao Zedong** (1949–1976), Christianity, especially Protestantism, revived in the post-1978–1979 period but with episodic restrictions, including the removal of crosses from churches in 2015–2020, as a limitation on religious expression.

Numbering 4 million at the founding of the PRC in 1949, 3 million Catholics and 1 million Protestants, the number of Chinese Christians grew to 44 million by 2018, according to official estimates and surveys, but with private groups putting that number at 67 million. Constituting about 2.6 percent of the total population, the largest number of Chinese Christians reside in Henan, along with Hebei, Jiangsu, and Anhui, with the smallest numbers in Qinghai and Ningxia, centers of the country's Islamic population.

Three state-sanctioned religious organizations exist, which believers are required to join, the Three-Self Church and the China Christian Council for Protestants, and the China Patriotic Catholic Church for Roman Catholics, along with unofficial house and underground churches, with unknown numbers accounting for the large discrepancy between official and private estimates of PRC Christian believers. While Chinese Protestants have generally accommodated the governing role of the PRC state, Catholic links to the Vatican proved a source of conflict, especially involving the appointment of bishops in the PRC, which was effectively resolved in 2018, in a "provisional agreement" between Pope Francis and the PRC government, ending the 70-year dispute.

There are 53,000 churches of the Protestant Faith, with 21 active seminaries, and 6,300 Catholic churches and cathedrals, with more than 70 of the latter, for example, Immaculate Conception (**Beijing**), Sacred Heart (**Guangzhou**), and St. Michael's (Qingdao). Small numbers of Eastern Orthodox Christians live in the PRC, while "heterodox" (*yizhi*) Christian religious groups also exist, for instance, the secretive "Eastern Lightning" (*Dongfang*

86 • CHRISTIANITY (JIDUJIAO)

Shandian), which proclaims the return of Jesus in the form of a Chinese woman and was declared "counterrevolutionary" (*fangeming*) in 1992, and effectively outlawed in 1995.

Historically, Christianity was introduced into imperial China by the Nestorians, a Middle Easter sect committed to the extension of the faith into Asia, with a stele recounting the event dating to the 8th century during the highly cosmopolitan Tang Dynasty (618–907). Banned, along with **Buddhism** and Zoroastrianism, in 845, during a major religious persecution enacted by Emperor Wuzong (840–846), Christianity was revived during the expansive Mongol-dominated Yuan Dynasty (1279–1368) with a Papal envoy sent to the Yuan capital of Khanbaliq, modern-day Beijing. Banned once again during the highly introverted Ming Dynasty (1368–1644), which opposed any and all foreign influence, Christian missionaries returned during the subsequent Qing Dynasty (1644–1911), led by the Jesuit Matteo Ricci, resident in China, including at the imperial court in the **Forbidden City**, from 1583 until his death in 1610. In addition to preparing the first European-style maps of Asia in Chinese, Ricci translated the classics of **Confucianism** into Latin, promoting the notion of an accommodation between Christianity and Confucian rituals.

Following the edict by Pope Clement XI banning any Christian from performing Confucian rituals, Christianity was banned again by Emperor Kang Xi (1654–1722), with the Jesuits expelled from China in 1720, and Emperor Jialing (1760–1820) including Christians in an edict aimed at "wizards, witches, and **superstition**." With Protestant missionaries arriving in large numbers from the 1840s onward and boosted by the Unequal Treaties following the two Opium Wars in the 1860s, such organizations as the China Inland Mission, founded in 1865, focused on **education** for the traditionally neglected poor population, with French missionaries led by the Holy Childhood Association (*L'Oeuvredela Sainte Enfance*) rescuing female babies from infantilization. Accused in Anti-Christian pamphlets of promoting prayers to pigs, as the character *zhu* for *Tianzhu* rhymed with the Chinese term for pig, also *zhu*, with the French rumored to be killing, not saving, babies, Christian missionaries and converts came under periodic assaults as the missionaries moved into inland provinces with little history of foreign contact. Led by J. Hudson Taylor of the China Inland Mission, moves to create a Chinese church free from foreign control resulted in the decision on "indigenization," enacted in 1910.

While the period from the collapse of the Qing Dynasty to the outbreak of the Second Sino–Japanese War (1937–1945) is considered a "golden age" for missionaries in China, anti-Christian outbursts occurred, most notably in 1923, with attacks on both foreign missionaries and their Chinese converts, leading prominent Chinese Christians like Y. C. James Yen to create such seminationalistic campaigns as the Rural Reconstruction Movement, aimed

CINEMA AND FILM (DIANYING) • 87

at strengthening the nation against foreign intrusion. While conversions remained relatively small, with some Chinese converts derided as "rice bowl Christians" whose conversion was attributed to physical survival more than **spiritual** reasons, Christian missionaries became noted for their indefatigable work in establishing hospitals, clinics, and medical and nursing schools, perhaps the real legacy of Christianity in China.

CINEMA AND FILM (*DIANYING*). Introduced into China in the late 19th century with a golden age of movie-making in the 1940s and subject to strict political **censorship** during the early years of the People's Republic of China (PRC), Chinese cinema and film has gained international renown, especially since the introduction of economic reforms and social liberalization (1978–1979). While the historical origins of Chinese cinema can be traced to the Han Dynasty (202 BCE–220 CE), with its trotting horse lamps and paper shadow plays, the first modern film, *The Battle of Dingjun Mountain*, a recording of a **Peking opera**, was made in 1905. Coming of age under the influence of Western cinema in the 1920s and 1930s, Chinese films were heavily left-wing in political and social content, with the industry centered in **Shanghai**, where a string of films was produced by such notable directors as Cai Chusheng, Cheng Bugao, Sun Yu, and Wu Yonggang. Following *Sing-Song Girl Red Peony* (1931), the country' first sound film, came numerous productions. These included *Spring Silkworms* and *Little Toys* (1933); *The Goddess*, *Plunder of Peach and Plum*, and *Song of the Fishermen* (1934); *The Big Road* (1935); and *Street Angel* (1937). These are all ranked as some of China's greatest films of the 20th century. China's queen of the silent film industry in the 1930s was Ruan Lingyu, star of *The Goddess* (Shennü), the story of a prostitute who wants the best for her son. Ruan died in 1935, at the early age of 24, but her work, now preserved, is still revered by generations of Chinese filmgoers.

Following the end of the Second Sino–Japanese War (1937–1945), the film industry quickly reestablished itself in Shanghai with a slew of films that showed the disillusionment with the Nationalist (*Kuomintang*) government of Chiang Kai-shek and depicted the **struggle** of ordinary Chinese during the Second Sino–Japanese War. Included were *The Spring River Flows East* (1947); *Myriad of Lights* (1948); and *San Mao, The Little Vagabond*, and *Crows and Sparrows* (1949). Films with nonpolitical content were also produced, for instance, *Unending Emotions* (1947), *Fake Bride, Phony Bridegroom* (1947), and *Springtime in a Small Town* (1948) by director Fei Mu, which is considered the best Chinese film of all time.

The establishment of the PRC in 1949, led to Chinese cinema, like all artistic endeavors, becoming subject to highly centralized control, with many Chinese filmmakers sent to the Soviet Union to learn the Soviet "socialist realist" (*shehuizhuyi xianshizhuyi*) **art** form of propaganda. In 1950, the

88 • CINEMA AND FILM (DIANYING)

Performing Arts Research Institute, renamed Beijing Film Academy in 1956, was set up under the Film Bureau of the Ministry of Culture by director Yuan Muzhi, following a tour of Soviet film institutes, to serve as the major training ground for actors and directors. One of the most notable major films is *The Biography of Wu Xun* (1950), a portrayal of the life of a 19th-century folk hero who was devoted to the promotion of free **education** for peasant children. The film's director, Sun Yu, was subject to withering **criticism** by Chinese Communist Party (CCP) chairman **Mao Zedong** for being insufficiently critical of Chinese "feudalism."

During the next two and a half decades, Chinese cinema took on an increasingly orthodox political and propagandistic flavor, as most films adhered to the regime's policy of "revolutionary realism." Such works as *Lin Zexu* (1959), the portrayal of China's subjugation by the West in the two Opium Wars (1839–1842, 1856–1860); *Red Detachment of Women* (1961); *The First Sino–Japanese War* (1963); and *Must Never Forget* and *Slaves* (1963) achieved none of the standards set by Shanghai filmmaking in the 1930s but dominated the industry because of their **ideological** and political acceptability. Throughout this era, filmmaking was under the strict and rigid control of government-run film studios, including Beijing Film Academy, the August First Film Studio, and the China Film Group Corporation, with the number of new films and the construction of **theaters** determined by central economic planning according to the country's system of five-year plans (1953–1978). Despite these controls, more than 600 films were made from 1949 to 1966, especially during the relative cultural and political thaw of the Hundred Flowers Campaign (1956–1957). Some of the most notable are *The New Year's Sacrifice* (1956); *The Lin Family Shop* (1959), based on a novel by prominent writer Mao Dun; *Five Golden Flowers* (1959); *Must Never Forget* about a man whose overwhelming desire for a new wool suit drives him insane; and *The Unfinished Comedy* (1957), later labeled a "poisonous weed" (*youda zacao*) and not screened again until after the death of Mao Zedong in 1976.

The era's most prominent filmmaker was Xie Jin, whose works included *Girl Basketball Player No. 5*, a distinctively nonpolitical film, and *The Red Detachment of Women*, a drama of two **women** going to war in the 1930s that was later turned into a ballet and "model" (*mofan*) revolutionary **opera**. These were followed by *Two Stage Sisters* (1965), a portrayal of two Yue opera singers struggling to perform throughout the political chaos and wartime era from the 1930s to 1950. Films covering military conflicts in China were also produced, for example, *Landmine War* (1962) and *Tunnel War* (1965), dealing with the Second Sino–Japanese War (1937–1945), and *The War in the South and North*, on the Chinese Civil War (1946–1949).

CINEMA AND FILM (DIANYING) • 89

During the **Cultural Revolution (1966–1976)**, when major film training facilities were shut down, the most prominent films were based on "model" Peking operas and ballets promoted by Jiang Qing, the radical leftist wife of CCP chairman Mao Zedong. The five were *The Red Detachment of Women*, *The White-Haired Girl*, *Taking Tiger Mountain by Strategy*, *Sand Village*, and *Seaport*. Other productions, for instance, *Breaking with Old Ideas* (1975), were relatively few and subject to strict regulation of plot line and narrative, as 54 previous productions were officially blacklisted. Post–Cultural Revolution films were dominated by so-called "scar dramas" (*shangren ju*), examining the emotional trauma of the previous decade, including *Hibiscus Town* (1986) by Xie Jin, *The Blue Kite* (1993) by Tian Zhuangzhuang, *In the Heat of the Sun* (1994) by Jiang Wen, and *Xiu Xiu: The Sent-Down Girl* (1998) by Joan Chen, all banned in the PRC.

The emergence of relatively young "fifth-generation" filmmakers in the 1980s and 1990s, so named for their exposure to international filmmakers from Europe the likes of François Truffaut and Jean-Luc Godard, led to greater international attention for Chinese films but with periodic run-ins with censorial authorities. Many from this generation, including **Chen Kaige** and **Zhang Yimou**, were graduates of Beijing Film Academy, which reopened following the Cultural Revolution. Along with a number of older, earlier "third-generation" and "fourth-generation" filmmakers, they created a "Chinese New Wave" that, while using historical events and story lines, explored such subtle psychological themes as the conflict between the ideological orthodoxy of the Maoist past, with its resistance to change, and the craving for human **freedom** and love. Among the most notable films of this genre were *Murder in 405* (1980), *One and Eight* (1983), *Yellow Earth* (1985), *Red Sorghum* (1986), *Old Well* (1986), *King of Children* (1987), *Farewell My Concubine* (1993), and *The Big Parade* (1986).

Camera and directorial work by Chen Kaige and Zhang Yimou were inspired by Italian neo-realism and reflected a respect for the traditional culture of China, especially in **rural** areas, where many of them had been "sent down to the countryside" (*xiaxiang*) during the Cultural Revolution. This new generation also showed interest in the marginal cultures of ethnic **minorities** that exist in China's border **regions** of Inner Mongolia, **Tibet**, and Xinjiang, and which were the subject of several documentary films. Included were *On the Hunting Ground* (1984); *Sacrificed Youth* (1985), which portrays the Dai minority people as sexually liberated; *Horse Thief* (1986), which, directed by Tian Zhuangzhuang, features traditional Tibetans; and *Poet on a Business Trip*, a film 12 years in the making by director Ju Anqi, portraying the **sexual** and other adventures of a poet during his travels throughout Xinjiang in the far west. Other "fifth-generation" directors included Wu Tianming, Huang Jianxin, Wu Ziniu, Hu Mei, and Zhou Xiao-

90 • CINEMA AND FILM (DIANYING)

wen, who like their colleagues saw their movement end with the military crackdown against the prodemocracy movement in **Beijing** and other cities (1989) as many directors went into self-imposed exile abroad.

Official censorship of films in China is carried out through the largely state-controlled studio system, of which Beijing, Shanghai, **Xi'an**, and Guangxi, although independent production companies, have become increasingly prominent. Final authority over the banning of films or editing to remove objected content is exercised by the CCP Publicity Department, formerly the Propaganda Department, which, in 2018, replaced an elaborate and frequently reorganized state system involving the Ministry of Culture, then the newly formed Ministry of Radio, Cinema, and Television, in 1986, followed by the State Administration of Radio, Film, and Television (SARFT) in 1998.

Major laws governing the industry include, most recently, the Film Industry Promotion Law (2017). This legislation prohibits content that harms national dignity, honor, and ambitions; exposes government secrets; endangers national unity; or supports extremism and terrorism. The law also requires special licenses for films to be shown in cinemas, at film **festivals**, or on television or streaming sites, with rules requiring Chinese films to account for two-thirds of annual cinema screening time, effectively limiting screenings of foreign-made films. Although a nationwide cinema evaluation system has not been introduced, in cases where the content is inappropriate for **children**, the law requires films to provide a parental advisory label. While some films with explicit political satire manage to pass the censors, for example, *The Black Cannon Incident* (1986), which took on the prevalence of **bureaucratism** in Chinese society, prominent banned films have included *The Blue Kite, Yellow Earth, Beijing Bicycle*, and *Summer Palace*, but these works have received international acclaim. Included is *Ju Dou*, the story of a young woman sold as a wife to an old man, directed by Zhang Yimou, which was nominated for the Best Foreign Film Oscar in the United States in 1990, and later screened in the PRC in 1992.

China's relationship with the international film community has gone through rapid changes, from the government's biting critique in 1974, of Italian director Michelangelo Antonioni for his film *Chungkuo-Cina*, in which Chinese life is portrayed as backward and insular, to China's decision in 1986, to allow filming of *The Last Emperor* in the **Forbidden City** in Beijing. During the period of general isolation from the international community prior to the 1970s, films from allied countries, mainly the Soviet Union and North Korea, were screened, with a few Chinese films, including *Daughters of China* (1949) and *The Butterfly Lovers* (1954), the country's first colored movie, entered in film festivals of fellow socialist and third-world nations. The first Shanghai International Film Festival, with 30 countries participating, was held in 1993, as outright propaganda films were re-

CINEMA AND FILM (DIANYING) • 91

duced in number and found it harder to compete in the increasingly competitive commercial film industry. One of few propaganda set pieces, *Jiao Yulu* (1990), tells the story of a famous CCP cadre martyr and was produced as part of the regime's anticorruption campaign. The breakdown of the studio system beginning in the 1990s led to the financing of more Chinese films from **Hong Kong**, Taiwan, and other foreign sources, as the industry became increasingly **commercialized** but with the government-run China Film Group still providing key financing for 100 to 250 films a year.

In this context, the "sixth generation" (*diliudai*) of more commercially adept and often-underground filmmakers in China emerged, whose works, with their sweeping themes of gritty **urban** life, were often played out by grungy malcontents. Script lines often spouted homegrown obscenities backed by hard-rock **music**, as sixth-generation films generally abandoned the fixation on **history** and **heroic** characters of emperors and **concubines** preferred by their fifth-generation predecessors. Major sixth-generation works include *The Days* (1993), replete with Jimi Hendrix's "Purple Haze"; *Beijing Bastards* (1993), with its homegrown punk; *Frozen* (1997), a rare look at the avant-garde world of Beijing; and *Xiao Wu* (1997), with its pickpocket and karaoke girl characters, and *Platform* (2000), both by Jia Zhangke, who in 1995, founded China's first independent film production group. Also addressed were issues involving the economy and social justice, including *Blind Shaft* (2003), with a focus on the country's profitable but dangerous coal mining industry, and *The World* (2004), examining the entry of the PRC into the global economy. Other sixth-generation films include *I Love You, If You Are the One, Green Tea, Spicy Love Soup, Cry Woman, Man Yan, Weekend Plot, Eyes of a Beauty, Suzhou River, East Palace, Postman, Rainclouds over Wushan/In Expectation, So Close to Paradise, The Making of Steel, West Palace, Shanghai Dreams*, and *Unknown Pleasures*, with many entered in international film festivals.

Most sixth-generation films avoid such explicitly political topics as the military crackdown against the prodemocracy movement (1989), while *Me and Dad* (2001), a film produced by the Supreme Concept Cultural Development Co., was the first fully independent Chinese film since 1949, with a law allowing the formation of independent companies enacted in 2002. Top film production companies, many now independent, along with their most notable films, include the following: Ningxia Film Group (*Painted Skin: Resurrection 1 and 2*); China Film Group (*Black and White: The Dawn of Justice*); Huayi Brothers (*Viral Factor and Love*); Bona Film Group (*The Great Magician* and *A Simple Life*); Enlight (*The Four*); Youyang Media (*Pleasant Goat*); Galloping Horse (*Guns N' Roses*); China Film Media Asia (*Love in the Buff*); Beijing New Pictures (*The Flowers of War*); Twenty-First Jisheng (*Caught in the Web*); and Le Vision Pictures (*All's Well Ends Well*).

92 • CINEMA AND FILM (DIANYING)

Fifth-generation filmmakers have adapted to the new forces of commercialization and **market** forces with Hollywood-style, big-budget works by Zhang Yimou, including *Hero* (2002), *House of Flying Daggers* (2004), and *Curse of the Golden Flower* (2006), the last at the time the most commercially successful film in China. Similar epics by Chen Kaige include *The Emperor and the Assassin*, which like the equally blockbuster-style *The Emperor's Shadow* took as the major story line the highly contentious role of emperor Qin Shihuang in uniting China in 221 BCE. More commercial ventures include *Together*, a sentimental story about a talented young violinist directed by Chen Kaige, and *The Blue Kite*, a portrayal of China in the 1950s and 1960s told through the life of a single **family** and their young son, torn apart by various political movements, directed by Tian Zhuangzhuang.

Sharply reduced government funding led the state-run studios to concentrate on so-called "main melody" (*zhuxuanlu*) films aimed at invigorating the national spirit and national pride with Hollywood-style music, "red **songs**," and special effects as concerns grew that films with heavy doses of "**spiritual** pollution" (*jingshen wuran*) were undermining core values in China. Productions with a strong nationalistic tinge include *Decisive Engagement* (1996); *Opium War* (1996), a remake of *Lin Zexu*, which did well at the Chinese box office but was virtually ignored abroad; and the state-financed *Confucius* (*2010*), starring Hong Kong film star Chow Yun Fat. Others of this genre include *The Founding of the Republic* (2009) and *The Founding of An Army* (2017). In 1999, China chose *Lover's Grief over the Yellow River* as its official submission to the American Academy Awards for Best Foreign Language Film, but the work attracted little attention from American critics and audiences, even though it was a box-office hit in China. Beijing Film Studio became involved in several joint ventures, one of which was the box-office hit *Be There or Be Square* (1999), about the lives of mainland China's new immigrants to the United States.

Top-rated domestic films in China perennially consist of works largely unknown and generally unreleased in the West: *Romance on the Lu Mountain* (1980), *Shaolin Temple* (1982), *The Magnificent Birth* (1999), *Liu Tianhua* (2000), *Life Show* (2001), *Big Shot's Funeral* (2002), *Cell Phone* and *World without Thieves* (2004), *The Warrior and the Wolf* (2009), the comedic *Lost in Thailand* (2012), *Kaili Blues* and *Wolf Totem* (2015), and *Long Day's Journey into Night* (2019). Chinese films receiving prestigious foreign awards, for example, the 1994 Cannes Grand Jury Prize recipient, *To Live*, by Zhang Yimou, and the 2001 Berlin Film Festival winner, *Beijing Bicycle*, often garner little box-office attention in China if they are not outright banned. *The Story of Qiu Ju* (1992), by Zhang Yimou, won over popular audiences in the West and was awarded the Golden Rooster, China's equivalent of the Oscar, for the best movie.

CINEMA AND FILM (DIANYING) • 93

A new documentary movement has also grown in the Chinese film world with such internationally acclaimed productions as the nine-hour tale of deindustrialization titled *Tie Xi Qu* (West of the Tracks); *Out of Phoenix Bridge*, by female director Li Hong, who relates the story of four rural women seeking employment in Beijing; *Bumming in Beijing: The Last Dreamers*, filmed directly after the Tiananmen military crackdown; *Dance with the Farm Workers*, a portrayal of poor farmers from **Sichuan** working in Beijing, where they annually perform their **dance**; and *Love for Life*, a stark report on the AIDS crisis in China. Many of these films also qualify as so-called "d-generation" films, as they were shot digitally.

Major historical events have also become the focus of such directors as Feng Xiaogang, whose film *Aftershock* (2010) portrays the horrors of the 1976 earthquake in the city of Tangshan (Hebei), and *Back to 1942* (2012), which chronicles the destructive impact of the famine in western Henan during the Second Sino–Japanese War (1937–1945), which led to as many as 3 million **deaths** from starvation. Popular **martial arts** films include *Fearless* (2002), *IP Man 1* and *IP Man 2* (2008 and 2012, respectively), and *The Grandmaster* (2013). Recent **crime** sagas include *No Man's Land* (2013); *Black Coal, Thin Ice* (2014); and *Ash Is Purest White* (2010), the last directed by Jia Zhangke and starring prominent actress Zhao Tao, also nominated for the Palme d'Or at the 2018 Cannes Film Festival.

Foreign films in China are limited in screenings to 34 annually, up from a previous limit of 20, with action-packed thrillers from the United States as the most popular genre, along with such animated films as *Avatar* and *Zootopia*. Historically, the highest-grossing foreign films in China have been *Titanic*, whose "rebellious and romantic" (*fengliu*) character Jack, played by Leonardo DiCaprio, appealed to Chinese audiences, and, more recently, *Transformers: Age of Extinction* and *Fast & Furious* installments 4, 6, and 7, while Western **pornographic** films like *Deep Throat* were outlawed but made available on the black market. Culturally refined films have also won Chinese audiences, for example, *The Red Shoes* (1948), a classic story of ballet set in Paris.

The importance of the Chinese market to foreign filmmakers is evident in the film *Iron Man III*, which contains a scene explicitly shot for Chinese audiences, who also are evidently enamored of Western 3-D movies. The popularity of foreign, particularly American, films is enhanced by the presence in Chinese cities and towns of large billboards and posters advertising the latest Hollywood product, especially films starring Brad Pitt. Exempt from screening restrictions are films coproduced by foreign and Chinese companies. Examples include the satirical comedy *Red Light Revolution*, *Great Wall* (2016), directed by Zhang Yimou and staring American actor Matt Damon; *Xuanzang* (2016), presented for Best Foreign Film at the American Academy Awards; and *The Chinese Widow* (2017), also known as

94 • CINEMA AND FILM (DIANYING)

In Harm's Way, which premiered at the Shanghai International Film Festival. In 1999, Hong Kong Chinese film star Jackie Chan replaced Arnold Schwarzenegger and Sylvester Stallone as the favorite foreign movie star among Chinese high school students in five coastal cities, while *Mulan*, a Hollywood film by Walt Disney specifically tailored to the Chinese market, crashed at the box office and was vilified in the Chinese press.

Recent foreign-made films on politically and socially sensitive topics like *Seven Years in Tibet*, *Red Corner*, and *Brokeback Mountain* received withering criticism and outright bans from the Chinese government, although PRC attempts to intimidate international film festivals from screening these works largely failed. Chinese films have confronted their own political problems, as in 1999, when, despite his earlier political problems in China, Zhang Yimou saw two of his films that had passed Chinese censors, *Not One Less* and *My Mother and Father*, rejected as "propaganda" by the Cannes screening committee. Political events, for instance, the 1999 bombing of the Chinese embassy in Belgrade, have affected viewership of foreign films in China, although an active underground DVD market makes many foreign films available for home watching. Films by Taiwanese director Ang Lee have had mixed success in the PRC, notably *Lust, Caution* (2007), dealing with the Japanese occupation of Shanghai in World War II. His multinational production of *Crouching Tiger, Hidden Dragon* (2000), starring many Chinese actors, achieved considerable success at Western box offices but bombed in China, since it was seen as pandering to foreign tastes, although it did evidently spur Zhang Yimou to shift to such large-scale, martial arts productions as *House of Flying Daggers* (2004). *Kungfu Panda* (Dreamworks) was praised in China, where it was lamented that the film could never have been made because no Chinese filmmaker would have been allowed to make fun of such nationally solemn subjects. Following the decriminalization of **homosexuality** in 1997, such films as *Queer China* were produced and aired at special forums like the Shanghai Pride film festival.

In 2013, total box-office receipts for China's 20,000 screens was RMB 210 billion ($35 billion), with estimates that China will soon become the world's largest movie market. Chinese domestic productions have accelerated with such large filming facilities as the Hengdian ("Chinese Hollywood") site in Zhejiang province and Oriental Movie Metropolis, one of the largest film and television studios in the world, in Qingdao, Shandong. Cooperative production with filmmakers from Russia has also advanced, for example, with the coproduction of *Ballet in the Flames of War*. The Chinese film industry also expanded its reach into the United States when the Wanda Real Estate Group, owned by one of China's richest men, acquired AMC entertainment, which runs America's second-largest movie theater chain.

CINEMA AND FILM (DIANYING) • 95

In both domestic and foreign-made films with a Chinese theme, female actors, especially Gong Li and Joan Chen, have generally outshone their male counterparts. Debuting in *Red Sorghum*, the beautiful Gong Li also starred in several films by Zhang Yimou, notably *Shanghai Triad* (1995), which won the star international attention for her defiant sensuousness that roiled under her silk dresses, along with comedies, *God of Gamblers III: Back to Shanghai* (1991) and *Flirting Scholars* (1993), and adventures, *The Monkey King 2*. The equally vivacious Joan Chen starred in *The Last Emperor* by Bernardo Bertolucci, as well as in American television shows, but she has also entered the director's chair with her Chinese-made film *Xiu Xiu: The Sent Down Girl*, a portrayal of the trials and tribulations of a young woman sent to the Tibetan highlands in western Sichuan during the Cultural Revolution whose efforts to return to the provincial capital of Chengdu by offering men of influence her sexual favors ends in abandonment and ultimately **suicide**. Other prominent films by women include *Three Women* (1987), *My Classmate and I* (1987), and the award-winning *Shanghai Women* (2002), by Peng Xiaolian; *Zhou Yu's Train*, by Sun Zhou, starring Gong Li; the romantic comedy *Sophie's Revenge*, by Eva Jin; and *Electric Shadows* (2005), by Xiao Jiang, a portrayal of the power of cinema to overcome the trauma of persecution and abandonment.

The crucial role of Chinese women in the country's history has also been the story line of such films as *The Song's Sisters* (1997), directed by Mable Cheung, which follows the lives of Song Ailing and her two younger sisters, Song Qingling, the wife of Republican leader Sun Yat-sen, and Song Meiling, the wife of Sun's successor, Chiang Kai-shek, against the backdrop of China's historical panorama from 1900 to 1949. Tragic events in the recent past, especially the Cultural Revolution, are also frequent plotlines, for instance, the 2002 production of *Balzac and the Little Chinese Seamstress*, by Dai Sijie, which tells the story of a young intellectual banished to the countryside, where he falls in love with a tailor's daughter. A showing of *Memoirs of a Geisha* (2005), an American production, was cancelled in China based on concern that the Chinese public might react negatively to a movie featuring Zhang Ziyi and Gong Li as geishas, whom many Chinese consider to be prostitutes.

The major film festivals in China are the Shanghai International Film Festival, which in 2002, screened 410 films from 47 countries; the China International Children's Film Festival, held annually in July; the Beijing Independent Film Festival, which, in 2014, was summarily shut down by police; and the Pingyao International Film Festival, begun in 2017. Chinese-made films have also been screened at international film festivals the likes of Locarno Switzerland, where films like *The Dossier*, about Tibetan dissident Tsering Woeser, were shown despite objections from the Chinese government.

96 • CITIES

Up-and-coming young directors include among them Lu Chuan, whose *City of the Ghostly Tribe* (2015) was one of China's first science fiction movies, a genre that in the past was distinctively unpopular. In addition to the Golden Rooster, other major film awards in China include the Huabiao Award and the fan-determined Hundred Flowers Award. In 2009, censorship of Chinese films was strengthened when authorities committed to "purifying screen entertainment" by banning explicit sex, rape, and **prostitution**, along with "abnormal sexual relations," which led to significant excision of scenes from such films as *Lust, Caution* (whose prominent Chinese actress, Tang Wei, immigrated to Hong Kong after being pilloried in the official PRC press), and Hong Kong's *Protégé* (2007) by director Er Dongsheng (in which a sex scene was limited to one minute, leading Chinese bloggers to wonder if foreign viewers of the film would think Chinese lovemaking only lasts a minute). Four of five top-grossing films in 2018 were made in China, with the following rankings: *Wolf Warrior 2*; *Ne Zha* (**animation**); *The Wandering Earth*; *Avenger's Endgame* (United States); and *Operation Red Sea*, a Chinese action war film.

CITIES. *See* URBAN AREAS AND URBAN LIFE (*SHIQU/SHIQU SHENGHUO*).

CLANS (*ZONGZU*). Defined as a patrilineal and patrilocal group of relatives sharing the same surname and common **ancestry**, clans, also known as extended **families**, have existed in China, especially in the south, since the Song Dynasty (960–1279). Following the establishment of the People's Republic of China (PRC) in 1949, concerted attempts to suppress clans, largely in **rural areas**, were carried out during the rule of Chinese Communist Party (CCP) chairman **Mao Zedong** (1949–1976). Revived after the introduction of economic reforms, including agriculture, (1978–1979) and concentrated in villages, clans numbering in the thousands carry out such major social functions as managing civil conflicts, safeguarding property, and collecting taxes, while clan leaders maintain clan "genealogies" (*zupu*) and protect ancestral shrines and temples. Restricted to males, clans in Northern China were usually weaker, as property was not shared and members did not necessarily live in the same village.

Undermined after 1949, by state authority, which took over many of the traditional clan functions, the old clan system was a prime target, especially during the Great Leap Forward (1958–1960), when the large-scale rural "people's communes" (*renmin gongshe*) were designed to supplant the clans that survived by going underground. With the dismantling of socialist agriculture by the establishment of the Agricultural Responsibility System in the 1980s returning lands to individual households and the faltering of local

CLASS (JIEJI) • 97

governmental authority, clans quickly revived as locals sought a group identity in a rapidly changing environment and more **individualistic** society. Restoring traditional functions of compiling genealogies and maintaining ancestral shrines, clan membership was liberalized, with entry, largely by **marriage**, and exit both made easier, turning the organizations into virtual social clubs.

Called upon to deal with issues of land and village boundaries, control of local forests, grazing lands, and irrigation networks, clan relations from neighboring villages have frequently degenerated into open conflicts, reigniting divisions dating back to the pre-1949 period. While elderly clan members tend to traditional functions, younger ones approach the clan in utilitarian, entrepreneurial terms, for example, seeking capital for new **businesses**. Most prominent in the country's poorest and less developed areas, clans are often the first venue sought by locals to resolve outstanding problems as opposed to police or the courts. Along with clans, local society in the PRC has also seen a reemergence of **secret societies**, including Triad-like organized **crime** groups.

See also CLASS (*JIEJI*).

CLASS (*JIEJI*). A centerpiece of Marxist–Leninist doctrine, with its emphasis on "class conflict" (*jieji zhongtu*) and "class **struggle**" (*jieji douzheng*), the concept of class has a long history in China, with patterns of social mobility offered by a relatively prosperous economy absent the rigid stratification, for example, castes and **family**-based aristocracies, found in India and other countries. During the imperial era (221 BCE–1911 CE), China was officially divided into four classes—"landlord" (*dizhu*), "peasant" (*nongmin*), "craftsman" (*gongjiang*), and "merchant" (*shangren*)—with a national registration system set up during the Ming Dynasty (1368–1644). With the rise of the Chinese Communist Party (CCP), landlords were essentially eliminated as a social class during the 1947–1953 "land reform campaigns" (*tugai*), with hundreds of thousands killed, sent to labor camps, or fleeing the country. Speaking in 1949, Chinese Communist Party (CCP) chairman **Mao Zedong** described four classes in China, the "working class" (*shi*), the "peasantry" (*nong*), the "**urban** petty bourgeoisie" (*gong*), and the "nationalist bourgeoisie" (*shang*), which he declared had unified behind the Communist revolution, essentially ending the life and death struggle between hostile classes. Yet, as Mao became increasingly committed to creating an egalitarian society in the People's Republic of China (PRC), new reputed " class enemies" (*jieji diren*) were targeted by Mao and radical leftist supporters, most notably Jiang Qing, his wife and a former **Shanghai** actress.

Included was a new elite in the CCP and government ranks, numbering 10 million, whose powerful positions had translated into privileged access to housing and other amenities, along with "capitalist roaders" (*zouzipai*), alleg-

98 • CLASS (JIEJI)

edly headed by the state chairman Liu, Shaoqi (1959–1968), who having penetrated top **leadership** levels were subjected to unrelenting **criticism** and "struggle" during the violent and chaotic **Cultural Revolution (1966–1976)**. "Class background" (*ji beijing*), "class status" (*ji zhuangtai*), and "class standing" (*ji diwei*) were also considered during the selection of "Red Guards" (*Hongweibing*) and "Red Successors" (*Hongse Jiebanren*) at local schools and colleges, as students descended from politically unacceptable families, referred to as the "Five Black Categories" (*Wuge Heise Leibie*) of "landlords, rich peasants, counterrevolutionaries, bad elements, and rightists," were excluded from the ranks.

Following the introduction of economic reforms and social liberalization (1978–1979), social stratification along largely wealth-based lines reemerged in both the countryside and urban areas as land ownership was decollectivized and private **businesses** emerged, while political **relations** and connections were a major determining factor of social status in the one-party state. Individual landowners benefited from consolidation of **rural** farmland beginning in the 1990s, while owners of and stockholders in such super wealthy companies as Alibaba and Tencent also emerged in the increasingly open and internationalized national economy.

Sociological analysis describes a nine-tier structure of class stratification, with contemporary China consisting of the following nine groups, with estimated numbers in parentheses: top leaders, the president and CCP general secretary, and members of the party Politburo and the National People's Congress (NPC) standing committee, with power to set the national policy agenda (30); "bigwigs" (*dalao*), the high ministerial and provincial officials, along with business magnates and bankers, for example, financier Li Kashing (200); "powerbrokers" (*quanli jingji ren*), mid-level ministerial and provincial officials, along with new business leaders, like Jack Ma of Alibaba, and heads of major universities (4,000–5,000); "privileged" (*tequan*), municipal and county party and state officials, owners of midsize and large companies, and prominent doctors and lawyers (5–10 million); "very comfortable," lower-level party and government officials, along with small and medium-sized companies and large rural landowners (100 million); "squeezed" (*jiya*), ordinary civil servants, white-collar and state-owned enterprise (SOE) workers, and small business owners (200–300 million); "marginalized" (*bianyuan hua*), urban and rural workers with odd jobs (500 million); "underclass" (*xiaceng jieji*), migrant workers and ordinary peasants (400 million); and "destitute" (*pinkun*), long-term unemployed, impoverished, largely landless peasants and residents of isolated inland and **mountainous** areas (100–200 million).

CLOTHING (FUZHUANG) • 99

Government antipoverty alleviation campaigns have been aimed at improving the living standards of people caught in the last three groups, while descendants of classes benefiting from CCP policies in the early 1950s, mainly land reform, continue to advance with increased access to the means of social mobility, for instance, **education** and vocational training.

CLOTHING (*FUZHUANG*). A relatively conservative society in terms of dress, especially for **women**, China has gone through radical changes in clothing styles, from traditional dress in the imperial era to various and conflicting styles, conformist and fashionable, in modern China. Traditional dress included "Han clothing" (*Hanfu*), so named for its popularization during the Han Dynasty (202 BCE–220 CE), and characterized by a cross-collar in which the right lapel wraps over the left with a sash around the waist and a blouse, plus a skirt for women and a long, generally blue gown for **men** known as the *changshan*. Traditional male dress also included the "Chinese suit" (*Tang zhuang*), which combined the male jacket of Chinese design and colors worn by ethnic Manchus during the Manchu-dominated Qing Dynasty (1644–1911) with a distinctive badge indicating political rank.

During the era of the Republic of China (ROC) on the mainland (1912–1949), dress styles underwent radical change, with prominent men donning the Chinese tunic suit with a turned-down collar and four pockets with flaps, which became known as the "Sun Yat-sen suit" (*Zhongsan zhuang*) for its popularization by the leader of the Nationalist Party (*Kuomintang*) and president of the ROC (1912–1925). For the fashion-conscious woman, the close-fitting *qibao*, also known as the cheongsam, was developed in **Shanghai** in the 1920s, with a Manchu design merged with Western patterns that showed off the **beauty** of the female **body**, especially partially exposed legs.

Following the establishment of the People Republic of China (PRC) in 1949, clothing styles for both leaders and the general population were standardized, with Mao Zedong appearing publicly in the Chinese tunic suit, dubbed the "Mao suit" (*Mao xizhuang*), with a distinctive, high-collar jacket also worn by other Chinese Communist Party (CCP) leaders. For the general population, uniforms were issued composed of baggy pants and the Mao jacket, made of polyester and available in the three **colors** of gray, olive green, or blue, with darker cloth for factory workers and technicians, and gray for administrators and clerical workers, with no distinction by gender or rank. Promoting a sense of egalitarianism at odds with a tradition where clothing distinguished the higher classes from the lower, simple, everyday wear was cheap to manufacture and made available to large swaths of the population. Clothing made of expensive fabric, especially silk, was discouraged, with violators subject to harsh public reprimand, while Western suits disappeared literally overnight, replaced for prominent men by the omnipres-

100 • CLOTHING (FUZHUANG)

ent tunic suit. Women were distinguished by wearing the fashionable Lenin suit, modeled on the well-known outfit identified with Vladimir Lenin, the Russian Bolshevik leader and head of the Soviet Union (1917–1924), consisting of jacket and trousers, and featuring a large turned-down collar with side buttons and pockets.

In the view of Mao and the CCP **leadership**, shared dress would produce a shared national identity, which during the **Cultural Revolution (1966–1976)** was marked by sartorial sobriety of drab military-style androgynous uniforms in brown or green hues legitimized by the chairman wearing military garb at massive Red Guard rallies held in Tiananmen Square in **Beijing**. With clothing distributed according to the strict rationing system, choices in dress were limited, although Western jeans did periodically appear among **youth** in **urban areas**, making such clothing a target of rebuke, including female high heels, Western-style coats, ties, **jewelry**, cheongsam, and long hair. Well-dressed wives of top CCP leaders, most notably Wang Guangmei, wife of accused "capitalist roader" (*zouzipai*) President Liu Shaoqi (1959–1968), were ravaged and publicly humiliated for "petty bourgeois" (*xiaozi*) displays of jewelry and stylish cheongsam dress, especially during trips abroad.

Following the introduction of economic reforms and social liberalization (1978–1979), conventional Western **fashion** combined with Chinese styles have come to dominate the dress of both Chinese women and men, with purely traditional outfits worn only for **festivals** and on holidays, while the "Mao suit" is donned by Chinese leaders primarily during national celebrations. Ethnic **minorities** are also free to wear their colorful traditional dress, which has become a major attraction for tourists, domestic and foreign. Popular styles blossoming among women include oversized blazers with huge sleeves and figure-forgiving cuts; updated cheongsams; athleisure style of loose hoodies and pants; monochrome white, cropped blazers with chunky sneakers; slightly revealing minidresses with oversize blouses; and long pajamas worn in public. Such outfits as Mandarin-collar blouses worn with plaid skirts or flared pants combine traditional detail and colors, particularly red, representing good **fortune** and prosperity. New styles and patterns, many locally designed, continue to be introduced at such major events as Shanghai Fashion Week, begun in 2011.

For Chinese men, especially white-collar workers, hand-tailored suits have become enormously popular, with the **art** of "tailoring" (*caifeng*) carried out largely in small shops in major **shopping** areas, with cities like Tianjin in the northeast known for producing good tailors and high-quality dress. Banned during the Cultural Revolution as "bourgeois" and "counterrevolutionary" (*fangeming*) when people reverted to sewing their own clothing to save money, classical tailoring, including traditional styles, has returned, along with Western designer clothing from international fashion centers the likes of

COLORS (YANSE) • 101

Paris and Milan offered at high prices determined by external tariffs, with many Chinese still preferring to sew their own fabric purchased on the open **market**.

COLORS (*YANSE*). Ranked in order of importance and associated with the **Five Elements** and the Five Cardinal Directions (north, south, east, west, and center), various colors in China are considered either "auspicious" (*jixiang*) or "inauspicious" (*buxiang*) with multiple symbolisms and representations in daily life. Historically, five standard colors were recognized (with the corresponding element and direction in brackets): "black" (*hei*) [water/north]; "red" (*hong*) [fire/south]; "white" (*bai*) [metal/west]; "yellow" (*huang*) [earth/center]; and *qing*, the last a combination of "green" (*lü*) and "blue" (*lan*) [wood/east]. The character *se* is the Chinese word for "color" and is also used to imply **sexual** desire and attraction.

Recognized as the king of colors in ancient China, black is considered a neutral color representing **cruelty**, destruction, evil, and sadness, and is associated with **crime** commonly referred to as "black society" (*hei shehui*), with illicit financial gains described as "black **money**" (*heiqian*). A common choice of color used in everyday clothing, black is not, as in Western culture, associated with **death**, as white is the accepted color for mourning. Red is undoubtedly the most auspicious color, symbolizing good **fortune**, joy, and fertility, with Chinese brides adorning the wedding dress with the color, which is also widely displayed during **festivals and holidays**, especially the **Spring Festival**. Strictly prohibited at **funerals**, red has been adopted as the official color of the People's Republic of China (PRC), notably on the national flag, which for some people elevates the color's prominence, while for those who have suffered under Communist rule there is widespread resentment of the color.

While symbolizing death, white also represents brightness, purity, and fulfillment, and along with gold it is the primary color of choice for automobile buyers in the PRC. Yellow has long been considered the most beautiful and prestigious color, representing power and royalty, as the color decorated royal palaces and was paired with red-donned imperial garments. Associated with nonworldly affairs, yellow is esteemed in **Buddhism** and is the color of the robes worn by monks. Tied to **heroism**, yellow is not used, as in the West, to describe cowardice but does imply sexual undertones and swearing in **humor**. Green is associated with **health**, prosperity, and **harmony**, along with cleanliness and freedom from contamination, which is why the color is used to describe **food** products, notably organic items. Wearing a green-colored hat is considered a sign of a woman's infidelity, although the color also has positive symbolism, including money and wealth. Blue represents advancement and "immortality" (*buxiu*), the latter also represented by "purple" (*zise*), which additionally symbolizes divinity and **romance and love**.

102 • COMEDY (XIJU)

COMEDY (*XIJU*). Dating back to the ancient Zhou Dynasty (1046–256 BCE) when aristocrats employed jesters to perform in their homes, different styles of comedy in China flourished in major cities from the late 19th century onward against the traditional Confucian disdain for comic shows. Among the older forms of comedy is "cross-talk" (*xiangsheng*), literally "**face** and voice," developed in the 19th century and involving two actors in dialogue with imitation, teasing, and **singing** rich in **puns** and illusions. Another is *errenzhuan*, literally "two-people rotation," a local folk **dance** from Northeast China involving a male and female using folding fans or square-shaped, red handkerchiefs twirled while singing with humorous dialogue and sketches. Following the establishment of the People's Republic of China (PRC) in 1949, comedies, including cross-talk, were generally stifled with attacks and destruction of scripts during the **Cultural Revolution (1966–1976),** despite the reputed admiration for the genre by Chinese Communist Party (CCP) chairman **Mao Zedong** (1949–1976). Poking fun at the CCP and making subversive jokes was generally common but done solely in private among friends and **family**, as the public realm was dominated by serious and often bitter revolutionary rhetoric with little or no room for laughter.

Following the introduction of economic reforms and social liberalization (1978–1979), comedies, traditional and modern, resurfaced, especially under the influence of Western comedy forms introduced into the PRC via **Hong Kong** and by Chinese expats, known as "sea turtles" (*haigui*), exposed to the genre while abroad in the United States and Europe. Popular comedy forms in the 1980s included the "Chinese skit" (*xiaopin*), making fun of relatively small and petty matters in people's lives, with qualities inherited from cross-talk, *errenzhuan*, and traditional comic **drama**. Most notable was the introduction of "stand-up comedy" (*tuokouxiu*), which originating in sleepy bars and coffee shops in major cities like **Shanghai** and **Beijing** spread throughout the country via multiple media forms, including **television** and online shows and social clubs, beginning in the 2010s.

Directed primarily at younger audiences born in the 1990s, major performers include such **foreigners** as Mandarin-fluent Canadian Mark Roswell and Chinese who first performed the genre while studying abroad. The most recognized of the latter is Huang Xi, also known as Joe Wong, who, famously declaring that people of his generation in their 40s "have no personalities," is the stand-up star of the hugely popular television show *Is it True?* Aware that Chinese people are generally not accustomed to watching stand-up routines, Huang and other popular Chinese stand-up comedians, with their "free souls" (*ziyou linghun*), engage in the highly **individualistic** expression of natural feelings and, within limits, personal opinions. Stand-up comedy is considered, first, an act of "rebellion" (*zaofan*), often subtly challenging

COMMERCE AND COMMERCIALISM (SHANGYE/SHANGYEZHUYI) • 103

official versions of reality, and, second, a display of "wit" (*jijing*), "satire" (*fengci*), and "ridicule" (*chaoxiao*), with the performer and the laughing audience becoming virtual partners in **crime**.

In a society generally lacking in deadpan **humor**, with people living highly reserved and self-**disciplined** lives, stand-up comedy represents an emotional outlet, especially at clubs offering open mics to anyone so inclined to give comedy a try. With government licenses required for comedy clubs and performers obliged to submit their scripts in advance for approval honored more in the breach than the observance, stand-up comedy confronts several prohibited red lines, including jokes or commentary on politics and **human rights**. Especially sensitive and off base are the so-called "Three T's," namely Taiwan, **Tibet**, and Tiananmen, the last referring to the military crackdown against the prodemocracy movement in 1989, which led to a virtual disappearance of provocative sketches for the next few years. Avoiding the ironic nihilism so prevalent in Western comedy, especially in the United States, and the physical, "slapstick" (*huaji*) routines of earlier Chinese comedic forms, contemporary stand-ups in the PRC rely heavily on storytelling to make audiences not only laugh, but also **think**. Popular comedy clubs include Kungfu Komedy Club, opened in 2015, in Shanghai, considered the stand-up comedy capital of the country; Watermelon (*Xigua*), located in **Guangzhou**; and Beijing Talk Show Club, in **Beijing**. Nationwide stand-up comedy competitions are held annually, and professional instruction in comedy is offered by the Beijing Arts Research Institute.

COMMERCE AND COMMERCIALISM (*SHANGYE/SHANGYE-ZHUYI*). A vibrant commercial society throughout much of imperial and modern history, the Chinese economy was also subject to strong state controls and regulation of commercial transactions that continued following the establishment of the People's Republic of China in 1949. Despite the contempt for economic activity in the official state **philosophy** of **Confucianism**, merchants and traders thrived, especially in the Song Dynasty (960–1279), while during the Qing Dynasty (1644–1911) the emperor, Qian Long, denied the need for economic exchanges with Britain, noting in a letter to King George III that, "We possess all things." While Chinese merchants during the early 20th century had to contend with powerful foreign economic interests in cities like **Shanghai** and a **corrupt** Nationalist (*Kuomintang*) government led by Chiang Kai-shek (1928–1949), commercial activities expanded, spurred by such colonial bases as **Hong Kong**.

The rise to power of the Chinese Communist Party (CCP) in 1949, led to a complete state takeover of commerce as many of China's most successful merchants fled the country, while private industry and even small shops were subject to government seizure. Shutdown of **rural markets** as a result of agricultural collectivization and the creation of state-owned enterprises

104 • COMMUNICATION (TONGXUN)

(SOEs) with an emphasis on heavy industry led to a near-halt in commercial activities outside the official Five-Year Economic Plan, especially by private companies. Overall, the Chinese economy was transformed into a cellular structure of self-sufficient provinces and **regions** subject to micro-state management, with commercialization condemned as "bourgeois" (*zichanjieji*) and contrary to socialism.

The introduction of economic reforms (1978–1979) dramatically reduced the state role in the economy. As private companies were allowed to form, commerce, both domestic and foreign, expanded rapidly, with the private sector accounting for two-thirds of economic growth and nine-tenths of job creation. Former commercial centers the likes of Shanghai and **Guangzhou** were revitalized, with nationwide ties established by such large-scale private companies as Alibaba and Tencent, becoming major commercial powers, especially in the new e-commerce sector. Commercialization extended into multiple areas previously immune from commercial impulses, including the **arts**, **cinema and film**, **entertainment**, and **religion**, the last composed of commerce-seeking temples of **Buddhism**, for example, Shaolin in Henan. Sales of memorabilia and icons of noted historical figures known for their hostility toward commercialism, for instance, Confucius (551–479 BCE) and **Mao Zedong**, have grown enormously, while their birthplaces have become major sites of an equally booming tourist trade.

Rampant commercialism is now strongly condemned in official media, while **ideological** groups like the so-called "neo-Maoists" call for a return to simpler and less commercially driven times. While reigning Marxist theoreticians advocate a complete elimination of private companies, such art forms as "theatrical skits" (*xiaopin*) lampoon commercial sectors, even as **holidays** like Christmas offer new commercial opportunities. The vitality of e-commerce in China is evidenced by the annual "Singles' Day" (11 November), a 24-hour online **shopping** event sponsored by Alibaba, although unethical behavior by Chinese companies both online and offline persists.

COMMUNICATION (*TONGXUN*). Styles and habits of personal communication in China reflect the long historical influence of norms and principles embedded in **Confucianism** with many unique features reinforced during the rule of the Chinese Communist Party (CCP) under **Mao Zedong** (1949–1976) and his successors, notably President **Xi Jinping** (2013–). In the Mao era, especially during the **Cultural Revolution (1966–1976)**, communication between individuals and groups often degenerated into angry and hate-filled exchanges of revolutionary slogans from the *Little Red Book* of Mao **quotations**. Following the introduction of economic reforms and social liberalization (1978–1979), more traditional and conventional forms of interpersonal communication were restored. With a greater reliance on indirect communication and expression of generally less emotion, personal ex-

changes in post-1978 China often involve attention to posture, facial expression, **hand gestures**, and tone of voice to draw meaning. Speech is consciously ambiguous and understates particular points of view, in the primary interest of maintaining **harmony** throughout a conversation, avoiding any loss of **"face"** on either end of an exchange. Seldom are absolute negative answers given to direct questions based on concern for face and to maintain "politeness" (*limao*). In any conservation, direct eye contact is preferred as a sign of politeness, with a slight pause taken before responding to an inquiry an indication of applying thought and consideration.

Differences in communication styles exist between **women** and **men**, with the latter speaking louder and more often than women, while any female who speaks loudly is considered ill-mannered. Between **classes**, peasants and workers also speak loudly from force of habit cultivated in the **workplace** of fields and factories, while Chinese "street talk" (*jietou tanhua*) and day-to-day conversation is generally blunt and abrupt, with a thick skin necessary to fend off potentially intrusive and personal inquiries, although raising one's voice is considered rude. Talking about someone within earshot of them and frequent interruptions are considered acceptable, with fewer restrictions on the flow of communication, making interaction among Chinese appear chaotic and bursting with "noise and excitement" (*renao*). **Family** terms are often invoked, with **children** casually referring to the "uncle policeman" (*jingcha shushu*), while names of people in the same generation carry "small or little" (*xiao*) as a prefix, with elderly people referred to as "old" (*lao*) with no implication of derogatory intent. General adherence to status and role differences are maintained, as the ultimate aim is to preserve a harmonious interaction, with both parties generally maintaining an impassive demeanor. Reading between the lines and careful examination of the meaning of words is common in Chinese society, with a preference for one-on-one meetings as opposed to use of the telephone or written communications, while bad news is often relayed with a smile and even laughter to defuse an unhappy situation.

COMMUNITY (*SHEQU*). Structure and character of communities in China have undergone substantial transformation from economic and political forces, domestic and foreign, beginning most prominently in the mid- to late 19th century and accelerated following the establishment of the People's Republic of China (PRC) in 1949. **Urban** communities, especially on the long eastern coastline of seaports and in nearby inland areas, were transformed by rapid industrialization and **commercialization** during the period of central economic planning adopted from the Soviet Union (1953–1978) and following the introduction of economic reforms and engagement in the international economy of trade and investment (1978–1979). While foreign enclaves in **Shanghai** and other coastal cities largely disappeared with the

106 • COMMUNITY (SHEQU)

near-isolation of the PRC from the global system under the planned economy, urban communities were subject to a communitarian form of living structured by the omnipresent "**unit**" (*danwei*) system, integrating **workplace**, housing, and social facilities.

While old **neighborhoods** dominated by one- or two-story single-**family** homes and narrow streets (along with many historical sites, including traditional **architecture**), were razed, Chinese cities developed a uniform landscape of giant, Soviet-style superblocks, gated communities, and wide boulevards almost impossible for pedestrians to cross. Overall livability eroded, with the intimacy of close-knit neighborhoods effectively destroyed as masses of urban residents were moved into multistoried apartment blocks often in newly developed suburban areas far from old friends and family, as a one-size-fits-all model of rapid urban growth with little to no quality planning turned China into a country of "a thousand cities with the same face."

Similar transformations occurred in the countryside, where the effects of an increasingly commercialized agricultural economy from the late 19th century onward increased ties to the outside world. Never a self-contained and self-sufficient unit, Chinese villages maintained extensive contacts with the outside world, including kinship and **clan** ties to neighboring **rural** communities with soon-to-be wives moving in and daughters moving out. The growth of rural **markets** and labor exchanges between neighboring villages and rural communities increased social networks, including remote inland and **mountain** areas throughout the early to mid-20th century.

The imposition of socialist agricultural organization in the 1950s, from the subvillage production teams, to village-wide production brigades, to multiple village "people's communes" (*renmin gongshe*), effectively cut off intervillage interactions. Thriving rural markets were closed, replaced by staid government procurement agencies, with intervillage labor swaps terminated, turning rural communities into insular social compounds largely unattached to the outside world, including neighboring villages. With the closed, corporate quality of village life of limited horizons, peasant perspectives on the community narrowed considerably to the point that during the outbreak of the Great Famine (1959–1961), villages with sufficient **food** were unaware of starvation occurring virtually next door.

The introduction of economic reforms, including in agriculture, and social liberalization (1978–1979) dramatically altered both urban and rural communities, with the gradual breakdown of the system of "household registration" (*hukou*), which had created the two separate worlds of countryside and city. Urban communities underwent major transformation, with migrants from labor-surplus villages, the "floating population" (*liudong renkou*), altering entire neighborhoods, along with the reappearance of foreign enclaves of businessmen and journalists in trade-intensive cities the likes of Shanghai and **Guangzhou**. With increased residential mobility and improved living

standards, neighborhood socialization subsided substantially, as the intrusive neighborhood committees, with their periodic "inspections" (*jiancha*) of family dwellings and apartments, were eliminated, as young millennials, populating posh neighborhoods and cohousing establishments, pursued a more highly **individualized** sense of community centered on friends and local **entertainment** and drinking spots.

Urban innovations include the creation of coworking spaces, especially for self-employed artists and technicians, introduced in Shanghai and other major cities from 2009 onward, along with pedestrian-only public spaces and parks, creating more tight-knit communities as the old mass-alienating super-blocks and gated communities are phased out. New types of open neighborhoods are also being pushed consisting of mixed-use development zones and easy-to-access public transportation, with the revival of the long and unique histories of many of the country's most famous cities. Comparable changes in village life have also occurred, with the social life of peasants expanding dramatically via the construction of modern housing units replete with television and internet connection, and easy access to national and international contacts by road, high-speed railway, and widely dispersed airports throughout the country.

COMPASSION (*SHAN/TONGQING*). Considerable controversy surrounds the issue of compassion in contemporary Chinese society, as **religious** and historical traditions suggest a strong compassionate strain in Chinese culture but with highly publicized cases of Chinese people ignoring the suffering of others, especially **children**, suggesting a high level of callousness and general lack of kindness. That compassion is inherent to Chinese culture is supported by the spread of **Buddhism**, especially the prominence in China of the Bodhisattva Guanyin, known as the "Goddess of Mercy," with compassion one of the major tenets of the doctrine. A good Buddhist recognizes the suffering of others and attempts to alleviate their suffering, with Guanyin motivated by supreme compassion, as the Bodhisattva is worshipped at such major sites as Shaolin Temple (Henan), where a compassionate heart is central to the training of Buddhist monks. Similar notions are also evident in ancient Chinese **philosophy**, which preached a compassionate mindset as a sign of inner strength while deriding "malice" (*eyi*), the opposite of compassion, as coming from a weakness of mind.

Lack of compassion in China has been a major theme in academic studies, most notably by world-renowned anthropologist Fei Hsiao-tung (1910–2005), who in pathbreaking works based on extensive fieldwork in **rural** and **urban** areas described Chinese people as "selfish" (*zisi*), committed solely to the interests of their immediate **family** and kin, while oblivious to people outside their personal social network. Chinese in the countryside and cities suffered from an egocentric ethical defect that ignored the wider

108 • COMPROMISE AND NEGOTIATION (TUOXIE/TANPAN)

public interest, something Fei witnessed in his hometown of Suzhou (Jiangsu), where families casually dumped their garbage into the city's famous canals, unconcerned with the impact on public **health** and well-being. Following the establishment of the People's Republic of China (PRC) in 1949, traditional moral and religious systems, with their message of compassion, were directly attacked by the Communist state. Reinforced by the "materialistic" (*weiwuzhuyi*) doctrine of Marxism–Leninism–Mao Zedong Thought, universal humanist values were rejected, with devotion to compassionate acts treated as a waste of resources, despite obligations by the Chinese government for locals to perform "good deeds" (*shanxing*) for others, for instance, repairing bicycles and providing free haircuts.

The introduction of economic reforms and social liberalization (1978–1979) led to a loosening of historical and contemporary social controls with greater tolerance for aberrant behavior previously subject to strict regulation and **punishment**, including marital infidelity and unethical **business practices**. Such popular notions as "avoid getting involved if it's not your business" (*shangguan xianshi*), along with a fear of lawsuits filed against Good Samaritans, as occurred in the city of Nanjing in 2006, have also accounted for public inaction in cases where individuals, including young children and frail elders, suffered injury from accidents, with bystanders and onlookers refusing to offer a helping hand or failing to even call police or an ambulance.

Citing monetary concerns and invoking rationalizations—"Somebody else will do it" or "That wasn't my kid so why should I bother"—generated social backlash from the 1990s onward, with a nationwide discussion about the state of morality in an increasingly freewheeling, self-centered, **individualistic** society. While plenty of commentary supported inaction, proposals were aired for a "duty to respond" (*huiying yiwu*) law modeled on European statues, while individuals, often elderly, were lauded for coming to the assistance of the injured party, while also setting up hospices to care for seriously ill or **disabled** children declared by authorities as having "no social value" (*meiyou shehui jiazhi*). The unprecedented numbers of volunteers and civic associations streaming into **Sichuan** following the enormously destructive earthquake in 2008, suggested that a natural outpouring of compassion exists in China on a collective, if not always individual, basis.

COMPROMISE AND NEGOTIATION (*TUOXIE/TANPAN*). In a society where moderation and social **harmony** were long-standing traditions, achieving compromise, known as "seeking the middle ground" (*xunqiu zhongjian lichang*), was highly valued but without sacrificing tough negotiating strategies. According to the "Doctrine of the Mean" (*Zhong Yong*) in **Confucianism**, "moderation" (*jiezhi*) and "propriety" (*li*) in social relations required never acting in excess or pursuing extreme positions. Similarly,

COMPROMISE AND NEGOTIATION (TUOXIE/TANPAN) • 109

Daoism called on parties to find a "middle ground" (*zhonglidi*) to achieve a balance between contending forces derived through the **ritual** of long-term haggling back and forth. Concerned more with the means and not the ends of engagement, Chinese tradition emphasizes the importance of establishing strong interpersonal ties, good "**relations**" (*guanxi*), as opposed to any abstract and absolutist notion of right and wrong.

Applied to the realms of diplomacy and international **business** negotiations by government and corporate officials in the People's Republic of China (PRC), traditional concepts join with the rhetoric and worldview of Marxism–Leninism acquired primarily from the Soviet Union and shaped by Chinese Communist Party (CCP) chairman **Mao Zedong** and Premier Zhou Enlai (1949–1976). Known for a distinctive and often unique negotiating style, the most obvious characteristic of Chinese negotiating behavior is the persistent effort to develop and manipulate strong interpersonal relationships in any negotiation process, while disdaining any highly legalistic or impersonal approach. Cultivating a sense of "friendship" (*youyi*) and obligation with negotiating counterparts is considered crucial to the Chinese achieving their negotiation objectives, with a process that proceeds in a linear fashion from opening moves, to a period of assessment, to the end game, to final implementation. For the Chinese, a political and business negotiation is an effort to bring together the principles and objectives of two sides while testing the counterpart's commitment to a long-term relationship.

In the first phase, "opening moves" (*kaiqi dongzuo*), Chinese negotiators press counterparts to accept certain principles that then act as a constraint on the other side's **bargaining** flexibility, even as such principles may be completely disregarded in any final agreement. In the second phase, or "period of assessment" (*pinggu qi*), Chinese will adamantly resist exposing their own position until the views, goals, and "attitudes" (*taidu*) of their counterpart are fully revealed, with frequent attempts to test their opposite's intentions and patience, employing requisite pressure tactics. Faced with a possible breakdown, Chinese negotiators will often resort to stalling tactics or even sign on to a partial agreement as a way to keep the process moving, preferably in their direction. Willing to present themselves as the injured party while willing to **shame** their counterpart with accusations of failing to live up to past agreements or principles, the Chinese are known for keeping meticulous records using past statements as pressure points for gaining leverage through the public media or by setting some artificial deadline and by so doing make the other side feel that their "positive" (*zheng*) relationship is somehow in jeopardy. Once the Chinese feel they have fully tested the limits of their adversary—often engaging in highly theatrical expressions of outrage concerning some putative violation—a relatively rapid conclusion of an agreement is possible. No agreement, however, is considered absolutely final, as

110 • CONCUBINAGE (XIAOQIE)

further conditions are often demanded for full implementation, with the Chinese generally exhibiting great flexibility in working out concrete arrangements.

While the Chinese often conduct negotiations in a highly purposeful and meticulous fashion with no hint of internal disagreement, they are not particularly nimble negotiators, as consensus from the top **leadership** is a necessity, often requiring constant delays for consultation and avoiding any impression of wanting immediate results. As many foreign observers have noted, the Chinese are generally not fully in control of the process, often "feeling their way" (*gangjue ziji fangshi*) in situations they do not fully comprehend, providing little immediate response to new conditions or changed circumstances. Imputing motives and intentions to their counterparts shaped by Marxism–Leninism, Chinese government officials rarely invoke official **ideology** during actual negotiations, although such interpretations are often the stuff of official media accounts. While flexibility, even on the part of top-level negotiators, is avoided in the early rounds of any discussion, compromise is often offered near the very end just to ensure a successful conclusion.

Outright confrontation, especially involving senior leaders, is generally avoided to preserve "**face**" and "social status" (*shehui dengji*), as efforts are constantly pursued to lure counterparts into a positive working relationship based on "mutual trust and good faith" (*renji hexie*), which can take weeks or months to acquire, often through the role of an "intermediary" (*zhongjian ren*) with good personal ties to both parties. Little significance is given to signed contracts or agreements, as special emphasis is given to personal "reciprocity" (*huibao*) by a negotiating partner that can extend years into the future. Virtually every issue can be raised at once, often in haphazard fashion, as an air of tension and uncertainty is often maintained until the end. Governed by "holistic thinking" (*zhengti guannian*), Chinese negotiators give an impression that nothing is ever finally settled, with additional demands made at the last moment in the spirit of "eating bitterness and enduring hardship" (*chiku nailiao*).

CONCUBINAGE (*XIAOQIE*). Defined as an interpersonal, **sexual** relationship in which couples are not or cannot be married, concubinage was a constant social phenomenon throughout Chinese history from ancient times to the establishment of the People's Republic of China (PRC) in 1949, when the practice was outlawed, only to be revived following the introduction of economic reforms and social liberalization (1978–1979). With polygamy outlawed throughout Chinese history, concubines provided additional heirs, particularly to a socially prominent and prestigious **family**, and brought sexual pleasure to **men**, including emperors, especially in loveless and sexless **marriages**. With concubines considered inferior in status to the wife, off-

CONCUBINAGE (XIAOQIE) • 111

spring were considered legitimate but retained an inferior position to the biological children of the wife. An even lower status was accorded so-called "unofficial concubines" (*biqie*), whose **children** were treated as illegitimate. With especially well-off men maintaining several women as concubines, each with a particular rank, intrigue involving concubines, wives, and children was a constant feature of family life, a prime topic in classical **literature**, most notably *Dream of the Red Chamber* (Honglou meng), published in the mid-18th century during the Qing Dynasty (1644–1911).

Introduced in the ancient China of the Shang (1600–1046 BCE) and Zhou (1046–256 BCE) dynasties, concubinage became an integral part of the imperial system, with expanding numbers that during the last Qing Dynasty reached more than 60 during the long reign of Emperor Kangxi (1661–1722). Eight different levels of "consorts" (*guifei*), concubines, and "attendant ladies" (*changzai*) were maintained, at great expense, with differences according to rank in **food**, **clothing**, and residence. Infamous imperial concubines include the sadistic Daji of the Shang Dynasty, whose personal machinations the likes of developing the *paolao* torture machine corrupted the last King Zhou of the Shang; Zhao Feiyan of the Han Dynasty (202 BCE–220 CE), who, unable to bear children, had the offspring of lower-ranking concubines murdered; and, most notably, Yang Guifei (719–756), a former Daoist nun and one of the "Four Beauties of Ancient China" (*Gudai Sige Meinü*), who became the favorite consort of Emperor Xuanzong (846–859) of the Tang Dynasty (618–907). In the case of the latter, the emperor was spending more time fraternizing with the seductive Yang than governing. Accused of alleged association with leaders of the highly destructive An Lu Shan Rebellion (755–763), Yang Guifei was ultimately strangled to death on the reluctant orders of the emperor. Concubines who emerged as de facto rulers in China include the following: Lü Zhi (195–180 BCE), Han Dynasty; Wu Zetian (690–705), Tang Dynasty; and Empress Dowager Ci Xi (1861–1908), Qing Dynasty. All were known as ruthless, although sometimes effective, rulers of the giant empire. Other concubines-turned-rulers were Deng Sui (81–121 BCE), Han Dynasty, and Empress Liu (1020–1033), Northern Song (960–1120), both known as humane and peaceful rulers.

Driven underground or eliminated during the period of puritanical rule by Chinese Communist Party (CCP) chairman **Mao Zedong** (1949–1976), concubinage reemerged following the introduction of economic reforms and social liberalization (1978–1979) but with the more socially sanitized label of "second wife" (*ernai*), "little sweetie" (*xiaomi*), or "mistress" (*qingfu*), fulfilling the sexual fantasies of male counterparts often referred to as "uncle" (*shushu*). Showered with expensive clothes, **gifts**, an apartment, and a healthy allowance by wealthy businessmen and government officials, the latter in violation of the law, mistresses of the rich and famous are relieved from the drudgery of seeking employment, while living close to one another

112 • CONFESSION (RENZUI)

in areas dubbed "second wife villages" (*ernaicun*) in high-flying cities like Shenzhen and **Shanghai**. A target of the anticorruption campaign in 2012, mistresses discovered by irate wives or equally jealous "third wives" or "fourth wives" (*sannai sinai*) are subject to beatings and public **shaming** as **homewreckers**, known as a "little third" (*xiaosan*), while their male partner openly boasts about his relationships, sometimes multiple, among colleagues at **banquets** and other male-only festive occasions.

See also FIDELITY AND INFIDELITY (*BAOZHENDU/BUZHONG*).

CONFESSION (*RENZUI*). A relatively conservative law-and-order society, China has a history of strong prohibitions and **punishments** for **crime**, also referred to as "excess" (*guo*), with confessions as the major basis for prosecution. Referred to as "self-indictment" (*zisong*) and "self-judgment" (*zice*) during the imperial era, all the major **philosophical** traditions in Chinese history condemned crime and sin, with Confucius (551–479 BCE) declaring that, "He who sins against heaven has none to whom he can pray." Adherents to **Daoism** believed that commission of sins caused illness, with a confession offering a salivating cure, while **Buddhism** considered "sin" (*zui*) an evil element that defiles the mind, obstructing the path to "enlightenment" (*qimeng*).

In the history of the People's Republic of China (PRC), crime, including political offenses, has been a major concern of the Chinese government, especially since the introduction of economic reforms and social liberalization (1978–1979). Despite a commitment to strengthening the "rule of law" (*fazhi*), with confessions alone considered inadequate evidence for conviction, filmed confessions on state television have become a staple in the PRC, prompting widespread **criticism** from Chinese lawyers, judges, and international **human rights** groups. During the period of rule by Chinese Communist Party (CCP) chairman **Mao Zedong** (1949–1976), confessions were intended as a form of "self-transformation" (*ziwo gaizao*) and "redemption" (*shuhui*) in pursuit of constructing a new political **subjectivism** and **utopian** society. Public **shaming** was launched during the **Cultural Revolution (1966–1976)** against such major political enemies as People's Liberation Army (PLA) marshal Peng Dehuai (1898–1974), along with haphazardly selected "class enemies" (*jieji diren*), with victims subject to personal **humiliation** and forced to confess to misdeeds, usually political, that they never committed. A major exception was Jiang Qing, the radical left-wing wife of Mao Zedong, who during her trial in 1980, remained unrepentant, refusing to confess to charges of plotting an armed rebellion to "usurp power" (*cuanduo quanli*) following the chairman's death in 1976.

With the ascension to power of **Xi Jinping** in 2102–2013, and the focus on eliminating **corruption** in the CCP and Chinese society at large, televised confessions of the accused, including resident **foreigners**, became part of a

larger effort to **monitor**, censor, and shape public opinion in creating a new kind of predictably obedient social and political order framed as a "harmonious society" (*hexie shehui*). In the absence of concrete incriminating evidence, detainees and **prisoners** were pressured to "own up" (*tanbai*) to committing criminal acts even before the inauguration of formal **legal** proceedings, with failure to confess resulting in harsh treatment and long terms of incarceration. Close collaboration between police and the CCP Propaganda Department targeted groups, most prominently outspoken **intellectuals** and journalists, along with residents in **Hong Kong**, where poking fun at authorities is still possible, while common criminals in the PRC are generally spared the honor.

Operating on the principle of *mo, xuyu*, roughly translated as "even if there is no case, one must be found," publicized confessions are carefully scripted and meticulously choreographed, with media professionals giving great attention to the smallest detail, for example, room lighting and the victim's usually shabby **clothing**. Counseled to deny being tortured and appearing contrite, subjects are known to have "disappeared" (*xiaoshile*) weeks or months prior to the televised confession, with **family** and friends left unknowing about their whereabouts, with intense **interrogation** involving sleep deprivation and other coercive measures preceding the filmed confession. Designed as a warning to others and an assertion of the infallibility of the CCP, many of the televised confessions are viewed by the public as "fake" (*jia*) and involving such minor offenses as engaging in illegal **gambling** and publishing news reports resulting in stock market declines. With some victims recanting their statements following release, Chinese media outlets, including China Central Television (CCTV) and China Global Television Network (CGTN), have been subject to harsh domestic and international criticism for airing what is seen as blatant state propaganda. Confessions by former Red Guards of cruel treatment of teachers and other victims, with admission of "pulling accusations out of nowhere" (*zhize wuchu buzai*) and committing severe acts of punishment, are considered more genuine as the PRC continues to come to terms with the immense hatred and **anger** unleashed during the Cultural Revolution.

CONFLICT AND CONFLICT RESOLUTION (*CHONGTU/JIEJUE CHONGTU*). Defined as a process of resolving intense interpersonal disputes or disagreements between two or more interdependent parties based on incompatible goals, needs, desires, or values, conflict resolution in the People's Republic of China (PRC) is shaped by historical traditions and **philosophies** along with contemporary **ideologies** and government policies. The major Chinese-**language** term indicating conflict is *maodun*, also translated as "contradiction," used by average people to describe daily conflictual situations, as well as, most notably, by Chinese Communist Party (CCP) chairman

114 • CONFLICT AND CONFLICT RESOLUTION

Mao Zedong (1949–1976) in his analysis of conflicts in Chinese society. Other terms include the following: *fenqi* ("difference"/"divergence"), *jiufen* ("dispute"), *chongtu* ("clash"), and *wenti* ("problem"). Major influences on Chinese approaches to conflict resolution range from the dominant philosophies and **religions**, namely **Confucianism**, **Daoism**, and **Buddhism**, to the political, diplomatic, and warfare strategies pursued during the Warring States (425–221 BCE) and outlined in *The Art of War*, by Sun Zi, 5th century BCE, and embedded in Communist and other ideologies promulgated in the 20th century.

Styles of conflict resolution and "conflict management" (*chongtu guanli*) in the PRC range from the preferred **compromise** and "endurance" (*nali*) to the less preferred "public obedience/private defiance" (*gongzhong fucong/ siren fankang*), "confrontation" (*duikang*), and "severance" (*qiansan fei*). With **harmony** as a primordial value in Chinese culture, maintaining cordial relations and protecting the **"face"** of the conflicting parties is the ultimate goal, with great emphasis throughout the process on "reciprocity" (*huhui*) and "courtesy" (*limao*). Obstacles to successful conflict resolution include failure to show respect for others' feelings; resorting to extremes; and engaging in aggressive behavior, especially in public. Confronting particularly intractable conflicts, help is often sought from intermediaries, with **family** members or friends serving as third parties in hopes of achieving an acceptable resolution. Individuals particularly adept at serving in such a role are the elderly, as seniority is connected with credibility and people in positions of authority, for example, local "leaders" (*lingdao*) in the **workplace** or the once-pervasive "neighborhood committees" (*juweihui*).

The possibility of successful resolution is enhanced by "evading" (*hubi*) direct confrontations, "turning big problems into small problems" (*dashi hua xiao*), "considering small conflicts as no conflicts" (*xiaoshi hualian*), and metaphorically "planting more flowers and creating fewer thorns" (*duo zaihua, shao zaici*). Domestic "disputes" (*jiufen*) involving family members should stay in the family, along with the admonition that "domestic shame should not go public" (*jiachou buke waikang*), with any resort to police or courts, generally seen as reserved for criminals, to settle disputes avoided if possible.

Reflecting a disdain for traditional values and support for **struggle** over harmony and compromise, Mao Zedong relied on his enormous authority as CCP chairman to provoke confrontations, particularly involving designated "class enemies" (*jieji diren*), as occurred during the chaotic and often violent **Cultural Revolution (1966–1976)**. Contrary to the traditionalist view that conflict represented a detraction from natural harmony with purely negative effects on the social order, Mao saw "conflicts" and "contradictions" (*maodun*) pervading all of society with benefits, most notably destruction of "class enemies" (*jieji diren*) and other opponents of permanent revolution. Ideologi-

cal work in the Maoist world was the medium for dealing with tensions, relying on personal, not institutional, authority to provoke rather than manage conflict through the heavy use of slogans and **quotations**, mainly his own. Declaring that "to rebel is justified" (*zaofan youli*), violent acts by Red Guards were tolerated and even encouraged until "rebel" (*zaofan*) groups were "sent down to the countryside" (*xiaxiang*) to virtual exile. While Maoist elements advocating confrontation still exist in contemporary China, the traditionalist approach stressing patience, perseverance, and mediation generally prevails, although new institutional mechanisms are needed to handle increasingly numerous and often-confrontational labor disputes.

CONFORMITY AND NONCONFORMITY (*FUHE/BU FUHE*). In a society stressing "obedience" (*fucong*) to a hierarchical and collectivist social and political order in the imperial and contemporary eras, conformity has been a dominant psychological force shaping individual behavior, with nonconformity historically a discouraged rarity. Major socializing agents in China's "obedience system" (*fucong xitong*) include parents and teachers, backed by traditional philosophies of **Confucianism**, with its stress on **filial piety** and an autocratic **political culture** built on principles of absolute conformity and personal **loyalty** to leaders.

Within the generally father-dominated "patriarchal" (*jiazhang*) **family**, parents assume a controlling and authoritative role, pushing **children** to conform to parental expectations, especially in schooling, with little or no emphasis on cultivating autonomy and independence. A similar role is assumed by teachers who, in the contemporary primary and secondary educational system in the People's Republic of China (PRC), are devoted to turning students into good "little soldiers" (*xiao shibing*), with hard-edged measures employed to maintain **discipline** and frequent **criticism** and "censure" (*zenan*) of moral failings, along with public competition and postings of everyday recordings of punctuality and politeness. Under the control of the Chinese Communist Party (CCP), universities in the PRC perpetuate conformist behavior, considering signs of **individuality** a nuisance, with students rarely being taught independent **thinking** or engaging faculty with challenging **questions** and alternative concepts. With professional success still considered synonymous with societal acknowledgement, few realms of employment, including in the **arts**, thrive on the basis of individual creativity, which has led to a national discussion about the country's inability to produce geniuses in **science** and **business**, the likes of Albert Einstein and Steve Jobs, with few Nobel Prize winners.

Chinese **women** are especially subject to pressure to conform, with images of the ideal woman including dressing and looking a certain way, studying in specific fields, usually excluding science and engineering, and marrying by a certain **age**. While divorce is **legal** and increasing in numbers, women face

116 • CONFUCIANISM (RUJIAZHUYI)

pressure to maintain a **marriage**, even with husbands who take on expensive mistresses, as a divorced woman is stigmatized and brings **shame** to a family. Among the forces encouraging greater nonconformity is the rock **music** scene, with **song** lyrics rejecting collective **harmony** and such iconic Western stars as Lady Gaga becoming popular. Tattoos are also considered purveyors and badges of individuality, as self-expression, especially by **youth**, is increasingly being considered attractive, although critics insist true independence of thought in China is still an enormous rarity.

Despite increasing consumerism and wider choices in **clothing** and lifestyle, conformist pressures, including among intellectuals, remain strong, recently reinforced by the introduction of the **social credit system** by the Chinese government in 2014, and the persecution of **scholars** for "expressing views outside the mainstream of society." That little outrage was expressed at the arrest of **human rights** advocate and Nobel Peace Prize winner Liu Xiaobo in 2009, demonstrates the power of conformist tendencies in Chinese society. Another example is the long-held prejudice against left-handed people, who were dismissively referred to as *zuodao*, literally meaning "left path," implying illegality, and considered a sign of nonconformity in a society where right-handedness was strongly incentivized among children.

CONFUCIANISM (*RUJIAZHUYI*). The reigning **philosophy** and state doctrine in Chinese imperial history from the Han Dynasty (202 BCE–220 CE) onward, Confucianism was a target of **criticism** by cultural iconoclasts during the 20th century from the New Culture Movement/May Fourth Movement (1917–1921) to the period of rule under Chinese Communist Party (CCP) chairman **Mao Zedong** (1949–1976). The English transliteration for Kong Qiu, also known as Kong Fuzi (551–479 BCE), Confucius preached that humankind would be in **harmony** with the universe if all people acted with "righteousness" (*yi*) and "humility" (*qianxun*), while adhering to specific, mostly hierarchical roles, namely father–son, husband–wife, older–younger, ruler–subject, and friend–friend, the last the only horizontal relationship. Cultivation of the inner self and one's personal life would benefit social relations, including between **men** and **women**, and among commonly tense relations in the **family**, especially between mothers and/or among daughters-in-law.

Children were also taught basic Confucian principles at a young age via the *Standards for Being a Good Pupil and Child* (Dizi Gui), composed during the reign of Emperor Kang Xi (1661–1722) during the Qing Dynasty (1644–1911). General social order would thus prevail, which, in turn, would produce a moral order of harmony and peace in the state, especially between ruler and ruled with material gain playing little or no role in measuring personal and collective success. The linchpin of the Confucian moral order is the "gentleman" (*junzi*) who brings harmony to life through mastering the

CONFUCIANISM (RUJIAZHUYI) • 117

"Six Arts" of archery, **calligraphy**, charioteering, **ceremony**, mathematics, and **music**, showing **empathy** beyond his immediate social network. One of the last major advocates of Confucianism in the pre-1949 period was Liang Shuming (1893–1988), who promoted the Rural Reconstruction Movement in the 1930s to rebuild Chinese villages as the foundations of a revived Confucian order and who, later in life, refused to criticize Confucius in campaigns directed against the great philosopher by the People's Republic of China (PRC).

Proclaimed as the "number-one hooligan" (*diyi liumang*) by Red Guards and assailed during the **Cultural Revolution (1966–1976)** and the Anti-Confucian Campaign (1973–1976) promoted by radical left-wing elements associated with Jiang Qing, wife of CCP chairman Mao Zedong, Confucian thought was portrayed as the antithesis of the Maoist order of persistent **struggle** and "permanent revolution" (*yongliu geming*). Continued teaching of the Confucian classics in private schools, including instruction in *Three Character Classic* (Sanzijing), designed for primary school students, was prima facie evidence for the persistence of "feudalism" (*fengjianzhuyi*) in the PRC and thus worthy of total destruction. Raids on private and public **libraries**, and the "ransacking of homes" (*chao jia*), resulted in the confiscation of thousands of ancient Confucian texts and manuscripts, with some torn up and burned but many others retained in clandestine reading groups, unintendedly exposing young people to Confucian ideas for the first time. Renowned Confucian **scholars** were subject to arrest and persecution but with many participants in the campaigns subsequently admitting they did not "believe any of the criticism" and took it all as an example of "black humor" (*heise youmo*). Undoubtedly, the worse desecrations occurred at major Confucian sites in the great philosopher's birthplace of Qufu, Shandong, including temple grounds and the Kong family cemetery, with five female corpses exhumed, tied together, and hung from a tree.

Following the passing of Mao Zedong in 1976, and the subsequent arrest of his radical supporters, dubbed the "Gang of Four" (*siren bang*), the official stance on Confucius was reversed, as damaged sites were restored, with annual celebration of the master's birthday, 22 September, beginning in 1984. Followed in subsequent years by a renaissance of Confucian research and studies, a Confucian Society was established, along with several international conferences on Confucianism held in the PRC. Top leaders, including presidents Jiang Zemin (1989–2002), Hu Jintao (2003–2013), and **Xi Jinping** (2013–), have advocated a return to Confucian ethics to combat widespread social and political problems, most notably **corruption** in the CCP and Chinese society generally. Such major doctrinal principles as the "eight honors and eight disgraces" (*ba rong, ba chi*) are now publicly honored, including traditional values of "hard work" (*nuli gongzuo*), "public service"

118 • CONFUCIANISM (RUJIAZHUYI)

(*gonggong fuwu*), "honesty" (*chengshi*), and "civil obedience" (*gongmin fucong*), as opposed to "lawlessness" (*weifa*) and "pursuit of profit and luxury" (*zhuqiu lirun*).

Considered an **ideological** instrument for maintaining domestic political order and "stability" (*wending*) in the PRC, Confucian teachings are also proselytized abroad in a network of Confucian Institutes established and financed by the Ministry of Foreign Affairs (MFA). In a society beset by myriad social ills, including increased rates of **crime**, **drug abuse**, and divorce, China is confronting a **spiritual** and moral vacuum from the collapse of the official doctrine of Marxism–Leninism–Mao Zedong Thought ever since the chaotic Cultural Revolution. Emphasizing family harmony and rules of humanistic conduct, the ancient doctrine provides a sense of belonging and meaning unavailable in the pure materialism of economic growth and prosperity.

Stressing the imperial Confucius lauded by the dynasties for preaching "obedience" (*fucong*) to the emperor and state, and justifying hierarchy and **loyalty**, Confucian doctrine is promulgated via lectures on television, "Confucian learning" (*ruxue*) exercises, and classical recital classes on Confucian basics for children. With the shift by the Chinese government from a pure focus on economic growth to addressing the social and psychological well-being of the population in October 2011, the Confucian principles of "benevolence" (*ren*), "righteousness" (*yi*), "propriety" (*li*), "**wisdom**" (*zhi*), and "sincerity" (*xin*) infused multiple realms of society, including "Confucian **business**" (*rushang*) and "benevolent" state and party officials. Identified as uniquely Chinese, Confucian doctrine is also lauded as a defense against foreign, largely Western ideas of democracy and dissent, and a buffer against the enormous personal anxieties produced by a rapidly changing Chinese social and economic order.

Seen as a powerful source of **self-esteem** and personal responsibility for maintaining a proper relationship to oneself, the **community**, the environment, and the world, Confucianism is still derided in some quarters as elitist and disparaging of women, while lauded for its principles of cultural diffusion and ethnic equality. The "Three Major Confucian Sites" (*Sankang*) in the great philosopher's birthplace in Qufu, Shandong include: "Confucian Temple" (*Kongmiao*), the largest building complex in China after the **Forbidden City**; "Confucian Mansions" (*Kongfu*), residences of direct descendants of Confucius from the Ming (1368–1644) and Qing (1644–1911) dynasties with more than 600,000 cultural relics; and, the "Confucian Forest" (*Kongling*), burial sites of Confucius and Kong family members. Extensive documentation, now digitized, is also available at the Archives of the Confucius Family of the Ming and Qing dynasties with records and materials dating from 1534–1948.

CONQUEST (*ZHENGFU*). Historically a major target of conquest by outside powers, most notably the Mongols and Manchus, founders of two of the last three dynasties, the Yuan (1279–1368) by the former and the Qing (1644–1911) by the latter, China also engaged in conquest of foreign lands in the northeast, especially Korea, and in Central and Southeast Asia. Primary targets included the far western corridors along the **Silk Road**, especially through the strategic Tarim Basin, conquered during the early Tang Dynasty (618–907) and in modern-day Xinjiang, and equally important routes through **Yunnan** and **Sichuan**. Both the conqueror and the conquered underwent a prolonged process of "Sinicization" (*Hanhua*), absorbing basic principles of Confucian culture often including the written **language**. While conquests dramatically expanded the imperial Chinese empires, excessive costs in manpower and finance frequently led to major political declines, as occurred with the Sui Dynasty (581–618) after the bungled conquest of Korea. Following the attempts by Western nations, led by Britain and Japan, to conquer the Chinese empire from the mid-19th to the mid-20th centuries, the People's Republic of China (PRC) was established in 1949, vowing to protect against any further foreign intrusions, especially by the United States, which ringed the country with foreign alliances and military bases, and the Soviet Union, which included border clashes in 1969.

Following the introduction of economic reforms and opening up to the global economy (1978–1979), and the normalization of relations with both the United States (1979) and Russia (1982), the PRC largely shifted to economic measures, including large investments and loans to neighboring countries like Bangladesh, Myanmar, and Sri Lanka, and on the African continent, which has been interpreted as a form of Chinese financial conquest. Manifested most recently by the One Road, One Belt Initiative (OBOR) announced in 2013, the PRC is extending economic assistance to 152 countries, backed by the well-financed China Export-Import Bank (ChinaExim). China has also moved into unoccupied islands in the South China Sea, claiming vast swaths of the area as PRC territorial waters, which, also claimed by neighboring countries, including Vietnam and the Philippines, has been treated as a form of conquest.

See also EXPLORATION (*KANTAN*).

CONSPICUOUS CONSUMPTION (*XUANYAOXING XIAOFEI*). Contrary to the emphasis on frugality in **Confucianism** perpetuated during the rule of Chinese Communist Party (CCP) chairman **Mao Zedong** (1949–1976) when personal interests and opportunity were sacrificed to **utopian** state goals, conspicuous consumption has become a major commercial force in the People's Republic of China (PRC), especially since the 1990s. Fueled by pent-up demand and rapid economic growth, high-level consumption has grown, especially for luxury products, mainly from such world-

120 • CORRUPTION (FUBAI)

renowned Western retailers as Chanel, Graff, Louis Vuitton, Prada, and Bottega Veneta, with stores and outlets in thriving eastern seaboard cities the likes of **Shanghai** and Shenzhen and such publications as *Purchasing Upscale Goods* and the widespread popularity of "Bobos" (*bubozu*), a reference to young white-collar employees for whom consumption is a major source of self-identity.

Consistent with the ideas outlined by Thorstein Veblen in *The Theory of the Leisure Class* (1899), affluent Chinese consumers convey their wealth and power through excessive leisure and **shopping**, spending a high percentage of their income on luxury products and services. Members of the rapidly expanding middle class, numbering 400 million people, these high-end customers, many young millennials, look to the consumption of conspicuous expensive goods, for example, expensive automobiles and services, including **prostitution**, as a form of self-expression and means to achieve elite social status. Abjuring any commitment to socialism or economic egalitarianism, material possessions are seen as the key to **happiness**, with particular emphasis on goods that can be worn or displayed in public, with product satisfaction derived from audience reaction as much as the actual product use. A rash of luxury-product apps on **smartphones** makes for easy and convenient purchases of luxury products online, along with a nationwide network of stores and king-size malls luring millennials to their doors. Buyers of the newest, most highly advertised products are seen as trendsetters and a source of envy, expanding the gap in Chinese society between the haves and have-nots, and further contributing to the country's growing inequality in cities and between **urban** and **rural areas**.

CORRUPTION (*FUBAI*). A perennial problem from the imperial era (221 BCE–1911) through the period of the Republic of China (ROC) on the mainland (1912–1949), and continuing into the People's Republic of China (PRC/ 1949–present), corruption involving state officials reached from the highest levels of authority to the local level. Despite the contempt for "profit" (*lirun*) in **Confucianism** and a topic for **criticism** in such major literary works as *The Book of Swindles* and *The Golden Lotus* (Jin Ping Mei), written in the 16th and 17th centuries, respectively, corruption was widespread, extending from the highest levels of the imperial court to the local level. Described as the greatest scourge on state and society during the Qing Dynasty (1644–1911), corruption had a devastating effect on the Chinese populace, described by one high-level official as "sucking out the lifeblood of the Chinese people." Fast forward to the era of rule by Chinese Communist Party (CCP) chairman **Mao Zedong** (1949–1976), which, despite a reputation for puritanical rectitude, experienced low-level corruption between party and social interests that accelerated dramatically following the introduction of economic reforms and social liberalization (1978–1979).

Major forms of contemporary corruption in the PRC include graft, namely bribes, kickbacks, embezzlement, and outright theft of public funds; "rent-seeking" (*xunzu*), granting near-monopolistic power over restrictive **markets** through licenses and other official devices for maximizing earnings; and "prebendalism" (*hunqianzhuyi*), where officials skim off shares of government revenue for personal benefit. Collusion between state and CCP officials with unsavory businessmen and criminal elements, for instance, such **secret societies** as the Triads, is carried out through immutable patronage networks that are largely untouched by weak **legal** and regulatory authorities. Fed by low salaries of government officials, corruption is most evident in the banking, construction, mining, and real estate industries, with tax collectors and judges singled out for blackmail and other nefarious practices.

With 25 percent of officials ranked "bad" or "very bad" in nationwide polls, corruption is considered responsible for multiple social problems, including rising prices for housing, lack of **food** safety, and the growing wealth gap between **classes**. Promoted by President **Xi Jinping** (2013–), the highly touted anticorruption campaign has generally failed to fundamentally alter practices of local officials operating in cahoots with powerful private interests, despite various charges against 1.5 million people. Ironically, in the country's one-party system, corruption is often highly correlated with effective performance in generating economic growth and prosperity, as witnessed in the case of Bo Xilai, former CCP secretary of **Chongqing**, who was prosecuted for corruption in spite of the effective promotion of the local economy and reduction in street **crime**. That President Xi Jinping rose to prominence on the strength of the high-level political position of his father, Xi Zhongxun (1913–2002), make the younger Xi an example of the corrupt "princeling faction" (*taizidang*) in the CCP.

COSMOLOGY (*YUZHOUXUE*). Denoting a **science** devoted to articulating the astronomical and physical universe, cosmology in China was traditionally related to virtually every scale and realm of being, with residual influence continuing into the modern era, including the People's Republic of China (PRC). Conceiving of the world as harmonious and proportionate, with everything ultimately connected and undergoing constant transformation, major cosmological principles of "heaven" (*tian*), the "way" (*dao*), **energy**, the **Five Elements**, cyclical change and phases, and **yin-yang**, among others, pointed to the ideal of a well-ordered universe understood through correlative **thinking**, a process grounded in informal and ad hoc analogical processes. Systematic correspondence among various organs of the universe include heavenly bodies, the body politic, and the human body, which all exist in a structural continuum, with no clear-cut beginning or end and no dualism of creator and created, as the formation of the universe was spontaneous and a self-generating system in line with the yin-yang concept.

122 • COURTESY AND ETIQUETTE (LIMAO/SUZHI)

In this traditional Chinese view, the world is a complete and complex organism with things operating in a particular way because their position in the ever-moving cyclical universe was endowed with an intrinsic, immanent nature determining inevitable behavior. While generally lacking a strong creation myth, heaven and earth were believed to be formed by the first god, Panggu, during a period of 18,000 years. Panggu was followed by three emperors sent to rule humankind by the Jade Emperor, Lord of Heaven.

Developed from the ancient Shang Dynasty (1600–1046 BCE) onward in such classic works as *The Book of Changes* (Yi Jing), the *Luxuriant Gems of the Spring and Autumn Annals* (Chunqiu fanlu), and the *Huainanzi*, Chinese cosmology painted a picture of an immense universe of infinite complexity that even an emperor could not control. Confronting powerful inhuman forces moving around, often unpredictably, humanity had no choice but to acclimate to an environment of eternal change and transformation with texts such as the *Yi Jing* providing a symbolic system to identify order out of chaotic events. Relegated in the modern era to occultism by elite intellectuals beginning with the New Culture Movement/May Fourth Movement (1917–1921), traditional cosmological principles, while generally replaced by modern scientific thought, are still evident in important social sectors, notably **traditional Chinese medicine (TCM)**. Similar influence is apparent in everyday **thinking**, especially in making important social decisions involving weddings, **funerals and burials**, and the raising of **children**. On the political level, such Chinese cosmological principles as "all under heaven (*tianxia*), "heavenly empire" (*tianchao*), and the "bridling and feeding of horses and cattle" (*jimi*) are said to influence Chinese policy. Notions like a "**family** state all under heaven" (*guojia tianxia*) and a global vision of the world as one "family all under heaven" (*tianxiajia*) suggest that Chinese sovereignty potentially extends anywhere Chinese people are found, from **Hong Kong** to other independent nations.

COURTESY AND ETIQUETTE (*LIMAO/SUZHI*). Considered throughout history as a place of etiquette and **ceremony**, Chinese society is suffused with a long list of dos and don'ts for both **festivals and holidays**, and in virtually every aspect of everyday life. Reinforced by such popular sayings as "Civility costs nothing" (*wenming bu hua qian*) and "Courtesy demands reciprocity" (*limao yaoqiu huhui*), Chinese people engage in a host of proper behavior, while avoiding actions and words that disrupt good **relations**, practices that have been generally sustained since the establishment of the People's Republic of China (PRC) in 1949. One of the everyday activities governed by relatively detailed rules of etiquette and proper behavior are personal greetings, in which gentle handshakes are expected and honorific **language** and behavior are followed in greeting the elderly, guests, teachers,

CREDIT AND DEBT (JINRONG XINDAI/JINRONG ZHAIWU) • 123

women, and people in superior positions. While hugging or personal touching of strangers is to be avoided, punctuality is expected, while receptions for special people can include applause, especially in large groups.

Public displays of affection and **anger** are frowned upon, along with whistling, which is considered a nuisance, although **youth** are increasingly willing to ignore many of these restraints. Touring **religious** sites also involves certain propriety, for instance, walking in a clockwise direction and removing hats in temples or monasteries and separating by gender when in mosques. Proper table manners are centered on use of **chopsticks**, with a host of standards governing **banquets** and **gift**-giving, especially for such special occasions as weddings, festivals, and holidays, most notably the **Spring Festival**. Etiquette rules also govern such unique cultural practices as **tea**-serving along with sober occasions, particularly **funerals and burials**.

Shoes, considered dirty, are always removed when entering homes and never pointed at another person or placed on tables or desks, while sitting across from another person while blowing the nose into a handkerchief is considered unhygienic. Polite words and phrases used in everyday exchanges include *xie xie* ("thank you"), *feichang xie xie* ("thanks so much"), *bukeqi* ("you're welcome"), *qing* ("please"), *qingwen* ("may I ask you"), *laojia* ("excuse me"), *mafan ni* or *darao ni* ("trouble you"), *jiegou* or *rang yixia* ("let me pass," as in a crowd), and *duibuqi* and *baoqian* ("sorry," the latter the more formal). Discourteous words or actions are indicated by saying "*bu limao*" or "*meiyou limao*," with *buhao yisi* meaning "embarrassing," while *meiyou guanxi* means "no matter." Sneezing in China is often accompanied by no comment, although in some areas people respond with the traditional *wansui* or *baisui* ("long live") and *baoyou ni* ("bless you").

CREDIT AND DEBT (*JINRONG XINDAI/JINRONG ZHAIWU*). An economically vibrant society throughout much of the imperial and modern eras, China has a long history of using credit and debt in **commercial** transactions, although generally guided by conservative practices of maximizing savings and avoiding excessive debt. With **Confucianism** devaluing short-term gratification, Chinese tradition generally favored long-term investment as a guarantee for future prosperity, especially for the **family**. The creation of early banks issuing credit began during the Song Dynasty (960–1279), with government-backed banks established under the Qing Dynasty (1644–1911), along with introduction of modern foreign banks in coastal cities like **Shanghai**. Credit was also advanced to farmers by buyers of cash crops and merchants by shops selling foreign goods, while Chinese **businesses** and families, including the poorer **classes**, emphasized the importance of spending wisely and investing for the future. Avoiding excessive debt, **children** and young people have been generally instructed in good **money** management, as sound financial practices were passed on from one generation to the next,

124 • CRIME (FANZUI)

reinforced by such traditional practices as the consumption of fish, pronounced *yu* in Chinese, during the **Spring Festival**, with hopes for a "surplus," also pronounced *yu*, in finances for the new year.

Following the establishment of the People's Republic of China (PRC) in 1949, private consumption, along with credit and debt, were severely restricted as national resources were channeled into the state-led development of heavy industry as the central government pursued conservative economic policies with little or no public debt. The introduction of economic reforms and social liberalization (1978–1979) provided a major boost to consumption by the rapidly emerging middle class but with the country remaining a cash-only economy well into the 2010s as the introduction of credit cards was thwarted by China's largely state-owned banking system. Leapfrogging to next-generation digital payment platforms like Alipay and WeChat Payment, accessed by readily available **smartphones**, cash remained the dominant form of purchase, even for large items, notably housing, as the domestic savings rate remained more than 20 percent of total income.

Greater availability of consumer goods, including luxury items, from such high-end foreign retailers as L'Oréal and Chanel, increased household consumption, especially among millennials, increasing the need for the use of credit. With household debt rising exponentially, credit financing and personal credit scores have become commonplace, with professional assistance provided to individuals and families caught in traps of excessive debt. Credit-starved small businesses also seek out new sources of borrowing as the Chinese government pressures major banks, for example, China Merchants Bank, the so-called king of retail, to increase access to consumer financing to boost the overall economy. Political authorities in commercially vibrant cities like Shanghai are also using lower credit scores to punish people who refuse to take care of needy parents, while so-called "shadow banks" (*yingzi yinxing*), charging excessively high interest rates, have been targeted for criminal prosecution.

CRIME (*FANZUI*). A generally low-crime country, the People's Republic of China (PRC) is described by national police authorities as "one of the safest places in the world," with 6.2 murders per 1 million people in 2016, although petty crimes generally go unreported, while questions exist concerning the validity of national crime statistics. Following the establishment of the PRC in 1949, the new government concentrated on reducing crime, including decreasing the influence of criminal **gangs and syndicates**, especially in major cities like **Shanghai**, along with attendant problems of **drug abuse**, **gambling**, and **prostitution**. Overall crime rates dropped in the early decades as the development of an effective police force, referred to as "public security" (*gong'an*), combined with strict **punishment**, including gratuitous use of the **death** penalty, carried over from the imperial era, with **rural**

CRIME (FANZUI) • 125

areas experiencing little criminal activity. Major exceptions came during the Great Leap Forward (1958–1960) and the **Cultural Revolution (1966–1976)**. During this time, famine and political **chaos** led to widespread robberies; theft of personal property, including antiques, **clothing**, gold bars, and expensive **jewelry**; open **sexual abuse and assault**; and politically inspired thuggery against intellectuals and **religious** figures by Red Guards, carried out with the consent of top leaders of the CCP, most prominently **Mao Zedong**.

Following the introduction of economic reforms and social liberalization (1978–1979), including the loosening of social controls enforced by the "**unit**" (*danwei*) system, criminal activity of all sorts reappeared, prompting the government to pass the country's first Criminal Law in 1979. During the 1980s, crime rates grew yearly, with a single-year high of 9 percent in 1981, as economic prosperity, combined with growing gaps between rich and poor, encouraged by **market** forces, led to many new crimes economic in nature. Included were attempts at making fast **money** through such illegal activity as the manipulation of share prices and stock-rigging schemes on China's fledgling stock markets, along with direct-marketing scams and elaborate pyramid schemes. Newly formed criminal groups included financially pressed but technologically sophisticated college students who took advantage of people, many the elderly and uneducated, unable to adapt to the increasingly cash-based economy. Fraud involving credit cards, letters of credit, and other financial instruments, which raked off huge sums of money, demonstrated a level of professionalism and high-tech finesse beyond the capabilities of police authorities to match.

Areas left behind by the improved prosperity in the post–1978–1979 era, especially rural and **mountain** areas, as well as desert **regions**, have witnessed such crimes as child selling, human trafficking, drug dealing, large-scale train robberies, and even **piracy** as the only escape from the grinding poverty still afflicting many households. Theft of China's rich collection of antiquities, scattered throughout the country in largely unguarded areas, has also risen, with many of the perpetrators of this and other such crimes citing their activities as the only recourse to pay off the loan sharks and other financial schemers who often prey on unsuspecting and destitute rural people. For similar reasons, increases occurred in prostitution, illegal gambling, and heroin trafficking, especially in the southwestern regions, as China has become a major transshipment point for illegal drugs produced in the Golden Triangle of Thailand, Laos, and Myanmar, all of which have emerged as major growth industries during the years of economic reform.

Groups especially prone to criminal activity include the vast number of migrant workers who make up China's floating population, estimated at more than 200 million people, and individuals involved in **secret societies** and **clan** organizations, long repressed in Maoist China, but which have

126 • CRIME (FANZUI)

reemerged and often morphed into gangland and mafia-like organizations with a level of national and international organization that has often defied police interdiction. Even perpetrators of less serious crimes, for example, the selling of fake train tickets and cigarettes, have often displayed high levels of organization, with ample uses of sophisticated technology and finance that span several provinces and involve international players.

Kidnapping, blackmail, gunrunning, and protection rackets—all features of classic mafia and gangland operations—afflicted many parts of the country, especially the more prosperous south. Although low by international standards, crime in China underwent dramatic increases throughout the 1990s, especially in personal injury cases, robbery, gang **violence**, fraud, smuggling, and counterfeiting. Accelerating in the early 2000s, the reported number of crimes—referred to in official documents as "social management" (*shehui guanli*) issues—more than doubled, from 4.8 million in 2003, to 12 million by 2010, with prosecutions also rising from 730,000 to more than 1 million in the same time period, although the official crime rate actually declined between 2000 and 2016, with only a slight increase in 2002 and 2004.

The greatest threat by crime to China's social "stability" (*wending*) has undoubtedly come from murder and other violent crimes that have struck both rural and **urban areas**. With the national murder rate at one per 100,000, for a total of 13,410 nationwide in 2011, especially hard hit were such high-flying cities as **Chongqing** and Shenzhen. Gangland and drug-related killings have accompanied the reemergence of a Chinese mafia, as the country has also witnessed a spate of the most heinous crimes, especially the notorious serial murders of adults and **children**, which in the world's worst-known case involved a man from Henan who confessed to 65 separate murders from 2001 to 2003.

While **business** tycoons, domestic and foreign, and members of the country's nouveau riche have often been targeted for killing and/or hostage taking by distraught former business associates or estranged spouses, young **women**, from college students to waitresses to prostitutes, have increasingly become the victims of violent crime, from rape to some of the country's most grisly murders involving bodily dismemberment, often by outspoken misogynists. No less shocking to the generally conservative social order in China was the spate of attacks in 2004, on school children, along with assaults by teachers on students and vice versa, often arising from sexual harassment. Domestic violence by **family** members has also grown to a global high of 30 percent, with children killing their parents and parents killing children, largely out of economic and psychological duress in the country's increasingly competitive environment. As the divorce rate in China has risen, so have revenge assaults and murders by former spouses and close relatives, while increasingly alienated and nihilistic young people turn to wanton acts of

CRITICISM AND SELF-CRITICISM (PIPING YU ZIWO PIPING) • 127

assault and violence, notably revenge bombings, on unsuspecting victims in internet cafés, on college campuses, and in their homes. With control of many remote rural areas shifting from increasingly lax local Chinese Communist Party (CCP) organs to more traditional clans, internecine warfare and violence by rival clans and gangs have reemerged, with authorities apparently incapable of stopping such outbreaks. Among the many factors cited for increased crime in China is the large gender imbalance, as **men** who do not have their sexual needs fulfilled and have no family responsibilities appear more likely to turn to crime, drugs, and prostitutes.

Other crimes that have become more common involve human trafficking, estimated at 10,000 to 20,000 annually, especially of women from neighboring countries like Mongolia, Myanmar (Burma), North Korea, Russia, and Vietnam. Crimes related to the vibrant sex industry have also grown, with estimated revenues of RMB 500 billion ($930 million), while various forms of fraud and embezzlement arising from the emergence of so-called mafia capitalism and the black economy, with estimates as high as 20 percent of gross domestic product (GDP), cost the country RMB 200 billion ($330 million) annually, as cash is funneled out of the country and into foreign bank accounts by fleeing officials. Other less frequent but lethal crimes include kidnapping and gun violence, although the private possession of weapons is illegal and strictly enforced. Major crime-prevention and crime-fighting techniques include artificial intelligence; **monitoring and surveillance** by cameras, reportedly located on every street corner in **Beijing**, using of facial recognition software; and crime hotlines. With salary increases and promotions of officials tied to lowering local crime rates, systematic underreporting of criminal activity and falsification of data is suspected.

CRITICISM AND SELF-CRITICISM (*PIPING YU ZIWO PIPING*). Originally a Leninist concept introduced into the Russian Bolshevik Party to ensure that members abided by the policies of the **leadership**, party members on the wrong side of policy and/or power struggles were forced to submit to criticism from others and criticize themselves. Adopted by the Chinese Communist Party (CCP) in the 1930s and 1940s, the same method was used to impose control over party members who wavered from the basic line of the CCP. Following the establishment of the People's Republic of China (PRC), criticism and self-criticism were carried out in periodic "**struggle** sessions" (*douzheng huiyi*) of public **humiliation** extended outside the CCP to groups targeted for attack during political campaigns, including the Anti-Rightist Campaign (1957–1959) and especially during the **Cultural Revolution (1966–1976)**. With the introduction of economic reforms and social liberalization (1978–1979), the practice was largely reverted to strengthening internal CCP **discipline** and designed to ensure a sense of vulnerability on the part of CCP members as opposed to any sense of entitlement.

128 • CRUELTY AND TORTURE (CANKU/ZHEMO)

CRUELTY AND TORTURE (*CANKU/ZHEMO*). Described as a place of **fear** and cruelty, China has a long history of political authorities resorting to torture and other inhumane methods of social control, with elements of the civilian population willing to engage in heinous acts of cruelty against other people and **animals**. During the imperial era, criminal suspects and other alleged enemies of the state were frequently subjected to torture to force **confessions** by local magistrates with uncooperative victims subject to dismemberment and even cannibalism. Included were non-fatal tortures like foot whipping, also known as bastinado, while the most serious criminal convictions resulted in "death by a thousand cuts" (*lingchi*) abolished by Empress Dowager Ci Xi (1861–1908) in 1905. Additional punishments included long, painful strangulation and beheadings, with the former favored over the latter, since in **Confucianism** the human **body** was considered a sacrosanct gift from parents, and thus it was considered a violation of **filial piety** and disrespectful to **ancestors** to bury a dismembered body. With the rise of the Chinese Communist Party (CCP) in the 20th century, suspected "**class** enemies" (*jieji diren*), most notably landlords, rich peasants, and unrepentant capitalists, were tortured and killed, usually by a bullet to the back of the head, preceded by beatings inflicted by hate-filled poor peasants. **Foreigners** and Westernized intellectuals incarcerated following the establishment of the People's Republic of China (PRC) in 1949 endured long periods of "thought reform" (*sixiang gaizao*) and psychological pressure, a continuing practice that is often deployed against **human rights** lawyers and **religious** dissidents, including Muslims and advocates of the heterodox religious "cult" (*xiejiao*) of Falun Gong.

Popular participation in acts of cruelty and torture was most evident during the **Cultural Revolution (1966–1976)**, when rampaging Red Guards physically abused and sometimes murdered alleged class enemies, including the elderly, primarily intellectuals, and even other competing "rebel" (*zaofan*) factions, egged on by CCP chairman **Mao Zedong** at mass rallies in Tiananmen Square in **Beijing**. With the return to "stability" (*wending*) following the passing of Mao in 1976, and the reemergence of Deng Xiaoping (1978–1992) as the country's "paramount leader" (*zhigaowushangde lingxiu*), acts of social **violence** were prosecuted but with torture, although technically illegal, carried out against virtually all inmates in the network of **prisons** and internment camps, reserved for political prisoners and an assortment of social, religious, and political malcontents.

According to international human rights groups, prison and camp guards routinely torture inmates with beatings using belts and cables, along with kicking, punching, and hitting using clubs with protruding nails. Other torture techniques include sleep deprivation; forcing inmates to stand for hours on chairs, commonly referred to as "exhausting an eagle" (*yong jin laoying*); and forcing inmates to assume for long periods the excruciating "jet plane

position" (*peng feiji weizhi*), bowing the head while the hands are pulled up and held at the highest point against a wall. Maximizing pain and suffering but with no long-lasting effects or obvious physical damage, like broken bones or scars, a practice referred to as "torture behind the veil" (*miansha beihou de zhemo*), proof of torture in the PRC becomes a matter of believing the personal accounts of alleged victims. **Sexual** assaults against **women** are also alleged, including **gang** rapes and electrical shocks to private parts, especially deployed against religious adherents, **Tibetan** nuns, Muslim women, and female followers of Falun Gong who refuse to denounce their beliefs and be "transformed" (*bianxingde*) in what is described as a "war on the soul" (*linghun zhizhan*).

CRYING (*KU*). In a culture that values people making a public show of strength while avoiding public displays of emotion, crying on the part of adults is generally considered a sign of weakness, while even small **children** have at times been prevented from crying. Historically, crying was more acceptable on certain occasions among **men** than **women**, with even the emperor shedding tears when the people experienced great suffering and losses, especially to foreign **conquests**, although adults crying in public was a rarity.

Videos and pictures of men and women bursting into tears have gone viral in contemporary China, for example, former president Hu Jintao (2003–2012) crying upon hearing of the arrest of a close associate at a meeting of the Chinese Communist Party (CCP) in January 2015. Official press reports also document President **Xi Jinping** (2013–) admitting to shedding tears on a few occasions, for instance, upon hearing of the death of his elder sister during the chaotic **Cultural Revolution (1966–1976)** and in 1975, when leaving a Shanxi village, where he had been "sent down" (*xiaxiang*) to engage in **manual labor** and befriended the locals. Victims of beatings and **humiliation** by rampaging Red Guards during the Cultural Revolution often broke down in tears, including elderly people and generally stoic workers who found the random acts of **violence** particularly upsetting. Mass displays of public weeping occurred during the official **funeral** for much-admired premier Zhou Enlai in January 1976, involving men and women, civilians and soldiers, workers and peasants, and recorded in an official documentary film, although less emotion was shown a few months later during the funeral for CCP chairman **Mao Zedong**.

More recent popular videos include people breaking down in tears from the pressure of an overtaxing work culture, known as "996" (*jiujiuliu*), a reference to 9 AM to 9 PM work schedules six days a week. **Beijing** even sports a "Cry Bar" (*Kuba*), where burned-out employees can engage in therapeutic crying in private, avoiding any public display that could affect their careers. Men filmed crying upon **marriage** after years of being spurned yield

130 • CUISINE AND CULINARY CULTURE (MEISHI/PENGREN WENHUA)

public sympathy, as do videos of customers, especially women, crying after being cheated by dishonest salesmen, for instance, foreign-car dealers. With crying expected at funerals as a show of respect for the deceased, professional mourners composed of out-of-work actors, mainly women, are sometimes hired as fill-ins for missing relatives to wail loudly as tradition dictates. Traditional practices in Southwestern China in **Sichuan** also encourage soon-to-be brides to be seen crying in the company of mothers and grandmothers, known as "sitting in the hall" (*zuo zai dating li*), which was also a natural response to prospects of an arranged marriage with a miserable husband courtesy of a poor matchmaker.

The approach of Chinese parents to crying by infants and young children has undergone considerable transformation from the draconian and puritanical rule of CCP chairman Mao Zedong (1949–1976) to the introduction of economic reforms and social liberalization (1978–1979). Strict prohibitions against childhood crying during the 1980s and 1990s were often enforced by parents who found the sound a reminder of the constant crying by neighboring children suffering intense parental abuse during the Cultural Revolution. Children, especially those of well-educated parents, who cry in public are considered both immature and embarrassing. The exact opposite occurred during the 2000s, when so-called "soft-touch parenting" (*qingfu yu'er*) and hangovers from the **one-child policy** (1979–2015) created a patience-testing generation of "bear kids" (*xiong haizi*) who readily ran through public places screaming uncontrollably, with parents claiming total helplessness. Usually an only child, bear kids were often raised by dotting and gratuitously tolerant grandparents, with parents resorting to screaming bloody murder at their misbehavior, with little or no effect. Contemporary parents exhibit greater responsibility for their offspring, handing out "apology notes" (*daoqian jilu*) to passengers on public transportation for having to endure crying babies. While children are urged not to cry on certain occasions, for example, the first day of **Spring Festival**, to avoid bad luck in the coming year, newer parents often encourage infants to cry or laugh on cue in front of a camera. Common terms for crying in Chinese include *tiku* ("crying or wailing"), *haoku* ("bawling"), *jiaosheng* ("braying or yelling"), and *kusheng* ("sound of weeping").

CUISINE AND CULINARY CULTURE (*MEISHI/PENGREN WEN-HUA*). Developed throughout the centuries dating to the Han Dynasty (202 BCE–220 CE), cuisine is an integral part of Chinese culture with a rich variety of culinary styles originating from the diverse **regions** of the country ranging from tropical and subtropical areas to cold, artic territory. Influenced by imperial and noble tastes, and foreign contacts, especially with India and

CUISINE AND CULINARY CULTURE (MEISHI/PENGREN WENHUA) • 131

the Americas via the Spanish and Portuguese, four major cuisines were recognized during the imperial era, as extensive construction of canals crisscrossing the empire led to an exchange of ingredients and cooking styles.

Modern Chinese cuisine consists of eight major types representing provincial areas noted for unique dishes composed of local ingredients and seasoning, and varied cooking styles, with Chinese names, followed by dominant culinary characteristics in parentheses: Anhui, *Huicai* (hearty peasant **food** with wild **mountain** herbs and **animals**, including roast duck and hams); Fujian, *Mincai* (light and mildly sweet seafoods and mountain fare); Guangdong, *Yuecai* (lightly seasoned and mild, sweet sauces braised and stewed); **Hunan**, *Xiangcai* (spicy, along with hot and sour, soups and sauces); Jiangsu, *Sucai* (fresh ingredients, moderately salty and sweet, with seafoods and soups artistically served, with famous regional fare including Huiyang, Yangzhou, and Nanjing); Shandong, *Lucai* (salty and crispy, with seafoods and preserved cuts, with few seasonings or spices); Zhejiang, *Zhecai* (fresh seafood and bamboo shoots served almost raw, similar to Japanese food); and **Sichuan**, *Chuancai* (hot and spicy, with chilis, garlic, and ginger, stir fried, steamed, and braised), the most widely served regional cuisine in the country. Major **urban** areas noted for local specialty cuisines include **Beijing**, **Chongqing**, **Guangzhou**, and **Shanghai**, with "Peking duck" (*Beijing kaoya*) perhaps the most famous.

Judged by aroma, taste, texture, and appearance, with an emphasis on a mixture of bright **colors**, Chinese gastronomy has been considered a high art throughout history, with **Buddhism**, **Confucianism**, and **Daoism** promoting culinary principles of **vegetarianism**, small portions, and **healthy** ingredients, respectively. With wheat and millet as the primary staples in the north served as noodles, usually in a hot soup and sticky rice in the south, food was considered a critical source of **"energy"** (*qi*) and essential to maintaining a personal balance between **yin-yang**. Possessing the four natures of "hot" (*re*), "warm" (*nuan*), "cool" (*liang*), and "cold" (*leng*), food also comes in five tastes: "pungent" (*pola*); "sweet" (*tang*); "sour" (*cu*); "bitter" (*ku*); and "salty" (*xian*), the last in the form of soy sauce. The several soy varieties include "skin" (*pifu*), "smoked" (*xunzhi*), "dried" (*gande*), and "fried" (*youzha*). Major sauces include "soy" (*jiangyou*); "fish" (*yuyou*); "oyster" (*haoyou*); and "Hoisin" (*Haixin*), consisting of fermented soybeans.

Meat and seafood dishes are always accompanied by vegetables, some unique to China, including "bok choy" (*baicai*), "snow pea pods" (*xuedou*), "straw mushrooms" (*caogu*), "bamboo shoots" (*zhusun*), "lotus roots" (*lian'ou*), "taro root" (*yutou gen*), and "bean sprouts" (*douya*), with such major seasonings as "red chili peppers" (*lajiao*), "ginger root" (*jianggen*), "garlic" (*dasuan*), "scallions" (*xiancong*), "Sichuan peppercorns" (*huajiao*), and "fennel" (*huixiang*), making most Chinese dishes rich in umami, pleasant and savory tastes. Methods of preservation include "drying" (*honggan*),

132 • CULTURAL CHANGE (WENHUA BIANQIAN)

"salting" (*yan*), "pickling" (*suanxi*), and "fermentation" (*faxiao*), with "fish" (*yu*), "sausages" (*xiangchang*), and "hams" (*huotui*) preserved during a span of days and even years but with "Cantonese salted fish" (*Guangzhou xianyu*) linked to high rates of cancer.

Cuisines imported from China's long history of contact with the outside world include "hot pot" (*huoguo*), "mutton" (*yang*), and "yogurt" (*suannai*) from Mongolia; "curry" (*gali*) from India; "breads" (*shaobing*) from Central Asia; and "red chili peppers" (*lajiao*), originally from Mexico. Authentic recipes include the following: dim sum, a Cantonese (**Guangzhou**) term meaning "touch the heart," consisting of small bite-sized dishes; "hot and sour soup" (*suanla tang*); "quick noodles" (*kuaimian*); "Sichuan chile chicken" (*gongbao jiding*); "spring rolls" (*chunjuan*); "pock-marked granny bean curd" (*mapo doufu*); "General Tsao's chicken" (*Zuozong Tanji*); and "moo-shu pork" (*mushu zhurou*). Delicacies generally unavailable outside China include "fried bee pupae" (*chaofeng yong*), "wormwood dumplings" (*aicao jiaozi*), "stinky bean curd" (*chou doufu*), "spicy frog stew" (*xiangla qingwa dun*), "beggar's chicken" (*qigai ji*), "tripe soup" (*niudu tang*), "preserved eggs" (*pidan*), and "pickled jellyfish" (*yanzhi haizhe*). Desserts consist primarily of "pastries" (*gaodian*), including egg puffs, steamed rice cakes, moon cakes, custard buns, rose ginger steamed cake, sugar donuts, and black sesame buns, as well as, soybean puddings, sweet red bean and mango soups, and such "fruits" (*shuiguo*) as the popular "shredded ice with sweet syrup" (*baobing*).

The consumption of "dogs" (*gou*), "shark fin" (*yuchi*), Bird's Nest (*Yanwo*), and other threatened or prized species has been restricted in the People's Republic of China (PRC). The most expensive dishes include "abalone" (*baoyu*); "Shanghai hairy crab" (*Shanghai dazhaxie*); "sea cucumber" (*haishen*); "grilled matsutake mushroom" (*kao Songrong mogu*); and the now-restricted Bird's Nest soup (*Yanwo tang*), made from Swiftlet bird saliva. Noted for their knowledge and familiarity with the great variety of regional cuisines, were the four great gastronomes in Chinese history: the poet Su Dongpo (1037–1101) of the Northern Song Dynasty (960–1127); the master painter Ni Zan (1301–1374) of the Yuan Dynasty (1279–1368); Xu Wei (1521–1593) known as one of the fathers of modern Chinese **painting** in the Ming Dynasty (1368–1644); and Yuan Mei (1716–1797), famous poet and author of the *Food Lists of the Garden of Contentment* in the Qing Dynasty (1644–1911).

CULTURAL CHANGE (*WENHUA BIANQIAN*). Defined as a change in the interplay between constraints and incentives embedded in the values and beliefs guiding individual and collective behavior, significant and enduring cultural change occurred throughout the imperial era (221 BCE–1911 CE), during the Republic of China (ROC) on the mainland (1912–1949), and since

CULTURAL CHANGE (WENHUA BIANQIAN) • 133

the establishment of the People's Republic of China (PRC) in 1949. Major factors include the introduction of new **religions**, especially **Buddhism** and **Christianity**; foreign **conquest**, bringing new cultural forms from Inner Asia, Mongolia, Manchuria, and the West; and major changes in **political culture**, **science**, and technology. For **Confucianism**, change begins from within and extends outward to social groups, elite and popular, with external and coerced cultural change attempted by political radicals in the PRC proving largely ineffective.

Substantive cultural change in the PRC has occurred on three major occasions, during the 1950s and early 1960s, during the **Cultural Revolution (1966–1976)**, and following the introduction of economic reforms and social liberalization (1978–1979). Major cultural changes instituted by the Chinese Communist Party CCP) included "land reform" (*tudi gaige*) from 1949–1953, and the establishment of economic central planning adopted from the Soviet Union (1953–1978), resulting in a decline of social and political power of traditional elites, mainly landlords, merchants, and classical **scholars**, and the emergence of CCP cadres as a new **class** in the **workplace**, on the farm, and in schools and universities. This was followed by the highly disruptive and chaotic Cultural Revolution, when the newly installed class of powerholders was attacked, led by CCP chairman **Mao Zedong**, with free rein given to social groups, particularly **youth** organized as Red Guards, to engage in harsh **criticism** and acts of **violence** against officially designated "class enemies" (*jieji diren*), and assaults on the **family**, with major institutions, including **education** and police, virtually shut down. The third, post-Mao period represented a sea change, with constraints reimposed in the name of achieving "stability" (*wending*) and social and career gain based on merit and heavily on schooling and earning degrees in higher education, with a more "open" (*kaifang*) and internationally engaged political and economic order.

Survey data of the Chinese population indicate that along with substantive changes in social values and expectations, especially among youth adapting to transformations of the overall economic and political environment, important features have persisted, as the culture demonstrates a resilience to excessively disruptive transformation. Among the major shift in values and beliefs is the rising importance of "materialism" (*wuzhihuiyi*), "wealth" (*caifu*), and **individualism**, in addition to a general embracing of more **freedom** and even "democracy" (*minzhu*) and **human rights**, but with an enduring attachment to family and friends, and a strong sense of patriotism.

With the traditional value of "shyness" (*haixiu*), especially among females, undergoing a secular decline, Chinese, both **men** and **women**, are developing a greater sense of "independence" (*duli*) and "self-orientation" (*ziwo daoxiang*), and a greater "self-assertiveness" (*ziwo kending*). Forces of urbanization, modernization, and Westernization have gradually undermined

134 • CULTURAL REVOLUTION (1966–1976)

the collectivist and interdependence characteristic of an agricultural society where survival and the demands of paddy rice production, especially in the south, encouraged "collectivist" (*jitizhuyizhe*) and nonconfrontational behavior. With basic survival no longer a concern in an era of prosperity and high consumption, such basic necessities as **food** and **clothing** are of less importance, while issues of gender equality and "diversity" (*duoyuanhua*) have become increasingly important. Traditional values of "restraint" (*yizhi*), "reserve" (*baoliu*), and blind "obedience" (*fucong*), especially in family and political hierarchies, have weakened, along with concern for a "**spiritual** life" (*jingshen shenghuo*), although the importance of "moral judgments" (*daode panduan*) remains strong. Cultural changes pursued during the Maoist era of **accusation** and confrontation have dissipated but not disappeared altogether, while the Maoist call to "serve the people" (*wei renmin fuwu*) was ephemeral and nothing more than lip service, many of the so-called "**four olds**" (*sijiu*) survived as tradition outlived vicious but temporary political assaults.

CULTURAL REVOLUTION (1966–1976). Primarily a political struggle among the top **leadership** of the Chinese Communist Party (CCP) promoted by Chairman **Mao Zedong** against perceived enemies and accused "capitalist roaders" (*zouzipai*) reputedly led by People's Republic of China (PRC) state president Liu Shaoqi, the "Great Proletarian Cultural Revolution" (*Wuchanjieji Wenhua Dageming*) also involved a wholesale assault on cultural realms. Deemed "feudal" (*fengjian*) and "bourgeois" (*zichan jieji*), primary targets for destruction included traditional and modern **literature** and the **arts**, **cinema and film**, and popular **customs and conventions**, especially involving the **family** and **religion**. Led by Jiang Qing, the radical left-wing wife of Mao Zedong, and followed by equally radical supporters, notably Wang Hongwen, Yao Wenyuan, and Zhang Chunqiao, later dubbed the "Gang of Four" (*sirenbang*) following their arrest in 1976, rhetorical and **violent** attacks were launched by "Red Guards" (*Hongweibing*) against historical and religious sites, including Buddhist and Daoist **pagodas and temples**, Islamic mosques, monasteries, and Christian churches, including the desecration of the Temple of Confucius and the great philosopher's reputed grave site in his birthplace of Qufu, Shandong.

Intellectuals, including composers, film directors, poets, writers, and especially teachers, along with some of the country's most distinguished institutions, for instance, Tsinghua University, were targeted as "representatives of the bourgeoisie who have infiltrated the . . . cultural world" and had nefariously "captured the minds of the masses." Other targets included people allegedly associated with the foreign-influenced "decadent" (*tuifei*) lifestyle, for example, barbers, book and street peddlers, photographers, and tailors, along with "bourgeois" possessions ranging from expensive **jewelry** and

CULTURAL REVOLUTION (1966–1976) • 135

gold bars to simple flower collections and **clothing** seized during intrusive, often middle-of-the-night house searches. **Pets** were also marked for elimination, especially "carrier pigeons" (*xinge*), often kept by elderly men, and "cats" (*mao*), wantonly wiped out in the "great cat massacre" (*mao da tusha*), carried out in major cities.

Declaring that "under heaven all is **chaos**" (*tianxia yipian hunluan*), Mao Zedong declared war on traditional values of social **harmony** and nonconfrontation with the frenzied adulation of the generally youthful Red Guards, who were the vanguard of widespread cultural assaults, sometimes against their own parents and relatives, including old **women** subject to **foot-binding**. For Mao, the Cultural Revolution was an **ideological** crusade to reinvigorate the Chinese revolution, train a new generation of "revolutionary fighters" (*geming yingxiong*), and radically alter Chinese culture, replacing the "**four olds**" (*sijiu*) of the ostensibly "feudal" society with a new culture, revolutionary ferment, and perpetual change imposed on the Chinese people, who were described by Mao as a "blank sheet of paper" (*kongbaizhi*).

The opening shot of the Cultural Revolution was the harsh **criticism** of the **opera**/play *Hai Rui Dismissed from Office*, authored by Wu Han, vice mayor of the capital city of **Beijing**, which, portraying the dismissal of an upright official during the Ming Dynasty (1368–1644), was interpreted as a veiled attack on Mao Zedong for his dismissal of People's Liberation Army (PLA) marshal Peng Dehuai in 1959, following his harsh criticism of the ill-fated and disastrous Great Leap Forward (1958–1960). Quickly expanding attacks on the **theater** and cinema and film claimed many victims, including the following: Tian Han, playwright and composer of the first national anthem of the PRC; Sun Weishi, female director of modern spoken **drama** (*Huaju*); Zhou Xinfang, grandmaster of **Peking opera** in **Shanghai**; Cai Shusheng and Zhang Junli, major film directors, respectively, of *Dawn Over the Metropolis* (1933) and *The Spring River Flows East* (1947); and major actors and actresses the likes of Wang Ying and Shuangshuang Yunzhu, the latter a rumored mistress of Mao Zedong who was personally targeted for persecution by Jiang Qing.

With wholesale assaults on "black line figures" (*heixian shuzi*) in literature and the arts announced by a vengeful Jiang Qing, popular writers of many classic works attacked were as follows: Mei Zhi, author and essayist of stories for **children**; Deng Tuo, poet and journalist; Lao She, novelist and dramatist best known for the novel *Rickshaw* and the play *Teahouse*; and Yang Shuo, lyricist and essayist, with the last two driven to **suicide** in 1966. Children's literature was especially singled out, with content radically transformed from promoting knowledge and scientific understanding to becoming nothing more than a megaphone of political slogans and **rhetoric**. Western and Chinese **music**, especially highly popular "Yellow Music" (*Huangse Yinyue*), were also targeted, with artists and musicians attacked, and their

136 • CURSES AND PROFANITY (ZUZHOU/XIEDU)

instruments and musical scores wantonly destroyed. Exceptions included the piano and violin, which were saved single-handedly by China's world-renowned pianist, Yin Chengzong, who in the heat of the attacks rolled out a piano onto Tiananmen Square in Beijing and played revolutionary odes to Mao Zedong, which served as a signal to stop beating up on pianists and violinists.

Educational institutions were particularly hard hit, with primary and middle schools shut down in 1966, along with colleges and universities, with attacks launched by Red Guards and students against teachers and professors, denounced as "members of the black gang" and "reactionary academic authorities." University campuses like Tsinghua University, the country' premier technical school, known as "China's MIT," and large cities, for example, **Chongqing**, were turned into virtual battlegrounds between competing Red Guard and "rebel" (*zaofan*) factions, with both students and faculty victimized and major clashes between combat units of the PLA and radical civilian groups. Ultimately "sent down to the countryside" (*xiaxiang*) and to factories to engage in **manual labor**, an entire generation of young people were denied an **education**, turning them into the country's "lost generation" (*shiluode yidai*) with few skills or talents.

Language became a major instrument of assault, as traditionally subtle, delicate, and moderate terminology known for its refined and elegant style was replaced by a militant and violent rhetoric consisting of stereotypical jargon and threats: "Those opposed to Chairman Mao will have their dog skulls smashed into pieces." Along with the ubiquitous "big-character posters" (*dazibao*) pasted on walls and buildings throughout the country, denouncing everyone and anyone, including virtually every cultural form, the country was inundated with 350 million copies of *Quotations from Chairman Mao Zedong* (Mao Zhuxi Yulu), with selections constantly cited in rhetorical battles and attacks, while some especially devoted followers of the great leader memorized the entire book. While many educated people, one of them writer Ba Jin (1904–2005), succumbed to the lure of political fanaticism, others staunchly resisted, most notably devoutly religious individuals, many of them Christians, who, refusing to chant "long live Chairman Mao" and other revolutionary paeans, were beaten, with bystanders prevented from providing assistance. Effects of the Cultural Revolution have been long-term, making recovery and revival of many traditional cultural practices, for instance, Qigong, difficult after years of having their "roots dug out."

CURSES AND PROFANITY (*ZUZHOU/XIEDU*). In a society dominated by concerns with **courtesy and etiquette**, the Chinese **language** contains a plethora of curse words, profanity, and **insults**, ranging from the very vulgar to the mildly offensive, used for dealing with appropriate situations. Commonly employed in curse words are references to **food**, particularly "eggs"

CUSTOMS AND CONVENTIONS (FENGSU/XISU) • 137

(*dan*), "bean curd" (*doufu*), and "melons" (*gua*); **animals**, mainly "dogs" (*gou*) and "tortoises" (*gui*); "**ghosts**" (*gui*) and "spirits" (*jingshen*); and valued relationships, including **ancestors**, current **family** members, relatives, and even **children**. Pejorative reference to gender is more common for **women** than **men**, with many vulgar words and phrases incorporating the **sexual** act and derogatory comments of female private **body** parts. A largely non-Christian society, no use of the word "God" or "Jesus" is employed in cursing, while scatological references are relatively few. Derogatory mention of **homosexuality** is also unknown, although sexual promiscuity and perversion, including **prostitution, concubines** and mistresses, and frequent visits to brothels, are prominent themes. Poor mental state and **madness** are common references, as are "girlish" (*shaonüde*), "inhuman" (*burendao*), and "illegitimacy" (*feifaxing*), along with use of the word "sticks" (*gun*), as in "gambler" (*dugun*).

Literal meaning of a word or phrase is often at variance with the implied concept, for instance "bad egg" (*huaidan*), referencing a bad guy or scoundrel, with many phrases having unknown or vague origins, for instance, the **number** "250" (*erbaiwu*), used to describe someone as stupid or worthless. Among the more colorful but socially acceptable curse words and phrases are *shagua*, literally "melon head," meaning a stupid jerk; *chi doufu*, literally "eat bean curd," meaning perverted man; *chi ruan fan*, literally "eat easy food," meaning depending on a girlfriend for livelihood; and *pa ma de pi*, literally "pat the horse's ass," meaning to brown nose or gratuitously seek favors. For a comprehensive list of curse words, insults, and phrases see the glossary.

CUSTOMS AND CONVENTIONS (*FENGSU/XISU*). A society in which virtually every facet of life is subject to rigorous guidelines and **rituals** governing behavior, customs and conventions define much of the Chinese cultural realm, including childbirth and childrearing, **funerals and burials, marriage**, weddings, and celebrations during the **Spring Festival**. With traditional "customs and habits" (*fengsu xiguan*) a target of iconoclastic **criticism** and political attack during the New Culture Movement/May Fourth Movement (1917–1921), the Chinese Communist Party (CCP) came to power in 1949, committed to ridding Chinese society of the worst and most humiliating customs, namely female **foot-binding**, "arranged marriages" (*baoban hunyin*), **kowtowing**, and gender inequality, with the status of **women** undergoing dramatic improvements in the professions and household since the establishment of the People's Republic of China (PRC).

Such widespread and socially acceptable customs and conventions as **loyalty** to **family** and reverence for the elderly were assaulted during the chaotic **Cultural Revolution (1966–1976)**, with the customary avoidance of confrontation and **violence** violated by Red Guards and other so-called "rebel"

138 • CUSTOMS AND CONVENTIONS (FENGSU/XISU)

(*zaofan*) groups. Since the introduction of economic reforms and social liberalization (1978–1979), long-standing and less offensive customs have been revived, for example, "forbearance" (*ren*), putting up with problems without protesting, bowing when greeting guests or **business** associates, and maintaining personal reputation (including the importance of "**face**"). Adhering to traditional customs is also important during major **festivals and holidays**, notably the multiday celebration of the Chinese lunar new year known as the Spring Festival and students engaging in traditional practices such as wearing purple underwear and eating *congzi* prior to taking the "national college entrance examination" (*gaokao*).

D

DALAI LAMA. *See* TIBET AND TIBETANS (*XIZANG/ZANGREN*).

DANCE (*WUDAO/TIAOWU*). A major form of **entertainment** throughout imperial and contemporary Chinese history, dance has taken on heavily varied forms consisting of traditional and modern genres, many imported from abroad. Included are the elaborate choreographs prepared for the dynastic imperial court and folk dances, many performed by China's ethnic **minorities**, as well as modern dance, especially ballet, and popular "ballroom" (*jiaoyiwu*) and "square dancing" (*guangchangwu*). Traced to ancient Chinese history with images of dancers appearing on "oracle bones" (*jiagu*), dancing began as a **religious ritual and ceremony** known as *yayue* and developed into diverse, sophisticated forms influenced by Chinese contact with foreign styles, particularly in Inner and Central Asia. Peaking during the magnificent and highly cosmopolitan Tang Dynasty (618–907), dancing was combined with **opera**, as tens of thousands of musicians and dancers performed at the imperial court, with dancers donning elaborate garb of long sleeves and multiple **colors**, along with striking **masks** and painted **faces**.

With the introduction of female **foot-binding**, dancing underwent secular decline, with men taking over most dancing roles and popular drum dances imitating such **animals** as lions and peacocks performed during **festivals**. During the subsequent Song (960–1279) and Yuan (1279–1368) dynasties, the performance form known as *Zaju* developed, combining dance with **drama** and **music**, splitting into northern and southern styles with powerful performances by male dancers related to **martial arts**. Southern influence was also important in development during the Ming Dynasty (1368–1644) of the *Kunqu* opera, also known as elegant drama, with dance-like movements combined with delicate singing. The Manchu-influenced *Gege* dance dominated imperial court performances during the Qing Dynasty (1644–1911), with Manchu ladies not subject to debilitating bound feet, wearing unique high shoes and taking small gingerly steps adorned with elaborate head

140 • DANCE (WUDAO/TIAOWU)

dresses, tassels, and handkerchiefs, while striking gentle poses. Preservation of traditional dance styles in the People's Republic of China (PRC) largely comes in performances at Confucian ceremonies.

Western dance styles were also introduced from the late 19th century onward, led by Yu Rongling (1882–1973), trained in Paris by American Isadora Duncan and dubbed the "first lady of modern dance in China," performing in the imperial court of Empress Dowager Ci Xi (1861–1908). On the popular level, "taxi dance halls" (*chuzu che wuting*) operated in **Shanghai**, where male patrons, Chinese and **foreigner** alike, "rented" a female dance partner, local Chinese and foreign ex-pats, at such famous sites as the Paramount Dance Hall for a swing to fast-paced jazz music. Banned over popular objections by the Nationalist (*Kuomintang*) government of the Republic of China (ROC) in 1947, taxi dancing remained illegal following the establishment of the PRC, and the Paramount was closed in 1957, while the major development in dance was the introduction of Western ballet from the Soviet Union, with *Swan Lake* and *Romeo and Juliet* becoming especially popular.

Training in ballet, along with classical, ballroom, folk, modern, and ethnic dancing, is carried out at the Beijing Dance Academy (Beijing Wudao Xueyuan), established in 1954, under Russian influence, with great emphasis on intense flexibility training. The first Chinese ballet company was established in 1959. So-called "dance dramas" (*wuju*), combining Western and Chinese styles, were produced as films in the 1950s and early 1960s, including *The Precious Lotus Lamp*, *The Small Sword Society*, *Hundred Phoenixes Face the Sun*, and *Colored Butterflies Fluttering About*.

Like all **art** forms in the PRC, dance has been subject to political influence and periodic **censorship**, with Western and modern forms like ballroom dancing banned during the **Cultural Revolution (1966–1976)**, so much so that when dancing was revived following the introduction of economic reforms and social liberalization (1978–1979), people who had grown up in the 1960s and early 1970s could not dance. Revolutionary operas produced during the Cultural Revolution, for example, *Red Detachment of Women* and *White-Haired Girl*, included considerable dancing, with the politically powerful People's Liberation Army (PLA) fielding its own Song and Dance Ensemble. Harsh **criticism** of dancing was directed against Western ballet and other dance forms, for instance, the lotus dance, a Russian-inspired folk dance, which was labeled as "bourgeois and decadent." While some traditional folk dances the likes of the "harvest dance" (*yangge*), associated with fertility, were performed as instruments to spread political propaganda during the Cultural Revolution, full restitution of dancing did not occur until after the passing of Mao Zedong in 1976. Especially popular since the 1990s has been ballroom dancing, with thousands of people doing the mambo, tango, and cha, cha, cha in such cities as **Beijing** and Shanghai, with the

DAOISM • 141

famous Paramount Dance Hall reopening in the latter and serving as the site of frequent international ballroom competitions. Equally favored square dancing, done to popular music in many **urban** public parks, attracts mainly retired and elderly **women**, labeled as "dancing grannies" (*tiaowu de laonainai*), but with **neighborhood** locals complaining of excessive noise, provoking government intervention in 2015.

Well-known dances often performed at festivals and holidays, especially during the **Spring Festival**, include the "lion dance" (*wushi*), a northern and southern version generally associated with **Buddhism**, and the "dragon dance" (*wulong*), with the dragon, made of fabric and bamboo, carried by several people and often more than 100 meters long, as the greater the length, the more good **fortune**. Other popular folk dances, many originally forms of military training, include the following: ballet lion, double sword, drum tassel, fan, flying apsaras, group sword, handkerchief, house of flying daggers, land boat, lantern, peace drum, rattle stick, red ribbon, stilt, Tai Chi kungfu, thousand-hand guanyin, *yangge* **flower** drum, year of the tiger, and *yanhua sunyue*. Ethnic dances, with the specific minority group listed in parenthesis, are as follows: *baishou* (Tujia), bamboo (Li), long drum (Yao), *mugam* (Uighur), peacock (Dai/Bai), reed pipe (Miao), and *zhamo* (**Tibetan**). National dance organizations and events include the annual National Dance Exhibition and the Central Nationalities Song and Dance Ensemble, established in the 1950s.

DAOISM. One of five major officially recognized **religions** in the People's Republic of China (PRC), Daoism, also rendered in English as "Taoism" and meaning simply "the way," was founded by Lao Zi (601?–531? BCE), literally the "Old Master," with further contributions from Zhuangzi (369–286 BCE). A **spiritual** alternative to the highly secular **philosophy** of **Confucianism**, and adopted as a state religion in the early Tang Dynasty (618–907), Daoism is closely tied to folk religion and influenced by the classic *Book of Changes* (Yi Jing), while also drawing on the **cosmological** principles of **yin-yang**. Preaching the importance of striving for "immortality" (*yongsheng*), Daoism emphasizes the "three treasures" (*sanbao*) of "**compassion**" (*tongqing*), "frugality" (*jiejian*), and "humility" (*qianxun*), while the doctrine preaches adherence to **nature**, a kind of naturalistic pantheism embracing a non-competitive lifestyle, shunning the trappings of material success, and avoiding injury to others.

Represented by the China Daoist Association, Daoist beliefs and historical sites, including prominent **pagodas and temples**, as well as monasteries, many in remote **mountain** areas, for example, the Jade Emperor Temple on Mount Tai (Shanxi), were attacked and destroyed by rampaging Red Guards during the chaotic **Cultural Revolution (1966–1976)**. Revived in the late 1970s and especially prevalent in small towns and the countryside, Daoism,

142 • DAOISM

as the only religion unique to China, has received substantial government support, including from the current administration of President **Xi Jinping** (2013–), for restoration of damaged temples and properties, with renewed training of priests and nuns.

Like Chinese **Buddhism**, Daoism represents little or no threat to state authority, as the doctrine laid out in the classical texts of the *Dao De Jing* (The Way and Its Power) and the *Zhuangzi* preaches "nonaction" (*wuwei*) and lacks organization or a single leading spiritual figure. With some Daoist temples dedicated to Chinese Communist Party (CCP) chairman **Mao Zedong**, the primary function of Daoist priests and nuns is to stage ceremonies for believers, summoning the assistance of the **gods** and spirits to deal with such personal or **family** maladies as healing the sick, saving the souls of the deceased, and performing exorcisms. Physical activity, notably Qigong, "life energy cultivation," along with breathing **exercises, martial arts**, and "Tai Chi" (*taijiquan*) shadowboxing, are central to the doctrine's stress on "wellness and **health**" (*yangsheng*), enhanced by the practice of "inner alchemy" (*neidan*).

With a rich pantheon of deities, emperors, officials, thunder gods, wealth gods, and terrifying demons for punishing the wicked, Daoism is generally no-frills, with temple abbots resisting **commercialization** of religious sites, especially as gaudy tourist attractions. While lacking a guiding spiritual statement or narrative story comparable to Buddhism, **Christianity**, or Islam, Daoist principles and concepts underline various Chinese cultural realms, including **calligraphy, fengshui**, "meditation" (*neigong*), and even **architecture**, along with distinctive Daoist **songs** and **music**, and surreal **paintings** of Daoist sages cavorting through the heavens atop fish and other assorted creatures, real and mythical.

The "four sacred mountains" (*sisheng shan*) of Daoism include Wudang (Hubei), Longhui (Jiangxi), Qiyun (Anhui), and Qingcheng (**Sichuan**), prominent historical sites replete with temples, monasteries, and palaces, providing scenic views that throughout history have inspired ancient poems and served as the location of annual religious services and ceremonies. Also revered are the "eight immortals" (*baxian*), also known as the "eight genies," **legendary** figures representing prosperity and **longevity** said to reside on five islands in the Bohai Sea. Dating to the Yuan Dynasty (1279–1368), the eight immortals include the following: Lü Dongbin, the leader; Cao Guojiu, a princely actor; Han Xiangzi, a flutist; He Xianqu, the only female; Lan Caihe, gender-neutral; Li Tieguai, with a crippled right leg and suffering mental illness; Quan Zhongli, associated with **death**; and Zhang Guolao, representative of old **age**.

As a philosophy, Daoism has shaped Chinese **thinking** and general habits of mind with its emphasis on intuitive spontaneity and the important lessons of daily practice, as opposed to elaborate theories, along with a general

DATING (YUEHUI) • 143

distrust of **language** and words. Seeing reality in a constant state of flux and change, Daoism imparts an attitude of seeking to accommodate whatever happens with a sense of equanimity and a general readiness to assimilate new ideas. Excessively rigid principles and nostrums are considered the bane of civilization, which Daoists generally oppose, especially on the part of rogue artists, **hermits**, and other social rejects and malcontents.

DATING (*YUEHUI*). Virtually unknown in traditional Chinese society, where arranged **marriages** with elaborate procedures and **rituals** governed relations among prospective partners, the "freedom to love" (*ai de ziyou*) became popular following the establishment of the People's Republic of China (PRC) in 1949, especially after the enactment of the first Marriage Law (1950). As young people in the PRC are generally devoted to **education** in preparation for the highly competitive national "college entrance examination" (*gaokao*), along with **family** obligations, **romance and love** are generally avoided until after high school, although secret liaisons may occur earlier. Less **individualized** than in the West, dating in China is often a collective affair, with "parents" (*fumu*) and even "grandparents" (*zufumu*) often playing a role in setting up prospective blind dates. A serious affair, dates are considered a major step toward marriage, as casual dating is generally frowned upon. Considerable pressure is put on young **women** to marry before the age of 26, as beyond that age unmarried females are pejoratively referred to as "leftover women" (*shengnü*), while unmarried **men** are at some point referred to as "single dogs" (*dashen gou*).

Wanting daughters to date and ultimately marry older men with a good income and an established lifestyle, with mutual feelings of love a secondary consideration, parents also prefer dates with a man known to the family, with aunts and uncles often acting as "matchmakers" (*meiren*) to make the initial "hook up" (*yuepao*). While men are expected to date younger women, flaunting their status with **gifts** and demonstrating good family background, the male partner is also expected to handle all major decisions involving an evolving relationship, for example, the choice of a chaperon on the all-important first date. Illegal before the 1990s, premarital **sex** was generally a taboo but with more liberal attitudes taking hold since the 2000s, as 71 percent of **adolescents** admitted to the experience in 2015, but with men still preferring their spouse be a virgin.

Chat and dating sites on the internet are increasingly popular, as individuals, particularly women, feel more empowered to make dating decisions on their own without the intrusive intervention of family and matchmakers. Popular sites include Zhenai.com, Jiayuan, Baihe, and Little Date, with professional counseling on flirting and personal appearance offered by "dating coaches" (*yuehui jiaolian*), especially for men lacking in social skills and derisively known as "losers" (*diaosi*). Mass speed-dating events have been

144 • DEATH AND MOURNING (SIWANG/SANG)

organized by such unlikely groups as the Communist Youth League (CYL), along with dating television shows likes *If You Are the One*, which is similar to the American television series *The Bachelor*.

China also sports six versions of Valentine's Day, including the conventional day on 14 February, with five others in March, May, August, and November (on the popular 11/11 Singles' Day). For the less well-off, walls and fences in public parks often serve as convenient and inexpensive places to hang personal dating profiles. Couples often display their intimate status by wearing matching outfits, socializing with the same friends, and sometimes calling one another "husband" (*zhangfu*) and "wife" (*qizi*) before tying the knot. Men competing for the same girl at once is generally acceptable, while unattached singles can rent a temporary boyfriend or girlfriend to ward off pressing questions at family events. In 2016, the Chinese government issued warnings against dating **foreigners** on suspicion of being spies and a threat to the country's national security.

DEATH AND MOURNING (*SIWANG/SANG*). Described as a "death-denying culture" (*fouren siwang de wenhua*) where even the mention of death is avoided to ward off bad luck, China has elaborate rules and **rituals** governing grief and mourning that reflect hierarchical relations and status within the **family** and society at large. Popular beliefs about death and the afterlife are influenced primarily by **philosophy** as opposed to **religion**, with the only exception being Chinese Christians and Muslims. Believing that merely uttering the words "death" (*siwang*) or "dying" (*chuiside*) can invite a person's demise, while even considering the possibility will bring bad luck, words that in the Chinese **language** sound like death, for example, the number "four" (also pronounced *si* but with a different tone), are generally omitted from license plates, phone numbers, and even floors of tall buildings. Also avoided is bringing up the subject of death with a person confronting a terminal disease, as even Chinese doctors are known to mislead gravelly ill patients, reserving discussions of actual conditions to relatives or friends. People bereaving a recently deceased family member or close friend are enjoined from attending ostensibly happy events like **birthdays** or weddings, while visits from friends and acquaintances with grieving people are also avoided for fear of attracting bad luck. The most important holiday for honoring the dead is the Qingming **festival**, "Sweeping the Graves" or "Pure Brightness," held in early April and combining reverence for **ancestors** with prayers, burning incense, and **food** offerings, along with **entertainment** and such fun activities as kite-flying, while **Daoism** includes holidays that incorporate respect for the dead.

Levels and intensity of bereavement within families depend on the status of the deceased. With **children** obligated to care for a dying parent, any failure on their part to witness the parent's passing or hear their last words is

DEPENDENCY (YILAI) • 145

considered horribly unfilial, especially for a son, whose absence at a parent's end is considered a curse. Traditionally, the oldest son upon the father's death remained in mourning for 72 days and, in wealthier families, lived in temporary quarters constructed next to the gravesite, with emphasis on a show of immense grief, even if not heartfelt. Equally unfortunate is the premature death of a male heir, especially an only child, although less traumatic is the death of a bachelor, whose passing is considered a failure to take on the responsibility of continuing the family line. In contrast is the loss of an aging grandparent, which is accepted with equanimity, as expressed in the ancient **saying** of "regarding death as going home" (*siwang jiuxiang huijia*), especially for an individual who enjoyed a life of "five blossoms" (*wuhua*), namely, **marriage**, having a son, being respected, having a loving grandson, and dying in sleep. At the other extreme, death of an infant or young child, particularly a girl, is considered a "bad death" (*huai siwang*), undeserving of an official mourning period and accompanied by little public display of grief, which is reserved for the privacy of the family. Death by accident is also considered a bad sign, while **suicide** is even worse, with any condolences emphasizing the importance of mourners exercising personal emotional control and restraint, as is also advocated by Daoism. Traditional beliefs held that the "gate of death" (*xuanmen*) closes 60 days after one's passing, closing off the opportunity in the afterlife to be with family members and acquaintances.

See also FUNERALS AND BURIAL CUSTOMS (*SANGZANG XISU*).

DEPENDENCY (*YILAI*). A major characteristic of interpersonal relations in China, with the superior–subordinate dyad prevalent throughout society, including in **family**, the **workplace**, and politics, dependency is considered a major obstacle to **cultural change** and reform in the People's Republic of China (PRC). Reverence for hierarchical authority structures in **Confucianism** perpetuated by 2,000 years of unbroken imperial rule with little or no development of civil society, social and political dependency is reinforced by the official doctrines of Marxism–Leninism–Mao Zedong Thought underlying the "leading role" (*lingdao zuoyong*) of the Chinese Communist Party (CCP) in multiple realms of Chinese life. Respect for authority at home, in the village and factory, and in political life remain strong, although changes have occurred in gender relations, as the once-all-powerful role of man over woman and husband over wife has been fundamentally altered by Marriage Laws (1950 and 1980), and in **education** and the professions, with **women** substantially less dependent on male counterparts.

Individual and collective assertiveness by people concentrated in subordinate roles sanctioned during the **Cultural Revolution (1966–1976)** obviously got out of hand, with acts of **violence** and brutality directed by workers against managers in factories, students against teachers in school, and **chil-**

146 • DISABILITY (CANJI)

dren against parents in families. Following the introduction of economic reforms and social liberalization (1978–1979), long-standing hierarchical relations were generally restored but with concerns that such new programs as the "minimum living standard guarantee system" (*dibao*) was creating a new form of "welfare dependency" (*fuli yilai*). Prevalence of cultural dependency in China is also cited as a primary factor explaining the absence of democracy, **human rights**, and civic associations and organizations, along with the persistence of a powerful "leader principle" (*lingdao yuanze*) in the PRC.

DISABILITY (*CANJI*). Traditionally stigmatized during the imperial era (221 BCE–1911 CE) and given little or no public or private assistance, disability has been a source of considerable controversy and conflicting policies in the People's Republic of China (PRC). For **Buddhism**, disability represented a **punishment** for committing sins in a previous life, with the Buddha presented as a perfect **body**. More forgiving were **Confucianism** and **Daoism**, with the former considering the disabled an inharmonious microcosm of the universe but calling for their respect and love, and the latter ritually celebrating the disabled in major works like *Zhuangzi* and in the Daoist pantheon of "eight immortals" (*baxian*), which includes "Iron-Crutch Li [Tieguai]," ugly, dirty, and relying on a crutch for his crippled right leg.

During the rule of Chinese Communist Party (CCP) chairman **Mao Zedong** (1949–1976), disabled people were ignored or mistreated, as physical disabilities and handicaps were seen as undermining national goals of strengthening the country through stronger bodies and greater physical **stamina**. Adopting notions from the Soviet Union that such problems as disabilities and poverty would disappear with the advent of socialism, Chinese propaganda films and posters portrayed powerful-looking **men** and **women** without a hint of physical defects or limitations. Described as "crippled and useless" (*canfei*), disabled people, particularly in the countryside, where the majority resided, were kept out of sight, confined to homes, and generally prevented from attending schools, as the country lacked any concept of special needs **education**.

Government policies, if not popular attitudes, began to change with the emergence of Deng Pufang, the paraplegic son of PRC leader Deng Xiaoping (1978–1992), as a national spokesman for the disabled. Having sustained serious injury in 1968, during the **Cultural Revolution (1966–1976)**, at the hands of Red Guards, Deng Pufang established the China Disabled Persons Federation (CDPF) in 1988, committed to protecting the rights and interests of the disabled in the PRC. New legislation pushed by the CDPF included Law on the Protection of Disabled Persons (1990) and Regulations on Education of People with Disabilities (1994), followed by Regulations on Employment of Persons with Disabilities (2007, updated 2016), the last requiring employers to hire a certain percentage of people officially registered as

DISCIPLINE (JILÜ) AND STAMINA (NAILI) • 147

"disabled." Terminology was also altered, with the pejorative *canfei* replaced by *canji* ("deformed"), with proposals to adopt the even more acceptable *canzhang*, meaning "incomplete and obstructed." National surveys of the disabled were also carried out in 1982 and 2006, as 32 million people were officially registered as disabled and given access to a range of benefits. A much higher number of 85 million was recorded by the national census in 2010, suffering visual, hearing, speech, physical, and mental disabilities, with only 15 percent receiving government welfare aid, which is calculated on the basis of the economic status of the recipient's province or village.

A major problem afflicting the disabled in the PRC is the enormous and persistent gap between official policy at the national level versus actual practice in **urban** and **rural areas**. Especially problematic are the realms of education and handicap access, where, despite the establishment of special schools for the blind, deaf, and intellectually impaired, many disabled students are enrolled in conventional primary and middle schools, where they face constant discrimination and **humiliation**, with teachers often lacking training in dealing with special-needs pupils. Universities too often reject otherwise qualified but disabled students, claiming "physical conditions do not meet [their] needs of study." While plans call for the creation of 100 barrier-free cities, wheelchair access is unavailable outside **Beijing** and **Shanghai**, with no provision for guide dogs, as most Chinese cities lack the infrastructure for accommodating the disabled, with city sidewalks ending abruptly and many other obstacles to easy movement.

International events like the Paralympics have been held in China, along with performances by such internationally renowned artistic groups as China Disabled People's Performing Arts Troupe. Yet, popular attitudes remain hard to change. Widely perceived as "abnormal" (*yichang*), with disability seen as something people must overcome or for which they must be pitied, there is little expectation in China of the disabled leading normal lives, as **children** suffering birth defects occasion **fear** and disgust. A signatory to the United Nations Convention on the Rights of Persons with Disabilities (2008), nongovernmental organizations (NGOs) representing the interests of disabled people also exist in China, most notably the Beijing Yirenping Centre, whose antidiscrimination efforts by activists have provoked government backlash, most recently in 2015. One of the Chinese laws confronting **criticism** for policies on the disabled was the notorious Maternal and Infant Health Law (1995), which, dubbed the "eugenics law" for encouraging abortions of "defective children" and allowing for "voluntary" sterilization of the disabled, was abolished in the early 2000s.

DISCIPLINE (*JILÜ*) AND STAMINA (*NAILI*). Highly prized throughout Chinese history and a staple of Chinese culture, personal discipline is fostered early in life by strong parenting reinforced in schools where corporal

148 • DISSENT

punishment is liberally applied as a means to achieve acceptable standards of behavior. Creating obedient **children** by "hitting and cursing" (*dama jiaoyu*) is strongly rooted in Chinese tradition, as Confucius (551–479 BCE) declared that a "dutiful son is made by the rod," while 60 to 70 percent of **adolescents** report being struck by parents and/or deprived of **food**. Similar patterns occur in Chinese schools, especially in poorer areas and usually in the countryside, where teachers suffering low pay and inadequate training resort to corporal punishment to maintain an orderly classroom of silently obedient students dutifully recording the teacher's every word. With most schools lacking clear rules and regulations on maintaining classroom discipline, the extent of physical punishment of students is left to teachers, with parents from lower socioeconomic groups supporting harsh discipline, while middle-class families are less tolerant, having generally avoided physical punishment in child-rearing.

Concerned with the destructive impact on student learning and overall physical and mental well-being of **youth**, government authorities in the People's Republic of China (PRC) issued a nationwide ban on corporal punishment in schools in 1986, followed by a law against domestic abuse, including against children, in 2016. While statistics on child abuse are few, harsh discipline is directed more at boys than girls, and at children older than age seven, with parents who experienced tough treatment as a young person more likely to resort to such actions. Changing attitudes, especially among so-called "helicopter parents" (*zhishengji fumu*), have led to closer **monitoring and surveillance** of teachers, with some complaining of excessive oversight and an overall decline in classroom decorum. Greater "self-discipline" (*zilü*) is also advocated for children with appeals to the ethical traditions of perfection and self-control in **Buddhism** and *Wushu* **martial arts**. A major concern in the Chinese Communist Party (CCP) especially involving alleged **corruption**, lack of discipline on the part of party members at every organizational level is a target of amelioration by the Central Discipline Inspection Commission.

DISSENT. *See* PROTEST, DISSENT, AND REBELLION (*KANGYI/YIYI/PANHUAN*).

DRAMA (*XIJU*). Coming in two dominant forms, one involving **music** and singing in **opera**, and the other Western-style "word drama" (*huqiu*), both historical and contemporary, drama is a mainstay of the Chinese stage and **theater**, subject to periodic **censorship** and political interference. A popular genre on **broadcasting and television**, along with online video, Chinese drama traces its roots to the creation of *Zaju* and *Chuangqi* theater in the 13th and 14th centuries, while foreign drama was introduced into the country in

DRAMA (XIJU) • 149

the early 20th century, as domestic dramatists thrived in port cities, mainly **Shanghai**. Following the establishment of the People's Republic of China (PRC) in 1949, dramas focused on such nationalistic themes as the opposition by the ruling Chinese Communist Party (CCP) to Japan in the Second Sino–Japanese War (1937–1945), along with detective stories, tales of **romance and love**, and veiled and not-so-veiled social **criticism**.

Developed during the Song (960–1279) and Yuan (1279–1368) dynasties, the *Zaju* dramatic form consists of four acts of singing mixed with spoken dialogue, as highly poetic lyrics trumped plot development and incidents. Subject lines often involved melancholy lovers and the crucial importance in life of **loyalty**, along with morality tales straight out of **Confucianism** involving **filial piety** to parents, husbands, elder siblings, and one's master. **Spiritual** and **magical** powers derived primarily from **Daoism** also underlie dramatic themes that were ethical, not **religious**, in direction. Serving as an alternate dramatic form was the *Chuangqi* style, with constant changes of scene and end rhymes in arias, especially popular in the south.

Banned during the Ming Dynasty (1368–1644) because of foreign origin from the Mongol rulers in the Yuan Dynasty, drama was gradually revived, taking on an increasingly operatic form composed of northern *Jingxi* and southern *Kunqu* styles. More than an **entertainment** medium, Chinese drama is fundamentally didactic in purpose, intended to uphold personal **virtues** and point out the consequences of "evil" (*xie'e*) actions. Bereft of notions popular in Western drama of an individual's incapacity to understand or control forces of the universe, typical Chinese dramas, both operatic and spoken, often conclude with a note of poetic justice as virtue is rewarded and evil punished, laying out the proper path of human conduct.

Imported into China in the early 1900s by Chinese students in Japan, Western theatrical dramas began with a Chinese adaptation performed in Shanghai of *Uncle Tom's Cabin*, by Harriet Beecher Stowe (1852). Also popular were plays by Norwegian playwright Henrik Ibsen, most notably *A Doll's House* (1890), with the female character Nora becoming an overnight sensation among Chinese progressives, female and male alike. Chinese ventures into the dramatic genre included *Thunderstorm* (Leiyu), a play in four acts by Cao Yu, published in 1934, decrying the rigid traditionalism and hypocrisy of a moderately well-off and Westernized **family** beset by oppression and incest. Additional works by the same author include the 1936 *Sunrise* (Richu), which was subsequently turned into an opera, and the 1940 *Beijing Man* (Beijing Ren), influenced by Eugene O'Neill and Henrik Ibsen. Against the backdrop of the Second Sino–Japanese War (1937–1945), such plays as *Qu Yuan* (1942), by Guo Morou, and *Heroes of the Bush* (1942) praised opposition to tyranny and foreign domination throughout Chinese history.

150 • DREAMS AND NIGHTMARES (MENGXIANG/E'MENG)

Dramas produced following the establishment of the PRC in 1949, include, most notably, *Teahouse* (Chaguan), by Lao She, which, published during the relatively liberal period of the Hundred Flowers Campaign (1956–1957), traces changes in the lives of various characters gathered in a **Beijing** teahouse. From the last years of the Qing Dynasty (1644–1911), to the period of the warlords following the establishment of the Chinese Republic (1910s to 1930s), to the Second Sino–Japanese War, the play reflects on the changes in Chinese society prior to the founding of the PRC. Other plays with contemporary and historical themes include *Longxu Slum* (1951) and *Rickshaw Boy* (1957), both by Lao She, and *Peach Blossom Fan* (1958), by Ouyang Yuqian. Banned during the **Cultural Revolution (1966–1976)**, which began with a critique of the historical drama *Hai Rui Dismissed from Office*, by Wu Han, drama disappeared from the theatrical world as so-called revolutionary model operas took center stage. Remerging following the introduction of economic reforms and social liberalization (1978–1979), dramatic performances included such foreign plays as *Death of a Salesman*, by Arthur Miller, with an all-Chinese cast, in 1983, along with original Chinese dramas the likes of *Wild Man* (Yeren), by Gao Xingjian, in 1985, which combined acting, singing, and **acrobatics** with diverse themes and no obvious story line.

Television and cinematic dramas were dominated by story lines from events, real and fictional, during the imperial era, for example, the hugely popular *Story of Minglan*, along with CCP political history, for instance, *Spy Hunter Detectives*, and contemporary dramas on the vicissitudes of family life and tried-and-true romance and love stories the likes of *Well-Intended Love* and *I Will Never Let You Go*. Outlets for dramatic production include the Central Experimental Drama Theater, with training carried out by the Central Academy of Drama, including such young dramatists as Xu Ruoxin, author of *Variations* (2017) and *The Hat Trick* (2015).

DREAMS AND NIGHTMARES (*MENGXIANG/E'MENG*). Interpretation and explanation of dreams, especially nightmares, have been major topics in Chinese **philosophy** and **traditional Chinese medicine (TCM)** for more than 4,000 years, beginning with the ancient Shang Dynasty (1600–1046 BCE). Not merely figments of the subconscious, as argued by Sigmund Freud (1856–1939), dreams in China were taken as complete worlds beyond our own, with status and wealth experienced in sleep no different from rewards in the "real world" (*zhenshi shijie*). Dreams and reality are interchangeable, with the soul communicating in a world of constant change during sleep that in one night's rest may contain a lifetime of experiences, while reflecting good or bad **fortune**.

In **Confucianism**, the Duke of Zhou (1042–1035 BCE), lauded as a paragon of a Chinese ruler, was closely linked to dream culture, with *The Interpretation of Dreams by the Duke of Zhou* (Zhougong Jiemeng) written during the Tang Dynasty (618–907). Serving as the most popular work on dream interpretation in the imperial era, the book presents more than 25 overlapping categories of dreams, with analysis of dream content based on a main motif. Dreams were also of major concern to Zhu Xi (1130–1200), founder of Neo-Confucianism, who explored the relation between dreams and principles of "propriety" (*li*) and "**energy**" (*qi*), and state of the heart, with dreams indicating an individual's capacity for moral improvement.

For **Daoism**, specifically the *Zhuangzi*, dreams are interpreted as a means of exploring the world of spirits and seen in Chinese folklore and **legends** as allegories of the human condition in this world. **Buddhism**, too, sees dreams as a conduit to other worlds related to the condition of the individual mind, and providing a special kind of **wisdom** though ordinary life is considered more important than dreams. For TCM, recurring dreams and nightmares indicate a profound imbalance of the five **body** organs, especially involving the heart, which is believed to control the mind. When the heart is weak, one dreams of **mountains**, fire, and smoke, while when the heart is in excess, dreams contain laughter and joy. And when the yin is greater than the yang, one dreams of floods. In the opposite case, of yang greater than yin, one dreams of being burned in fire.

Increasingly popular in the People's Republic of China (PRC) is *The Interpretation of Dreams* (1899), by Sigmund Freud, in apparent reaction to a number of horrible **crimes** and **suicides** in the early 2010s that shocked the public and were unexplainable in traditional Chinese cultural terms. Along with the enormous popular appeal of the Western film *Inception* (2010), involving a man able to explore other people's dreams, among the most notable Chinese **films** dealing with dreams is *The Looming Storm*, a murder mystery in which the protagonists liken their present reality in a dreary, rain-soaked industrial zone to a dream within a dream.

DRINKING CULTURE (*YINJIU WENHUA*). Omnipresent in Chinese daily life, drinking culture in the People's Republic of China (PRC) has undergone major expansion and transformation, as rapid economic growth has produced mass consumerism, including **alcohol**. Once limited to special social occasions like **festivals and holidays**, as well as **business** meetings occurring primarily at homes or in restaurants, alcohol consumption has expanded to casual social occasions with the growing popularity of "clubs" (*julebu*) and "bars" (*jiuba*). Considered a good way to cultivate friendships, experience culture, and just have fun and relax, drinking in China is governed by a set of **rituals** and rules, as the more formal the occasion, the more formal the drinking protocol.

152 • DRIVING HABITS (JIASHI XIGUAN)

Reflecting traditional principles of self-control and personal **discipline** embedded in **Confucianism**, Chinese, while respecting and encouraging substantial alcohol consumption, especially at **banquets**, with multiple toasts among hosts and guests, generally frown upon becoming drunk or behaving badly. A communal affair, with singles rarely seen at Chinese clubs or bars, thinly veiled drinking contests even among friends are largely a male-dominated event, with healthy low-alcohol and nonalcoholic drinks becoming increasingly popular, particularly among **women**. Along with such popular Chinese spirits as *baijiu* ("white liquor") and *gaoliang*, made from sorghum, expensive foreign spirits like cognac and red wines have become staples in China's drinking culture, especially in major cosmopolitan **urban areas** like **Beijing, Chongqing, Shanghai**, and **Guangzhou**.

DRIVING HABITS (*JIASHI XIGUAN*). A country of 300 million automobiles, driving habits in the People's Republic of China (PRC) are described as "chaotic" (*hunluan*), "insane" (*feng*), and "kamikaze" (*shenfeng*), with traffic rules and regulations blithely ignored by taxi, bus, and casual drivers alike. No place for hesitant or anxious drivers, common and often dangerous habits on Chinese roads include the following: texting or using mobile phones while driving, with the operator oblivious to what is going on around their vehicle, something even police have been observed doing; lane hogging, with vehicles swaying between two or three lanes, or even driving provocatively on lane dividers while taunting drivers tailing behind; stopping in the center of a road, selfishly blocking the throughway, while fiddling with a GPS device; and failing to use flash indicators out of concern that other drivers will take advantage of one's planned movements. Heavy breaking is also common among bus and taxi drivers, with little or no concern shown for the safety and well-being of passengers, while constant honking of horns is standard operating procedure for all drivers. Among the major national laws governing road safety is the Law of the PRC on Road Traffic Safety (2003), which includes provisions to reduce traffic accidents, which result in the **deaths** of 260,000 people annually, an average of 700 a day, consisting primarily of pedestrians, cyclists, and motorcyclists.

DRUG ADDICTION AND ABUSE (*YONGYING/YONGYAO*). In a country severely afflicted both domestically and internationally by the distribution and consumption of addictive drugs, growing use of natural and synthetic opioids in the People's Republic of China (PRC) is a major problem, with considerable controversy surrounding government eradication and remediation programs. Following the prosecution by foreign powers, primarily Britain, of two Opium Wars (1839–1842/1856–1860), the importation and cultivation of "opium" (*yapian*) in China increased dramatically to the point that

DRUG ADDICTION AND ABUSE (YONGYING/YONGYAO) • 153

85 percent of the global opium supply was produced in the country in the early 1900s, with one-fourth of the adult male population becoming regular users.

Following the establishment of the PRC in 1949, a massive and often-violent nationwide antidrug campaign was launched against drug traffickers and users, with the country officially declared "drug free" (*wu dupin*) in 1952. Reappearing soon after the introduction of economic reforms and social liberalization (1978–1979), drug use has increased annually to 2.47 million officially registered drug users in 2013, with unofficial estimates of as many as 13 million. Primary drugs of choice are heroin, with major importation from neighboring countries, especially Myanmar, located, along with Thailand and Laos, in the drug-rich Golden Triangle, and crystal methamphetamine, a synthetic drug known as "ice" (*bingdu*) manufactured in-country. Others include morphine, smokable opium, nimetazepam, temazepam, MDMA (or ecstasy), and ketamine, with production largely in Southern China.

Users are concentrated in the wealthy coastal cities and consist primarily of unemployed, poorly educated, single males from relatively poor families age 35 and older (68 percent), including such high-profile individuals as Jaycee Chan, son of the movie actor Jackie Chan. Popular sites for drug use include bars and karaoke clubs, with production and distribution largely in the hands of loosely affiliated **gangs** and criminal syndicates operating out of transit points in the border provinces of **Yunnan**, Guangxi, Xinjiang, and Liaoning, with international suspicions of heavy drug exports from the Democratic People's Republic of Korea (North Korea).

A signatory to the United Nations Drug Convention (1988), Chinese government antidrug efforts in the 1990s and 2000s included highly publicized arrests of traffickers and users, along with seizures of large quantities of drugs. Policy toward drug offenders has historically relied on harsh treatment, including compulsory detoxification with long-term incarceration in labor camps for recidivists under the direction of the criminal justice system, mainly the Narcotics Control Bureau in the Ministry of Public Security (MPS), with little or no professional counseling. Clinics and community treatment for chronic addicts have been introduced, with growing emphasis on prevention and not just **punishment**, notably the introduction of a methadone maintenance program but with scant financing, as public sympathy and support are generally lacking. Little reliance on psychotherapy is also evident, along with a general absence of professional measures employed in the West, for instance, the Addiction Severity Index and Hopkins Symptom Check. An annual Drug Enforcement Report has been published since 1998, but with few statistics on the efficacy of government eradication and remediation programs. Ongoing research on drug addiction is carried out by the China Medical Dependency Research Institute at Peking University.

DUTY AND PROFESSIONALISM (*YIWU/ZHUANYE JINGSHEN*). Lacking versatile professions during the first decades of the People's Republic of China (PRC), globalization of the economy and increasing international contact since the late 1970s have led to the establishment of ethical standards and codes of conduct for multiple professions, including "cadres" (*ganbu*) in the ruling Chinese Communist Party (CCP). During the period of rule by CCP chairman **Mao Zedong** (1949–1976) and the adoption of central economic planning from the Soviet Union (1973–1978), professional standards and ethics were subordinated to political and state interests, with personal **loyalty** to the chairman and his "thought" (*sixiang*) trumping all other professional obligations and standards. National associations for such professions as lawyers, engineers, and doctors acted as mere "transmission belts" (*chuandongdai*) for enforcing national policy and accompanying **ideologies**, with members considered workers of the state. Independent realms of professional activity and standards of behavior were virtually unknown, with primary duty to serving state and party interests often at the expense of clients, notably medical patients, for whom care was often withheld on political grounds, as occurred with the dying premier Zhou Enlai (1898–1976), denied care by a revengeful Mao Zedong in 1976.

Following the introduction of economic reforms and social liberalization (1978–1979), concepts of professional standards were gradually introduced, with codes of conduct issued for judges, engineers, journalists, filmmakers, and other professions, with CCP cadres instructed in 2010, not to engage in activities "going against . . . professional ethics." Chinese companies, especially those involved in the global economy, for example, China Telecom, followed suit with provisions calling for "honest and moral behavior," as well as "good faith and integrity," and avoiding "conflicts of interests" by refusing any bribes or improper behavior, with primary devotion to the company. Career services at colleges and universities previously underdeveloped have also been strengthened as part of the 13th Five-Year Plan on Employment (2016–2020), with greater clarity given to job titles and responsibilities, especially in Chinese multinationals employing **foreigners**.

See also NATIONALISM (*MINZUZHUYI*).

EATING HABITS (*YINSHI XIGUAN*). An important part of everyday life, reflected in the well-known saying, "Fashion is in Europe, living in America, but eating is in China," Chinese enjoy eating with the thought that "**food** is heaven" (*min yi shi wei tian*). Bringing **harmony** and closeness among **family** and friends, eating is also considered a good way to establish new social or **business** relationships. **Banquets** are particularly popular, involving as many as hundreds of guests, with people in China rarely eating alone. Less concerned with nutrition and more so with texture, **color**, flavor, and aroma of food, Chinese typically balance their meals, three a day in cities and two in **rural areas**, with the four major food groups of grain, vegetables, meat, and fruit, the latter often served as a dessert at variable intervals of the meal. Included are soy milk and "bean curd" (*doufu*), as few, if any, dairy products are served, as Chinese people are generally lactose intolerant. Fresh vegetables and meats or fish are preferred, since Chinese rarely consume canned or frozen foods, although the advent of large grocery chains is transforming habits, making for more convenient and ready-to-eat lunch boxes, especially with many employees facing 12-hour work days six days a week.

Meals, especially more formal affairs, generally include both "cold" (*yin*) and "hot" (*yang*) dishes, the latter including chili peppers, garlic, onions, and other spices, with rice served in separate bowls and prepared dishes placed family style on a revolving lazy Susan at the table center. **Chopsticks** are the normal utensil of choice, often used to place food items on the plate of a guest as a traditional expression of politeness, despite the potential for transmission of communicable diseases. Special events, including **festivals and holidays**, along with **birthdays**, usually entail the consumption of special foods, most notably "rice dumplings" (*zongzi*) for the Dragon Boat Festival (25 June), "moon cakes" (*yuebing*) for the Mid-Autumn "Moon" Festival (late September or early October), "dumplings" (*jiaozi*) for the **Spring Festival**, and "noodles" (*mian*) and "peaches" (*taozi*) for birthdays.

Foods believed to bring good **fortune** include "peanuts" (*huasheng*), associated with **longevity**; "oranges" (*juzi*) and "water chestnuts" (*biji*), with "good luck" (*haoyun*); "lotus seeds" (*lianzi*), with having many **children**;

156 • EDUCATION (JIAOYU)

"dried bean curd" (*doufugan*), with fulfillment of wealth and **happiness**; "bamboo shoots" (*zhusun*), with wellness; and "seaweed" (*haizao*), with becoming rich. Bad luck may occur after cutting a pear in half, as the words in Chinese are a homonym for "depart" (both pronounced *fenli*), or flipping a fish over on a plate, representing the capsizing of a fishing boat, especially avoided in coastal Southern China. Unique culinary habits and elaborate rules govern eating in China especially among the wealthy and upper classes and include: eating from a common lazy Susan or dish; placing rice cookers on the floor; drinking hot water with meals; eating desserts before or during the main meal; eating rice or noodles every day and sometimes at every meal; never eating food dropped on a table; and being offered tissues, not napkins, and avoid eating too fast which is considered low class. Breakfast varies widely, consisting of porridge, noodles, and fritters in the north, and shrimp dumplings, steamed buns, and soy milk in the south, with "soups" (*tang*) generally served last. Conducted annually since 1989, the China Health and Nutrition Survey examines the **health** and nutritional status of the Chinese population by international and Chinese researchers.

EDUCATION (*JIAOYU*). One of the most competitive systems in the world and traditionally revered in **Confucianism**, education in the People's Republic of China (PRC) has undergone numerous reforms and experimentation, some with disastrous results, with heavy focus on "innovation" (*gexin*) and cultivation of "creative thinking" (*chuangzaoxing sixiang*) by students, especially since the 1980s. With literacy rates less estimated at 20 percent in 1950, the commitment to education by the new government of the PRC in 1949, was readily apparent in the Decision of the Reform of Education (1951), which, in the context of "learning from the advanced experiences of the Soviet Union," mimicked the Soviet institutional model. Almost the entire higher education system in China was "readjusted" (*chongxing tiaozheng*) in 1952, with consolidation of institutions around individual academic disciplines, especially the **sciences**, and a separation of teaching from research, with the latter performed in institutes, most notably the Chinese Academy of Sciences (CAS).

Despite reservations on the part of some Chinese educators and researchers, many trained in the United States, the "readjustment" was quickly implemented, assisted by the 800 Soviet advisors working in the higher education sector. At the same time, throughout the 1950s, the new government committed substantial resources to the establishment of new universities and institutes, with a focus on science and technology at such facilities as Huazhong University of Science and Technology, Shenyang Institute of Technology, and Dalian Petroleum School, institutions that by 1988, numbered more than 140. In 1954, the government established the system of designating "national

EDUCATION (JIAOYU) • 157

key universities," including Peking University, Tsinghua University, Harbin Institute of Technology, Beijing Agricultural University, and Beijing Medical Institute, for special treatment and financing.

Although primary schooling was not compulsory, national enrollments increased from 25 million in 1953, to 86 million in 1958. Secondary schooling during the same period consisted of six-year junior and senior secondary, or middle school, focusing on general academic training, although these schools were largely restricted to **urban areas**, with schools in **rural**, especially poor areas, falling substantially behind, with insufficient investment and inadequately trained teachers. A system of vocational and polytechnical schools was also established, with the latter employing half-work and half-study in preparing students for work in industry and agriculture. Enrollment in secondary schools grew from 2 million in 1953, to more than 9 million in 1958. Higher education consisted of comprehensive universities with full-time students and polytechnic universities, for example, Tsinghua University, while many Chinese university students studied in the Soviet Union, especially in science and technology disciplines.

Overall enrollment in higher education in China grew from 110,000 in 1950, to 800,000 in 1959, with admission to universities based on demanding "national entrance examinations" (*gaokao*) conducted nationwide, which, by 1965, had produced a competitive system, as only 36 percent of students who attended senior secondary school could expect to enroll in a university. Nationwide, of those who entered primary school, only half of 1 percent would end up in a university.

During the Great Leap Forward (1958–1960) and the **Cultural Revolution (1966–1976)**, various educational experiments were attempted, usually with dire results. Vocational and polytechnic education was expanded at enormous rates during the Great Leap, with an emphasis on half-work, half-study and heavy doses of political education. Following the abolition of the national college entrance examination in June 1966, many schools and universities in China became the scene of **violence** and factional strife among Red Guards often aimed at teachers, educational administrators, and Chinese Communist Party (CCP) cadres, with some being beaten to **death** in what was officially lauded as "revolutionary actions" (*geming xingdong*). While conflicts broke out on university campuses, the most severe and pointless violence occurred at secondary schools in **Beijing, Shanghai**, and **Guangzhou**, especially institutions like the Foreign Languages College and the Middle School of Tsinghua University, which were attended by the offspring of high-level political leaders, who became some of the most aggressive and violent members of the Red Guards. With schools closed beginning in late 1966 until 1968, teachers and school administrators became open targets, condemned by Red Guards and organized into "ox-ghost and snake-demon teams" (*niugui sheshen dui*), where they were forced to do such dirty work as

158 • EDUCATION (JIAOYU)

clean toilets and could be insulted or beaten at any time. Among those killed were Bian Zhongyun, the vice principal of the Girls' Middle School, attached to Beijing Normal University, who died on 5 August 1966, as the first victim of Red Guard violence, and Zhang Furen, a Chinese-**language** teacher at the middle school attached to the Beijing Foreign Languages College.

More than 40 institutions in Beijing alone experienced similar violence. Targeted was everyone from school janitors; to "class directors" (*banzhu ren*), whose job it was to **discipline** students; to the school head; and even to officials in the Beijing City Education Bureau, with many educational personnel preferring **suicide** to beatings. While teachers were targeted in the Cleansing of the Class Ranks Campaign (1967), most Red Guards were ultimately "sent down to the countryside" (*xiaxiang*) in 1968, as the country's entire population of university and senior secondary school students failed to continue their education, with the 1966, 1967, and 1968 entering classes skipped altogether.

Gradually reopened in the early 1970s, schools and formal education underwent major change, with the average length for primary and secondary education reduced from 12 to 9 years in the cities and to 7 years in the countryside. Most youth entered the urban and rural workforce at the ages of 15 or 16, while students planning to attend the universities that had reopened were required to engage in "practical" (*shijide*) work for two to three years before admission. Reopened in 1970, universities admitted students on the basis of nominations from their work "**unit**" (*danwei*), which stressed political reliability and appropriate **class** background, while students from "bad" families were generally excluded irrespective of their performance on the renewed national college entrance examination. Educational administration was given over to Revolutionary Committees at the expense of professional educators, which saved the central government money but produced poor-quality students.

Following the death of CCP chairman **Mao Zedong** in 1976, the Chinese educational system underwent a major readjustment to fit the nation's newly established goals of the "Four Modernizations" (*sige xiandaihua*), especially in science and technology. In 1977, the government restored the system of competitive examinations for university admissions based on performance alone, as political qualifications were pushed aside, while at the primary and secondary levels in urban areas, it revived "key-point schools" (*zhongdian xuexiao*). Condemned by radical Maoists as "elitist," these schools received special government funds and the best-trained teachers for the brightest students. Previously taboo subjects like **art**, classical **music**, and **philosophy** were added to secondary and university curricula, while the role of political-**ideological** studies was significantly downgraded. With the promulgation of the Law on Nine-Year Compulsory Education (1986), school-age children were required to attend at least nine years of school, as government funding

EDUCATION (JIAOYU) • 159

for education was increased to more than RMB 240 billion ($40 billion) per year, with 150 million students receiving some form of state assistance. Regulations for the awarding of bachelor's degrees, master's degrees, and doctorates were passed by the National People's Congress (NPC) in 1980, as university admissions increased dramatically, with party–state control of curriculum and student life significantly reduced as university administrators operated under a "presidential responsibility system" generally free of direct political controls.

National expenditures on education reached 4 percent of gross domestic product (GDP), RMB 2.2 trillion ($357 billion), in 2012, a goal set by the government in 1993. This included substantial government assistance to support nine years of compulsory, tuition-free education in China's poorer rural areas, subsequently extended to urban areas. Chinese students, numbering 504 million in 2019, attend "primary school" (*xiaoxue*) from ages 6 to 11, "junior secondary school" (*chu zhong*) from ages 12 to 14, "senior secondary school" (*gao zhong*) from ages 15 to 17, and "college or university" (*daxue*) usually from ages 18 to 22, with many **children** beginning "preschool" (*you'er yuan*) as early as age 2. While 99 percent of Chinese children now attend five years of primary school, 80 percent complete both primary and junior secondary school, with admission to senior secondary school based on performance on the *zhongkai* examination, similar to the national college entrance exam. Almost 80 percent of Chinese senior secondary school graduates attend college, an increase from 20 percent in the 1980s, with 25 percent of college-age students attending institutions of higher learning.

Literacy in China was a little more than 95 percent in 2013, slightly higher for **men**, at 97 percent, than for **women**, and compared to 65 percent in 1982, but with major differences between advanced cities and poorer rural areas in such high-poverty regions as **Tibet**. Doctoral degrees were conferred on the first batch of postgraduate research students trained in the PRC by its own educators in 1982, as all ministers in the central government possessed university degrees, with the Decision on the Reform of the Educational System (1985) calling for education to serve the modernization program. Universal basic education and overall educational improvements were also established as major goals, with administrative control of primary and secondary education ceded to the county governments. University students were also increasingly required to contribute financially to their education, as the central government abolished tax-funded higher education, replacing it with competitive scholarships, as students were generally not allowed to choose majors assigned on the basis of test performance. The 1980s also witnessed the creation of private schools in China, many run by Americans, which now number more than 70,000, along with night schools and television universities offering taped lectures by renowned professors.

160 • EDUCATION (JIAOYU)

Following the military crackdown on the prodemocracy movement in Beijing and other cities in June 1989, the flow of university students interested in studying abroad increased significantly, while only about one-quarter of the more than 65,000 Chinese students overseas had returned by 1990. At centers of university-student protests, for instance, Peking University, political education and controls were reestablished following the crackdown, and curricula with so-called Western biases were significantly altered. At the same time, the allure of opportunities in the economy drew increasing numbers of students and teachers away from education and into the **market**, raising questions about the future quality of Chinese education. State spending on education remained flat, and as a result, China's goal of achieving universal, compulsory education was not achieved, as parents often faced so-called sponsorship fees that could amount to as much as RMB 96,000 ($16,000) to gain entry into the best schools, a widespread practice known as "going through the back door" (*zou houmen*), which has spurred innumerable government investigations into **corruption**. For many families in China, especially in the countryside, the **commercialization** of education imposes enormous economic pressures, one among many reasons for the growth of the floating population of migrant workers into Chinese cities, where their children can now qualify to enroll in local schools.

Colleges and universities number 2,914 in the PRC, with 20 million students and 6 million graduates in 2017. While matriculating students often complain of the overly theoretical content of course curricula, Chinese leaders, including presidents Jiang Zemin (1989–2002) and **Xi Jinping** (2013–), have called on educators to strengthen the teaching of patriotism, national integrity, and Chinese history. As universities were granted increased authority over curriculum, the reforms of the Soviet era were gradually reversed, with universities able to advertise themselves as "multidisciplinary" institutions with a variety of programs in the sciences, humanities, and arts, and an emphasis on cultivating innovation and creative thinking. Campaigns at primary and middle schools have been launched to inculcate students with "honesty and credibility" (*chengshi/xinyu du*) and a stronger sense of "collectivism" (*jitizhuyi*) to counter the increasingly self-interested student orientation fostered by the economic reforms and loosening of social controls, while Chinese college students often approach their education with a casual, "carefree" (*wuyou wulü*) attitude, as academic expectations and failure rates are notoriously low.

Traditionally revered in China beginning with Confucianism, teachers in the PRC, currently numbering 15 million, are governed by the national Teachers Law (1993), with employment based on a renewable contract ending previous permanent employment, known as the "iron rice bowl" (*tiewanfan*). Honored on the nationally recognized Teachers' Day (10 September), teachers, especially in underfunded rural schools, are slated for retraining and

better pay. Other ongoing educational reforms, many outlined in the National Long-Term Education and Development Plan (2016–2020), call for greater financial support to underfunded and overcrowded schools, especially in poorer parts of the countryside and the country's backward Western regions. Less orientation in curriculum and classroom activities to examination preparation for entry into senior secondary schools and especially universities is also advocated, although such reforms are a tough sell, with the *gaokao* still serving as a primary, if not the only, measure of qualification for prized university placement. The C9 League of universities in China, known as the country's "Ivy League," consists of Peking University (Beijing), Tsinghua University (Beijing), Zhejiang University (Hangzhou), Harbin Institute of Technology (Harbin), Fudan University (Shanghai), Shanghai Jiaotong University (Shanghai), Nanjing University (Nanjing), the University of Science and Technology of China (Hefei), and Xi'an Jiaotong University (**Xi'an**), with only two (Peking and Tsinghua) appearing in the World University Rankings of the 100 best universities.

Foreign students in the PRC have grown in number, with China announcing plans for transforming 100 universities, such as Shanghai's Jiaotong University, into world-class research institutions, with many Chinese faculty lured back from posts in the United States. While foreign students matriculating at such major universities as Peking University and Tsinghua constitute less than 3 percent of the student body, the country has also looked to expanding foreign-funded education, along with cooperative agreements with foreign companies like Microsoft, to develop educational software and train software engineers. Online courses on the internet and education websites have been introduced, while a major expansion of education for senior citizens at special schools and universities has been pushed for retired civil servants and other retirees.

Despite commitments from education leaders in China to guarantee "academic freedom" (*xueshu ziyou*), especially at universities, Chinese students are not encouraged to challenge authority or received **wisdom**, which may explain why the country, up until 2015, had never won a Nobel Prize in the sciences. Curriculum reform is needed, especially in primary schools, where the emphasis on so-called "stuffed-duck-style education" (*tianyashi jiaoyou*), involving rote memorization of 5,000 Chinese characters required for basic literacy, is seen as stifling early childhood creativity, which continues into the later grades, where Chinese classrooms are notorious for largely silent and "obedient" (*fucong*) students with authority of the teacher rarely challenged.

EMPATHY (*TONGQING*). Defined as a cognitive and affective ability to understand the feelings of others by recognizing their emotions, behavioral actions, and situation, empathy is said to be lacking in contemporary Chinese

society with multiple historical and contemporary causes, notably the impact in the People's Republic of China (PRC) of the **one-child policy** (1979–2015). With **Confucianism** promoting a strong moral grounding as the basis of human empathy, Chinese people are generally known for their friendly and polite behavior toward others as demonstrated in traditional **sayings** such as "protect the weak" (*baohu ruozhe*). Yet beyond immediate **family** or social group, the same people are said to lack day-to-day empathy as obligations to assist others, especially strangers, is fraught with potential problems, including major financial losses. Personal **loyalty** and devotion are only due to relatives or close associates with broader commitments to the wider public good generally ignored and studiously avoided. Demonstrated in everyday life by lack of queuing in lines for public transportation, several highly-publicized cases of people, including **children**, injured in accidents being abandoned by perpetrators and ignored by bystanders have also provoked national debate on popular insensitivity primarily on **social media**.

Noted in ancient times by **Daoist** philosopher Zhuangzi (368–289 BCE), who believed in the basic impossibility of empathy, more recent analyses include that of renowned anthropologist Fei Hsiao-tung, who in the 1940s noted the lack of universal "love" (*ai*) without distinctions in Chinese society, causing a differentiated sense of obligation. Similar views have also been expressed by contemporary artist **Ai Weiwei** but with the culprit more economic than social, believing Chinese people have been overwhelmed by materialism and love of **money**, robbing them of such basic human qualities as **compassion**. Social researchers coming to the same conclusion cite the impact of the one-child policy, leaving single children without siblings and raised by doting parents and grandparents who refuse to say "no" to any childhood desires, creating what has been labeled the "little emperor syndrome" (*xiao huangdi zonghe zheng*). Asked by researchers how they would feel if caught in a life-threatening situation, many Chinese subjects found it difficult to answer, indicating basic problems in social learning that persist to the present.

"ENERGY" (*QI*). A pseudoscientific concept central to the practice of **traditional Chinese medicine (TCM)** and popular forms of **exercise**, for example, Qigong ("life energy cultivation") and "Tai Chi" (*taijiquan*), the word *qi* is defined as "energy" in the very broadest sense, encompassing the entire universe, including the human **body**. All life is considered a gathering of *qi* existing in a constant state of flux, transforming endlessly from one aspect to another, neither created nor destroyed, but simply changing manifestations. Closely related concepts include the notion in **Daoism** of **fengshui** ("wind and water"), with the Chinese "magnetic compass" (*luopan*) used to detect the flow of *qi*. Also related is **yin-yang**, with yin as the material manifestation of *qi*—solid, heavy, cold, moist, passive, and quiescent, among others—

ENTERTAINMENT (YULE) • 163

and yang as the relatively immaterial manifestation—amorphous, hollow, light, hot, dry, bright, and aggressive. Good human **health** and overall **harmony** in the universe are achieved by balancing the vital force of qi with any "deficiency" (*hui*), from excessive stress or other debilitating activity, or "excess" (*guoliang*), to environmental pollution or excessive physical activity, interrupting the flow of qi as an energy field, which in modern physics has been confirmed by the Higgs-Boson view of the universe.and leading to illness and disruption.

Traced to the 5th century BCE and similar to the classical Western concept of the four humors (blood, yellow bile, black bile, and phlegm), qi is also a pervasive topic in traditional Chinese **philosophy**, notably **Confucianism**, in the *Analects* (Lunyü) and the *Mencius* (Mengzi), along with works by Mozi (*Mohism*) and in Daoism, where qi is considered the basic "life force" (*shengmingli*). The Five Cardinal Functions of qi for the human body are as follows: "actuation" (*qudong*), necessary for growth and development; "warming" (*biannuan*), ensuring proper functions of body organs; "defending" (*baowei*), providing protection against pathogens; "containment" (*ezhi*), regulating bodily fluids; and "transformation" (*zhuanxing*), converting air and **food** into blood. Four types of qi include "parental" (*yuanqi*), inherited from parents; "pectoral" (*zongqi*), breathing; "nutritional" (*yingqi*), **eating** healthy foods; and "defensive" (*weiqi*), protecting the body.

Found in air, food, and water, qi binds together all things in the universe and, paradoxically, is both everything and nothing, with a didactic concept informing the **martial arts**. Among **animals** considered experts at inhaling qi are the gibbon and crane, with their extraordinary powerful bodies able to climb and fly. Attacked as a **superstition** for decades during the People's Republic of China (PRC) and associated with the outlawed Falun Gong **religious** group, belief in qi has undergone a resurgent popularity since the 1980s, with an institute established in **Shanghai** using scientific methods to study the effects of qi.

ENTERTAINMENT (*YULE*). Enjoying greater leisure time with more disposable income, Chinese people, especially the growing middle class in **urban areas**, are seeking a variety of entertainment forms, both traditional and contemporary. Among the former experiencing a renaissance in the People's Republic of China (PRC) are high culture, for instance, **opera**, including **Peking opera** and Sichuan opera, and **music** performances with traditional instruments like the *pipa* (lute) and *erhu* (spike fiddle), as well as the piano and violin, mastered by a number of world-class Chinese musicians the likes of Lang Lang and Wang Yuja. Popular cultural sources of entertainment include such **individualized** activities as "kite-flying" (*fang fengzheng*), "cricket fighting" (*banqiu zhandou*), and "songbird competitions" (*mingqin jingsai*), along with crowd-pleasing "circus" (*maxituan*) and **acrobatics** per-

164 • EXERCISE (YUNDONG)

formances, notably an "acrobatics Olympics" (*zaji Aoyunhui*), held annually. More than 1,000 acrobatic troupes exist in the PRC, most notably in **Beijing** and **Shanghai**, with frequent tours of **rural areas** and many performances pitched to foreign tourists featuring such acts as high-wire balancing on a bicycle, multiplate spinning and bowl balancing, ballet dancing on shoulders, human lion balancing on a globe, balanced group riding on a single bicycle, and contortionists showcasing skills of extreme flexibility.

Entertainment forms include such major spectator events as previously banned horse racing and newly established Formula One motorsports, mainly in Shanghai, along with **martial arts** performances and dragon boat racing. Competitive **games** gaining popularity include in-door pastimes like billiards, snooker, and bowling, with playing video games the largest form of personal entertainment, especially among Chinese **youth**. Crowd-pleasers, especially at **festivals** and on holidays, include **fireworks** displays and **dance** and **singing** performances, usually by large choral groups. Also popular are bars, karaoke clubs, and night clubs with many, especially foreign run, offering entertainment including bizarre floor shows and scantily clad pole dancers. A major moneymaker, the entertainment industry, including **cinema and film**, has been called upon by political leaders, including President **Xi Jinping** (2013–), to serve as a vehicle for boosting the global image of the PRC by encouraging **nationalism** and promoting "mainstream values" (*zhuliu jiazhiguan*) defined by the ruling Chinese Communist Party (CCP) and countering foreign notions of a "China threat" (*Zhongguo de weixie*).

EXERCISE (*YUNDONG*). Championed by Chinese Communist Party (CCP) chairman **Mao Zedong**, who proclaimed, "We should civilize our spirits and be brutal on our bodies," exercise and calisthenics is a daily regimen throughout much of **urban** China, usually in the morning, at schools, in the **workplace**, and in public parks, especially by the elderly. Routines generally involve a form of "Tai Chi" (*taijiquan*) or Qigong, life **energy** cultivation, with an emphasis on engaging in natural rhythmic movements of swinging and circling the arms, walking backward, crawling, stooping, **body** pulling, and other various movements, including **dancing**, for improving balance, boosting the immune system, and gaining mental clarity. Based on principles in **Daoism** of blending body and breath, and balancing essence and "energy" (*qi*), exercises often involve loosening and stretching the body, with a focus on strengthening spinal muscles, combined with controlled breathing. Soft-style and slow-motion "morning exercises" (*zaocao*), especially among the elderly, carry such mystical names as "single whip" (*danbian*), "cloud hands" (*yunshou*), "playing the lute" (*chui pipa*), and "carrying the moon" (*xiedai yueliang*).

Exercise involving **sports** includes badminton, ball-playing, and *jianzi*, the last an Asian form of shuttlecock traced to the Han Dynasty (202 BCE–220 CE) in China, involving continuous "throwing" (*reng*) or "kicking" (*ti*) of a feather ball with the inside and outside of the foot. In the history of the People's Republic of China (PRC), city-wide exercise conducted by radio broadcast (twice daily, at 10 AM and 3 PM) was introduced in 1951, with many residents engaging in Tai Chi, softball, boxing, and fan and sword dancing, and Qigong, notably the "great dance" (*dawu*), which continued following the chaotic **Cultural Revolution (1966–1976)** with a Qigong craze in the 1980s and 1990s, followed by a near-total shutdown after the banning of Falun Gong in 1999. Gym culture and workout apps are also becoming increasingly popular, with 37,000 gyms and health and fitness centers located nationwide in 2018.

EXPLORATION (*KANTAN*). Chinese exploration of foreign lands in Central and Southeast Asia, and East Africa, mainly modern-day Ethiopia, extended from the 2nd century BCE during the Han Dynasty (202 BCE–220 CE) to the early 16th century during the Ming Dynasty (1368–1644), when exploration was effectively halted until the end of the imperial era in the early 20th century. Led mainly by merchants, exploration was overland, primarily along the **Silk Road**, and maritime, with the latter facilitated by the development of the stern rudder and the invention of the magnetic compass in the 1st and 11th centuries, respectively. Trade, especially in Chinese **ceramics and porcelains**, extended as far as Egypt, with Chinese explorers entering the Persian Gulf and sailing up the Euphrates River to modern-day Iraq, while indirect contact between China and the Roman Empire involved trade and the exchange of travelers, the first occurring in 166 AD, during the rule of Roman emperor Marcus Aurelius (161–180).

Visits to Southeast Asia led to the establishment of permanent Chinese settlements in Java, Malaya, and Vietnam, while travels by Buddhist monk Xuanzang to India in the 7th century resulted in the transmission of hundreds of Buddhist scriptures to China. The last major Chinese foreign exploration was carried out by Admiral Zheng He (1405–1433) via a fleet of 300 ships, known as the "Treasure Fleet" (*Baozang Jiandui*), traversing Arab trade routes in Africa and India, making it to modern-day Kenya, reputedly bringing back to China the first-ever giraffe. Turning inward under the influence of conservative Confucian officials apparently alarmed by a growing merchant **class**, further foreign exploration came to an end, as the construction of oceangoing junks was banned in the early 1500s and trade limited to coastal waters, just as relatively poor powers in Europe, for example, Portugal and Spain, began outward expansion, including in Asia.

166 • EXTREMISM (JIDUANZHUYI)

From the mid-19th century to the establishment of the People's Republic of China (PRC) in 1949, China was subject to foreign contact and **conquest**, especially by European powers, robbing the country of the wherewithal for further exploration. Among the major post-1949 projects has been the polar exploration to the north and south poles beginning in 1961, largely for scientific research, enhanced by the country's construction of all-weather research icebreakers and the establishment of a research outpost in Antarctica. China has also inaugurated a robust space exploration program in the 2000s, involving unmanned and manned space craft, with the successful launch of the *Shenzhou* capsules and *Tiangong* space laboratory, along with participation in the International Space Station.

EXTREMISM (*JIDUANZHUYI*). A society historically dominated by traditions of moderation and balance embedded in **Confucianism** and **Daoism**, with little experience of **religious** fundamentalism in Chinese **Buddhism**, political and religious extremism have been a rarity, with the government of the People's Republic of China (PRC) targeting extremism among followers of Islam in the 2000s. Notable examples of religious and political extremism in Chinese history include the Taiping Heavenly Kingdom rebels (1850–1864), whose fanatical views of **Christianity** led to civil war, with a massive death toll of as many as 30 million people, and the chaotic **Cultural Revolution (1966–1976)**, during which the generally young and often-violent Red Guards adhered to a radical concept of "permanent revolution" (*yongliu geming*) espoused by Chinese Communist Party (CCP) chairman **Mao Zedong**. Moderate policies on the economy and society in general followed the introduction of economic reforms and social liberalization (1978–1979), with Chinese political leaders calling for "social **harmony**" (*shehui hexie*) and national inclusion of all **classes** of people, including previously persecuted intellectuals.

Confronted by the rise of radical Islam in the 1980s and an increasingly restive Muslim population in the far western Xinjiang-Uyghur Autonomous Region (XUAR), a major "counterextremism" (*fanjiduanzhuyi*) movement was initiated with the enactment of a national Anti-Terrorism Law (2016), which lists extremism as one of "three evils" (*san'e*) confronting the country, along with "separatism" (*fenlizhuyi*) and "terrorism" (*kongbuzhuyi*). Further action by the government of the XUAR included the legislation Regulations on Anti-Extremism (2017), which calls for the total elimination of religious extremism but with the proviso that extremism be distinguished from legitimate ethnic traditions and religious practices. Prohibitions in the law include the following: enforcing compulsory religious activities over others; interfering in other people's **marriages** and **burials**; interfering in social interactions between people of different ethnicities; rejecting the consumption of mass media and **entertainment** programs on false religious grounds; practicing a

loose interpretation of "halal" (*qingzhen*) in everyday life by extending the concept to areas other than the halal diet; enforcing the wearing of a veil or so-called "abnormal" beards as a sign of religious dedication; preventing **children** from receiving national **education**; publishing, distributing, or possessing extremist media content; and destroying resident identification cards or damaging Chinese banknotes. Confronting international **criticism** of state policies that have led to the mass internment of Uighurs in "reeducation" (*zai jiaoyu*) camps, China has defended these policies, while releasing many of the detainees.

F

"FACE" (*MIANZI*). Perhaps the most important concept in Chinese culture, with subtle idiosyncrasies and intricacies involving personal "dignity" (*zunyan*) and "prestige" (*shengwang*), along with a sense of **shame**, "face" constitutes the basic delicate standard by which social intercourse is regulated. Abstract and often intangible, face, in China, is more pervasive and nuanced than in most other societies, reflecting the crucial importance of "hierarchy" (*dengjizhi*), "social roles" (*shehui juese*), and "obligations" (*yiwu*) in the Chinese cultural milieu. A metaphor for personal reputation, the Chinese **language** has two words for "face," the more common and older is *mianzi*, which generally refers to personal status and position, as in "have face" (*you mianzi*), while the newer is *lian*, conveying a sense of shame and embarrassment, as in the common phrase to "lose face" (*diu lian*), which is often displayed by covering one's face with the hands, for example, the case of arrested prostitutes forced into public "shame parades" (*chiru youxing*).

"Giving face" (*gei mianzi*) to another is achieved by heaping praise and compliments on them, especially in the presence of superiors; giving expensive **gifts**; and/or inviting someone to an expensive meal or **banquet**. Multiple ways of losing face include the following: revealing someone's lack of knowledge or incompetence, especially in the presence of others; being unwilling to show deference to superiors or elders; turning down outright an invitation, especially to a banquet, as opposed to giving an excuse, even fabricated; being openly **angry** or calling out a lie on the part of another; and expressing open disagreement, especially in public, as such differences are best discussed in private and using the passive voice. "Shared face" (*gongxiang de lian*) refers to an entire group gaining prestige or sharing in shame because of the actions, good or bad, of one member, while intentionally causing another to lose face is the root of many irreparable personal conflicts.

Prominent Chinese writers commenting extensively, some critically, on the importance of face include the cultural iconoclast and author of *A Madman's Diary* **Lu Xun** (1881–1936), who described face as the guiding principle of the Chinese mind but something rarely talked about. Calls for eliminating the importance of face in Chinese social relations came from multiple

170 • FAMILY AND FAMILY LIFE (JIATING/JIATING SHENGHUO)

quarters to encourage people to tell the **truth** and avoid the obsession with appearance and personal reputation. Commenting less critically was Lin Yutang (1895–1976), who writing in *My Country and My People* (1935), noted that the all-pervasive notion of face could be granted, lost, fought for, and even presented to others as a gift. Many idioms and phrases referencing the importance of face include the adage that "men cannot live without face, trees cannot live without bark" (*ren yao lian, she yao piao*) and "a family's ugliness should never be shared" (*jiachou buke waiyang*). Acting shamelessly is said to "not want face" (*bu yao lian*) or "blacken one's face" (*wang lian shang mohei*), while efforts to regain one's reputation are described as "face-saving projects" (*mianzi gongcheng*). People attempting to gain favor, especially with a superior, are less subject in China to an accusation of "brown-nosing" (*pa made pi*), as in many Western cultures. Minor infractions of face can often explode into major personal confrontations including violence.

FAMILY AND FAMILY LIFE (*JIATING/JIATING SHENGHUO*). The foundation of the Chinese social order established as the core structure of the state by Emperor Wu Di (141–87 BCE) of the Han Dynasty (202 BCE–220 CE), the family, nuclear and extended, has undergone enormous changes from government policies and economic forces since the establishment of the People's Republic of China (PRC) in 1949. A "patriarchal" (*jiazhang*) and "patrilineal" (*fuxide*) society, the family, in Chinese history, was idealized in **Confucianism**, as three of the five major social relations involve family members, father–son, husband–wife, and elder–younger brother. Respect and reverence for parents and elders was embedded in the great philosopher's concept of **filial piety**, with both father and son committed to covering for one another in **legal** and other matters of conventional morality. Traditionally a rigid and hierarchical structure with sons and daughters numbered in the order of their birth, the ideal family consisted of three generations—grandparents, parents, and **children**—with the grandfather or eldest male considered the family head, with expectations of maintaining and protecting the family, along with paying for **education** and other vital needs. Broad authority was granted to the family head in making a variety of decisions involving family life, including the legal right to kill an especially disobedient child, along with less drastic matters, for example, **dating** habits and **marriage** of offspring, especially females, with fathers maintaining a highly formalized relations with sons and designated "godfathers and godmothers" (*jidie, jimu*) often assuming major roles in families with perennially absent parents.. Given little, if any, discretion over their lives in the family, children were rigorously trained to serve their elders, respecting the wisdom and **spirituality** that come with **age**. Families lacking a male heir were derisively referred to as "cut short sons and grandsons" (*juezi juesun*).

FAMILY AND FAMILY LIFE (JIATING/JIATING SHENGHUO) • 171

Major **rural** and **urban** differences in the Chinese family have existed both prior to and following the establishment of the PRC. With most families residing in the countryside before 1949, the largest and often extended families existed among the wealthy and local officials, while poorer peasant families living off small plots of land were fewer in **number**, with landless laborers and wanderers generally unable to marry and start families. Commercial enterprises in both rural and urban settings were generally small-scale and often based on family and patrilineage, with **clan** and large kinship groups economically and socially predominant, especially in the south. Family ties were also critical in the imperial court where some generally strong emperors kept extended family members at political arms-length out of court affairs and others, often weak rulers, were creatures of ambitious family members relying on them for political advice with appointments to influential official positions. Sacrificing family obligations to the larger public and political good also has a strong tradition in China exhibited by the **legendary** "Yu the Great" (*Da Yu*) who put aside familial concerns, including the birth of a son, during his decade-long struggle to bring the raging waters of the Yangzi and other rivers under control.

The takeover of China by the Chinese Communist Party (CCP) led to a wholesale assault on patrilineage organizations in the 1950s with the enactment of the Marriage Law (1950), undermining the patriarchal system by freeing couples to marry on their own and prohibiting child or forced marriage, the sale/purchase of infants, and **concubinage**. Assaults on the family occurred during the **Cultural Revolution (1966–1976)**, as children were pressured to denounce parents from "bad" (*huai*) **class** backgrounds and accused of political crimes, with some youngsters declaring, "CCP chairman **Mao Zedong** was closer to us than our parents." Families, especially those subject to political attack, were broken up, while family genealogies and **ancestral** tablets were systematically destroyed by rampaging Red Guards, along with altars and **temples** devoted to **ancestor** worship. Political considerations often dictated marriages, for example, urban intellectuals "sent down to the countryside" (*xiaxiang*) conjoined with local peasants, while peer-to-peer marriages were consummated at the workplace, mainly to provide protection, with the family emerging tattered but intact from the chaotic decade.

In the absence of any family planning during the rule of Chairman Mao Zedong and state agricultural policies beginning with the establishment of people's communes (*renmin gongshe*) in the Great Leap Forward (1958–1960), incentivizing larger families, including income-producing child laborers, family size increased, leading to the adoption of the **one-child policy** (1979–2015). Severe gender imbalance was also evident in rural families, with boys substantially outnumbering girls due to high rates of abortions, female infanticide, and disposing of baby girls in "orphanages" (*gu'eryuan*), with China the only country in the world with higher **suicide**

172 • FAMILY AND FAMILY LIFE (JIATING/JIATING SHENGHUO)

rates among **women** than **men**, three times greater in rural areas than in cities. Domination of the urban economy by large state-owned enterprises (SOEs) with limited residential space led to smaller Chinese families in urban areas, as wives often worked outside the family, although children, unlike their rural counterparts, generally did not contribute to family income.

The introduction of economic reforms and social liberalization (1978–1979) produced equally important changes in rural and urban families, including continuous diminution of authority for the father and parents in general, along with the dramatic impact of accelerating divorce rates. Rural laborers, both male and female, made superfluous by the Agricultural Responsibility System introduced in the 1980s, migrated into cities in search of work, leaving children behind to be raised by grandparents or other relatives, with only periodic visits during special **festivals and holidays**, especially the family oriented **Spring Festival**. One of the major changes in urban families, especially those with higher incomes, is separation from grandparents, with 70 percent of people age 60 and older in major cities living on their own and 67 percent of polled couples indicating a general satisfaction with married life.

New familial phenomena include "DINK families," meaning "double income, no kids" (*shuang shouru meiyou haizi*), and "4–2–1 families" (*si, er, yi jiating*), referring to four grandparents, two parents, and one child, the result of both the one-child policy and the high cost of urban living space and **education**. Family disputes, especially in larger extended families, still evident in rural areas, often involve the mother and daughter-in-law relationship, long a source of tension in Chinese families. With sons and mothers often close, following marriage the mother and daughter-in-law often compete for love of the son–husband. Considering themselves as "master of the house" (*fangzhu*), wives usually oversee household finances, while wealthier families often treat their live-in servants as unofficial family members deserving of protection and support, especially after retirement. Bound by law and **custom** to support aged and **disabled** family members, households often pool income, with the individual's standard of living dependent on the number of family wage earners and dependents.

Importance of family is evident in the many idioms and "**four-character idiomatic phrases**" found in the Chinese **language**, for example, the adage that "couples must respect each other as noble guests" and the lure of family life described as "falling leaves returning to the root of the tree." Different terms exist for older and younger siblings, with *gege* and *jiejie* for older males and females, and *didi* and *meimei* for younger brothers and sisters. All relations on the maternal side are prefixed by the word *wai*, meaning "outside," indicating that marrying into a family does not confirm full membership. Family terminology is also evident in the political realm, with *guojia*, "state," literally meaning "national family," and CCP chairman Mao Zedong

FASHION (SHISHANG) • 173

sometimes referred to as *Mao yeye*, "grandfather Mao," with policemen often called *shushu*, "uncle," especially by small children. Specific terms also exist for close family relatives, namely *bobo* for father's older brother; *shushu* father's younger brother; *jiujiu*, mother's brother; *gufu*, husband of the father's sister; and *yifu*, husband of the mother's sister.

FASHION (*SHISHANG*). Slated to become the largest fashion and apparel **market** in the world in 2020, China has a long history of elegant fashion for both **men** and **women** from imperial times to recent decades in the People's Republic of China (PRC). Popular brands of casual and formal wear include major foreign designers, largely European and American, selling to higher-income buyers, while domestic fashion designers and producers offer increasingly appealing simple and clean-cut lines targeting an ever-expanding mass market.

Historically, fashion in China was shaped by the various dynasties, domestic and foreign, with male and female **clothing** often indicating social status and official rank, especially for men. Common styles included robes for men with a variety of headwear, while women, especially in the higher classes, wore long gowns with "large sleeves" (*daxiushan*) and silk shoes, with the color red generally preferred, as yellow was reserved for the imperial family. Some styles, for example, the narrow, ankle-length skirt for women, date to the ancient Shang Dynasty (1600–1046 BCE), with subsequent dynasties having an enduring impact, beginning with the Han Dynasty (202 BCE–220 CE) and the introduction of crossed collars, right lapels, and sashes, with black and then red the preferred **colors**, and later referred to as *Hanfu*, literally "Han clothing."

During the highly cosmopolitan Tang Dynasty (618–907), Central Asian styles and colors assumed great influence, with high-class women wearing looser-fitting and more revealing dress, along with exotic silk shoes, while more conservative and plain dress generally dominated the subsequent Song Dynasty (960–1279). Outside influences continued during the subsequent Yuan Dynasty (1279–1368) of the Mongols, with the introduction of furs, leather, and sheep skin, along with double-sided coats for easier horse riding. While traditional styles of status-determined robes and long gowns regained prominence in the Han-dominated Ming Dynasty (1368–1644), external influences reappeared in the Manchu-dominated Qing Dynasty (1644–1911), when early versions of the *qipao*, imported from Manchuria and also known as the cheongsam, began to replace more traditional female styles, in addition to the introduction of "flower pot shoes" (*huapenxie*) with middle high heels that made walking difficult.

Appeal of fashionable dress continued into the modern era, as designs combining traditional Chinese and Western styles became enormously popular in the 1930s and 1940s, especially in **Shanghai**, which with its cultural

174 • FASHION (SHISHANG)

hybridity became known as the "Paris of the East." Fashion lines for women were transformed from the looser styles of the past to a more **body**-hugging fit, epitomized by the elegant and more revealing cheongsam, with its high collar and split skirt, as courtesans from **dancing** hostesses to film stars clad in glamorous dresses appeared in city nightclubs and other **entertainment** hot spots. Considerable sartorial inventiveness of casual dress exuding Western influence was also shown by the many writers, **artists**, and students residing in the highly cosmopolitan city.

Following the establishment of the PRC in 1949, under the one-party rule of the Chinese Communist Party (CCP), fashion largely disappeared, including from the once-elegant Shanghai, as European and American designs, including high-heel shoes, were frowned upon. Direct assaults on fashionable and generally Western-style wear by women and men was especially pronounced during the hyper-radical and sartorially dull **Cultural Revolution (1966–1976)**, when drab, military-style green and brown wear was the clothing of choice among Red Guards and other rabble-rousers.

Gradually restored following the introduction of economic reforms and social liberalization (1978–1979), the fashion industry appealed to a growing middle class, especially in coastal cities, where high-end walkway designs and street fashion became enormously popular, propagated by such fashion magazines as *Ray Li* and websites like Yoka.com. Internationally proclaimed Chinese designers include Shanghai Tang (**Hong Kong**), NE-Tiger, Guo Pei, and Laurence Xu (Paris), along with such global fashion leaders as Armani, Chanel, Christian Dior, Gucci, Hermes, Louis Vuitton, Miu Miu, Prada, Tiffany, and Versace. Luxury fashion is especially appealing to young, up-and-coming Chinese consumers wanting to stand out rather than blend into a crowd, with foreign designer Estée Lauder creating new lines just for the Chinese **market**.

Along with major global fashion centers the likes of Paris, London, Milan, and New York, China hosts a "fashion week" (*shizhuangzhou*) twice a year where such popular foreign and inexpensive brands as Uniglo (Japan) and Zara (Spain) are unveiled, along with new Chinese designs and brands the likes of Bosideng, Me & City, Peacebird, Urban Revivo (known as "China's Zara"), and Ochirly. Supported by e-commerce giant Alibaba and led by Generation Z, born in the 1990s, avant-garde fashion brands include the following: Particle Fever, high-end sportswear; Angel Chen, wide-cut baggy garments; Shushu/Tong, girlie aesthetic by "Shanghai's sweethearts" (*Shanghai tianxin*); Fake Natoo, sustainable garments from reused material; and Ms Min, sleek and sophisticated silk shirts and blouses, with models the likes of the famous An Tiantian and the 71-year-old Yang Guang, affectionately known as "Granny Sunshine," engaging in so-called speed posing for photographs, wearing as many as 500 dresses a day.

Fashion-conscious consumers in the PRC are also drawn to "street styles" (*jietou fengge*) based on individual tastes as opposed to current "trendy" (*chao*) fashion worn by ordinary people. First introduced in the United Kingdom, two street styles dominate the Chinese market, the angelic "little freshness" (*xiao qinxin*) and the more serious "heavy flavor" (*zhong kouwei*), a term originally coined to describe certain kinds of **food**. The former sports light **colors**, cotton and linen material, canvas shoes, and images with vintage effects, while the latter is characterized by dark and bold colors, stimulating the senses and conveying dramatic, sexy, and evil effect, with models often striking angry poses.

Recent fashion trends among men include snug-fitting pants and simple jackets with cutout prints. Graphic floral, **animal**, and graffiti designs are popular among women, who are also known to dress like a man in suits and ties while mimicking the dramatic styles of their grandmothers and mothers from previous eras. Especially eye-catching are the sleeveless and backless halter top for women based on the traditional *dudou*, literally "cover the belly"; undershirts, along with plum-blossomed *qipao*; and jackets and tweed culottes with **Chinoiserie** silk lining. Many young Chinese designers honed their skills in the corridors of London College of Fashion, the Royal Academy, Central St. Martins, and Parsons, with a search for a new Chinese identity encompassing every influence of their country's rich history, at the heart of their pursuit of pride and cultural experimentation.

FATE AND DESTINY (*MINGYUN/FANGDANG*). Traditionally believed to be set at birth under the profound influence of star constellations and the "heavenly stems" (*tiangan*) and "earthly branches" (*dishuzhi*) of the ancient Chinese calendar, fate in Chinese culture is seen to be knowingly and predictably different from destiny, which is the finale of life's ambitions. Traced to ancient philosophies of **Confucianism** and **Daoism**, along with **Buddhism**, and important to both elite and folk culture, fate in China was generally used to interpret one's status of social interaction. Neither negative nor passive, fate combines two seemingly contradictory notions of *ming*, also translated as "destiny," with *yun*, meaning "**fortune**" or "good luck," with one's understanding of fate leading to generally beneficial results, for instance, winning at **gambling**. Knowing one's fate saves a person from trying to move down a blocked and obstructed road. Often confused with "fatalism" (*suminglun*), which sees life's outcomes as dictated and beyond human affect, fate involves boundaries within which people can shape their lives through personal actions and efforts.

Fate imposes constraints on people's lives but does not rob one of personal control or responsibility. Of the five major areas of influence determining life's outcomes, fate is the most important, followed by forces of **fengshui**, "luck" (*yunqi*), **virtue**, and **education** and "effort" (*dushu*), with the calcula-

176 • FEAR AND ANXIETY (KONGJIU/JIAOLÜ)

tion of fate carried out by astrology and the **Zodiac**. A related concept is *yuanfen*, the binding force uniting two people in a serendipitous relationship resulting from fate and destiny, which also serves as a coping mechanism to combat anxiety. That a couple may be fated to meet but not end up together is, in the Chinese view, an example of how one can "have fate without destiny."

FEAR AND ANXIETY (*KONGJIU/JIAOLÜ*). A collectivist society, China displays culturally unique forms of fear and anxiety intimately influenced by **relations** with larger groups, including **family**, the **workplace**, and ethnicity, with major differences existing between genders. Along with conventional fears of illness, **death**, accidents, and loss of loved ones, Chinese people exhibit an "other-concerned anxiety," with a major fear of interpersonal rejection or abandonment by groups with which a strong sense of personal identity has been established. In excessive need of approval and acceptance by others, individuals in China are more willing than their Western counterparts to sacrifice personal interests in favor of groups with which they have a functional relationship, which leads to more anxiety. Strict upbringing by parents leads Chinese **children** to display a heightened fear of social evaluation, which generally continues throughout the school years and into adulthood in a society dominated by didactic resolve, including the omnipresent state. More tolerant of socially reticent behavior, China, like most collectivist East Asian societies, suffers from less "social anxiety disorder" (SAD), with dramatically lower rates compared to the West of **suicide**, **drug abuse**, and such mental disorders as depression.

Especially pronounced are differences in the fears and anxieties among Chinese **men** and **women** along several dimensions, including personal well-being, **marriage**, and careers. While the greatest fear indicated by men is not having enough **money** to sustain a good life for themselves and their family, women are generally most concerned with getting older, as the key to female success in China is looking young and beautiful. According to a Chinese idiom, "At 40 man is a flower (*hua*), at 40 a woman is bean curd (*doufu*)," although men evidently fear being single and alone more so than women. Both genders are equally fearful of becoming **sexually** impotent with **age**, as men are concerned about developing a beer belly and women facial wrinkles and gray hair, along with sagging breasts and excess weight. Failure at work and lack of career advancement is a major source of worry for men, while for women a top concern is getting pregnant. Discovery of extramarital affairs by wives is a major fear among wandering husbands, while wives are afraid that said affairs will occur.

"Phobias" (*kongbuzheng*) unique to China include so-called "returning home" (*huijia*) fears among migrant workers and young people, especially during **festivals and holidays**, and the **Spring Festival**, as inevitable and

FEMININITY AND FEMINISM (NÜXING QIZHI/NÜQUANZHUYI) • 177

often embarrassing queries regarding not-so-perfect careers and marital status will be raised by family members. Ongoing problems with restive Islamic groups in China's far western Xinjiang province of the People's Republic of China (PRC) have also led to a growing "fear of Muslims" (*haipa Musilin*) among the dominant Han majority, which, in turn, has been accused of **chauvinism**.

FEMININITY AND FEMINISM (*NÜXING QIZHI/NÜQUANZHUYI*). Shaped by traditional **philosophy**, primarily **Confucianism**, and the centralized and coercive **legal** control of **women** by the imperial Chinese patrimonial state, reigning concepts of femininity in China were transformed by the introduction of largely Western views on the feminine ideal beginning in the late 19th century and by state policies enacted since the establishment of the People's Republic of China (PRC) in 1949. During the period of rule by Chinese Communist Party (CCP) chairman **Mao Zedong** (1949–1976), a socialist model of femininity was pursued characterized by hardworking and politically **loyal** women, as all **sexual** differences with **men**, including **clothing**, were effectively erased. Following the introduction of economic reforms and social liberalization (1978–1979), radical changes in femininity occurred, especially via popular women's magazines, as doctrines of feminism gained influence, particularly in coastal cities among young, generally professional and independent-minded women. An ensuing backlash led by the administration of President **Xi Jinping** (2013–) has called for a return to "traditional family values" aimed at a resubordination of women, with the Chinese version of the "MeToo" movement concerning **sexual harassment** effectively squashed by the virtually all-male **leadership** of the CCP state.

Considered "vexatious" (*wuliqunao*) and "troublesome" (*taoyan*) creatures, Confucian doctrine placed enormous strictures on women, most notably the "three obedience's" (*sange fucong*) of submission to father, husband, and adult son, along with the "four **virtues**" (*sige meide*), involving speech, appearance, work, and personal virtue. Ancient texts like the *Book of Odes* spoke to the desires and longing of women with fairly explicit sexual imagery, but overall the life of a woman historically was embedded in the **family** in their roles as daughters, wives, **concubines**, and mothers. In the powerful **cosmology** of **yin-yang**, females naturally embodied the receptive yin, while the male represented the active yang, imbued with powerful sources of **energy** (*qi*).

The publication of *Women's Paper* (Nü Xuebao), the first magazine exclusively for women, in 1898, marked the beginning of a feminist movement in which the country's modernization overlapped with female emancipation from the strictures of Confucian kinship symbolized by **foot-binding**. Early proponents of a Chinese feminism included Qiu Jin, a young revolutionary clad in male clothing who, in 1906, left her husband and **children** to study in

178 • FENGSHUI (WIND AND WATER)

Japan and, upon her return, called for male–female equality, only to be executed in 1931. A young Mao Zedong joined the fray, denouncing arranged **marriages** in an article for *New Youth* (Xin Qingnian), the flagship publication of the culturally iconoclastic New Culture Movement/May Fourth Movement (1917–1921).

Following the establishment of the PRC, women were granted more choice in marriage with the implementation of the Marriage Laws (1950 and 1981), as Mao proclaimed that "women hold up half the sky" (*nüren ju qi banbiantan*). Yet, for all the pro-feminist hoopla in official propaganda, CCP rule generally reduced women to traditional roles of dutiful wives, mothers, and baby breeders, with female laborers pursuing collectivist public roles portrayed as manlike, unfeminine, and exuding physical "strength" (*qiangdou*). With greater economic and social opportunities afforded by the 1978–1979 reforms, **criticism** of socialist femininity during the Maoist years was voiced in neo-conservative terms as having distorted "natural femininity" (*ziran nüxing qizhi*) of caregiving, self-sacrifice, and family orientation. Contrarily was the advocacy of "power femininity" (*quanli nüxing qizhi*), with calls for women to exhibit more assertive **individualism** and power, serving as a consumerist agency in pursuit of a glamorous and globalized lifestyle.

Heavily influenced by the introduction of such glossy, Western-style magazines as *Cosmopolitan China* and *Elle China*, a truly feminine Chinese woman should pursue a natural, "free" (*ziyou*) human self, fulfilling material and sexual desires with emotions and needs separate from men and the family. Advised to "just be yourself," the strong and self-confident Chinese woman needed to avoid the self-repressive female tendency to focus on pleasing a man and instead "strive for success" unfettered by unending familial obligations and seeking self-realization. Such is not the message in the New Era Women's Schools financed by the current Chinese government, where young women are taught to wear the right amount of makeup and instructed how to sit with stomachs pulled in and legs together. Driving home an antifeminist message, the prominent Weibo account Feminist Voices, was terminated on International Women's Day (8 March), as the crackdown on feminist activists continues as part of a concerted assault on autonomous civil society.

FENGSHUI (WIND AND WATER). A form of Chinese geomancy and "divination" (*bu*) developed during ancient times and influenced by **Daoism**, fengshui is a pseudoscientific concept that claims to use "**energy**" (*qi*) to harmonize individuals with their surrounding environment. One of the Five Arts (*Wushu*) of Chinese metaphysics, the other four being "**mountain**" (*shan*), "medicine" (*yi*), "life" (*ming*), and "appearance" (*xiang*), and traditionally used prior to the invention of the magnetic compass to ascertain the correlation between humans and the universe, the concept of fengshui is

FESTIVALS AND HOLIDAYS (JIE/JIAQI) • 179

employed in modern times primarily to orient buildings, notably burial tombs, to the most auspicious location and **architectural** style. Locations with favorable *qi* and thus good fengshui have shielding mountains, navigable waters, and fertile soil that affect the **health**, wealth, and overall quality of life, including the **family**, by connecting people to and going with the flow in the environment.

Related concepts include the **Five Elements**; **yin-yang**, which is a bipolar expression of fengshui similar to a magnetic dipole; and the "eight trigrams" (*bagua*) espoused as a model for **urban** design and architectural planning. Cities with good fengshui are more believed to produce especially talented people and, in the People's Republic of China (PRC), include cities surrounded by mountains and close to large bodies of water, namely **Beijing**, Nanjing, Hangzhou, Wenzhou, Kunming, Chengdu, **Xi'an**, and Tekes. The last is located in the Kazakh region of far western Xinjiang-Uighur Autonomous Region (XUAR) and is the largest urban area, modeled on the *bagua* in the world, with four concentric circle ring roads and eight roads radiating out from the city center. Fengshui and the *bagua* are also employed in interior design, including individual rooms, with beds put in the all-important "commanding position" (*zhihui weizhi*), facing but not directly in line with the door. Considered by some as a **superstition**, which the Chinese government has generally attempted to stamp out, fengshui lives on as a subject taught in Chinese universities, including prestigious Peking University.

FESTIVALS AND HOLIDAYS (*JIE/JIAQI*). Two types of festivals and holidays are observed in the People's Republic of China (PRC), traditional and official, the former dating to ancient times during the imperial period and the latter to largely political celebrations of PRC history and specific social groups, including **women**, labor, and **children**. Major traditional festivals follow the Chinese lunar calendar, with actual festival dates varying from year to year, while official holidays fall on specific dates according to the universal Gregorian calendar. Linked to religious devotions, **superstitions**, and **legends and mythologies**, with many traced to the Han Dynasty (202 BCE–220 BCE), festivals honor both the living and the deceased, and generally involve performances, **rituals**, and consumption of specific **foods** specially prepared for the observance.

The most important traditional holiday is the **Spring Festival**, the Chinese lunar New Year, occurring from first to the 15th day of the first lunar month, a major get-together during a span of several days for **family** members, with paper cuts symbolizing luck and good **fortune**, and specially prepared Chinese "dumplings" (*jiaozi*) consumed as food. The Qingming, or "Sweeping the Graves," Festival, falling in early April, is the second most important, with family members cleaning and sprucing up **ancestral** graves while children fly kites to bring about good luck. Other major festivals include the

180 • FESTIVALS AND HOLIDAYS (JIE/JIAQI)

Lantern Festival (*Yuanxiao jie*), coming at the end of the Spring Festival, in which paper lanterns are lit and carried, often somewhat dangerously, by children, along with lion **dances** and the consumption of round "rice balls" (*tangyuan*), symbolizing wholeness; the Dragon Boat Festival (*Duanwu jie*), occurring on the fifth day of the fifth lunar month, featuring highly competitive boat races commemorating patriotic poet Qu Yuan (340–278 CE), with the consumption of "glutinous rice dumplings" (*zongzi*); the Mid-Autumn "Moon" Festival (*Zhongqiu jie*), also called the Moon Festival, held on the 15th day of the eighth lunar month, with "moon cakes" (*yuebing*) eaten while gazing at the bright new moon in memory of previous forlorn lovers; and the Hungry Ghost Festival (*Egui jie*), inspired by **Buddhism** and **Daoism**, and occurring on the 15th day of the seventh month, considered the "ghost month" (*guiyue*), when restless spirits roam the Earth.

Official holidays include, most notably, National Day (*Guoqing jie*), on 1 October, commemorating the formal establishment of the PRC in 1949, announced in Tiananmen Square in **Beijing** by Chinese Communist Party (CCP) chairman **Mao Zedong**, with the annual event including elaborate **fireworks** displays and celebratory speeches by national leaders, as well as the following: May Day, 1 May, formally International Labor Day (*Guoji laodong jie*), celebrated by trips to scenic areas and **shopping** sprees in malls; International Women's Day (*Guoji funü jie*), 8 March; Children's Day (*Liuyi ertong jie*), 1 June; Youth Day (*Qingnian jie*), 4 May; and Army Day (*Jianjun jie*), 1 August, commemorating the formation of the People's Liberation Army (PLA) in 1927.

Ethnic **minorities** also celebrate their own festivals, for instance, the famous Water Splashing Festival (*Poshui jie*) of the Dai people in **Yunnan**, celebrating their calendar and separation from the dominant Han people; the Ongkor Festival by **Tibetans**; the Torch Festival (*Huoju jie*) by the Yi and Bai people in Yunnan and **Sichuan**, featuring wrestling and dance shows; and Nadaam Festival in Inner Mongolia, involving horse racing and other competitions. Christmas (*Shengdan*) is also celebrated by Chinese Christians, who constitute 1 percent of the population, with non-Christians treating the holiday as a great **commercial** venture but with the Chinese government imposing restrictions on Christmas decorations and observances as unwelcome "foreign cultural elements" (*waiguo wenhua yuansu*). Celebrations of the **birthday** of the Buddha, 12 May by the lunar calendar, also occur with visitations to Buddhist temples and the burning of incense, while Uighur adherents to Islam celebrate the Carbon Festival, on the 10th day of the second month of the Islamic calendar, with attendance at a mosque, along with singing, **dancing**, and fasting, followed by feasting on slaughtered livestock.

FIDELITY AND INFIDELITY (*BAOZHENDU/BUZHONG*). Reflecting the great respect traditionally given to matrimony in Chinese culture, fidelity in **marriage** is highly valued, although more so by **women** than **men**, but with the highest rate of extramarital affairs in the world. Marriage was treated as supremely important in **Confucianism** as a primary social device for forging alliances among competing **clans**. During the years of rule in the People's Republic of China (PRC) by Chinese Communist Party (CCP) chairman **Mao Zedong** (1949–1976), infidelity was generally unknown, as married couples dealt with severe economic deprivation and social dislocation by "improvising together" (*couhe*), learning to be content with patched **clothing**, bland leftover **food**, and crowded residential housing, maintaining serviceable, if unromantic, unions. Economic progress and growth in personal disposable income following the introduction of economic reforms and social liberalization (1978–1979) has led many husbands to want an "upgrade" (*shengji*) in everything, including women. Mistresses, known as "little third" (*xiaosan*), have been taken on, sometimes in multiples, to show off wealth and power, as divorce, although increasingly common, was messy and often financially costly, and harmful to careers.

Survey data indicate infidelity is unacceptable to 74 percent of women and 60 percent of men but with 35 percent of the latter admitting to extramarital affairs versus 15 percent of the former (2015), with men 13 times more likely to engage an additional partner than women. Reasons given for infidelity include **sexual** deprivation in marriage by men and deficit in love by women, with a general belief that Chinese men always cheat, while fear of being "left behind" (*beiliu xialai*) by unmarried women in their mid-20s make them available for casual sex, especially with wealthier older men. Included were top CCP and military officials unveiled in anticorruption campaigns the likes of security chief Zhou Yongkang, who reportedly had 400 kept women.

Prevalence of infidelity has created a new "mistress dissuader" (*qingfu shoufuzhe*) industry of investigators and even detectives, usually hired by suspicious wives to infiltrate the lives of mistresses and persuade them to break off affairs with their wandering husbands. Once "marriage investigations" (*hunyin diaocha*) have ascertained the existence of said affairs, substantial financial benefits are generally offered to the "little third," although in some cases threats of physical harm have been made by infamous "mistress killers" (*qingfu shashou*). With husbands often unwilling to participate in marriage therapy, considering it a loss of "**face**" and emotional honesty, a taboo in the Chinese **family**, primary pressure is often on the wife to accept a retrograde version of marriage, with compromises carried out between the three parties, as **divorce**, tending to favor men over women, is conveniently avoided. The Institute for Research on Sexuality and Gender at People's University is among the organizations involved in collecting data on marriage.

182 • FILIAL PIETY (XIAOSHUN)

FILIAL PIETY (*XIAOSHUN*). Considered the core cultural value in the Chinese **family** and, by extension, the state, filial piety, also translated as "family reverence," is a virtual **religion** with a strong set of mutual obligations between parents and **children**, and ruler and subject. Idealized in **Confucianism**, with the great philosopher declaring that, "Of all the virtues, filial piety is the first" (*baishan xiao wei xian*), with similar reverence in **Buddhism** and **Daoism**, filial piety involves principles of hierarchy, obligation, and obedience. In return for being born and raised by parents with provision of **food** and **education**, children are obligated to take care of parents in their old **age** and follow proper **rituals** of mourning upon their **death**, with equal respect shown to **ancestors**, including proper care of their graves. With the Chinese character *xiao*, a combination of two characters, *lao* meaning "old" and *zi* meaning "son," appearing on ancient "oracle bones" (*jiagu*), classic texts elaborating on the **virtue** include the *Classic on Filial Piety* (Xiao Jing), attributed to Confucius (551–479 BCE), and the *24 Filial Exemplars* (Ershisi Xiao), compiled during the Yuan Dynasty (1279–1368). Included in the latter are outlandish and exaggerated stories of filial obligation, for example, the father who agrees to bury his son to ensure adequate food for his mother and ends up discovering a pot of gold when digging the child's grave.

Vilified by progressive writer **Lu Xun** (1881–1936), filial piety was targeted for intense **criticism** as a product of archaic Confucian **philosophy** during the culturally iconoclastic New Culture Movement/May Fourth Movement (1917–1921), with participants including a young **Mao Zedong**. Condemned as an example of the "**four olds**" (*sijiu*) in the People's Republic of China (PRC), filial piety was often ignored in modern Chinese families, especially in major **urban areas** following the introduction of economic reforms and social liberalization (1978–1979).

Among the unfortunate consequences of the decline in the obligation is the abandonment of elderly parents, especially in **rural areas**, where migrant couples spend little time at home, leaving their parents to confront aging on their own. Pictures of abandoned elderly have ended up on the Chinese internet, as higher rates of **suicide** among rural elderly have also been recorded, leading to an official reaffirmation of the importance of filial obligations to parents. In addition to republishing the *24 Filial Exemplars*, extensive media coverage has been given to such filial acts as school children **kowtowing** to parents, along with the selection of model "filial children" (*xiaozi*) by local governments.

Propagation of filial values is also apparent at facilities like Modern Filial Piety Culture Museum in **Sichuan**, with exhibits of such stories as two children who towed their mother in a wheel barrel on a tour of hundreds of China's cities to fulfill her dying wish to travel. Party and state officials have

FIVE ELEMENTS (WUXING) • 183

also been advised by President **Xi Jinping** (2013–) to read the classic *Standards for Being a Good Pupil and Child* to shore up their own filial sensibilities.

Whereas providing for material needs of parents was sufficient in the past, filial obligations have expanded to providing for the **spiritual** and mental well-being of aging parents, with married children living nearby and making frequent visits and taking parents on trips. **Legal** obligations to provide assistance to aging parents instituted in 2013, have been criticized as a poor excuse for inadequate social security and poor funding of a medical care system for the elderly in the PRC.

FIREWORKS AND HOLIDAY DISPLAYS (*YANHUA/JIAQI ZHANSHI*). Invented in imperial China during the Tang Dynasty (618–907), reputedly by a monk who filled bamboo tubes with black powder, fireworks were considered a means to scare away evil spirits and mythical creatures, for example, the fire-fearing Nian, while also bringing about good **fortune** and **happiness**. Pyrotechnic displays were presented for the **entertainment** of emperors and at major **festivals**, most notably the **Spring Festival**, marking the lunar new year, a tradition that continues in the People's Republic of China (PRC). Major displays also occur throughout the PRC on National Day (1 October), notably in Tiananmen Square in the national capital of **Beijing**.

The development of a rocket-propelled firework in 1264 eventually led to the invention of gunpowder for use in warfare, which spread to the Arab world and ultimately Europe in the 17th century. Referred to as "Chinese flowers" (*Zhongguo hua*), fireworks in contemporary China are produced primarily in Liuyang city, Hunan, known as the world capital of fireworks, where quality and innovation suffered during the period of central economic planning adopted from the Soviet Union (1953–1978). Revived after the introduction of economic reforms and social liberalization (1978–1979), Chinese-made fireworks dominate the global market, providing 90 percent of supply. Popular holiday displays in China also include giant, brightly lit lanterns paraded during the Lantern Festival (the 15th day of the first lunar month) and hanging of scrolls usually colored red imprinted with the character *fu* for good fortune during the Spring Festival.

FIVE ELEMENTS (*WUXING*). An ancient theory used to describe interactions between all things and phenomena in the universe, Five Elements is short for "five types of **energy** dominating at different times" (*wu zhong liuxing zhi qi*), with "wood" (*mu*), "fire" (*huo*), "earth" (*tu*), "metal" (*jin*), and "water" (*shui*) constituting the fundamental elements in the universe created by the forces of **fengshui**. Dating to the Spring and Autumn Period

(770–476 BCE), the theory is used in **traditional Chinese medicine (TCM)**, **fortune-telling**, and **martial arts**, with broad influences on such cultural realms as **music**. Each element has specific characteristics and is associated with different aspects of nature. Examples include direction, season, **color**, shape, and weather, with astrological connections to certain planets; heavenly creatures, specifically the mythical azure dragon and vermillion bird; "heavenly stems" (*jia, yi, bing* etc.), specific **virtues** like benevolence and propriety; and representative actions like creativity and passion. The cycle of interaction of the five elements proceeds with fire melting metal, metal penetrating wood, wood separating earth, earth absorbing water, and water quenching fire.

Complementary processes, the **yin-yang** of the Five Elements, consist of two forces, "generating" (*chansheng*), which leads to development, and "overcoming" (*kefu*), which controls development. Five separate actions exist for each, namely, fueling, forming, containing, carrying, and feeding for the generating force, and melting, penetrating, separating, absorbing, and quenching for the overcoming force. Interactions of the Five Elements do not exist in a vacuum, but have a substantial effect on the year and its corresponding **Zodiac** sign, with extensive analysis for each of the 12 **animal** signs, from the rat and ox to the dog and pig.

FOLKTALES AND FAIRY TALES (*MINJIA/TONGHUA GUSHI*). Stories written for both the young and old, folktales and fairy tales were used to teach certain admirable values and moral imperatives, especially to **children**, thereby providing China with a self-healing capacity, allowing other cultural forms to be integrated, while maintaining a relatively stable cultural identity and unity. Influenced by **Confucianism**, **Buddhism**, and **Daoism**, along with traditions imported from Central Asia and India, Chinese folklore imparted such values as the importance of keeping promises, respecting elders, aiding the infirmed and weak, and understanding the power of **wisdom**. Especially popular were tales of **gods**, **magic**, "**ghosts**" (*gui*), and **animals**, with the last, especially monkeys, portrayed as possessing human qualities with an ability to speak, reason, and perform human tasks.

The four greatest Chinese folktales selected by the Folklore Movement (*Minsu yundong*) in the 1920s include the following titles, along with a short description of story lines: *Liang Shanbo and Zhu Yingtai*, a legend of two lovers transformed by **death** into butterflies; *Tale of the White Snake* (Baishezhuan), a white reptile becomes a young woman whose husband remains married even after discovering her true nature; *Lady Ming Jiang*, the wife of a laborer on the **Great Wall**, upon learning of her husband's death, cries so heavily that part of the great edifice collapses; and *The Cowherd and the Weaver Girl* (Niulang, Zhinü), two lovers banished to opposite sides of the Milky Way, known as the heavenly river, are brought together on a bridge

FOOD (CANYIN) • 185

built by magpies once a year on the seventh day of the seventh lunar month, becoming Chinese Valentine's Day, also known as the Double Seven or Qixi Festival.

Neglected during the period of rule by Chinese Communist Party (CCP) chairman **Mao Zedong** (1949–1976), folktales and other folklore were revived by the "searching for the roots" (*xungen*) movement of the 1980s. Equally numerous were elaborate and similarly didactic fairy tales and bedtime stories also involving adventures of remarkable humans and creatures possessing transformative and magical powers, with the pleasures of **food** as a popular theme, while glorifying such traditional values as **filial piety**. Well-known titles, among others, are as follows: *The Golden Beetle, Giauna the Beautiful, Nodding Tiger, The Talking Fish, The Two Jugglers, The Golden Nugget, Bamboo and the Turtle, The Bird with Nine Heads, The Moon Cake, The Kingdom of the Ogres,* and *The Mad Goose and the Tiger Forest.* Fairy tale princesses are generally portrayed as beautiful young **women** with long, flowing hair dressed in exquisite gowns and possessing extraordinary talents while capable of infinite love.

FOOD (*CANYIN*). Believing "food is heaven" (*min yi shi wei tian*), with a rich diversity of regional **cuisines**, Chinese people have a great love of **eating**, as food, along with **family** and **money**, has been a cornerstone of Chinese culture and civilization since ancient times. Subject throughout history to severe food insecurity from frequent droughts and floods, access to sufficient food for a large population, numbering 1.4 billion in 2019, has been a major concern of the Chinese state from imperial times to the People's Republic of China (PRC). Obsession with food is a natural reaction to the fear of famine, with the most recent crisis in food supply occurring in the Great Famine (1959–1961) in the midst of the disastrous Great Leap Forward (1958–1960), with estimated **deaths** from starvation of 20 to 30 million people, mostly in **rural areas**.

Food references are omnipresent in such traditional texts as the *Book of Odes* (5th century BCE) and a common theme in **Confucianism, Five Elements** theory, **yin-yang**, and **folktales and fairy tales**, and throughout the Chinese **language**, including the common everyday greeting of "have you eaten yet?" (*ni chi haole meiyou?*). Food is also considered essential to personal **health**, with the kind and amount of food intake affecting individual well-being, as certain foods, for instance, "garlic" (*dasuan*), "ginseng" (*renshen*), "walnuts" (*hetao*), "cinnamon" (*rougui*), and "ginger" (*shenjiang*), constitute major ingredients in **traditional Chinese medicine (TCM)**, with regulation of diet as a preventive measure and even considered as a cure of disease.

186 • FOOT-BINDING (CHANZU)

Divided into five types—cold, cool, neutral, warm, and hot—the overconsumption of any one type can lead to imbalance in the **body**, with attendant physical disorders and illnesses. The "three general categories" (*sanda caixi*) of food include the following: Han/Man (Han and Manchurian ethnicities); Muslim/Kosher, for adherents to Islam; and **vegetarianism**, for followers of **Buddhism**. Good food was especially important to the imperial court, as strict rules governing selection and preparation of the emperor's diet were established in the ancient Zhou Dynasty (1045–256 BCE). Feasts and **banquets** included cuisines from throughout the empire, particularly Shandong and Jiangsu, along with the most accomplished **chefs** and best ingredients, with imperial health a major consideration in food preparation.

In the contemporary PRC, average per capita caloric intake is 3,073, well above the basic minimum standard of 1,020, and double the amount in 1979, when poor agricultural policies and an exploding population limited consumption largely to basic staples. More rational and **market**-oriented policies adopted since the 1980s have provided the Chinese consumer with broader choices of meats, aquatic products, vegetables, and fruits, with declines in the consumption of the staple grains of rice, corn, and wheat. Long considered an **art** form, food preparation was revived dramatically beginning in the 1980s, as popular everyday dishes, especially for the emerging middle class, are as follows: "sweet and sour pork" (*tangcu paigu*), "kungpao chicken" (*gongbao jiding*), "spring rolls" (*chun juan*), "hot pepper bean curd" (*mapo doufu*), several kinds of "dumplings" (*jiaozi, baozi,* and *shuijiao*), "wonton" (*yuntun*), "fried rice" (*chao fan*), "fried noodles" (*chao mian*), "Peking duck" (*Beijing kaoya*), and "hot pot" (*huoguo*).

Ridding China of food insecurity, especially among the rural poor, is a major target of the antipoverty campaigns pursued by the administration of **Xi Jinping** (2013–), with the undernourishment rate in the PRC dropping from 24 percent in 1990, to 9.3 percent in 2015. Small-scale agriculture, especially in rice production, poses continuing food supply challenges, even as the country plans to achieve full self-sufficiency in grains by 2035. **Gifts** of food, especially fruit, are also common, especially during such holidays as the **Spring Festival**, and among couples they are a greater expression of love and affection than hugs and kisses.

FOOT-BINDING (*CHANZU*). The most dramatic demonstration of the subjugation of **women** in China and **symbol** of a woman's commitment to Confucian values of male superiority, foot-binding lasted for 1,000 years until banned by the Republic of China (ROC) in 1912. Inspired by a dancer in the imperial court during the Tang Dynasty (618–907), foot-binding spread to the wealthy classes during the Song Dynasty (960–1279) and by the 19th century had become common throughout China for all but the poorest families, with many ethnic **minorities** rejecting the practice.

FORBIDDEN CITY (GUGONG) • 187

A symbol of Han ethnicity and cultural superiority, particularly over the Mongol and Manchu **barbarians** who ruled China in the Yuan (1279–1368) and Qing (1644–1911) dynasties, foot-binding reputedly improved the erotic appeal of women and thus their prospects for **marriage**. In a process begun during female childhood at age five or six, tight binding was applied to the feet of young girls, modifying shape and size during a period of two years, making extraordinarily small feet, as small as three inches in length, and known as "golden lotus" (*jin lianhua*), the symbol of female refinement.

Associated with excruciating pain, as toes were broken and foot arches strained, the practice had an economic rationale, keeping women securely at home to weave cloth and engage in other income-producing practices, while indicating the **family** was wealthy enough not to employ female labor in the fields. Falling out of favor in the 1930s and opposed by both the ROC (1912–1949) and the People's Republic of China (PRC), foot-binding has virtually disappeared except among elderly women in a few **rural areas**, with the last factory producing the small silk "lotus shoes" (*lianhua xie*) fitted to bound feet closing in 1999.

FORBIDDEN CITY (*GUGONG*). The imperial palace of Chinese emperors during the Ming (1368–1644) and Qing (1644–1911) dynasties, and traditionally considered the absolute "center of the world" (*shijie zhongxin*), the Forbidden City is located on a north–south axis in the national capital of **Beijing**. Constructed during a period of 14 years (1406–1420) by as many as 1 million workers and 100,000 craftsmen on 72 hectares (180 acres) of land, the complex houses 980 buildings, all facing south in accord with principles of **fengshui**, providing protection from cold winds, wandering **ghosts**, and invasions of **barbarians**, all associated with the north. The largest collection of wooden palatial structures in the world, this "city within a city" is also the site of numerous courtyards, waterways, and imperial **gardens** enclosed on all sides by high scarlet walls and a moat.

Considered the earthly version of the heavenly purple palace of the celestial emperor ensconced in the polar North Star with its 10,000 rooms, the Forbidden City, also once known as the "Purple Forbidden City" (*Zijincheng*), is rectangular in shape, with 8,886 bays and rooms, not 9,999, as myth would have it. Divided into the Outer Court and Inner Court, the former is the site for official ceremonial duties of the imperial court, most notably in the Hall of Supreme Harmony (*Taihedian*), where a large plaque above the entrance is inscribed with the imperial motto of "upright, magnanimous, honorable, and wise" (*zheng, da, guang, ming*). The latter "inner court" (*neiting*) is the residential area of the emperor in the "Palace of Heavenly Purity" (*Qianqinggong*) along with a separate residence for the empress in the "Hall of Union and Peace" (*Jiaotai dian*). Additional living quarters in the area also existed for the many imperial consorts, **concubines**, and eu-

188 • FORBIDDEN CITY (GUGONG)

nuchs, the last the only **men** other than the emperor and his male offspring allowed to live in the city. Strict rules governed all matters of living in the Forbidden City with prohibitions against eunuchs leaving the grounds along with rigid rules governing the lives of concubines and even members of the imperial court, especially **women** including the Empress Dowager Ci Xi (1861–1908) who per traditional prescriptions was barred, like all women, from the entire "front court" (*qianchao*) reserved for **ceremonial** purposes and the main Meridian or South Gate.

Known as "forbidden" for the exclusion of ordinary people, entry and exit into the complex were under strict imperial control, with high-ranking imperial officials from throughout the empire attending early morning audiences with the emperor where important edicts were announced. Rooftops consist of glazed tiles in imperial yellow, so smooth that even birds are unable to land, with walls, pillars, and doors painted red, the **color** of joy and **happiness**. Images, **sculptures**, and statuettes appear throughout the complex, including on rooftops, with the most important structures having the largest number of carvings. Especially prominent is the imperial "dragon" (*long*) with five claws, which traditionally served as a **symbol** of water, along with pairs of guardian stone "lions" (*shi*) fronting important buildings and sites.

Damage to buildings, notably the Hall of Supreme Harmony, occurred on numerous occasions, usually caused by fires sparked by lightning strikes, with reconstruction carried out without use of nails or glue, as the structures are held together by a complex system of interlocking wood block joints. Occupied by foreign forces during the Second Opium War (1856–1860) and abandoned by the imperial **family** during the Boxer Rebellion (1899–1901), the city was renamed the Palace Museum (*Gugong Bowuguan*) and opened to the public in 1925, one year after the last emperor, Aisin Gioro Puyi, and his family, were expelled from the complex.

Thousands of cultural relics, including valuable **ceramics and porcelains**, and other cultural treasures, remain within its walls but were removed for safe keeping during the Second Sino–Japanese War (1937–1945). Following the establishment of the People's Republic of China (PRC) in 1949, public access to the Forbidden City was restored and protected from rampaging Red Guards during the chaotic **Cultural Revolution (1966–1976)** by armed guards apparently on direct orders of Premier Zhou Enlai (1949–1976).

Transformed into a major tourist attraction from the late 1970s onward and recognized as a World Heritage Site by the United Nations Educational, Scientific, and Cultural Organization (UNESCO) in 1987, the Forbidden City contains approximately 1.8 million cultural artifacts, with large numbers of them removed to Taiwan by the Nationalist (*Kuomintang*) government of the Republic of China (ROC) in the waning days of the Chinese Civil War

FOREIGNERS AND FOREIGN INFLUENCE • 189

(1946–1949) and displayed at the National Palace Museum in Taipei. A major restoration project to correct the deteriorating conditions in the Forbidden City was inaugurated in 2002, with a projected completion date of 2021.

FOREIGNERS AND FOREIGN INFLUENCE (*WAIGUOREN/WAIGUO YINGXIANG*). Foreign presence and influence have had a major impact on Chinese culture from the imperial era (221 BCE–1911 CE) to the present involving other Asian cultures and **religion**, particularly India, and Western contact, especially from the 19th century onward, with missionaries and **commercial** influences especially strong. Subject to foreign, **barbarian** rule during the Yuan Dynasty (1279–1368) of the Mongols and the Qing Dynasty (1644–1911) of the Manchus, the Chinese empire absorbed multiple cultural influences from abroad through trade and territorial expansion. Among the major port cities was Quanzhou, Fujian, the primary hub of the Maritime **Silk Road**, where foreigners were welcome as residents, including Arab and Persian traders who exchanged spices and incense for such Chinese goods as white **ceramics and porcelain**, made in nearby Dehua and known in the West as "*Blanc de Chine.*" Foreign influences include **food, literature** and the **arts, warfare**, and especially religion, with the introduction of **Buddhism** from India, Islam through Quanzhou, and **Christianity** from the Nestorians. Subject to coercive Western power following the two Opium Wars (1839–1842/1856–1860), Christianity was given free rein to resident missionaries but with relatively few converts, while the percentage of Chinese addicted to opium imported from India reached catastrophic levels of an estimated 90 million people out of a population of 300 million.

Foreign enclaves in such major Chinese cities as **Shanghai** opened the door to multiple but geographically limited influences on popular culture, including **music**, both classical and modern, **dance**, and **architecture**, as Western-style buildings sprang up in foreign concessions throughout coastal cities from Tianjin to **Guangzhou**. Foreign professionals also staffed senior positions in the Chinese government, most notably the newly established Imperial Maritime Customs Administration, a customs tax collection agency, along with the School of Combined Learning that translated major works on international law and world history. Antiforeign sentiment was particularly strong in the north, which, during the violent Boxer Rebellion (1899–1901), led to large-scale massacres of foreign residents, especially missionaries, referred to prejudicially because of their excessive body hair as "hairies" (*maozi*) with their Chinese converts called "secondary hairies" (*er maozi*) and treated most violently.

With the downfall of the Qing Dynasty, Chinese intellectuals looked to the West as a primary source of guidance in the political and cultural realms, especially during the New Culture Movement/May Fourth Movement (1917–1921). American John Dewey became popular through the writings of

190 • FOREIGNERS AND FOREIGN INFLUENCE

Hu Shi (1891–1962) for his **philosophy** of **pragmaticism**, while more radical ideologues, for example, Karl Marx and Vladimir Lenin, provided an economic and political rationale for Chinese backwardness. Russian and Japanese influence was also pronounced throughout Manchuria, including in such cities as Harbin, where significant numbers of foreign expatriates took up residence. Included were White Russians and European Jews fleeing the Bolshevik Revolution (1917) and the rise of Nazis (1933–1945), along with Japanese merchants and officials, especially following the establishment of Manchukuo (1932–1945) as a Japanese puppet state, where modern concepts of **urban** administration and **education** were introduced. American presence, both military and cultural, also grew with the outbreak of the Second Sino–Japanese War (1937–1945), as Americans assumed important positions in such Chinese institutions as Yenching University (later Peking University), headed by John Leighton Stuart, subsequently U.S. ambassador to the Republic of China (1912–1949).

Following the establishment of the People's Republic of China (PRC) in 1949, foreign presence in China diminished considerably with the expulsion of missionaries and most Western businesses, and the persecution of Chinese citizens with substantial foreign contacts. Particularly affected were the realms of education, **entertainment**, and especially medicine, as institutions like Peking Union Medical College lost crucial foreign support from such well-off financiers as the Rockefellers. With the establishment of the Sino–Soviet Alliance (1950–1962), Russian/Soviet presence, along with that of such allied Communist states as East Germany, had substantial influence, ranging from university curricula to piano lessons, as contact with Western countries, particularly the United States, was effectively eliminated. During the intense **xenophobia** of the **Cultural Revolution (1966–1976)**, any form of foreign contact or influence, including novels, plays, and musical scores, was denounced, with foreign embassies subject to attack, including the burning of the British Consulate by rampaging Red Guards in August 1967.

Following the introduction of economic reforms and social liberalization (1978–1979), notably the adoption of an "open-door policy" (*kaifang zhengce*), foreign presence in the PRC was once again allowed, with major cultural influence in multiple areas of the arts and **sciences** but with persistent Chinese–foreign conflicts concerning sensitive realms. Tensions related to religion and **human rights** broke out periodically, with Chinese government crackdowns on Christian missionaries, along with groups, both domestic and foreign, advocating for democratic and open-society principles. In the aftermath of the military crackdown on the prodemocracy movement in **Beijing** and other cities in June 1989, China ratcheted up antiforeign rhetoric, claiming the largely student demonstrations were orchestrated by the "black hand" (*heishou*) of foreign interests, particularly the United States. Similar and even

FOREIGNERS AND FOREIGN INFLUENCE • 191

harsher antiforeign rhetoric gushed forth in the 2010s, with Chinese **accusations** that foreign companies and governments were "plotting" (*mimou*) to overthrow the ruling Chinese Communist Party (CCP).

Singled out was American cultural influence, which one popular blogger, publicly praised by President **Xi Jinping**, claimed was "eroding the moral foundations and self-confidence of the Chinese people," with "hostile foreign forces" engaged in "slaughtering and robbing China" and "brainwashing" (*xinao*) the susceptible population. Foreigners residing in the PRC numbered 600,000 in 2010, according to the National Census, largely in major cities, headed by Shanghai and coastal provinces, with the greatest number in Guangdong, with South Koreans constituting the largest group, at 21 percent (126,000), and Americans, at 12 percent (72,000). That foreigners care only about **money** and smell badly remain common prejudices in contemporary China.

See also VICTIMIZATION (*SHOUHAIHUA*).

FORTUNE AND FORTUNE-TELLING (*CAIFU/SUANMING*). In a society generally lacking belief in a single great creator and ultimate source for order in the universe, fortune and fortune-telling have thrived for centuries in China as ways of dealing with potentially chaotic situations and an unknown future. Traced to ancient times, belief in the vagaries of personal fortune and the power of fortune-telling became widespread, especially during the Ming Dynasty (1368–1644), and persisted into the 20th century, with fortune-tellers patrolling the streets or setting up shop outside **pagodas and temples** offering their services of "divine foresight" (*shensheng yuanjian*) to all comers for a fee. Attacked as a **superstition** in the People's Republic of China (PRC), especially during the **Cultural Revolution (1966–1976)**, popular beliefs in fortune and "good luck" (*zhu haoyun*) were condemned as part of the **"four olds"** (*sijiu*). Public displays of the Chinese-**language** character "good fortune" (*fu*) at weddings and other auspicious events was forbidden, while fortune-tellers were forced underground well into the 1990s when economic reforms and social liberalization (1978–1979) led to a revival of traditional practices.

Multiple **symbols** and representations of fortune and good luck exist in Chinese culture as a means of strengthening or rejuvenating positive **"energy"** (*qi*) and offering cures for ailments drawing auspicious *qi* into the home or workplace. **Animals**, real or mythical, are a common symbol of good fortune, particularly the "four benevolent" (*siren*) creatures "dragon" (*long*), "unicorn" (*qilin*), "phoenix" (*feng*), and tortoise (*wugui*), only the last a real animal believed to possess **spiritual** powers, with "tortoise shells" (*guike*) used for divination, beginning with ancient "oracle bones" (*jiagu*). Most popular is the mythical dragon, associated with imperial power and coming in incarnations, including the "celestial" (*tian*), "spiritual" (*shen*), and "hid-

192 • FORTUNE AND FORTUNE-TELLING (CAIFU/SUANMING)

den treasures" (*fucang*), along with nine hybrid sons of the dragon, for example, the fierce *yazi*, combining wolf and dragon. Other animals include the "flying bat" (*fu*), whose pronunciation in Chinese is a homonym for "fortune" (also *fu*), with the portrayal of five bats together considered a sign of five blessings: **longevity**, wealth, **health**, **virtue**, and a peaceful **death**. Lucky charms include the "three-legged toad" (*sanzu chanchu*) and the two-sided "Golden Cat" (*Jinmao*), with the front, smiling cat symbolizing abundance and protection, and the back, frowning cat holding a broom to sweep away troubles and worries. Also revered are carp and goldfish, as the word for "fish" (*yu*) is a homonym for "surplus" (*yu*), with an entire fish inevitably served at **banquets** during the **Spring Festival** to bring good fortune in the coming year.

Inanimate lucky symbols and charms are numerous and include three Chinese lucky coins; "red envelopes" (*hong bao*), usually containing **money**; "wealth pots" (*caifu guan*); "crystals" (*shujing*); and "mystic knots" (*wujin jie*). Also included are iconic images in **Buddhism**, for instance, statues of the Laughing Buddha with round belly and a big smile. Certain **numbers** are also considered lucky, particularly "eight" (*ba*), rhyming with *fa*, meaning "to prosper," and "nine" (*jiu*), rhyming with *liu*, meaning "flow," with the phrase *liuliu dashun* expressing hope that "everything flows smoothly," while the most unlucky number is "four" (*si*), a homonym of "death" (also *si*). Multiple terms for fortune and luck include *xi*, "gladness," with two of the characters joined together meaning "double happiness," often appearing at weddings, with *youxi* meaning "to have joy," said to couples expecting a child. The word for "auspicious" (*jixiang*) appears on many occasions, along with "**four-character idiomatic phrases**" referring to **happiness**, for example, *jixiang ruyi* and *xiqi yangyang*. The word in Chinese for "orange" (*juzi*) is similar to "happiness" (*ji*), which is why the fruit appears on banquet tables, especially at the Spring Festival. Scrolls with the character *fu* are often deliberately hung upside down, increasing the possibility that good fortune will flow down from heaven.

Six categories of "fortune-telling," *suanming*, literally meaning "fate calculation," exist in China, specifically astrology, calendars, bone-reading, the **Five Elements**, **dream** analysis, and analysis of physical objects, with **feng-shui** masters often serving in the role as fortune-teller. **Body** features examined by the fortune-teller include facial structure in "**face** reading" (*mianxiang*) and "palm reading" (*shou pai*), along with comparison of the client's skin complexion to animals. The so-called "Ziping method" (*Ziping bazi*) focuses on the four pillars of time—hour, day, month, and year of birth—to determine the client's fortune. Still considered by the Chinese government as a superstition, surveys indicate that more than 50 percent of county-level officials in the PRC believe in divination, especially during political campaigns, a legacy of the disruptive era of rule by Chinese Communist Party

(CCP) chairman **Mao Zedong** (1949–1976). Fengshui masters routinely set up shop in cities, including the national capital, **Beijing**, near the famous Lama Temple, offering to "guide your future and change your fate," with the most famous and expensive masters secretly contacted by high-level government leaders for advice on a variety of issues, for example, dates and places of major infrastructure projects and events.

"FOUR OLDS" (*SIJIU*). Consisting of "old **customs**, culture, habits, and ideas" that had purportedly "poisoned the minds of the people for thousands of years," the "four olds" were targeted for destruction in August 1966, during the early stages of the **Cultural Revolution (1966–1976)**. With Red Guards and other groups mobilized to "smash the four olds" (*posijiu*), traditional and foreign **literature** and the **arts**, including props and costumes from **Peking opera** and valuable classical **paintings**, were singled out for destruction, along with so-called "feudal" (*fengjian*) **architecture**, including **religious** temples, churches, and mosques. Ancient archways, historical monuments, and even graveyards of Chinese and **foreigners** alike were damaged, notably an attack on the **family** graveyard of Confucius in the birthplace of the great philosopher in Qufu, Shandong, where locals rebuffed rampaging gangs, intent on wreaking major desecration.

Singled out was anything that reeked of traditional and foreign influence, for instance, **clothing** and **hairstyles**, sheath dresses, high heels, and short skirts worn by **women**, and narrow trousers and long hair worn by **men**, with tradition-bound elderly, including old women who had suffered from **footbinding**, subject to especially insulting public **humiliation**. Operating according to the principle that Chinese tradition was primarily responsible for the country's economic backwardness, a theme pursued in China since the New Culture Movement/May Fourth Movement (1917–1921), calls were also made for the creation of notoriously vague "Four News" (*Sixin*). Revolutionary "model works" (*yangbanxi*) in **dance**, **opera**, and **song** were introduced, although the new forms were often stylistically similar to the condemned "forbidden works" (*jinshu*) they were intended to replace.

Temporary and fleeting, with participants often merely parroting the official political line of the Chinese Communist Party (CCP), "smashing" (*dapo*) often amounted to no more than changing names of roads and shops, with individual participants adopting such new, more revolutionary given names as *zhihong*, meaning "determined red." Renowned historical sites like the **Forbidden City** were afforded armed protection, while the biggest change among common people was in becoming less polite, with such traditional events as weddings and **funerals** made simple. Also denounced was so-called "black literature" (*heise wenxue*), although an official blacklist was never issued, as an estimated 7 million books, classical Chinese and foreign,

194 • "FOUR-CHARACTER IDIOMATIC PHRASES" (CHENGYU)

were looted from private and public **libraries**. While book burnings took place, many volumes were retained and exchanged among clandestine reading groups, with Russian and French literature especially popular.

"FOUR-CHARACTER IDIOMATIC PHRASES" (*CHENGYU*). Traditional expressions and phrases in the Chinese **language** usually consisting of four characters or words, *chengyu* number in the thousands, containing the collective wisdom from ancient times and previous generations. Derived from the classical texts of **Confucianism**, along with **poetry**, novels, and even a few Western sources, the phrases, while generally following the grammatical rules of outmoded "classical Chinese" (*wenyan*), have been incorporated into everyday vernacular popularized in China by the language reform movement during the New Culture Movement/May Fourth Movement (1917–1921). One of four types of formulaic expressions, including "collocations" (*peizhi wenjian*), "two-part allegories" (*liang bufen yuyan*), and "proverbs" (*yanyu*), *chengyu* often employ somewhat obscure historical and cultural metaphors and allusions to convey moral concepts and admonitions. Major classical sources include *Zuozhuan* (Commentary of Zuo), a primary source on ancient Chinese history with commentary on the *Chunqiu* (Spring and Autumn Annals) by Confucius; *Shiji* (Records of the Grand Historian), compiled during the Han Dynasty (202 BCE–220 CE); and the *Shijing* (Classic of Poetry), also known as the *Book of Songs*, a text attributed to Confucius, with more than 300 works, many in *chengyu* form from the ancient era.

Examples of highly metaphorical *chengyu* with literal and implied meaning include the following: *pofu zhenzhou*, "break the pot and sink the ships," or point of no return; *guantian lixia*, "melon field beneath the plums," or appearance of impropriety; *bingshan yijiao*, "one corner of an ice mountain," or tip of the iceberg; *zhilü weima*, "call a deer a horse," or deliberately misrepresent; and *lebu sishu*, "so happy to forget Shu," to indulge in pleasures. The top five most popular *chengyu* with clear-cut meanings in reverse order are as follows: *lisuo dangran*, or "go without saying"; *quanli yifu*, or "give it your all"; *xinxue laichao*, or "spur of the moment"; *luanqi bazao*, or "total mess"; and *buke siyi*, or "amazing." See the glossary for an extensive list of *chengyu*.

FREEDOM (*ZIYOU*). In a society where the collective from **family** to the state has generally prevailed over individual interests, the concept of freedom remains alien, especially in the political realm, but with greater freedom of choice possible in the economy and nonpolitical realms of society, especially from the late 1970s onward. Leading exponents of reform in early 20th-century China were clear that freedom in the Western, individualized sense was not possible with influential journalist Liang Qichao (1873–1929), as-

FREEDOM (ZIYOU) • 195

serting "freedom for the group, not freedom for the individual," as national power and modernization were the dominant goals. Reinforced by the rise of the Chinese Communist Party (CCP) and the establishment of the People's Republic of China (PRC) in 1949, as a one-party state, strict constraints were imposed on many realms of life impacting the individual, from **clothing**, to speech, to **education**, to **cinema and film**, to **literature** and the **arts**, to **religion**, especially during the period of rule by CCP chairman **Mao Zedong** (1949–1976).

Among the social realms granted greater freedom was **marriage**, as traditional arranged and childhood marriage practices were outlawed by the first Marriage Law (1950), with individuals free to choose their spousal partners and divorce made easier, especially for **women**. Overall, crushing **conformity** was imposed, especially in **urban areas**, during the **Cultural Revolution (1966–1976)**, when any suggestion of individual freedoms in **thinking** and personal preference, for instance, in **music**, was subject to wholesale denunciation and public **humiliation**, with every realm of the national economy under firm state control.

Following the introduction of economic reforms and social liberalization (1978–1979), wider freedoms were made available as the Chinese government withdrew from various realms, most notably the economy, where private **businesses** could be established, notably a functioning stock market, where limited shares are freely bought and sold. Activities previously under tight state control were freed up, including academia, cinema and film, clothing, literature and the arts, travel, and celebrations of **festivals and holidays** (including Christmas). Religious freedoms were also expanded, particularly for such native Chinese faiths as **Buddhism** and **Daoism**, with some restrictions retained for Christians, especially Catholics as a result of continuing disputes between the PRC and the Vatican on the selection of priests, effectively resolved in 2018.

Red lines include restrictions on press reportage, especially involving **criticism** of government policies in highly sensitive areas like **human rights**, although former and retired senior leaders exercise some latitudes in voicing criticism, as do professionals and academics at closed conferences and symposia on such controversial topics as the widely used **death** penalty in the PRC. While the emergence of the internet, with chat rooms and websites, offers greater opportunity for freer expression by ordinary people, government efforts at **censorship**, especially under the administration of President **Xi Jinping** (2013–), have imposed tighter controls. Greater restrictions are also apparent in the press and in academia, where commitment to the "freedom of thought" in university charters of such prominent institutions as Tsinghua University (**Beijing**) and Fudan University (**Shanghai**) have been removed and replaced with pledges to obey the **leadership** of university CCP committees. Despite **legal** guarantees for various political and social free-

196 • FUNERALS AND BURIAL CUSTOMS (SANGZANG XISU)

doms in the state constitution, including religion, government crackdowns on Muslims in the Xinjiang-Uighur Autonomous Region (XUAR) indicate that the future of many freedoms perceived as threatening in the PRC appears rather bleak. Common throughout both **urban** and **rural areas** and considered the sacrosanct realm of afterlife for the deceased, tombs were to be free of any disturbances which led to persistent opposition to railways with their noise and black smoke along with other modern technologies throughout much of the 19th century.

FUNERALS AND BURIAL CUSTOMS (*SANGZANG XISU*). Associated with Chinese folk **religion** in a society with a prevailing belief in the afterlife, funeral and burial customs in China are highly elaborate, with major differences based on **religion** and character of the deceased, including **age**, marital status, and cause of **death**. Ancient imperial tombs are among the most magnificent in the world, notably the mausoleum of Qin Shihuang, first emperor of the short-lived Qin Dynasty (221–206 BCE) and unifier of the Chinese empire, with the still-unexcavated tomb surrounded by the massive Terracotta Army of approximately 8,000 soldiers, located near **Xi'an** in Shaanxi. Equally magnificent are the 13 imperial tombs of the Ming Dynasty (1368–1644) and the Eastern and Western tombs of the Qing Dynasty (1644–1911), both located near **Beijing** and based on the precepts of traditional Chinese geomancy and **fengshui** principles.

Funeral and burial practices among the general population begin with vigils by **family** over a dying person to the very last moment of life, referred to in Chinese as *shouling*, as the final act of **filial piety**. Funeral preparations begin prior to death, including choice of an auspicious date for the funeral according to the Chinese Almanac, with notices to relatives and friends, as any error or flaw in the rites and procedures will plague the family of the deceased with bad luck and future disasters. With the **body** of the deceased dressed in formal attire, the dress of mourners is somber, usually black, with a white flower worn, as white is the **color** of death throughout Asia, with the mourning period lasting from seven to 49 days, during which time somber dress among family continues. Decorations of the funeral hall include white banners and appropriate Chinese **"four-character idiomatic phrases"** (*chengyu*) fitting the occasion, with offerings of **food** to the living and the deceased, and the burning of incense and spirit paper to accompany the "soul" (*hun*) to the afterlife. All-night vigils by family members include pictures of the deceased, flowers, and candles, while statues in the home are covered with red paper, with mirrors removed to avoid seeing images of the casket, which invites another death.

Funerals for the deceased age 80 and older are less somber, with pink, not white, the prevailing color, while elders show less respect for death of a younger person, especially an unmarried male, and complete silence for an

FUNERALS AND BURIAL CUSTOMS (SANGZANG XISU) • 197

infant child. Funeral processions are traditionally led by a band playing **music** to drive away evil spirits, with mourners wearing a sleeve band, left for a male, right for a female, during the mourning period. Professional mourners are often hired to provide the appropriate level of grief, with Buddhists bringing a small statue of the "Delivering the Departed Spirit" (*Yuedu Wangling*) to accompany the deceased on the rough road to the afterlife, with coffins appropriately designed for the harrowing journey. With land increasingly dear in Chinese cities, inhumation is increasingly rare, with cremation occurring in 45 percent of deaths recorded in 2014, a practice that became widespread during the chaotic **Cultural Revolution (1966–1976)**, with tomb stones banned outright. In a display of international Communist obligations, the PRC paid for upgrades to the tomb of Karl Marx (1818–1883) located in Highgate Cemetery, north London.

G

GAMBLING AND GAMING (*DUBO*). A popular pastime and primary source of **entertainment**, high-stakes gambling and low-stakes gaming have been prevalent throughout Chinese history, with gambling seen as means to garner great wealth and serve as a major source of government revenue. Traced to the Spring and Autumn Period (770–476 BCE), with the first appearance of "dice" (*shaizi*), gambling spread from the upper classes throughout society, including the countryside, especially from the prosperous Tang Dynasty (618–907) onward. Virtually every dynasty in Chinese history imposed periodic bans on gambling backed by threats of severe **punishment**, for example, the chopping off of hands, but with little to no effect, as cash-strapped local governments depended on gambling to finance crucial public services.

Similar prohibitions were issued during the period of rule by the Republic of China (ROC) on the mainland (1912–1949) but with illegal gambling flourishing, especially in the coastal areas of Fujian and Guangdong. Wealthy cities like **Shanghai** were centers of gambling in nightclubs and bars, as local entrepreneurs joined up with criminal **gangs**, associated **secret societies**, and **corrupt** officials throughout the 1930s and 1940s. Following the establishment of the People's Republic of China (PRC), all forms of gambling were considered a major "social evil" (*shehui xie'e*) and banned immediately. Harsh crackdowns were carried out by the government of the Chinese Communist Party (CCP), especially during the **Cultural Revolution (1966–1976)**, including on purely social games the likes of "mahjong" (*majiang*). Individuals prosecuted for illegal gambling and bookmaking were sent to camps for reeducation through labor beginning in 1957, while the introduction of economic reforms and social liberalization (1978–1979) led to the spread of illegal casinos, numbering 30,000 by the 2000s, along with popular online gambling sites. **Legal** gambling is allowed in the former Portuguese colony and current special administrative region (SAR) of Macao, which, with 41 casinos, along with greyhound dog racing, **sports** betting, and lotteries, attract millions of gamblers annually, many from mainland China, making the city the largest gambling center in the world.

200 • GAMES (YOUXI)

The popularity of gambling in Chinese society is linked to the widespread belief in **fortune**, good luck, and **superstition**, with the successful gambler exuding an aura of control and use of the supernatural powers of **fengshui**. Preferring table games involving social interaction to singular gambling outlets like slot machines, Chinese gamblers range from wealthy high rollers frequenting Macau, **Hong Kong**, and such international gambling venues as Monte Carlo to small-timers often composed of elderly **women** and even **children**. Games of wager originating in China include an early form of "keno" (*jinuo*), known as "white pigeon ticket" (*baigepiao*), and "Fish, Prawn, and Crab" (Hoo Hey How in the southern Fujian Hokkien dialect), played with three dice featuring pictures instead of **numbers** and similar to Crown and Anchor in the West. Various games of "cards" (*pai*), for example, *Zheng Shangyou* (Struggling Upstream) and *Bao Huang* (Protecting the Emperor), originated in China, along with games involving "dominoes" (*gupai*). Included were *Pai Gow* and *Tian Gow* and *Fanting*, the last a game of pure chance, with similarities to "roulette" (*luopan*), with all three still played in Macao casinos. Other betting opportunities imported from the West beginning in 1840 include "poker" (*puke*), "horse racing" (*saima*), "Baccarat" (*Baijiale*), and roulette. Although gambling disorders and addiction have grown substantially along with growing prosperity in the PRC, no national program of prevention and treatment exists.

GAMES (*YOUXI*). Dating back hundreds and in some cases thousands of years, nonwager games come in various forms in China for both adults and **children**, with board games particularly popular in both the imperial and modern eras. Most notable is *weiqi*, literally "board game of surrounding," the oldest continuously played board game in the world for 5,000 years, known in Japan as "Go." Considered by Confucius (551–479 BCE) as one of the four ancient **arts** to be mastered by the "gentleman" (*junzi*) and involving two players, *weiqi* is an abstract strategy game employing black and white beads, known as "stones" (*shi*), with the winner claiming the most territory and "capturing" (*buzhuo*) rival stones, surrounding them on all orthogonally adjacent points. Also popular is *xiangqi*, known as Chinese chess, representing a battle between two armies, with the object of the game to capture the opposing general. Using flat camembert-shaped pieces with imprinted Chinese characters, areas on the playing board known as "rivers" (*heliu*) and "palaces" (*gongdian*) restrict, or enhance, the movement of some pieces, which are placed on the intersection of board lines.

Other popular games include "tangram" (*qiqiaoban*), literally "seven boards of skill," a dissection puzzle in which seven flat "shapes" (*tang*) form special figures using all seven pieces, which cannot overlap; "mahjong" (*majiang*), commonly played by four players and employing 144 tile-based Chinese-**language** characters, forming a symbolic universe depicting the

winds, seasons, and the noble **plants** of Confucianism, with the object of the game to collect the highest-scoring combination of tiles; *fangqi*, a strategy board game brought to China from Central Asia and similar to the Nine Men's Morris checkerboard game; *liubo*, made up of six game pieces moved around points on a square board, similar to *xiangqi*; *Shengguantu*, "Promoting Officials," a game in which players adopt the role of government officials, with the goal of achieving the highest promotion and monetary gain, and used to train people for actual civil service; and *Sanguoqi*, "Game of the Three Kingdoms," a three-player variant of *xiangqi* replicating the various tactics and battles pursued by famous military figures, for example, the notorious Cao Cao (155–220), during the contentious historical period of the Eastern Han Dynasty (25 BCE–220 CE), followed by the Three Kingdoms (220–280).

Games specifically designed for children include "Pong Hao K'I" (*Kudangqi*), a traditional board game used for childhood **education**, along with other more active forms of recreation, for instance, kite flying, hide-and-seek, and juggling the diabolo, a rotating hollowed-out piece of bamboo twirled on the end of a rope. Also played is stone balls, consisting of small stones shaped into balls and kicked along by players, dating to the Qing Dynasty (1644–1911) and included by the People's Republic of China (PRC) in the National Ethnic Group Sports Events.

See also ENTERTAINMENT (*YULE*).

GANGS AND SYNDICATES (*BANGPAI/XINDIJIA*). Prevalent throughout Chinese society in both **urban** and **rural areas**, gangs and syndicates are especially active at the local level, where central government authority has been limited in both the imperial and modern eras. So-called "Mafia-style gangs" (*heishou dang*), literally "black-hand gangs," are involved in multiple criminal activities, from the most serious, including **drug** trafficking, kidnapping, possession of firearms, and "blackmail" (*qiaozha*), to the lesser but still illegal activities of underground banking, illegal mining, harassment, smuggling, and **prostitution**. Traced to the 18th century, with the formation of the "Heaven-Earth Society" (*Tiandi Hui*), initially a fraternal organization, the group spread and subsequently fragmented into the "Three Harmonies Society" (*Sanhehui*), adopting the **symbol** of a triangle with images of swords and ultimately becoming the Triad **secret society**, with extensive criminal activities.

Suppressed in the early years of the People's Republic of China (PRC), gangs like the Triads largely escaped to **Hong Kong**, Macau, and other cities with a global reach. On the mainland, gangs are divided into two groups, the loosely organized "dark forces" (*hei'an liliang*) and the more mature and well-organized "black societies" (*heiren shehui*), which often operate with police protection backed by **corrupt** Chinese Communist Party (CCP) offi-

202 • GARDENS AND GARDENING (HUAYUAN/YUANYI)

cials. Cities in the PRC with the most extensive criminal activities include **Chongqing, Guangzhou, Shanghai**, Shenyang, Shenzhen, and Tianjin, where private companies and firms often act as **legal** fronts for organized **crime**. Combined with towns and villages at the county level and below, where collusion is rampant, with local officials often providing a "protective umbrella" (*fanghu san*), the number of individuals involved in criminal activities was estimated at 1.5 million in 2000, an increase from 100,000 in 1986, with kidnapping of young **children** particularly problematic.

Periodic government crackdowns on gangs and criminal activity involve coordinated action among police, prosecutors, and nongovernmental organizations (NGOs), most recently in 2018, when criminals were urged to turn themselves in and citizens called on to report suspects. Yielding 79,000 arrests, the campaign was officially described in highly politicized terms as a "people's war" (*renmin zhanzheng*) to shore up CCP legitimacy in running the country.

GARDENS AND GARDENING (*HUAYUAN/YUANYI*). Evolving during a period of 3,000 years, Chinese gardens consist of vast enclosed parks built by a string of emperors largely for pleasure and to impress visitors, along with more intimate and smaller venues created by **scholars** and former government officials as places for calm contemplation and escape from a hostile world. An idealized, miniature version of natural landscapes of **mountains** and lakes, Chinese gardens consist of highly stylized creations of ponds, rocks, **flowers**, plants, and trees, combined with an assortment of halls and pavilions connected by winding paths and surrounded by walls. Consistent with the major philosophical principles of **Confucianism** and **Daoism**, gardens are designed as a visual and aesthetic expression of the **harmony** between humanity and **nature**, with the first reference to such man-made landscapes appearing on ancient "oracle bones" (*jiagu*).

Beginning with the Shang Dynasty (1600–1046 BCE), the first enclosed parks were **hunting** grounds for wild game by kings and nobles, while also serving as agricultural lands for raising vegetables and fruits. Lavishly decorated gardens, notably the Terrace of Shanghua, were built during the Spring and Autumn Period (760–476 BCE), while during the Qin Dynasty (221–206 BCE) the Lake of the Orchids garden was built as a replica of the mythical Isle of the Eight Immortals and located near the imperial capital of Xianyang in modern-day Shaanxi. Centered around Mount Penglai, the **symbol** of humanity's constant search for paradise, the Isle served as a model for even more magnificent gardens built during subsequent dynasties beginning with the Garden of General Jiang Ji during the Han Dynasty (202 BCE–220 CE). Containing artificial mountains, ravines, and forests, the garden was also

GARDENS AND GARDENING (HUAYUAN/YUANYI) • 203

filled with exotic, rare birds and domesticated wild **animals**, along with the Lake of the Supreme Essence, which with three artificial islands would inspire Chinese garden design in future centuries.

Dynastic decline into a long period of political and social instability known as the Six Dynasties (220–589), along with the introduction and spread of **Buddhism**, led to the building of temple and "scholar gardens" (*wenren yuan*) for prayer and contemplation of nature and composition of **literature** during turbulent times. Featured in Chinese **paintings**, gardens were built in Hangzhou, Zhejiang, capital of the short-lived Sui Dynasty (581–618), which reunified the empire and led to the first golden age of large and small classical gardens during the subsequent Tang (618–907) and Song (960–1279) dynasties. Included was the Garden of the Majestic Clear Lake, built near the Tang Dynasty capital of Chang'an, modern-day **Xi'an**, in Western China, with **plant** cultivation during the highly cosmopolitan dynasty developed to an advanced level, highlighting the aesthetic properties of plants. The magnificent Hamlet of the Mountain of the Serene Spring was built near the city of Luoyang, Henan, with 100 pavilions and structures, and rocks with unusual shape, known as "scholars' rocks" (*xuezhe yaogun*), becoming essential features of Chinese gardens.

Aesthetic garden traditions continued under the Song Dynasty, with The Basin of the Clarity of Gold garden featuring an artificial lake, rocks, and plants brought in from throughout China, and the Garden of the Monastery of the Celestial Rulers in Luoyang, famous for its blossoms of "peonies" (*mudan*). Gardens built in Suzhou, the city of canals in Jiangsu, include the small but impressive Master of Nets Garden of **architectural** achievement, creating a mood of tranquility and harmony, along with the garden of the Blue Wave Pavilion. Built in 1044, Blue Wave is the oldest surviving garden in Suzhou, unlike the many gardens destroyed by the invading Mongols who destroyed the Song Dynasty and established the short-lived Yuan Dynasty (1279–1368). Mongol rulers built a summer palace with an imperial garden in the capital of Xanadu, in modern-day Inner Mongol Autonomous Region, which was reportedly visited and richly described by Marco Polo.

Equally stunning were gardens, imperial and scholarly, built during the Ming Dynasty (1368–1644), with the Humble Administrator's Garden in Suzhou introducing the distinctive feature of "borrowed scenery" (*jiejing*), siting gardens in carefully framed vistas of nearby mountains and **pagodas**, creating an illusion of a much larger garden. Also notable were the Lingering Garden (1506–1521) and Garden of Cultivation (1541), both in Suzhou, with ponds filled with "goldfish" (*jinyu*) and the distinctive *penjing* trees, miniature landscapes of rock and small trees that became known in Japan as bonsai. Also notable is the Yuyuan Garden, with exquisite **sculptures** and carvings, built near **Shanghai** in 1559.

204 • GARDENS AND GARDENING (HUAYUAN/YUANYI)

During the last, Manchu-ruled Qing Dynasty (1644–1911), gardens were major features of the imperial Summer Palace and Old Summer Palace (*Yuanming Yuan*) near **Beijing**, the latter with exquisite buildings and gardens, burned down by invading foreign troops at the end of the Second Opium War (1856–1860). Imperial palaces and gardens were also built north of the capital at the Chengde Mountain Resort, Hebei. They have been kept intact as a major tourist site by the government of the People's Republic of China (PRC). Famous scholar gardens include Prince Gong Mansion (1777); Couple's Retreat Garden (1874); Garden of Retreat and Reflection (1883); and the Keyuan Garden (1850), of triangular shape, one of four major gardens in Guangdong.

Designed not to be seen all at once, Chinese gardens present visitors with a serious of perfectly composed and framed glimpses of scenery evoking an idyllic feeling of wandering through a natural landscape and getting closer to the ancient way of life. Revered for hiding the vulgar and the common as far as the eye can see, while exhibiting the excellent and the splendid, Chinese gardens vary in size, from hundreds of hectares (2.47 acres) to less than an acre, and represent a quest for paradise of a lost world and a **utopian** universe. Garden imaginary represents the personal emotion and aesthetic taste of the individual designer, letting visitors feel they understand the best part of the garden, which transfers individual emotion to the scenery. The many halls, pavilions, galleries, and **pagodas and temples** in gardens are used for major social occasions, including **banquets**, celebrations, ceremonies, and reunions, with a **library** and study central to the scholar garden, providing solitude for creative compositions of **calligraphy**, **music**, and **poetry**, while drinking **tea** or wine, engaging all the senses, not just sight.

Major physical features represent important symbolism, including water for **communication** and **dreams**, mountain peaks for **virtue** and stability, lotus for purity and the search for **knowledge**, bamboo for humility and honor, and apricot trees for the way of the scholar, with rocks vertically shaped and riddled with cavities and holes. Popular plants and trees include, among others, the Manchurian apricot, flowering almond, Peking cotoneaster, Manchurian golden bell, maidenhair tree, primrose jasmine, and tree peony. Notable names for halls and pavilions include the Hall of Distant Fragrance, Pavilion of the Moon and Wind, Listening to the Rain Pavilion, Pavilion Leaning on the Jade, and Pavilion of the Mandarin Duck. Influenced by traditional classics of Confucianism and Daoism, notably the *Book of Changes* (Yi Jing), on the coexistence and unity of mankind and nature, Chinese gardens, with their asymmetrical design of free-flowing curves and patterns, while avoiding sharp angles, have had international influence, including in Japan and Europe.

GENDER. *See* MEN AND MASCULINITY (*NANREN/YANGGANG ZHI QI*); WOMEN (*NÜREN*).

GHOSTS (*GUI*). Rich in variety and all types of ghosts, "demons" (*emo*), "monsters" (*guaishou*), and "ogres" (*shenrenmo*), Chinese history is replete with ghost stories, **folktales**, and **legends and mythology** dating to ancient times and perpetuated by **festivals**, including, notably, the famous Hungry Ghost Festival, celebrated annually, usually in mid-July. Believed to be the spirit of a deceased person, ghosts are typically considered malevolent and easily provoked, with ill intent toward the living and protection afforded by offerings of **food** and **gifts**, as well as the presence of dogs, either real or as guardian statues. Associated with **ancestor** worship, ghosts are said to arise from faulty and poorly performed **funeral and burial customs**, with stories of various types of ghosts found throughout ancient Chinese **literature** and folktales, including in Chinese **Buddhism** and **Daoism**. As in many ghost-believing cultures, **communication** with ghosts and other spirits is carried out by "mediums" (*meijie*), usually **women**, through a process described in the Cantonese dialect as "asking the rice woman" (*mun mai poh*).

The most notable and even celebrated ghosts include the following: *nügui*, the "female ghost" of women abused in life, sometimes murdered, who in the afterlife become a fiend in human form known as a succubus; *shuigui*, the "water ghost," a spirit of someone who died from drowning and whose **body** was never recovered; *jiangshi*, the "hopping ghost," also known as the "zombie ghost," who moves around with outstretched arms and kills people by absorbing their bodily **energy** (*qi*); and *guishen*, the "nature demon," a mischievous spirit and, unlike other spirits, not formerly a human being. With many possessing transformative abilities derived from the heavenly way and manifested in the classic *Book of Changes* (Yi Jing), ghosts can change into objects, as well as **animals and insects**, and even become pure darkness. Other types of ghosts are as follows: *yaogui*, "weird"; *bagui*, "drought"; *meigui*, "trickster"; *gudugui*, "venomous"; *yangui*, "nightmare"; *wangliang-gui*, "goblin"; *yishigui*, "servant"; *chuansongqi*, "messenger"; and the infamous *egui*, "hungry ghost."

Representing a threat to a comfortable and secure everyday life, including excess litigation, ghosts appear in many classical literary works, for example, *Journey to the West* (Xi Youji), featuring the Monkey King, Sun Wukong, on the way to India encountering goblins and ogres intent on eating the flesh of revered Buddhist monk Xuanzang. Examples of folklore include *The Kingdom of the Ogres* (Shirenmo Wangguo) and many other similar tales largely directed at **children**, with important lessons in leading a good, exemplary life by being respectful and kind to one another, and keeping one's word, espe-

206 • GHOSTS (GUI)

cially when confronting such evil-doing spirits as child-eating ogres. Personal safety is also a major theme, with stories warning **youth** to stay away from dangerous situations like turbulent waters.

Ghosts portrayed in Chinese books and **paintings** are generally gruesome figures with a wild look of bulging eyes and long, disheveled hair, and, in the case of the greedy and ignorant hungry ghost, a small mouth and huge belly that no amount of food can fill. Numerous films and television shows have taken on the topic of ghosts, which historically have often served as surreptitious critiques of governmental authority, which is why many such tales have been banned in the People's Republic of China (PRC). With a story line of a haunted Victorian estate frightening a young bride, the foreign-made *Crimson Peak* (2015) was kept out of Chinese **theaters**, although such domestic creations portraying ghosts as *Painted Skin* (2008) and *The Ghost Inside* (2005), the latter a horror flick featuring murder and **suicide**, made it onto Chinese screens. **Rituals** like the **Tibetan** practice of "beating ghosts" (*dagui*) are still performed in the PRC, largely for tourists, while the particularly horrendous "ghost marriages" (*youling hunyin*) have been banned since 2006, as the practice of providing a spouse to an unmarried deceased man has often led to the murder of young women, whose corpses garner huge bride prices.

Impact of the belief in ghosts is evident in many aspects of Chinese life, for instance, residential **architecture**, with construction of a shadow wall outside the front door to foil ghosts from entering, along with images of the "kitchen god" (*chufang shen*) hung as a protection of food preparation from malicious ghosts. Images of Zhong Kui, the traditional vanquisher of ghosts, were also displayed, especially at the end of the **Spring Festival**, when evil spirits are known to wander about. With ghosts believed to travel in straight lines, roads in China are constructed with plenty of curves, while ghosts, rather than reckless drivers, are believed to be a major cause of traffic accidents. Daily activities affected by ghosts include avoiding any kind of home renovation or construction around the time of the Hungry Ghost Festival, as the noise may disturb the roving ghosts. Women should also refrain from wearing high-heel shoes during the festival, as they run the risk of being possessed by an angry spirit, while freshly washed **clothes** should also not be hung up toward evening because ghosts will try them on, bringing bad luck to whoever wears them next.

References to ghosts are replete in the Chinese **language**, with such phrases as "hero among ghosts" (*guixing*) referring to a person undergoing a **hero's** demise and as largely pejorative terms for **foreigners**, for instance, "foreign devils" (*yangguizi*) and "ghost men" (*guilao*). Political phrases are also replete with ghost references as in "ox-ghost and snake-demon" (*niu gui she shen*) used to describe suspected "counterrevolutionaries" (*fangeming*) during the **Cultural Revolution (1966–1976)**. China is also home to the

GIFTS (LIWU) • 207

Fengdu Ghost City, located near **Chongqing** along the Yangzi River, with its rich array of shrines, **pagodas and temples**, and monasteries, and featured in many classical novels, but with substantial areas flooded by the reservoir of the giant Three Gorges Dam.

GIFTS (*LIWU*). In a connected-centered society with important **festivals and holidays**, gifts and "gift-giving" (*songli*) are a common occurrence, mainly on such special occasions as celebrations of **birthdays**, the **Spring Festival**, and the Mid-Autumn "Moon" Festival. An important method of building "trust" (*xinren*), especially in **business**, gifts are also essential in maintaining all-important personal **relations**, a crucial factor in Chinese social interactions. During the imperial era, gifts flowed to and from the emperor and the imperial family as a way to elicit **loyalty** and as rewards for meritorious actions in the face of periodic crises with the Empress Dowager Ci Xi (1861–1908) well-known for extravagant gifts to Chinese and foreign dignitaries alike, a practice replicated by Madame Chiang Kaishek, Soong Meiling (1898–2003) during Nationalist (*Kuomintang*) rule on the mainland (1928–1949) and Taiwan. A frequent practice in the **workplace**, gifts are given to business partners and clients often consisting of valuable items like watches and engraved fountain pens, with cash delivered in "red envelopes" (*hongbao*), usually to **children** and at weddings. Gloves and even vitamins and supplements are also common gifts, especially to the elderly. A demonstration of respect and commitment to others, especially colleagues and superiors, gifts should neither be too extravagant nor restrained, with the same gift never given to people of different rank.

Proper gift-giving is governed by fairly elaborate rules of etiquette, including proper wrapping with ribbons and bows using paper of bright favorable **colors**, with red representing good **fortune** and luck, yellow symbolizing **happiness**, and gold representing success and wealth, but never white, which is the color of **death**. Acceptable gifts depend on the nature of the occasion and the status of the recipient(s), with safe fallbacks including **alcohol, tea**, tobacco for smokers, and fruit baskets, but without "pears" (*li*), as the phrase "sharing pears" (*fenli*) is a homonym for "splitting up" (also *fenli*). Taboo gift items likely to bring ill-fortune and bad luck, and associated with death and **funerals**, include clocks, handkerchiefs, cut **flowers** (especially white ones), and candles.

Items with pronunciations in Chinese similar to descriptions of evil or unhappy events include "umbrellas" (*yusan*) or sharp objects like knives, as both suggest "separation" (*san*), along with "shoes" (*xiezi*), as the Chinese word *xie* also means "evil." Avoided for similar homonymic reasons are "plum blossoms" (*meihua*) and "jasmine" (*moli*), while "mirrors" (*jingzi*),

208 • GODS AND GODDESESES (SHEN/NÜSHEN)

which are believed to have the power to attract **ghosts**, are also verboten. Gifts of necklaces, ties, and belts should only be exchanged between couples, with books, chocolate, toys, and red envelopes of cash suitable for children.

Acceptance of gifts should be with both hands, and gifts should never be opened immediately, nor in public, although gifts may be initially rejected once or even twice. According to the Chinese principle that "courtesy demands principle" (*lishang wangle*), reciprocation of gifts should occur relatively quickly. Officially banned in the People's Republic of China (PRC), offers of gifts, especially to public officials, can be considered an attempt at bribery and lead to prosecution. Gifts of love and intimacy include fruit, especially peaches; **jade** pendants as a **symbol** of **wisdom**, status, and wealth; satchels, symbolizing intimacy; red beans, representing lovesickness; handkerchiefs to wipe away tears of joy; combs and hair pins; and "love knots" (*aiqingjie*).

GODS AND GODDESESES (*SHEN/NÜSHEN*). A largely polytheistic society with primary exceptions of Christians and Muslims, China's traditional **religious** pantheon consists of innumerable gods and goddesses, with a view that divinity is inherent to the world. A manifestation of **energy** (*qi*), the power or pneuma (breath) of "heaven" (*tian*) in the world, gods and goddesses are believed to exist for virtually every phenomenon, with one or more organized in a celestial hierarchy. Included are all-powerful cosmic gods and gods of terrestrial events, including earthquakes and the weather, human **virtue** and **handicrafts**, and various **animals** and vegetables, with separate gods for towns, villages, and even **family** graveyards, with personalized temples and shrines for individual gods. Inhabiting trees, **gardens**, and even faraway places like **mountains**, rivers, and lakes, the gods have broad influence on every aspect of life, from **sexual** intimacy between couples to the collapse and fall of dynasties.

Major gods in the Chinese pantheon in rough rank order include the following: "Dragon god" (*longwang*), a composite of **yin-yang** and considered the balancer of heavenly and terrestrial forces, while serving as the god of the sea and water; Shangdi, the "supreme deity" or "highest deity," overseeing law, order, and justice, also known as the "Jade Emperor" (*Yudi*) or "Yellow Emperor" (*Huangdi*), and considered the **ancestor** of all Chinese people, with the name taken from the ancient Shang Dynasty (1600–1046 BCE); "Queen Mother of the West" (*Xiwangmu*), goddess of the "immortals" (*buxiu*), residing in the sacred Kunlun Mountains, whose fruit juices from peaches grant immortality, with rewards and **punishments** meted out to good and bad actors; Guanyin, the Chinese translation of an Indian Bodhisattva and considered goddess of mercy, with 11 heads and 1,000 arms, and eyes to hear and respond to the cries and suffering of humankind; Yan Wang, the god of **death** and afterlife who rules the underworld; and Nüwa and Fuxi,

GREAT WALL (CHANGCHENG) • 209

mother and father deities responsible for creating human beings out of the mud of the Yellow River and constructing a palace that became the model for Chinese **architecture**, along with granting to humans writing and **music**.

Also popular are Caishen, the god of wealth, revered by merchants and businessmen; Chang'e, goddess of the moon who lived with the immortal "jade rabbit" (*yutu*) and is found in **literature**; Zaoshen, the kitchen god, responsible for **happiness** and prosperity in the family; Niulang and Zhinü, god and goddess of **romance and love**, whose meeting day on the seventh day of the seventh month became China's version of Valentine's Day; Menshen, the door god, protecting rooms and insuring peaceful sleep; and Pang'gu, god of creation, portrayed as both a dwarf and a giant, with a hairy **body** and horns, whose eyes, blood, and flesh became the sun, rivers, and farmland following his death.

In the Chinese **language**, "god" is *shen*, "deity" is *di*, and a person achieving "immortality" is *xian*, with *shennong* the "peasant god." Criticized as **superstition** following the establishment of the People's Republic of China (PRC) and denounced as an example of the "**four olds**" (*sijiu*) during the **Cultural Revolution (1966–1976)**, popular belief in many of the gods and local deities reappeared following the introduction of economic reforms and social liberalization (1978–1979).

GREAT WALL (*CHANGCHENG*). An iconic and revered **symbol** of Chinese civilization and an engineering masterpiece, the Great Wall, literally "long wall" in Chinese and popularly referred to as "stone dragon," spans from Eastern China to far Western China, measuring 8,850 kilometers (5,500 miles). With a height ranging from 5 to 8 meters (16 to 26 feet) and a width at top of just less than 5 meters (16 feet), the wall was constructed as a barrier against invasions by northern **barbarians**, primarily the Xiongnü, although the defensive structure proved totally ineffective against the Mongols in the **conquest** of China and establishment of the Yuan Dynasty (1279–1368).

Following the southern edge of the Ordos Desert, the wall and its immediate surroundings feature watchtowers, troop barracks, garrison stations, and other fortifications, while also serving as a transportation route adjacent to the **Silk Road**, especially through the strategic Hexi Corridor in western Gansu. The main line of the wall extends from the eastern shore of Shanhaiguan on the Bohai Sea in Hebei, referred to as "old dragon's head" (*laolongtou*), to the western terminus at Jiayuguan in Gansu, where a giant castle was built to protect the site from foreign invaders. Never fully continuous, several separate branches of the Great Wall extended defensive lines northward and to the south into areas living with the constant threat of invasion.

Traced to the 7th century BCE, when independent states constructed separate walls, Emperor Qin Shihuang of the Qin Dynasty (221–210 BCE) joined together the disparate parts as part of a larger effort to create a single,

210 • GUANGZHOU

unified empire. The early form of the wall consisted of rammed earthen works composed of wood and reed, with the minimal use of gravel, of which little survives to the present day. Repaired and expanded during the Han (202 BCE–220 CE) and Sui (581–618) dynasties well into the Gobi Desert, the wall was generally ignored under the highly cosmopolitan and trade-oriented Tang (618–907) and Song (960–1279) dynasties. Major construction work was renewed during the inward-looking Ming Dynasty (1368–1644), with earthen works replaced by a fully integrated battlement wall composed of brick and stone, with mortar consisting of sticky rice flour and slackened lime. Designed to stave off frequent nomadic barbarian invasions of plunder, especially threatening the dynastic capital at **Beijing**, the 100-year effort employed an army of master builders, masons, and engineers, with brick kilns located near the construction sites operating on a mass industrial scale. Coming at great financial cost that contributed to the dynasty's collapse, the Ming wall followed unlikely routes along steep hills and into deep valleys evidently laid out by **fengshui** masters.

Finished in 1644, the wall was generally ignored during the Qing Dynasty (1644–1911) as the empire expanded into Inner Mongolia and other areas north and west of the edifice. Threatened largely from the seas by Europeans and Japanese, conquest of Chinese territory occurred primarily along the coasts and in Manchuria throughout the 19th and 20th centuries, making the Great Wall irrelevant as a defensive measure. A United Nations Educational, Scientific, and Cultural Organization (UNESCO) World Heritage Site and major tourist attraction in the People's Republic of China (PRC), particularly around Beijing, well-preserved sections of the Ming wall exist at Badaling, Mutianyu, and Juyongguan, the last the site of a major fort. Systematic surveys of ancient and Ming-era Great Wall structures were carried out by Chinese and international teams in 2009, employing sophisticated global positioning system (GPS) technologies while an annual Marathon race is run on the Huangyaguan section of the wall in May. Several examples of the wall in artistic works include Franz Kafka's short story *The Great Wall of China* (1917), where construction of the giant edifice is recounted as the product of a remote and unknowable emperor, and in the co-produced film *Great Wall* starring Matt Damon and Andy Lau (2019), which was a box-office flop.

See also SYMBOLS (*FUHAO*).

GUANGZHOU. Site of the most outstanding branch of the Lingnan culture, which encapsulates Guangdong and Guangxi provinces, and northern Vietnam, Guangzhou is the political, economic, and cultural center of South China and historically a major contact point for foreign trade and investment. Dating back 2,000 years and known as "Chuting" during the Zhou Dynasty (1045–256 BCE), the city and surrounding Lingnan areas were incorporated into the Chinese empire during the Qin Dynasty (221–206 BCE), with city

GUANGZHOU • 211

walls reconstructed and expanded on several occasions under the Song Dynasty (960–1279), with disparate areas united during the Ming Dynasty (1368–1644). Renamed "Guangzhou" in 256 CE, and located on the north bank of the Pearl River Delta at the confluence with the South China Sea, the city became a major foreign trade hub as contacts spread throughout the South Pacific and Indian oceans, with Arab and Hindu traders taking up residence in the city.

Ultimately surpassed as the major port on the Maritime **Silk Road** by Quanzhou, Fujian, during the Yuan Dynasty (1279–1368), Guangzhou became the site of the first foreign embassies in China beginning with the Portuguese and the British East India Company in the 17th century. So-called "factories" consisting of warehouses and stores were set up by the British and other major Western interests on the Pearl River waterfront, and were the sole **legal** site of Western trade with China from 1757 to 1842. The only Chinese port open to the outside world under the "Canton System" of limited trade allowed under the largely isolationist Qing Dynasty (1644–1911), the city became a major center of foreign commercial interests following the defeat of the Chinese empire in the First Opium War (1839–1842). Trade, especially in opium, was carried out, with Chinese addiction to the drug gradually spreading from Guangzhou to other parts of the country. Shamian Island, located in the Pearl River, running through the city, became the exclusive enclave of the British and French residents living in Western-style mansions that survive to this day. Guangzhou was also a major transit point for Chinese "coolies" (*kuli*) recruited from the empire's interior and shipped out to foreign lands, including the United States.

According to mythology, Guangzhou was the creation of five celestial "rams" (*gongyang*) who saved the city from starvation, with sheaves of rice from their mouths bestowed upon residents and **animals** praying for favorable weather and good harvests. Nicknamed the "Ram City" (*Yang Cheng*), the city is a center of multiple cultural forms, including **literature** and the **arts**, **opera** (Yue and Chao styles), **handicrafts**, **puppetry**, and **calligraphy**. Reflecting the local passion for **food**, Cantonese **cuisine** features such unique dishes as fried snake, cooked fish maw, and fried chicken feet, along with famous Cantonese dim sum, served with tea in early afternoons.

Major **religious** sites in Guangzhou include the Huaisheng Mosque, the oldest in China, built and rebuilt during a period of 1,300 years; the Six Banyan Tree Temple of Chinese **Buddhism**; the Temple of the Five Immortals of **Daoism**; and the Sacred Heart Catholic Cathedral. Traditional Chinese **architecture** is preserved in the old quarters of the city, located north of Shamian Island, with modern skyscrapers, notably the Canton Tower. Located in a subtropical zone and a distribution center for rare tropical **plants**, the city is the site of an international **flower** show held annually during the **Spring Festival**.

212 • GUANXI

GUANXI. *See* RELATIONS AND CONNECTIONS (*GUANXI*).

GUILT (*YOUZUI*). A major means of socialization and mechanisms of social control for maintaining individual responsibility in any society, the sense of guilt is a powerful force shaping personal behavior in China, with a great influence in the country's collectivist-oriented society. Requiring a sense of **individual** responsibility, the two emotions provide channels for individuals to process stress and deal with violation of important social norms subtly shaping behavior, with initial concepts of guilt, along with **shame**, established in **Confucianism**. Formulating a duty-based ethics with primary concern for maintaining social order, Confucius (551–479 BCE) extolled positive duties for the individual beginning in the **family**, conceptualized as the "great self" (*dawo*), with the boundaries of self-identity including family members. Requirements for the Chinese individual were centered on taking care of **aging** parents and rearing **children**, with respect also shown for superiors, making for a social code that defined relations to others in a largely hierarchical order. Rules and standards are flexible, adjusting for social context and subjectively conceived with little or no concern for impersonal, universal definitions popular in Western cultures.

Historically, group orientation in China was apparent in the **legal** practices of the imperial era, when, for instance, in murder cases **punishment** was meted out against relatives of the accused, as well as the individual. With emphasis on the individual fulfilling group requirements, several terms exist in the Chinese **language** for guilt with fine distinctions and a broader range of social triggers. Words for "guilt" in Chinese include the following: *neijiu*, failure to practice certain positive duties based on an internalized sense of obligation and responsibility; *zui e gan*, transgressions of personal morality but without harming others; and *fan zui gan*, an impersonal sense of guilt stemming from breaking the law. Conferring objective guilt on a single person remains difficult in a society where personal identity extends beyond the single individual to a group, which may explain the lack of **empathy** in Chinese society. Unlike the West, guilt in China is also applied even in cases of individuals lacking abilities to fulfill obligations.

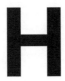

HAIRSTYLES (*FAXING*). Ranging from simple to highly elaborate forms, especially for **women**, hairstyles in China have been subject to harsh state regulation in both the imperial and modern eras, and a major form of personal identity and nonconformity by both women and **men**. Historically, the most extreme example of state-mandated hairstyles occurred during the Qing Dynasty (1644–1911), when Manchu rulers required their male ethnic Han subjects to style their hair in the "queue" (*tifaling*) as a **symbol** of submission to foreign Qing rule, although hairstyles for women went unregulated. Similar constraints on men and women were imposed in the People's Republic of China (PRC), when during the rule of Chinese Communist Party (CCP) chairman **Mao Zedong** (1949–1976), women were restricted to either a short bob style or long pony-tail braids, with men limited to a short, military-style cut.

In the traditional Chinese philosophy of **Confucianism** and **Daoism**, long hair was sanctioned, with Confucius considering the cutting of hair as a violation of **filial piety**, as hair was part of the **body** bestowed upon a person by their revered parents and traditionally wrapped around in a "topknot" (*toudingfa*). Unkept hair, particularly among men, became a symbol of dishonorable ways, while young girls maintained simple styles until their coming-of-age hair-pinning ceremony at the age of 15, indicating their eligibility for **marriage**. Long, lustrous hair for a woman was a sign of good **health**, with hair often parted down the middle and a lock of hair often given as a **gift** of love, while married woman were relegated to wearing their hair tied up in a simple bun.

Highly stylized hair, especially for women, came into vogue among the higher classes during the cosmopolitan Tang Dynasty (618–907), when court ladies and courtesans added **flowers**, hairpins made of coral and **jade**, and combs to their rich variety of hairstyles, many remaining popular to this day. Fairy tale princesses were portrayed with intricate hair buns in fancy ornamental style with remaining long strands falling down the back in flowing fashion. For men, long hair became a symbol of resistance, especially during the Qing Dynasty, when the rebels of the Taiping Heavenly Kingdom (*Taip-*

ing Tianguo) became known as the "long hairs" (*changfagui*) in their massive resistance campaign from 1850 to 1864. Symbolizing his break with the past, the last Qing emperor, Aisin Gioro Puyi, severed his queue in 1922, as the issue of cutting queues and confronting the penalty of execution is a central theme in the short story *Storm in a Teacup* (1920), by **Lu Xun** (1881–1936), China's most famous modern literary figure.

Following the introduction of economic reforms and social liberalization (1978–1979) in the PRC, female hairstyles, both traditional and modern, elaborate and simple, became popular, along with overall interest in **fashion**, especially among **celebrities**. Simple styles range from a pixie cut with bangs, conveying an innocent look; to braided buns; to a bob with long or sideways bangs; to medium cuts with bangs; to short hair curled with cutoff of long strands. The more elaborate hairstyles, dominated by the traditional hair bun, also known as the topknot, include the cobra bun, the bubble-piped side pony Buddha bun, the hair brooch, the sagging bun, the hammer bun, orbit circles, and the two-braided hair lock, some virtual **art** forms requiring long preparation time. Special hairstyles for women also exist for weddings and other festive occasions, with long hair especially popular among celebrity men in **music** and other avant-garde art forms. In a country where black is the dominant natural hair **color**, dying and bleaching hair has become increasingly popular, with 46 percent of women choosing such natural colors as brown and red, along with unnatural green, pink, and purple, while encroaching gray hair is dyed black among both women and men, including the **leadership** of the ruling CCP.

HAND GESTURES (*SHOUSHI*). In a society of densely populated **urban areas** with high noise levels from everything ranging from street **markets** to traffic congestion, hand gestures are an important method of **communication**, with many unique to China and some imported from abroad, including both polite and impolite forms. Common gestures used in everyday interaction include referring to yourself by pointing at the nose, not the chest, and indicating agreement or promises with another by interlocking last fingers or the "pinky" (*xioazhi*). Calling for another person to come over is done with palm down and fluttering fingers, as facing the palm upward is considered arrogant and equated with fetching a dog. Strong disapproval is indicated by holding one's palm close to the **body** and making a slight side-to-side motion, and this is a common method for shooing away troublesome hawkers or rejecting further offerings of **food**.

Many hand gestures are derived from Chinese **opera**, for example, *douhua*, a way of cupping one's hands in obeisance or greeting, and the infamous *hongbao*, with a raised hand partially covering the **face** while stroking an eyebrow, used to indicate foul play and that someone has been caught red-handed. Expressions of gratitude and good **fortune**, especially during **festi-**

HANDICRAFTS (SHOU GONGYIPIN) • 215

vals and holidays or formal occasions, are done via the tradition of "hand bowing" (*zuoyi*), with the right fist covered by the left hand, bringing it close to the chest, performed by both adults and **children**. While indication with the fingers for the **numbers** 1 through 5 is the same as in the West, references to 6 through 10 use finger forms mimicking the Chinese-**language** characters for the respective numbers. Fingers in the form of a "V" with palms forward stands for **happiness** or expressions of "great!" but not "victory," as in the West, and is often used by young girls when having their photograph taken to appear "cute" (*ke'ai*). Moving the thumb and little finger in a wide arc indicates "perfection" (*wanmei*), a hand gesture popularized by a famous television talk-show host, which is a common source of new habits in the **celebrity**-obsessed culture of the People's Republic of China (PRC). The hand gesture indicating "okay," with the thumb and middle finger formed in a circle when held close to the body, is a signal for help, with videos of such a practice by young **women** held against their will going viral.

Impolite hand gestures have traditional and foreign sources, with the former consisting of sweeping or big hand movements, getting touchy with others, especially a female by a male and with strangers or elders, and pointing a single finger straight at someone. Among the obscene gestures imported from abroad is raising the middle finger, a practice learned from films and other less-sophisticated Western cultural forms. Raising the little finger is a comparable traditional gesture, although the implication is slightly different, although equally rude. Curling the hands and fingers with the thumb inserted between the thumb and index finger, a form known as *dulya* in Slavic countries, is also used in some parts of China, indicating "I have your nose."

HANDICRAFTS (*SHOU GONGYIPIN*). The embodiment of multiple strands and expressions of culture, handicrafts developed in major **art** and functional forms during the course of imperial Chinese history, with production continuing in the People's Republic of China (PRC). Traced to ancient periods as early as the semimythical Xia Dynasty (2205?–1766? BCE), the first imperium in the empire's history, various handicraft art forms were refined and altered throughout the centuries, including "paper cuts" (*jianzhi*), "wood carving" (*mudiao*), "lacquerware" (*qiqi*), "embroidery" (*cixiu*), "fans" (*fengshan*), "kites" (*fengzheng*), "knots" (*jie*), and, most recently, "clay figurines" (*nisu*), with functional handicrafts still practiced on **urban** streets and the byways of **rural areas**.

One of the oldest and most popular handicrafts is paper cuts, composed of famous patterns from **nature** and well-known characters from Chinese **opera** produced in bright dyed **colors** and put on **clothes** or pasted on walls, windows, and even roofs. Dating to the Northern Wei Dynasty (386–534), paper cuts originated in remote rural areas in Shaanxi and gradually spread to

216 • HANDICRAFTS (SHOU GONGYIPIN)

Nanjing and areas in the south, for example, Foshan, Guangdong. A form of **nature** worship with portraits of flora and fauna made larger than life, the handicraft was especially popular during **festivals and holidays**, most notably the **Spring Festival**, and once finished it was attached to white paper and placed over a lit candle, making the exquisite pattern appear on the sheet.

Equally stunning and tasking in production are wood carvings, of which there were two types, the ornamental for decorations and ostentatious display, and the functional in the form of attractive chairs, tables, and other items for daily use. Traced to the turbulent period of the Warring States (475–221 BCE), wood carvings were of three types: three-dimensional design, particularly of **animals** and representations of mast-sailing vessels and other such intricate objects; relief forms involving undulating carvings on the wood surface with similarities to **paintings**; and root carving of natural shapes with added artificial creations. Requiring woods both tough and firm the likes of red sandalwood and scented woods, the handicraft became increasingly sophisticated and alluring, especially during the Song (960–1279), Yuan (1279–1368), and Qing (1644–1911) dynasties.

Unique to China and dating to the Xia Dynasty, lacquerware is produced by painting surfaces of ornamental furniture and such wares as bowls, musical instruments, and even weapons with red or black lacquer, a natural, raw liquid taken from the lacquer tree and subject to heating and chemical treatment. Water and corrosion-proof, and resisting high temperatures, lacquerware became widespread during the Han Dynasty (202 BCE–220 CE), including such items as lacquer boxes, earrings, **masks**, and chessboards, peaking in popularity in the Ming (1368–1644) and Qing dynasties.

Tedious, skilled work was also required in producing embroidery, kites, and fans, with paper, silk, and bird feathers the major choice of materials by artisans involved in such work, frequently performed by young girls seeking to improve their prospects for a good **marriage**. Bright colors and artistic renderings of animals, flowers, and mythical creatures, for instance, the flying "phoenix" (*fenghuang*), were common themes, with support for such crafts as embroidery by the imperial court and considerable **regional** variation between centers of artistic and handicraft production, for example, Suzhou and Nanjing (Jiangsu), and similar areas in **Sichuan**. Inscriptions on fans by well-known artists like Qi Baishi (1864–1957) added to their value, while such new forms as painted clay figurines, usually painted in bright, garish colors, often of chubby **children**, were introduced, along with traditional crafts dating to the Tang Dynasty, for instance, decorative lanyard knots. Functional handicrafts, many threatened by modern industry and technology, are as follows: knife grinding; pen mending; silversmithing; bamboo weaving; shoemaking; making dough figurines; **seal carving**; and female facial threading to remove unwanted hair, especially the eyebrows.

HAPPINESS (*XINGFU*). A pervasive aspiration in Chinese society throughout history and among virtually every **class**, happiness in present-day People's Republic of China (PRC), circa 2020, shows significant signs of stagnation and even decline, despite the country's rapid economic growth and increasing global influence. According to the United Nations World Happiness Report (2018), the PRC ranks 86 out of 156 nations surveyed, a drop of seven places from the previous year and at virtually the same level as 1988, when the country was substantially poorer and less influential internationally. Peaking in the year 1990, levels of happiness showed secular declines, reaching a trough from 2000–2005, with only minor recovery in the ensuing decade. Factors generally correlated with greater social contentment, including higher gross domestic product (GDP) per capita, improved **health**, and longer life expectancy, although present in the PRC, have not resulted in substantial improvements in overall happiness, as Chinese respondents show considerable sentiments of apprehension, despair, loneliness, and thwarted **dreams**. Official plans for the PRC to become a "happy society" (*xingfu shehui*) by the year 2021, were announced by the administration of President **Xi Jinping** (2013–), with the decision to eliminate presidential term limitations in 2018, justified as "ensuring people live happy lives."

Sociological investigations and surveys suggest multiple causes of this slump in happiness, ranging from inadequate pay to overly demanding bosses, to excessively long work commutes and even longer work hours and weeks, pejoratively known as the "996" (*jiujiuliu*) phenomenon of 9 AM to 9 PM, six days a week. Along with numbing routine and high living costs, especially in housing, large segments of the population feel they are constantly scrambling just to keep up, as most benefits of China's progress and prosperity go to a fortunate few, usually on the basis of personal connections and good **relations**. Especially pronounced among **urban** residents in such large cities as **Shanghai** and **Beijing**, similar negative sentiments afflict migrants from **rural areas**, who worry about the continuing threat of unemployment, and the elderly, particularly in the countryside, concerned about the disappearance of the social safety net. Also contributing to the national malaise and angst is discomfort with the prevailing hegemonic discourse on **nationalistic** sentiment and official prescriptions of adaptation to Han culture as the only source of happiness for **minorities** and other out-groups.

Domestic commentary on the situation has focused on the notion that too many people in the PRC "pretend" (*jiazhuang*) to be happy in an effort to please **family** members and coworkers, with all kinds of hidden unhappiness that comes out in increasing **alcohol** and **drug abuse**. With many successful people choosing to leave the country with no plans to return and others failing in the Chinese version of the rat race in major cities and returning to hometowns or villages, major cities like Beijing are "overloaded" (*chaozai*) with people suffering from "disaffection" (*sang*) and "**spiritual** ennui" (*fenj-*

ing). Confronted with decisions once rendered by the state and family concerning work, **marriage**, and even where to live, they are overwhelmed by "individualized" (*gerenhua*) decisions, becoming increasingly dysfunctional. Solutions include adoption of a more carefree attitude of "living without ambition" (*foxi*), a notion borrowed from **Buddhism** and intended to bring greater balance in life and ultimately more happiness.

HARMONY (*HEXIE*). The ultimate and most prized social value in Chinese culture for **family** and nation, harmony, with the Chinese word *hexie* also translated as "consensus," was praised in every major traditional **philosophy** of **Confucianism**, **Daoism**, Legalism, and **Buddhism**, and has become a staple of the ruling Chinese Communist Party (CCP) in the People's Republic of China (PRC). Considered a basic and enduring principle in **nature**, humanity, and society, including everything from **food** to **music**, social and political harmony was based on **loyalty** and justice, requiring individual self-restraint and a proper and balanced coordination of interested parties. Mindless consensus and artificial uniformity were not the path to true and enduring social harmony, as genuine differences and opposing views and opinions must be recognized and thoughtfully addressed without rancor or pursuit of extremes. Self-cultivation of **virtues**; respect for others, particularly the elderly; and performance of appropriate **rituals** from the emperor down to individuals, especially within the family via **ancestor** worship, is the route to harmony, resulting in a peaceful world and an end to economic scarcity. Harmony also requires people to avoid open displays of emotions and deep feelings, including during periods of discomfort, dissatisfaction, and even mourning for the dead, while saving the "**face**" of others in any social interaction.

Embracing the traditional principles of harmony by CCP rulers has evidently occurred as a reaction to increasing economic inequality, social injustice, and outright political conflict, most evident in the 1989 prodemocracy movement and the subsequent military crackdown. First enunciated in October 1989, the goal of a "socialist harmonious society" was incorporated into the Scientific Development Concept endorsed by the administration of President Hu Jintao and Premier Wen Jiabo (2003–2012). Shifting from a pure focus on economic growth to the overall well-being and "stability" (*wending*) of the social order, the Chinese government has essentially abandoned the rhetoric of "permanent revolution" (*yongjiu geming*) and unending **struggle** pursued during the era of rule by CCP chairman **Mao Zedong** (1949–1976). Used more sparingly in the administration of President **Xi Jinping** (2013–), the term, in Communist garb, is criticized as simply a rhetorical justification for suppression of dissent and oppositional views fundamentally at odds with the original Confucian call for tolerance and acceptance of differences. Traditional warnings against self-satisfied kings praising fawning councilors for

HATRED (CHOUHEN) • 219

being "in harmony with him" obviously are not at work in the CCP ruling Politburo and its harsh policy of **censorship**. That multinational giant Huawei named its new operating system "harmony" is indicative of the enduring appeal and influence of the term in Chinese national psychology. By contrast, the rogue artist **Ai Weiwei** lampoons such simple-minded Party sloganeering with his handcrafted **sculpture** of 3,200 porcelain and homophonic similar "river crabs" (*hexie*), a sarcastic jibe at an overweening political authority suggesting the oppressive regime aims to make citizens all the same, like so many crabs caught in a trap, with no individuality or rights.

HATRED (*CHOUHEN*). Generally reviled throughout Chinese history as contrary to basic humane values, hatred has been periodically sanctioned and even encouraged by the Chinese Communist Party (CCP) against politically and ideologically targeted groups, especially by Red Guards during the chaotic and often-violent **Cultural Revolution (1966–1976)** promoted by Chairman **Mao Zedong** (1949–1976). For Confucius (551–479 BCE), hate was too easily expressed and therefore unworthy of the "gentleman" (*junzi*), who was tasked by the great philosopher to achieve the good things in life that were inherently difficult. Confucius was also opposed to a life of seeking nothing more than economic gain, seeing such actions as "rich in hate." Similar sentiments were expressed by Lao Zi (601?–531? BCE), founder of **Daoism**, who bemoaned the ordinary man for "hating solitude," while the master or superior man put private time to good use and asserted that the "best fighter is never angry." No less derisive were the basic principles in **Buddhism**, which considered hatred, along with "aversion" (*yanwu*), a fundamental character flaw and the opposite of lust and desire.

In the campaign to win political power and as the ruling party of the People's Republic of China (PRC), the CCP channeled popular animosities against landlords, rich peasants, pro-Western intellectuals, and members of the rival Nationalist Party (*Kuomintang*) in periodic **struggle** sessions. Targeted groups expanded enormously during the Cultural Revolution, with Red Guards mobilized to direct their revolutionary hatred against supposed "capitalist roaders" (*zouzipai*) in the CCP, along with other competing rebel groups. Levels of hatred reached titanic proportions, as targets included parents and other **family** members, along with largely defenseless elderly and anyone labeled a "**class** enemy" (*jieji diren*)—or even worse, "counterrevolutionary" (*fangeming*)—making them subject to summary execution in front of equally hate-filled crowds, often in large stadiums.

Following the passing of Chairman Mao Zedong in 1976, the political temperature in the PRC was reduced dramatically, and society shifted from political and **ideological** struggle to the less emotion-laden pursuit of wealth and economic prosperity. While staged orchestration of hate-filled demonstrations and protests are a rarity, spontaneous outbursts concerning the inter-

220 • HEALTH AND ILLNESS (JIANKANG/SHENBING)

net are common among so-called "angry youth" (*fennu qingnian*). Well-educated and generally prosperous, these individuals employ the web to direct a profound hatred for Japan, with the evident encouragement of the PRC government for the reputed failure of the Japanese to fully apologize and atone for the mass killings of Chinese civilians in Nanking (1938) and other cities and towns during the Second Sino–Japanese War (1937–1945). Hate speech on the internet is also often directed at **minorities**, especially Muslims, and other out-groups in the PRC, with little to no controls by regulatory authorities.

HEALTH AND ILLNESS (*JIANKANG/SHENBING*). The concept of bodily health in China is based on the traditional principles of **yin-yang** and "**energy**" (*qi*), with homeostasis as the key element determining health versus illness. Considered a state of physical and **spiritual harmony**, good health is considered just another domain of submissiveness to the principles of yin-yang, a holistic approach emphasizing a stable relationship between interdependent elements of the **body** and the mind. Illness is caused by a state of disharmony and disruption, either being "too hot" (*shanghuo*), namely an excess of fire, also known as the masculine yang energy in the body, or "too cold" or "catching a chill" (*zhaoliang*), an excess of female yin energy. The former generally leads to such maladies as inflammation, rashes, dry skin, canker sores, sore throat, heartburn, and fever, while the latter causes fatigue, lethargy, depression, joint and muscle aches, chills, and diarrhea. Combined with such climatic forces as heat, cold, dampness, dryness, wind, and summer heat, traditionally known as the Six Pernicious Influences, homeostasis is upset within the body, leading to illness.

Individual health and well-being are also tied to the performance of normal social roles and maintaining social harmony, being at ease with life, in contrast to the purely biomedical model popular in the West, which focuses purely on the physical state of the body, with illness considered solely a function of physiological processes. Targets of national health policy in the People's Republic of China (PRC) include reducing **smoking**, **obesity**, and exposure to environmental hazards, along with improving dietary habits and increasing physical activity for both the elderly and the young.

See also MADNESS AND MENTAL ILLNESS (*KUANG/JINGSHEN JIBING*).

HERMITS (*YINSHI*). An important tradition throughout Chinese history, hermits in imperial times sought seclusion to gain **wisdom** and understanding to guide society, while "modern hermits" (*xiandai yinshi*) in the People's Republic of China (PRC) seek refuge from the hustle and bustle of a fast-paced, **money**-driven social and economic order. Devoted to simple living

HERMITS (YINSHI) • 221

and surrounded by natural landscapes, hermits seek solace in isolated areas, most notably in the Zhongnan Mountains, near the city of **Xi'an** in Shaanxi, where the number of hermits was estimated at 5,000 in 2014, with one-half consisting of **women**. Often residing alone in thatch huts and even caves, hermits spend their time practicing **martial arts**, playing **music**, and, for followers of **Buddhism**, meditating and chanting sutras, sometimes a hundred times a day. Livable but limited income comes from such activities as the collection of valuable **mountain** herbs or the production of **jewelry**, as many hermits, especially among millennials, have given up prestigious and high-income employment in the cities. Pursuing a more laid-back lifestyle, millennial hermits spend their days reading books, exploring natural surroundings, and sitting on rocks contemplating the meaning of life.

Historically, the hermitic lifestyle was initially identified with **Daoism** and **shamans**, joined later by Buddhists, with a general commitment to turning their backs on everyday life, described as the "world of red dust" (*hongchen shijie*), by eking out poor lives in remote areas rather than serving **corrupt** rulers. Considered by many emperors as possessing great wisdom, including a **knowledge** of medicinal herbs, natural forces, and the **gods**, while maintaining an intimate contact with "heaven" (*tian*), hermits were often rewarded with high-ranking government positions over conventional officials. Persecuted periodically during the rule of Chinese Communist Party (CCP) chairman **Mao Zedong** (1949–1976), especially during the **Cultural Revolution (1966–1976)**, when religious sites and temples in the Zhongnan Mountains were destroyed, small communities of hermits have reappeared, with the Chinese government assuming a more tolerant policy since the introduction of economic reforms and social liberalization (1978–1979).

The choice of the Zhongnan Mountains, a branch of the Qingling range, as the preferred hermitic refuge is based on the belief that powerful **"energy"** (*qi*) exists at the remote site, indicated by local long-living pine trees, with powerful influence on the mental state and acuity of residents. Limited water supplies and the presence of wild **animals**, notably snakes and tigers, make life difficult, with most hermits usually staying for a minimum of five years and some for a lifetime. Full of shrines, monasteries, and huts, Zhongnan is known for famous past residents. These include Jiang Shang, king of the Wu State in the Zhou Dynasty (1046–256 BCE) and considered the master of all cultures; Zhang Liang, a strategist and leading figure in the founding of the Han Dynasty (202 BCE–220 CE); and Li Bai (701–762), China's most renowned poet from the Tang Dynasty (618–907). Recent and current residents come from all walks of life, including writers, businesspeople, college students, and lovers of traditional cultures, with the most devoted hermits living in hard-to-reach locations, avoiding any and all contact with outsiders as they seek to focus on one task, for example, reading sutras, to gain a clear and

222 • HEROES AND HERO WORSHIP

uncluttered mind. Reminiscent of past imperial practices, CCP officials are known to visit hermits on-site to provide them with assistance and learn from their unique experiences.

HEROES AND HERO WORSHIP (*YINGXIONG/YINGXIONG CHONGBAI*). Revered in the classics of **Confucianism** for their willingness to die for **virtue** and ideals, heroes and "martyrs" (*liesi*) have a long tradition in Chinese imperial history that has continued during the People's Republic of China (PRC). Two prominent types are **legendary and mythical** people, usually occupants of powerful government posts in the military and especially emperors, and, secondly, individuals who sacrificed their lives for important principles and beliefs. Examples of the former from the imperial era include the possibly mythical Yan and Yellow emperors, the earliest heroes for originating the Chinese race and civilization, along with real people like Qin Shihuang, founder of the Qin Dynasty (221–206 BCE) and unifier of China, and Emperor Taizong, cofounder of the prosperous and cosmopolitan Tang Dynasty (618–907). Others from imperial times include Qu Yuan (340–278 BCE), accomplished poet and diligent minister in the Chu State, who refused on principle to serve the more powerful Qin state during the Zhou Dynasty (1046–256 BCE); Zhuge Liang (181–234), a quick-witted and **loyal** strategist during the tumultuous Three Kingdoms (220–280); Guanyu (160–220), also in the Three Kingdoms, representing the virtues of honor and righteousness, while glorified in the classical novel *Romance of the Three Kingdoms* (Sanguo Yanyi) and venerated as a **god** in Chinese folk **religion**; Bao Zheng (979–1062), an upright judge serving justice during the Northern Song Dynasty (960–1120); Yue Fei (1103–1142), a renowned military commander in the Southern Song Dynasty (1127–1279) unjustly executed on false charges; and Lin Zexu (1785–1850), a fierce opponent of opium imports and a **symbol** of Chinese resistance to foreign powers.

Fast forward to the periods of the Republic of China (ROC) on the mainland (1912–1949) and the PRC (1949–), and the appeal of the hero and hero worship, especially in national politics, was prevalent and included both foreign and domestic figures. During the New Culture Movement/May Fourth Movement (1917–1921), admiration for the role of the heroic personality in history was aired by critics of Confucianism, including examples drawn primarily from Western history, for instance, Napoleon I and George Washington, as China was portrayed as generally lacking history-changing heroes. With the establishment of the Chinese Communist Party (CCP) in 1921, operating under strong influence by the Soviet Union, Russian leaders, namely Vladimir Lenin (1917–1924) and Joseph Stalin (1927–1953), were lauded as internationalist heroes but with CCP leaders losing out on internal political struggles, with one example being Li Lisan (1928–1930), criticized for aspiring to heroic qualities. Contrary to the antihero historical narrative of

HEROES AND HERO WORSHIP • 223

the pre-1949 CCP, chairman **Mao Zedong** was ascribed heroic qualities, especially during the **Cultural Revolution (1966–1976)**, when the Mao personality cult reached epic proportions.

Heroic themes also shaped the propaganda line of the CCP toward the Chinese people, with a 10-story-high Monument to the People's Heroes (*Renmin Yingxiong Jinianbei*) erected in Tiananmen Square, in **Beijing**, in 1958, as a recognition of revolutionary struggles during the 19th and 20th centuries. Common laborers and peasants were also singled out as heroic "models" (*mofan*), similar to the "heroic" qualities of Stakhanovite steelworkers in the Soviet Union, for their diligent work in building a "new China" (*xin Zhongguo*) in such places as the Daqing Oilfields in Liaoning. Heroic military and CCP officials included Lei Feng, a People's Liberation Army (PLA) soldier who, according to **legend**, heroically sacrificed his life for the collective good, and Jiao Yulu, a model county-level party secretary who was posthumously honored as a "revolutionary martyr" (*geming liesi*) for his tireless work, despite personal illness, in overcoming economic backwardness and fighting natural disasters afflicting Lankao county, Henan. Heroic characters and themes also dominated CCP posters, radio and television shows, and especially films depicting events in CCP history, with heroic party and military personnel taking center stage.

With the passing of Mao Zedong in 1976, and a return in CCP orthodoxy to an impersonal form of "collective **leadership**" (*jiti lingdao*), antiheroic rhetoric reappeared, although in muted tones, with subsequent leaders, especially President Hu Jintao and Premier Wen Jiabo (2003–2012), assuming a decidedly nonheroic, **technocratic** leadership style with a policy emphasis on **education**, **science**, and technology replacing heroic acts as the keys to progress. While television and movies switched from heroic portrayals to less dramatic but alluring themes of **romance and love**, official CCP narratives of heroic fighters were also challenged by journalists and historians, including the sacrosanct saga of the "Five Heroes of Langya Mountain," whose reputed tale of glorious resistance to the invading Japanese during the Second Sino–Japanese War (1937–1945) was criticized as a historical exaggeration done to strengthen the fading legitimacy of the CCP.

Coming to power with a commitment to strengthen personal leadership, along with a reaffirmation of the accomplishments of Mao Zedong, President **Xi Jinping** (2013–) has revived a heroic vision of CCP history, with the critic of the Langya Mountain story forced to issue a public **apology**, while enactment of the Heroes and Martyrs Protection Act (2018) is designed to maintain party hegemony over the historical narrative. The establishment of a national Martyrs Day in 2014, observed on 30 September, one day before the 1 October National Day, strengthens the hero-centered story line. Increasingly appealing to the Chinese public are the country's international heroes in **sports**, especially in swimming and football (soccer), with national medals

224 • HEROES AND HERO WORSHIP

awarded to such top scientists as Yuan Longping in agronomy and Tu Youyou, a Nobel Peace Prize winner in medicine in 2015. Martyrs also include individuals like Yu Luoke, Zhang Zhixin, and Ms. Lin Zhao, critics of the CCP and especially the Cultural Revolution who were summarily executed for their outspoken views and subsequently rehabilitated.

HIGH CULTURE (*GAO WENHUA*). Defined as the cultural objects of great aesthetic value that a society collectively esteems as exemplary **art**, high or elite culture in Chinese history also includes intellectual works of supreme importance in the realm of **literature, philosophy**, and **history** and **education**, which cultivate such refinement. Historically, the realm of artistic forms in Chinese high culture consisted of **calligraphy, music, painting**, the **game** of *weiqi* (Go), **poetry**, and appreciation of good wine and beautiful **flowers**, with the Confucian "gentleman" (*junzi*) exhibiting good tastes, dignity, elegance, and grace. Members of these privileged groups attended parties and gatherings with friends where poems or couplets were composed and philosophical ideas exchanged, often accompanied by fine wines and the playing of music on such traditional instruments as the *guqin*, the seven-string Chinese zither mastered by intellectual giants, including Confucius (551–479 BCE), and considered the **symbol** of high cultural refinement.

Essential elements of high culture also involved maintaining a **spiritual** superiority over ordinary folk and adhering to a strict moral code of personal behavior, with the ideal lifestyle portrayed in such classic literary works as *Dream of the Red Chamber* (Hong Lou meng/1791). While ordinary folk tried to emulate their cultural superiors, **scholars and intellectuals** in high standing often drew from folk, or low, culture, transforming and refining their art forms, eliminating any diametrical opposition between the upper and lower layers of Chinese society. Attacked in the People' Republic of China (PRC), especially during the rule of Chinese Communist Party (CCP) chairman **Mao Zedong** (1949–1976), most elements of traditional Chinese high culture were revived following the introduction of economic reforms and social liberalization (1978–1979).

HISTORY AND HISTORIOGRAPHY (*LISHI/SHIXUE*). Meticulously recorded for virtually all of the 35 separate dynasties in the imperial era, history is considered an integral part of high **literature**, with historiography, the study of history, reflecting political and **ideological** interests, especially in the People's Republic of China (PRC). Much more than a mere functional type of writing, history began with written documentary evidence of human activities dating to recordings on bronze vessels and "oracle bones" (*jiagu*) during the ancient Shang Dynasty (1600–1046 BCE). The first and oldest major written histories include the classics of **Confucianism**; the *Book of*

HISTORY AND HISTORIOGRAPHY (LISHI/SHIXUE) • 225

Documents (Shangshu), with texts of royal speeches; and the famous *Spring and Autumn Annals* (Chunqiu), with records of major political developments from 772–419 BCE and natural events.

Written in the annalistic style, which would dominate historical writing in China for centuries, Confucian historiographic works involved moral **criticism** of rulers and nobles that instructed the population of the present on historical lessons from the past. One of the less doctrinaire texts from the same era included *Discourse of the States* (Guoyu), with an anecdotal narrative style that would inform unofficial, private writings on imperial history. Frequent political efforts to erase the historical record also occurred, most notably during the Qin Dynasty (221–206 BCE), with the burning of the Confucian books, the burying alive of **scholars**, and wanton attacks on the historical record during the chaotic **Cultural Revolution (1966–1976)**.

Documenting the historical record of dynasties, present and past, began during the Han Dynasty (202 BCE–220 CE), with the *Hanshu*, by Ban Gu, covering the Eastern Han (25 BCE–220 CE), along with broader "universal histories" (*tongshi*) covering the entire breadth of Chinese history, including the impact of Chinese civilization on such neighboring areas as Vietnam and Korea. Most notable are the writings of Sima Qian (145–86 BCE), author of the *Records of the Grand Historian* (Shiji), with Sima Qian considered the father of Chinese historiography. With the establishment of the Historiography Institute (*Shiguan*) during the Tang Dynasty (618–907), the "veritable records" (*shilu*) of each reign were systematically compiled and official "dynastic histories" (*guoshi*) produced, a practice that continued throughout all the dynasties to the last Qing Dynasty (1644–1911). While state officials and archivists were responsible for the compilation of "correct histories" (*zhengshi*), with their inevitable critiques of ill-advised imperial practices in the past, private historians, often composed of scholars who failed the official civil service examinations, produced so-called "wild histories" (*yeshi*), unofficial and less-than-complimentary records of the past.

Increasingly important topics in history included "statecraft" (*zhiguo zhidao*), with major works produced, most notably by Sima Guang (1019–1086), a scholar-official during the Song Dynasty (960–1279) and author of *Comprehensive Mirror to Aid in Government* (Zizhi Tongjian), which covered the period from 403 BCE to 959 CE in 294 volumes. One of the most important histories of China, these volumes freed Chinese historians from an exclusive focus on dynastic cycles with a follow-up by Zhu Xi (1126–1271), founder of influential Neo-Confucianism and author of *Outlines and Details of the Comprehensive* Mirror (Tongjian Gangmu), which illustrated the moral principles of government. Also prominent were so-called "historical romances" (*tongsu yanyi*), with plots involving court con-

226 • HISTORY AND HISTORIOGRAPHY (LISHI/SHIXUE)

spiracies and illicit love affairs, for instance, the enormously popular *Scarlet Heart* (Bubu Jing), which along with other similar tales were subsequently made into films in the modern era.

Official dynastic histories were usually produced in two alternative versions, for example, the *Yuan Shi* and *Xin Yuan Shi*, for the short-lived Mongol Yuan Dynasty (1279–1368). During the subsequent and long-lasting Ming Dynasty (1368–1644), private histories flourished in the form of so-called "brush notes" (*biji*), for instance, *Records of Daily Gains in Knowledge* (Rizhilu), by Gu Yanwu (1613–1682), along with more standard works like *Confucians in the Ming Dynasty* (Mingru Xue'an) and *An Obscure Paragon of Virtue Awaiting a Royal Visit* (Mingyi Daifanglu), both by Huang Zongxi (1610–1695). Local "gazetteers" (*difangzhi*) also flourished in the Ming Dynasty and into the Qing Dynasty, providing rich historical records of individual provinces and locales. Also notable in the Qing was the new movement known as School of Antiquity Studies (*Kaogu xuepai*), with **antiquarian** analyses employing phonology, philology, and the new field of "textual criticism" (*kaozhengxue*), with Wei Yuan (1797–1857) considered one of the last traditions historians for his works on military history during the Qing, including the two Opium Wars (1839–1842, 1856–1860).

Exposed to Western ideas and philosophies from the mid-19th century onward, more and more Chinese historians approached history from a more universalistic perspective, with the traditional focus on the glorious past of the country replaced by the Western emphasis on future progress, a concept largely alien to Chinese historians. This was especially true after the culturally iconoclastic period of the New Culture Movement/May Fourth Movement (1917–1921), as Marxism–Leninism became increasingly appealing, although some historians, for example, Qian Mu (1895–1990), one of the "Four Great Historians" (along with Lü Simian, Chen Yinke, and Chen Yuan), in modern China, continued in the traditional focus on dynastic history and textual criticism. Marxism–Leninism was particularly appealing, as the doctrine offered an economic and historical explanation of China's backwardness, as well as a prognosis for future development led by the disciplined Communist Party of Vladimir Lenin. Chinese Communist Party (CCP) historians, led by Guo Morou (1892–1978), focused on previously ignored topics, especially peasant rebellions, which had occurred throughout Chinese imperial history, while including in the historical narrative previously ignored non-Han **minority** ethnic groups.

In international terms, the PRC was treated as just one nation among many, as opposed to the classical view of the empire as the "center of the world" (*zhongguo*), an empire unto itself surrounded on all sides by reputed **barbarians**. While official historiography generally adhered to the guiding ideological doctrine of Marxist–Leninist–Mao Zedong Thought during the period of rule by CCP chairman **Mao Zedong** (1949–1976), following the

introduction of economic reforms and social liberalization (1978–1979), historiographical debate broke out about the origins of "feudal despotism" (*fengjian zhuanzhi*), political code words for Maoist tyranny. For ideologically orthodox historians, economic and historical factors were considered primary, tying Maoist "despotism" to China's long history of small-scale peasant agriculture, while others looked to purely political factors, mainly the lure and pursuit of absolute power, as the key, with numerous examples of other equally tyrannist figures in Chinese history, beginning with Qin Shihuang of the short-lived but historically significant Qin Dynasty (221–206 BCE), who Mao openly praised. Depicting the pre-Qin period in ancient Chinese history as an embryonic democracy, similar to classical Athens and the Roman Republic, these same historians argued for democratic possibilities in contemporary China absent power-hungry leaders.

Similar arguments are currently targeting President **Xi Jinping** (2013–) for his apparent power lust in eliminating the two-term limit on the presidency in 2018, a **legal** reform that had been adopted in 1982, to avoid a replay of Mao-like power grabs. For Chinese unwilling to accept the universality of **human rights**, "historicism" (*lishizhuyi*) has become increasingly appealing, as the doctrine rejects any notion of a universal human nature, while emphasizing the importance of specific historical periods, geographical location, and local cultures the likes of the current Chinese combination of economic prosperity and authoritarian, one-party rule.

HOBBIES (*AIHAO*). In a work-intensive society where leisure time is a luxury, personal hobbies were generally limited in Chinese history, but with the growth of the middle class from the 1980s onward hobbies became more common and widespread, both conventional and some unique to China. Traditional hobbies pursued during imperial times included **calligraphy**, cooking, reading books, playing **music**, and **art** and **jade** collection, primarily among the prosperous and well-educated higher classes. Following the establishment of the People's Republic of China (PRC), hobbies, many imported from the West, were labeled as "bourgeois" (*zichan jieji*) and driven underground, especially in the notoriously antiforeign and anti-individualistic **Cultural Revolution (1966–1976)**.

Following the introduction of economic reforms and social liberalization (1978–1979), greater prosperity and growth of a middle class with increasing leisure time led to the pursuit of various hobbies and other forms of personal **entertainment**. Most notable was the rapid growth and popularity of "philately," or "stamp collecting" (*jihou*), with an estimated 20 million collectors, one-third of the global total of 60 million, as both a hobby and, for some, an investment strategy, as Chinese stamps, both pre- and post-1949, garner high prices at international auctions. With PRC collectors relatively young com-

pared to their global counterparts, stamp shows, auctions, and online exchanges have proliferated, with stamp collection seen as "patriotic" (*aiguo*) and Chinese collectors described as having "gone crazy" for the practice.

Especially popular and expensive are stamps produced in small quantities during the Qing Dynasty (1644–1911) following the creation of a modern postal system in 1877. Included are the "large dragon" (*dalong*) stamps, the first official issue in 1878; the so-called Red Revenue stamps (1897), commemorative issues for the reign of the Xuantong emperor, Aisin Gioro Puyi (1909–1911); and "three-cent" (*sanfen*) blue-green stamps, issued in 1910, the last of the imperial era. Stamps from the era of the Republic of China (ROC) on the mainland (1912–1949) include issues bearing the image of ROC founder Sun Yat-sen (1931) and his mausoleum in Nanjing (1929), followed by stamps portraying Sun's successor, Chiang Kai-shek (1945), and stamps with overprint value, reflecting the hyperinflation of the late Republican era on the mainland.

From the PRC, stamps featuring portraits or images of Chinese Communist Party (CCP) chairman **Mao Zedong** are particularly valuable, as the issue was limited, with many collections destroyed during the Cultural Revolution. Strong **nationalistic** and Communist internationalist themes dominated other issues, including the commemoration of major events in CCP history, portrayals of Vladimir Lenin and Joseph Stalin, along with generic People's Liberation Army (PLA) soldiers and workers, male and female, on the Chinese labor and industrial front. Stamps produced since the introduction of economic reforms (1978–1979) generally involve nonpolitical themes featuring well-known Chinese natural landscapes and **monuments**. Examples include the Lushan Mountains and the **Great Wall**, year-specific **animals** from the Chinese **Zodiac**, mascots adopted at international **sports** events, or commemoration of major scientific accomplishments, for instance, China's launching of a space satellite in 1970.

HOMEWRECKERS AND GIGOLOS (*POHUAIZHE/JIGELOU*). An increasingly common phenomenon among the prosperous middle class in the People's Republic of China (PRC), homewreckers generally consist of young **women** serving as "mistresses" (*qingfu*) to older **men** and young, usually unemployed male **prostitutes** to middle-aged and generally bored "housewives" (*jiating zhufu*). With spousal cheating as the primary cause behind the country's rising rate of divorce, detective-like agencies have emerged to investigate and expose husbands involved in illicit affairs, while equally aggressive entrepreneurs have put together groups of young men, commonly referred to as "ducks" (*yazi*), for hire by wealthy but disaffected wives often virtually abandoned by wandering husbands.

HOMOSEXUALITY (TONGXINGLIAN) • 229

With polygamy outlawed since the establishment of the PRC in 1949, and mistresses and **concubines** a prominent sign of wealth and influence in imperial China, "shameless" (*buyaolian*) homewreckers have grown in number, especially in wealthy coastal cities like **Shanghai** and **Guangzhou**. Major preventive measures include identification of known offenders with public beatings and forced disrobement, some videotaped, meted out in vigilante style with police looking the other way. Aggressive "mistress hunter and killer" (*qingfu lieren/shashou*) agencies have been established, along with so-called National Anti-Mistress Conferences (2009) and emotional support groups for abandoned and generally older women. As wives of serial cheaters are inclined to self-destructive behavior, with one example being **suicide**, preventive actions include the introduction of an alluring and handsome young man, known as the "secret weapon" (*mimi wuqi*), to lure away the female intruder from the wayward husband.

Easy to pick out sporting tight **clothes** and wearing sunglasses, the male "duck" can be bought by women for a few hours of chatting, drinking, and flirting with considerably higher prices for intimate relations. As an ever-growing and younger clientele frequent city nightspots and karaoke bars, new "ducks" are recruited into the business through newspaper advertisements, with many takers consisting of second-generation farmers in need of funds to pay off major **gambling** debts. Among the "meet-up" (*jianmian*) events are luxury river cruises sometimes offering Caucasian "ducks" with wild "Ukrainian dances" (*Wukelan wu*) featuring small Chinese men dressed in skimpy black sadomasochistic gear pretending to have epileptic seizures to trashy techno **music**.

HOMOSEXUALITY (*TONGXINGLIAN*). Lacking a strong heterosexual and homosexual dichotomy in Chinese culture, homosexual relations have been treated with ambivalence and controversy throughout Chinese history, including during the People's Republic of China (PRC). Traced to the Shang Dynasty (1600–1046 BCE), homosexuality was a persistent if subtle theme in **literature** and the **arts**, with even emperors, notably the infamous Emperor Ai (7–1 BCE) of the Han Dynasty (202 BCE–220 CE), involved in a same-sex relationship with a male imperial **concubine** that apparently ended in tragedy and **violence**. While traditional **philosophy** and **religion** were either largely silent on the matter, as in **Confucianism**, or at best neutral, as in **Daoism** and **Buddhism**, same-sex relations were especially popular in erotic literature for example, the *Poetical Essay on the Supreme Joy*, produced during the Tang Dynasty (618–907), and the *Cap but Pin* (Bian Er Chai), from the Ming Dynasty (1368–1644), with *Dream of the Red Chamber* (Honglou meng/1791) containing suggestive homosexual scenes. With the Qing Dynasty (1644–1911) issuing the first statute against homosexual sexual conduct, antigay attitudes at the elite and popular levels were strength-

ened by Chinese contact with such Western countries as Britain, where opposition to homosexuality was intense and made illegal. Traditional and generally cryptic descriptions of homosexuality included "passion of the cut sleeve" (*duanxiu zhipi*) and "divided peach" (*fentao*).

During the period of rule by Chinese Communist Party (CCP) chairman **Mao Zedong** (1949–1976), homosexuality was pathologized and criminalized, with Mao apparently advocating "castration" (*qushi*) for all **sexual** deviants. Officially, homosexuality was treated as a mental illness, with gay people subject to "electric shock therapy" (*dianli liaofa*) and facing systematic discrimination and harassment in the **workplace**. Following the introduction of economic reforms and social liberalization (1978–1979), government policy was softened, with adult consensual and noncoercive same-sex acts legalized in 1997, and homosexuality no longer considered a form of mental illness in 2001. Among the general public, attitudes toward homosexuality remain ambivalent, with 3 percent of **men** and 6 percent of **women** declaring themselves "completely out" (*wanqian taotai*) but with concerns for **family** and social **harmony** keeping others underground. While gay bars, restaurants, and discoes have proliferated in the PRC, especially in **urban** cities, along with gay websites, Chinese gay life is still largely underground, particularly with the spread of AIDS.

Global LGBT symbols like the rainbow flag remain generally unrecognized, with such pejorative terms as "homowife" (*tongxing qizi*) used to describe married women who lose their husbands to another man. Bans on homosexual images on television in 2016, and as a discussion topic on Weibo in 2018, have been instituted, with gay scenes deleted from foreign films. Commercially, gay life is still profitable, for instance, in the form of so-called "money boys" (*maide*), young men offering sexual services to gay men without themselves being gay. Despite the cancellation of many planned LGBT events in China according to harsh policy by President **Xi Jinping** (2013–), petitions supporting legalized gay marriage have been submitted to the National People's Congress (NPC), the top legislative body in the PRC.

Chinese-**language** terms referring to homosexuals common in the gay community include *tongzhi*, which also translates as the more politically correct "comrade," and *jilao*, or "gay guy," with "lesbians" called *lazi* or *lala*. Hardly qualifying as gay, young women in China fearing pregnancy and frankly uncomfortable with overly aggressive male partners often choose female companions for their first "safe" (*anquan*) asexual encounters, even while pursuing boyfriends and future husbands.

HONG KONG (*XIANG GANG*). A royal colony of Great Britain from 1842 to 1997, and a special administrative region (SAR) since reincorporation into the People's Republic of China (PRC) in 1997, Hong Kong has had profound economic, cultural, and political effects on mainland society, particularly in

HONG KONG (XIANG GANG) • 231

neighboring Guangdong and the city of **Guangzhou**. A phonetic translation of the city's name of *"heung gong"* in Cantonese, Hong Kong, prior to the takeover by Great Britain, was an isolated and thinly populated island under the influence of the ancient Nanyue kingdom in Southern China and incorporated into the Chinese empire from the Han Dynasty (202 BCE–220 CE) onward. Targeted as a potential entrepot by British entrepreneur William Jardine (1784–1843) in the run-up to the First Opium War (1839–1842), Hong Kong island was ceded to Britain in perpetuity by the Treaty of Nanking (1842), with expansion by subsequent agreements into Kowloon (1860) and the New Territories (1898), the latter involving a 99-year lease.

A major port, especially for imports into China of opium and woolen products, and Chinese exports of **tea** and such luxury products as silk and **ceramics and porcelain**, Hong Kong had a transformative **commercializing** effect on the local economies of neighboring Guangdong from the mid-19th century onward. With a free, largely unregulated economy and a highly developed global trading and financial system, the city served as a major source of equity and debt financing during the years of economic autarky (1953–1978) in the PRC under the **leadership** of Chinese Communist Party (CCP) chairman **Mao Zedong** (1949–1976). An open port to major international shipping, Hong Kong has been an outlet to the international economy for mainland Chinese companies, most recently for such new private Chinese companies as Tencent, located in nearby Shenzhen.

A freewheeling society combining the diverse cultures of the southern Lingnan **region** in China with the local Han Chinese, constituting 92 percent of the population, the city is composed of subethnicities of Punti and the Tanka boat people, largely from Guangdong, and the Hakka and Hokio ethnicities, from the farther reaches of the empire in Fujian, Jiangxi, and Guangxi. British influence on the local population came primarily through the Anglified system of free public **education** and use of English as the standard **language** of the colony. Adhering to political and **legal** principles centered on the "rule of law" (*fazhi*) with a local Legislative Council, sovereign authority over Hong Kong was retained in London.

The impact of Hong Kong on mainland culture has come primarily via television shows, pop **music**, and films, the last especially prominent in the 1990s, when Hong Kong studios produced more than 200 movies annually. Actors from Hong Kong with a large mainland following include Bruce Lee and Jackie Chan, along with world-renowned directors the likes of Wong Kar-wai (*Days of Being Wild, In the Mood for Love*), Stanley Kwan (*Rouge, Centre Stage*), and Mable Cheung (*The Soong Sisters*). A prime tourist attraction for wealthy mainlanders with extensive **shopping** and nightlife, including openly gay bars and hotspots, Hong Kong also offers some **gam-**

232 • HUIZHOU CULTURE (HUIZHOU WENHUA)

bling, most notably horse racing at the Hong Kong Jockey Club, along with lottery and football (soccer) betting, although not on the scale of casino-rich Macau.

Operating under the Hong Basic Law (1997), guaranteeing "one country, two systems" (*yiguo liangzhi*) of governance, Hong Kong enjoys an independent judiciary with freedom of **religion**, including **fengshui** and faiths banned in the PRC, for instance, Falun Gong. Large-scale demonstrations and street protests have broken out, especially among **youth**, against attempted PRC imposition of an **ideologically** biased school curriculum in 2012, and threats to basic civil and legal rights in 2019–2020, most notably a proposed extradition law allowing Hong Kong residents to be tried in mainland courts controlled by the CCP. Evidently fearful that demands for such protections could spread onto the mainland, PRC government officials have supported crackdowns on the demonstrations by local Hong Kong authorities, led by Chief Executive Ms. Carrie Lam, but without direct interference by PRC security forces, a situation that may change with the adoption of a National Security Law in 2020, applied to the former colony. Stay tuned.

HUIZHOU CULTURE (*HUIZHOU WENHUA*). Located in the southeastern province of Anhui and isolated by surrounding **mountains** of the Huangshan range, Huizhou is one of three distinct **regional** cultures in China. Situated in the six counties of Huizhou prefecture, villages, towns, and **urban areas** are sites of traditional **architecture**, especially in such well-preserved villages as Xidi and Hongcun, with ancient bridges, **pagodas**, and "archways" (*paifang*), the last devoted to famous regional **ancestors** and **families**. Also distinctive are the narrow streets and alleyways in the villages, with local housing characterized by intricate interiors of wood, stone, and brick carvings, and roofs of upturned eaves. Laid out according to **fengshui** principles, Huizhou villages take advantage of mountain slopes and water flows with simple but elegant architectural styles and an overall design coexistent with **nature**. High, washed-out, white walls were an inspiration for traditional Chinese ink wash **painting**, also found in local towns and urban areas. Included is Huizhou Ancient City, with its winding cobbled lanes and such structures as theatrical stages, teahouses, and archways dating to the Ming (1368–1644) and Qing (1644–1911) dynasties. Equally impressive is Huangshan city, dominated by a massive stone gate leading into the city featuring the Xuguo archway, built for Xu Guo (1527–1596), famous grand secretary in the Ming Dynasty, with the city a major tourist site of narrow streets filled with domestic and global retail outlets.

Lacking natural resources with a large population, including many immigrants from the north since the Song Dynasty (960–1279), Huizhou is known for a prosperous merchant **class** extensively involved in **commerce** and trade, including salt, **tea**, and silk, along the nearby Xin'an River. Huizhou

HUMAN RIGHTS (RENQUAN) • 233

culture is also distinguished by **seal carving**, wood block printing, painting, classical inks, and a distinctive **cuisine**, with local **opera** forms influencing the development of renowned **Peking opera**. Historically, the culture was also known for the publication of traditional texts on genealogy, classical **literature**, illustrated novels, and **drama**, with financial support from local well-educated merchants.

Famous people born in Huizhou include Zhu Xi (1126–1271), the preeminent founder of the idealistic Neo-Confucian **philosophy**, and Hu Shih (1891–1962), Chinese advocate of **pragmatism**, as advocated by American philosopher John Dewey. Left to rot for decades following the establishment of the People's Republic of China (PRC), the Huizhou region was revived by a major reconstruction effort begun in the 2000s, with two sites designated United Nations Educational, Scientific, and Cultural Organization (UNESCO) World Heritage Sites.

HUMAN RIGHTS (*RENQUAN***).** Issued in 1948, following the horrible transgressions of human dignity in World War II, the Universal Declaration of Human Rights raised the question of whether Chinese culture, with an emphasis on collective and state interests, often at the expense of the **individual**, was a major obstacle to applying the document to Chinese society, especially following the establishment of the People's Republic of China (PRC). Historically, the **language** of human rights was adopted during the Qing Dynasty (1644–1911) but with the granting of rights to Chinese citizens interpreted as a means to enhance state power as opposed to the Western enlightenment notion of promoting individual rights to curb state power. This approach continued during the period of rule under the Republic of China (ROC) on the mainland (1912–1949) and during the PRC by Chinese Communist Party (CCP) chairman **Mao Zedong** (1949–1976), when emphasis of both regimes was on developing state power and fending off hostile foreign powers.

Human rights rhetoric, while rare in the PRC, was directed at select groups, most notably workers and peasants at the expense of such alien groups as landlords and capitalists. Following the introduction of economic reforms and social liberalization (1978–1979), human rights were explicitly guaranteed in the new State Constitution (1982), including rights of property and **religion**, but with any infringement on the "interests of the state and society" restricting full expression of individual rights. For self-proclaimed human rights advocates in China the likes of Noble Peace Prize winner Liu Xiaobo (1955–2017), China's long history of "human rights disasters and unaccountable struggle" demand the full implementation of fundamental "universal" (*pubian*) rights in line with the 1948 Declaration, as outlined in Liu's *Charter 08* document dismissing the notion of intrinsic cultural obstacles to a robust human rights regime. For others, China's human rights needs

234 • HUMILIATION (QURU, CHIRU)

are more unique and influenced by the country's unique culture involving restoration of individual dignity and integrity in daily life, as originally laid out in **Confucianism**, consistent with the government's pursuit of national dignity.

HUMILIATION (*QURU, CHIRU*). A major political narrative pursued by both the governments of the Republic of China (ROC) and the People's Republic of China (PRC), "national humiliation" (*guochi*) focuses on the hostile treatment of China by foreign powers during a 100-year period from roughly 1839 to 1949. The most notable events contributing to China's "humiliation" began with the two Opium Wars (1839–1842/1856–1860) and included the Sino–French War (1884–1885), First Sino–Japanese War (1894–1895), Eight Nation Alliance in the Boxer Rebellion (1900), British Expedition to **Tibet** (1903–1904), 21 Demands by Japan (1915), Japanese Invasion of Manchuria (1931–1932), and Second Sino–Japanese War (1937–1945). Epitomized by the wanton and unnecessary destruction of the Old Summer Palace (*Yuanmingyuan*) by foreign troops in 1860, a National Humiliation Day was first proposed in 1915, and initially held on 9 May, the anniversary of China succumbing to Japan's 21 Demands. While the ROC honored the holiday between 1927 and 1940, the anniversary was virtually ignored during the period of rule in the PRC under Chinese Communist Party (CCP) chairman **Mao Zedong** (1949–1976), as **nationalistic** propaganda stressed China's many victories over humiliation.

Revived by the PRC government under Deng Xiaoping (1978–1992) following the military suppression of the prodemocracy movement in Tiananmen Square in **Beijing** in June 1989, National Humiliation Day is commemorated on 18 September, the anniversary of the bombing of a Japanese-run railway by Japanese troops near Mukden (modern-day Shenyang), blamed on the Chinese, which served as a pretext for the subsequent Japanese invasion of Manchuria. Often provoking anti-Japanese protests among Chinese **youth**, commemoration of the day, renamed National Defense Education Day in 2001, is part of the larger patriotic **education** movement aimed at fostering the collective memory of victimhood and conferring political legitimacy on the CCP in the wake of the virtual collapse of Marxism–Leninism–Mao Zedong Thought among the general population.

On a personal level, the continued emphasis on national humiliation often leads to a supersensitive reaction by the Chinese public to any slight in global affairs, no matter how small, as has frequently occurred at the Olympics, most recently in 2016, involving members of the Chinese team against competitors and judges. Personal humiliation is also a staple of treatment for detainees in Chinese **prisons** and internment camps, where any semblance of

HUNAN • 235

self-esteem is shattered on a daily basis by denial of such basic necessities as clean drinking water and adequate space to sleep, as recounted by former inmates on WeChat.

HUMOR (*YOUMOU*). Characterized by tone and linguistics, with little emphasis on physical **comedy** or exaggeration, as in the West, humor in China is highly conditioned by **language**, with topics involving personal "**face**," **family**, and general economic circumstances normally off-limits in conventional discussion. Dark, sarcastic, and very despondent and moody, humor is often a stepping-stone to more serious conversation generally exchanged with people of equal standing, as "joking around" (*kaiwenxiao*) with superiors, particularly at the **workplace**, is generally unknown.

Among the major types of humor unique to China is traditional "crosstalk" (*xiangsheng*), literally "face and voice," a classic style of stand-up comedy usually involving two quick-witted people in rapid-fire exchanges employing puns and allusions. Often poking fun at conventional standards involving gender roles and relations between **women** and **men**, cross-talk is also a common form of political satire still subject to **censorship** by the supersensitive government of the People's Republic of China (PRC). Equally unique are so-called "cold jokes" (*leng xiaohua*), involving humor relying heavily on puns and homonyms without a punch line or ending and considered so "bad" (*huai*) they are taken as funny.

Lacking facial expressions when delivering witty one-liners is also appreciated as funny by Chinese audiences, while explicitly "stupid humor" (*yuchun youmou*) is generally not well received, although some forms of Chinese humor are perceived by outsiders as downright mean. With the growth of a prosperous, consumer-oriented middle class, television commercials have become humorous, with the butt of jokes usually reserved for awkward subordinates at work or young men on their first date.

HUNAN. Located in Central China in the middle reaches of the Yangzi River, Hunan has a long history of unique cultural refinement and practices, as surrounding **mountains** cut off the province from other parts of China. Meaning "south of the lake," in reference to Dongting Lake in the northeast corner of the province, Hunan is known for several prominent political leaders. These include Zeng Guofan, who suppressed the Taiping Rebellion (1850–1864) in the Qing Dynasty (1644–1911), and in the modern era, Chinese Communist Party (CCP) chairman **Mao Zedong** (1949–1976) and People's Republic of China state president Liu Shaoqi (1959–1968).

Home to 64 million people in 2019, some of them Tujia and Miao **minorities**, the people of Hunan generally speak the Xiang dialect of Mandarin Chinese and are famous for local **tea culture** and hot and spicy **food**, with

236 • HUNGER (JI'E)

chili peppers, garlic, and shallots, one of eight major Chinese **cuisines**. Important historical sites include Han Dynasty (202 BCE–220 CE) imperial tombs and the well-preserved ancient towns of Fenghuang and Furong, dating back 300 years. Ancient **architecture** is represented by the impressive Yueyang Tower (*Yueyang lou*), built during the period of the Three Kingdoms (220–280) and standing on the city gate of Yueyang, with distinctive yellow tiles and overhanging eaves. One of three preeminent towers in China, the other two being the Pavilion of Prince Teng (Nanchang, Jiangxi) and the Yellow Crane (Wuhan, Hubei), the roof of Yueyang Tower is shaped like a general's helmet, the only one in China. Other architectural gems include Yuelu Academy (*Yuelu Shuyuan*), built during the Song Dynasty (960–1279) in Changsha, one of four major Confucian **academies** in imperial history, with lectures by Zhu Xi (1126–1171), founder of Neo-Confucianism.

Decorative **arts** include **ceramics and porcelains** developed during the Tang Dynasty (618–907) and Xiang embroidery employing silk thread, satin, and nylon, one of four distinctive Chinese regional embroidery traditions, along with **Sichuan**, Suzhou, and **Guangzhou**. Local **opera** is referred to as the "Flower Drum style" (*Huaguxi*), with earthy qualities, few props, and **music** provided by Chinese instruments, including the "fiddle" (*datong*), "moon lute" (*yueqin*), and "bamboo flute" (*dizi*). Known as the "land of lakes and rivers" (*xaoxiang*), natural scenery in Hunan is dominated by forests and mountains, most notably Mount Heng, one of the five great mountains in China, with the Grand Temple of Mount Heng located at the foot. Waterfalls, rock spires, and sandstone pillars, along with gentle, rolling plains like the Peach Blossom Land, have throughout the centuries inspired **paintings** and **poetry**, the latter most notably by Tao Yuanming (365–427). Famous dishes from Hunan include "Mao Family red-braised pork" (*Maojia hongshao zhurou*), grilled pork with onions, ginger, and garlic covered with a chili-based wine-fermented sauce, considered the "brain food" the CCP chairman used to defeat Nationalist (*Kuomintang*) leader Chiang Kai-shek

HUNGER (*JI'E*). One of the basic experiences of life in China for centuries, hunger has posed a constant threat, especially to the lower classes, as only 15 percent of the country's territory is arable, with a population exceeding 400 million by the Qing Dynasty (1644–1911). Memories of extreme hunger and **food** deprivation are still fresh, particularly among the older generation, which experienced the Great Famine (1959–1961) in the midst of the disastrous Great Leap Forward (1958–1960), surviving the difficult three years on rice gruel, vegetable scraps, and vinegar and soy sauce soups. While hunger generally has been overcome since the introduction of economic reforms and social liberalization (1978–1979), especially in the agricultural sector, with staple grain supplies growing dramatically and exceeding macro demand, pockets of severe malnutrition still exist, particularly in the poorest **regions**

of the country. The case of Wu Huayan, a young girl in relatively underdeveloped Guizhou who died from years of an inadequate diet, sparked outrage on Chinese **social media**.

Described as the "land of famine" (*jihuang zhidi*) in 1927, with more than 1,800 major famines occurring throughout 2,000 years of history (108 BCE–1911), China was replete with stories of hunger, real and mythical, in Chinese **folktales and fairy tales**. Most common are accounts of the inhumane denial of food to those in need, along with tales of pervasive fear of famine, especially among young **children**, who worried about being eaten by their own parents. Descriptions of hunger and its deleterious effects on both **body** and mind filled Chinese **literature** in the 1980s, with the elderly warning younger generations that, "You don't know hunger."

Years of food insecurity also led to the creation of simple but nutritional dishes and soups often preferred over fancy, rich dishes. With days of hunger and despair as was experienced in the darkest period of the **Cultural Revolution (1966–1976)** fading into the past, fears of hunger have been replaced by anxieties concerning recent cases of food poisoning, along with **obesity** and diabetes stemming from overeating, especially by the young. Recent films, for example, *Back to 1942* (2012), directed by Feng Xiaogang and starring American actor Tim Robbins, provide stark portraits of famine and maddening hunger during the Second Sino–Japanese War (1937–1945) in Henan. Everyday **language** in China indicates the importance of "eating one's fill" (*chibaole*), which is a common response to greetings of, "Have you eaten yet?" (*ni chiguole meiyou?*).

HUNTING AND FISHING (*SHOULIE/DIAOYU*). Largely restricted to ethnic **minorities** living in areas with plentiful wildlife and members of the imperial court, hunting in China was a major source of elite identity beginning in the Zhou Dynasty (1046–256 BCE) although generally not a major **food** source in an overwhelmingly agrarian culture. While some wild **animals** were hunted for food, most were killed to acquire ingredients for **traditional Chinese medicine (TCM)**, particularly horns, bones, fins, scales, and other body parts from tigers, rhinoceros, black bear, and musk deer, many now listed as endangered species. Hunting parks were established in areas of dense animal life, with the highlight for the elite during the Qing Dynasty (1644–1911) coming in the annual imperial hunt, held for one month in autumn, with Chinese hunters often relying on falcons and even eagles to bag their prey.

Following the establishment of the People's Republic of China (PRC), Chinese Communist Party (CCP) chairman **Mao Zedong** (1949–1976) issued a proclamation banning shooting and hunting that remains in force to the present, ending centuries-old traditions. Exceptions included Chinese Tigers, most notably the South China Tiger, which became a target following a

238 • HUNTING AND FISHING (SHOULIE/DIAOYU)

declaration by Mao in 1959, that the animal was an "enemy of man" and should be eradicated. Numbering several thousand in the 1950s, South China Tigers were reduced to 30 to 80 animals, with none in the wild, as an outright ban on tiger hunting was not issued until 1979, following Mao's passing. Other frequently targeted animals, largely hunted by illegal hunters, and many endangered, include the following: **Tibetan** antelope; "pangolins" (*chuanshanjia*), prized for their tasty meat, with their scales thought to contain medicinal benefits; and a rich variety of birds, for example, the yellow-breasted bunting, considered a delicacy in Chinese **cuisine**.

A major transit point for massive bird migrations, especially along the coasts in spring and summer, China is beset by a large number of bird poachers relying on tree nets and even Carbofuran pesticide to trap an estimated 7 to 10 million birds each year. With huge numbers ending up in local restaurants or ensconced on breeding farms, some bird species, for instance, the spoon-billed sandpiper, have been driven to near-extinction. Offenders, if caught, face stiff fines, jail time, and property confiscation, with execution as the ultimate penalty for killing a giant panda, with a commensurate crackdown on TCM pharmacies. While limited hunting of nonthreatened species is allowed on regulated hunting grounds established in the 1980s, for example, the Taoshan International Gameland, hunting by falconry is still popular in parts of Southern China and among ethnic minorities, including the Naxi in **Yunnan** and the Kirghiz people in the far northwest. With guns still banned in most parts of China and **urban** residents generally unattracted to the **sport**, **legal** hunting is largely the province of the nouveau riche, often at the expense of wildlife in less regulated foreign lands, especially Africa.

In a country of more than 20,000 rivers, lakes, and reservoirs, and a coast on the Pacific Ocean measuring 14,000 kilometers (9,000 miles), fresh fish and seafood are major staples in Chinese cuisine, with the country maintaining strong **riverine and maritime traditions**. Especially unique is the reliance on trained "cormorant" (*luci*) birds by fishermen, many of them members of the Bai minority, in Guilin and Guangxi to capture fish. Diving into the waters of the relatively shallow Lijiang River and Erhai Lake, the birds retrieve fish with a snare around the neck to prevent swallowing their prey. Dating back to the Sui Dynasty (581–618), the practice is now largely performed for tourists and no longer a major source of food. Also noteworthy are the "Tanka people" (*Danjia ren*), traditional fishermen who live on junks along Chinese coastal cities, including **Hong Kong** and Macau. While fully Sinicized throughout the centuries, Tanka were traditionally treated as outsiders, considered "sea gypsies" (*hai jipusai ren*), with many abandoning fishing and their junks to pursue jobs inland. With one of the largest and most modern fishing fleets in the world and local waters overfished and/or suffering major pollution, China's insatiable demand for fish is largely supplied from dwindling stocks off the shores of Africa.

HYGIENE AND SANITATION (*WEISHENG*). The condition of personal hygiene and public sanitation in China is a story of diametrical opposites, as individual Chinese are fastidious about personal cleanliness and appearance, while the quality of public sanitation in both **rural areas** and such major cities as **Beijing** has been seriously lacking. With foreign tourists and international bodies like the International Olympic Committee (IOC) complaining about unsanitary conditions throughout the country, major efforts were begun by the government of the People's Republic of China (PRC) from the 2000s onward to improve public sanitation, as China hosted the World Toilet Summit (2004). Inaugurating a "toilet revolution" (*cesuo geming*) in 2015, the administration of President **Xi Jinping** (2013–) announced plans for the construction of 68,000 public facilities during the next two years. Targeting heavily touristed sites, new toilets featured automatic flushing devices accompanied by blow dryers, climate control, and previously unavailable "toilet paper" (*weisheng zhi*). Expansion of the program is planned into areas lacking sanitary accommodations, especially for underserved **women**, in the countryside and such **urban** communal areas as the densely populated "alleyways" (*hutong*) found in many Chinese cities.

Historically, China has a long tradition of maintaining personal and public sanitation, with household toilets for the wealthy dating to the Zhou Dynasty (1045–256 BCE) and the invention of the world's first flush toilet during the Western Han Dynasty (202 BCE–9 CE). Production and use of toilet paper began in the period of the Northern and Southern dynasties (386–589), again mainly for the wealthy, while pay-for public toilets were installed in urban areas during the Tang Dynasty (618–907). Expanded during the Song Dynasty (960–1279), public and private toilets were major sources of fertilizer, often sold to peasants and carried into adjacent rural areas in so-called "honey pots" (*miguan*), with concomitant increases in dysentery rates.

Fast forward to the modern era, and sanitary conditions are particularly problematic in rural areas, as the emphasis on increasing agricultural production in the PRC from the 1950s onward left wide swaths of the countryside lacking basic sewage treatment facilities. As much as 45 percent of rural residents had no access to suitable toilet facilities in 2010, living in houses without washrooms and relying on outdoor shed-like facilities built of cinder blocks, with few basic amenities, for example, clean toilet paper. Urban areas have also been beset by unsanitary personal habits, for instance, allowing infants lacking diapers and wearing slit pants to defecate on city streets. Rural and urban areas undergoing the recent housing boom have seen demand for modern plumbing facilities skyrocket, with cutting-edge toilets employing highly efficient flushing systems and heated seats with built-in bidets especially popular. Other threats to public health include the persistence of so-called "wet markets" (*shi shichang*), with an array of wild **animals**, including hedgehogs, peacocks, and even crocodiles, which some Chi-

nese still believe enhance the immune system more than domesticated farm animals but create severe sanitation problems that may have led to the outbreak of COVID-19 from such a market in Wuhan, Hubei, in 2020.

I

IDEOLOGY (*SIXIANG TIXI*). Defined as a system of ideas and ideals forming the basis of an economic or political theory, official ideologies from **Confucianism** to Marxism–Leninism–Mao Zedong Thought have had enormous appeal throughout Chinese history to intellectual elites and the educated population alike. With traditional and modern **education** acting as a major proselytizer of a single, all-encompassing doctrine, China has been generally unreceptive to competing, oppositional ideologies like "anarchism" (*wuzhengfuzhuyi*) and "liberal democracy" (*ziyou minzhu*), although historical coexistence was achieved between Confucianism and **Daoism**, the latter considered a **religion** more than a secular ideology.

A one-party state since the establishment of the People's Republic of China (PRC), the Chinese Communist Party (CCP) was long dominated by "Mao Zedong Thought" (*Mao Zedong sixiang*). Nationwide promulgation of principles associated with "Chairman Mao" (*Mao zhuxi*) occurred, especially during the **Cultural Revolution (1966–1976)**, when radical Red Guards spouted Maoist phrases taken from *Quotations from Chairman Mao Zedong* (Mao Zhuxi Yulu), commonly known as the *Little Red Book*. Endurance of ideologies in China is strengthened by the almost-exclusive emphasis on rote memorization in Chinese education, with classical Confucian **scholars** and modern-day ideologues capable of reciting selective passages or entire texts.

Following the passing of Mao Zedong in 1976, a line of new leaders put their personal imprimatur on new ideas and concepts, although without explicitly negating principles espoused by the founding father of the PRC. Included were "Deng Xiaoping theory" (*Deng Xiaoping lilun*), outlining the major economic and political characteristics of the country in the "Primary Stage of Socialism" (*Shehuizhuyi Chuji Jieduan*); the concept of "Three Represents" (*Sange Daibiao*) advocated by president and CCP general secretary Jiang Zemin (1989–2002), promoting the CCP as representing the overwhelming majority of the Chinese people, including groups previously discriminated against, for instance, intellectuals; the "Scientific Outlook on Development of a Harmonious Society" (*Hexie Shehui de Kexue Fazhan*), pro-

242 • INDIVIDUALISM (GERENZHUYI)

moted by president and CCP general secretary Hu Jintao (2003–2012); and "Xi Jinping Thought" (*Xin Jinping Sixiang*), unveiled at the 19th National Congress of the CCP (2017), with 14 specific concepts and policy goals.

With **Xi Jinping** the only leader whose political principles have been characterized as "thought" (*sixiang*), a term previously reserved for Mao Zedong, the personal ideology of the PRC president and CCP general secretary is promoted by university research institutes established explicitly for "study" (*xuexi*) of his profound ideas on "Socialism with Chinese Characteristics for the New Era." Mao-like quotations appear on public transport and city walls, along with benevolent images of the Chinese leader, with stories on media recounting his glorious past a la Mao Zedong. While Xi has roundly denounced the appeal of liberal democracy and other Western ideas, especially to Chinese **youth**, the attempt to impose "Xi Jinping Thought" on curriculum at Fudan University, **Shanghai**, was met by stiff resistance from students and faculty, citing the threat to "academic freedom" (*xueshu ziyou*).

INDIVIDUALISM (*GERENZHUYI*). Dominated throughout Chinese history by a reverence for "collectivism" (*jitizhuyi*) from imperial times into the modern era, especially during rule by the Chinese Communist Party (CCP) in the People's Republic of China (PRC), individualism had little space for development until the adoption of economic reforms and social liberalization (1978–1979). Historically, the singular dominance of **Confucianism**, with emphasis on the interdependence of individuals, especially within the **family**, created multifaceted collectivist pressures in favor of personal obligations and duties as opposed to autonomy and free will. With "individualism" (*gerenzhuyi*), an imported term not indigenous to the classical Chinese **language**, social and political traditions stressed respect for age and social hierarchy, importance of relationships and social interaction, and self-identity based on **"face."** Reinforced by a prevalence of "passive fatalism" (*beidong suminglun*) in the Chinese mindset and the crucial importance of **harmony** to the social order, pursuit of individual interests was considered a destructive and degenerate force, a traditional view reaffirmed in the early years of the PRC. Taken to extremes during the chaotic **Cultural Revolution (1966–1976)**, the collectivist spirit of Communist rule has gradually eroded as capitalist **markets** with expanding consumer choices and greater personal determination of careers has turned the individual into more of a centerpiece of Chinese society.

The growing centrality of the individual reflects an emerging consensus, especially among the rapidly expanding middle class, to live a life without fulfilling the many societal expectations of the past. Past collective traditions and values are subject to increasing scrutiny and even "sarcasm" (*fengci*), especially by younger generations, as Chinese people increasingly prefer to act as individuals rather than members of a group both at home and in the

workplace. Social and cultural metrics of growing individualism include parents giving **children** unique and obscure names; prominence in popular **songs** of singular pronouns like "I" and "me" (*wo*), as opposed to the "we" (*woman*) and "our" (*womande*) of the past; and, according to the World Value Survey, greater importance by Chinese employees placed on personal leisure time. Product personalization and customization are increasingly evident in such advertising campaigns as "you don't have to" (*ni bu di*), turning the individual consumer into king, or queen, with personal **happiness** the basis of life satisfaction. Concerned that such individualization may transform into a democratic impulse, the Chinese government has replaced the outmoded collectivism of the era dominated by CCP chairman **Mao Zedong** (1949–1976) with an appeal to **nationalism** and national pride as a basis for its continued political legitimacy, with individualism described in such publications as *The Sea of Words* dictionary as "the heart of the bourgeois worldview."

See also PERSONAL RESPONSIBILITY AND SELF-RELIANCE (*GEREN ZIREN/ZILI GENGSHENG*).

INFANTILISM AND INFANTILIZATION (*YOUZHIBING/YING'ER HUA*). Respectively defined as adults behaving like **children** and adults treating other mature adults like children, infantilism and infantilization reflect the inherent "patriarchal" (*jiazhang*) character of both traditional and modern Chinese culture. Most evident in the imperial era (221 BCE–1911 CE) was the practice of referring to government authorities as "father–mother officials" (*fumuguan*), in effect declaring the general population children, while in the modern era familial principles, especially the dominant role of the father and males in general, was strengthened by the adoption of **market** principles and the influence of domestic and foreign media. Lamented as a major cultural and psychological attribute of Chinese people, progressive writer and political activist Liang Qichao (1873–1929) likened the Chinese mind to child psychology, wholly **dependent** and lacking any sense of **personal responsibility**, which explained the country's long history of "despotism" (*zhuanzhi*) in the **family** up to the imperial state. Emotional, easily excitable, devoid of judgment, and disorderly, Chinese people were considered "childlike" (*tongqu*) and suffered from an "extreme individualism" (*jiduan de gerenzhuyi*), making them highly malleable and easy to control, and thus totally unprepared for the adoption of a Western-style democracy. A strong advocate of "enlightened despotism" (*kaiming zhuanzhi*), Liang Qichao rejected democratic forms, while encouraging the adoption of more authoritarian rule as developed in both the Republic of China (ROC) on the mainland (1912–1949) and the subsequent People's Republic of China (PRC). From Chiang Kai-shek (1928–1949) to Chinese

Communist Party (CCP) chairman **Mao Zedong** (1949–1976), China has been under the rule of a singular **leadership** exuding "patriarchal" tendencies, a pattern continuing under President **Xi Jinping** (2013–).

Outside the political realm, patterns of infantilism and infantilization appear in many venues, from the childlike treatment of **women** in the workplace to the growing "cosplay" (*juese banyan*) market, especially among Chinese **youth**. Suffering employment discrimination in hiring and promotions, Chinese women confront an increasingly hostile workplace informed by such infantilizing treatment as demands to avoid pregnancy and frequent **sexual harassment**. Portrayed in commercial advertisements as child-like "little fairies" (*xiao xiannü*), with adult female models donning childhood garb, Confucian values of women as **loyal**, devoted, and willing to sacrifice are undergoing a renaissance promoted by an overwhelmingly male corporate leadership obsessed with controlling the narrative. Institutions designed to promote such values include female morality schools, where women learn everything from scrubbing floors to proper ways of apologizing to their husbands.

Strengthened by similar infantilizing patterns found in Western media popular in the PRC, notably Kidult films, the immaturity and child-like character of adults is also apparent in popular reality shows consisting of mindless fun and **entertainment** as adult guests often scream and **dance** around just like children. With young women projecting an image of "cuteness" (*ke'ai*), the Chinese word often used to describe infants, reverting to childhood is linked to a state of innocence and moral purity not found in an increasingly complex and emotionally taxing real world. In such an environment, cosplay is particularly attractive, with young people, including marrying couples, dressing up like fictional characters who generally embody innocence and childishness, with marketing firms and foreign corporations facing pressure to infantilize their business model to this rapidly expanding consumer group. Heavily influenced by Japan, cosplay in China has involved a sexualization of women, including portraying young girls in revealing and seductive swimsuits and children's underwear, with an intimate connection to the overall appeal of infantilization.

INSULTS (*WURU*). Along with cursing, profanity, and **slang**, the Chinese **language** is replete with insults, from the mild to the vicious, many intended for misbehaving and licentious **women**, along with lecherous older **men**. Reflecting the agricultural origins of Chinese civilization, many insults use **animal** and **food** references, while some of the harshest terms and phrases invoke **family**, undoubtedly the most revered Chinese social institution. Animal insults include both domesticated farm animals, especially pigs and cows, and wild animals, including "dogs" (*gou*), "rabbits" (*tuzi*), "wolves" (*lang*), and "foxes" (*huli*), the last generally reserved for devious and seduc-

tive women known as "fox spirits" (*hulijing*). Other examples include the following: "pig's head" (*zhutou*) to describe, as in many cultures, being stubborn; "blowing up cow's skin" (*chuiniu*), traced to Mongolians and a fairly tame reference to a braggart; "dog whelp" (*gouzaizi*), meaning "SOB"; "color-seeking wolf" (*selang*), used for predatory older men; "freshwater turtle" (*bie*), for promiscuous women; and "dead-eye fish" (*siyuyan*), for a vapid and out-of-touch person.

Among the many food-based insults, especially involving "eggs" (*dan*), are "lazy egg" (*landan*) and the more severe "mixed egg" (*hundan*), basically meaning scumbag, and the most vicious, "turtle's egg" (*wangba*), essentially meaning bastard. Claiming a man is "eating soft rice" (*chi ruan fan*) suggests he is living off his girlfriend, while a misbehaving child is often told, "It would have been better to have a piece of barbecue pig" (*shengge you shao-kao zhudou hao guosheng ni yi*). Accusing someone of being a "green tea bitch" (*lücha biao*) is used to describe a woman who exudes innocence on the outside but is devious at heart, while condemning a person's "ancestors to the 18th generation" (*cao ni zuzong shibadai*) is an especially harsh rebuke invoking a person's entire family line. Reference to **ghosts** appears in many insults, for instance, calling someone a "coward" (*danxiaogui*) or "cheap" (*xiaoqigui*).

INTERROGATION (*SHENXUN*). A common practice used by police and prosecutors in the People's Republic of China (PRC), interrogation methods have been criticized by global **human rights** organizations as amounting to "**torture**" (*zhemo*), in violation of Chinese domestic Criminal Law (1997 and 2012) and international human rights prohibitions against torture, to which the PRC is a signatory. Designed to generate **confession** of a **crime** by a detainee, especially when there is a lack of other incriminating evidence, interrogations can be very intense, lasting hours or days, and conducted at odd hours, oftentimes the middle of the night. Methods include shackling a detainee in a so-called "tiger chair" (*laohuyi*), a seat with rings to immobilize and keep a detainee in an uncomfortable position for long periods; "sleep deprivation" (*shuimian buzu*); and isolation from friends, **family**, and, most importantly, defense lawyers. Usually kept in secret sites located in major cities and the countryside, detainees are subject to a constant stream of re-peated questioning and **accusations** designed to break down resistance and yield confessions, which are then signed by the detainee and constitute 99 percent of criminal prosecutions in the PRC.

Denying these methods amount to torture, Chinese police have been known to post videos of interrogations to **social media**, often accompanied by blasting rock **music**, officially designed to promote the "spirit of police sacrifice" (*jingcha xisheng de jingshen*). With the creation of the increasingly intrusive **social credit system**, interrogations are likely to increase, sparking

even greater international reaction and condemnation. Victims of enhanced interrogations include writer and activist **Ai Weiwei**, who was detained for 81 days in 2011, and prodemocracy **foreigners** of Chinese descent, most recently in 2019.

J

JADE AND JADE CARVINGS (*YU DIAOKE*). The favorite gemstone in China, known as the "imperial stone" (*diguo shi*) for its long association with emperors throughout Chinese history, jade carving became a major **art** form beginning with the Song Dynasty (960–1279). Traced to the Neolithic era from 3,000–2,000 BCE and prominent in virtually every Chinese dynasty, jade in China is considered a lucky charm and full of **virtues**, revered by Confucius (551–479 BCE) as embedding wisdom, **energy**, and truth, making the stone as precious as the "*Dao*" (the Way) itself. According to mythology, jade was fashioned by "thunder" (*lei*) and captured the force of the heavens in the form of "crystallized moonlight" (*jiejing de yueguang*), imputing the stone with **magical** powers of warding off decay and disease, which is why the stone was often included in the **burial** tombs of the nobility and emperors. Considered a bridge between the physical and **spiritual** world, jade represented purity, **beauty**, **longevity**, and even immortality, and was valued for its smooth touch, as well as its modest and humble appearance.

Preferred over the more bedazzling and glitzy gold or silver, jade reached its apex with the famous "jade suits" (*yufu*) from the Han Dynasty (202 BCE–220 CE), composed of jade plaques sown together and made for deceased emperors and nobles to ward off evil spirits in the afterlife. **Ceremonial** carvings of jade included blades known as *gui* and *zhang*, and disk-shaped ornaments known as *bi*, along with **ritual** vessels, figurines of such mythical **animals** as the dragon and the phoenix, daggers and swords, and various forms of statues and relief **sculptures**. Exclusive carvings for the emperor included the *cong*, a cylindrical tube encased in rectangular blocks symbolizing **yin-yang**, with square for yin and circle for yang, along with official **seals** of state made of jade.

The most common form of jade in China was nephrite, known as "soft jade" (*ruanyu*), used by cutters from ancient times to the end of the Ming Dynasty (1368–1644) and coming in a variety of **colors**, most commonly white. Switching to the harder "jadeite" (*yingyu*), largely imported from Burma (modern-day Myanmar) beginning in the Qing Dynasty (1644–1911), with a greater range of colors, most prominently green, daily-use items like

248 • JEALOUSY (JIDU)

cups, bowls, and drinking vessels of jade were produced, mainly for the wealthy. Too hard for metal tools, traditional jade carvings involved wearing away the stone with carborundum abrasives and sand and soft tools, which were replaced in modern times by rotary tools with diamond-head drills. The more complex and intricate carvings included images of the Buddha and the Bodhisattva Guanyin, along with elaborately designed vases and ritual vessels that at modern-day auctions garner hefty prices.

The most prized jade is known as *hetian*, found in the Xinjiang-Uighur Autonomous Region (XUAR), while the Chinese-**language** term for "jade," *yu*, also covers other hard stones, including serpentine and bowenite, with nephrite and jadeite the only true jades, with colors including blue, red, yellow, orange, black, white, and green. Jade was also put to wider use as the mouth of opium pipes to prolong the **longevity** of the smoker; **eating** utensils, primarily **chopsticks**, to transfer the energy in **food** to the diner; and various forms of **jewelry**, including earrings and bracelets, believed to ward off rheumatism.

Dormant for years during the years of poor economy throughout much of the 20th century, the **market** for jade in the People's Republic of China (PRC) has undergone a revival following the introduction of economic reforms and growth of a prosperous middle class since the 1980s. Included are jade exhibitions, auction houses, wholesale trading centers, large retail spaces, and online sales, especially of jade pendants worn by **children** and adults alike, as a lucky charm, ensuring good **health** and well-being. According to estimates based on auction prices from master jade carvers who still practice their craft, China's nephrite jade market in 2016, was put at $30 billion, with rare imperial green jade the most expensive gem in the world.

JEALOUSY (*JIDU*). Ranging from intense negative feelings toward others from competing **romantic** and **sexual** partners to successful workplace colleagues, jealousy is widespread in Chinese society, tracing its historical roots to **Confucianism** and the policy of "absolute egalitarianism" (*jiedui pingjunzhuyi*) pursued during the rule of Chinese Communist Party (CCP) chairman **Mao Zedong** (1949–1976) in the People's Republic of China (PRC). By praising the person who withholds **anger** and resentment, Confucius (551–479 BCE) encouraged the cultivation of an introverted personality, more likely to develop strong feelings of resentment, including jealousy, which Maoist policies reinforced, as individuals in the socialist system were subordinated to the collective, with everyone rising or falling together. With the introduction of economic reforms and social liberalization (1978–1979), individuals receiving promotions, bonuses, and even praise from bosses are often not made public, to prevent jealous reactions from psychologically unbalanced coworkers. **Children** excelling in school and other activities may

JEWELRY (ZHUBAO SHOUSHI) • 249

confront similar reactions of jealousy, especially from parents of fellow students unable to achieve such accolades in the increasingly competitive realm of contemporary **education** in the PRC.

Particularly intense is the reaction of intimate partners to suspicions of sexual cheating, evidently common among **men**, with extreme jealous reactions bordering on sexual **violence**. Described in Chinese as "eating vinegar" (*chicu*), the phrase is traced to a **legend** attributed to the Taizong emperor in the Tang Dynasty (618–907). Admiring the willingness of the wife of the prime minister to kill herself by drinking poison rather than bow to the emperor's will of granting a beautiful, young **concubine** to her husband, the emperor forced the wife's hand, giving her a vial of poison and telling her to either accept the concubine or her **death**. She drank the vial without hesitation, only to find it full of vinegar, and since then, "eating vinegar" has become the metaphor of jealousy and envy. Similar word play targeted at the easily jealous type includes the **slang** phrase "lemon turned genie" (*ningmeng jing*), used to describe arrogant people who enjoy criticizing others for their success and personal **happiness**, and traced to legends claiming **animals** and fruit can be given **magical** powers by the **gods**.

JEWELRY (*ZHUBAO SHOUSHI*). Produced throughout Chinese history from the Shang Dynasty (1600–1046 BCE) onward, primarily for **women** but with some designs also for **men** serving in the imperial court, jewelry comes in many prominent traditional and exquisite styles, along with cheaper designs intended for modern-day wholesale **markets** targeted by foreign and domestic companies operating in the People's Republic of China (PRC). Major traditional styles largely produced for export in the late 19th and early 20th centuries included the following: Beijing "enamel" (*xiaojiang*), literally "burnt blue," popular during the Qing Dynasty (1644–1911) and also known as silver enamel; "cloisonné" (*jingtailan*), the top jewelry export from China, especially in the Ming Dynasty (1368–1644), still produced today with more modern designs; "**jade** carving" (*yudiao*), with annual jade-carving contests held in the PRC; "filigree inlay" (*huasi qiangxian*), traced to the Shang Dynasty and one of the eight unique **handicraft** skills of Yanjing (the former name for Beijing), now in danger of fading away; "engraving" (*diaoke*), traced to the Spring and Autumn Period (770–476 BCE), and used to decorate gold and silver bracelets, as well as ornaments, with patterns of peonies, fairies, and such **mythical animals** as unicorns, dragons, and phoenixes; "kingfisher feather ornamentation" (*cuiniao yumao zhuangshi*), which peaked during the Qing Dynasty reign of the Qianlong emperor (1735–1799) and is now almost lost due to restrictive environmental considerations; and "gold and silver threading" (*jinyin xian*), traced to the Shang and Zhou (1046–256 BCE) dynasties, and used to decorate bronze vessels, with contemporary attempts to revive the exceedingly complex process.

250 • JEWS (YOUTAIREN)

Materials, in addition to jade, used in traditional Chinese jewelry included gold, "coral" (*shanhu*), "pearls" (*zhenzhu*), "turquoise" (*lüsongshi*), "cinnabar" (*chensha*), and "ox bone" (*niugu*), the last often used as an imitation of rare "ivory" (*xiangya*), with "diamonds" (*zuanshi*) generally avoided as too bright and vulgar. Among the many types of jewelry worn largely by women from the upper classes were "armlets" (*bizhang*), some solid gold, "bangles" (*shuzhou*), "earrings" (*erhuan*), "headpieces" (*toushi*), "necklaces" (*xianglian*), "hairpins" (*fajia*), and "pendants" (*diaozhui*), the last two especially popular in the early dynasties of ancient China. Many items were also buried in tombs with wealthy owners, while others were exported to Europe and the United States in the 19th century, now on exhibit in Asian art museums. Also produced were gold garment "plaques" (*wenyi*) worn by members of the imperial court, usually with images of dragons, a **symbol** of the emperor, with blue-colored dragons designed especially for the royal person.

See also SEALS AND SEAL CARVING (*ZHUANKE*).

JEWS (*YOUTAIREN*). Located primarily in the city of Kaifeng, Henan, with small communities in cities like **Shanghai**, Harbin, and Tianjin, along with **Hong Kong**, Jews settled in China more than 1,000 years ago during the Tang (618–907) and Song (960–1279) dynasties, with most Chinese Jews fleeing the country following the establishment of the People's Republic of China (PRC). Initially, the Jewish population consisted of merchants and traders from along the ancient **Silk Road**, primarily Sephardi, from Babylonia, Persia, India, and the Middle East, invited by Chinese emperors to establish residence in Kaifeng, then the imperial capital of China. Adhering to a Chinese-inspired Judaism, the Kaifeng Jews, declaring "Our religion and **Confucianism** differ only in minor details" (1489), integrated into Chinese life, engaging in intermarriage, which throughout the centuries diminished their numbers, culminating in the destruction of the Kaifeng Synagogue in 1860.

Foreign-born Jews migrated to China, especially from the Middle East, known as the Baghdadi Jews from the mid-19th century onward, concentrating in Shanghai, where prominent merchant families emerged, including the Kadooris, Sassoons, and Hardoons, using their profits from the opium trade to dominate the local real estate market, primarily in the city's economically and socially vibrant foreign concessions. Contributing to the medical and educational needs of the local foreign and Chinese community, such important figures as Silas Hardoon (1851–1931), known as *Hatong* in Chinese, engaged in major efforts at preserving China's cultural heritage, while building stately houses and elegant **gardens**. Fleeing Czarist pogroms and the Bolshevik Revolution (1917) in Russia, and the rise of the Nazis in Germany (1933–1945), Russian and European Jewish refugees, largely Ashkenazi,

JEWS (YOUTAIREN) • 251

poured into Shanghai, one of the few truly open cities in the world, along with Harbin in the northeast, as European nations and the United States effectively closed their doors to mass Jewish immigration.

Granted visas by the sympathetic Chinese consul, Ho Fengshan, in Vienna, Austria, where a son of Republic of China (ROC) president Chiang Kai-shek joined a pro-Nazi military regiment, Jews generally avoided harm in China, treated with benign neglect by Chinese locals. Becoming major employers, prominent Jews, like the bon vivant Victor Sasson (1881–1961), built major hotels and contributed to the city's vibrant social scene of swanky bars and ritzy nightclubs, attracting international celebrities. Spared assaults by Japanese occupation forces in Shanghai during the Second Sino–Japanese War (1937–1945), a "final solution" for the local Jewish population suggested by German advisors was rumored but never carried out. Numbering 20,000 and forced to live in the wall-less Shanghai "Ghetto" (*Gedu*) of Hongkou (known locally as Hongkew), the Jewish population had a major impact on local society, especially medicine and **music**, with many doctors and musicians among the refugees and a Shanghai Jewish school established in the city. Following the end of the war and the subsequent rise to power of the Chinese Communist Party (CCP), large numbers of Chinese Jews fled to the United States and Israel in the late 1940s.

Several prominent Jews of European extraction resided as "foreign friends" (*waiguo pengyou*) in the PRC, generally working as pro-CCP journalists and writers, including Sidney Rittenberg, Israel Epstein, Sidney Shapiro, and Ruth F. Weiss, the last teaching at the Shanghai Jewish School. Following the introduction of economic reforms and the "open-door policy" (*kaifang zhengce*) in 1978–1979, the PRC and the state of Israel established official diplomatic relations in 1979, while well-known indigenous Jewish sites, particularly Kaifeng, became tourist attractions with the assistance of the Sino–Judaic Institute, subsequently closed, and the Institute of Jewish Studies at Nanjing University.

While Shabbat services and Passover gatherings have been held in Kaifeng by a small community of approximately 1,000 people claiming Jewish ancestry and maintaining Jewish traditions, the administration of President **Xi Jinping** (2013–), while denying anti-Semitic motives, has pressured local officials to terminate these practices, as Judaism is not one of the five recognized **religions** of the PRC, namely **Buddhism**, Catholicism, **Daoism**, Islam, and Protestantism. Part of a larger campaign to weaken the influence of religious faith, this effort to remove all signs of the country's Jewish past is being met with resistance, especially in Kaifeng, where remnants of the indigenous Chinese Jewish population are said to be living in nonpolitical "survival mode" (*shengcun moshi*), demanding official recognition as Jews.

252 • JEWS (YOUTAIREN)

Multiple synagogues exist in cities, including **Beijing**, Shanghai, and Hong Kong, primarily to serve foreign businessmen and diplomatic officials of the Jewish faith.

KNOWLEDGE AND WISDOM (*ZHISHI/ZHIHUI*). A constant pursuit, especially by the educated elite, throughout much of Chinese history, knowledge was gained through the rigorous process of "study" (*xue*) and "**thinking**" (*si*), and considered a prerequisite to the acquisition of wisdom, which relied heavily on experience. For Confucius (551–479 BCE), there were three stages to becoming wise. There was the first and most noblest, involving intellectual "reflection" (*fanshe*); the second, consisting of "imitation" (*mofang*), considered the easiest, as it builds on previous discoveries; and the third, involving "experience" (*jingyan*), the most bitter of the three, providing strength and conviction, for which there are no substitutions. Reinforced by the reverence for **education** in Chinese history, wisdom was considered a major characteristic of the Confucian "gentleman" (*junzi*), while a life dominated by "**chaos**" (*luan*) made acquiring and exercising wisdom a virtual impossibility. Similar principles were embedded in Chinese **Buddhism**, with wisdom considered an innate human quality and the Amida, celestial Buddha, representing the "light of wisdom" (*zhihui zhi guang*).

With the collapse of the imperial order at the end of the Qing Dynasty (1644–1911) and the outbreak of the culturally iconoclastic New Culture Movement/May Fourth Movement (1917–1921), debate about "**science** versus metaphysics" (*kexue yu xing'er shangxue*) occurred among Chinese intellectuals in the 1920s, with crucial contrasts drawn between the Western pursuit of scientific truth and the Chinese **obsession** with what were seen as largely useless metaphysical concepts. While the former resulted in scientific advances and technological achievements, leading to Western "wealth and power" (*caifu he quanti*), the latter saddled China with an outworn and archaic mindset, making the country the "sick man of Asia" (*Yazhou bingfu*), easily conquered and controlled by foreign powers. Fast forward to the establishment of the People's Republic of China (PRC) and virtually all knowledge and wisdom was considered embedded in the official doctrine of Marxism–Leninism–Mao Zedong Thought, with especially dogmatic interpretations of the doctrine, especially the Maoist elements, on full display during the chaotic **Cultural Revolution (1966–1976)**.

254 • KOWTOW (KETOU)

Following the introduction of economic reforms and social liberalization (1978–1979), including greater intellectual **freedom**, the issue of knowledge and wisdom was revisited by Chinese philosophers, most notably Feng Qi (1915–1995). Arguing for an "epistemology in a broad sense" (*guangyi shang de renshilun*), Professor Feng proposed a solution to scientific thought versus humanistic, metaphysical concerns involving a "transformation of knowledge into wisdom" (*jiang zhishi zhuanhua wei zhihui*), with the mere accumulation of knowledge without wisdom doing more harm than good. Innumerable Chinese-**language** phrases and proverbs embracing the importance of knowledge and wisdom but filled with traditional misogynism include the following: "great doubts, deep wisdom"; "no wisdom to silence"; "intelligence is endowed, wisdom is learned"; "wise men may be learned, learned men may not be wise"; and "beauty is the wisdom of women, wisdom is the beauty of men." Knowledge is also revered by the "knowledge deities" (*zhishi shen*), three of which are as follows: Wang Wenchang, a Daoist **god** of **literature** and scholarship; Gui Xing, the god of examinations; and Bao Zheng, the star of literature.

KOWTOW (*KETOU*). An act of supplication by an inferior to a superior by knocking the head to the floor, kowtow was common throughout Chinese history until abolished during the People's Republic of China (PRC) but with a revival of the practice in nonpolitical settings in recent years. Most notable was the performance of an elaborate prostration **ceremony** involving "three kneelings and nine prostrations" (*sangui jiukou*) by officials, Chinese and foreign, when appearing before the emperor, with similar but less elaborate demonstrations of respect by commoners at **religious** ceremonies and in dealings with local imperial government magistrates. Derived from the enormous importance assigned to "respect" (*zunzhong*) by **Confucianism** and evidently adopted as a custom during the Qin Dynasty (221–206 BCE), the kowtow was rejected by British diplomats led by Lord George Macartney in 1793, and formally abolished for most foreign officials at the imperial court following the two Opium Wars (1839–1842/1856–1860), although the emperor himself kowtowed in front of the Confucius shrine at the philosopher's birthplace in Qufu, Shandong, while Buddhists kowtowed three times before statues and images in Buddhist temples.

Criticized by Chinese intellectuals in the culturally iconoclastic New Culture Movement/May Fourth Movement (1917–1921), the kowtow was performed in front of portraits of Republic of China (ROC) president Sun Yat-sen following his death in 1925, by school **children** to Confucius twice a month, and by abbots to statues of the Buddha. While banned in the PRC and never practiced in front of political leaders, most notably Chinese Communist Party (CCP) chairman **Mao Zedong** (1949–1976), one of the more recent cases of kowtowing included long lines of children prostrating before

parents at a school in **Shanghai** in 2015, sparking considerable controversy on Chinese **social media**. Taken from the Cantonese dialect and entering the English **language** in the early 19th century, the English "kowtow" is generically used to describe any act of submission or groveling and has been aimed at multinational companies and even the American National Basketball Association (NBA) in China for reputedly acquiescing to controversial PRC government policies.

L

LANGUAGE AND LANGUAGES (*YUYAN*). Rich in linguistic diversity, the dominant language in the People's Republic of China (PRC) is Mandarin, known as the "common or national language" (*putonghua*), spoken by 955 million people, 68 percent of the total population of 1.4 billion, with a goal of reaching 80 percent by 2020. Living languages, that is languages that are still spoken in the contemporary period, number 302 in the PRC, 279 of them indigenous, mostly among non-Han ethnic **minorities**, often spoken at home, with Mandarin learned at school and spoken as a second language. Major language groups other than Mandarin are as follows: *Yue*, commonly known as Cantonese and spoken in clacks with a nasal sing-song style primarily in the south by 60 million people, especially in Guangdong; *Gan*, spoken by 41 million people, concentrated in Jiangxi, located in Eastern China; *Kejia*, or Hakka, with 47 million speakers scattered throughout several provinces, including Guangdong, Jiangxi, **Hunan**, and **Sichuan**; *Min*, spoken by 40 million people, largely in the coastal province of Fujian; *Wu*, spoken primarily in the city of **Shanghai** and surrounding areas by 85 million people; and *Xiang*, the predominant language in Hunan, with 36 million speakers.

Other non-Sinitic languages spoken primarily in outlying areas of the country include the following: Uighur, a Turkic language spoken by 11 million people, with Persian and Arab influences, using an Arabic script and predominant in the Xinjiang-Uighur Autonomous Region (XUAR); Mongolian, spoken in Inner Mongolia and other parts of the northeast, with traditional Mongolian script; Hmong, spoken by 3 million people, largely in **Yunnan**; Korean, spoken in Jilin in the northeast and bordering the Democratic People's Republic of Korea (DPRK); Kazakh, a Turkic language similar to Uighur; and Tibetan, with three major subgroups, U-Tsang (**Tibet**), Kham (western Sichuan), and Amdo (Qinghai province).

All spoken languages have subgroups and innumerable local dialects that can vary between neighboring villages, with languages spoken by small numbers and in limited areas on the verge of dying out with generational changes. Major tonal languages include Mandarin, with four tones, and Cantonese, with nine, as the same syllable with different tones have different

258 • LEADERSHIP (LINGDAO)

meanings; in the Wu dialect, prominent in Shanghai high and low tones exist for entire words with a profusion of S and Z sounds. "Classical Chinese" (*wenyan* or *guwen*), while replaced in written texts by the vernacular, based on Mandarin, in the 1920s, infiltrated and influenced other groups and dialects, and is still employed in theatrical performances and some **music**, while requiring mastery by **scholars** of **Confucianism**, **Daoism**, and other traditions, with a working knowledge of Sanskrit needed for a full understanding of **Buddhism**.

Written language in the PRC is common among every major Sinitic language group, consisting of nonalphabetic "characters" (*Hanzi*) standardized since the Qin Dynasty (221–206 BCE). Simplified versions composed of fewer strokes for many commonly used characters were developed in the PRC since the beginning of language reforms in 1955. The romanization of Chinese characters in Latin alphabetic script is the Hanyu pinyin system, adopted in the PRC in the 1950s to replace other, largely foreign-produced romanization systems, using diacritic marks to indicate variable tones and accepted as the international pinyin script in 1982. Chinese **calligraphy** is the visual design and execution of Chinese characters and a major **art** form throughout Chinese history.

LEADERSHIP (*LINGDAO*). Dominated by centuries of strong "patriarchal" (*jiazhang*) sentiments rooted in the Chinese **family** and extending to the political realm in the imperial and modern eras, leadership in China is a largely male-dominated realm but with notable cases of **women** assuming leadership roles, many of them leading to negative outcomes. Emperors from the Qin Dynasty (221–206 BCE) onward generally ruled without significant institutional limitations on their power, with imperial bureaucrats invoking familial sentiments as "father–mother officials" (*fumuguan*) and cultivation among the populace of strong emotional and personal **loyalty** to superiors, local and distant, up to and including the emperor, with no hint of democratic selection or accountability. Rare was a female empress of any influence, with the major exception of Wu Zetian during the Tang Dynasty (618–907), with Wu ruling with an iron fist often more draconian than her male counterparts, while also carrying out major administrative and social reforms.

Fast forward to the modern era and the two dominant political leaders, Nationalist Party (*Kuomintang*) leader Chiang Kai-shek (1928–1949) and Chinese Communist Party (CCP) chairman **Mao Zedong** (1949–1976), projected a strong aura of patriarchalism, with Chiang Kai-shek playing up his military credentials as the "Generalissimo" (*Dayuanshuai*) and a man of letters, authoring *China's Destiny* (1943), and Mao Zedong a **scholar** and poet with his didactic *Quotations from Chairman Mao* (1964), widely available in the *Little Red Book*. Offering views on everything from the appropriate size of **wedding** parties (Chiang) to prescriptions on how to raise toma-

LEADERSHIP (LINGDAO) • 259

toes (Mao), both leaders asserted primacy over virtually all aspects of life, political and otherwise. Unlike Generalissimo Chiang Kai-shek, Mao Zedong appeared more as a civilian than a military figure, except during the **Cultural Revolution (1966–1976)**, when appealing for support from the People's Liberation Army (PLA), the CCP chairman briefly donned army guard. Appearing in front of massive crowds, something avoided by the generally reclusive Chiang Kai-shek and unprecedented in Chinese politics, Mao also sought direct mass support, led by radical Red Guards chanting, "long live" (*wansui*), literally meaning "ten thousand years," a phrase previously reserved for emperors.

Following the passing of the chairman in 1976, his radical wife, Jiang Qing, made a bid for power but was quickly slapped down, along with her radical supporters, labeled the "Gang of Four" (*Sirenbang*), as the CCP embraced Deng Xiaoping (1978–1992) as a more conventional leader. While promoting "Deng Xiaoping Theory" (*Deng Xiaoping Lilun*) on economic reform and other important issues, the aging Deng refused to assume ultimate formal authority, as the post of "chairman" (*zhuxi*), last held by the low-key Hu Yaobang (1981–1982), was abandoned and superseded by the less politically potent post of general secretary in 1982. Lowering the historical profile of Mao Zedong in the official *Resolutions on Certain Questions in the History of Our Party* (1981) by recognizing the chairman's "mistakes" (*cuowu*) but without **accusations** of "crimes" (*fanzui*), as in the denunciation of Joseph Stalin by Nikita Khrushchev at the seminal 20th Party Congress (1956), top Chinese leaders, from Jiang Zemin (1989–2002) to Hu Yaobang (2002–2012), assumed generally lower profiles.

Officially banned in the PRC, personality cults the likes of that pursued by Mao Zedong were avoided by both Jiang and Hu, as the **ideologically** loaded word "thought" (*sixiang*) was absent from their political initiatives. Emphasis was also given throughout the CCP apparatus and state-owned enterprises (SOEs) on the more group-oriented notion of "collective leadership" (*jiti lingdao*), with input into final decisions coming from multiple sectors, especially technical experts. Institutional limits on executive authority in the government headed by the National People's Congress (NPC) were also adopted, with the five-year presidency restricted to two terms in 1982, and adhered to by both Jiang Zemin and Hu Jintao. Such is not the case with President **Xi Jinping** (2013–), who has indicated his Maoist credentials by overseeing the abolition of the two-term limit on the presidency in 2018. With his policy proposals and general ideological musings labeled as "Xi Jinping Thought," pictures of the well-groomed leader adorn walls and homes, and—unlike Mao Zedong—accompanied by his wife, the famous folk-singing Peng Liyuan. **Criticisms** of this semireversion to Maoist principles of leadership have been limited, with large swaths of the Chinese population still evidently receptive to patriarchal sentiments and appeals.

260 • LEGALITY (HEFAXING)

LEGALITY (*HEFAXING*). Issues involving the role of "codified law" (*bianzuan fa*) in Chinese society and government began in the imperial era and extended into modern times, including during the People's Republic of China (PRC), with influences drawn from traditional **philosophy** and foreign legal principles and practices. Formulated during the period of the Warring States (475–221 BCE), the philosophy of "Legalism" (*Fazhizhuyi*), with an emphasis on codified law backed by criminal sanctions and the threat of "**punishment**" (*chengfa*), was adopted by the imperial state, while retaining **Confucianism** as the moral foundations of the political order. Purely secular in nature with no claim of divine origins or inspirations, classical Chinese law was embodied in major dynastic codes, the Tang (624), Ming (1397), and Qing (1740), with major amendments and alterations added in other dynasties. Absent any mention of individual "rights" (*quanli*), a term that did not exist in the classical Chinese **language**, the traditional legal structure also lacked a clear distinction between "criminal" (*xingfa*) and "civil" (*minfa*) codes, as emphasis was on exacting **confessions** from the accused, including through torture, with the convicted publicly repenting the error of their ways. While "statutes" (*ke*) from previous dynasties were important, along with legal "precedents" (*bi*), ultimate legal authority rested with imperial "orders" (*ling*), as direct approval by the emperor was required in all cases of capital punishment.

Confronting the realities of Western power and imperialism, Chinese interest in Western legal traditions and principles began in the late Qing Dynasty (1644–1911), with translations carried out by the "School of Combined Learning" (*Tongwen Guan*) in the 1860s, especially of Germanic codes. Efforts to establish legal codes were pursued in the later years of the dynasty based on the Japanese experience in the Meiji period of reforms (1868–1912). Similar policies on the legal front were followed by the newly established Republic of China (ROC), as the Provisional State Constitution (1912) included such basic Western legal concepts as "equality under the law" (*falü shang de pingdeng*) and legal rights for **women** and the broader citizenry. Separate codes were also adopted involving civil, civil procedures, criminal, criminal procedure, and administrative laws, backed by an embryonic legal profession of lawyers and judges, many trained abroad and in China at newly established law schools.

Replacing individualistic-based Western concepts with legal concepts adopted from the Soviet Union under Joseph Stalin (1927–1953), the PRC considered law and legal institutions as existing to support CCP and state power, with specific laws taking the form of general principles and changing policies rather than detailed and constant rules and procedures. New laws were written in simple language easily comprehended by the average individual, while highly technical language and strict legal procedures for the police and courts were abandoned, with many Republican-era legal officials re-

LEGENDS AND MYTHOLOGY (CHUANSHUO/SHENHUA) • 261

moved from their positions and Western-oriented law schools shut down as a cohort of new legal cadres were trained based on Soviet legal precepts embedded in the PRC's first State Constitution (1954). Influenced by the principle of "class struggle" (*jieji douzheng*) promoted by CCP chairman **Mao Zedong** (1949–1976), criminal prosecutions, especially of relatively minor offenses, were carried out by **neighborhood** and village committees, with the police and courts reserved for the most serious offenses and totally sidelined during the chaotic and lawless **Cultural Revolution (1966–1976)**.

The emergence of a post-Mao **leadership** in the late 1970s led to a complete turnabout in official policies on law, with the new paramount leader, Deng Xiaoping (1978–1992), calling for adherence to the "rule of law" (*fazhi*) with the introduction of individual rights, especially regarding property and **religious** practices, into a new 1982 State Constitution (revised in 1988, 1999, 2014, and 2018), with provisions requiring adherence to the law by CCP cadres and leaders. Calling for the "legalization" (*fazhihua*) of the PRC and "governing the country by law" (*yi fazhi guo*), criminal law has undergone piecemeal revision, with, for example, the abolition of such politically tainted offenses as "counterrevolution" (*fangeming*). Empowering local citizenry has also occurred, with a right to sue public officials for "malfeasance" (*duzhi*), according to the Administrative Procedure Law (1994), and expansion of the traditional right to submit "petitions" (*xinfang*) for redress of grievances to local and provincial governments, as well as the central government.

A **market** for legal services has also emerged, with new law schools established and foreign law firms allowed to operate, with limitations, in the PRC. Mediation committees involving citizenry have also been established, with the previously common practice by CCP officials of interfering in legal cases generally avoided in civil cases but still an occurrence in criminal cases, as the criminal law is still considered a tool of social control and political repression. While President **Xi Jinping** (2013–) has promised to "rule the country according to law" and with the 19th National Congress of the CCP (2017) focused heavily on the rule of law, Chinese judges are prohibited from citing the State Constitution as the basis of any legal interpretation, along with the requirement in any ruling to accept the "leadership of the CCP."

LEGENDS AND MYTHOLOGY (*CHUANSHUO/SHENHUA*). Illustrative of the duality in any civilization between the real and imaginary, legends and myths have an episodic history in China, strong during periods of **chaos**, conflict, and natural disasters, and weak in the relatively long periods of prosperity and internal peace. With the exaggeration of tales and story lines for greater effect, legends had the greatest impact, while mythology, a product of constructive imagination and usually involving the divine, was less

262 • LEGENDS AND MYTHOLOGY (CHUANSHUO/SHENHUA)

evident and largely restricted to the purely popular level. Varying across **regions**, **language** groups (Han, **Tibetan**, and Turkic), ethnic **minorities**, and historical periods, legends and especially mythologies explained the unknown, most notably the underworld, with portrayals in oral and written traditions of fantastic figures, many displaying **magical** powers protecting the people from such disasters as flooding and contributing to the creation of Chinese culture and a powerful state.

Historically, legends reflected the deepest and most enduring parts of the culture and were pervasive throughout both imperial and modern Chinese history. Mythology, in contrast, was largely a product of the early imperial era, the "age of **heroes**" (*yingxiong shidai*), with persistent conflict and social disorder, from the Zhou Dynasty (1046–256 BCE) to the Sui Dynasty (581–618). Found in **paintings**, wood artifacts, relief carvings, and lacquer **art**, mythology was prompted by the quest for the supernatural in **Daoism** and **Buddhism**, contrary to the strong rationalistic and historicist bent of **Confucianism**. Gradually eliminated from the Chinese cultural scene following the Song Dynasty (960–1279), mythology virtually disappeared during the later imperial era from the Yuan (1279–1368) through the Ming (1368–1644) and Qing (1644–1911) dynasties.

Lacking a great epic the likes of *The Iliad* in Greek history and the instructive Edda of Norse mythology, Chinese stories, while frequently described as monotonous and puerile, involved astrological **superstitions** and a spiritualization of everything from stones to the sky. With a heavily populated pantheon of **gods and goddesses** controlling the natural world, especially the weather, legendary and mythological figures created the bases of Chinese civilization, including agriculture, writing, and humanity itself. Mythical creatures, some with extraordinary powers, include the following: unicorn (*qilin*), capable of using its horns to jab evil people; dragon (*long*), with power over water, rainfall, typhoons, and floods; "Monkey King" (Sun Wukong), who took on the gods and could travel thousands of miles in one somersault; "white snake" (*baishe*), inhabiting a lake near Hangzhou and capable of transformation into a human; and Guanyin, the Buddhist Bodhisattva, who in the Great Pilgrimage mythology introduced Buddhism to China.

Renowned figures, many of them real people, in historical legends are as follows: "Yu the Great" (*Dayu*), who controlled the floods and established the semimythical Xia Dynasty (2205?–1766? BCE); Ho Yi, the "grand archer" (*da gongjian shou*), who assisted the gods with his precise bowmanship; and Fuxi, head of the legendary 10 kings (3000?–2197 BCE?), who taught the Chinese people survival skills, including combat, **hunting and fishing**, and **fortune-telling**. Among the legends popularized in the People's Republic of China (PRC) is the heroic "crossing of the Yangzi River" (*du Jiang zhanyi*), bringing about the capture of Nanking and **Shanghai**, ensuring vic-

LIBRARIES AND ARCHIVES (TUSHUGUAN/DANG'AN) • 263

tory to Chinese Communist forces in the Civil War (1946–1949), suggestive of the legend of Bodhidharma crossing the same waterway on a reed in the 13th century.

LIBRARIES AND ARCHIVES (*TUSHUGUAN/DANG'AN*). Essential to public **education** and the diffusion of important information, public libraries in the People's Republic of China (PRC) numbered 3,200 in 2016, with major historical archives at the national, provincial, and county levels. Established during the late 19th century with substantial Western influence, including Christian missionaries, libraries established in the PRC include, most notably, the Shanghai Library, the country's second largest, in 1952. Traced to the ancient Shang Dynasty (1600–1046 BCE), the accumulation of books, genealogies, and imperial documents were sorted out according to chronological order and category throughout Chinese history and housed in buildings known as *cangshulu*, along with temples, private schools, and private abodes of individual **scholars**. Succeeding dynasties constructed imperial libraries and archives to house literary treasures and official records but with access limited to a few scholars and archivists, with virtually no public-access facilities until the introduction of modern libraries in the 19th century. Public libraries at the county level and above numbered a mere 55 at the establishment of the PRC in 1949, with most located in coastal, **commercial, urban areas** serving a mostly well-off, cosmopolitan population.

While the **legal** foundations for a national network of libraries were established by the enactment of the National Book Coordination Act (1957), comprehensive modernization in the 1980s led to the expansion of the library system, with universities establishing academic departments in library science and information technology. By far, the largest collections are in the National Library of China (*Zhongguo Guojia Tushuguan*), established in **Beijing** in 1909, the third largest in the world, and Shanghai Library, both with several million volumes including "oracle bones" (*jiagu*) and other ancient treasures. Major university collections include the libraries of Peking University and Zhejiang University, the former the fifth largest in the country and founded in 1902. Other major collections established in the early 1990s include (among others) the public libraries of Nanjing (1907), the oldest public library in China; Shandong (1909); **Sichuan** (1912); and Tianjin (1908); and the Zhongshan Library (1912), named after Republic of China (ROC) president Sun Yat-sen (1866–1925). Most prominent among scientific collections is the National Science Library, the public library of the Chinese Academy of Sciences (CAS), with the futuristic Binhai Library, known as the Eye, built as a major cultural center in Tianjin.

The role of libraries as retaining historical documents was tainted when local libraries in Zhenyuan, Gansu, oversaw the burning of politically incorrect books in 2019, leading to widespread denunciations and comparisons to

264 • LITERATURE (WENXIAN)

Nazi Germany on Chinese **social media**. Oversight of library operations is handled by the Library Society of China, established in 1979, as the successor to the Chinese Literary Association (1927), while digital library alliances have also been established among major institutions.

Major archives include the First Historical Archive of China (Beijing), housing collections from the Ming (1368–1644) and Qing (1644–1911) dynasties, and the Second Historical Archive (Nanjing), housing documents from the Nationalist (*Kuomintang*) era on the mainland (1912–1949). Documents and materials of the ruling Chinese Communist Party (CCP) and the government of the PRC are contained in the Central Archives, merged with the National Archives Administration in 1993.

LITERATURE (*WENXIAN*). One of the major and richest literary traditions in the world dating back 3,000 years, literature in China ranges from **drama** to exquisite **poetry**, to various forms of prose and essay writing, to novellas and novels, both historical and fictional. Confronting periodic **censorship** and political controls in both the imperial and modern eras, especially during the rule of the Chinese Communist Party (CCP) in the People's Republic of China (PRC), Chinese literature has blossomed, with authors composing in both the "classical" (*wenyan*) and "vernacular" (*baihua*) Chinese **language**, and dealing with themes ranging from major historical events and notable personages, to good and evil, to **heroes** and villains, to **romance and love** stories with some **sexually** explicit scenes, including young girls, bordering on **pornography**.

Influenced by scientific and technological developments, including the creation of woodblock printing in the Tang Dynasty (618–907) and movable type in the Song Dynasty (960–1279), literary publications spread to the educated **classes**, with literacy rates in the Qing Dynasty (1644–1911) estimated at 40 to 45 percent for **men** and 2 to 10 percent for **women**. With major works focusing on the life of common people, for example, the Qing-era *Strange Stories from a Chinese Studio* (Liaozhai Zhiyi), by Pu Songling (1640–1715), literature has served as a major factor in cultivating and maintaining a distinctive Chinese cultural identity and unity.

One of the earliest forms of fictional writing in imperial China were the "tales of the miraculous," also known as "tales of the strange" (*zhigai xiaoshuo*/later referred to as *chuanqi*), originating in the Han Dynasty (202 BCE–220 CE) and extending into the Tang Dynasty, and dealing with the existence of the supernatural. Such works as *In Search of the Sacred* (Soushen Ji), from 350 CE, describe **gods, ghosts**, and other supernatural phenomena, while extensive profiles and biography of prominent literati, musicians, and painters from this early era can be found in *A New Account of the Tales of the World* (Shishuo Xinyu), written between 420 and 479.

LITERATURE (WENXIAN) • 265

Collections of anecdotes, miscellanea, and stories, including *chuanqi*, were also popular, for instance, *Variety Dishes from Youyang* (Youyang Zazu), from the 9th century, along with "plain tales" (*pinghua*), "novellas" (*huaben*), and **Buddhist** "transformative tales" (*Bianwan*), with the last represented by *Mulian Rescues His Mother* (Mulian Jiumu), written in the 9th century, with subsequent reiterations, including as an **opera**. Inspired by these and other early literary forms, more elaborate novellas and novels emerged between the 14th and 19th centuries, peaking in the Ming (1368–1644) and Qing dynasties with the four great classical novels *Water Margin* (also known as *All Men Are Brothers* [Shuihu Zhuan/1589], *Romance of the Three Kingdoms* [Sanguo Yanyi/14th century], *Journey to the West* (also known as *Monkey King* [Xi Youji/16th century], and *Dream of the Red Chamber* [Hong Lou meng/1791].

As with any distinguished literary heritage, China has a rich variety of literary styles, including the following: "travel records" (*luxing jiliu*), the likes of *Record of Stone Bell Mountain* (Shilingshan jiliu) by Su Dongpo, known early in life as Su Shi (1037–1101) in the Northern Song Dynasty (960–1127); "crime dramas" (*zui'an ju*), for instance, *Chalk Circle* (Huilan Ji), from the Yuan Dynasty (1279–1368); folk legends and romances with explicit **sex** scenes, for example, *Slapping the Table in Amazement* (Pai'an Jingqi) from the 17th century; "erotic novels" (*qingse xiaoshuo*), most notably *The Carnal Prayer Mat* (Roputuan), an attack on Confucian puritanism from the 17th century long banned and censored; "love comedies" (*aiqing xiju*), for instance, the play *Romance of the Western Chamber* (Xixiang Ji), considered China's "lover's bible" (*qingren de shengling*), from the Yuan Dynasty; novels of political "exposure" (*puguang*) mocking **bureaucratic** rulers, most notably *The Scholars* (Rulin Waishi), published in 1750; and "fantasy novels" (*huanxiang xiaoshuo*), represented by *Flowers in the Mirror* (Jinhuan yuan), published in 1827.

The influence of Western and other **foreign** literatures, particularly Russian, began in the late Qing Dynasty, with various schools of literary style emerging. Examples are as follows: "Mandarins Ducks and Butterflies" (*Yuanyang Hudie Pai*), with stories of scandal, **comedy**, and detective work described as a "fiction of comfort" (*shushi xiaoshuo*) and condemned by radical intellectuals in the New Culture Movement/May Fourth Movement (1917–1921); the "New Sensationalists" (*Xin Ganjue Pai*), with the introduction of **humor** into the literary genre; and politically active and leftist writers like **Lu Xun** (1881–1936), who organized the League of Left-Wing Writers in **Shanghai** in 1930, and was known for his biting **criticism** of traditional Chinese culture in such short stories as *Diary of a Madman* (Kuangren richi) and a series of bitingly "satirical essays" (*zawen*). Similar culturally iconoclastic and socially critical works include *Family* (Jia), a portrayal of the insufferable familial patriarchy, by Ba Jin (1904–2005); *Midnight* (Ziye),

266 • LITERATURE (WENXIAN)

insight into the cosmopolitan life of Shanghai, by Mao Dun (1896–1981); *Rickshaw Boy* (Luotuo Xiangzi), tales of desperation in the dog-eat-dog life of a rickshaw puller, by Lao She (1899–1966); *Miss Sophie's Diary* (Shafei Nüshi Riji), about a young woman's confused romantic and sexual feelings, by prominent **feminist** writer Ding Ling (1904–1986); and *Love in a Fallen City* (Qingcheng Zhi Lian), on love in wartime **Hong Kong** by ex-patriot writer Eileen (Ailing) Chang (1920–1995).

Strict censorship of literary works followed the establishment of the People's Republic of China (PRC) in 1949, under the doctrinal influence of the talks at the Yan'an Forum on Literature and Art (1942), given by CCP chairman **Mao Zedong**. Confronting a uniform style of "socialist realism" (*shehuizhuyi xianshizhuyi*) adopted from the Soviet Union, Chinese writers who bucked the censorious system and called for **freedom** of expression were subject to withering **ideological** and personal attacks, most notably Wang Shiwei (1906–1947) and Hu Feng (1902–1985), the latter a prime target of a criticism campaign begun in 1955, engulfing thousands of writers and poets. Politically acceptable and immediately forgettable titles produced in this era included *The Builder*, *The Song of Youth*, *Keep the Red Flag Flying*, and *The Red Sun*, while political pressure on independent-minded writers continued, especially during the **Cultural Revolution (1966–1976)**, when the only novels published were by political sycophants like Hao Ran (1932–2008), while Lao She was driven to **suicide** by rampaging Red Guards in 1966.

Following the passing of CCP chairman Mao Zedong (1976), a new "scar literature" (*shanghen wenxue*) emerged recounting experiences of persecuted intellectuals and "sent-down" (*xiaxiang*) **youth**, exemplified in such works as *The Class Monitor* (Banzhu Ren). Surviving the turmoil, Ba Jin produced *Random Thoughts* (Suixianglu), in which the renowned author explored the role of Chinese people, including himself, in provoking the 10 years of political turmoil and suffering. Other literary trends included the "Roots Movement" (*Xungen*), aimed at reviving the pluralistic image of China damaged during the Cultural Revolution, with stories featuring ethnic **minorities**, along with avant-garde works by such writers as Su Tong (1963–), author of *Wives and Concubines*, made into the film *Raise the Red Lantern*, by **Zhang Yimou**, along with scathing attacks on China's hidebound literary traditions by such writers as Xu Bing (1955–) whose book *From the Sky* was composed entirely of fake pictograms. Hard-edged works followed the crackdown on prodemocracy demonstrators in **Beijing** and other Chinese cities in 1989, and became known as "vagabond literature" (*liulang wenxue*), with titles like *Running Through* and the subversive "nonsense writings" (*feihua*) by the likes of Xu Bing (1955–) that attack China's literary legacy with illegible and abstruse works that make no sense to the reader. Thousands of underground publishing houses now exist in the PRC for circumventing the

official censorship system but with the country's literary world lacking the sophistication and magnificence of past eras. Notable children's literature includes the popular work *Beatings of the White-Boned Spirit by the Monkey King* (Sun Wukong Sanda Baiguijing) read by young students in the PRC and made into a series of films and television programs.

LIVE STREAMING. *See* SOCIAL MEDIA (*SHEJIAO MEITI*).

LONGEVITY (*SHOU*). One of the three attributes of a good life along, with **happiness** and "status" (*lu*), longevity is revered in multiple realms of Chinese culture, with the Chinese-**language** ideograph *shou* appearing on decorative **arts**, **ceramics**, **clothing**, furniture, **jewelry**, and scrolls. Symbolic representations in the natural and **animal** world include pine trees, flying cranes, spotted deer, peaches, and especially tortoises, with turtle soup reputedly fed to Qing Dynasty (1634–1912) empress Dowager Ci Xi (1861–1908), known as the "old master Buddha," on her deathbed but evidently with no effect. Reflecting the traditional emphasis in **Confucianism** on respect for the elderly, the search for longevity and immortality are also strong themes in **Daoism**, with a human-like **god** figure created as part of the "three stars" (*sanxing*) in the Ming Dynasty (1368–1644). Consisting of three gods in the form of male figurines, the images are found on the facades of religious **temples** and ancestral shrines, and in many Chinese homes and shops, usually on small altars with a glass of water, an orange, or other auspicious offerings, especially during the **Spring Festival**. The most famous phrase involving longevity is found on scrolls reading *Shoushan fuhai*, meaning "May your life be as steadfast as the **mountains** and your good **fortune** as limitless as the seas."

The importance of long life is also evident in the popularity of "longevity villages" (*changshou cun*), generally located in isolated, often mountainous and pollution-free areas with the locals leading a modest and stress-free lifestyle. Maintaining a diet primarily of vegetables, nuts, seeds, legumes, and fish, China's nonagenarians and centenarians avoid both overeating and undereating, with a history of **manual labor** in the fields and morning exercise in their golden years. Among the famous and heavily touristed longevity sites are Bama Village, Guangxi, home to the Yao **minority**; Hetian Village, Xinjiang-Uighur Autonomous Region (XUAR), located in an oasis; and Taoyuan Village, Guangdong, with tourism bringing revenue to these poverty-stricken areas but along with more polluted air and rich **food**.

LOYALTY (*ZHONG*). The foundation of modern Chinese **nationalism**, loyalty has been a major cultural value throughout Chinese history, along with "benevolence" (*ren*), "**harmony**" (*hexie*), "righteousness" (*yi*), and "**fil-**

268 • LOYALTY (ZHONG)

ial piety" (*xiaoshun*). Revered as a prime **virtue** in **Confucianism**, loyalty, as well as "trust" (*xinren*), was considered essential to the cultivation of the "gentleman" (*junzi*) and the basis of righteous rule by the "**scholar**-officials" (*rujia*). Loyalty to the ruler was essential on the part of ministers and the governed but without a pure subservience to authority, as "reciprocity" (*huhui*) was required by the morally upstanding ruler even in the face of rightful remonstrations from subordinates. Historical models of loyalty without subservience include the Duke of Zhou (*Zhou Wen Gong Dan*), whose actions ensured the survival of the Zhou Dynasty (1046–256 BCE), and Zhuge Liang (181–234 CE), accomplished strategist of the Shu-Han State during the Three Kingdoms (220–280). Reflecting the emphasis in China on personal **relations** over impersonal rules and regulations, loyalty extends beyond the political sphere to commercial and workplace environments, where long-standing personal ties, fused by emotional loyalties, can often trump considerations of quality and merit in such major decisions as promotions.

Promoted throughout the imperial era as a means to legitimate state autocracy, political loyalty was also an essential ingredient in fostering popular support for government authority during the period of rule by the Republic of China (ROC) on the mainland (1912–1949) and since the establishment of the People's Republic of China (PRC) in 1949. Traditional **symbols** of loyalty to country were employed. Among these were national flags, featuring Blue Sky, White Sun, and wholly Red Earth for the ROC, and the five-starred red flag for the PRC, along with national anthems, "Three People's Principles" (*Sanmin Zhuyi*) for the ROC and "March of the Volunteers" (*Yiyongjun Jinxingqu*) for most years in the PRC. Reverential attachment and personal loyalty to national leaders was also stressed, from Sun Yat-sen (1912–1925) and Chiang Kai-shek (1928–1949) in the ROC, to **Mao Zedong** (1949–1976) and **Xi Jinping** (1913–) in the PRC, with all four cultivating levels of loyalty amounting to personality cults. The most egregious was the fanatical **leadership** cult surrounding Chinese Communist Party (CCP) chairman Mao Zedong, especially during the **Cultural Revolution (1966–1976),** with the nationwide distribution of *Quotations from Chairman Mao Zedong* (Mao Zhuxi Yulu), also known as the *Little Red Book*, along with such practices as "loyalty dances" (*zhongcheng wu*) performed by one and all, including young **children**.

In the aftermath of mistreatment and persecution at the hands of Red Guards during the Cultural Revolution, Chinese people have come to rely primarily on **family** and friends, with little or no real loyalty, at least voluntarily, to distant political leaders. With the shift to a consumer-oriented and **market**-based economy since 1978–1979, loyalty to political parties and leaders has gradually yielded to considerations of loyalty to brands of consumer goods, with Chinese companies paying hefty fees to ensure the loyalty of

their all-important customers. While loyalty among friends and **business** associates is highly valued in the PRC, doubts exist as to the depth of such sentiments among **foreigners** when dealing with Chinese associates.

LU XUN (1881–1936). Writer, essayist, poet, translator, and literary critic, Lu Xun, pen name for Zhou Shuren, authored some of the most influential works in Chinese **literature** during the period of the New Culture Movement/May Fourth Movement (1917–1921) and thereafter. Included were "The True Story of Ah Q" (*A Q de Zhenshi Gushi*) and "Diary of a Madman" (*Fengzi Riji*), both published in the avant-garde journal *New Youth* (Xin Qingnian), with the latter inspired by the short story of a similar title by Nikolai Gogol (1809–1842). A critic of traditional China, especially **Confucianism**, Lu Xun depicted Chinese culture as "cannibalistic" with the people turned into unfeeling, excessively compliant subjects driven to madness, similar to Gogol's protagonist Poprishchin, by a tyrannical, "patriarchal" (*jiazhang*) **family** and repressive state.

A participant in the New Culture Movement/May Fourth Movement (1917–1921), Lu Xun headed the League of Left-Wing Writers, established in 1930, and emerged as a major critic of the Nationalist (*Kuomintang*) government, especially following the imposition of strict **censorship** laws and the execution of 24 local writers in 1931. Initially trained in medicine in Japan and converting to literature as a means of reforming China's backward culture, he was influenced by Chinese literary traditions, especially from the Tang (618–907) and Song (960–1279) dynasties, as well as modern Western literature, notably *Uncle Tom's Cabin*, by Harriet Beecher Stowe, and *Dead Souls*, by Nikolai Gogol, which Lu translated from Russian into Chinese.

Involved in Chinese **education**, including serving as head of Zhongshan University in **Guangzhou** and lecturer at Peking University in **Beijing**, Lu Xun saw the creation of "revolutionary men" as the ultimate solution to China's multiple social, economic, and cultural problems, with Lu commenting to American Edgar Snow in 1933 that, "Now it's Ah Q's who are running the country." Proclaimed the "saint of modern China" by Chinese Communist Party (CCP) chairman **Mao Zedong**, Lu Xun was eulogized by the creation of the Lu Xun Academy of Fine Arts in 1938, in the CCP redoubt of Yan'an, and continued after 1949 in Shenyang, Liaoning, along with the Lu Xun Literary Prize and the Lu Xun Park in **Shanghai**. Major literary works by Lu Xun include the following: "Nostalgia" (1909), his first short story; the major essays "My Views on Chastity" (1918), "Knowledge Is a Crime" (1919), and "Thoughts before the Mirror" (1925); *A Brief History of Chinese Fiction* (1925); *Wild Grass* (1927), a collection of prose **poetry**; *Dawn Blossoms Plucked at Dusk* (1932), an autobiography; and *Call to Arms* (1923),

270 • LU XUN (1881–1936)

Wandering (1926), and *Old Tales Retold* (1935), collections of short stories, with the last published one year prior to Lu's death from tuberculosis, exacerbated by his years of heavy **smoking**.

MADNESS AND MENTAL ILLNESS (*KUANG/JINGSHEN JIBING*).
Until the introduction of modern psychology and psychiatry primarily via Christian missionaries in the 19th century, mental disorders in China were considered a form of individual madness that threatened the social order, with treatment by healers lacking specialized **knowledge** or expertise of the illness. Traced back to such ancient medical texts as the *Inner Canon of the Yellow Emperor* (Huangdi Neijing), authored between the Warring States (475–221 BCE) and the Han Dynasty (202 BCE–220 CE), mental and emotional disturbances were subject to multiple diagnoses, from somatic imbalances of **yin-yang** stemming from dysfunctions in the "Five Viscera" (*Wuge Neizang*)—the liver, heart, spleen, lung, and kidney—to "demonic possessions" (*emo caichan*), with exorcism by **shamans** the only real cure.

Women, especially spinsters, widows, and nuns, were considered particularly susceptible to the disorder, labeled as "love madness" (*ai de fengkuang*) reputedly due to **sexual** frustration and emotional disruption. With individuals suffering from mental disorders and becoming involved in criminal activity imprisoned and even executed by Qing authorities, Western missionaries brought to light the plight of the mentally disturbed, as the first asylum was established in **Beijing** in the early 1900s. The fusion of Western biomedicine and **traditional Chinese medicine (TCM)** was brought about with the first Chinese psychiatrists graduating from Peking Union Medical College, funded by the Rockefeller family, and a shift in medical terminology and concept from "madness" to "mental illness."

Since the establishment of the People's Republic of China (PRC), considerable resources have been directed toward improving mental health, especially through community-based programs, but with many Chinese unwilling to seek treatment because of **religious** and cultural beliefs about the importance of upholding social **harmony** and maintaining personal and familial reputations. Of the 173 million people (16 percent) living with some form of mental disorder in the PRC, including depression, according to a 2001–2005 national psychological survey, 90 percent have avoided any treatment, as an intense stigma is still associated with mental illness as a form of weakness

272 • MAGIC (MOSHU)

and moral failure. Introduced into China during the New Culture Movement/ May Fourth Movement (1917–1921), the psychoanalytic theories of Sigmund Freud were criticized and denounced in the PRC, especially during the **Cultural Revolution (1966–1976)**. With the enactment of the Mental Health Law (2012), 17,000 psychiatrists now practice in the PRC, one for every 83,000 people, an important tool for addressing mental disorders, which know no racial or political boundaries.

MAGIC (*MOSHU*). Steeped in magic and magical beliefs throughout history, China has many forms, notably "alchemy" (*lianjin shu*) and "divination" (*zhanbu*), along with both "black magic" (*heimoshu*), aimed at bringing harm to people, and "white magic" (*baimoshu*), designed to provide such benefits as rainmaking. Replete with psychic powers, evil spirits, potions, and spells, magic has permeated the daily life of commoners and the imperial household, despite the periodic outlawing of the practice by imperial decree, with assorted "magicians" (*moshi*), "sorcerers" (*wushi*), and "wizards" (*xiangdao*) subject to serious **punishment**, including execution. Dating back to ancient history with records of sorcerers and magical acts appearing on "oracle bones" (*jiagu*) from the Shang Dynasty (1600–1046 BCE), Chinese magic began with peasants in poverty-stricken Northern China engaging in **acrobatics** and magical tricks to bring in extra income from street performances and shows at **market** fairs.

Prevalent in the imperial household, Daoist magicians exerted a dark influence over emperors who believed in the casting of "spells" (*zhouyu*) on enemies, both real and imagined, with the most lethal form involving preparation of a "paste" (*gu*) from dead poisonous snakes and **insects**, administered to the intended victim in the hopes of securing wealth or seeking revenge. Widespread purges were carried out during the Han Dynasty (202 BCE–220 CE) of individuals suspected of practicing such black magic techniques as using dolls (*yangwawa*) and manikins (*renti moxing*) modeled on real people to bring about illness and **death** in the imperial household. Magic was also employed by Han rulers to set random objects on fire so as to frighten criminals and commoners into obedience; during the Tang Dynasty (618–907), a female dwarf magician created an illusion of turning into a bamboo stalk with a human skull. Notable actions taken against magicians include the efforts of Emperor Qian Long (1735–1796) to suppress thousands of reputed "soul stealers" (*touhunzhe*) ravaging the empire in 1768. Items unique to Chinese magic include the "money box" (*qianxiang*), with secret and hard-to-find compartments, and the "magic mirror" (*mojing*), which, composed of bronze, can appear to be transparent by shining a bright light on its surface.

Chinese magic in the modern era has prospered, with talented and innovative magicians like the internationally renowned Ching Ling Foo (1854–1922) serving as the official court conjurer to Empress Dowager Ci Xi (1861–1908). Ching's bag of tricks included breathing smoke and fire; passing a sharp knife blade through his nose; and, in the water bowl illusion, tossing a large shawl into the air and then onto the floor to show a weighty bowl of water with an apple or sometimes a child on it. These were familiar feats in China for more than 1,000 years. Gaining world fame with such tricks, Ching toured Europe and North America in the late 19th century and was mimicked by aspiring **foreign** magicians, one of whom was American William Robinson, who took the name Chung Ling Foo and donned Chinese dress and **hairstyle** with his own magic performances.

While magic was attacked as "deceitful" (*pianren*) in the People's Republic of China (PRC), especially during the **Cultural Revolution (1966–1976)**, the practice has made a comeback, with local magician clubs established in cities like **Beijing** and performances by such famous magicians as Liu Qian at official PRC state functions. Traditional centers of Chinese magic include Wu Qiao county, Hebei, considered the cradle of Chinese magic, conveyed throughout the centuries from teacher to student, with current training in **acrobatics** preceding formal classes in magic. Magic is also practiced by **women** of the Zhuang **minority** in Guangxi, who are said to invoke magical powers by singing and **dancing** naked in local rivers. The secrets of magic tricks have been revealed via the Chinese internet, a violation of the Magician's Oath to never divulge an illusion to nonmagicians. Magical thinking has also become more prevalent among average people embarking on inventions, many farcical, such as a kidney dialysis machine made out of kitchen goods and medical parts with the inventing farmers known as "peasant da Vincis."

MANUAL LABOR (*TILI LAODONG*). In a society historically dominated by agriculture and, in the modern era, industry, manual labor has been the primary form of work, with mental labor limited in the imperial era to Confucian "**scholar**-officials" (*rujia*) with nonmanual office and staff workers increasingly prominent in the modern economy of the People's Republic of China (PRC). Despite the absolute importance of **food** production to the well-being of the imperial empire, contempt for manual labor was demonstrated by scholar-officials growing their fingernails to disproportionately long lengths and dressing in exquisite silk **clothing** as a sign of their inability and unwillingness to engage in any physical activity. Coming to power in the name of the laboring workers and peasants, the Chinese Communist Party (CCP) pursued policies requiring intellectuals and students, including young

274 • MAO ZEDONG (1893–1976)

children, to engage in manual labor in their **neighborhoods** or during periodic visits to nearby farms and workshops, sharing food and living quarters with their working-class "comrades" (*tongzhi*).

Adhering to basic principles in the guiding **ideology** of Marxism–Leninism, the CCP regime was devoted to bringing about the eventual elimination of the "antagonistic" (*didui*) division between physical and mental labor through the ultimate achievement of Communism, which CCP chairman **Mao Zedong** indicated would occur during the Great Leap Forward (1958–1960). Failing in this **utopian** goal, during the subsequent **Cultural Revolution (1966–1976)** young people, including Red Guards, were "sent down to the countryside" (*xiaxiang*) to engage in agricultural tasks that lasted for years. One of these individuals was a young **Xi Jinping**. With local farmers often finding their young guests more of a burden than a source of value-added labor, the practice was abandoned in the post-Mao era as economic reforms and social liberalization (1978–1979) channeled China's labor force into more productive sectors, with less reliance on manual labor, as automation and computerized production in factories and on the farm eliminated many manual tasks.

MAO ZEDONG (1893–1976). Born into a prosperous peasant **family** in Shaoshan, **Hunan**, Mao Zedong led the Chinese Communist Party (CCP) as chairman (1949–1976), launching widespread assaults on Chinese cultural forms, while engaging in such traditional practices as **poetry**. Working as a young student in the **library** of Peking University, Mao participated in the culturally iconoclastic New Culture Movement/May Fourth Movement (1917–1921), publishing in the signature journal *New Youth* (Xin Qingnian) two articles, one on female **suicide** in China's male-dominated, "patriarchal" (*jiazhang*) culture and other on the importance of physical education to Chinese **youth**.

Overseeing the adaptation of Marxism to Chinese conditions, known as "Sinicization" (*Zhongguohua*), Mao singled out **literature** and **art** for transformation and politicization in the talks at the famous Yan'an Forum on Literature and Art (1942), included in *Quotations from Chairman Mao Zedong* (Mao Zhuxi Yulu), also known as the *Little Red Book*. Attacking the courtly role of traditional art forms, including **dance**, **drama**, and **songs**, Mao called for literature and art to reflect the lives of the working class and peasantry, with the two groups serving as a primary source of popular **music** and folk **customs** requiring study and emulation. Rejecting any notion of "art for art's sake" (*wei yishu er yishu*), Mao called for all art forms to serve politics and advance the achievement of socialism, with opponents to such ideologically driven views, for example, writer Wang Shiwei (1906–1947), subject to purge and ultimate execution.

Following the establishment of the People's Republic of China (PRC), creating a "revolutionary culture" (*geming wenhua*) became a political priority, with the status of **women** the first target in the Marriage Law (1950), granting wives the right to inaugurate divorce. Launching a virtual war on Chinese culture, Mao pushed radical policies, most notably the Great Leap Forward (1958–1960), which, in addition to inaugurating dramatic changes in **rural** organization with formation of the "people's communes" (*renmin gongshe*), launched attacks on traditional **religion**, with people destroying temples and burning ancient liturgical texts and music scores. Confronting increased opposition in the top ranks of the CCP for a string of policy reversals culminating in the Great Leap, Mao drew on the traditional reverence for leaders, formerly reserved for emperors, by personally sanctioning a fanatical personality cult, expanding his personal authority while ravaging all forms of "bourgeois culture" (*zichanjieji wenhua*), especially among intellectuals and writers.

Granting his wife, Jiang Qing, near-total control of cultural realms, especially music and **opera**, Mao launched the **Cultural Revolution (1966–1976)**, with **education** a major target of revolutionary transformation. Despite radical policies, for example, "sending down to the countryside" (*xiaxiang*) **artists**, writers, and students to engage in **manual labor**, following Mao's passing in 1976, and the subsequent arrest of Jiang Qing and her supporters, Chinese cultural realms, traditional and modern, were quickly revived, with most of the Maoist innovations ending up in the dustbin of history.

MARKETS (*SHICHANG*). An essential component of the Chinese economy from ancient times to the post-1978 period of economic reforms in the People's Republic of China (PRC), relatively free markets for agricultural and other products account for the periods of general prosperity in imperial and modern times. With markets operating at the local level of villages, towns, and major **urban areas**, and at the macro level of international **commerce** and trade, particularly along the fabled **Silk Road**, China developed a hybrid system of an autocratic state, imperial and then Communist, along with a system of property rights and an active, although sometimes restrained, merchant class. Supported in various realms of traditional Chinese **philosophy**, including **Confucianism** and **Daoism**, along with such famous scholars as Sima Qian (145–86 BCE) and Qiu Jun in the Ming Dynasty (1368–1644), excessive state taxation and economic controls were opposed, while **individual** interests and the pursuit of profit were advocated, sometimes to doubting emperors and Chinese Communist Party (CCP) leaders.

While the imperial state adopted a policy of maintaining monopolies on crucial commodities like salt, wine, iron, and steel, agricultural goods and **handicrafts** were exchanged in vibrant, largely unregulated markets where

276 • MARRIAGE AND DIVORCE (HUNYIN/LIHUN)

prices were generally set by the forces of supply and demand, along with the development of factor markets for land and an embryonic credit and financial system. Seeking more than self-sufficiency, Chinese farmers produced surpluses sold in local market towns, while merchants sought out buyers and sellers, local and abroad, with such cities as Chang'an (modern-day **Xi'an**) becoming the most powerful economic centers in the world during the Tang Dynasty (618–907). With massive amounts of silver flowing into the empire from the 15th to the 19th centuries, post-tax agricultural output subject to market exchange was estimated at 40 percent during the Qing Dynasty (1644–1911), a situation that continued into the modern era of the Republic of China (ROC) on the mainland (1912–1949) and the early 1950s under the PRC.

Adopting from the Soviet Union the system of central economic planning and government control of major economic sectors through state-owned enterprises (SOEs) beginning in 1953, private markets and property rights were subject to withering **ideological** assault and denunciation in the CCP-led land reform movement (1947–1951). Reaching draconian levels during the Great Leap Forward (1958–1960), crucial linkages between **rural** producers and market towns were disrupted, with catastrophic consequences, leading to the Great Famine (1959–1961), with an estimated 30 million fatalities, mostly in the countryside. While the restoration of the infrastructure of rural markets and exchanges in the early 1960s produced an economic recovery, not until the passing of CCP chairman **Mao Zedong** in 1976, was the transition from a planned to an emerging market economy pursued, with a goal of achieving a rule-based market system set in 1994, including a concomitant reduction in SOEs in favor of more market-oriented private companies the likes of Alibaba and Tencent.

While state control of black markets and other illicit economic activities, for instance, shadow banking, are generally maintained in northern industrial centers, black markets and the production of "counterfeit goods" (*shanzhai*), for example, cheap mobile **smartphones**, thrive in southern cities, most notably Wenzhou, Zhejiang, where state regulatory authority is all but nonexistent as markets exist for virtually every form of goods and services, many illegal.

MARRIAGE AND DIVORCE (*HUNYIN/LIHUN*). Considered the foundation of society from ancient times to the contemporary period of the People's Republic of China (PRC), marriage has been promoted and incentivized by the Chinese state, with divorce, a historical rarity, becoming increasingly frequent and largely initiated by **women**, especially since the introduction of economic reforms and social liberalization (1978–1979). Idealized in **Confucianism** as essential to the cultivation of **virtue** and continuation of the **family** line, marriage traditionally involved more than just two individuals,

MARRIAGE AND DIVORCE (HUNYIN/LIHUN) • 277

extending to the entire family and **clan**. A primary subject in Chinese **legends and mythology**, marriage was said to have been created by the union of Nüwa, the mother-goddess, and Fuxi, the emperor-**god**, who despite being brother and sister were allowed to marry to populate a barren land bereft of people.

Throughout imperial history, marriage practices and wedding **rituals** were shaped by state policies, beginning in the Han Dynasty (202 BCE–220 CE) with the mutual exchange of dowries and betrothals between families of the bride and groom. Any marriage lacking such **gifts** was considered dishonorable, with the wife treated as nothing more than a **concubine**, while widows of deceased husbands were expected to remain within their adopted family. Fast forward to the Ming Dynasty (1368–1644) and the role of marriage "brokers" (*jingjiren*), generally elderly women referred to as "grannies" (*ama*), was written into the Ming Legal Code (1397) to bring together members of wealthy but socially unconnected families, with obligations subjected to written contract.

In imperial times, marriages were prearranged and promoted as matters of convenience forming important political and economic alliances with little to do with **romance and love** between the partners, and generally endogamous, involving members of the same **class** and social rank, with polygamy strictly outlawed, which tended to encourage concubinage. Unique marital practices included the marriage of poor **men** into wealthy but sonless families to protect the lineage, known as *ruzhui*, literally "into the burden," and polyandry, wives with multiple husbands, practiced in **minority** areas like **Tibet**. Wedding preparations and the ceremony were highly ritualized, involving appropriate attire, especially for the bride, and multiple bows and expressions of deference to the elderly and new relatives, with the nuptials culminating in a memorable wedding **banquet** and multiple toasts by any and all guests.

Legally recognized since the Tang Dynasty (618–907), with power of initiation generally held by the husband or government intervention, divorce initiated by women was legally recognized in the 1950 Marriage Law, with further amendments (2001, 2003) making for an easier and less obstructionist application process. Tracked down by irate husbands and relatives, women seeking release from unwanted, forced marriages, especially in the countryside following enactment of the 1950 Marriage Law, were killed or committed **suicide**, revealing the extent of dissatisfaction with the traditional notion of "marry a dog, stick with the dog."

While divorces were few during the era of rule under Chinese Communist Party (CCP) chairman **Mao Zedong** (1949–1976), when the daily struggle for survival trumped personal interests, the introduction of reforms spurred the pursuit of divorce, especially by younger, generally well-educated, and financially independent women concentrated in the wealthier coastal and **urban areas** like **Shanghai** and Zhejiang. With the social stigma of divorce

278 • MARTIAL ARTS (WUSHU/WUYI)

weakening, although by no means dead, 74 percent of divorces are initiated by women caught in marriages unraveling after a mere three years, with the number of divorces rising to 4.4 million in 2017, although with rates lower than other developed countries, for example, the United States.

Concerned with the impact of growing divorce and marital separation on social "stability" (*wending*), local governments have instituted policies and procedures for preserving marital bonds, for instance, mandatory "cooling off" (*liangkuai*) periods lasting from three to six months prior to initiating formal divorce proceedings, with "civilized household" (*wenming fangzi*) awards granted to couples who remain together by none other than President **Xi Jinping** (2013–). Major issues involving divorce include financial liability of wives for debts run up by wandering husbands and "sham divorces" (*jia lihun*), sought by couples trying to circumvent **legal** restrictions on property ownership of married couples in major cities. Single women, especially from **rural** villages, reluctant to marry often confront enormous pressure from irate parents, grandparents, and even siblings to find a husband and avoid becoming a "leftover woman" (*shengnü*), in a society of enormous gender imbalance, as men outnumber women by 30 million, largely a result of the **one-child policy**.

MARTIAL ARTS (*WUSHU/WUYI*). An umbrella term for several hundred fighting and **exercise** styles, martial arts developed throughout the centuries in China with divisions into different "families" (*jia*), "sects" (*pai*), and "schools" (*men*). Inspired by ancient **philosophies** and **religions**, most notably **Daoism**, along with **legends and mythology** from heroic periods in Chinese history, martial arts traces its history to the semimythical Xia Dynasty (2205?–1766? BCE), with the initial writings on the topic attributed to the equally semimythical "Yellow Emperor" (*Huangdi*). Referenced in the classic *Spring and Autumn Annals* (5th century BCE), martial arts developed along with other physical regimens, for example, Chinese "wrestling" (*jiaodi*), incorporating sword **dances** during the Tang Dynasty (618–907) and becoming a fully developed **art** form in the Ming (1368–1644) and Qing (1644–1911) dynasties. So-called "internal" (*neibu*) martial arts emphasizes strength of the upper **body** and legs, while "external" (*waibu*) martial arts refers to training of the arms and legs. Northern and southern styles differ with the former, characterized by deep, extended postures connected by fluid transitions and quick changes in direction, with emphasis on legwork, kicking, and **acrobatics**, and the latter by low stances and short, powerful movements, considered softer and more fluid.

The three major schools of martial arts include Shaolin, Wudang, and Emei, each associated with a different **region** and different fighting styles. Known for the "long fist" (*chang quantou*), monks of the Shaolin Buddhist Temple in Henan engage in martial arts as part of their monastic duties,

MARTIAL ARTS (WUSHU/WUYI) • 279

training and performing fast and powerful kicks, high jumps, and generally fluid and rapid movements dating to the 6th century. The core of the Shaolin style is an imitation of movements and fighting techniques of five **animals**, specifically the tiger, crane, leopard, snake, and mythical dragon. Wudang, so named for the Wudang Mountains, a small range in Hubei with a complex of Daoist temples and four sacred **mountains**, is most noted for "Tai Chi" (*taijiquan*), a fist system based on the dynamic relationship of the **yin-yang** polarities and considered a major personal **health** regimen. Emei, named after the famous mountain with Buddhist holy sites in **Sichuan**, is characterized by swiftness and flexibility, with many **women** as practitioners. Styles modeled on animal movements include "Eagle Claw," "Northern and Southern Praying Mantis," and "Fujian White Crane."

Especially popular and internationally renowned in the period of rule by the Republic of China (ROC) on the mainland (1912–1949), the association of martial arts with the **family, religion**, and other cultural traditions led to discouragement by the government of the People's Republic of China (PRC), especially during the chaotic **Cultural Revolution (1966–1976)**. Enjoying a revival since the introduction of economic reforms and social liberalization (1978–1979), Shaolin and other training centers, for Chinese and **foreigners** alike, have become major tourist attractions since martial arts became a major theme in Chinese films from the 1960s to the 1980s, with prominent Chinese stars, many from **Hong Kong**, the likes of Bruce Lee and Jet Li.

Chinese **literature** was also impacted in the form of so-called "martial hero" (*wuxia*) novels, with influences extending to dance, **theater**, and **opera**, particularly **Peking opera**. Involving rigorous drills of pushing the hands, striking, throwing, thrusting, and "sparring" (*duida*) with partners, martial arts also involve twirling such weapons as swords, spears, and whips, and "controlling" (*kongzhi*), which includes joint locks and the striking of nerve points. Seeking **spiritual** enlightenment through strict physical and mental **discipline**, *wushu* masters focus on the cultivation of a martial morality of "deed" (*qiju*) and "mind" (*xin*), achieving a balance and inner **harmony** between emotions and mind, with the ultimate goal of "no extremes" (*wuji*), approximating the Daoist state of "doing nothingness" (*wuwei*). Deeds include "humility" (*qian*), **virtue**, "respect" (*li*), "morality" (*yi*), "trust" (*xin*), and "mind" (*xin*), consisting of "concept" (*yong*), "patience" (*ren*), "endurance" (*heng*), "perseverance" (*yi*), and "will" (*zhi*). Famous martial arts figures in Chinese history include Yue Fei (1103–1142), famous general and poet in the Southern Song Dynasty (1127–1279), and Ng Mui, in the late 17th century, the first female *wushu* master and one of China's famous "Five Elders" (*Wushu*), survivors of the destruction of the Shaolin Temple in the early Qing Dynasty.

280 • MASKS (KOUZHAO)

MASKS (*KOUZHAO*). Worn during theatrical, operatic, and celebratory **dances**, especially around the **Spring Festival**, Chinese masks come in a rich variety of **colors** and types, and are worn for everything ranging from the birth of newborns to **funerals and burials**. Dating back 3,500 years, masks were first used by **shamans** engaged in exorcisms to scare away evil spirits and at funerals to ward off intrusive apparitions to ensure a peaceful resting place for the deceased. Most prominent in Chinese **opera** and **theater** productions, different masks with different colors allow audiences to identify characters immediately, with red, purple, and black connoting the well-intentioned, and white, blue, green, and yellow signaling evil, violent, and cruel characters. Considered by many Chinese as their second "**face**" to don the personality of another, masks are seen as a form of **spiritual** uplift used to tell stories of great **heroes**, magnificent **gods**, and remarkable deities, while also communing with the recently departed.

Covering the entire face and designed to look like a human being or **animal**, masks are often made out of cloth, leather, wood, and even paper, with some painted directly on the face in intricate detail with nostrils and pupils in proper proportion. Favored among many ethnic **minorities**, for example, the Miao, Dong, and Yao peoples, and frequently worn by local "sorcerers" (*wushi*) in **Yunnan** and Guizhou, masks are particularly popular in **Tibet**, painted on the face of inhabitants in blood to scare away enemies and usually in an animal, demon, or human form, with pearls and shells serving as prominent teeth. Most popular among Chinese are the dramatic "lion" (*shizi*) and "dragon" (*long*) masks, worn during Spring Festival celebrations, with such bright colors as gold and silver representing divine beings bringing blessings to the living by warding off diseases and preventing disasters in the forthcoming year. Bronze masks with large protruding eyes have also been excavated from the *sanxingdui* **archaeological** site dating to the 12th century BCE in **Sichuan**.

MAY FOURTH MOVEMENT (WUSI YUNDONG). A series of demonstrations that broke out in **Beijing** and other large cities in Spring 1919 protesting the acquiescence of the Chinese government to the decision of the Paris Peace Conference in Versailles to convert control over territory in Shandong from Germany to Japan in the wake of World War I, the May Fourth Movement is considered the birth of modern Chinese **nationalism**. Inspired by the principles of self-determination espoused by United States President Woodrow Wilson and organized by students, intellectuals, and some workers, the movement quickly expanded into a demand for fundamental changes in Chinese society, politics, and culture embodied in the concepts of "Mr. Science" (*Sai Xiansheng*) and "Mr. Democracy" (*De Xiansheng*). Dove-tailing with the ongoing New Culture Movement (*Xin Hua Yundong*) that had begun in 1917 with calls to convert from the "classical" (*wenyan*) to

the "vernacular" (*baihua*) language in Chinese **literature** and which held **Confucianism** responsible for China's political and cultural backwardness especially vis-à-vis the West and Japan, May Fourth included such prominent figures as Peking University professors Chen Duxiu (1879–1942) and Li Dazhao (1898–1927), co-founders of the Chinese Communist Party (CCP). Considered an intellectual turning point in modern Chinese history shaping all subsequent discussions over the necessity of enacting fundamental cultural changes, May Fourth was opposed by cultural conservatives, many associated with Nationalist (Kuomintang) leader Chiang Kai-shek (1928–1949), but enthusiastically embraced by CCP chairman **Mao Zedong** (1936–1976).

MEDICAL ETHICS (*YIXUE LUNLI*). Reflecting the long history of practicing medicine, both **traditional Chinese medicine (TCM)** and modern medical sciences, medical ethics in China developed from the 7th century onward with influence from foreign, primarily Western, sources. Beginning with the works of physician and writer Sun Simiao (581–682), considered the author of the Chinese version of the Hippocratic Oath, doctors should be guided by a rigorous conscientiousness and self-discipline, avoiding any desire for material wealth and treating every patient, noble, and commoner equally, while doing no harm. A practitioner of Daoist alchemy and a meticulous gatherer of medicinal herbs, Sun laid out his guidelines for compassionate and beneficent medical practice in an essay entitled "On the Absolute Sincerity of Great Physicians," part of two massive medical encyclopedias where the subsequently honored "king of medicine" indicated his opposition to the taking of any life, including **animals**, for medical treatment. Calling for extensive **education**, Sun also advocated for aspiring physicians to cultivate a virtuous character equal to the "gentleman" (*junzi*) idealized in **Confucianism**, as the practice of medicine was considered the ultimate realization of "humanness" (*ren*).

Subsequent writers in the imperial era expanding on ethical issues included Zhang Gao (1149–1227), with prescriptions for a morally good physician in his *Teaching on Medicine* (*Yishuo*); Zhu Huiming (16th century), on the importance of doctors being truthful and not engaging in deceitful practices; and Gong Tingxian (17th century), on the 10 maxims for physicians and patients. With the entry of Western missionaries, especially in the 19th and 20th centuries, ethical concepts were introduced on the importance of the **individual** and the professional autonomy of the physician, as a generation of Chinese doctors was trained in such foreign-established medical schools as Peking Union Medical College (*Beijing Xiehe Yiyuan*), funded by the Rockefeller Foundation (1921) in **Beijing**.

Following the establishment of the People's Republic of China (PRC), research and study on medical ethics began in the 1960s, with mandatory courses on biomedical ethics taught at Chinese medical schools and the pub-

282 • MEDICAL ETHICS (YIXUE LUNLI)

lication of the textbook *Medical Ethics* by Qiu Xiangxing. With radical politics and **ideological** orthodoxy intervening in virtually every aspect of life, especially during the **Cultural Revolution (1966–1976)**, major ethical violations occurred, most notably the denial of crucial medical care ordered by Chinese Communist Party (CCP) chairman **Mao Zedong** to ailing premier Zhou Enlai, which probably led to the latter's untimely death from a treatable cancer in early 1976.

Following the introduction of economic reforms and social liberalization (1978–1979), priority was given to the promotion of medical ethics with the establishment of the Chinese Association for Medical Ethics in the 1980s and the release of the first guidelines on medical ethics by the Ministry of Public Health, although not legally binding. Attention to the importance of abiding by medical ethics on the part of hospital staff in the face of political authorities came in a newspaper editorial by Liu Junqi, a professor of journalism and a columnist for *Health News* (Jiankang Bao), as well as director of the Journalism Research Department in the Ministry of Public Health. Inspired by the movie *Tear Stain* (Leihen), which portrays the case of a high-level government official denied medical treatment for political reasons during the Cultural Revolution, Liu described how the tears of nurses symbolized the consciousness of medical staff and their helplessness in having to follow orders in withholding treatment for a gravely ill patient labeled as an arch enemy of the Maoist regime.

Provisional regulations defining procedures for ethical review of biomedical research involving human subjects were issued by the reformed Ministry of Health in 1998. Citing ethical standards accepted by the international community, the regulations involved such topics as informed consent, the responsibilities of investigators, the rights of research subjects, and the administrative management of ethical reviews and **legal** responsibilities. Continued violations included cases of researchers using tissue from aborted fetuses and genetic engineering research on human embryos, the so-called "Crispr babies" created by Chinese scientist He Jiankui. Among the further administrative measures taken against such research has been the establishment of the National Ethics Advisory Committee in 2019, to oversee clinical trials and counter the fragmented framework of oversight responsibilities apportioned among different government agencies and ministries, a perennial problem in the bloated bureaucracy of the PRC. More and better training of educators in medical ethics is also advocated to match the substantial growth of the biotechnology sector with an equally strong medical ethics regime. That first the inquiries to blood and organ donors at hospitals involve questions regarding their "support for the **leadership** of the party" indicates the continuing politicization of medical ethics in the PRC.

MEN AND MASCULINITY (*NANREN/YANGGANG ZHI QI*). The role of men and the dominant images of masculinity have undergone dramatic changes in Chinese history from the imperial era through the modern period, including various phases of changing gender identity in the People's Republic of China (PRC). A "patriarchal" (*jiazhang*) society, men dominated much of Chinese society from the **family** to the imperial court, with male identity split between the "scholarly" (*wen*) versus the "martial" (*wu*), the former considered "soft" (*ruan*), associated with intellectual and artistic pursuits, and the latter seen as "hard" (*ying*), involving fighting skills and **military** command as idealized in such classical novels as *Water Margin* and *Romance of the Three Kingdoms*. Traditional notions of the "four handsome men" (*sige mei nan*) likened the ideal male to white **jade** and flowers, with **scholar**-officials in the imperial bureaucracy noted for growing long, effeminate fingernails and wearing refined silk gowns. With soldiers ranked at the bottom of the traditional social order and **manual labor** in agriculture and other physically taxing occupations considered inferior, masculine identity in imperial China lacked the qualities of male strength and emotional toughness.

Fast forward to the period of the PRC and official male roles and masculine images during the rule of Chinese Communist Party (CCP) chairman **Mao Zedong** (1949–1976) were reversed, with traditional notions of scholarly activity subordinated to the strength and emotional devotion of workers, peasants, and soldiers. In an **ideological** vision feeding a strong sense of **nationalism**, the scholarly and refined male was considered a convenient scapegoat for the country's national **humiliation** at the hands of **foreign** powers since the 19th century. Building national power began with strengthening the **body**, as portrayed in countless posters and **paintings** of young strapping men, and **women**, with muscular arms, chiseled faces, sharp jaw lines, and fierce looks evocative of the European neoclassical style popular in the Soviet Union. Men were "red and bright" (*hongse he mingling*), devoid of any **sexuality**, with no hint of emotional vulnerability, angst, or melancholy.

Integration with the global community since 1978–1979 has exposed China to dramatically different images of masculinity, led primarily by media-savvy pop **music** singers the likes of Cai Xuken, known as "little fresh meat" (*xiaoxianrou*), a term coined by adoring fans. Young, with delicate and boyish features, including makeup and earrings with dyed hair, wearing androgynous **clothing** and slender figures, these models of the new man, heavily influenced by South Korean pop stars, are the antithesis of the male ideal supported by official agencies, along with such popular **martial arts** stars as Bruce Lee and Jet Li. Opposed to entrenched notions of male privilege, these

new expressions of male gender identity are motivated by a quest for **individuality** and a promotion of a culture of tolerance and diversity reinforced by wider acceptance in Chinese society of **homosexuality**.

Denounced in official circles as "sick" (*bing*) and "decadent" (*tuifei*), and considered a mortal threat to national security—"a calamity for our country"—efforts to counter this virtual cultural assault on the resilient Chinese man of old have most notably included **censorship**, particularly of offensive pop music performances, along with films portraying men as "wimps, cowards, losers, and idiots." The establishment of Real Men Training Clubs and the publication of new *Little Men* textbooks target **youth**, with clubs organizing shirtless, midwinter runs to "toughen up" young boys and "remasculinize" vulnerable fourth and fifth graders. **Criticism** is also directed at female school teachers, who constitute a large majority in Chinese schools, for reputedly conveying risk-averse sentiments contrary to the alpha males China is so in need of to deal with a hostile world, with the less well-educated male displaying a profound envy and jealousy for his more well-educated female counterpart. Exacerbated by the popularity of ostensibly male music bands composed of cross-dressing women, top leaders, including President **Xi Jinping** (2013–), are on record as idolizing real men with a commitment to becoming People's Liberation Army (PLA) soldiers as the model of true masculinity essential to national power, in contrast to pop singers and actors, who are berated as "shrieking" (*jianjiao*) "sissy pants" (*niangpai*).

MILITARY SERVICE AND CULTURE (*JUNSHI BINGYI/WENHUA*). Extending from 2,200 BCE to the modern era of the Republic of China (ROC) on the mainland (1912–1949) and the People's Republic of China (PRC), military culture and service have presented contrasting realities, with a strong antiwar sentiment in traditional **philosophy** balanced by strong armies, innovative weapons, and the strategic thinking of Sun Zi in the classic *Art of War* (Bingfa), written in the 5th century BCE. **Confucianism**, **Daoism**, and **Buddhism** emphasize the preference of resolving conflicts by peaceful means while showing a general contempt for brute force, with Mencius (372–289 BCE) describing great generals as criminals and military weapons as evil implements.

Throughout the imperial era, the Chinese military posture was basically defensive, as indicated by a reliance on static fortifications, most notably the **Great Wall**, along with walls surrounding **urban areas** and even individual residences. Exceptions included Chinese invasions and **conquests**, especially during the Yuan (1279–1368) and Ming (1368–1644) dynasties, when targets included Japan, northern Vietnam, and even the Middle East, specifically modern-day Iraq, along with naval battles against Dutch and Portuguese colonialists. Weapons developed included the lethal repeating crossbow, with as many as 10,000 soldiers armed with the weapon; the "proto-gun,"

MILITARY SERVICE AND CULTURE (JUNSHI BINGYI/WENHUA) • 285

employing gun powder for the first time; cast-iron canons; flamethrowers; and even rockets. There were also advanced metallurgical standards for arms and armor. Mounted cavalry were an important component of Chinese military formations, borrowed from such nomadic invaders as the Xiongnü and the Mongols, and effectively deployed in the invasion of far-flung territories.

The development of well-trained armies in Chinese history began from the period of the Warring States (475–221 BCE) onward, with professionally trained officers replacing amateur aristocrats as conscripted infantry and mobile cavalry armed with iron weapons replaced chariot-riding aristocrats. Subordinated to centralized state power in the Han Dynasty (202 BCE–220 CE), armed units benefited from improvements in iron casting, with stronger swords and stirrups for horses, allowing for expansion of the empire. Professionalization significantly advanced during the Tang (618–907) and Song (960–1279) dynasties, with the establishment of officer training schools, while long-range archery was perfected during the Yuan Dynasty. Organized into "Banners" (*Biaoyu*) and regular standing armies during the Manchu-dominated Qing Dynasty (1644–1911), the development of modern firearms was largely ignored in favor of traditional cavalry, leaving the Chinese empire open to a series of internal rebellions, most notably the Taiping Rebellion (1850–1864) and ultimate conquest by Western and Japanese imperialist powers.

Trained by Western military professionals and in such Chinese institutions as the Hanyang Arsenal, Chinese military personnel became increasingly professionalized, serving in military units of the Republic of China (ROC) government under the **leadership** of Chiang Kai-shek (1928–1949), who, adopting the title "Generalissimo" (*Dayuanshuai*), defeated regional warlords in the successful Northern Expedition (1926–1927). Donning elaborate military garb and assuming multiple and largely fictitious ranks, Chiang violated the traditional cultural abhorrence for a military man as national leader while the forcibly conscripted and ill-disciplined Nationalist armies that had opposed the Japanese invasion ultimately lost out to the more **disciplined** Communist armies led by Chinese Communist Party (CCP) chairman **Mao Zedong** in the Chinese Civil War (1946–1949).

Formally established in 1945, as the People's Liberation Army (PLA), military forces of the PRC were subject to rigorous professionalization during the 1950s and early 1960s, operating according to the principle of "the party controls the gun" (*dang kongzhi qiang*), with Mao Zedong avoiding military garb despite his titular role of commander in chief through the CCP Central Military Commission. Appointing PLA leader Lin Biao (1907–1971) as his official successor, Mao opened the doors to greater military involvement in politics, especially during the **Cultural Revolution (1966–1976)**, when military authority and personnel superseded the CCP, while formal military ranks in the PLA were abolished. With Lin Biao reputedly attempt-

286 • MINORITIES (SHAOSHU MINZU)

ing a failed military coup, leading to his death in a plane crash while attempting to flee the country in 1971, military involvement in the civilian sector declined. Following the passing of Mao Zedong in 1976, the Chinese military "returned to the barracks" (*huidao bingying*), with post-Mao leaders, beginning with Deng Xiaoping (1978–1992), committed to reviving and strengthening a fully professionalized military under firm civilian control, with PLA soldiers serving as models of **loyalty** to the CCP.

MINORITIES (*SHAOSHU MINZU*). Constituting 8.5 percent of the total population of the People's Republic of China (PRC), at 1.45 billion (2019), minority ethnic groups, officially numbered at 55, exhibit a range of cultural patterns, from great diversity and uniqueness, to near-full assimilation, to the dominant Han majority of 91.5 percent. Formally a multiethnic state with minorities concentrated in the southern, western, and southwestern **regions** of the country, the PRC has pursued diametrically opposed policies, from forced assimilation during the rule of Chinese Communist Party (CCP) chairman **Mao Zedong** (1949–1976), especially during the **Cultural Revolution (1966–1976)**, to increased tolerance and **freedom** of cultural expression from the late 1970s onward but with continuing restrictions on some sensitive cultural and **religious** outlets.

Major minority groups, many of the Muslim faith, receiving official PRC government recognition include the following (in order of relative numbers in millions): Zhuang (16.9), Hui (10.5), Manchu (10.3), Uighur (10), Miao (9.4), Yi (8.7), Tujia (8.3), Tibetan (6.2), and Mongol (5.9), with several hundred additional groups, for example, **Jews**, petitioning for official recognition. Benefits and cultural freedoms accorded to that status are especially pronounced in "autonomous areas" (*zizhiqu*), including five regions at an administrative rank equal to provinces, Guangxi, Inner Mongolia, Ningxia, **Tibet**, and Xinjiang.

During China's imperial era, from the Qin Dynasty (221–206 BCE) to the Qing Dynasty (1644–1911), a policy of "rule by custom" was adopted toward ethnic minorities in which political unification of the empire was maintained, while non-Han ethnicities were allowed to preserve their own social systems, **languages**, and cultures. As the empire extended to its greatest size, largely through western expansion under the Qing, a separate bureaucratic organ, the "Court of Colonial Affairs" (*Lifan Yuan*), was set up to manage relations with minorities in the far-flung places the Qing had recently conquered, with **urban areas** subjected to significant "Sinicization" (*Zhongguo hua*). Showing a general lack of respect for minorities, Qing rulers employed carrot-and-stick policies to enhance ethnic integration, while specific minorities, for instance, the Manchus, were granted special privileges. While the Mandarin dialect, known as the "national language" (*putonghua*), was spread throughout the empire, especially in urban areas, minority languages were

MINORITIES (SHAOSHU MINZU) • 287

recognized, with four non-Chinese scripts used in the Qing Dynasty, namely Manchu, Mongol, Tibetan, and Uighur. With the expansion of the empire into non-Han regions, imperial China remained a multicultural patchwork but with national unity maintained by a centralizing bureaucratic state, a model sustained by the PRC, especially following the introduction of economic reforms and social liberalization (1978–1979).

During the era of the Republic of China (ROC) on the mainland (1912–1949), Nationalist (*Kuomintang*) leaders, including both Sun Yat-sen (1912–1925) and Chiang Kai-shek (1928–1949), brandished their **nationalist** credentials by declaring everyone in the country "Chinese" (*Zhonghua ren*), denying the virtual existence of minorities or even an ethnic majority. Pursuing a vision of China as a culturally homogenous society, the ROC government admitted to only five groups constituting the Chinese "race" (*zongzu*), Han, Manchu, Mongolian, Tibetan, and Hui. Traversing heavily minority areas during the epic Long March (1934–1935), CCP leaders promised greater rights and freedom for minorities upon taking power, with direct appeals to minorities in the subsequent Second Sino–Japanese War (1937–1945) and the establishment of a Nationalities Institute in 1941, in the Communist redoubt of Yan'an. While the Common Program (September 1949), promulgated by the CCP, declared the inherent equality of all minorities, coercive measures were employed against minority areas resisting rule from **Beijing**, particularly in Tibet and Xinjiang. Campaigns were also launched to "stamp out **superstition**" (*xiaochu mixin*), with Muslims, particularly in the western regions, as primary targets of forced secularization.

The first national census of the PRC, conducted in 1953, recorded 400 distinct minority groups, as institutions set up to benefit and celebrate the country's minorities included the Cultural Palace of Nationalities, built in Beijing in the 1950s, and several universities established primarily for minorities, along with celebratory ethnic **festivals**. At the same time, PRC state policy was increasingly influenced by the policy on nationalities pursed in the Soviet Union under Joseph Stalin (1927–1953), with **ideological** rhetoric of the CCP supporting minority diversity but with the reality of a "civilizing project" (*wenming gongcheng*) aimed at minorities, considered "backward" (*luohuo*) and a threat to national unity. Numerous assaults and persecutions against minority peoples were carried out during the Anti-Rightist Campaign (1957–1959), the Great Leap Forward (1958–1960), and especially the **Cultural Revolution (1966–1976)**, when the central government imposed tighter controls on minority areas and extended political campaigns to the local level. In many minority-dominated areas, for example, Tibet and **Yunnan**, minority cultural artifacts, including temples, religious shrines, and artwork, were wantonly destroyed by Red Guards, with minorities forced to reorganize their social and economic systems along the socialist lines dictated by

288 • MONEY AND MONEY LENDING (QIAN/FANGDAI)

Beijing. Radical political campaigns also imposed restrictions on the use of minority languages, reversing the emphasis on bilingual **education** that had dominated government policy in the early 1950s.

Following the introduction of economic reforms and social liberalization (1978–1979), state policy on minorities was softened, with minorities granted limited self-governance and considerable **freedom** to practice their indigenous cultures, notably the use of native languages, according to the 1984 Law on Regional Ethnic Autonomy (amended in 2001). By 2003, China had established 155 ethnic autonomous areas, including 30 autonomous prefectures and 120 autonomous counties (known in Inner Mongolia as banners), with central policy on minorities implemented by the State Commission of Ethnic Affairs. Institutions tailored to minorities were also established by the central government, including the Nationalities Affairs Commission and the Central University for Nationalities. **Criticism** of contemporary policies emphasizes the continuous marginalization and exoticization of minorities too often portrayed **dancing** and singing in bright costumes and described as "simple-hearted, honest, and very kind," with minority cultures "feminized" (*nüxinghua*), while genuine indigenous **literature** and **art** remain politically stifled by a government devoted to creating political and cultural uniformity.

MONEY AND MONEY LENDING (*QIAN/FANGDAI*). In a long and continuous history of trade and **commercial** prosperity, China developed coinage and other forms of currency dating back 3,000 years, to the Neolithic age, including the first use of paper money, referred to as "flying cash" (*feiqian*), in the Tang Dynasty (618–907). With cowry shells serving as the first type of coinage, standardization of the currency system was achieved during the Qin Dynasty (221–206 BCE), as copper became the metal of choice for coinage, molded in a round shape, representing heaven, with a square in the middle, representing earth. Worn around the neck as amulets to ward off evil spirits and demons, coins were also used in consultations, employing the *Book of Changes* (Yi Jing), with special coins tossed in the direction of brides at Chinese weddings to bring good **fortune** and luck. Ancient coinage was also produced in the shape of knives and spades, with strings of cash, usually consisting of 100 coins, a common store of value, along with other valuables, for example, bolts of silk, also serving as currency.

Gradually replaced by the lighter and more easily used paper currency as trade expanded, especially along the **Silk Road**, the first fiat currency was issued in the Yuan Dynasty (1279–1368) as valuable metals were freed up for other uses. During the prosperous Ming Dynasty (1368–1644), large quantities of silver imported via the Spanish from Mexico became the currency of choice, while bimetallic coinage consisting of copper and silver was

employed during the Qing Dynasty (1644–1911) and mass produced by modern machinery. The modern-day yuan paper currency was introduced by the government of the Republic of China (ROC) during the period of rule on the mainland (1912–1949), subsequently replaced by the "people's currency" (renminbi), also commonly referred to as "yuan," during the People's Republic of China (PRC).

Lacking the **religious** objection to money-lending found in both **Christianity** and Islam, Chinese merchants from the Song Dynasty (960–1279) onward offered letters of credit, ultimately replaced by commercial banks, although such financial transactions were subject to intense **criticism** and restriction during the period of central economic planning adopted from the Soviet Union (1953–1978) in the PRC. Fake ritual money, also referred to as "hell money" (*diyu qian*), is burned at **funerals** as **spiritual** offerings to the recently deceased, while "red envelopes" (*hongbao*) are traditionally filled with cash and given to **children** during the **Spring Festival**. *Shaking the Money Tree* is also a famous **opera** performed largely for children. Money and love were also more closely linked in China than in the West with a Chinese bride's parents paying a dowry and the groom's parents paying a substantial sum known as the "bride's wealth" which during the rule of **Mao Zedong** (1949–1976) was generally constituted by grain replaced from the 1980s onwards by consumer items from wristwatches to new automobiles and apartments.

MONITORING AND SURVEILLANCE (*JIANKONG/JIANSHI*). Devoted to controlling the Chinese population through both bureaucratic and technological means, the government of the People's Republic of China (PRC) has relied on various systems of monitoring and surveillance, with reliance primarily on human sources of information beginning in the 1950s and 1960s, and transitioning to modern computer and internet-based technology in the 2010s. Historically an authoritarian state since the Qin Dynasty (221–206 BCE), organizational measures introduced to oversee the general population in the imperial era began with the *baojia* system introduced by reformer Wang Anshi in the 11th century during the Song Dynasty (960–1279).

Enhanced as a system of collective civil control and moral oversight in the Ming Dynasty (1368–1644), the system consisted of groups of 10 families in each *jia* and 10 *jia* organized into a *bao*, with special surveillance of the excessively rambunctious and disputatious community of artists and playwrights maintained by Ming rulers. Retained as a mechanism for maintaining public order, *baojia* was initially strengthened by the Qing Dynasty (1644–1911) but suffered irreparable decline throughout the contentious and conflict-ridden 19th century. While considered a tool of asserting and maintaining local political control, the government of the Republic of China

290 • MONUMENTS AND MEMORIAL HALLS (JINIANBEI/JINIANGUAN)

(ROC), especially President Chiang Kai-shek (1928–1949), the system proved ineffective in rooting out grassroots operations of the Chinese Communist Party (CCP), whose underground network proved largely impenetrable, even in centers of Republican dominance, for instance, the city of **Shanghai**.

Following the establishment of the PRC in 1949, monitoring and surveillance of potentially restive populations relied on such local, grassroots organizations as the ubiquitous **neighborhood** committees, along with the willingness of the Chinese citizenry to keep tabs and report on their neighbors. Virtually all personal information was subject to government scrutiny, for example, trips to the **market**, **hygienic** conditions of **family** residences, and, most importantly, anything related to family planning controls, including the menstrual cycles of young married women. Individual records, particularly of important personages, were kept in personal "files" or "archives" (*dang'an*) maintained by work "**units**" (*danwei*) but with collation of such paper-based data exceedingly difficult and subject to easy bureaucratic overload. Fast forward five decades and the advent of multiple new technologies have eliminated many of these deficiencies, with new devices, from video cameras to phone scanners, making tracking of vast numbers of people more amenable to state interests. Supplemented by additional technological marvels like facial recognition software and various mobile phone apps, the capacity of the Chinese government to track the daily movements of the population, especially in **urban areas**, has been substantially advanced, with plans under the **social credit system** to develop files on the entire citizenry.

With an estimated 200 million video cameras already installed, eight of the 10 most monitored cities in the world are in the PRC, as plans call for increasing the number of cameras to more than 600 million by 2020, but with official sources emphasizing the importance of this electronic "skynet" to such nonpolitical purposes as **crime** control. Installed and maintained by local police sources, with doubts raised about the effectiveness of facial recognition software to predict personal behavior, the capacity of these systems to ward off specific political actions, notably the increasing frequency of mass incidents and popular protests in China, remains questionable.

MONUMENTS AND MEMORIAL HALLS (*JINIANBEI/JINIAN-GUAN*). In addition to the rich diversity of great historical sites from the imperial era, for example, the **Forbidden City** and the **Great Wall**, monuments and memorial halls have also been constructed to commemorate major events and prominent personalities in the modern period of the Republic of China (ROC) on the mainland (1912–1949) and the People's Republic of China (PRC). As respective leaders of the two political regimes, Sun Yat-sen (1912–1925) and **Mao Zedong** (1949–1976), have been honored with "mau-

MONUMENTS AND MEMORIAL HALLS (JINIANBEI/JINIANGUAN) • 291

soleums" (*lingmu*), memorial halls, statues, and "obelisks" (*fangjianbei*) throughout the country, especially in the political centers of **Beijing**, **Guangzhou**, and Nanjing, Jiangsu, the last the former capital of the ROC.

Constructed in 1929, soon after his untimely passing in 1925, the Sun Yat-sen Mausoleum in Nanjing (previously known as Nanking), located at the foot of the famous purple **mountain**, is a blend of traditional Chinese imperial tombs and modern pavilion design, with a blue roof and 392 steps leading up to the central vault, housing a marble sarcophagus of the first ROC president. Also honoring Sun is a memorial hall in Guangzhou constructed on the site of the revolutionary headquarters of the Nationalist Party (*Kuomintang*), headed by Sun Yat-sen, along with a Great Obelisk to the former president. Equally imposing is the Mausoleum of Mao Zedong (*Mao Zedong Jinian Tuan*), located in the middle of the giant Tiananmen Square in Beijing, on the former site of the main southern gate into the Forbidden City and constructed from materials from throughout China. Reputedly based on the design of the Lincoln Memorial in Washington, DC, the remains of the former "chairman" (*zhuxi*) are wrapped in the flag of the Chinese Communist Party (CCP) with hammer and sickle, and contained in a crystal glass sarcophagus. Famous sayings by the two national leaders are inscribed in the buildings, including the declaration by Sun Yat-sen that "what is under heaven is for all" (*tianxia weigong*) and **poetry** by Mao Zedong.

Lesser-known figures in modern Chinese history have also been memorialized, like Wu Tingfang, a senior political leader and diplomat in the ROC, whose statue near his tomb in Guangzhou portrays a calm, **scholar**-like persona. Monuments and statues to mythical figures and creatures in Chinese history also exist, for instance, the rock carvings of the Five Goats and Five Geniuses who reputedly saved the ancient residents of Guangzhou from starvation.

National pride and glorification are also evident in the Monument to the People's Heroes (*Renmin Yingxiong Jinianbei*), a 10-storey obelisk located in Tiananmen Square in front of the Mausoleum of Mao Zedong and dedicated to revolutionary heroes of the 19th and 20th centuries in China. Adorned with inscriptions by Mao Zedong declaring "eternal glory to the people's heroes" and an epitaph written by Premier Zhou Enlai (1949–1976), the Cenotaph-type monument sits on a Buddhist-style base positioned on a granite pedestal with bas-relief carvings of eight major revolutionary episodes and flowers and pine trees. Completed in 1958, the monument includes a statue of assorted and unidentified members of the masses striking assertive poses with outstretched arms. Taken over by protestors in the prodemocracy movement in 1989, access to the monument, including laying of wreaths, is strictly controlled. A second Monument to the People's Heroes was built in **Shanghai** in 1993, 24 meters (79 feet) high in a stylized form of three rifles leaning against one another located on the city's famous Bund.

292 • MOUNTAINS AND MOUNTAIN LIFE (SHAN/SHANDI SHENGHUO)

Politically loaded structures include the Monument to the Peaceful Liberation of Tibet (*Xizang Heping Jiefang Jinian Bei*), an abstract spire-like rendition of Mount Everest (*Qomolangma*, in Chinese) located just outside the World Heritage Site of the Potala Palace in Lhasa, **Tibet**, built in 2001, on the 50th anniversary of the incorporation of the territory into the PRC in 1951, which, critics point out, was anything but "peaceful," with subsequent invasions by the People's Liberation Army (PLA). Commemoration of historical and natural disasters have also been memorialized, notably a memorial hall to the victims of the Nanking Massacre by Japanese forces in 1938, built in Nanjing, Jiangsu province, in 1985, and the Zhong'Anlun Monument to the 800 victims of a ferry sinking in 1945, at the beginning of the Chinese Civil War (1946–1949), built in Taizhou, Jiangsu, in 1987.

China is also known for its many giant statues of historical and religious figures, some of the largest in the world, including the following: the Spring Temple Buddha Vairocana, also known as the primordial Buddha, which, constructed of copper at 420 feet, is the third-highest statue in the world, located in Zhaocun, Henan; a statue of Confucius, at 236 feet and located near the great philosopher's birthplace on Mount Ni, Shandong; images of the early mythical emperors Yan and Huang, 348 feet in height, carved out of a mountain near the Yellow River in Henan; two statues of Guanyu, a general serving under Liu Bei (161–223 CE) during the period of the Three Kingdoms (220–280) and considered the God of War, with locations in Hubei and Shanxi; and God of the Red Mountain, a local manifestation of the Sea God (*Haishen*), at 193 feet in Shandong.

MOUNTAINS AND MOUNTAIN LIFE (*SHAN/SHANDI SHENGHUO*). In a country where 69 percent of the land mass consists of mountains, 33 percent (mainly in the west and southwest) highlands and plateaus, and 26 percent hills, mountains and mountain life have had a profound impact on various realms of Chinese social life and culture. According to traditional **legend and mythology**, mountains in China were pillars holding up the sky, serving as mediums between heaven and earth. As birthplaces of major rivers and growing areas of valuable herbs and medicinal **plants** used in **traditional Chinese medicine (TCM)**, mountains nurtured life and were springs of wealth and fertility. Ruled by dark forces beyond the "civilized" plains and valleys, mountains were worshipped as religious sites, with the "Five Great Mountains" (*Wuyue*) representing an ordered world emanating from the "God of Heaven" (*Tian Shangdi*) and serving as the **ritual** site of imperial **ceremonies** of worship and sacrifices.

Many philosophers, painters, poets, and religious thinkers inhabited mountainous **regions** searching for the greatness of humanity and **nature**, and seeking the **harmony** of internality and externality. Inscriptions of **poetry** and religious **thinking** are cut into mountain rock faces, especially on Mount

MOUNTAINS AND MOUNTAIN LIFE (SHAN/SHANDI SHENGHUO) • 293

Tai, the most sacred of Chinese mountains, located in Shandong, with the famous "stairway to heaven" (*tiantang de jiedi*) leading to Jade Emperor Peak and the site of numerous temples and shrines. Mountains also served as the birthplace of the mystical principles of **fengshui**, while mountain scenes of tall peaks enshrouded in mist and covered with greenery are a major theme in Chinese landscape **painting**. Remote and isolated regions in mountains include caves and other sites of reclusion for **hermits** and "**scholar**-officials" (*rujia*) fleeing messy situations in state administration, along with locations of various educational **academies** where the natural environment of clean air and rich plant life spurred **philosophical** speculation and aesthetic appreciation.

For the imperial state, the Five Great Mountains served as a basis of political legitimacy, with the emperor of a new dynasty hurrying to the mountain sites to lay claim to the imperial domain. Coincident with the primordial Five Cardinal Directions in Chinese geomancy of north, south, east, west, and center, the five mountains are as follows: Taishan, the "tranquil" (*ningjing*) mountain, located in the east and associated with the rising sun, representing birth and renewal, and popular among **women** hoping for childbirth; Huashan, the "splendid" (*canian*) mountain, located in the west, the direction of the setting sun, representing **death** and the underworld, and located in Shaanxi; Hengshan, the "permanent" (*changzu*) mountain, in the north, famous for the Buddhist Hanging Temple, cut into the mountainside, and located in Shanxi; another Hengshan, the "balancing" (*pingheng*) mountain, in the south, sacred to the three major religious traditions of **Buddhism**, **Daoism**, and **Confucianism**, with 72 separate peaks, located in **Hunan**; and Song, the "lofty" (*chonggao*) mountain in the "center" (*zhongxin*), with 36 peaks, and the site of the Shaolin Buddhist Temple and several Daoist temples, located in Henan.

Four sacred mountains also exist for both Buddhism and Daoism, serving as major sites for religious "pilgrimages" (*chaosheng*), the short version of the adage of "paying respect to a holy mountain" (*chaobei shengshan*). For Buddhists, all four sacred mountains are home to Bodhisattvas, with temples and shrines, and include the following: Wutaishan, home to more than 50 temples, some dating to the Tang Dynasty (618–907), and including the oldest wooden temple in China, located in Shanxi; Putuo, home of Guanyin, goddess of mercy and **compassion**, with three of the most elaborate temples in China, located on an island off the coast of Zhejiang; Emei, the highest peak of the four, located near the giant, 77-meter-high Leshan Buddha at the confluence of the Min and Dadu rivers in **Sichuan**; and, Jiuhua, featuring 99 peaks, meandering streams, waterfalls, and bizarre rock formations, dedicated to Dizang, protector of beings in the underworld, with a giant, 99-meter-high statute of the Bodhisattva, located in Anhui.

294 • MUSEUMS (BOWUGUAN)

For Daoism, the four sacred mountains include the following: Wudang, with a complex of temples and shrines dedicated to the **god** Xuanwu, dating to the Tang Dynasty, with local monks practicing "Tai Chi" (*taijiquan*) **martial arts**, located in Hubei; Longhu, literally "tiger dragon" mountain, considered one of the birthplaces of Daoism and site of the hanging coffins of the Guyue **minority** people, located in Jiangxi; Qiyun, literally "cloud high" mountain, with inscriptions and tablets, once visited by Tang Dynasty poet Li Bai (701–762), located in Anhui; and, Qingcheng, site of many palaces and temples, known as the "most peaceful and secluded mountain under heaven," and the place where Zhang Daoling founded the Daoist Celestial Masters in 142 CE, located in Sichuan.

In the modern era of the PRC, while many of these mountainous areas, with their rich historical sites and dramatic scenery, are major tourist attractions, large numbers of villages and towns, many populated by minorities, suffer high poverty rates. Located in the less developed western and southwestern regions of the country, these remote and isolated areas are major targets of the poverty-alleviation program pursued by the government of President **Xi Jinping** (2013–).

MUSEUMS (*BOWUGUAN*). Covering a broad range of historical and contemporary topics, museums in China are organized at the national, provincial, and local levels, numbering more than 5,000 in 2019, many of unique **architectural** design and subject matter. Most notable are the many museums containing antiques and artifacts from the long history of the imperial state from the Shang Dynasty (1600–1046 BCE) to the Qing Dynasty (1644–1911), with major collections of rare bronzes, **ceramics and porcelains**, **jade** carvings, musical instruments, **paintings**, and tomb murals, providing a rich vision of the country's **antiquarian** past.

World-renowned collections include the following: the Palace Museum in the **Forbidden City** in **Beijing**, with more than 1 million rare and valuable works of **art**, one-sixth of all collections in the People's Republic of China (PRC); the Museum of the Terracotta Army, near the mausoleum of Qin Shihuang (259–210 BCE), the first emperor of the unified Chinese empire, located outside the city of **Xi'an** (formerly known as Chang'an), Shaanxi; Shanghai Museum, containing rare historical relics, including bronze wine, **food**, and water vessels, as well as numerous musical instruments, pieces of furniture, and weapons from the city's storied past, housed in a building designed in the shape of an ancient cauldron with a round dome and square base; Shaanxi History Museum, featuring the largest collection of antique treasures, including bronzes, gold and silver wares, tomb murals, and unique Yaozhou porcelain from the giant five-kilometer-long kiln located in the

MUSEUMS (BOWUGUAN) • 295

province; and the National Museum in Tiananmen Square, Beijing, the third-most-visited museum in the world, with a collection of antique treasures second only to the Shaanxi History Museum.

Historical sites serving as museums include the well-known Potala Palace, residence of the Dalai Lama in Lhasa, **Tibet**, with 1,000 rooms and 13 stories, and the less well-known Qianling and Maoling mausoleums. Among the generally well-preserved imperial tombs is Qianling, the **burial** site of Emperor Gaozong and Empress Wu Zetian of the illustrious Tang Dynasty (618–907), constructed as a replica of the capital city of Chang'an and following the traditional north–south axis. Equally impressive is Maoling, the tomb of Emperor Wu (157–87 BCE) of the Han Dynasty (202 BCE–220 CE), referred to as the "Chinese pyramid" (*Zhongguo jinzita*) because of its great cone, measuring 47 meters (787 feet) high. Both sites are replete with stone statues of real and mythical **animals**, for example, winged horses, and human figures, situated along approaches to the tombs and located near the city of Xi'an.

Museums with major and unique **archaeological** collections include the Sanxingdui Museum, containing striking **masks** with protruding eyes and some of the world's largest objects, both made of bronze, from a previously unknown civilization unearthed near Chengdu, **Sichuan**. Dating to the era of the Shang Dynasty and discovered in the 1980s, the peoples of *Sanxingdui*, literally "three-star mounds," also produced rare jade objects, along with the world's oldest statue of a human being, included in the collection.

Museums with both a historical and more contemporary focus, especially on modern art, include public and private facilities, with most located in major cities, including Beijing, **Guangzhou**, Nanjing, and **Shanghai**. Among the most prominent are the National Art Museum, the Central Academy of Fine Arts, Himalayas Art Museum, Sifang Art Museum, Today Art Museum, Shanghai Art Palace, and Long Museum, the last located in an abandoned warehouse. Museums with unique collections include the Propaganda Art Poster Museum in Shanghai, featuring colorful portraits of Red Guards and other dramatic political scenes, including striking images of Chinese Communist Party (CCP) chairman **Mao Zedong**, primarily from the **Cultural Revolution (1966–1976)**. Museums with unusual and dramatic locations include the so-called Limestone Gallery, nicknamed the "floating museum" (*piaofu bowuguan*), built on the edge of a stone cliff in Guizhou with glass walls, as the building projects an illusion of growing out of the **mountain**. Also unique is the Baiheliang underwater museum of the White Crane archaeological site, with fish carvings and hydrological inscriptions flooded by waters of the Three Gorges Dam, located on the Yangzi River near **Chongqing**.

296 • MUSIC (YINYUE)

Ancient art forms and **handicrafts** featured in museums include Sichuan **opera** (Chengdu), block printing (Suzhou), stone relief (Xuzhou), bamboo slips (**Hunan**), folk art (Xi'an), imperial **seals** (Fujian), and **traditional Chinese medicine (TCM)** (Hangzhou), along with such major historical projects as the **Silk Road** (Gansu) and the Grand Canal (Hangzhou, at the southern terminus of the man-made waterway). Major events in modern China featured in museums are as follows: the Taiping Rebellion (1850–1864), the Nanking Massacre (1938), and the revolutionary history of the CCP (1921–1949), with famous writers like Ba Jin (1904–2005) calling for the creation of a museum on the Cultural Revolution, yet to be acted upon as of 2020.

Museums have also been established covering a variety of modern topics, including aviation, **cinema and film**, railways, **science** and technology, steam locomotives, and space exploration, with museums also devoted to such prehistoric subjects as dinosaurs and natural history, along with excavated Neolithic human sites like Banpo Village, Shaanxi. Future plans call for every county in the PRC to establish at least one museum but with complaints that many museums with thin and uninteresting collections are nothing more than costly vanity projects of local leaders, with the government covering the tab, as admission is free to most state-run museums.

MUSIC (*YINYUE*). A combination of native and foreign styles, the latter imported from Central Asia, India, Europe, and the Americas, music tracks the historical development of China from ancient times to the modern era, making the country one of the premier musical civilizations in the world. Traced to the legendary "Yellow Emperor" (*Huangdi*), music began when an equally mythical Ling Lun was instructed by the emperor to create a system of music employing a simple bamboo pipe to mimic the singing of birds, most notably the revered and immortal phoenix. As early as the 7th century BCE, during the Zhou Dynasty (1045–256 BCE), Chinese composers and musicians, with imperial backing, developed a system of pitch generation and a pentatonic scale of five notes per octave. For Confucius (551–479 BCE), the "correct" (*zhengque*) form of music, in **harmony** with nature and morally uplifting, known as *yayue*, literally "elegant music," was essential to the cultivation and refinement of the "gentleman" (*junzi*), and essential to good governance and a stable society.

Second only to the vital role of **ritual** in the effective management of society, music, in various native and imported forms, became a staple of imperial courts, with the establishment of an Imperial Music Bureau from the Qin Dynasty (221–206 BCE) onward for overseeing and supervising court music and musicians, the latter with a social status just below painters. Integrated into the binary universe of the **yin-yang**, traditional Chinese music

MUSIC (YINYUE) • 297

developed in conjunction with **dance**, also performed for the imperial court, and **poetry**, which was often sung to the accompaniment of simple and tranquil tunes, as Confucius and other philosophers advocated.

Dynasties noted for grand musical traditions included the Han (202 BCE–220 CE), with the creation of such venerable instruments as the Chinese "harp" (*konghu*) and the "lute" (*pipa*), and especially the cosmopolitan Tang Dynasty (618–907), which imported "western" musical styles from Central Asia and maintained as many as 10 different orchestras, one of which was an outdoor contingent of 1,400 performers. Noted for the creation of large-scale "**banquet** music" (*yanyue*), the Tang court oversaw the meticulous training of hundreds of musicians at the Peach Garden in the capital of Chang'an (modern-day **Xi'an**), with commercial and "common music" (*suyue*) popularized in local taverns, teahouses, and brothels.

Musical scores were attributed to individual Tang emperors, notably such compositions as *Music of Grand Victory*, *Imperial Birthday*, and *Long Live the Emperor*, while during the Ming (1368–1644) and Qing (1644–1911) dynasties, music accompanied imperial sacrifices, known as *zhonghe shaoyue*, while the long-serving Kang Xi (1661–1722) and Qian Long (1735–1796) emperors were especially enthusiastic about music, particularly Western styles introduced in the 18th century. Assembling full-scale chamber orchestras, Kang Xi even went so far as having their instrument-playing eunuchs don European dress and wigs.

Traditional Chinese musical instruments include woodwind, percussion, bowed strings, and plucked strings, including the famous two-stringed *erhu*, four-stringed *pipa*, zither-like *guqin* (with seven strings), and *dizi* (the Chinese flute), all of which had to be reconfigured with the introduction of Western musical forms. Traditional musical types include **opera**, especially **Peking opera** (*Jingxi*), "ensemble" (*hezou*) and "orchestral" (*yuetan*), and "solo" (*duzou*), with such notable performers as Abing (1893–1950), the blind *erhu* and *pipa* player. The introduction of Western music began in 1601, via Peking resident Jesuit Matteo Ricci (1552–1610), with the first orchestra established in **Shanghai** in 1878, composed completely of foreign musicians and exclusively for the **entertainment** of local ex-patriots. The first Western-style score, *Funeral March*, was composed by Xiao Youmei in 1916, while the first music conservatory was established in 1927, in Shanghai, with the many restaurants, nightclubs, and bars in the city becoming popular venues for Western pop, notably American jazz. By the 1940s, a movement to create "Chinese New Music," combining traditional Chinese and Western forms, had taken root, while in accord with the dictates of Chinese Communist Party (CCP) chairman **Mao Zedong** presented at the Yan'an Forum on Literature and Art in 1942, a rich and varied selection of local folk music and **songs** was collected by CCP cadres, with lyrics altered to reflect revolutionary goals.

298 • MUSIC (YINYUE)

Following the establishment of the People's Republic of China (PRC), Chinese New Music was allowed to continue, with publications like *People's Music* spreading musical appreciation, even as the country's music scene was increasingly influenced by the Soviet Union. While compositions flourished during the cultural liberalization of the Hundred Flowers Campaign (1956–1957), Marxist–Leninist **ideological** orthodoxy and anti-Western sentiments culminated in the **Cultural Revolution (1966–1976)**, as Jiang Qing, the radical wife of Mao Zedong, took over much of the cultural realm, including music. Symphonies, orchestras, and conservatories were shut down, as music, traditional and Western, was criticized as a private space preserving an **individualized** spirit at odds with the socialist collective. Rampaging Red Guards searched private residences for Western musical instruments, particularly pianos and violins, as music teachers and connoisseurs, fearing for their lives, destroyed any evidence of musical affections, breaking records and disposing of verboten musical scores. Targets included such major Western composers as Beethoven, Chopin, Debussy, Dvořák, and Respighi, while pop music was denounced as "yellow music" (*huangyue*), equating it with **pornography**.

Following the passing of Mao Zedong in 1976, and the subsequent arrest of Jiang Qing and her supporters, China's diverse musical scene quickly revived, with CCP leaders like President Jiang Zemin (1989–2002) openly admitting his love of classical music, especially the piano. Flooded by music, domestic and foreign, classic and pop, music in China flourished from the 1980s onward, with world-class classical musicians the likes of pianist Lang Lang (1982–) and Wang Yuja (1987–), along with such composers as Ye Xiaogang (*Farewell My Concubine*), trained abroad, and Guo Wenjing (*Wolf Club Village*), trained domestically. Renowned performances included a staging in the **Forbidden City** of Puccini's *Turandot* (1992), which was set in China, and a variety of music festivals, notably the Beijing Festival for classical and jazz and the Midi Festival for rock.

Among the notable music venues is the National Center for the Performing Arts, nicknamed the "Giant Egg" (*da dan*), with two large halls, one for concerts and the other for opera, constructed in 2007. Professional symphonies number 80 in the country, with some of the most significant being the China National Symphony Orchestra, established in 1956, and the Shanghai Symphony Orchestra, with the venerable and German-trained Long Yu serving as music director, along with the China Youth Symphony for aspiring **youth** 14 to 21 years of age. Estimates are that from 30 to 60 million Chinese **children** are learning piano and violin in the PRC, while music in major cities is a rich mixture of classical orchestras, neo-punk girl rock bands, and indie rock. New, unconventional compositions, often frowned upon by the still-censorious PRC government, are often digitized on the internet, with traditional music relegated to spontaneous performances by elderly amateurs

in public parks. Chinese influence on international music was exemplified by the compositions of the American composer John Cage (1912–1992) who employed the *Book of Changes* (Yi Jing) as his standard composition tool in producing his internationally renown chance-controlled music, most prominently *4'33'*.

N

NAMES (*MINGZI*). Considered an **art** form in Chinese culture, with an unlimited combination available from thousands of Chinese written characters, people's names generally involve two or three syllables, with the one-syllable "surname" (*xing*) coming first, as a testimony to the traditional importance of **family** or **clan**, and the one- or two-syllable personal or "given name" (*ming*) coming second. Symbolizing ancient treasures, **virtues, nature**, and historical personages and events, Chinese surnames number approximately 6,100, but with the top 100 constituting 85 percent of the population in the People's Republic of China (PRC), as the Chinese people were once colloquially referred to as the "old hundred names" (*laobaixing*).

The three most common surnames in rank order are *Wang*, meaning "king," *Li*, meaning "plum," and *Zhang*, name of the grandson of the mythical "Yellow Emperor" (*Huangdi*) and reputed inventor of the bow and arrow, together constituting 20 percent of the PRC population. Filling out the top 10 in rank order are the following: *Liu*, a royal surname from the Tang Dynasty (618–907); *Chen*, meaning "exhibit," and popular in the south and Romanized as *Chan* in the Cantonese dialect; *Yang*, a type of tree and a royal surname in the Zhou Dynasty (1045–256 BCE); *Huang*, meaning yellow and also popular in the south; *Zhao*, a royal surname in the Song Dynasty (960–1279); *Wu*, meaning "god-like"; and, *Zhou*, from the ancient state of Zhou in the Shang Dynasty (1600–1046 BCE). The most common full name according to a household survey in 2007, is Zhang Wei, with **minorities** in China having multiple syllabic names or, in the case of Mongolians, no surname, with only a singular, multiple syllabic given name.

Numbering more than 30,000, given names for males are commonly linked to strength and firmness, while for females the link is to **beauty** and flowers with poetic or phonetic appeal. Especially popular full names are drawn from famous characters in **literature** and **legends and mythology**, with such poetic meanings as *Ying Yue*, "reflection of the moon" and *Mo Chou*, "free of sadness," with many names, for example, Feng Mian, Nian Zhen, and Wang Shu used for both genders. Names exclusively for females accentuate beautiful smiles (Yu Yan), liken youthful **feminine** beauty to

302 • NATIONALISM (MINZUZHUYI)

herbal **plants** (Zhi Ruo), or follow famous Chinese courtesans (Ru Shi). For boys there is *Fei Heng*, the famous name of a **martial arts** master and meaning "swan gone soaring in the sky," suggesting future success in life, and *Qing Shan*, meaning "blue colored mountains," symbolizing persistence.

Historically, Chinese nobility, especially in the Zhou Dynasty, had several names representing clan, lineage, and personal "courtesy" names (*zi*) added on to the surname as in *Kongfuzi* (Confucius), *Mengzi* (Mencius), and *Laozi*. Commoners were not accorded surnames until the Han Dynasty (202 BCE–220 CE), while comprehensive normalization of personal names did not occur until the New Culture Movement/May Fourth Movement (1917–1921), with aliases and courtesy names generally eradicated. Ancestral and imperial names were generally avoided, as people with names similar to reigning emperors were forced to change, while naming **children** after elders was also prohibited to avoid competing property claims.

During especially radical periods in the PRC, like the **Cultural Revolution (1966–1976)**, names with revolutionary qualities were given to **youth** of that era, notably *Qiangguo*, "strong nation," and *Dongfeng*, "eastern wind," which people so named later changed to more conventional forms. Changing names, family and given, was also a frequent practice especially to reflect a new, generally higher social status as occurred with the famous Soong sisters (Ailing, Chingling, and Meiling) whose father replaced "Soon" with "Soong," after the Song Dynasty (960–1279). Chinese "nicknames" (*chouhao*) were often taken from **animals**, while greater integration with the West since 1978–1979 and the widespread study of English in schools has led many young Chinese to adopt Western given names phonetically similar to their Chinese given name, for instance, "Kitty" after Kit and "Raymond" after Wai Man, often to facilitate **communication** with **foreigners** unfamiliar with hard-to-pronounce Chinese names. Popular with writers and artists are pseudonyms and pen names, for instance, famous author **Lu Xun** (1881–1936), whose real name was Zhou Shuren. Babies in China were traditionally given "milk names" (*ruming*) for the first 100 days after birth, now reduced to 30 days by PRC law. Common formal terms of address include such professional titles as "teacher" (*laoshi*) or "manager" (*jingli*), or the prefixes "little" (*xiao*) for the young and "old" (*lao*) for people older than 35, with the all-purpose "comrade" (*tongzhi*), from the Maoist era, dropped out of use since 1978–1979.

NATIONALISM (*MINZUZHUYI*). An outgrowth of persistent **humiliation** and military defeats by foreign powers from the West and Japan in the 19th and 20th centuries, modern nationalism is a potent political force, drawing on prominent themes in Chinese culture. Spurred on by Chinese defeats in the two Opium Wars (1839–1842, 1856–1860) and especially the First Sino–Japanese War (1894–1895), Chinese nationalistic sentiment developed

NATIONALISM (MINZUZHUYI) • 303

at the elite and popular levels, the former evident in the Hundred Days of Reform (1898–1899), led by Kang Youwei (1858–1927), Liang Qichao (1873–1929), and other Chinese intellectuals, and the latter during the Boxer Rebellion (1899–1901), consisting of intensely anti-Western and anti-Christian **secret society** groups with the imprimatur of Empress Dowager Ci Xi (1861–1908).

With Western tracts on nationalism translated into Chinese by Liang Qichao, a national consciousness gradually took hold in China, especially following the collapse of the Qing Dynasty (1644–1911) and creation of the Republic of China (ROC), as President Sun Yat-sen (1912–1925), who had described Chinese society as a "loose sheet of sand" (*yipan sansha*), advocated nationalism as one of the guiding Three Principles of the People (*Sanminzhuyi*). Confronting increasingly aggressive encroachment from Japan, leading to the outbreak of the Second Sino–Japanese War (1937–1945), both major Chinese political parties, the Nationalist Party (*Kuomintang*) and the Chinese Communist Party (CCP), brandished their nationalistic credentials, with the CCP building popular support, especially in areas subject to Japanese military atrocities, exemplified by the Nanking Massacre (1938).

Following the establishment of the People's Republic in China (PRC), Marxist–Leninist doctrine directed the CCP to pursue "internationalist" (*guojizhuyi*) obligations in conjunction with the Soviet Union, while PRC identification with nationalist interests was strengthened by opposition to United Nations, primarily American, armed forces in the Korean War (1950–1953). With Marxist–Leninist–Mao Zedong Thought weakened as a basis of regime legitimacy by multiple disasters, notably the **Cultural Revolution (1966–1976)**, nationalism became increasingly important to the post-Mao **leadership** based on economic progress and enhanced international stature.

Resonant of the past luminance of the celestial empire (221 BCE–1911) as the "center of the universe," China's "new nationalism" (*xin minzuzhuyi*), promoted since the 1990s, contains a strain of cultural superiority that critics have labeled as a form of de facto Han ethnic superiority, despite the official description of the PRC as a multiethnic state. Promising a "peaceful rise" (*heping jueqi*) and rejecting comparisons of an emboldened China to the disruptive influence of Germany on the international order of the late 19th century by some Western historians, Chinese leaders from Jiang Zemin (1989–2002) to Hu Jintao (2003–2012) and **Xi Jinping** (2013–) cast the country's nationalistic aspirations as nonthreatening and generally supportive of global peace and security. Driven by such events as the accidental bombing of the PRC Embassy in Belgrade, Serbia, in 1999, and Japan's design on disputed island territories in 2005, in the East China Sea, nationalistic protests, mainly by **youth**, have erupted with enormous fury and periodic acts of **violence**, evidently sanctioned by the Chinese government.

304 • NATIVISM (XIANGTUZHUYI)

Replayed by so-called pro-China protests directed against demonstrations in **Hong Kong** for greater **freedom** and democracy in 2019–2020, one variant of Chinese nationalism has taken on a revanchist and even **racist** form driven by **xenophobic** elements, accentuating the country's long history of humiliation and **victimization** by foreign powers. A more **pragmatic** and "instrumental" (*gongjiuxing*) nationalism is also espoused rooted in traditional **Confucianism** and supporting the pursuit of national interests but without pervasive emotional insecurity and vulgar insults. Rejecting globalist demands for greater democracy and international **human rights**, the dominant narrative of the PRC is that the West is committed to preventing China's rise, a goal deemed doomed to failure.

NATIVISM (*XIANGTUZHUYI*). Defined as a resort to familiar aspects of personal identity amid a storm of confusion brought on by the economic, political, and especially cultural forces of "globalization" (*quanqiuhua*), nativism is a powerful supplement to the forces of Chinese **nationalism** in the modern era. Rooted in conservative values opposed to foreign influence and corrosion of cultural traditions, nativism has influenced various political movements in modern China, from Fascist political movements in the 1920s and 1930s to, most recently, elements within the ruling Chinese Communist Party (CCP) led by President **Xi Jinping** (2013–) in the People's Republic of China (PRC). A reaction to the enormous influence of modernism and Westernization affecting China since the later years of the Qing Dynasty (1644–1911), nativist activists focused primarily on protecting the interests of peasants from the vagaries of capitalist **market** forces and the systematic breakdown of the traditional culture based on **Confucianism**.

Right-wing political movements like the Blue Shirt Society (*lanchenshan shehui*), operating as a political arm of the Nationalist Party (*Kuomintang*) on the mainland (1927–1949), called for a strong state capable of taking on hostile powers and interests, and imposing efficiency and **discipline** throughout society, especially in supposedly "chaotic" (*luan*) **rural areas**. Cultural realms, including **literature** and **art**, were considered especially important in bringing about the individual transformation necessary for collective "national rejuvenation" (*minzu fuxing*), leading to the movement for a "nativist literature" (*xiangtu wenxue*) in the aftermath of the New Culture Movement/ May Fourth Movement (1917–1921). Major concerns included the excessive **sexuality** and leisure lifestyle pursued by young Chinese **women**, especially in woefully indulgent cities like **Shanghai**, with its proliferation of restaurants, nightclubs, and bars, fostering loose living and immorally. For the new cultural guardians, eradicating the corroding influence of foreign **music** and "hedonistic" (*xianglezhuyi*) lifestyle was considered essential to regaining the imagined life that was being lost due to infectious foreign influences. Equally opposed to Communist **ideology** perceived as an unnatural foreign

import, nativist defenders of the Chinese cultural realm, led primarily by military men and engineers, emerged as advocates of a conservative modernization opposed to both liberal democracy and Communism, ideologies considered fundamentally at odds with Chinese traditions under constant threat from an alien, "modern" (*xiandai*) world.

Nativist concepts have also influenced contemporary approaches to international relations in the People's Republic of China (PRC) propounded by theorists and policy consultants in such research organizations as the Marxism Institute of the Chinese Academy of Social Sciences (CASS). Confronting the deleterious effects of "reform" (*gaige*) and globalization on the country's socialist integrity, including the undermining of national sovereignty and autonomy, China should effectively close its doors to an international system that is weighted heavily in favor of wealthy imperialist countries, with globalism denounced as a venue for the spread of international capitalism. Popularized in such works as *China Can Say No* (Zhongguo Keyi Shuo Bu), by Qiao Bian (1996), and *Why Is China Unhappy?* (Zhongguo Weishenma bu Gaoxing), by He Xiongfei (2009), nativist views have become increasingly influential, driven by a use of organic metaphors comparing foreign influence to an invasion by "flies and bugs" (*cangying chongzi*). Critics of increasing nativism point to blatantly discriminatory state policies, especially toward Muslims and other non-Han **minorities**, with a total disregard for **human rights**, all in the name of protecting a fragile Chinese body politic.

NATURE (*XINGZHI, ZIRAN*). Revered as part of the spontaneous flow of life and represented in various realms of Chinese culture, including **poetry** and landscape **painting**, nature exists above the **gods**, more mysterious and powerful. Serially abused in imperial and modern China, the natural world was disrupted by massive infrastructure projects and out-of-control industrial pollution, especially with the pursuit of mass industrialization and consumerism since the establishment of the People's Republic of China (PRC). Embedded in classic **philosophical** concepts like the "unity of humanity and nature" (*tianren heyi*) and considered a sacred realm in both **Buddhism** and **Daoism**, nature was to be respected by humanity, with the preservation of such sacred sites as remote **mountain** peaks with lush forests as pristine homes for wandering **hermits** and **religious** figures. Yet, severe disturbance also occurred from the spread throughout the empire of sedentary agriculture, primarily by water-demanding rice paddies, and the major transformation of the natural order mainly by giant waterway projects the likes of the Grand Canal and the Dujiangyan irrigation and flood control project in **Sichuan**, the latter dating back to 256 BCE.

306 • NEIGHBORHOODS (LINLI)

Large rock cliffs in mountainous areas are also the site of elaborate carvings of ancient petroglyphs dating back 7,000 to 8,000 years, located in Damaidi, literally "big wheat field," in the Beishan range in the Ningxia-Hui Autonomous Region in Northwest China. More recent cliff carvings of Chinese characters, among others, can also be found in Red Stone Gorge (Yulin, Shaanxi), Solitary Beauty Peak (Guilin, Guizhou), and the sacred Mount Tai (Shandong).

Desecration of the natural world proliferated in the PRC, especially during the period of mass industrialization adopted from the Soviet Union (1953–1978), along with such highly destructive experiments as the notorious backyard steel furnaces during the Great Leap Forward (1958–1960), which led to massive deforestation through excessive logging. Followed by major denigration of water and soils by excessive use of fertilizers and pesticides throughout the 1980s and 1990s, China established central and local environmental protection bureaucracies beginning in 1993. The concomitant passage of substantial environmental protection laws and regulations have led to major efforts to restore and preserve China's natural world, becoming a national priority under the administration of President **Xi Jinping** (2013–). While such practices as continued reliance on coal burning for electrical production, 66 percent in 2016, and the massive growth of private automobiles have made these goals a serious challenge, international assistance has come from organizations like the Nature Conservancy, which entered the PRC in 1998, and has engaged in several projects in such biodiverse hot spots as **Yunnan** and Sichuan, with board members including Jack Ma of the Alibaba Corporation.

NEIGHBORHOODS (*LINLI*). The center of much of Chinese everyday life in **urban areas**, neighborhoods in the People's Republic of China (PRC) are the lowest administrative level of the four-tier city government organization, generally composed of 2,000 to 10,000 families. The location of local **markets** and small shops, neighborhoods of alleyways and narrow streets are generally the site of younger **children** playing **games**, older men sitting on the stoop while **smoking** cigarettes and chatting, and elderly ladies exchanging opinions on daughters-in-law and **family** affairs. Subdivided into smaller residential units of 100 to 600 families and quarters of 10 to 40 families, oversight and social management is carried out by "neighborhood committees" (*shequjumin weiyuanhui*) composed of local residents, allowing for a measure of autonomous urban self-governance.

Established as an essential grassroots organization in the 1950s and expanded to every city by the 1980s, the neighborhood committees are generally composed of older **women**, referred to as the "neighborhood grannies," in their 60s and 70s, with the assistance of younger, more well-trained social service personnel. Serving as the front lines of police and security services,

major local issues and complaints dealt with by committee members range from petty **crimes** to illegal advertisements to problems between residents within large housing units. Considered the local watchdogs, on the lookout for strangers while tracking the behavior of local residents, including their visits to local **food** markets, the committees are also involved in arranging **entertainment** activities, especially for the elderly, while also attending to any special needs.

During the period of the **one-child policy** (1979–2015) of family planning, neighborhood committees were essential to the enforcement of the controversial family-planning policy, **monitoring** the menstrual cycles of married women of child-bearing age, along with carrying out periodic **hygiene** checks of individual apartments. Seen as unnecessarily intrusive by younger and generally more well-educated residents, the committees have been active in dealing with the local reaction to the outbreak of COVID-19, beginning in 2020. While crucial to the social management of such traditional, densely populated neighborhoods as the *hutongs* (alleyways) in **Beijing**, neighborhood committees are fading in importance in rapidly growing, less densely populated, and largely middle-class suburbs of major cities.

"NEW CULTURE" (*XIN WENHUA*). Representing a strong dislike for traditional Chinese culture, especially **Confucianism**, the concept of a "new culture" for China emerged most prominently in the New Culture Movement/ May Fourth Movement (1917–1921), calling for the adoption of global and Western values centered on "democracy" (*minzhu*) and "**science**" (*kexue*). Promoted primarily by Chinese intellectuals from Peking and Tsinghua universities in **Beijing**, the site of major anti-Japanese and antigovernment demonstrations on 4 May 1919, a major goal of the movement was to replace the use of "classical Chinese" (*wenyan*) in **literature** with the more accessible "vernacular" (*baihua*) Chinese. Other goals included the following: ending the traditional "patriarchal" (*jiazhang*) structure of the Chinese **family**, adopting democratic and egalitarian political and social values, accepting China as one nation among equals and not culturally superior or unique, and orienting to the future and not the past.

Led by such intellectual luminaries as Hu Shih, Cai Yuanpei (president of Peking University), Chen Duxiu (cofounder of the Chinese Communist Party [CCP] in 1921), and prominent author **Lu Xun** (1881–1936), the concept of a "new culture" was proselytized by publications like *New Youth* (Xin Qinglin) and *New Tides* (Xin Chao). Considered the root of the Chinese revolution and influential among leaders of the CCP, including **Mao Zedong** (1893–1976), the authoritarian People's Republic of China (PRC) failed to achieve major new culture goals, especially democracy, although progress in science has been substantial. Among the memorials to the New Culture Movement is the preservation of Red Mansion, the building housing the

308 • NUMBERS AND NUMEROLOGY (SHUZI/MINGLIXUE)

library on the campus of Peking University, a center of such early new culture advocates as Hu Shi (1891–1962) and Cai Yuanpei (1868–1940). Contemporary critics suggest that the "New Culture Movement" was merely a buzzword, with little to no effect on the substance and enormous depth of Chinese culture.

NUMBERS AND NUMEROLOGY (*SHUZI/MINGLIXUE*). A branch of **knowledge** dealing with the significance of numbers, numerology in China is based on similarity in sounds between the pronunciation of numbers and other words having an "auspicious" (*jixiang*) or "inauspicious" (*bujixiang*) meaning. Used to assist in the promotion of **health**, wealth, and prosperity, numerological principles are also employed in important decision-making in **business**, especially the stock **market**, and politics, including the all-important binary concept of **yin-yang**, with even numbers represented by the former and odd numbers, considered more fortunate, by the latter. Traced to Emperor Fu Xi (mid-2800s BCE?), known as the "Great Bright One" and the first of the mythological Three Sovereigns (*San Huang*), early numerology was based on patterns detected on tortoise shells, which led to the Lo Shu grid, a 3 x 3 square comprised of numbers that add up to 15 for each row, column, and diagonal. A view of the universe based on numbers gradually evolved, influencing the interrelated cultural realms of **fengshui**, the *Book of Changes* (Yijing), astrology, geomancy, and the practice of 9 Star Ki.

Much of Chinese numerology is concerned with the numbers 1 through 9, with 6, 8, and 9 considered lucky and 4 and 7 considered unlucky, with the remaining either neutral or having both good and bad connotations. Numbers 8 and 9 are considered particularly auspicious, with the former, pronounced *ba*, similar to the word for *fa*, meaning "prosperity" and good **fortune**, and the latter pronounced *jiu*, with the same pronunciation of the Chinese word meaning "**longevity**" (*jiu*), and associated with the emperor, whose long robes were decorated with images of nine dragons, a mythical **animal** with nine offspring. Most unlucky is the number 4, pronounced *si*, homonymous with the word also pronounced *si* meaning "**death**," along with the number 7, *qi*, referring to the seventh "**ghost** month" (*guiyue*) in the Chinese lunar calendar and also homonymous with "deceive" (*qipian*). Numerical combinations also have homonymous meanings based on similar sounds, with "514" (*wu yi si*), for example, comparable to "I want to die" (*wo yao si*) and 168 (*yi liu ba*) comparable to "fortune all the way" (*yi lu fa*).

OBESITY (*FEIPANG*). Defined as the accumulation of abnormal or excessive **body** fat, presenting a serious **health** risk, obesity has become an increasing problem among adults and especially **children** in the People's Republic of China (PRC) since the 1990s. Attributed to sustained economic growth since 1978–1979, producing more disposable income for **families**, especially in well-off **urban areas**, the obesity rate is 5 to 6 percent nationwide and more than 20 percent in major cities like **Beijing** and Tianjin, among the most obese places in the country, with poorer areas, for instance, Guizhou and Hainan island, having the lowest obesity rates.

Factors leading to substantial body-weight gain other than rising incomes include the greater availability of such fast, high-calorie, largely Western **foods** as McDonald's and Kentucky Fried Chicken, with sugary drinks, and reduced **manual labor** by adults and less outdoor activities by schoolwork-obsessed and computer-addicted **youth**. While only one in 20 children were classified as obese in 1995, that number grew to one in five by 2019, representing a fourfold increase, with 17.5 percent of children ages five to nine rated as obese or seriously overweight in 2015. Similar rates are apparent among adults, with 14 percent of **men** and **women** suffering from general obesity, and 31 and 32 percent, respectively, suffering from abdominal obesity, according to data collected between 2004 and 2014. Having experienced serious malnutrition during the period of rule by Chinese Communist Party (CCP) chairman **Mao Zedong** (1949–1976), some people, especially doting grandparents, believe that being fat, particularly among children, is a sign of family prosperity and adequate food in a country where **eating** borders on an **obsession**.

OBSESSIONS (*CHIMI*). In addition to the near-**religious** attachment to **food** and **eating**, obsessions in China include the traditional consumption on a daily basis of "hot water" (*kaishui*), modern gaming (including video-sharing), and the posting of selfies on **social media**. Preferred over cold beverages and drinks, even during hot summer weather, devotion to hot water, usually carried in large thermos bottles, can be traced to the 4th

310 • ONE-CHILD POLICY (DUSHENGZI NÜ ZHENGCE)

century BCE, when, according to **traditional Chinese medicine (TCM)**, benefits included expulsion of humidity and cold from the **body**. Often consumed in conjunction with ginseng, goji berries, or chrysanthemum flowers, heavy doses of hot water were credited, probably incorrectly, with protecting Southern China from a cholera outbreak in **Shanghai** that spread to North China in the 1860s. Available from street vendors known as "tiger stores" (*laohuzao*), hot water has also been promoted for its medicinal benefits by Chinese governments, including both the Republic of China (ROC), where frequent consumption was advocated in the New Life Movement (*Xin Shenghuo Yundong*) in the 1930s, and the government of the People's Republic of China (PRC), with daily consumption urged for **children**. Hot water dispensers are also common in schools, **business** offices, and government agencies, as well as passenger compartments on China's high-speed trains, although Chinese **youth** seem more attracted, especially during the summer, to conventional cold drinks, among them **alcohol**.

Equally obsessive, especially for Chinese youth, is the opportunity to upload personal videos on such internet platforms as Meitu in hopes of becoming an "internet celebrity face" (*wanghong lian*) the likes of HoneyCC, perhaps the most famous and widely watched digital star, with millions of hits to her website. Serving as venues for online sales of **clothing**, cosmetics, and assorted **beauty** products, and a centerpiece of a growing **celebrity** culture in China, internet apps have also become outlets for selfies, with personal appearances dramatically improved by computer enhancement. Images of **women**, in particular, are altered to conform with traditional concepts of beauty, including large eyes, double eyelids, white skin, a high nose bridge, and a pointed chin, creating an alternate realm of living, as in China, being like everyone else is now considered uncouth, with apps like Meitu filling profound feelings of personal emptiness.

ONE-CHILD POLICY (*DUSHENGZI NÜ ZHENGCE*). Adopted in 1979, and terminated in 2015, the "one child per **family**" program has had a profound and long-lasting impact on Chinese society, skewing the gender distribution of the population and shaping the early life experiences of the single child. As the centerpiece of family planning in the People's Republic of China (PRC), the policy is credited with reducing the number of expected births by as many as 400 million people between 1979 and 2005, with the average number of **children** per family dropping from 5.8 in the 1970s to 1.55 in 2014. Estimates are that 20 percent of families in the PRC have one child, approximately 35 million families, almost all of whom live in **urban areas**, as families in the countryside were allowed to have two children beginning in the late 1980s and where policy enforcement confronted enormous political and social resistance, as larger families contribute to agricultu-

ONE-CHILD POLICY (DUSHENGZI NÜ ZHENGCE) • 311

ral production. Overall, the population drop is credited with contributing an extra 2 percent of annual growth in the country's gross domestic product (GDP), while also boosting labor productivity by 1.5 percent annually.

One of the most deleterious social effects of the policy has included the production of an entire generation of spoiled and self-centered children, as fawning parents, grandparents, and aunts doted on the single child, especially boys, turning them into self-centered "little emperors" (*xiao huangdi*) and "little suns" (*xiao taiyang*), the latter term previously used to describe Red Guards during the **Cultural Revolution (1966–1976).** Suffering from various personal problems, notably high levels of **obesity** and "uncivil" (*bu wenming*), antisocial behavior, as the only offspring and the sole hope for a family's future, these children have often been driven mercilessly to succeed in school, with concomitant negative effects on personal **happiness**.

During the 2002–2003 SARS crisis in **Beijing** and other cities, single children were sheltered at home for weeks on end during the shutdown of schools, while as adolescents and adults they have pursued a lifestyle of high consumption and a general lack of interest in permanent relationships. As the relative numbers of **women** declined in China, their role in the household increased, with improved employment and economic opportunities, with many prospective brides apparently more concerned with their future husband's bank account and standard of living, including a home and an expensive automobile. "I would rather be crying in a BMW," a popular saying goes, "than happy on the back of a bicycle."

While enforcement of the one-child policy produced an abuse of power, primarily by local family planning officials and intrusive **neighborhood** committees, in recent years women were no longer obligated to report their menstruation cycles to ensure they did not have unwanted pregnancies. With 33 million more men than women in the PRC, **marriage** has become more difficult, with men known as "bare branches" (*luo shuzhi*) feeding the **sex** industry and often resorting to human trafficking of women from poorer regions of Southeast Asia, while childless families have become more common, especially in urban areas.

Difficulties in enforcing the one-child policy stemmed from the fear by parents that a single child, especially female, would not be sufficient to provide for them in old **age**, as the PRC still lacks a comprehensive social security system. The widespread preference for male offspring led to a highly skewed gender ratio in China, especially in poorer, more **rural** provinces, like Fujian, Shaanxi, Guangxi, **Hunan**, Anhui, Hubei, Guangdong, and Hainan Island. Resistance also occurred in such **minority** areas as the Xinjiang-Uighur Autonomous Region (XUAR), where the indigenous population of Uighurs and other Central Asians resented any interference in family life.

312 • OPERA (XIJU)

With mass sterilizations, especially of females, the policy also involved major **human rights** violations, including female infanticide and coerced abortions, which are illegal according to Chinese law, along with the use of ultrasound examinations to determine the gender of a fetus, which many Chinese women attained illegally. Following official termination of the one-child policy in October 2015, couples are now allowed to have two children, largely in response to declining fertility and birth rates, a shrinking labor force, and the gradual aging of the population, with the Chinese government actively encouraging families to have more children, now declared a "matter of state affairs."

OPERA (*XIJU*). One of the three oldest dramatic **art** forms in the world and the primary form of **entertainment** throughout much of Chinese history for nobility and commoners alike, classical opera, including world-famous **Peking opera**, is a rich combination of **music**, singing, **dance, martial arts**, and bright costumes, along with elaborate makeup and **masks**. Traced to the early imperial era, opera evolved during a span of 1,000 years as an accumulation of various art forms, maturing during the Tang (618–907) and especially the Song (960–1279) dynasties, with performances primarily for the imperial household. Known as "Disciples of the Pear Garden" (*Liyuan Dizi*), after the musical school established during the Tang Dynasty, opera professionals began training as early as seven and eight years of age, with requirements to master various musical instruments, along with subtle **hand gestures** and movements, including 50 different ways of moving their "water sleeves," each with dramatic meaning to evoke joy or sadness.

Drawn from **folktales**, **legends and mythology**, and classical **literature**, opera began roughly in the 4th century CE, then known as *Canjun*, consisting of simple comedic forms involving two performers engaged in **song** and dance, with more complex plot and dramatic twists added during the Tang Dynasty, as well as more performers. The development of the *Zaju* and *Nanxi* schools during the Song Dynasty involved rhyming schemes and the creation of specialized roles of "female" (*dan*), "male" (*sheng*), "male with a painted face" (*hua*), and the "clown" (*chou*), while lyrics were gradually converted from "classical" (*wenyan*) to "vernacular" (*baihua*) Chinese beginning in the Yuan Dynasty (1279–1368). The *Kunqu* school of opera, combing northern and southern styles, primarily from Shanxi, **Shanghai**, and Suzhou, emerged as the dominant form during the Ming (1368–1644) and Qing (1644–1911) dynasties. Famous scripts include *Peony Pavilion* (Mudan Ting), *Peach Blossom Fan* (Taohua Shan), and *Romance of the Western Chamber* (Xi Xiang Ji), the latter considered "China's most popular love comedy" set during the Tang Dynasty (608–907). All roles were performed by **men** because females were prohibited from performances by Qing emperor Qian Long (1735–1796).

ORALITY (KOUYOU) • 313

With Peking opera becoming the most popular from the late 19th century onward, performances of classical opera continued after the establishment of the PRC, blossoming during the liberal Hundred Flowers Campaign (1956–1957), with **women** restored to singing female roles. Subject to withering **criticism** and the virtual shutdown of troupes and training centers during the **Cultural Revolution (1966–1976)**, classical opera was replaced by the "eight model" operas, consisting of strong revolutionary and political themes, overseen by Jiang Qing, the wife of Chinese Communist Party (CCP) chairman **Mao Zedong**. Revived in 1976, classical operas number 162, down previously from more than 360, and are freely performed in such magnificent venues as the China National Opera House, although only on special occasions, as the appeal of the traditional genre is generally limited to the elderly.

The staging of classical opera comes with few props, allowing for performances outdoors in natural settings accompanied by a small band playing traditional musical instruments, most prominently the "bamboo flute" (*pipa*). Much of the acting is based on illusion, gracious hand gestures, footwork, and **body** movements mimicking the riding of a horse, rowing a boat, or opening a door. Elevated to a status of "essence of the nation" (*guocui*) in the imperial era, operas were performed as **dramas**, **comedy**, and farce, either as "civilian plays" (*wenxi*) or "military plays" (*wuxi*), with any portrayal of living emperors or empresses strictly forbidden. Regional variations other than Peking opera include the following: *Huju*, performed in the Wu dialect and based on local folk songs in the lower Yangzi River valley, with actors wearing common street clothes, enormously popular in the 1920s and 1930s; *Qingqiang*, a product of musically fertile Shanxi, featuring joyous and sorrowful tunes, along with fire-breathing and elaborate **acrobatics**, at one time numbering 10,000 separate operas; and Cantonese, traced to the Ming Dynasty, with emphasis on gymnastics and martial arts skills, and including such Western musical instruments as the violin, cello, and saxophone. Chinese opera audiences openly express their approval or disapproval of the singers and actors while engaging in casual conversation among themselves and munching on snacks throughout the often long and tedious performances. Western opera is increasingly popular in the PRC, with performances of *La Traviata*, by Verdi, and *Turandot*, by Puccini, held in the **Forbidden City**, as well as *Semele*, by Handel, and the *Ring Cycle*, by Richard Wagner.

ORALITY (*KOUYOU*). A major basis for **folktales** and classical **literature**, oral traditions and word-of-mouth storytelling have a long history in Chinese culture, with tales learned in oral form written down and turned into major **philosophical** treatises, notably **Confucianism**, and popular novels. With **education** involving substantial chanting and memorization of texts, along

314 • ORALITY (KOUYOU)

with the lectures of master teachers, strong oral residues existed in China's highly literate society beginning with oral recitation by young **children** of such early learning texts as the *Three Character Classic* (Sanzi Jing), *Hundred Names* (Baijia Xing), and *Thousand Character Classic* (Qian Zi Wen), yet often without any understanding of textual meaning. Continued into more advanced study, memorization of classical texts was basically an oral exercise facilitated by the rhythm and balance of texts written in "classical" (*wenyan*) Chinese **language**, which as no one's mother tongue was an artificially created linguistic style used by officialdom to maintain the monopoly of a single state **ideology**. Major works attributed to Confucius (551–479 BCE), for example, the *Analects* (*Lunyu*), consisted primarily of stories and conversations involving the great philosopher and his disciples, with little or no cultivation of logical reasoning and **argumentation**, as the emphasis was on implicitness through metaphor and simile. Both the texts and accompanying explanations were highly standardized and regurgitated by teachers, leaving little intellectual basis for challenging the monopoly on **knowledge** and political power by educators and the ruling elite.

"Oralization" as interpreted in the psychoanalytic works of Sigmund Freud has also become popular in the People's Republic of China (PRC), where the concept has been used to explain the reputed passive receptivity of the Chinese people to all forms of authority. Introduced into China in the 1920s and revived in the 1980s, after being suppressed during the period of rule by Chinese Communist Party (CCP) chairman **Mao Zedong** (1949–1976), Freudian analysis, including by trained Chinese psychoanalysts, sees a plethora of oral imagery in Chinese descriptions of male genital sexuality, along with the popular belief that in the **sexual** act male libido is easily depleted, while female libido is virtually inexhaustible. Similar distorted views bordering on stereotypical "orientalism" (*dongfangzhuyi*) were drawn by early Western analyses of Chinese "national character" (*minzu tese*), notably in the modern semiscientific field of **political culture**.

P

PAGODAS AND TEMPLES (*TA/SI*). Major **religious** sites, along with churches and mosques, pagodas and temples have been centers of devotion to **Buddhism**, **Confucianism**, and **Daoism** throughout Chinese history, including in the People's Republic of China (PRC), especially since the introduction of economic reforms and social liberalization (1978–1979). Generally located in physical settings contributing to a devotional religious experience, for example, secluded **mountain sites** and auspicious locales in **urban areas**, pagodas number about 2,000 in the country, with temples even more numerous, as there are 1,500 in Shanxi province alone. Representing a rich variety of traditional **architecture**, including low-slung pavilions and high tiered-towers with upward eaves and roofs dotted with religious figures and symbols of good **fortune** (for instance, the tortoise), the oldest structures consist of wood, with the more recent ones made of brick and stone.

Derived from the stupa in ancient India, where the buildings symbolized sacred mountains and preserved the crystallized sacred beads composed of the remains of Sakyamuni and known in Sanskrit as *sarira*, pagodas were built relatively late in China, beginning in 68 CE, with the White Horse Temple (Luoyang, Henan) as a site for proselytizing Buddhism and housing sacred texts and holy relics. With a generally hollow interior and a series of staircases always odd in **number** ranging from three to 13, situated on an octagonal base, pagodas were a major inspiration for **poetry** and often decorated with elaborate Buddhist iconography. Originally erected to serve religion, pagodas were also used for more secular purposes, notably astronomical observation, while also serving as watchtowers offering spectacular views, particularly in urban areas, and ornate structures for attracting the favors of spirits, deities, and immortals.

Among the most famous was the "Porcelain Tower" (*Caoci*), a nine-story structure measuring 260 feet high with walls of glazed white porcelain bricks constructed in Nanjing during the Ming Dynasty (1368–1644) in 1431, and considered one of the Seven Wonders of the Medieval World. Destroyed by marauding invaders of the Taiping Rebellion (1850–1864) because of its Buddhist devotionalism, a replica of the tower constructed of modern materi-

316 • PAINTING (HUIHUA)

als was rebuilt in 2010. Other famous pagodas include the following: "Giant and Small Wild Goose" (*Da/Xiao Yanta*), **Xi'an**; "Six Harmonies" (*Liu He*) and "Thunder" (*Leifeng*), Hangzhou; "Tiger Hill" (*Hushan*), Suzhou; Songyue, Zhengzhou (Henan); Famen, Baoji (Shaanxi); Three Pagodas, Dali (**Yunnan**); Wooden Pagoda, Ying County (Shanxi); "Flying Rainbow" (*Feihong*), Datong (Shanxi); and Iron Pagoda, Kaifeng (Henan).

Comprised of buildings, halls, and shrines with green or yellow glazed-tiled roofs supported by intricately carved stone pillars, temples in China are laid out on a north–south axis and are also the site of monasteries and pagodas. Rendered in the Chinese **language** as *si*, "temple" is the second-highest bureaucratically ranked word behind "palace" (*gong*), constructed for all major religious traditions, while also serving as sites for major imperial **rituals**, especially the "Temple of Heaven" (*Tiantan*) in **Beijing**. Other major temples include: Nanshan, Sanya (Hainan); South Putuo, Xiamen (Fujian), with rare Buddhist relics; Jokhang, Lhasa, **Tibet**; Wannian, Mount Emei, **Sichuan**; Yonghe Lama, Beijing; White Horse, Luoyang, the first Buddhist temple in China; Daxiangguo, Kaifeng (Henan), used by the royal family; Lingyin, Hangzhou; Jade Buddha, **Shanghai**; Confucian, Qufu, Shandong; Islamic Great Mosque in Xi'an, oldest in China built in 742; and Shaolin, Zhengzhou, Henan, the last with the famous **martial arts** monks.

PAINTING (*HUIHUA*). One of the oldest continuous artistic traditions in the world, dating to 200 BCE, and similar to **calligraphy**, classical painting in China employed brushes dipped in black ink and colored pigments without the use of oils. Done on paper or silk, finished works were usually presented in the form of hanging scrolls along with decorated lacquer ware or folding screens. Subjects included portraits, especially of the royal family and gentry nobility, flowers, birds, **animals and insects**, and "landscapes" (*shanshuihua*), the last considered the highest **art** form. The two main techniques of classical painting are the "meticulous" (*gongbi*) style, involving highly detailed brush strokes and rough coloring, with subjects ranging from natural scenery to formal imperial portraiture, and the "freehand" (*xieyi*) style, involving more **individualistic** approaches using spontaneous lines to bring out the inner spirit and essence of the subject.

Considered one of the "four arts" (*siyi*) practiced by the Confucian "gentleman" (*junzi*), Chinese classical painting was based on such long-standing concepts as the following: respecting the past and learning the craft by emulating past masters, treating human subjects as small specks in the vast breadth of space and time, and viewing paintings as a revelation of the artist's inner spirit and character. Known as "national" or "native painting" (*guohua*), Chinese traditional styles are distinguished from modern, Western-styles of painting that gained influence among Chinese artists from the mid-19th century onward.

PAINTING (HUIHUA) • 317

Historically, Chinese painting advanced in the 6th century CE, with an emphasis on a flow of **"energy"** (*qi*) encompassing the theme and artistic resonance of works, along with brush strokes closely linked to calligraphy and an appropriate application of **color** and tone. Portraitures, especially of the royal family and court, extended from the Six Dynasties (220–589) to the Tang Dynasty (618–907), with many works preserved in tombs and at burial sites. Depicting towering **mountains**, rolling hills and rivers, and rough stones in a generally peaceful countryside with bold strokes and black lines, the "golden age of Chinese landscape" extended from the Five Dynasties (907–960) to the Northern Song Dynasty (960–1120), the latter with many famous artists, some trained at the Imperial Painting Academy, like Li Cheng (10th century), as well as Guo Xi and Fan Kuan (11th century). Major works from this period in the school of "monumental landscapes" (*juda de fengqing*) on silk scrolls include the following: *Solitary Temple among Clearing Peaks* (Li Cheng), *Early Spring* (Guo Xi), and *Travelers amid Streams and Mountains* (Fan Kuan).

Serving as a celebration of a well-ordered empire, landscapes dominated the genre, with many attaining an almost mythical quality. Inscriptions of **poetry** were added to paintings beginning in the Yuan Dynasty (1279–1368), along with a tradition of painting simple subjects, for example, a few tree branches and flowers, and a horse or two, while the development of color printing techniques led to the publication of illustrated books and manuals during the Ming Dynasty (1368–1644). Increasing prosperity led many wealthy gentry families to serve as patrons to the arts, notably painting, during the Qing Dynasty (1644–1911) as new styles were created, while rigid rules of traditional schools were challenged by individualistic painters employing freehand brushwork.

Many aspiring Chinese painters studied abroad beginning in the 19th century, in such major art centers as Paris and Berlin, where Western styles, including French Expressionism, Italian Futurism, and German Expressionism, became influential among aspiring Chinese artists. Following the New Culture Movement/May Fourth Movement (1917–1921), a blend of Western and Chinese styles emerged, especially in **urban areas**, with a flourishing arts community mainly in **Shanghai** and Yangzhou, Jiangsu. With the establishment of the People's Republic of China (PRC), paintings generally followed the propagandistic rules of "socialist realism" (*shehuizhuyi xianshizhuyi*) borrowed from the Soviet Union but with traditional styles revived during the liberal period of the Hundred Flowers Campaign (1956–1957). As part of the attack on the **"four olds"** (*sijiu*) during the **Cultural Revolution (1966–1976)**, both traditional and modern painting were suppressed as art schools were shut down, along with exhibits and **museums**. Revived beginning in 1978–1979, Chinese painters, released from rigid political controls

318 • PAINTING (HUIHUA)

and propaganda duties, created new styles, for instance, "Heaven Style Painting" (*Tiantang Fengge Hua*), based on traditions from the Song Dynasty (960–1279).

Chinese painting maintained considerable diversity throughout Chinese history between professional and **scholar**-amateur artists, and among various "schools" (*pai*) of painting stressing contrasting styles. For advocates of "literati painting" (*wenrenhua*), going beyond just a representation of form was absolutely necessary for capturing the rhythm of **nature** in a landscape and grasping the basic emotion or atmosphere of the subject, with the painting serving as a venue for conveying the artist's inner beliefs. For the scholar-amateur artist alienated from the political world, as occurred most notably during rule by the foreign dynasties of the Yuan (Mongols) and Qing (Manchu) dynasties, painting became an indirect vehicle of political commentary and instruction, with portrayals of bamboo suggesting moral integrity, pine trees symbolizing survival, and good horses serving as a metaphor for recognizing **men** of talent. For the consumer of the classics, "reading the painting" (*duhua*) is a method of art appreciation, engaging the past through slow scrutiny of a scroll, sharing an intimate experience and gaining a sense of meaning transmitted throughout time.

Competing schools of painting styles included the Wu and Zhe schools in the Ming Dynasty, with the former consisting of scholar-amateurs idealizing the personalization of works, with inscriptions describing a work and the reason for its creation, and the latter composed of painters with a more conservative outlook, emphasizing large decorative works reviving the landscapes of the Southern Song Dynasty (1127–1279). Others included the Orthodox School of professional painters, supported by the imperial court during the Qing Dynasty, as opposed to more individualistic painters operating largely on their own, such as the Eight Eccentrics of Yangzhou (*Yangzhou Baguai*) including Jin Nong (1687–1764), known for his highly unconventional Cat and Bamboo scroll painting.

Top-rated paintings and their painters and time period include the following: *Five Oxen*, Hang Huang, Tang Dynasty; *Noble Ladies in the Tang Dynasty*, Zhang Xuan and Zhou Fang, Tang Dynasty; *Emperor Taizong Receiving the Tibetan Envoy*, Yan Liben, Tang Dynasty; *Nymphs of the Luo River*, Gu Kaizhi, Eastern Jin Dynasty (317–420); and *Riverside Scene at the Qingming Festival*, Zhang Zeduan, Northern Song Dynasty, the last considered "China's Mona Lisa." The most recognized painters are as follows: Qi Baishi (1864–1957), with his simple portraits of human figures, animals, and landscapes; Zhang Daqian (1899–1983), creator of natural landscapes with splashed ink and color technique; Xu Beihong (1844–1927), considered the father of modern Chinese painting, fusing Chinese and Western styles; Wu

PEER GROUPS AND PEER PRESSURE (TONGBAN YALI) • 319

Chengshuo (1844–1927), of the Sea Painting School, using freehand style employing inks and oils; and Pan Tianshuo (1897–1971), employing freehand style, noted for works of flowers and birds, along with **seal** carvings.

PANICS AND MOBS (*KONGHUANG/BAOMIN*). A perennial problem in Chinese society during both the imperial and modern eras, collective outbursts by mobs and outright social panics were spurred on by pervasive **fear** and **rumor** mongering involving a variety of social and economic forms, from **superstitions** to financial disruptions. The most notable of the former was the social panic and "sorcerer scare" (*wushi kongjiu*) concerning reputed "soul stealers" (*touhun*), pursued at the behest of Emperor Qian Long (1735–1796) in 1768, during the Qing Dynasty (1644–1911). Groups casually accused of "witchcraft" (*wushu*), which was said to bring sickness and **death** to their victims, included **beggars**, monks, and priests, who were subject to arbitrary persecution, including torture and **sexual** violence. Originating in Zhejiang, panic spread throughout much of the empire and lasted for six months until cooler heads prevailed, including the emperor. Similar panics involving popular belief in "black disasters" (*heisheng*) struck several areas of China, including **Beijing**, in the 15th and 16th centuries. Powerful and lethal flying objects were supposedly created by "magicians" (*moshushi*) and directed at **children** and other unsuspecting victims, bringing great harm and suffering.

Fast forward to the modern era in the period of the People's Republic of China (PRC) and several panics have taken place, including food panics in reaction to episodic shortages of staple grains and, more seriously, social panics brought about by the widespread outbreak of the SARS virus in 2002 and 2004, ultimately shut down by rigorous social control measures. The integration of the PRC into the global economy since 1978–1979, brought periodic financial panics, especially involving the newly established and largely underregulated stock **market** in 2015. Fed by a closed and hierarchically dominated, one-party political system, and a state-run, compliant press, China's air waves and **social media** are rife with misinformation that can easily lead to panics, as demonstrated by the mass buying of toilet paper in **Hong Kong** in 2020, based on a widespread and unsubstantiated fear of impending shortages. A country with a moral culture, China is also a particularly fertile breeding ground for moral panics engineered by political and cultural elites, with many occurring in the more recent past involving addictions, most recently among **youth**, to video gaming and the internet.

PEER GROUPS AND PEER PRESSURE (*TONGBAN YALI*). In a society dominated by **family** and other networks of social **relations**, peer groups and peer pressure have become increasingly important in shaping personal

behavior in China, especially **youth** in the realm of **education**. A product of growing economic prosperity and rapid expansion of a middle class, peer pressure is exacerbated by overriding parental concerns for status **symbols**, especially involving their **children**, a trend that intensified in the 2000s. With bilingual schools popular in major cities like **Shanghai** and **Beijing**, wealthier families face considerable pressure to send students abroad for study and international experience, expensive programs that are a considerable source of anxiety sparked by comparing the opportunities afforded their children to others. Prevalent in **urban** and **rural areas**, with substantial influence on consumption patterns, the impact of peer pressure and attraction to the latest social fad in the People's Republic of China (PRC) has been exacerbated by new technologies, primarily **social media** and the internet.

Peer influence is strengthened by the widespread fear of declining living standards, especially among the middle class, for whom falling into the lower classes is a perennial worry and a powerful force in shaping behavior. Peer and family pressure on students to perform well academically in preparation for the national college entrance examination (*gaokao*) is high, with one-third of primary school students showing heightened levels of stress, in the most severe cases leading to **suicide**, but with many students subject to such pressures also achieving superior results in mathematics and other academic disciplines.

PEKING OPERA (*JINGXI*). The dominant form of **opera** in China, developed in the mid-19th century during the Qing Dynasty (1644–1911) and especially popular at the imperial court of Empress Dowager Ci Xi (1861–1908), Peking opera involves a combination of **music**, singing, mime, **dance**, and **acrobatics**, including substantial sword play, with emotions of love, hate, and **jealousy**, among others, expressed by **hand gestures** and **body** movement with little or no change in facial expression. Originally for the average folk of **urban** alleyways and **rural** villages and generally considered by the literati as "vulgar" (*yongsu*), the **art** form was long shunned by the imperial court until given national prominence and sophistication by Ci Xi, an ardent lover of music who professionalized and expanded the repertoire enormously rewarding singers and actors lavishly. Adhering to a variety of stylistic conventions with layers of meaning in movements expressed in time with musical accompaniment, Peking opera, also rendered in English as Beijing opera, is sung in arias, fixed-tuned melodies, and percussion patterns, with performers clad in elaborate and colorful costumes sporting painted faces mimicking famous character **masks**. The four major operatic roles include the "gentleman" (*sheng*), the "female" (*dan*), "rough men" (*jing*), and the "clown" (*chou*), with two dominant types of music, *xipi*, literally "skin puppet show," indicating the roots of Peking opera in traditional singing **puppetry**, and *erhuang*, low, soft, and despondent folk tunes. In a total

PERFECTIONISM (WANMEIZHUYI) • 321

repertoire of 1,400 works, Peking opera includes tales of preceding dynasties, major historical events (especially involving emperors, empresses, ministers, and generals), and various popular **legends and mythologies**.

Historically, Peking opera traces its roots to regional opera troupes in Anhui and Hubei brought to Beijing for the 80th birthday of Emperor Qianlong (1711–1799). With additional influences from regional *Kunqu* (**Shanghai**/Suzhou) and *Qingqiang* (Shanxi) opera, Peking opera emerged as a coalescence of many operatic forms, appealing to the public for its simplicity. Originally exclusively a male pursuit, as Emperor Qianlong issued a ban on **women** performers, unofficially lifted in the late 19th century, Peking opera, in the history of the People's Republic of China (PRC), was attacked as "feudalistic" (*fengjian*) and "bourgeois" (*zichanjieji*) during the **Cultural Revolution (1966–1976)**, and replaced by the so-called eight revolutionary model operas. Revived following the introduction of economic reforms and social liberalization (1978–1979), the overall popularity of Peking opera has suffered, especially among **youth**.

Among the renowned Peking opera stars was famous male performer Mei Lanfang (1894–1961), known as the "Queen of Peking Opera" for his remarkable performances of female roles, especially in *Peony Pavilion* (Mudan Ting) and *The Drunken Concubine* (Zuifei), the latter virtually a one-person show with a number of difficult movements. Singing since the age of 11, the often-turbulent personal and public life of Mei Lanfang is portrayed in the film *Forever Enthralled*, directed by **Chen Kaige** (2008), with a major opera house in Beijing named for the great singer. Promoting Peking opera in the global community through several international tours, including in the United States, where he was initially detained as an illegal immigrant, Mei Lanfang had enormous **feminine** appeal, as noted in the popular saying, "For a lucky marriage look for a woman like Mei." Popular Peking operas, in rank order, include the following: *The Drunken Concubine, Monkey King, Farewell My Concubine, A River All Red, Unicorn Trapping Purse, White Snake Legend, The Ruse of Empty City, Female Generals of the Yang Family, Wild Board Forest, The Phoenix Returns Home*, and *Havoc in Heaven*.

PERFECTIONISM (*WANMEIZHUYI*). A major characteristic among Chinese intellectuals and students with deep historical and philosophical roots, primarily in **Daoism**, the "relentless pursuit of perfection" (*jingyi qiujing*) has led to remarkable achievements by scientists, including Noble Prize winners, but it is also responsible in its pathological form for deleterious mental illness, in some cases leading to **suicide**. Founded in the 12th century, the Daoist Way of "Complete Perfection" (*Quanzhen*) preached the possibility of human perfection through self-cultivation and training regimen requiring personal celibacy and refinement involving various physical and mental

322 • PERSONAL RESPONSIBILITY AND SELF-RELIANCE

exercises. Suppressed in the People's Republic of China (PRC) during the **Cultural Revolution (1966–1976)**, the monastic order is the most popular in contemporary China with its doctrine of self-perfection.

In the secular realm, especially in **education**, the perfectionist mentality and personality are evident among high-achieving students, characterized by **individualistic** tendencies of demanding high standards with little tolerance for mistakes. Anything less than perfect is considered unacceptable and a source of possible social ridicule from classmates and **peers**, especially in schools where grades and overall performance ratings are posted for everyone to see. Taken to the extreme and constituting a kind of pathology, unhealthy perfectionism with an overly critical self-evaluation can lead to a variety of **health** problems, including depression, anxiety and **eating** disorders, chronic fatigue, and obsessive compulsory disorder (OCD), as the individual aims to become the perfect child with perfect grades and perfect behavior. Other characteristics include an unending need to always be right and never saying or doing the wrong thing, while engaging in a hypervigilance with interactions and conversations heavily scripted, lacking any spontaneity based on fear of being judged harshly. A healthy or adaptive perfectionism also exists among Chinese high achievers characterized by a **pragmatic** approach to overcoming personal shortcomings and a less neurotic **fear** of failure and social reproach. The criterion of "perfect" (*wanmei*) is also used, rather casually, to describe important public figures, notably the wives of top officials.

PERSONAL RESPONSIBILITY AND SELF-RELIANCE (*GEREN ZI-REN/ZILI GENGSHENG*). Contrary to the enormous individual **dependence** on government authority and local work "**units**" (*danwei*) that existed in the People's Republic of China (PRC) during the years of rule by Chinese Communist Party (CCP) chairman **Mao Zedong** (1949–1976), the introduction of **market** reforms since 1978–1979 in agriculture and the **urban** economy has dramatically magnified individual responsibility in a variety of life affairs, including employment and **family** matters. Social surveys indicate a greater sense of personal responsibility related to taking care of themselves, including parents and grandparents, as the number of **children** with the long-standing Confucian responsibility of caring for the elderly was dramatically reduced by the **one-child policy** (1979–2015), along with the absence of a universal social security system. Greater responsibility has also devolved on individuals regarding personal **health** and heath care, with responsibility for such matters as layoffs from jobs, broken relationships and **marriages**, and even theft of personal property assumed by the individual. No longer considered a major function of government, career success and life outcomes are considered a function of good family, **education**, hard work, and just plain luck and good **fortune**, as individuals indicate a greater openness to new

PERSONAL RESPONSIBILITY AND SELF-RELIANCE • 323

experiences as traditional values erode. Requiring less external validation of risky ventures, Chinese also have an abiding belief, perhaps misplaced, in the role of the emerging **legal** system to remedy improprieties and arbitrary treatment at the hands of private and public authorities.

PERSONALISM (*RENGEZHUYI*). A major school of **philosophy** popular in the Western world and embedded in the **religions** of India, personalism is evident in various facets of Chinese society, especially **political culture**, where the "rule of **men**" (*renzhi*) has generally superseded the "rule of law" (*fazhi*). Major characteristics of personalism include the proposition that personality is the supreme value and the key to the search for **knowledge** into the basic nature of reality. Positing a radical difference between the person and nonperson, especially **animals**, a personalistic philosophy considers the transformation of individual character as the prerequisite for broader social and cultural insights, and the basis for substantial reform, while resisting any attempt to reduce the personal life to **ideological** or institutional impersonalism.

Personalistic values were central to major Chinese philosophical and religious traditions, and accentuated by the centrality of individual emperors in the imperial system, a tradition continued by the pursuit of strong **leadership** and a personality cult in both the Republic of China (ROC) during the years on the mainland (1912–1949) and the People's Republic of China (PRC), especially during the rule of Chinese Communist Party (CCP) chairman **Mao Zedong** (1949–1976). Personalistic themes were evident in **Confucianism**, most notably in the emphasis on humanistic moral-character formation as the foundation of social order, although the philosophy does not attribute any eternal essence to the person, a generic theme in Western theories of personalism. Similar personalistic principles inform both **Buddhism** and **Daoism**, with specific practices and physical **exercises** targeted on the individual, although the two traditions, absent a personal deity, maintain an impersonal vision of ultimate reality and existence.

With traditional personalistic principles, especially in politics, a prime target of **criticism** during the New Culture Movement/May Fourth Movement (1917–1921), radical Chinese intellectuals, including future leaders of the CCP, were attracted to the impersonal economic determinism embedded in Marxism–Leninism. While initial leadership doctrine in the CCP downplayed the role of individual leaders and criticized the personality cults surrounding Nationalist Party (*Kuomintang*) leaders Sun Yat-sen (1912–1925) and Chiang Kai-shek (1928–1949), considerable attention and fascination was shown for leaders of the Soviet Union, namely Vladimir Lenin (1917–1924) and Joseph Stalin (1927–1953). Following the establishment of the PRC, the person of Mao Zedong was gradually afforded a fanatical cult treating the party "chairman" (*zhuxi*) as a political demiurge and virtual **god**

with infallible qualities, reaching a peak during the **Cultural Revolution (1966–1976)**. While official criticism of personality cults became a major ideological theme during the rule of Jiang Zemin (1989–2002) and Hu Jintao (2003–2012), the elevation of **Xi Jinping** (2013–) to CCP general secretary and president was accompanied by a reassertion of a personalistic leadership style, including the propagation of the single leader's "thought" (*sixiang*) and widespread promotion of individual charisma through the proliferation of life stories, **family** photos, and wise sayings.

PETS (*CHONGWU*). A relatively recent phenomenon in the People's Republic of China (PRC), pet ownership is booming, especially among wealthier and relatively young **urban** residents, with approximately 150 million pets of various **animal** breeds and 74 million pet owners expending as much as to $29 billion annually on generally pampered critters. Declared illegal in urban areas until the 1990s and denounced by Chinese Communist Party (CCP) chairman **Mao Zedong** (1949–1976) as a "bourgeois vanity" (*zichanjieji xurongxin*) during the **Cultural Revolution (1966–1976),** pet ownership became a trendy fad beginning in the 2010s, especially among singles, childless couples, and the elderly, for whom a companion animal provided much-needed emotional support and was often treated as a **family** member.

Popular pets include dogs and cats, at 34 and 20 percent, respectively, along with fish, hamsters, tortoises, and rabbits, at 16, 10, 9, and 7 percent, respectively. Pet stores have proliferated in major cities, and there are estimates that the total population of dogs and cats in the PRC will reach 300 million by 2022. With most pets purchased, as relatively few are adopted, preferences are for dogs and cats of pure breeds. The exponential growth in demand has led to the emergence of black markets, with national and local state regulations of the industry ranging from weak to nonexistent. Major problems include lack of oversight of the rapidly expanding breeding farms and wholesalers where animal abuse is rife, including long-term caging and general mistreatment, along with forged documentation of immunization and other protective measures. Particularly abusive is the perking up of animals with antisera injections prior to sale; once the drug wears off, the animals quickly deteriorate, colloquially described as "week dogs" and "week cats" for their short life spans.

Untutored owners are another problem, as the dedication and time required for taking care of a pet is underappreciated, with animals often kept in cramped apartments and given little **exercise** or, in the more serious cases, totally abandoned, with an estimated 40 million stray dogs and cats, 200,000 of the latter in **Beijing** alone, as a general lack of sterilization has led to an explosion in the number of urban strays. Cities like Suzhou have imposed registration and other requirements to gain control of local animal populations, with new owners who fail to clean up after their pets outdoors subject

to reproach. The lack of national standards and an effective management system in the PRC has left these problems to be addressed by such non-governmental organizations (NGOs) as the international group PETA, devoted to animal protection and control.

Pets unique to China include insects, especially "crickets" (*xishuai*), kept throughout imperial history for their **songs** and fighting skills, along with the "praying mantis" (*tanglang*) and "cicadas" (*chan*), the former symbolizing bravery and the latter resurrection. Also popular are song birds, often kept in bamboo cages and taken on early morning walks in nearby parks by their elderly owners, with periodic bird-singing competitions, but with the animals, along with the favorite, "goldfish" (*jinyu*), attacked and even outlawed during the Cultural Revolution. Exotic pets, some a threat to public safety, include monkeys, lizards, frogs, raccoons, geckos, snakes, alligators, and parrots, with many now outlawed. Fears of the spread of COVID-19 via pets, largely unwarranted, in early 2020, led to mass extinctions of dogs and cats by private owners and local state authorities.

PETTINESS (*PEIDI*). Consisting of various unsavory social actions and behavior by untutored individuals, pettiness has been a target of **education** and proper socialization throughout Chinese history. Encouraging such deviance is the emphasis on political "**struggle**" (*douzheng*) in the People's Republic of China (PRC), especially during the **Cultural Revolution (1966–1976)**, followed by an intensely competitive economy following the introduction of economic reforms and social liberalization (1978–1979). Compared unfavorably to the nobility of the "gentleman" (*junzi*) in **Confucianism**, the "small" or "petty person" (*xiaoren*) was described by the great philosopher as someone who failed to grasp the value of **virtue**, while seeking only immediate gain. With the petty person overwhelmed by egotism and unconcerned with the negative consequences of their narrow-minded actions, any ruler surrounded by such people, Confucius (551–479 BCE) warned, will suffer the ignominies of poor governance along with society at large. Absent the gentleman in government, small-mindedness will reign, as sensual and emotional pleasures triumph over wisdom and righteousness, while an incessant pursuit of power and fame will dominate the career politician.

Examples of petty behavior by the public in the PRC include acts of vandalism; cutting into lines; spitting in public; and petty **corruption** by shop owners and vendors using inaccurate scales and measures, resulting in overcharging for goods and services. Explanations for such behaviors include the legacy of arbitrary and capricious rule under Chinese Communist Party (CCP) chairman **Mao Zedong** (1949–1976), when major social groups were pitted against one another in endless campaigns of "class struggle" (*jieji douzheng*) and open **conflict**. Another factor is the dog-eat-dog economic competition following the introduction of economic reforms (1978–1979),

326 • PHILOSOPHY (ZHEXUE)

which has increased the number of "petty hoodlums" (*xiao liumang*) engaging in purse snatchings and other disruptions in daily life, often to the consternation of a population that generally abides by informal rules of etiquette and basic **courtesy**.

Famous portrayals of petty types in Chinese society include such books as *The New Year's Sacrifice* (1924), by **Lu Xun** (1881–1936), featuring the character Aunt Xianglin as a petty nag **begging** on the streets and telling passers-by her tales of woe. That some Chinese so easily throw fits about the smallest of inconveniences or problems, smashing their expensive iPhones and engaging in public temper tantrums, is considered another sign of unwarranted pettiness in the country's increasingly hyperactive and frenetic social life.

PHILOSOPHY (*ZHEXUE*). Dominated throughout much of the imperial era by **Confucianism**, with ancillary influences of **Daoism** and **Buddhism**, philosophy in China lacked the dynamic interplay of fundamentally different schools of thought characteristic of Western philosophical traditions. Replacing the traditional Confucian orthodoxy with a new orthodoxy of Marxism–Leninism in the People's Republic of China (PRC), the philosophical realm often involved nothing more than elaborations and tweaking of the accepted dogma, most notably the emergence of Neo-Confucianism during the Song Dynasty (960–1279) and the various emendations to Marxist–Leninist principles, especially by the addition of the "Thought" (*Sixiang*) of Chinese Communist Party (CCP) chairman **Mao Zedong** (1949–1976). Such alternate schools as Mohism, Chinese naturalism, and Logicians in ancient China fell into obscurity, a fate repeated in the modern era by anarchism and liberal democracy, swept aside by a state-supported single doctrine.

Historically, classical philosophy arose during the Spring and Autumn (770–476 BCE) and Warring States (475–221 BCE) eras, especially during the period of the "Hundred Schools of Thought" (*Zhuzi Baijia*), when China experienced an especially rich development of philosophical conjecture and speculation. With the establishment of a single dynastic order beginning with the Han Dynasty (202 BCE–220 CE), vibrant philosophical exchange was replaced with an intellectual monism perpetuated throughout the succeeding dynasties, exacerbated by the absence of an institutionally and theologically powerful church comparable to Catholicism in the West. The Chinese version of an "enlightenment" (*qimeng*) came in the form of well-established philosophical schools imported from abroad, especially the West, during the New Culture Movement/May Fourth Movement (1917–1921), with major philosophical exchanges like the "Debate between Metaphysics and Science" in 1923. Translations included major works of philosophy by John Dewey,

PHOTOGRAPHY (SHEYING) • 327

René Descartes, Immanuel Kant, Karl Marx, John Stuart Mill, Friedrich Nietzsche, Herbert Spencer, Lugwig Wittgenstein, and Georg Wilhelm Friedrich Hegel, with the last claiming that, "There is no philosophy in China."

While Chinese intellectuals were perfectly comfortable with wide-open debate and controversy, political leaders, especially Mao Zedong, were committed to establishing a new single orthodoxy, in this case Marxism–Leninism–Mao Zedong Thought, with any real philosophical debate, as in the short-lived Hundred Flowers Campaign (1956–1957), replaced by hard-edged, state-imposed orthodoxy of a single, unquestioned doctrine. Following the introduction of economic reforms and social liberalization (1978–1979), major and even minor international schools of philosophical thought the likes of Ludwig Wittgenstein's philosophy of **language** were open to research and discussion though with the Chinese state still based, in theory, on a single and sometimes mind-numbing orthodox philosophy.

PHOTOGRAPHY (*SHEYING*). Introduced into China by foreign missionaries and journalists in the 19th century initially via the Portuguese colony of Macau, documentary and commercial photography rapidly spread throughout China, especially in the wealthier coastal cities, like **Shanghai** and **Guangzhou**. Popular as a **hobby** and used for record-keeping, journalism, and political propaganda, and a form of fine **art**, photography studios specialized in portraitures of **families**, wedding couples, and even Empress Dowager Ci Xi (1861–1908), who sat for several photo shoots outfitted in her elaborate imperial garb. Dramatic wartime photos included, most famously, the "Bloody Saturday" image of a Chinese baby crying on a railway platform amid bombed-out Shanghai in the Second Sino–Japanese War (1937–1945). Iconic photographs from the People's Republic of China (PRC) include shots of Chinese Communist Party (CCP) chairman **Mao Zedong** swimming in the Yangzi River (1966) and the benevolent "grandpa Mao" (*Mao yeye*) meeting with **children**, with these and many other photos widely distributed to strengthen the leader's political legitimacy and popular appeal.

Photos also became a venue for **protest and dissent**, most notably the famous "tank man" staring down People's Liberation Army (PLA) tanks during the military crackdown against prodemocracy demonstrators in Tiananmen Square, Beijing, in June 1989. Photographic records of major political events include the honest portrayal of the destructive and violent actions during the **Cultural Revolution (1966–1976)**, by photojournalist Li Zhensheng (1940–), to counter what he considers the Chinese penchant for historical amnesia. Others include photographs, largely by amateurs, of the April Fifth Movement (1976), when crowds filled Tiananmen Square to mourn the death of Premier Zhou Enlai (1898–1976). While official photographs appearing in newspapers are required to present only "positive" (*zheng*) images, photographers like **Ai Weiwei** have published "negative" (*fu*) images

328 • PIRACY AND PIRATES (HAIDAO)

via the internet and other unofficial outlets portraying the many problems confronting the PRC, including stark images of widespread environmental pollution.

An adjunct to experimental performing arts, with photos inspired by traditional **painting** techniques, with **calligraphy** attached to photos, Chinese artistic photography has been compared to Western pop art of the 1960s. Subjects include everyday street scenes and dramatic landscapes. So-called "shock" (*xiuke*) photography includes images of naked bodies in contoured poses, dead babies, and elephant dung, along with "Chinese kitsch" (*Zhongguo meisu*), for example, the many "Mao goes pop" photographs, mocking the former CCP chairman.

Prominent indigenous photographers include the following: Chen Man, with stylistic images of **women**; Chen Jiagang, internationally known for street scenes and depictions of environmental pollution; Ren Hang, the target of state harassment for **sexually** explicit photos, banned by the PRC in 1949; Xiao Muji, with photos documenting poverty; and Hou Bo and Xu Xiaobing, official photographers of such CCP leaders as Mao Zedong. Foreign photographers known for capturing the country's land, cities, and social life dating back to the 19th century are as follows: Felice Beato (1832–1909), an Italian-British photographer known for photos of **architecture** and major historical events, notably the Second Opium War (1856–1860); John Thompson (1837–1921), a Scottish photographer who documented a trip up the Min River, **Sichuan**; and Mark Riboud (1923–2016), a French photographer famous for documenting the Cultural Revolution and trips along the Yangzi River. A robust commercial photography **market** is evident in the immense popularity of prewedding photo shoots, some in dramatic and sometimes dangerous seaside locations, costing as much as $500,000, while state regulations prohibit photos of prominent historical and politically sensitive national security sites. Major Chinese photography publications include *China Photography* (Zhongguo Sheying) and *Popular Photography* (Dazhong Sheying), initiated in 1957 and 1958, respectively.

PIRACY AND PIRATES (*HAIDAO*). A pioneer of maritime attacks and thievery dating to the ancient Zhou Dynasty (1046–256 BCE), Chinese piracy became a persistent problem in the modern era of global trade, especially along the southern coasts and in the South China Sea. Taking over for the Japanese, who had raided Chinese (and Korean) coastlines from the 4th to the 16th centuries, Chinese pirates formed alliances among themselves and in conjunction with counterparts in Vietnam, reaching a peak in the late 18th and early 19th centuries. Fed by increasing land scarcity and economic privation among rural peasantry and fishermen, Chinese and Vietnamese pirates

PLANTS AND FLOWERS (ZHIWU/HUAHUI) • 329

preyed on local and foreign shipping, especially as trade expanded under the Canton System (1757–1842) and was concentrated in the Pearl River Delta, including the important port of **Guangzhou**.

Formed into a series of separate "fleets" (*jiandui*) designated by a series of different **colors** (red, black, white, green, and blue), led by the Red Fleet and captained by the notorious Zheng Yi (1765–1807) and his aggressive wife, Ching Shih (1775–1844), Chinese pirates and their Vietnamese allies constituted a powerful naval force composed of hundreds of junks and tens of thousands of men successfully taking on British, Portuguese, and Qing forces. Operating out of such pirate hot spots as the Leizhou peninsula, the Wanshan archipelago, and **Hong Kong** island, along China's southern coastline, pirates plundered entire villages and controlled intraregional trade at considerable cost to local economies and government finance. Emerging as the "pirate queen" (*haidao nüwang*), the newly widowed Ching Shih imposed a strict Code of Laws on her fleet allies but ultimately accepted an offer of amnesty from the Qing government, leading to a general diminution of pirate activity, with individual pirates conscripted into the Chinese navy. Defensive measures included paintings of huge eyes on the bow of commercial junks out of a belief these magical oculi could spot pirates lying in wait ahead. Captured pirates confronted a dire fate of being killed and then having their corpses eaten to prevent their reincarnation. From historic perpetrator to contemporary victim, Chinese and other foreign shipping are primary targets of pirates, largely from poor Southeast Asian nations, with the South China Sea and nearby Malacca Strait ranked as the most dangerous pirated areas in the world.

PLANTS AND FLOWERS (*ZHIWU/HUAHUI*). A predominantly agricultural society throughout history, plants and flowers in China gained enormous symbolic importance, representing a rich variety of human **virtues** and emotions, and widely displayed in traditional **paintings** and **poetry**. While plants crucial to Chinese life and well-being, for example, "bamboo" (*zhu*), were revered, flowers were celebrated for conveying positive messages and good feelings in everyday life. Especially noteworthy is the label "Four Noblemen in China" (*Zhongguo Sige Guizu*), assigned to "plum blossoms" (*meihua*), "orchids" (*lanhua*), "chrysanthemums" (*juhua*), and bamboo, all with reputed natural characteristics in common with humans. Considered a "friend of winter" (*dongtian pengyou*) for flowering in late winter and early spring, plum blossoms are valued for their endurance and fragrance. A **symbol** of the inner strength and tempered souls of the Chinese people gained from years of undaunting suffering, plum blossoms, with their five petals, are traditionally known as the "five kinds of happiness" (*wuzhong xingfu*), namely joy, good **fortune, longevity**, prosperity, and peace. Famous sites in China named for the flower include Plum Blossom Hill, at the base of Purple

330 • PLANTS AND FLOWERS (ZHIWU/HUAHUI)

Mountain near Nanjing, covered with a forest of fragrant plum trees, and the Plum Garden, a botanical garden of a former Qing Dynasty (1644–1911) **scholar** in Wuxi, Jiangsu.

Equally rarefied are orchids, representing integrity, nobility, and friendship, and compared by Confucius (551–479 BCE) to the "gentleman" (*junzi*), as well as chrysanthemums, symbolizing elegance and **longevity**, which originating in China bloom in late Autumn, surviving heavy frosts. A metaphor for vitality, longevity, and an abundant posterity, bamboo, which is widely used in building construction, with the shoots consumed as **food**, is compared to the man with exemplary conduct and nobility of character. Appreciated in all three major religions—**Buddhism**, **Confucianism**, and **Daoism**—bamboo was memorialized by poet Su Shi (1037–1101), who wrote, "I would rather eat without meat than live without bamboo." Conveying a feeling of softness, plants were absent from the **Forbidden City** out of fear their calming presence would diminish the sense and awe and power so crucial to imperial authority.

Other venerated flora included the "lotus" (*lianhua/hehua*) and the "peony" (*mudan*), with the former considered the gentleman's flower and symbolizing purity for growing out of mud and yet remaining unstained. One of the eight precious things in Buddhism, with the flower said to bloom on 8 April, Buddha's birthday, and 8 January, celebrated as Lotus Day, the lotus is also the basis of the "lotus culture" (*hehua wenhua*) in China, associated with strong emotions of love and intimacy, while the term "red lotus" (*hong lianhua*) refers to court courtesans in the imperial era, as the words also apply to female **sexual** organs. Even more culturally significant is the peony, popular since the Tang Dynasty (618–907) and symbolizing opulence, luxury, honor, and high social rank. Informally designated as the country's national flower, the peony is celebrated in **Peking opera**, with a Peony Festival held annually in the ancient city of Luoyang, Henan. Also native to China is the rose (*rose chinensis*) from Guizhou and **Sichuan** with images of the flower painted on **ceramics and porcelain** during the Han Dynasty (202 BCE–220 CE).

Flora displays are also governed by certain rules. Examples include incorporating unopened buds, indicating the continuous nature of all life; using an odd number of stems, conveying the irregularity of the life force; and coordinating the **color** of plants with containers, creating an appearance of the flowers spilling out naturally. Other plants, flowers, and fruits, with their associated symbolism and representation in parentheses, include the following: apples (peace-loving); apple and magnolia (rich household); apricot (beautiful **women** and good **fortune**); lily (innocence); daffodil (prosperity); orange (abundant **happiness**); peach blossom (good luck); peach fruit (longevity); peach petals (intense love); pomegranate (fertility); sunflower (prosperous future); and willow branch (adaptability).

POETRY (*SHIGE*). Prominent throughout Chinese history, with various classical and modern forms held in high regard by literati and commoners alike, poetry is a major venue for expressing the deep emotions and inner feelings of Chinese writers. Traced to the origins of Chinese civilization, the evolution of classical Chinese poetry was closely associated with development of other artistic forms, especially **songs**. Major periods of poetic creativity began during the Zhou Dynasty (1045–256 BCE), with such prominent poets as Qu Yuan (340–278 BCE), and continued into the Six Dynasties (220–589), including the famous "Seven Sages of the Bamboo Grove" (*Zhulin Qixian*) of **scholars**, writers, and musicians, along with poets of the "Orchid Pavilion Gathering" (*Lanhua Ting Juhui*) as both groups combined their poetic musings with substantial consumption of **alcohol**. Individuals included the "fields and gardens" (*tianyuan*) poet Tao Yuanming (365?–427) and Cao Cao (155–220) the feared military figure of the Eastern Han Dynasty (25–220 CE) who was also known for his poetic creativity. Peaking in the Tang (618–907) and Song (960–1279) dynasties, poet luminaries included Li Bai (701–762), Du Fu (712–770), and Su Shi (1037–1101), known later in life as Su Dongpo, China's greatest poets, along with emperors like Qian Long (1735–1796), who personally composed 40,000 poems.

Incorporated into the imperial civil service examination system, classical poetry was simple in style, with easy-to-grasp content, making the poems accessible to contemporary readers, with major collections from this prolific era, including the Five Dynasties (907–960). Available in the *Complete Tang Poems* (Quan Tangshi), with 49,000 poems by 2,200 poets, and the *Three Hundred Poems of the Tang* (Tangshi Sanbai Shou), both were compiled in the Qing Dynasty (1644–1911), with copies of the latter provided to primary school students in the People's Republic of China (PRC).

Throughout the course of imperial Chinese history, five styles of classical poetry emerged, *Shi, Ci, Ge, Qu,* and *Fu,* on topics ranging from love and intimacy to the magnificence of the country's natural landscape. Especially popular are the *Shi* and *Ci* styles, the former composed of two or more coupled lines of four Chinese characters each, with many written anonymously and collected in the Confucian-era *Classic of Poetry* (Shijing), and the latter a lyrical poetic form based on certain, definitive musical song lines. *Ge* and *Qu* are predominantly song forms, the latter taken from **opera** and popular songs, and made into poems and generally freer in form. The *Fu* form is highly descriptive in nature but using rare and unusual Chinese characters, making the poems relatively inaccessible to the casual reader. Du Fu, Li Bai, and Su Shi all served as officials in the imperial court. Du Fu authored highly realistic poems reflecting his experience in the enormously destructive An Lu Shan Rebellion (755–763); Li Bai led a wild life of de-

332 • POETRY (SHIGE)

bauchery and drunkenness, while befriending the emperor; and Su Shi served as a pharmacologist and produced **calligraphy** and **paintings**, while also known as an accomplished gastronome.

Becoming more erudite and esoteric, poets in the latter three dynasties of the Yuan (1279–1368), Ming (1368–1644), and Qing generally lacked creative impulse, while Western poetic forms were introduced in the wake of the New Culture Movement/May Fourth Movement (1917–1921). The most notable were Ai Qing (1910–1986), founder of "new poetry" (*xinshi*) of free verse, and Wen Yiduo (1899–1946), author of two major collections, *Red Candle* (1923) and *Dead Water* (1928), with poems integrating themes of **music**, painting, and **architecture**. Wen Yiduo was assassinated by the Nationalist (*Kuomintang*) government for his critical political stance. The most popular classical poems are as follows: *Thoughts in the Silent Night* (Jingye Si), by Li Bai; *A Poem by a Leaving Son* (Youzi Yin), by Meng Jiao; *Grasses* (Fu de Guyuan Cao Songbie), by Bai Juyi; *Quatrain of Seven Sages* (Qi Bu Shi), by Cao Zhi; and *On the Stork Tower* (Deng Guan Que Lou), by Wang Zhihuan. Comedic play on homophonic words through classical poems is evident in *The Lion-Eating Poet in the Stone Den* (Shi-shi Shi Shi Shi), composed of 92 Chinese characters all pronounced *shi* although with different meanings and tones.

In the modern era, poetry was produced by Chinese Communist Party (CCP) chairman **Mao Zedong** (1949–1976), who authored many poems throughout the Communist revolutionary era (1928–1949), mainly with political themes, for example, *The Warlord Clash* (1929) and *The Long March* (1935), with periodic poetic musings following the establishment of the PRC. While such poems as *Farewell to the God of Plague* (1958) supported major campaigns aimed at eliminating the scourge of schistosomiasis in **rural areas**, others by the CCP chairman evoked more traditional themes of revering **nature**, for instance, *Ode to the Plum Blossom* (1961) and *Two Birds: A Dialogue* (1965), the latter his last poetic creation. That Mao relied on poems like *Swimming* (1956) to call for major policy initiatives, for example, the construction of the Three Gorges Dam on the Yangzi River, was subsequently denounced as "using poetry to govern the nation."

Notable poets in the PRC since the introduction of economic reforms and social liberalization (1978–1979) include the "misty poets" (*menglong shiren*), who emerged in reaction to the cultural and literary restrictions of the **Cultural Revolution (1966–1976)**. Denounced as "misty" by the Chinese government for their obscure and hazy writings, this group, consisting of poets the likes of Bei Dao, Gu Cheng, Mang Ke, and Shu Ting, and associated with the publication *Today* (Jintian), was most active from 1979 until the crackdown on the prodemocracy movement in 1989, with their translated works available in various anthologies.

POLITICAL CULTURE (*ZHENGZHI WENHUA*). A central concept in political science, political culture is defined as the shared views and normative judgments held by a population regarding a country's political system and politics in general, with impact on governmental legitimacy. Influenced by historical and institutional developments in government and major schools of **philosophy** and **ideology**, political culture in China has been dominated by an overwhelmingly authoritarian and leader-centered tradition pervading the imperial and modern eras, including the People' Republic of China (PRC). With social and political **harmony** serving as a top priority of **Confucianism**, the vast majority of the Chinese people were treated as subjects, not participants, in the imperial political order, with close linkages between the political realm and ethical and social life that emphasized hierarchy over equality and obedience over **protest and dissent**. Cultural norms emphasized a standardization of behavior and homogenization of the social order, with emperors and modern political leaders, unlike in the West, freed from the moral consequences of their actions as anything prioritizing the individual over society was targeted for elimination. State support and patronage of **literature** and the **arts** was a centerpiece of the traditional political regime, with the Manchu rulers of the Qing Dynasty (1644–1911) providing considerable largesse to every realm of China's rich artistic practices, from **ceramics and porcelains** to **calligraphy** and **painting**, with emperors like Qian Long (1735–1796) becoming major collectors of cultural relics and an accomplished poet.

Despite the dramatic political change from an imperial system to the Republic of China (ROC) in 1912, the dominant political culture of revering the single leader continued, with personality cults propagated for both presidents Sun Yat-sen (1912–1925) and Chiang Kai-shek (1928–1949), with submissive political attitudes among the Chinese public largely unchanged and generally unchallenged. Rhetorically embracing the concept of a politically involved citizenry, the Chinese Communist Party (CCP) regime of the PRC pursued such ideologically defined practices as the "mass line" (*zhiliang xian*), emphasizing a direct connection between state and society. Changes to the dominant political culture pursued by CCP chairman **Mao Zedong** (1949–1976) included an emphasis on "**struggle**" (*douzheng*) over harmony and activism over submissiveness, but with a personality cult propagated above and beyond previous adulations. Support for the arts also continued, with Republican and then Communist leaders channeling financial and administrative support to fledging Chinese musicians and painters in centers of cultural life like **Beijing** and **Shanghai**, with the PRC establishing national conservatories and academies of **music**, **drama**, and fine arts, as such CCP leaders as Premier Zhou Enlai (1949–1976) and Shanghai mayor Chen Yi (1949–1958) singled out specific performers and **artists** for support.

334 • PORNOGRAPHY (SEQING)

Following the introduction of economic reforms and social liberalization (1978–1979), major changes occurred in **leadership** style with a shift to **commercialization** of the arts, as direct state support was substantially reduced. Lower profiles were assumed by political leaders, from Deng Xiaoping (1978–1992) to Jiang Zemin (1989–2002) to Hu Jintao (2003–2012), with an end to mass political campaigns and greater, although still limited, openness in the media, where the **market** increasingly dictated artistic forms and performances. Living in a system described as "fragmented authoritarianism," the Chinese people, after years of autarkic isolation under Mao Zedong, have been exposed to cosmopolitan ideas and principles, from liberal democracy to modern art and music, with some imports, for example, paintings of nude women, creating great controversy and substantial public interest.

Among the agents of change away from the political and cultural absolutism of the past has been the rapid expansion of **social media**, introducing a rich variety of political ideas and cultural forms, as social surveys suggest an increasingly liberal-minded and culturally tolerant public, but one governed by a single political party rife with **corruption**, organizational laxity, and lack of **discipline**. Rejecting the adoption of a multiparty democratic system, which has evidently gained more support among increasingly prosperous and well-educated segments of the Chinese population, President **Xi Jinping** (2013–) has reaffirmed the political authority of the single leader, abolishing the two-term limit on the presidency and glorifying, a la Mao Zedong, his own "thought" (*sixiang*), but with indeterminate effects on the popular mind and enduring political culture, with continuing criticism of certain cultural and artistic forms, especially imports from the West, and the CCP acting as the final arbiter of morality and conscience.

PORNOGRAPHY (*SEQING*). Portrayed in such classical literature as *The Golden Lotus* (Jin Ping Mei), published during the Ming Dynasty (1368–1644), pornography was banned by the government of the People's Republic of China (PRC) in 1949, and generally unavailable during the period of rule by Chinese Communist Party (CCP) chairman **Mao Zedong** (1949–1976). Following the introduction of economic reforms and social liberalization (1978–1979), pornographic materials have ballooned, largely via the internet, with repeated state antipornography efforts in the 2000s apparently having a negligible effect on popular consumption of the illicit **entertainment**. While Chinese film and television studios producing pornographic materials have been shut down, with proprietors subject to **legal** action, pornographic videos, many pirated from foreign sources, especially Japan, are readily available on the internet, including Chinese-language websites established outside the country with virtual private networks (VPNs) used to circumvent internet blocks installed by the government into comput-

PRAGMATISM (SHIYONGZHUYI) • 335

ers sold in the PRC. Especially popular, with millions of downloads, are such homemade pornographic videos as the widely viewed tape of a couple having intimate relations in the dressing room of a Uniglo department store in a popular commercial area of **Beijing**. Also popular is so-called "Boys' Love" pornography, a genre of homoerotic fiction largely by female authors aimed primarily at **women**. While established pornographic sites have been subject to episodic government restrictions, enforcement of antipornographic laws and regulations remains uneven, with **censorship** relatively lax in wealthier **urban areas**, where books and DVDS are readily available in local street **markets**.

With 30 percent of people in the PRC admitting to viewing pornographic material, **men** more than women but with the gap shrinking, especially among young women, and couples more than singles, especially those with higher income, pornography is largely an urban phenomenon, with viewing on the increase. Contrary to claims made by critics of the genre, no scientific connection has been found between consumption of pornography and commission of sex **crimes** or other forms of **sexual perversion**. Government institutions empowered to restrict the availability of pornography, especially the growing problem of child pornography, include the National Office for the Fight against Pornography and Illegal Publications, with government offerings of substantial financial awards for people reporting illicit content but with 2,000 legal sex shops in Beijing alone.

Prominent individuals investigated for allegations of disseminating pornographic materials include among them **Ai Weiwei**, while for some young women untutored by parents in basic **knowledge** of **sexual** matters, watching pornographic films and reading erotic literature is their only form of sex **education**. Euphemisms used in the Chinese **language** to describe pornographic activities include "old drivers" (*lao siji*), for collectors of pornographic materials; "driving" (*kaiche*), for the sharing of porn videos; "car seat" (*zuo che*), for recipients of pornography; and "welfare" (*fuli*), for pornography itself. International sites popular in China but blocked from the internet include Porn Hub and YouPorn.

PRAGMATISM (*SHIYONGZHUYI*). Defined as an experimental approach to social life, including **religion**, politics, ethics, the **arts**, and **science**, with a focus on the actual consequences of actions and beliefs, pragmatism as a formal **philosophy** gained substantial influence in 20th century China from the New Culture Movement/May Fourth Movement (1917–1921) onward. Opposed to sclerotic **ideologies** and a dogmatic mindset of infallibility and personal overconfidence, pragmatism was initially subject to withering **criticism** during the period of rule in the People's Republic of China (PRC) by Chinese Communist Party (CCP) chairman **Mao Zedong** (1949–1976), especially in attacks in the 1950s on Hu Shih (1891–1962), a liberal thinker and

336 • PREGNANCY AND CHILDBIRTH (HUAIYUN/FENMIAN)

major advocate of the pragmatism propounded by American John Dewey (1859–1952), who visited in China from 1919–1921. Revived with the introduction of economic reforms and social liberalization (1978–1979), pragmatic policies guided China in multiple realms, especially economics, with top leader Deng Xiaoping (1978–1992) extolling pragmatic thinking by famously proclaiming, "It doesn't matter whether a cat is white or black as long as it catches mice" (*zhiyao shi zhuazhu laoshu, mao shi baise haishi heishi dou meiguanxi*).

As a formal philosophy, pragmatism regained substantial intellectual interest from the late 1970s onward, including new translations of the works and lectures given by Dewey during his visit to China, along with an examination of pragmatic principles in ancient Chinese philosophies, notably **Confucianism**. In a society dominated by **atheism**, with Confucian philosophy fundamentally secular and a weakness of abstract principles, pragmatism infused Chinese traditional approaches to **science** and other policy realms, with an emphasis on meeting the immediate needs of the population with little or no concern for adherence to abstract principles. Heavily influenced by Darwinian ethics on evolving an adaptive response to practical problems in social life, the introduction of Western pragmatic principles shifted the intellectual consensus in the country from Confucian collectivism to **individualism**, undermining the notion that China was culturally unique and distinctive. While both pragmatism and Marxism shared a common belief in Western materialism, the latter involved a resort to ideological dogma that, while generating enthusiasm and even fanaticism, especially during the **Cultural Revolution (1966–1976)**, quickly gave way to the more familiar pragmatic outlook, with truth considered fallible and equated with helpful consequences, and untruth indicated by uselessness.

PREGNANCY AND CHILDBIRTH (*HUAIYUN/FENMIAN*). Surrounded by a litany of traditional dos and don'ts, pregnancy and childbirth in China is traditionally a crucial time, with enormous expectations for additional **family** members, tempered by the threats of infant and maternal mortality, which following the establishment of the People's Republic of China (PRC) have been substantially improved. Behavioral guidelines for the expectant mother and her newborn derive from central Chinese concepts, primarily **yin-yang**, along with unique features, most notably the practice of the "sitting month" (*zuo yuezi*), a 30-day period following childbirth during which the mother follows various dietary and behavioral restrictions.

Major advisory nostrums for the period of pregnancy include the following: abstaining from heavy work during the early months and a complete avoidance of **sexual** intercourse; avoiding putting such sharp objects as knives on bed, as this will result in the baby being born with a cleft lip or palate; refraining from touching glue or any adhesive that could cause the

newborn to have unsightly birth marks; avoiding criticizing anyone, as the baby will end up looking and acting like the person criticized; and consuming largely cold foods to offset the effects of the "hot" (*re*) **body** state created by pregnancy. Belief was also prevalent in a so-called "gender chart" (*xingbie tubao*), used to predict the newborn's gender, with a supposed 90 percent accuracy rate based on the mother's **age** and month of conception.

Similar principles and beliefs govern childbirth and its immediate aftermath. These are as follows: The pregnant woman's mother should be present at the first delivery but not subsequent ones; the mother must remain silent during childbirth, as crying attracts evil spirits to the newborn; a necklace should be placed around the newborn's neck before cutting the umbilical cord; labor must be carried out by squatting rather than lying prone on a bed; and the father, who should not be present at birth, should give the newborn its first bath. In the subsequent "sitting month" (*zuo yuezi*), the new mother should avoid a range of activities, including combing or washing her hair, taking showers, having sex, watching television, climbing stairs, or crying, and she is to switch to the consumption of hot foods to counter the "cold" postpartum yin period. Such practices, it is still believed, will gradually restore the mother's yin-yang balance, disturbed by pregnancy and childbirth, when her body is considered "broken." Evidence also indicates that these and other restful practices reduce the incidence of postpartum depression, with 27,000 luxurious centers specializing in providing such "sitting month" (*zuo yuezi*) services in the PRC, although the extent of traditional beliefs in contemporary China is hard to determine.

Reducing maternal and infant mortality rates has been a major priority of the Chinese government since 1949, with maternal mortality rates dropping from 80 per 100,000 (1991) to 19.6 (2017), and infant mortality (younger than age 5) from 54 per 100,000 (1990) to 12.5 (2015), with national data collected annually. The rate of C-section births in China is high, at 40 percent of total births (2016), as giving birth on days designated auspicious is preferred, while pregnancy in reputedly inauspicious years is also avoided.

PRISONS AND PRISONERS (*JIANYU/QIUFAN*). Numbering more than 1.5 million individuals (118 per 100,000) in various forms of incarceration, the most in the world, prisons in the People's Republic of China (PRC) also serve as contract labor and production facilities, including for exports, as a primary source of revenue, with little-to-no financial support from the Chinese government. Based on penal laws formalized in the 1950s, with additional **legal** mechanisms enacted throughout the decades, prisons in the PRC have been described as centers of **cruelty** and **violence**, with prisoners forced to sleep on concrete floors and subject to **torture** for disobedience, for example, electric shock treatment, with prison cells controlled by individual "bosses" (*laoban*) operating on a basis of bribery and sadistic violence.

338 • PRIVACY (YINSI)

Generally large in size, prisons and detention centers consist of populations composed of hardened criminals, murderers, and rapists, along with petty criminals and individuals accused of "civil disobedience" (*gongmin kangming*). Living conditions in formal prisons are generally better than in the mismanaged administrative detention system, with separate facilities for **women** and juveniles, and opportunities offered for **education** and work training. While the highly arbitrary "labor reeducation" (*laojiao*) system, allowing incarceration without trial at the sole discretion of the police, was abolished in 2013, secret, extra-legal "black jails" (*hei jianyu*) still exist for detaining disruptive "petitioners" (*shangfangzhe*) to the national government. Reflecting increases in the national **crime** rate, the number of detainees has grown during the administration of President **Xi Jinping** (2013–), although commutations and pardons have also been issued. Greater transparency of the role of prisons in the production of export goods, for instance, popular Christmas decorations, has been brought about by international **human rights** organizations like China Labor Watch and Human Rights Watch.

PRIVACY (*YINSI*). In the cultural lexicon of China, the concept of privacy has carried a generally negative connotation of "having something to hide" (*you dongxi yao yincang*), with a general belief that in a highly collectivist society little value is placed on personal privacy. Attitudes toward the issue in the People's Republic of China (PRC) are complicated and subject to change with major intrusions of privacy, most notably house invasions by rampaging Red Guards during the chaotic **Cultural Revolution (1966–1976)**. Following the introduction of economic reforms and social liberalization (1978–1979), greater concern for personal privacy has been shown with the growth of a free-**market** economy and a concomitant reduction in state power, especially in the economic realm. Most noteworthy is the ongoing controversy concerning the collection of personal financial data, largely by private digital financial services, which, leaked into the public realm, has led to an explosion of financial scams and spurred popular resistance.

In the absence of a comprehensive national law protecting online privacy, an array of Chinese companies, including digital giants Baidu, Tencent, and Alibaba, collect reams of private data with little or no public scrutiny or **legal** oversight. With such executives as Robin Li (Baidu) declaring that the new e-commerce entails "trading privacy for convenience" (2018), reselling of personal data, often at cut-rate prices, has led to the creation of commercial data privacy firms, with individual consumers employing such protection as carrying two cell phones to avoid the illegal collection of user information via **smartphones**. Asserting the "right to be forgotten" (*you quan duzi yiren*)

by digital financial companies extant in PRC e-commerce law, Chinese consumers, especially in relatively wealthy coastal cities like Shenzhen, demand the right to access, correct, and erase any and all personal data.

Equally disconcerting to a more attentive and protective Chinese population is the actions of the PRC government to collect massive amounts of data on the daily activities and movements primarily of the **urban** population, with a particular concern for rooting out potential political dissidents. Relying on advanced artificial intelligence drawn from a huge number of video cameras, numbering 200 million nationwide and expected to rise to more than 600 million by 2021, extensive data mining and storage capacity is being employed by Chinese authorities to construct a national identification database, with numerical **social credit** scores assigned to individuals, in the name of "stability maintenance" (*wending xing weihu*). Major organizations established to deal with data collection and dissemination is the Cyberspace Administration of China (CAC) with Data Protection Regulatory Guidelines issued in 2019.

PROSTITUTION (*MAIYIN*). A perennial social phenomenon in imperial and modern China, prostitution has constituted a major industry, with an estimated 3 to 20 million "**sex** workers" (*xing gongzuozhe*) in the People's Republic of China (PRC), despite repeated efforts by the Chinese government to control and ultimately eliminate the practice. Historically traced to the Spring and Autumn Period (770–476 BCE), brothels were initially established as a means to increase state revenues, reaching a peak during the Tang (618–907) and Song (960–1279) dynasties, as female courtesans, combining musical and **dancing** talents with seductive qualities, proliferated at the imperial court and among wealthy families. From the Song to the Ming (1368–1644) dynasties, government-run and privately run brothels coexisted, while during the Qing Dynasty (1644–1911) government involvement ended, with prostitution becoming a purely private affair that continued during the period of rule of the Republic of China (ROC) on the mainland (1912–1949).

Coming to power in 1949, the newly established government of the People's Republic of China (PRC) made banning prostitution a high priority, with public brothels shut down in raids in major cities like **Beijing**, where 224 establishments were shuttered, with similar numbers in **Shanghai**. **Legal** prohibitions on prostitution were imposed by the enactment of a national Public Security Law (1957), with severity of **punishment** for involvement in the industry increased in 1980, as special detention camps were established for offenders. Varying between treating prostitutes as common criminals versus victims in need of "reeducation" (*zai jiaoyu*), Chinese government action was centered on periodic raids on brothels and other venues, for example, massage parlors, karaoke bars, and **beauty** salons, with arrests and detentions numbering in the thousands, but with new outlets appearing virtually

340 • PROTEST, DISSENT, AND REBELLION (KANGYI/YIYI/PANHUAN)

overnight, fed by a large, generally well-off clientele, as 17 percent of **men** ages 18 to 61 admit to soliciting a prostitute with little or no fear of punishment.

While public display of prostitution largely disappeared, especially in the **urban areas** of China, during the puritanical rule of Chinese Communist Party (CCP) chairman **Mao Zedong** (1949–1976), so-called "invisible prostitution" (*kanbujian de maiyin*) continued, with **women** and young girls, usually in dire economic straits, offering their "services" to government and even CCP officials. Following the introduction of economic reforms and social liberalization (1978–1979), prostitution boomed, along with the growing economy, as cities in the south, for instance, Dongguan, **Guangzhou**, and Shenzhen, became seedy prostitution hot spots, fed by young girls usually from poor **rural areas** with little **education** and even less tolerance for the drudgery and low pay of factory work. Associated with organized **crime**, official **corruption**, and human trafficking, prostitutes include the following: so-called "heroin hookers" (*hailuo yin jinü*), **drug addicts** who rely on illicit earnings to support their habit; single mothers who convert the surplus wealth of the nouveau-riche to support their **children**; and young girls who share their earnings with needy retired parents and grandparents.

New technologies employed to expand the range of clientele include text messaging, beepers, and mobile phones, along with "visiting cards" (*fangwen ka*) of sex workers left at strategic spots in five-star hotel rooms. Popular terms for prostitutes offering their services from different venues are as follows: "door-bell girls" (*dingdong xiaojie*), located in rented hotel rooms; "hair-dressing salon sisters" (*falang mei*), operating under the guise of massage parlors and beauty salons; "street girls" (*jienü*), soliciting male buyers on city streets; "down the work shack" (*xiaogongpeng*), women who sell sex to migrant workers from the countryside, often out in the open; and "Big Whites" (*Dabai*) a reference to high-priced foreign prostitutes, especially from Russia. Prostitution and its social effects are also a topic in Chinese film, for example, *Blush* (1995) and *Xiu Xiu: The Sent-Down Girl* (1998), as well as novels, for instance, *Lotus* (2017). While the legalization of prostitution in the PRC is considered a virtual impossibility, calls for legal reform include eliminating police power to charge a woman for prostitution simply for the mere possession of a condom.

PROTEST, DISSENT, AND REBELLION (*KANGYI/YIYI/PANHUAN*). A highly centralized state throughout most of its history beginning with the short-lived but tyrannical Qin Dynasty (221–206 BCE), China confronted constant political opposition and social upheaval during the imperial era, including many large and highly destructive rebellions, along with lower levels of protest and dissent, including during the People's Republic of China (PRC). Major factors in the downfalls of dynasties and vehicles for the

PROTEST, DISSENT, AND REBELLION (KANGYI/YIYI/PANHUAN) • 341

establishment of new dynasties, most prominently the Ming Dynasty (1368–1644), created out of the massive peasant uprising led by Li Zicheng (1606–1645), rebellions were often rooted in agrarian discontent, mainly excessive taxation, massive natural disasters, and extensive official **corruption** by local magistrates and the imperial court. Headed by charismatic leaders often drawn from **secret societies** and espousing heterodox religious principles and ideologies, traditional rebellions generally lacked any institutional alternative to the imperial system, limiting offerings to newly titled dynasties dominated by substitute families.

The most prominent and destructive rebellions, with high military and civilian fatalities, include the following: the Yellow Turbans (*Huangjin zhi Luan*), directed against Emperor Ling of the Eastern Han Dynasty (25 BCE–220 CE) and lasting from 184–205; the An Lu Shan Rebellion (755–763), directed against Emperor Xuanzong (685–762) and his **family** by a powerful and disillusioned regional military commander during the Tang Dynasty (618–907), with an estimated 13 to 36 million fatalities; the Taiping Heavenly Kingdom (*Taiping Tianguo*), a pseudo-Christian rebel force led by the charismatic and self-proclaimed younger brother of Jesus Christ, Hong Xiuquan (1814–1864), and directed at an increasingly corrupt and inept Qing Dynasty (1644–1911), extending from 1850–1864, with an estimated 40 million fatalities; the Nian Rebellion (1851–1868), a reaction to devastating floods along the Yellow River in Southern China, driven by the slogan, "Kill the rich and aid the poor"; and the ill-fated Boxer Rebellion (1899–1901), composed of secret societies known as "Boxers" (*Yihetuan*), aimed at foreign missionaries and Chinese converts, sanctioned by Empress Dowager Ci Xi (1861–1908) and suppressed by the intervention of the Eight-Nation Alliance of European, American, and Japanese foreign powers.

Other major rebellions were as follows: Rebellion of the Three Guards, Zhou Dynasty (late 11th century BCE); Liu Bang insurrection, Qin Dynasty (206 BCE); Rebellion of the Seven States, Han Dynasty (154 BCE); Five Pecks of Rice Rebellion, Han Dynasty (184 CE); Red Turban Rebellion, Yuan Dynasty (1340s); Revolt of the Three Feudatories, Qing Dynasty (1655); White Lotus Rebellion, Qing Dynasty (1796–1804); Eight Trigrams Uprising, Qing Dynasty (1813); Du Wenxiu Rebellion, Qing Dynasty (1856–1872); and Dungan Revolts, Qing Dynasty (1862–1877). The last two involved Chinese Muslims. With their limited political goals, rebellions were ultimately replaced by "revolutions" (*geming*) committed to establishing alternative political institutions in the form of the democratic Republic of China (1912–1949) on the mainland and the Communist PRC (1949–present).

A one-party dictatorship and a weak and largely ineffective judicial system, protest and expressions of dissent, while technically **legal** and protected in the state constitution of the PRC, are often suppressed, while growing in

342 • PROVERBS, IDIOMS, AND PUNS

number and intensity from the late 1970s to the 2000s. Consisting of public speeches, mass demonstrations, and, at times, physical clashes, most protests are aimed at local government and Chinese Communist Party (CCP) officials concerning a range of grievances, including corruption, environmental degradation, ethnic divisions, **freedom** of **religion**, labor rights, **nationalistic** interests, and forced evictions, with the last the largest source of public resistance against forced land requisitions, usually for high-profile development projects.

Fueling oppositional forces is the growth of an active "rights consciousness" (*quanli yishi*) among a significant element of the population, including an emergent and increasingly assertive middle class and such outspoken ethnic **minority** groups as the Uighurs in the Xinjiang-Uighur Autonomous Region (XUAR), propagated by **social media**, with blogging and microblogging on sites like Weibo but subject to **censorship** and other controls, including antisubversion laws. So-called "mass group incidents" (*qunzhong tuanti shijian*) have grown annually, from 8,700 (1993) to 90,000 (2006) to 180,000 (2010), including protests at universities, for example, Fudan in **Shanghai**, against increasing CCP intrusion on academic freedom in 2019. Major outbreaks since 1949 have included the **Tibetan** Uprising (1959), opposing the imposition of Chinese rule; the April Fifth Movement (1976), protesting the lack of official mourning for the recently deceased Premier Zhou Enlai (1898–1976); the Democracy Wall (1979), calling for dramatic political change on posters pasted on walls, primarily in **Beijing**; Falun Gong (1999), with sit-downs by members of the outlawed religious group outside the CCP **leadership** compound at Zhongnanhai, Beijing; and riots against police officers and other officials, with police stations set aflame in Guizhou (2008/2011).

PROVERBS, IDIOMS, AND PUNS (*YANYU/CHENGYU/SHUANG-GUANYU*). In a **language** with relatively few syllables, as complex thoughts and meanings are often conveyed by tonal variation, a rich array of proverbs, idioms, and puns are central to China's long cultural heritage but with the government of the People's Republic of China (PRC) attempting to limit their use to avoid "cultural and linguistic chaos" (*wenhua yuyan hunluan*). Historically, many famous sayings are traced to China's great philosophers, notably Confucius (551–479 BCE) and Laozi (601?–531? BCE), with collections produced from ancient times to the modern era. Most significant are the recordings of proverbs dealing with agriculture and other economic pursuits in the book *Farmers' Monthly Guide* (Simin Yueling), by Cui Shi, published during the Eastern Han Dynasty (25 BCE–220 CE), along with subsequent collections on a broader variety of topics. Examples include *Explanation of Common Sayings* (Shi Chang Tang), by Gong Yizheng, in the Song Dynasty

PROVERBS, IDIOMS, AND PUNS • 343

(960–1279); *Ancient and Contemporary Sayings* (Gu-Jin Yan), by Yang Sheng'an, in the Ming Dynasty (1368–1644); and *Origins of Common Sayings* (Suyu Kaoyuan), by Li Jiantang, in the contemporary era.

Grammatically a complete sentence in a formal structure usually consisting of two lines of four or more syllables each and in a topic–comment structure, Chinese proverbs present an observation or judgment, usually on such practical matters as the weather or important personal **relations**, especially involving the **family** and significant others. With so few syllables in the spoken and written word, frequent punning is also preeminent for conveying both serious and comedic meanings, for which the Chinese seem to have a natural affinity.

Expressive of Chinese cultural themes in intellectual and popular realms, proverbs and sayings cover the following major topics, with several examples provided for each: for **knowledge and wisdom**: "Learning is like the horizon, there is no limit," "Unless there is an opposing wind, a kite cannot fly," and "To know the road ahead, ask those coming back"; for love, **marriage**, and family: "Love for a person must extend to the crow on the roof," "Married couples who love each other tell each other a thousand things without talking," and "Respect for one's parents is the highest duty in life" (attributed to Confucius); for friendship: "Better to drink the weak tea of a friend than the sweet wine of an enemy," "A good friend shields you from the storm," and "Love is blind, friendship closes its eyes"; for work: "Failure is the mother of success," "A journey of a thousand miles begins with a single step" (attributed to Laozi), "Our greatest glory is never failing but in rising every time we fail" (attributed to Confucius), and "Tiger's head, snake's tail" (meaning start out big, end up small); for **money**, "Wealth is but dung, useful only when it spreads," "When luck visits, everyone will know where you live," and "He who will not economize will have to agonize" (attributed to Confucius); for **age**, "Men grow old, pearls grow yellow, there is no cure for it," "Nature, time, and patience are the three great physicians," and "A smile will gain you 10 more years of life"; for **food**, "He that takes medicine and neglects diet wastes the skills of the physician," "Talk doesn't cook the rice," and "If you want your dinner, don't insult the **chef**"; and for **comedy** and **humor**: "Do not use a hatchet to remove a fly from your friend's forehead," "You must have crossed the river before you may tell the crocodile he has bad breath," and "You want no one to know it, then don't do it." Declaring that the excessive use of such proverbs was misleading the public, especially **children**, making the promotion of cultural heritage more difficult, government bans on their use in **broadcasting and television** have been announced, citing laws on the use of standardized spoken and written Chinese, with as yet unknown effect.

344 • PROVERBS, IDIOMS, AND PUNS

PSYCHOLOGY (*XINLI XUE*). Introduced into China in the late 19th and early 20th centuries, primarily from Germany, psychology developed as an academic discipline and profession, with Chinese trained abroad and domestically, that continued into the People's Republic of China (PRC), although with periodic interruptions, especially during the **Cultural Revolution (1966–1976)**. With the first psychological research laboratory set up at Peking University by university president Cai Yuanpei (1868–1940), academic departments of psychology were established at prominent universities, with translations of major Western works, notably by Sigmund Freud, along with the production of university textbooks. In conjunction with **traditional Chinese medicine (TCM)**, mental disorders were considered a major physical problem, and influenced by the writings of American John Dewey, a visitor to China in 1919–1921, psychology emerged as an independent discipline advanced by the world-renowned Chinese Society of Psychology, established in 1921.

Historically, ancient Chinese **philosophy** exhibited elements of psychological thinking regarding **relations** between mind and **body**, and the role of nurture versus nature in determining the human personality, with an emphasis on the importance of **education**. Both **Confucianism** and **Daoism** contain undertones of psychology in elaborating principles involving human intelligence, mental ability of self-control, and balancing human relations. Reflecting the influence of the Soviet Union on the PRC from the 1950s to the 1970s, Pavlovian psychology, with its emphasis on classical conditioning, predominated, with the establishment of an Institute of Psychology in the Chinese Academy of Sciences (CAS) in 1951. Weakening of the discipline occurred with the merging of university academic departments of psychology with philosophy, while research and study, and the training of psychologists, came to a complete halt during the Cultural Revolution, when psychology was described as a "pseudoscience" (*wei kexue*).

Revived in the late 1970s, university academic departments of psychology grew from a mere five in the 1980s to 187 in 2007, with cognitive psychology becoming preeminent as Chinese psychologists reestablished international contacts. Topics of particular interest were the increasing prevalence of **suicide**, especially among **women** in **rural areas**; the psychological impact of the **one-child policy** (1979–2015); and neuropsychological studies of **workplace** tensions and substance abuse, with continuing strong influence of Western psychological models. In the Institute of Psychology at CAS, the five branches include the following: mental health, cognitive psychology, developmental psychology, behavior psychology, and behavior genetics, with mental **health** a primary concern.

Popular psychology has also boomed, with such controversial books as *The Country of "Giant Babies"* (Ju Ying Guo), in which psychoanalyst Wu Zhihong describes the Chinese people as suffering from a "great infant

dream" (*weida ying'er meng*) deeply rooted in Chinese tradition and derived from early childhood relations between mother and child, which account for the myriad of social problems confronting the country. Suggesting that the close mother–child relationship and the reputed absence of the father from **family** life has left many Chinese susceptible to the influence of authority figures, ranging from parents to powerful political leaders, the book was banned from bookstores and the internet in 2017. The priority for most Chinese psychologists is publishing research papers in Western, English-**language** journals, while popular accounts of psychology and the appeal of Freud to Chinese readers is evident in contemporary novels like *Feathered Serpent* (She), by Xu Xiaobin (1998).

PUBLIC ART AND TASTE (*GONGGONG YISHU/PINWEI*). Referred to as "urban **sculpture**" (*chengshi diaosu*) in the People's Republic of China (PRC), with a long history of state support for the genre, public art has, throughout the years, ranged from the beautiful and exotic to the ugly and downright bizarre. Not merely public decoration, statues and **monuments** promote political themes supportive of the Chinese Communist Party (CCP) and glorify major CCP leaders and historical events, while more artistic modes, both traditional and avant-garde, are also especially popular, along with memorials to historical figures and events from the imperial era. While official public works are subject to long-term planning and rigorous exam-ination and approval, unofficial works, mainly street art and graffiti, have popped up in major **urban areas**, for instance, **Beijing**, **Shanghai**, and **Chongqing**, with street art produced by officially approved **artists** and sculptors from "inside the system" (*xitong neibu*) and graffiti by independent craftsmen from "outside the system" (*xitong waibu*). With the commitment of the Chinese government to creating more open public spaces in the coun-try's notoriously densely populated cities of high-rise residential buildings and industrial facilities, all forms of public art have blossomed, consisting of a hybridization of Communist, **nationalistic**, and capitalist symbols and themes, both futuristic and nostalgic, growing inexorably along with the building boom since the 1980s.

Political themes dominate many outdoor sculptures, with statues of re-vered political leaders and major events from modern China including impor-tant uprisings and revolutionary actions, especially in the history of the CCP, for example, the May Thirtieth Movement (1925) in **Guangzhou**. Described as art "for the masses" (*wei qunzhong*), such exhibits include the following: Rent Collectors Courtyard (*Shouzu Yuan*), consisting of 114 life-size sculp-tures in the courtyard of a former **rural** landlord in Dayi County, **Sichuan**; Dancing for Loyal Souls (*Wei Zhongcheng de Linghun Tiaowu*), in the Lon-ghua Memorial Park for Revolutionary Martyrs in Shanghai; and the massive Monument to the Martyrs of Gele Mountain (*Geleshan Lieshi Jinianbei*), the

346 • PUNISHMENT (CHENGFA)

site of jails and execution sites of underground CCP operatives in Chongqing during the revolutionary period (1928–1949). Birthplaces of major historical figures, imperial and modern, in small cities and towns are memorialized with statues and monuments, with other national policies, for instance, the promotion of social **harmony**, embodied in two cuddly, stainless-steel panda bears in Shanghai. More artistic and aesthetically oriented works include *Blind Man Study the Elephant*, Wuhan; *Electronic World*, Shenzhen; *Huangpu Wave*, Shanghai; *Reincarnation of Mammoth*, Zhangzhou, Fujian; and *Mirrored Cloud Sculpture of Obscure Reality*, Beijing.

PUNISHMENT (*CHENGFA*). In terms of both state policy and popular belief, harsh punishment has been the norm throughout Chinese imperial and modern history, with the People's Republic of China (PRC) applying the **death** penalty for a multiplicity of **crimes**, as the annual number of executions in the country exceed all the countries throughout the world combined. Historically, imperial China, since ancient times, was known for the "five punishments" (*wuxing*), which evolved into a variety of physical penalties meted out by the **legal** system against offenders and were standardized with some of the most notorious punishments, such as castration, abolished from the Sui Dynasty (581–618) onward. Applicable to **men** only, with less severe forms for offending **women**, the five punishments, from least to most severe, were as follows: "beatings" (*chi*) on the buttocks with a light bamboo cane, ranging from 10 to 50 lashes, depending on the offense; "beatings with a large stick" (*zhang*) on the back, buttocks, or legs, ranging from 60 to 100 strokes; "penal servitude" (*tu*), including work on major infrastructure projects like the **Great Wall**, with sentences ranging from one to three years; "exile" (*liu*) to remote **regions** of the empire, for example, Xinjiang, for a term that could last a lifetime; and "death" (*si*), involving "strangulation" (*jiao*) or "decapitation" (*zhan*), with the most gruesome execution method consisting of "death by a thousand cuts" (*lingchi*), involving 8 to 120 cuts of pieces of skin, muscle, and **body** parts, with the corpse frequently chopped into small fragments so no one would claim the mortal remains. Until abolished by the Sui Dynasty, forced castration was also a form of capital punishment, for men known as *geshi* (and occasionally for women, involving extraction of ovaries and known as *youbi*), with the grand historian Sima Qian (145–86 BCE) of the Han Dynasty the most famous victim. Also gratuitously employed by the imperial state were various forms of torture, including hanging offenders by their thumbs (often from a horizontal pole), kneeling on chains, crushing of ankles, extracting blood veins from the body, and the famous dripping of water on the forehead in a slow manner (commonly known as "Chinese water torture"). Restricted to men, lesser forms of punishment were applied to offending women, ranging from the mandated grinding of grain, to sequestration, to forced **suicide** (the most severe).

Policies on punishment in the PRC varied, with efforts to mitigate the application of the most severe penalties but with retention of the death penalty, applied to nonviolent crimes, including embezzlement and **corruption**. Limits on capital punishment, which is generally carried out by a gunshot to the head, were announced in 1956, while the Chinese Supreme Court has been granted the power of review of all death penalty cases, overturning approximately 15 percent of extant cases, with the penalty banned for people older than 75. Yet, with increasing crime rates, the PRC continues to execute a large number of people annually, estimated by foreign observers at 5,000, as the actual number is considered a "state secret" (*guojia jimi*), with open-air public-sentencing hearings and a short period between conviction and execution, allowing for an ineffective appeal procedure. Academics and other liberal-minded PRC citizens have called for an end to the death penalty, as there are too many executions, with an average of 14 per day, and they are generally too swift, with some offenders executed a mere eight days after the initial conviction.

PUPPETRY (*MU'OUXI*). A traditional **art** form dating back to the Han Dynasty (202 BCE–220 CE), puppetry in the People's Republic of China (PRC) is especially popular in **rural areas**, with performances during weddings, **religious** events, **funerals**, and **banquets**. As a form of visual and theatrical **entertainment** preceding the advent of films and television, and borrowing story lines and **music** from traditional **opera**, puppetry was often performed following auspicious events to thank the **gods** for good **fortune**, with elaborate shows presented by the upper classes to show off their wealth. Composed of five members, known as "business of the five," performance troupes are headed by a master puppeteer operating as many as five puppets at a time, demonstrating a dexterity often compared to the 1,000-hand Guanyin Bodhisattva. With audiences often made up of **children** and **youth**, puppet shows provide audiences with lingering music, vivid costumes, brisk **colors**, and lively, generally humorous performances.

The four major types of puppetry include the following: marionettes on strings or wires, often performed in the open air without a curtain; rod puppets, with life-size puppets often clad in traditional robes and manipulated by three rods connected to the head and two arms moving the puppets' eyes and mouths; shadow plays, popular in the Tang (618–907), Song (960–1279), and especially Yuan (1279–1368) dynasties; and hand-manipulated glove-type puppets, largely for children, with highly crafted stages. Originally constructed of stone, most puppets are made out of leather or paper, with the images hand carved by elderly and rapidly disappearing craftsmen.

Individual puppet figures have a large head and small body, which tapers down, with a big head and square face for a man, along with a broad forehead and a tall, strong body, without being too masculine. A woman has a thin

348 • PUPPETRY (MU'OUXI)

face, small mouth, and slim body, without being too plump. Effeminacy and tenderness are the norm for Chinese **beauty**, with **scholars** dressed in long robes, exuding an elegant demeanor, while generals, in martial attire, bring to mind bravery and prowess. The design of the figures follows traditional moral evaluation and aesthetics, with **masks** indicating a figure's character. As in **Peking opera**, a red mask represents uprightness, a black mask, fidelity, and a white one, treachery. The positive figure has long, narrow eyes, a small mouth, and a straight bridge of nose, while a negative character has small eyes, a protruding forehead, and a sagging mouth. The "clown" (*chou*) has a circle around his eyes, projecting a humorous and frivolous air even before performing any act.

Reputedly created by a Daoist priest to console Emperor Wu Di (141–87 BCE) during the Han Dynasty after the death of a favorite **concubine**, shadow puppetry involves a colorful silhouette with the figures manipulated to create the illusion of a moving image on a translucent screen illuminated from behind. Conveyed in oral and written forms with 12 to 24 movable parts for each puppet, training in puppetry was based on the traditional master–student relationship, as each puppet is an amalgamation of Chinese **philosophy**, imagery, and love of **harmony**, projecting various emotions. Banned at times by Manchu rulers during the Qing Dynasty (1644–1911), puppetry also faced scrutiny in the PRC for its grassroots origins during the **Cultural Revolution (1966–1976)** but with new forms developed featuring propaganda messages supportive of the Chinese Communist Party (CCP).

Revived after the introduction of economic reforms and social liberalization (1978–1979), puppetry is performed at the China Puppet Theater in **Beijing** and the **Shanghai** Puppet Theater, with the art form supported by state funds. Subject to protection according to the Law Protecting Intangible Cultural Heritage (2011), the China Shadow Puppetry Museum is located in Chengdu, **Sichuan**, with systematic recording of scripts and performances for historical preservation. Drawing on **legends and mythology**, with themes connected to the daily lives of the common people in 30 genres, famous puppet plays include *The Five Chinese Brothers*, *Mouse and Cat*, *Smart Monkeys*, *The Secret of Lu Tai the Vase Master*, and *Turtle and Crane*, the last the first national shadow play in the PRC. Especially popular in Shanxi, Hubei, and Shandong, the genre is generally performed by local farmers in the off-season, with local folk melodies and singing styles accompanying performances.

QUESTIONS AND QUESTIONING (*WENTI/ZHIYI*). In a culture in which maintaining personal prestige and dignity, generally referred to as "**face**," constitute the basic standard by which social interaction occurs, posing questions, particularly to people in authority, is often treated as a threat to personal status. With **Confucianism** and other traditional **philosophies** taking on an epigrammatic form with the propagation of supposedly well-known truths and widely accepted social values like **filial piety**, the learning process was dominated by rote memorization and preparation for the imperial examination based on **knowledge** of the Confucian classics as the Western Socratic method of **argumentation**, emphasizing asking and answering questions, was not cultivated. Lack of an inquisitive and skeptical mindset continued following the establishment of the People's Republic of China (PRC), when under the rule by Chinese Communist Party (CCP) chairman **Mao Zedong** (1949–1976), **education** was reduced to memorization and regurgitated chanting of the *Quotations from Chairman Mao Zedong*, especially during the **Cultural Revolution (1966–1976)**.

In terms of policy-making, asking questions of top leaders, including the imperial-like Mao Zedong, was prohibited, even for top aides, as the chairman's every word was taken as law, most notably during the Great Leap Forward (1958–1960), when Mao's comment that "People's communes are good" (*renmin gongshe hao*) was quickly translated into a nationwide creation of the ill-fated rural production organs that contributed to the outbreak of the Great Famine (1959–1961).

The prevalence of quiescent and submissive attitudes is also apparent in the Chinese educational system, where in the classroom asking questions is often interpreted as "challenging" (*juyou tiaozhanxing*) the authority of the teacher, with even fellow students resenting the questioner. Figuring out problems, particularly basic ones, is considered the responsibility of the individual student, with questions to the teacher often considered too complex and too long, with no interest to others. Posing a question in public is also seen as a sign of weakness, with political leaders in the PRC shunning press conferences, although the Ministry of Foreign Affairs (MFA) has inaugurat-

350 • QUOTATIONS (BAOJIADAN)

ed the practice, while highly scripted, on a weekly basis. On a personal level, Chinese are likely to ask questions of others, which **foreigners** may find curious, on such personal matters as **age**, height, weight, **marriage**, and income.

QUOTATIONS (*BAOJIADAN*). A highly literate society ruled for centuries by "**scholar**-officials" (*rujia*), with emperors well-trained in the classics, political leaders and well-known personages are often identified with widely propagated and recognized quotations conveyed in speeches, publications, and conversations. Considered a font of **knowledge and wisdom** and drawn from great events or just ordinary experiences, most notable quotations are relatively short and taken as a guideline for various facets of life, from fighting wars to dealing with everyday problems. Major sources include the following: the ancient classics, including **Buddhism**, **Confucianism**, **Daoism**, and others; historical figures with both good and bad reputations; and modern-day cultural and especially political figures, the latter using pithy and easy-to-understand comments to strengthen their personal legitimacy in the public eye.

Confucius (551–479 BCE) was undoubtedly the most quoted, especially his extensive comments on the "gentleman" (*junzi*) and the importance of self-cultivation and learning, while he dismissed a "fellow who is ashamed merely of shabby clothing or modest means [as] not worth conversing with." "Life is really simple," the great philosopher also stated, "but we insist on making it complicated," a quotation particularly relevant in increasingly frenetic modern China. Equally relevant are quotations from Laozi (601?–531?)—"A journey of a thousand miles begins with a single step"—to Buddhism—"It is better to conquer yourself than win a thousand battles"—to the less well-known Xunzi (310–237 BCE)—"Human nature is evil." Lessons from ancient history include the quotation from Tan Daoji, a great general from the period of the Southern and Northern dynasties (386–581)—"If all else fails, retreat"—and the infamous Cao Cao (150–220 BCE) of the Three Kingdoms (220–280)—"I'd rather do wrong to others than allow them to do wrong to me."

Memorable quotations from the modern era begin with leaders of the Republic of China (ROC), with President Sun Yat-sen (1912–1925) most known for his Three Principles of the People (*Sanminzhuyi*) and for describing Chinese society as a "loose sheet of sand" (*yi pan san sha*), while declaring, "The world is for all" (*tianxia wei gong*). His successor, Chiang Kaishek (1928–1949), is also well-known for such anti-Communist assertions as proclaiming that, "The Japanese are a disease of the skin; the Communists are a disease of the heart." Cultural critics like **Lu Xun** (1881–1936) issued

memorable quotes commenting on the highly conformist Chinese social order by asserting that, "Fierce-browed I coolly defy a thousand pointing fingers. Head bowed like a willing ox, I serve the youngsters."

Proclamations from CCP chairman Mao Zedong spanning a long political career include a series of famous declarations the likes of, "Revolution is not a dinner party" (1927), "Political power grows out of the barrel of a gun" (1927), "All reactionaries are paper tigers" (1957), and "Everything under heaven is in utter chaos; the situation is excellent" (1966), with many sayings by the chairman collected into *Quotations from Chairman Mao Zedong*, the bible for Red Guards during the **Cultural Revolution (1966–1976)**. Equally voluble is the successor to Mao, Deng Xiaoping (1978–1992), whose memorable statements, some also quoted by others, include the following: "Seek truth from facts" (1978), "Let some people get rich first" (1992), and "Crossing the river by feeling the stones" (1984). For President **Xi Jinping** (2013–), his primary concerns are evident in the statement, "**Corruption** could lead to the collapse of the Party and downfall of the state." Instructions in daily life often are metaphorical, for instance, the quotation, "Three monks have no water to drink," which is understood to mean, "Too many cooks spoil the broth."

RACE AND RACISM (*ZHONGZU/ZHONGZUZHUYI*). A country where an overwhelming majority of the population is a single ethnicity, known as *Han*, named for the preeminent Han Dynasty (202 BCE–220 CE), China also has a long history of racial tensions based on racist attitudes cultivated at the elite and popular level. Characterizing the Chinese people as the "yellow race" (*huangzu*) was derived from the patrilineal notion of the Han people as descendants of the mythical "Yellow Emperor" (*Huangdi*), said to have ruled from 2691–2597 BCE, preceding the use of the term by Europeans and separating the Han from numerous **barbarians** surrounding the empire. Given great stress from the 19th century onward, during the latter years of the Qing Dynasty (1644–1911), connotations of racial purity among the Chinese, which included the ruling Manchus, became centerpieces of appeals to emerging nationalist sentiments and claims of superiority, especially against the West. Similar notions informed the **thinking** and policy proposals of early Chinese reformers and opponents of the Qing, notably Kang Youwei (1858–1927) and Zhang Binglin (1868–1936). The former proposed a hierarchical order of racial groups, from the superior white and yellow races to the generally inferior red and black races, while the latter directed **criticism** at the Qing Manchu rulers for failing to protect the pure descendants of the Yellow Emperor.

Racial discourse was also highly influential among leaders of the Nationalist Party (*Kuomintang*), with Sun Yat-sen (1912–1925) and his supporters calling for a race war between the Han majority and the Manchu minority, along with generalizations of "fit" (*shihe*) versus "unfit" (*bushihe*) racial groups. Fed by the growing popularity among educated circles of such pseudosciences as craniology and distorted interpretations of "genetics" (*yichuanxue*) strengthened by Social Darwinist influences from works from the likes of Herbert Spencer, a perpetual struggle for survival was foreseen between lighter- and darker-skinned peoples, as notions of race were rooted in **nature** by equating social groups with biological units. Adopting the focus on **class** in Marxist–Leninist ideology, Chinese Communist Party (CCP) leaders linked racist themes to Western imperialism and asserted the **legal**

354 • REGIMENTATION (LEIBIE)

equality of all peoples in the People's Republic of China (PRC) but with notions of Han superiority affecting state policies toward **minorities**, especially dissident **religious** groups in **Tibet** and Xinjiang.

Despite declarations of "racial solidarity" (*zhongzu tuanjie*), especially with exploited Third World countries, racialist views impacted PRC international policies, with preferences shown for monocultural countries over highly racially diverse ones, with some poor countries, especially in Africa, seen as being in need of Chinese leadership because of their reputed childlike qualities. Racist attitudes prevail against some groups, particularly Japanese, whom Chinese often refer to as "devils" (*gui*) and "little Japanese," while demonstrations against black African exchange students broke out among Chinese students in Nanjing (1988–1989). Racial tensions between Chinese and Africans are also evident in cities with large foreign populations, for example, **Guangzhou**, with racism more common in remote areas than large **urban** centers, as darker skin is generally associated with less favorable personal traits.

While racism is essentially considered an Western phenomenon, after long years of international isolation of the PRC during the period of rule by CCP chairman **Mao Zedong** (1949–1976), economic globalization has apparently reinforced traditional notions that being Chinese is primarily a matter of biological descent and "blood purity" (*xieye chundu*). Effectively rejecting the view of all of humanity having a common descent originating in Africa, Chinese anthropologists and **archaeologists** have sought to locate the earliest human origins and a separate strain, in East Asia not Africa. In the Chinese **language**, the word *zu* is used for both lineage and race.

REGIMENTATION (*LEIBIE*). Defined as the strict control of the way a group of people behave and think or the way something is done, regimentation has been a central feature of life in the People's Republic of China (PRC) in **education**, the **workplace**, and even everyday social life, especially during the rule of Chinese Communist Party (CCP) chairman **Mao Zedong** (1949–1976). In schools, as well as in agricultural production teams and factory production lines, individual actions and behaviors were subject to an overweening system of **monitoring and surveillance**, with great emphasis via propaganda organs on dictating **thinking**, especially of the educated classes. With the military often held up as a model of **discipline** and uniform behavior, social regimentation peaked during the "everyone a soldier" (*mei geren dou shi shibing*) campaign during the ill-fated Great Leap Forward (1958–1960), followed by the **Cultural Revolution (1966–1976)**, with demands for total obedience to the vagaries of "Mao Zedong Thought" (*Mao Zedong Sixiang*).

Most evident is the extraordinary regimentation in Chinese education, from preschool onward, where virtually every aspect of student life, from study, to classroom behavior, to playtime, are strictly regulated by the teacher, with little or no spontaneity or creative imagination on the part of students encouraged or allowed. With the teacher "governing" (*guan*) student behavior and thinking, classroom décor calls for students to sit up straight in chairs, arms folded behind their backs, staying perfectly quiet as the teacher lectures, while early morning marching and calisthenics in straight lines make schools more like an army base than an institution for cultivating creativity. More broadly, Chinese society has traditionally embraced a belief that **food** and other necessities can only be obtained by regimentation, with excessive **freedom** leading to unbridled "**chaos**" (*luan*).

Following the introduction of economic reforms and social liberalization (1978–1979), a growing **individualism** and self-aspiration has gradually replaced the collectivism of the past, especially among the emerging middle class and aspirational **youth**. Countering this trend are the efforts of President **Xi Jinping** (2013–) to reimpose bureaucratic controls of **social media**, the internet, and freedom of speech in general, with public opinion described as the "throat and tongue" (*houlong/shetou*) of the CCP singled out for enhanced regulation. Along with greater controls on both domestic and foreign nongovernmental organizations (NGOs), the Xi administration has also enacted an enhanced National Intelligence Law (2017), putting the government more on "offense" (*zuixing*), enlisting greater roles for the public in blunting negative influences, both domestic and foreign.

REGIONS (*DIQU*). Divided along geographical, economic, and historical lines, regional subcultures developed in China throughout the centuries, with the largest difference between the wheat-growing areas of the north and rice paddy areas of the south, with the Yangzi River serving as the border. Despite an overwhelming majority of the Han ethnicity constituting 90 percent of the total population, Chinese culture is far from monolithic, with northerners, given the nature of wheat cultivation, more **individualistic** and self-inflationary, and southerners reflecting the collective labor demands of wet-rice agriculture, possessing a more holistic mindset and a greater sense of group orientation and **dependency**, with major linguistic divisions between Mandarin- and Cantonese-speaking populations. Spatialized cultural identities were shaped throughout time by individual dynastic groups, beginning in the Bronze Age under the Shang (1600–1046 BCE) and extending into subsequent and highly diverse imperial regimes from the Tang (618–907) and Song (960–1279) dynasties to the territorially expansive Qing Dynasty (1644–1911). Contacts with the outside world shaped regionally specific subcultures, especially along eastern coastal and **urban areas** of great West-

356 • REGIONS (DIQU)

ern influence since the 19th century, including Christian missionaries, and in western and southwestern regions, where interactions with Southeast Asian and Central Asian societies had a major impact on the local cultures.

Major regional cultures in the People' Republic of China (PRC), largely defined along geographical lines, with differences in local economies, **cuisines**, and presence of **minority** nationalities, include the following: the Northeast (*Dongbei*), historically known as Manchuria, constituting the four provinces of Jilin, Liaoning, Heilongjiang, and eastern Inner Mongolia, with heavy Han in-migration since 1949, and an economic base of heavy industry; the North China Plain (*Huabei Pingyuan*), constituting all or parts of five provinces, including Henan, Hebei, and Shandong, and northern regions of Jiangsu and Anhui, heavily agricultural, with isolated villages surrounded by fields and local life shaped by the **riverine** culture of the Yellow River; the Loess Plateau (*Huangtu Gaoyuan*), concentrated in Shanxi, Shaanxi, and eastern Gansu provinces, along with parts of the North China Plain, including substantial interactions with non-Han nomadic peoples and trade ties along the historic **Silk Road**; the Northwest (*Xibei*), concentrated in the four provinces of Gansu, Inner Mongolia, Ningxia, and Xinjiang, and consisting of heavily desert, wasteland, grassland, and **mountainous** areas generally sparsely populated, with few cities and substantial minority populations, including Muslims; South-Central (*Zhongnan*), concentrated in the provinces of Anhui, Henan, Hubei, **Hunan**, Jiangsu, Jiangxi, and Zhejiang, and such major cities as **Shanghai** and Wuhan, with many rivers and lakes, shaping local lifestyles in densely populated and economically prosperous areas; **Maritime** and the Southwest, concentrated in the five provinces of Fujian, Guangdong, Guangxi, Hainan, and Zhejiang, with **tea** and rice production, and the country's richest areas in the Pearl River Delta, with heavily minority cultures of Min, Yao, She, Li, and Zhuang peoples; the Southwest (*Xinan*), concentrated in the culturally distinctive regions of Guizhou, **Sichuan**, and **Yunnan**, with large minority populations, including in the major cities of Dali and Lijiang; and the Qinghai–Tibetan Plateau, with highly unique cultures strongly influenced by **Buddhism**, along with a hostile environment.

Aware of the need to maintain the country's many regional subcultures, the Chinese government has established a policy of "state reserves of cultural ecology," 21 in number and begun in 2009, with attention aimed at preserving threatened subcultures and minorities, for instance, the Hakka and Qiang ethnicities. Also applied to the PRC is the concept of "cultural tightness," namely the degree to which a society is characterized by rules and norms, and the extent to which people are punished for deviance, indicating the level of constraints on daily life. Contrary to most international studies indicating higher levels in generally conservative **rural areas**, in the PRC the highest levels of cultural tightness exist in urban and generally wealthier areas, including cities like Shanghai and **Guangzhou**. Politically, the interior regions

of China present themselves as the true, organically pure expression of Chinese culture as opposed to coastal and peripheral regions, strongly influenced by cosmopolitan values and beliefs, particularly from the West and Japan.

RELATIONS AND CONNECTIONS (*GUANXI*). A crucial system of beliefs and behavioral expectations within a broad social network generally involving mutual obligations, reciprocity, and trust, relations and connections play a major role in virtually every aspect of Chinese life, from **family** to **business** to politics. Closely related to other major concepts and notions influencing Chinese social behavior, for example, "in-debt feelings" (*ganqing*), "**face**," **filial piety**, **loyalty**, and **empathy**, personal relations were a major focus in **Confucianism**, with social networks developed throughout time all through the social order to protect the Chinese people from capricious and arbitrary rulers, as the idea of inalienable rights was virtually nonexistent.

Building and maintaining good relations and ongoing connections with family, former classmates, coworkers, and people of the same provenance is often the key to getting things done, especially when navigating the complex web of official bureaucracies and working around a system where adherence to abstract rules and regulations prove totally ineffective. With obligations and social debts lasting a virtual lifetime, failure to return a favor constitutes a major moral transgression, leading to a bad and largely irrecoverable personal reputation. Good personal relations can often overcome major obstacles to moving the government or corporate machinery by offering access to key decision-makers and greasing the wheels of **bureaucratic** routine.

Possible drawbacks include a tendency toward **corruption**, including bribery, nepotism, and loss of meritocratic standards, with a never-ending cycle of favor-for-favor involving such unethical abuses as the buying and selling of positions, trumping civic and professional duties. Varying in importance by business sector, geography, generation, and level of **education**, networks of personal relations persist in the People's Republic of China (PRC), including within elite levels of the Chinese Communist Party (CCP). These same networks provided crucial protection to potential victims of the **violence** perpetrated during the chaotic **Cultural Revolution (1966–1976)** and have served to advance **commercial** transactions in the period following the introduction of economic reforms and social liberalization (1978–1979).

RELIGION (*ZONGJIAO*). Historically a cradle and host to many religions, and the site of episodic antireligious movements, religious practices in China have garnered both state support and persecution in the imperial era and during the People's Republic of China (PRC). Major religions, as a percentage of the total population, are **Buddhism** (10–16), **Daoism** (10), **Christian-**

358 • RELIGION (ZONGJIAO)

ity (2.4), Islam (1.6), and various forms of folk religions (3–13), with Christianity officially divided between Protestants and Catholics, while the small number of Chinese **Jews** are not officially recognized. Several religious orders considered disruptive have been banned by the Chinese government, including Falun Gong (1999) and the Church of Almighty God, also known as Eastern Lighting, with government oversight primarily by the State Administration of Religious Affairs, including direct management of such religious organizations as the Larung Gar Buddhist Study Center in **Sichuan**. Total believers in the PRC are estimated between 100 and 370 million, with the lowest number provided by the Chinese government and the higher by foreign religious organizations, as the ruling Chinese Communist Party (CCP) is officially **atheist**, with members prohibited from engaging in any religious activities.

After being downplayed in favor of secular **Confucianism** during the Qing Dynasty (1644–1911), religion was subject to withering attacks as a **superstition** during the New Culture Movement/May Fourth Movement (1917–1921), with major antireligious movements against Buddhism and Daoism by the proto-Christian Taiping rebels (1850–1864), and against Christians during the antiforeign Boxer Rebellion (1899–1901). Assaults on Christian missionaries and their Chinese converts also occurred in 1923, with church steeples seen as disruptive of local **fengshui**. Both presidents of the Republic of China (ROC), Sun Yat-sen (1912–1925) and Chiang Kai-shek (1928–1949), were Christians, with the latter converting on the advice of his Christian wife, Soong May-ling (1898–2003), as local "folk religions" (*minjian zongjiao*) were subject to considerable harassment by ROC authorities, with many religious **temples** seized and converted into schools.

With religion characterized as "feudal" (*fengjian*) in Marxism, following the establishment of the PRC in 1949, religious practice was restrained, although tolerated within limits, by many local officials, as religious practice was conducted through state-sanctioned churches. Major conflicts involved Chinese government opposition to the Vatican's appointment of Catholic bishops in the PRC, which festered for 30 years, with many Chinese Catholics joining underground churches, finally resolved in an agreement between the PRC and the Holy See in 2018. Subject to assaults and disruption during the chaotic **Cultural Revolution (1966–1976)**, religious practice revived with the introduction of social liberalization (1978–1979), with religious **freedom** guaranteed in the state constitution (1978) but with the requirement that all religions follow "normal practices."

During the administrations of presidents Jiang Zemin (1989–2002) and Hu Jintao (2003–2012), the growth of Buddhism was "passively supported" in the name of China's "peaceful rise" (*heping jueqi*). Folk religions have also revived and are subject to state protection according to the Law Protecting Intangible Cultural Heritage (2011), with the annual worship of the **god**

REST AND RELAXATION (XIUXI/SONGCHI) • 359

Cancong conducted at the ancient shrine of Sanduixing in Sichuan, while new folk gods have been invented, notably a "motor vehicle god" (*cheshen*). Granted the right to own property, publish literature, and train and approve clergy in 2018, religious organizations are required to register with the state, as the Chinese government remains deeply ambiguous about the growth of religious groups, especially Lamaist Buddhism in **Tibet** and Islam in the Xinjiang-Uighur Autonomous Region (XUAR), which remain frequent targets of state harassment and religious persecution.

REST AND RELAXATION (*XIUXI/SONGCHI*). A major concern of ancient Chinese **philosophy**, adequate rest and relaxation have become increasingly prominent topics in the frantic, stressed-out lives of **urban** residents in the People's Republic of China (PRC). For both **Confucianism** and **Daoism**, living a relatively free and leisurely life was key to achieving peace and **harmony**, with the former stressing the importance of good governance and the latter emphasizing cultivation of a natural unoccupied spirit unencumbered by excessive talk, thought, and **food**. Ancient remedies for undue stress and tension included such physical activities as "Tai Chi" (*taiqiquan*) **exercise**, described as "meditation in motion," with gentle motions and free-flowing postures, and regular foot massage, believed, according to **traditional Chinese medicine (TCM)**, to conduct "**energy**" (*qi*) from the earth to crucial organs in the **body**, most importantly the heart and liver. Acupuncture and daily "meditation" (*mingxiang*), the latter also promoted in **Buddhism**, are additional remedies, along with the consumption of special valerian root and chrysanthemum **tea**.

With the pace of life quickening after the introduction of economic reforms and social liberalization (1978–1979), most notable with "996" work schedules, 9 AM to 9 PM, six days a week, Chinese have sought out new venues of rest and relaxation. Especially popular for average income earners is a walk in the park with spouse and/or **pet**, along with listening to soothing **music**, most popularly the Zen-healing bamboo flute or the calming ring of **Tibetan** bells. Along with wellness centers located in such tranquil surroundings as the Summer Palace outside **Beijing**, Chinese cities known for their generally relaxed environments of pleasant landscapes, **gardens**, and waterways include the following: Suzhou, Hangzhou, Xiamen, Zhuhai, Lhasa, and Sanya, the last on Hainan Island. Also valued as leisure time for parents is spending time outdoors with young **children** to "soak up sun" (*sai taiyang*), while for the elderly **dancing** and playing board **games** are major sources of leisure, also in parks. A "rest hour" (*xiuxi shi*) has also been established at the **workplace**, taken after lunch, mainly in Southern China.

360 • RITUALS AND CEREMONIES (LIJIE/YISHI)

RITUALS AND CEREMONIES (*LIJIE/YISHI*). Known throughout history as a state of etiquette and ceremonies, China has a strong tradition of elaborate rituals, which serve as the vessels of cultural expression and meaning. Required of the emperor on multiple occasions, rituals and ceremonies extend to the broader society, especially during important events, from births to coming-of-age ceremonies for young **men** and **women** to weddings. Important national ceremonies and celebrations were also established during the period of rule under the Republic of China (ROC) on the mainland (1912–1949) and following the establishment of the People's Republic of China (PRC) beginning in 1949.

A centerpiece of traditional Chinese **philosophy**, imperial practice, and guidance for daily life of elite and commoners alike, rituals and ceremonies can be traced from ancient times to the present, with China dubbed a "state of ritual courtesy" (*lijie zhuangtai*). Historically, ritualized practice and elaborate ceremonies, especially for the emperor, can be traced to the ancient Zhou Dynasty (1045–256 BCE) and were a major theme in **Confucianism**, promulgated in such prominent philosophical tracts as the *Rites of Zhou* (Zhou Li) and the *Classic of Rituals* (Lijing). Virtually every aspect of Chinese society was governed by ritualistic expectations and standards, including the **arts**, **customs**, laws, **literature**, politics, and **religion**, as the emphasis on formalities and proper behavior were considered essential to appeasing the general population and stabilizing society. Rituals governed every important stage of life, from birth to **marriage** to mourning the dead, with important coming-of-age observances for both men and women, as capping and hair-pinning ceremonies are held at ages 20 and 15, for the former and latter, respectively. Passed down through the generations, rituals constituted an elaborate code of conduct for the Chinese people to engage in interpersonal relations, distinguish right from wrong, resolve disputes, and express piety and sobriety, in effect separating humans from **animals**.

A major responsibility and function of the emperor and the imperial household, rituals and ceremonies evolved throughout the dynastic era and involved such major religious–political observances as the worship of "heavenly bodies" (*tiandi*), conducted on the winter solstice and aimed primarily at the "Supreme God" (*Shangdi*), ruler of the universe, with the emperor as the earthly embodiment. Worship to "mother earth" (*dadi muqian*) was also conducted on the summer solstice and originally involved human sacrifice, which, criticized by Confucius (551–479 BCE), was abolished during the Han Dynasty (202 BCE–220 CE). Other major ceremonial acts included ancestral rituals, as the emperor was accorded seven ancestral temples, the most for anyone, with "**scholar**-officials" (*rujia*) accorded three temples, along with worship of ancient "master sages" (*shengxian*). Included were the Duke of Zhou (11th century BCE), lauded for his opposition to **corruption** and refusal to accept a high administrative post, and especially Confucius,

RITUALS AND CEREMONIES (LIJIE/YISHI) • 361

for whom ceremonies were performed annually from the Tang Dynasty (618–907) onward. Temples and imperial colleges dedicated to the great philosopher and his teachings were established during the Ming (1368–1644) and Qing (1644–1911) dynasties, with ceremonial sites in buildings, notably the Temple of Heaven in **Beijing** and the Giant Wild Goose Temple in **Xi'an**, formerly known as Chang'an and the imperial capital of the Han and Tang dynasties.

Among the major sites for important imperial ceremonies in Beijing was the Hall of Supreme Harmony, located on the central axis behind the Gate of Supreme Harmony in the **Forbidden City**, where important events were held, including enthronement, weddings, and Grand Audiences with imperial officials, many from outlying provinces. Equally important was the "Temple of Heaven" (*Tiantan*), a complex of religious buildings and altars where twice yearly, the emperor, having abstained from eating meat, would come dressed in special ceremonial robes and, in public, perform a series of prostrations and praying to heaven for good harvests. The high point was the ceremony on the winter solstice of the lunar calendar, when every imperial act had to be perfect, as the smallest mistake constituted a bad omen for the coming year.

Overseeing imperial rituals was the Ministry of Ceremonies (*Taichang Si*), also known as the Ministry of Rites during the Sui (581–618) and Tang (618–907) dynasties, headed by a Grand Master of Ceremonies, responsible for state ceremonies involving the Cult of Confucius and the Imperial Cult, along with proclamations of imperial edicts, as nothing was left to chance. Strict ceremonial rules and regulations also governed imperial **banquets**, particularly for emissaries of tributary states, codified during the reign of Emperor Qian Long (1735–1796).

At the popular level, important ceremonies included several following the birth of a child, at three days" (*sanzhao*), "one month" (*manyue*), and "100 days" (*bairi*), with coming-of-age ceremonies at age 15 for women and 20 for men. The former involved hair-pinning and the creation of a large bun, indicating the female was available for marriage, with the latter consisting of a capping ceremony, indicating male entry into adulthood. Ceremonies were also an important aspect of weddings, with the bride wearing a traditional red cloth and the couple bowing three times to their parents, and a host of ceremonial acts at the wedding banquet. **Funeral and burial customs** also entailed ceremonies, with rituals becoming increasingly elaborate for the higher nobility, while ceremonial aspects were also an important component of the **tea culture**, especially from the Tang Dynasty onward.

Everyday life governed by rituals covered a range of common activities, with some of the guidelines quite elaborate, and many, but not all, gradually abandoned in the modern era. In a collectivist, group-oriented society, social contacts involved several dos and don'ts applying to proper stance, posture,

362 • RITUALS AND CEREMONIES (LIJIE/YISHI)

and sitting, with strict rules governing interactions between males and females, especially in a public setting. Rules also prescribed proper ways of walking, traditionally known as *qu*, particularly for people of lower status, who were to hang their heads, bend their waists, and take short, quick steps as a way of showing respect to a superior and/or elderly person, for whom the middle of a walkway was reserved. Personal greetings entailed showing concern for another person by inquiring about their **health**, social life, and even income, and expressing personal praise and compliments on appearance, which **foreigners** often find off-putting. While all Chinese employ **chopsticks** as the primary **eating** utensil, special versions made of valuable gold and ivory were restricted for use by the imperial household and noble families, along with other rare and expensive materials, including various animal skins, reserved for only a few. As for sleeping, general prescriptions called for "sleeping in a bow-like stance," avoiding stretching out or sleeping facedown.

With the collapse of the Qing Dynasty, imperial practices were criticized extensively, especially during the culturally iconoclastic New Culture Movement/May Fourth Movement (1917–1921), as many traditional rituals and ceremonies, especially for commoners, were cast aside, along with the defunct imperial performances. Nationalistic observances performed by ROC leaders included, most notably, honorary remembrances at the Sun Yat-sen Memorial Hall in Nanking following the passing of Sun Yat-sen in 1925, with President Chiang Kai-shek (1928–1949) appearing for ceremonial occasions accompanied by an entourage of Nationalist army officers and trainees. Retreating to the island of Taiwan following defeat in the Chinese Civil War (1946–1949), **ancestral** worship and other traditional ceremonies were revived under President Chiang Kai-shek (1950–1975).

In the PRC, flag-raising ceremonies are carried out on National Day, 1 October, and the first day of every month by a special detachment of the People's Liberation Army (PLA). National meetings of the National People's Congress (NPC) and the congresses of the CCP also have a strong ritualistic and ceremonial atmosphere, with highly scripted, long speeches methodically given by top leaders, with equally methodical audiences and preordained, unanimous votes given by the Confucian-like attendees. Equally ritualistic and ceremonious are the National Day parades and speeches, with nothing left to chance, the only exception occurring in 1989, when student parade marchers carried signs of personal greetings for paramount leader Deng Xiaoping, who one month later would order in the army to crush the prodemocracy movement.

RIVERINE AND MARITIME TRADITIONS (*HELIU/HAISHANG CHUANTONG*).

Traversed by three major river systems with thousands of tributaries and a coastline of 14,500 kilometers (9,010 miles), China has strong riverine and maritime traditions, although the latter was periodically downplayed, especially during the imperial era. Considered one of the great riverine civilizations in world history, along with Mesopotamia and Egypt, the Yellow River (*Huanghe*) basin in the north was the cradle of early Chinese civilization, with the Yangzi River, literally "long river" (*changjiang*), shaping the social life and economy of Central China, notably the port city of **Shanghai**, and the Pearl River (*Zhujiang*) having an equally major impact on the south, especially in Guangdong and the capital city of **Guangzhou**. With riverine traditions generally characterized as inward-looking and built on the aching backs of peasant labor, such negative cultural and economic forces were countered by the empire's outward extension involving **exploration** of the seas and global interaction from the Tang Dynasty (618–907) onward, peaking during the maritime expansion by Admiral Zheng He (1371–1433) and his massive fleet of 10-masted ships to India and the east coast of Africa in the early 15th century, during the Ming Dynasty (1368–1644).

The core of the riverine tradition in China is the Yellow River, 1,900 kilometers (1,080 miles) in length, flowing from west to east through nine provinces, so named for its heavy load of yellow silt and known as the "mother river" (*muqin he*) for its enormous impact on the development of Chinese civilization during a period of 4,000 years. With the Chinese people characterized as the "children of the Yellow River" (*Huanghe haizimen*), the waterway had major influence on the **arts**, including **painting** and **poetry**, while providing a primary source of water for agriculture and, more recently, electrical power, through the construction of numerous dams and water-control projects. Also referred to as "China's sorrow" (*Zhongguo de beishang*) for its frequent floods, along with periodic dry-ups leading to regional droughts, the Yellow River came to symbolize the spirit of grittiness, industriousness, and assiduity characterizing the Chinese people but was also blamed for their parochialism and closed-minded conservatism, as emphasized in the popular film *River Elegy* (Heshang), produced in 1988. For political leaders, beginning with the mythical "Yu the Great" (*Da Yu*) and extending into the People's Republic of China (PRC), managing the frequently disruptive river required the building and maintenance of massive waterworks and control projects, including a massive system of dikes. Similar challenges were posed by the Yangzi River, the longest river in China, with its enormous water volume threatening massive flooding of productive farmland and major cities but also serving as a major trading route linking the Chinese interior up to **Chongqing** in the west to Wuhan in Central China and Shanghai on the coast.

364 • RIVERINE AND MARITIME TRADITIONS

According to the "hydraulic hypothesis," promoted most notably by historian Karl Wittfogel (1896–1988), the need for highly integrated irrigation and flood-control systems led to the creation of a powerful administrative state capable of coordinating massive labor forces over great distances, which may explain the unending pattern of political centralization in China from imperial times to the PRC. Cities, towns, and villages along all three rivers, including the Pearl, and the approximately 28,000 tributaries and branches, are profoundly affected by river life in various aspects. These include work (especially the vibrant freshwater fishing industry), **food, entertainment**, and **legends and mythologies,** the latter leading to such major **festivals** as those involving famous dragon boat races.

From the creation of the Maritime Silk Road beginning in the Western Han Dynasty (202 BCE–9 CE), global interaction and trade, particularly in the South China Sea, became an important but episodic element of maritime traditions, as the major threats to the empire came from the land more than the remote seas. Considered virtually impregnable with a large land mass, China broke off major exploration and trading regimes, especially during the Ming and Qing (1644–1911) dynasties, only to be subject to **conquest** from the seas by the West and Japan. While the maritime tradition throughout the centuries had less of a cultural impact on Chinese values and beliefs, cities with strong trading traditions, for example, Ningbo, Zhejiang, have established such facilities as the Ninghai Maritime Museum, while the PRC now maintains the largest freshwater and oceangoing fishing fleet in the world.

ROMANCE AND LOVE (*LANGMAN/AIQING*). An enduring theme in contemporary Chinese **literature** and the **arts**, including **films**, romance and love were diminished and even shunned in traditional **philosophy**, especially **Confucianism**, and during the People's Republic of China (PRC) under the puritanical rule of Chinese Communist Party (CCP) chairman **Mao Zedong** (1949–1976). Revived following the introduction of economic reforms and social liberalization (1978–1979), an idealization of romantic involvement and intimacy has occurred, with primary focus on the "attraction" (*xiyinli*) phase of "falling in love" (*tan liang ai*). For writers and film producers, romance is presented as a "magical" (*shenqi*) moment, with love seen as something fragile that is easily lost, causing enormous personal anguish and pain. Chinese love tales convey the implicit value of the romantic experience, glorifying the positive qualities of love while highlighting the frequent occurrence of crushes and broken hearts, as opposed to the satisfactions and **happiness** produced by companionship and stable marital relationships.

Historically, political and intellectual elites frowned upon romantic intimacy, with Confucius (551–479 BCE) counseling self-control and restraint, while noting the importance of relationships between **women** and **men** in creating a **harmonious** society. Discouraging romantic relationships between

RULES AND REGULATIONS (GUIZE/GUIDING) • 365

spouses, traditional conventions treated public affection by a husband for the wife as a sign of weakness, even as ancient Chinese literature was filled with stories of electrifying "love at first sight" (*yijian zhongxing*) and "erotic bliss" (*seqing xingfu*). Warnings against pushing the line of passion too far were also issued, as the result could end in a **marriage** to an evil "fox spirit" (*huli jingshen*), namely a woman, according to Chinese **legend**, magically transformed from a fox and seductive on the outside but devious on the inside. During the era of Republic of China (ROC) on the mainland (1912–1949), the realities of romantic love were openly acknowledged, with one of the first feature films, *Laborer's Love* (Laogong zhi Aiqing), also known as *Romance of the Fruit Peddler* (1922), dealing in a comedic fashion with a troubled love affair.

Following the establishment of the PRC, romantic love was largely ignored, as the population, particularly **youth**, was encouraged to embrace revolutionary action and socioeconomic transformation but with secret and highly discreet love interests occurring even among Red Guards during the **Cultural Revolution (1966–1976)**. While love stories have filled magazines and other media since 1978–1979, puritanical opinions and views still inform CCP leaders, who routinely denounce the **obsession** with romance and love affairs as silly and counter to the larger interests of society, warnings generally ignored by "those in love." At the same time, tragic love stories routinely pop up, for instance, the case of a 13-year-old girl who, prevented by her grandmother from pursuing a love interest, died from drinking poison. As universities offer so-called romance courses instructing students on how to get along with the opposite sex, popular story lines include the traditional tale of the "phoenix man marrying a peacock woman" (*fenghuang nanzi jia kongque nüren*), the former from the countryside and the latter from the city. Popular Chinese romance films, among many, include *A Love So Beautiful*, *Love 020*, *Memory Loss*, *My Amazing Boyfriend*, and *Meteor Garden*.

RULES AND REGULATIONS (*GUIZE/GUIDING*). Governed according to the principle of "rule by man" (*renzhi*), with emperors and other political leaders, for example, Chinese Communist Party (CCP) chairman **Mao Zedong** (1949–1976), granted near-absolute lawmaking authority, since the late 1970s the People's Republic of China (PRC) has engaged in a virtual frenzy of rule-making and enhanced regulatory guidance covering multiple areas of the economy and society. Aimed at providing greater certainty and clarity to **business** and in the political arena, the emergent regulatory regime is also designed to reign in socially destructive behavior unleashed by the introduction of economic reforms and social liberalization (1978–1979), especially among **children** and **youth**, and for the protection of the elderly. Also targeted for greater state control is new technologies, especially the internet,

366 • RUMORS (CHUANWEN)

along with **social media**, which by providing opportunities for more open interaction and less subject to **censorship** have the potential for generating unwanted political and social transformations.

With Chinese society becoming increasingly fragmented by rapid social and economic change, undermining the cohesion of the traditional **family**, social obligations and protections have been strengthened for both the young and elderly. Exhibiting a new version of Confucian "benevolence" (*ren*) amid growing concern with addiction by youth to video **games**, regulations call for limiting playing time to 90 minutes on school weekdays and no later than 10 PM. Grown children are also now required to visit their **aging** parents and grandparents on a regular basis, avoiding the isolation that has occurred among too many of the country's elderly, with particular attention to caring for the "**spiritual** needs of the elderly." As enforcement and specified times for these obligations have not been enunciated, such regulations are considered a form of educational messaging more than **legal** obligation. In the same spirit, with high mortality rates among pedestrians and cyclists in major cities where traffic has taken on the form of demolition derby, children walking the streets of major cities in some provinces have been instructed to salute oncoming vehicles as a way to ensure they are spotted by often-distracted drivers.

On the economic front, local government officials have been encouraged to visit advertised historical and **entertainment** sites to boost tourism and buy locally produced goods to bolster local economies. Given the flush of new advertising in print and on media, **celebrities** have been warned that there are legal consequences for endorsing products with false and misleading ads, as regulations now provide a range of consumer protection, notably **food** safety and tobacco control. Other areas of economic activity also subject to greater regulation include cybersecurity, data protection, banking, and foreign investment, along with a slew of regulatory guidance on the environment, maligned after decades of deterioration and abuse. Cultural controls also target films and journalism, both domestic and foreign, and increasingly popular but politically sensitive **religious** groups, for instance, Falun Gong, especially those with foreign ties.

RUMORS (*CHUANWEN*). A society often lacking in transparency with an absence of free-flowing information by governments from the imperial era to the current People's Republic of China (PRC), rumors and "rumor-mongering" (*sanbu yaoyan*) are rife, with people seeking out alternative sources of information, as official sources are treated with distrust and outright contempt. Relying on new modes of **communication**, especially **social media** and the internet, notably online forums and Weibo sites, along with such recent technologies as **smartphones** and mobile telephone apps, the rumor mill has proliferated, turning China into a virtual "People's Republic of

RURAL AREAS AND RURAL LIFE (NONGCUN SHENGHUO) • 367

Rumors" (*Renmin Chuanwen Gongheguo*). While offering the Chinese public multiple and alternative sources of information, both true and tainted, and providing the basis of a grassroots resistance to an authoritarian state, deleterious effects include triggering mass incidents and outright **panics**. Most rumors emerge as a channel of unofficial communication circumventing the heavy reliance by the Chinese government on **censorship** and generally involving close-knit networks of individuals and groups less susceptible to government intrusion.

In the eyes of Chinese authorities, rumors are false and fabricated disinformation often promulgated at the behest of usually unnamed "foreign forces" (*waiguo budui*) and no different in their deleterious effects on society from **pornography**, **gambling**, and **drugs**. Reenergized by advanced technologies, rumors have become a new-style political weapon with an ultimate goal of undermining the authority and legitimacy of the Chinese Communist Party (CCP). Surveillance and investigation of rumors and rumor-mongering have been stepped up, with antirumor laws and regulations enacted (2006 and 2013), making anyone intentionally posting rumors downloaded more than 500 times subject to detention and arrest. With the actual **legal** definition of what constitutes a "rumor" remaining vague, the arrest of individuals, some quite young, on such charges as "picking fights and stirring up trouble" have resulted not in prosecutions, but in authorities ultimately dropping the charges. This occurred most recently in the central Chinese city of Wuhan with doctors and other health professionals, who having alerted the public on the impending danger of COVID-19 were accused of "rumor-mongering," only to be subsequently released, although one of the doctors, Li Wenliang, passed away. The widely publicized tragedy led to widespread popular demands for the Wuhan municipal government to issue a formal **apology**, even as antirumor regulations remain on the books.

See also ENTERTAINMENT (*YULE*).

RURAL AREAS AND RURAL LIFE (*NONGCUN SHENGHUO*). Constituting approximately 40.85 percent of the total population, with standards of living generally below the more prosperous and populated **urban areas**, rural areas in the People's Republic of China (PRC) have become increasingly diverse with enhanced contacts with the outside world, including vital rural **markets**. A major political base of the Chinese Communist Party (CCP) during the revolutionary period from the 1930s onward, the Chinese countryside has been a primary target for transformative policies of the social and economic order, and the site of considerable economic growth, along with serious human catastrophes. Major policy initiatives pursued during the PRC dramatically impacting rural life began with land reform (1947–1953), which redistributed agricultural land ownership and eliminated landlords as a social **class**, although "surplus" land holdings were relatively small. The

368 • RURAL AREAS AND RURAL LIFE (NONGCUN SHENGHUO)

formation of production teams and brigades was implemented in the country's approximately 900,000 villages, with a focus on expanding the availability of electric power, clean water, and a transportation infrastructure.

Serving as a target of social, economic, and technological experimentation during the Great Leap Forward (1958–1960), rural life was upended by the creation of giant rural "people's communes" (*renmin gongshe*), aimed at integrating several villages into a single production unit, along with highly polluting and generally ineffective "backyard furnaces" (*xiaogao lu*) for the production of steel. Along with irrational agricultural practices actively promoted by CCP chairman **Mao Zedong** (1949–1976), including deep plowing and close planting of crops, grain production of wheat and rice dropped precipitously, even as statistically flawed official data indicated substantial production increases. The resulting Great Famine (1959–1961) cost an estimated 30 million lives, most in isolated and self-contained villages where connections with vibrant rural markets had been severed and social mobility severely restricted.

Recovery occurred gradually in the 1960s, with state intervention and control substantially reduced, as the countryside, perceived by Mao Zedong as receiving fewer benefits than the privileged urban areas from the revolution, assumed a new role of "reeducating" (*chongxin jiaoyu*) intellectuals and **youth** "sent-down to the countryside" (*xiaxiang*). A centerpiece of government policy, especially during the **Cultural Revolution (1966–1976)**, participants included future president **Xi Jinping**, who spent years in rural Hebei, sometimes living in a cave. The overall impact of CCP policies on rural areas during the Maoist era was to increase the closed, corporate quality of village life, with greater political and ideological integration between state and rural society.

With the introduction of the Agricultural Responsibility System under the leadership of Deng Xiaoping (1978–1992), effective control of and responsibility for production decisions were returned to the household, as the entire system of collectivized agriculture was dismantled, with township–village enterprises (TVEs) created to bolster rural industrial and commercial production, along with the elimination of agricultural taxes. While inequality between countryside and city remained problematic, as income in the former averages only one-third of the latter, some rural areas, especially in the south and located near major cities, approached urban levels of prosperity, with the poorest rural areas located in the northwest and western **regions** of the country.

A major source of migrant labor in the cities known as the "floating population" (*liudong renkou*), poor rural areas also suffer from a loss of young people lured to jobs and a better lifestyle in the cities, even as such amenities as cell phones, motor vehicles, television, washing machines, and, most importantly, paved roads and better housing become increasingly avail-

RURAL AREAS AND RURAL LIFE (NONGCUN SHENGHUO) • 369

able to rural consumers. Limited for decades by the "household registration" (*hukou*) system, which effectively prevented rural residents from moving in and overburdening cities, greater mobility is now possible but with many rural residents, especially older **age** groups, choosing to remain in the countryside, although problems remain for the elderly and disabled, as **suicides** among older rural **women** remain abnormally high. Other problems include the spread of rural black markets and the reemergence of **secret societies** and other criminal organizations, with unelected government officials imposing fees, taxes, and other exactions but with more outspoken rural populations engaging in social **protests** against land seizures and other offensives to daily life. Phrases describing the frequent sense of helplessness felt by rural people, especially toward government authority, include the following: *wunengweili*, literally "powerless"; *shushouwuce*, meaning to be at wit's end; *pifuhandashu*, ants trying to topple a tree; *tangbidangche*, a praying-mantis arm attempting to stop a horse-drawn carriage; and *yugongyishan*, "the foolish old man who removed the mountains," made famous by frequent use by Mao Zedong.

S

SCHOLARS AND INTELLECTUALS (*XUEZHEMEN/ZHISHIFEN-ZI*). In a society with enormous reverence for **education**, scholars and intellectuals assumed prominent positions in the imperial era, dominated by **Confucianism** with an equally important, although sometimes challenged, role in the People's Republic of China (PRC). Recruited as "government officials" (*shi dafu*) from the Tang Dynasty (618–907) onward largely by an imperial civil service examination system established to counter the influence of military aristocrats, these "scholar-officials" (*rujia*), also known as "literati" (*wenren*), brought morality and **virtue** to the social and political order at both the elite and popular levels. Having passed the highest *jinshi* imperial examination, officials serving the emperor elevated the level of artistic and cultural appreciation at the court, while offering advice on a range of administrative and political matters affecting the empire. For the majority of scholar-officials, with their numbers empire-wide peaking at 3,000 to 4,000, serving in the provinces down to the **urban** and **rural** county levels, official functions included providing social welfare, resolving minor **legal** disputes, supervising major **commercial** projects, collecting taxes, and maintaining law and order, while also teaching in private schools and training the next generation of scholar officialdom.

Coming primarily from the socially dominant "scholar-gentry" (*shenshi*) **class**, with training beginning at the early age of seven or eight, scholar-officials cultivated the "Four Arts" (*Siyi*) of **calligraphy**, **painting**, playing Chinese "chess" (*weiqi*), and mastering the "zither" (*guqin*), an ancient Chinese musical instrument, while also engaging the intricate poetic requirements of the "eight-legged essay" (*baguwen*). As an independent social class, scholars and intellectuals reached a peak of influence and power during the Tang and Song (960–1279) dynasties but with official positions subject to sale during periods of social and financial crisis, for example, in the aftermath of the highly destructive An Lu Shan Rebellion (755–763). The role of the scholar-official was also enhanced by the creation of imperial training **academies**, with the invention of paper and printing making possible widespread dissemination of written material, including books. With increasing

371

372 • SCIENCE AND SCIENTIFIC THOUGHT (KEXUE/KEXUE SIXANG)

scholarly attention to **literature** and the **arts** from the 19th century onward as the basis of personal moral cultivation, scholars like Wang Yangming (1472–1524) stressed the importance of innate moral **knowledge** drawn from Chan **Buddhism**. Serving the imperial order until the collapse of the Qing Dynasty (1644–1911), scholar-officials, with their persistent idealization of simple rural values and disdain for commercial pursuits, were blamed for contributing to the country's backwardness and lack of modernization.

While abolition of the imperial civil service examination system in 1905, eliminated the social need for scholar-officials, education remained a revered value, with many young Chinese studying abroad and in such modern Chinese **universities** as Tsinghua University, established as the country's premier technology institution using Boxer Indemnity funds in 1911. Active in the culturally iconoclastic New Culture Movement/May Fourth Movement (1917–1921), Chinese intellectuals, including a young **Mao Zedong** (1893–1976), were attracted to various modern **ideologies**, notably Marxism–Leninism, with many joining the ranks of the Chinese Communist Party (CCP), established in 1921. Essential to the goals of economic modernization and development of **science** and technology pursued by the People's Republic of China (PRC), intellectuals, upon becoming frequent critics of the political offenses of the regime, were targeted in such government-instigated, antiintellectual outbursts as the Anti-Rightist Campaign (1957–1959) and especially the **Cultural Revolution (1966–1976)**. Following the introduction of economic reforms and social liberalization (1978–1979), mass political campaigns came to an end, with university education fully restored and intellectuals retaining crucial roles in the country's pursuit of economic prosperity and world-class scientific and technological progress.

SCIENCE AND SCIENTIFIC THOUGHT (*KEXUE/KEXUE SIXANG*). Once a center of scientific and technological innovation during the imperial era followed by dramatic slowdowns into the 20th century, China has re-emerged as a scientific powerhouse since the establishment of the People's Republic of China (PRC) but with continuing concerns about the weakness of scientific thought and creativity. Leading the world in several scientific fields from the 1st through the 15th centuries, China is most noted for the "Four Great Inventions" (*Sida Faming*), the "compass" (*zhinanzhen/luopan*), "gunpowder" (*huoyao*), "papermaking" (*zaozhi*), and "printing" (*yinshua*).

The earliest was papermaking, developed by Cai Lun in 105 CE, with paper produced from tree bark, rags, and wheat stalks, which replaced tortoise shells and bamboo strips, followed by woodblock printing, with the first book, composed of Buddhist sutras, produced in 868, and movable type, consisting of baked fine clay, devised by Bi Sheng in the 1040s during the Song Dynasty (960–1279). A product of the Chinese attraction to alchemy, gunpowder, made from saltpeter, sulfur, and charcoal, was developed and

SCIENCE AND SCIENTIFIC THOUGHT (KEXUE/KEXUE SIXANG) • 373

deployed as flying fireworks in the Tang Dynasty (618–907), grenades in the Song Dynasty, and cannons in the Yuan Dynasty (1279–1368). The Song Dynasty recorded the use of the Chinese compass in the 1080s, made from lodestone, with one version designed as a ladle on a flat plate and another as a fish and known as the "pointing south needle" (*zhinanzhen*) for the presence of the magnetic ore in the fish tail.

Other scientific achievements during the imperial era included the first astronomical observations of supernovas, as Chinese astronomy dates to the Shang Dynasty (1600–1046 BCE), with detailed observational records, including star maps, kept from the Han Dynasty (202 BCE–220 CE) onward. Collaborative observations were carried out between Chinese, Indian, and Islamic astronomers, with the Peking observatory refitted by the Flemish Jesuit Ferdinand Verbiest in 1669. Additional inventions or scientific breakthroughs include, among others, lacquerware, cast iron and steel, the wheel barrel, the fishing rod, the stirrup for horses, the rudder, and kites, with an average of 15 new inventions per century up to the Ming Dynasty (1368–1644). For a variety of largely unexplained reasons, scientific innovation in imperial China slowed dramatically from the Ming Dynasty onward, as few scientific or technical innovations of the modern era were developed. Among the most notable early books on scientific topics is *The Dream Pool Essays* (Mengxi Pitan), by Shen Kuo (1031–1095), published during the Song Dynasty and including chapters on astronomy, natural phenomena, and "strange happenings."

Scientists who used the brief period of free expression during the Hundred Flowers (1956–1957) to air complaints about political interference in scientific work were criticized during the subsequent Anti-Rightist Campaign (1957–1959), as all scientists were encouraged to be both "red and expert" (*hongse he zhuanjia*). With attacks on large numbers of scientists during the **Cultural Revolution (1966–1976)**, China's scientific establishment and capacity for technical innovation were all but shut down, as individual scientists were labeled as "counterrevolutionaries" (*fangeming*), with entire staffs of research institutes "sent down to the countryside" (*xiaxiang*), where they engaged in **manual labor**. Scientific journals also ceased publication, and subscriptions to foreign journals were allowed to lapse as Chinese scientists were effectively cut off from the outside world for 10 years, with the only progress occurring in nuclear weapons development and fusion research, which, as major military projects, remained largely untouched by the political turmoil. In the early 1970s, a revival of science was attempted but with emphasis on mass participation; eradication of distinctions between scientists and workers; and concentration on immediate practical problems in agriculture, industry, and the field of earthquake prediction. This produced few real scientific accomplishments.

374 • SCIENCE AND SCIENTIFIC THOUGHT (KEXUE/KEXUE SIXANG)

Fundamental reorganization and redefinition of scientific and technological goals began in the early and mid-1970s, as modernization of the science and technology sectors was included in the Four Modernizations laid out by CCP leaders Zhou Enlai and Deng Xiaoping. With the arrest in 1976, of the radical Gang of Four, led by Jiang Qing, the wife of CCP chairman **Mao Zedong**, their ill-trained supporters in newly opened research institutes and **universities** were quickly replaced by professionally qualified personnel, as state media began to refer to previously condemned scientists and technicians as part of society's "productive forces" (*shengchan li*).

A National Science Conference, convened in **Beijing** in 1978, was attended by more than 6,000 scientists, administrators, and top Chinese leaders, as a rapid and ambitious plan of scientific development was announced but scaled back in 1981, as priority was given to the application of science to practical problems of agricultural and industrial production, and the training of a new generation of scientists and engineers. By 1985–1986, China had more than 8 million personnel working in science in research institutes, state-owned enterprises (SOEs), and government offices, with 350,000 designated as "research personnel" (*yanjiu renyuan*), many of whom had studied abroad, especially in the United States.

By far the greatest employers of scientists in the 1980s were the more than 10,000 research institutes directed and funded by various central and regional government authorities, and whose research tasks were often set by higher-level administrators as part of an overall research plan. Organized into five major subsystems with little lateral contact or **communication**, the major research organization remained the Chinese Academy of Sciences (CAS), which was originally modeled on the Soviet Academy of Sciences and managed 120 separate research institutes scattered throughout the country, employing 40,000 scientific personnel. Formally subordinate to the State Science and Technology Development Commission (reorganized in 1998), CAS reports directly to the State Council and oversaw institutions like the Chinese University of Science and Technology in Hefei, Anhui, where in 2005, plans were announced to create China's first "science city" (*kexue chengshi*), modeled on Silicon Valley in the United States. For years, the many research institutes embedded in such major ministries as electronics, coal, and railway were overseen by the State Science and Technology Commission. Military-related research organs have some of the best-trained scientific and technological personnel in China and have been supervised by the Commission of Science, Technology, and Industry for National Defense (created in 1982), while generally operating in comparative isolation from the civilian economy.

Following the introduction of economic reforms and social liberalization (1978–1979), limited changes were enacted in the organization of science and technology in the PRC to address the perennial problems of poor coordi-

SCIENCE AND SCIENTIFIC THOUGHT (KEXUE/KEXUE SIXANG) • 375

nation among scientific fields, lack of communication between research and production units, duplication of research, and maldistribution of personnel. While the military crackdown against the prodemocracy movement in June 1989 led to the exile of such prominent Chinese scientists as astrophysicist Fang Lizhi (1936–2012), the scientific community benefited from a major decision in 1995 to increase spending on research and development to the equivalent of 1.5 percent (later expanded to 2.5 percent) of gross domestic product (GDP), with scientific personnel encouraged to move out of their isolated institutes into private enterprises. New funding organizations were set up, including the National Science Foundation of China, which grants peer-reviewed awards along with the Ministry of Science and Technology, while what was then known as the Science and Technology Development Commission issued a document in 1992, approved by the State Council, entitled "National Medium- and Long-Term Program for Science and Technology Development (2006–2020)," establishing a goal of achieving levels of technology equal to developed countries. Initiating a human genome project headquartered in **Shanghai** in 1993, the PRC also participated in international scientific conferences on such macro issues as climate change and global warming. Joining the International Thermonuclear Experimental Reactor (ITER) planned for construction in France as a pilot project for electricity-producing fusion power plants, the China–U.S. Science and Technology Agreement was also renewed.

With CAS conducting 122 key national projects on basic research from 1998–2004, China also announced support for stem cell research and has engaged in an aggressive campaign known as the Thousand Talents to lure Chinese and foreign researchers and scientists to the PRC with substantial monies for laboratories and staff. Major scientific and technological breakthroughs achieved in the past 20 years include the following: the development of a new supercomputer, which went online in 1992; the successful trial flight of a supersonic unmanned plane in 1995; the world's first synthesis and identification of the new nuclide americium (Am-235) in 1996; the first replication in the world of a human ear from the body of an **animal** through extrinsic cell reproduction in 1997; the birth of China's first test-tube twins in 1998; the genetic modification of **food** and **insect**-resistant crops in 1999; the cloning of neural deafness genes in 1999, and a female goat in 2000; the development of advanced ocean-wave power systems for stable electricity flow; experimentation on fuel cell and hybrid automobiles; explorations of the structure of the evolution of the universe by high-resolution simulations of galaxy formation; navigation to the Arctic Ocean by a scientific research vessel to study the interaction of the sea, ice, and atmosphere, and their impact on climate; linking entangled photons or light particles on a quantum physics level aboard a Chinese satellite and beamed back to locations on earth, potentially revolutionizing global communications; and continued

376 • SCULPTURE (DIAOSU)

work on developing an inhibitor of the SARS and COVID-19 viruses. Also singled out for development are artificial intelligence, aviation, and robotics as centerpieces of the "Made in China 2025" program, announced in 2015.

Accomplishments in the scientific and technical fields in the PRC undoubtedly reflect the commitment of central leaders, many trained in the sciences, for instance, President Hu Jintao (engineering), Premier Wen Jiabao (geology), and President **Xi Jinping** (chemical engineering), to accelerate science and technology development. In terms of the innovativeness of Chinese research papers in 2005, as measured by the number of citations, Chinese scientists performed well in the fields of mathematics, material science, chemistry, and engineering, but with dramatically fewer citations in agriculture and life sciences, as China's share in world patents is even smaller than its share in research papers. While science in China was given a boost in 2015, when Dr. Tu Youyou was awarded the Nobel Prize in Medicine, the first Nobel Prize for a citizen of the PRC in the natural sciences, for developing antimalaria drugs based on **traditional Chinese medicine (TCM)**, officials in the scientific community still bemoan the general lack of scientific **thinking** and creativity in the country, as personal **relations and connections**, rather than merit, often determine crucial appointments to important scientific positions.

See also TECHNOCRACY AND TECHNOCRATS (*JISHU GUANLIAO*).

SCULPTURE (*DIAOSU*). One of the great artistic traditions in China, dating from the Neolithic period, beginning in 10,000 BCE, and extending into the modern era of the People's Republic of China (PRC), sculpture has taken on two dominant types, **religious**, particularly related to **Buddhism**, along with **Daoism** and **Confucianism**, and secular, primarily **carvings** in **burial** tombs and mortuary temples. Dominant forms include exquisite bronzes, terracotta statues, and carvings of such delicate objects as **animals**, **plants**, and landscapes, with materials ranging from the expensive and the rare, most notably **jade**, ivory, and bronze, to the more ordinary, including **ceramics**, clay, coal, nuts, sand, stone, wood, and even glutinous rice flour and butter, the last in **Tibet**. Employing knives and axes, the **art** of sculpting was concentrated in major **urban areas**, including **Beijing**, **Shanghai**, Suzhou, and Yangzhou (Jiangsu), and at sites of such specialized stones and materials as the following: carnelian (Heilongjiang); pyrophyllite (Shoushan, Fujian); chrysanthemum stone (Liuyang, **Hunan**); Changhua heliotrope, similar to cinnabar (Zhejiang); bamboo (Jiangsu); and Qingshan slate (Qingtian, Zhejiang), the last considered the "hometown of Chinese stone carving;" also used in **seal** carvings.

SCULPTURE (DIAOSU) • 377

Historically, Chinese sculpture flourished beginning most prominently with bronze figures and ceremonial vessels for the multiple imperial households and the noble **classes** in the Zhou Dynasty (1045–256 BCE), followed by a rich variety of clay figures of animals and household utensils embedded in burial tombs of the Han Dynasty (202 BCE–220 CE). The apex of bronze craftsmanship was evident from the exquisite *Galloping Horse Treading on a Flying Swallow*, a portrayal of the "heavenly steed" (*tianma*) of Chinese **legend** expressing the horse-breeding culture of Western China. Combining realism and romanticism, along with perfect balance, the elegant piece was found in a tomb located in Gansu dating to the Eastern Han Dynasty (25 BCE–220 CE) and is considered the essence of ancient Chinese sculpture. Extending into and peaking during the Tang Dynasty (618–907), iron and stone replaced bronze as the primary sculpted material, with substantial production of glazed terracotta figures of imperial courtesans and Buddhist deities and images. Mass graves from this era, especially of the nobility, were filled with sculpted stone images, simple and honest, of crouching pigs and tigers, prancing horses, otters, bats, and short- and long-mouth (longnose gar) fish.

A major source and inspiration of Chinese sculpture, Buddhism was represented in carved images of Siddhartha Gautama, the "enlightened" one, along with monks, deities, and the bodhisattvas Guanyin and Wenshu, the goddesses, respectively, of mercy, and wisdom and passion, central to the Chan, "pure land" (*jingtu*) school prevalent in China. Begun in the 4th century, rock-cut, bas-relief, and painted stone of various Buddhist images, reflecting a blend of Indian and Chinese influences, were carved into caves and on mountainsides, most famously the grottos at Yungang (Shanxi), Longmen (Henan), and Mogao and Majishan (Gansu). As the influence of Buddhism declined beginning in the Song Dynasty (960–1279), sculpture gradually lost its vigor, with Marco Polo (1254–1324) bringing examples of the elegant Chinese genre back to Europe in the 13th century, while Chinese styles also influenced Japan.

During the period of rule by Chinese Communist Party (CCP) chairman **Mao Zedong** (1949–1976), sculpture, like most of **literature** and art, was used for propaganda purposes, with statues of the chairman, large and small, dotting urban and **rural** landscapes, particularly during the **Cultural Revolution (1966–1976)**. Unmemorable carvings of anonymous common people striking revolutionary poses were also produced, while traditional religious figurines, especially from **pagodas and temples**, were wantonly destroyed by marauding Red Guards.

Following the introduction of economic reforms and social liberalization (1978–1979), Chinese sculpture blossomed into various realms, particularly modern, abstract forms, with heavy use of industrial materials, for example, stainless steel and fiberglass, with such innovations as suspending crystal

378 • SEALS AND SEAL CARVING (ZHUANKE)

beads on threads. Reacting against a staid, overwhelmingly conformist and didactic society, modern Chinese sculptures are often designed to engender shock, with grotesque portrayals and an overlay of sarcasm and contempt at mass consumerism and social niceties, along with comedic treatment of Chinese history and culture during both the imperial and Communist eras. Examples of popular sculptures sited in exhibits and public areas, including on loan to other countries, followed by a short description, with the artist's name in parenthesis, include the following: *Three-Legged Buddha*, a self-portrait of the artist engaging with Buddhist **philosophy** (Zhang Huan); *Large Red Guy*, a commentary on the importance of the **color** red in Chinese history and on contemporary **money**, power, **fear**, and **cruelty** (Chen Wenling); *Chinese Offspring*, sculpted bodies hanging from a ceiling, meant as a testimony to the faceless crowd of migrant workers in China (Zhang Dali); *Center of Quietude*, the imperfect nature and realness of **women** conveyed by a sculpted nude young girl (Xiang Jing); *A-Maze-Ing Laughter* and *The Tao of Laughter*, cynical realist views portrayed through sculpted groups of laughing, giggling men (Yue Minjun); *An Itinerant Poet*, a large black bloc of compressed pu'er **tea** leaves (**Ai Weiwei**); *Artificial Rock*, a recreation of a **scholar's** rock, popular in traditional Chinese **gardens**, in an industrial medium; *Melody*, a giant stainless steel image of a violin in Yantai, Shandong; and *Soko.barefoot*, a group of cold, yellow-sculpted naked children (Chen Wenling). Periodic carving and sculpting competitions are held in China, with online exhibitions for aspiring sculptors and such major publications as *Chinese Sculpture* magazine. Commercial production of fine-art sculptures, including by 3-D printing, is provided by Memory Sculpture Co. of **Guangzhou**.

SEALS AND SEAL CARVING (*ZHUANKE*). Also referred to in English as the "chop" and dating to the Shang Dynasty (1600–1046 BCE), seals with names and signatures carved into the bottom face are then dipped into red ink and stamped on important documents and used to mark artwork. The **art** of seal carving and engraving employs a chisel and precise cutting techniques, usually into soft stone, while requiring an intimate **knowledge** of **calligraphy**, especially nine-curve characters, with intricate arcs and lines difficult to decipher. Serving both practical and ornamental purposes, seals were initially made out of tortoise shells, **animal** bones, copper, and pottery, and became a basis for officials in the Shang Dynasty and during the Spring and Autumn (770–476 BCE) and Warring States (475–221 BCE) periods, to project authority and power, with the *hufu* seal used by generals to deploy military forces.

Formalized by the standardization of the written **language** during the Qin Dynasty (221–206 BCE), small, delicately made seals of **jade** were restricted in use to the emperor and rendered in Chinese as *xi*. Expanded in use during

SECRECY (BAOMI) • 379

the Han Dynasty (202 BCE–220 CE), seals were used by private individuals as personal stamps to authenticate commercial and other transactions and to make artwork. A practice extending into the Tang (618–907) and Song (960–1279) dynasties, seal-making was popularized by **scholar**-artists. The stamps were composed of soft Qingtian and Shoushan stone, along with ivory and other semiprecious materials, for instance, rhinoceros horns, and used to mark artwork.

Developed into a separate art form in the Yuan Dynasty (1279–1368), with stones quarried in Mongolia, seal-making experienced a golden age during the Ming (1368–1644) and Qing (1644–1911) dynasties, with official seals revealing the rank of the user. Among the notable seal-makers was Wen Peng (1498–1573), who skilled in the "six writings of Chinese character composition" (*liushu*) is considered the father of Chinese seal-making. Using ivory and Qingtian stone, Wen became famous for such intricately carved seals as *Deep Place among the 72 Peaks* (Qishier Feng Shen Chu) and *After Playing Zither, Leaning on a Pine to Play with Crane* (Qin Ba Yi Song Wanhe), with his student, He Zhen (1541–1600), developing a unique seal-making style evident in *Creating a Rainbow during Talk* (Xiao Tan Jian Qi Tu Ni Hong).

Private seals were carved in accordance with personal preference, with only a prohibition on use of the imperial character *xi*, as considerable artistic **freedom** led to enormous diversity of seals featuring names, some pseudonymous, expressions of good **fortune** and luck, and "literary" (*wenxuede*) seals with **poetry** and aphorisms. Seal engraving types include *zhuwen*, characters carved in relief in a pure rectilinear style, and *baiwen*, intagliated characters, with use of *tianhuang* and *jiuxe* stones, both peculiar to China, with the most important schools associated with specific **regions** indicated in parenthesis: *Zhe* (Zhejiang), *Hui* (Anhui), and *Hai* (**Shanghai**). Personalized stamps were also used to ensure confidentiality of writings on bamboo strips, which put inside wooden troughs were sealed into mud, with custom stamps carved deeply to make a clear and distinct mark. Most prominent among modern seal makers was Qi Baishi (1864–1954), a painter who considered seal-making his best work, with a highly individualistic style shaped by earlier training in woodworking. Other favorite images for carvings include **insects**, especially "cicadas" (*chan*), made into rings and other **jewelry**, for example, brooches.

SECRECY (*BAOMI*). With a long tradition of authoritarian, nontransparent government and a social order obsessed with protecting information from outsiders, China is one of the most secretive societies in the world. "State secrets" (*guojia jimi*) are closely guarded but vaguely defined, with even **family** and friends withholding the truth from one another, especially in the presence of **foreigners**. Among Chinese political leaders in the People's Republic of China (PRC), the instinct when confronting a problem is to shut

380 • SECRET SOCIETIES (HUI/GONGSI)

down all reporting while denying any difficulties, as local officials in fear of superiors withhold crucial information. Fearing public unrest, particularly during crises, authorities often find it easier to keep new problems a secret even when public **health** and safety are at risk, as evidently occurred with the outbreak of the COVID-19 virus in Wuhan, Hubei, in 2019.

Following years of underground political struggle, confronting constant threats from political enemies, the Chinese Communist Party (CCP), upon coming to power in 1949, created an atmosphere of paranoia, fearing "spies" (*tewu*) and "subversives" (*dianfuzhe*) from remnants of the defeated Nationalist (*Kuomintang*) government and foreign enemies, particularly the United States. Enacting the first State Security Law (1951), the definition of state secrets was open-ended, with even the disclosure of meteorological predictions subject to protection, as reams of official documents, even on the most minor matters, were labeled for "internal" (*neibu*) use only. While a new Law on Guarding State Secrets (1989) provided for more specific **legal** criterion, with distinctions between "top secret" (*zuigao jimi*), "highly secret" (*gaodu jimi*), and "secret" (*mimi*), the concept of state secrets applied to broad areas of government activities, including "major policy decisions," "diplomatic activities," "**science** and technology," and "activities for promoting state security."

Cases of the PRC government withholding crucial information from the Chinese public and suppressing attempts at public disclosure include the massive loss of life to floods and disease in the aftermath of a series of river dam collapses (1975), massive civilian casualties and damage following the great earthquake in the city of Tangshan (Hebei) in 1976, and the death of Chairman **Mao Zedong** in 1976. Despite the relaxation of controls and the growth of **social media**, secrecy is still a priority of the administration of President **Xi Jinping** (2013–), with calls for strengthening confidentiality, especially involving military affairs and events, along with enhanced cybersecurity protections. Within Chinese families, distressing health information is often withheld from elders, along with ongoing problems between husband and wife, all to maintain the veneer of **harmony**.

SECRET SOCIETIES (*HUI/GONGSI*). A unique feature of Chinese society, especially from the 19th century onward, with concentrations primarily in the south and southwest, secret societies emerged as "nerve centers" (*shenjing zhongshu*) of opposition to the imperial order and a major force in the creation of both the Republic of China (ROC) and the People's Republic of China (PRC), with the latter launching an effort at their elimination. Popular venues of conflict between the ruler and the ruled, secret societies entailed a mixture of **religion** and political dissatisfaction involving a proposition of a rival order to the existing system of emperors and mandarins. Led by leaders claiming **spiritual** healing and supernatural powers, members of secret soci-

eties, usually from the lower and poorest **classes**, were bound by strict internal **discipline**, with gratuitous use of initiation **rituals and ceremonies**, arcane teachings, **symbols** and **magical** amulets, and secret passwords. Following traditional notions that "officials draw their powers from the law, the people from the secret societies" and built on the basis of relatively parochial ties of **clan** kinship, native place, and contractor–worker **relations**, secret societies are highly decentralized and autonomous, with strong millenarian appeals drawn from **Buddhism, Christianity**, and Islam. While generally limited in spatial expansion, secret societies, when pushed to extremes, had a latent capacity to break out in great rebellions, leading to the overthrow of dynasties, as occurred during the Han (202 BCE–220 CE) and Yuan (1279–1368) dynasties.

The most influential secret societies included the White Lotus and Triads, the latter also known as the Society of Heaven and Earth, with large memberships ranging from 20,000 to 200,000, and having dramatic effects on the course of modern Chinese history. Included was Zhu Yuanzhang (1328–1398), founder of the nativist Ming Dynasty (1368–1644) and a member of the White Lotus, which blended the ideas of Buddhism and **Daoism** with elements of Gnosticism imported from Central Asia. Similar roles were played by the Triads in opposing the Manchu rulers of the Qing Dynasty (1644–1911), by calling for "overthrowing the Qing and restoring the Ming," with membership in the Triads by revolutionary Republican leader Sun Yat-sen (1866–1925). Interest in the structure and role of secret societies was also expressed by Chinese Communist Party (CCP) chairman **Mao Zedong**, who appealed to the "revolutionary spirit" (*geming jingshen*) of the groups during the struggle with the Nationalist (*Kuomintang*) government for political supremacy and control of the government (1928–1949).

Following the establishment of the PRC in 1949, CCP policies toward the societies underwent a total reversal, with a campaign in the 1950s to rid the "New China" of the "reactionary secret societies" (*fandong hui daomen*) as part of a larger effort against unorthodox religious groups, which extended into the **Cultural Revolution (1966–1976)**. Following the introduction of economic reforms and social liberalization (1978–1979), which dramatically reduced state social controls, long-dormant secret societies the likes of the Triads reemerged, in conjunction with criminal **gangs**, especially in the south, including such cities as Shenzhen.

SELF-ESTEEM AND SELF-CONFIDENCE (*ZIXUN XIN/ZIXIN XIN*).
Defined as confidence in one's own worth and abilities, and trust in personal judgment, self-esteem and self-confidence in China varies enormously between **age**, gender, and other groups, with more emphasis generally placed on individual performance, achievements, and rankings, particularly by **children**, in **education** and personal **hygiene**. With words like "self-esteem"

382 • SELF-ESTEEM AND SELF-CONFIDENCE (ZIXUN XIN/ZIXIN XIN)

absent from the Chinese lexicon and utilitarian approaches dominant in socializing agencies, including the **family** and schools, a child's self-regard is rarely as important as a stark evaluation of performance in multiple realms, from work ethic to recognition of Chinese-**language** "characters" (*wenzi*) to musical skills. Any notion of personal **privacy** is generally ignored, as student rankings are publicly posted outside classrooms, with exceptional performance noted by stars and happy faces, including even personal medical information. Reinforcing the orientation toward achievement, children's storybooks in China celebrated behavior associated with learning and hard work, along with humility and a general respect for the elderly and the importance of enduring hardship.

During the period of rule in the People's Republic of China (PRC) under Chinese Communist Party (CCP) chairman **Mao Zedong** (1949–1976), **ideological** and political rhetoric was often characterized by fatuous and self-aggrandizing language of power and inflated praise for leaders and people alike. Following the introduction of economic reforms and social liberalization (1978–1979), journalists and news organizations, in particular, emphasized the importance of an openness to new ideas in the previously autarkic country, while denouncing the "falsehood, bluster, and emptiness" (*jia da, kong*) of the past, especially during the **Cultural Revolution (1966–1976)**. With low self-esteem correlated with higher levels of depression and other mental disorders, and Chinese subjects in psychological studies showing greater agreement than their Western counterparts with a negative worldview, efforts to enhance personal self-evaluation are being pursued via such measures as the publication of textbooks like the *Self-Esteem Workbook for Teens* (2007).

People from well-functioning families of one child, higher income, greater **harmony**, and a reduced child-rearing role by doting grandparents overall exhibit greater self-esteem, while less self-confidence is shown by older **women** and females, especially after undergoing plastic surgery. While efforts to improve family life and "stability" (*wending*) are being pursued, the government of President **Xi Jinping** (2013–) has taken a strong stand, advocating a "confidence doctrine" (*zixinlun*) calling on the country to "be confident in our chosen path, confident in our political system, and confident in our guiding theories," with special attention given to China's ancient culture as a primary source of "civilizational self-confidence" (*wenming zixin xin*), which is borne out by survey data.

Among the persistent social habits associated with low self-esteem is increasing addiction, especially among **adolescents**, to **smartphone culture**, although Chinese in general score low on explicit, more conscious and reflective self-esteem but high on spontaneous and automatic, implicit self-esteem. While Xi Jinping continues to hail China as one of the world's premier "cradles of civilization," with such official and highly popular

videos as *Amazing China* (Lihaile Wode Guo/2018) highlighting the country's many achievements in **science** and technology, warnings of the pitfalls and corrosive effects of "boastful and arrogant" (*zikua jiao'ao*) discourse have appeared in the official *People's Daily* (Renmin Ribao), with the *Amazing China* video ultimately pulled from the shelves.

See also INDIVIDUALISM (*GERENZHUYI*).

SELFISHNESS (*ZISI*). Considered a major character flaw of Chinese people traced to the fiercely competitive nature of the contemporary social order, selfishness takes on many behavioral forms, especially in the public arena. Historically, **criticism** of self-centeredness in Chinese culture came from commentators like Ming Dynasty (1368–1644) philosopher Gu Yanwu (1613–1682), who emphasized the importance of **shame** and "responsibility" (*ze*), and anthropologist Fei Hsiao-tung (1910–2005), who explained the self-centered nature of the Chinese by their close ties to the land. Similar themes inform contemporary commentators like female writer and journalist Zhang Lijia (1964–), who describes China as a nation of 1.4 billion "cold hearts" (*xin leng*). Common selfish behaviors, among others, include the following: throwing rubbish and other household trash, including human excrement, out of windows and into nearby streets and canals with little or no regard for the public good; general refusal to assist anyone in need, particularly strangers, including **children**; the inability to "wait in line" (*paidui*), with large crowds quickly turning into mobs; filling public spaces with a cacophony of loud voices, showing no consideration for others; and clogging up traffic by wanton violation of **driving** rules, with highways turned into **death** races.

Major causes of self-centered, ill-behavior have been traced to **Confucianism**, with the emphasis on personal **relations** limited primarily to **family** and associates, with little concern outside such personal networks. Others focus on the long history of poverty and immiseration, which created a society of "every man for himself" (*meili ren dou weile ziji*), with yet others focusing on recent political events, mainly the **Cultural Revolution (1966–1976)**, when groups were pitted against one another in life-or-death struggles, including **youth** against parents and the uneducated against the well-educated, as traditional constraints, including Confucianism, were effectively destroyed. And for others, the major culprit is seen as the introduction of an unregulated economy, superseding the collectivist spirit that had existed during the period of centralized economic planning (1953–1978), backed by strong state-imposed social controls.

With the "Me" culture of giant **shopping** malls and WeChat dominating social life, Chinese lack a moral compass, which for some has led to an appeal of **religious** activity, including **Buddhism** and **Christianity**. Chinese government efforts to improve people's sense of social obligation to others have included television advertisements imploring parents to assume respon-

384 • SEX AND SEXUALITY (XING/XINGYU)

sibility to teach their children "civilized behavior," along with other spots emphasizing mutual help between strangers, countering the attack on selfishness and excessive **individualism** during the rule by Chinese Communist Party (CCP) chairman **Mao Zedong** (1949–1976).

SEX AND SEXUALITY (*XING/XINGYU*). Traditionally a conservative society on matters involving sex and sexual relations, with substantial state controls for individual sexual behavior, China has been undergoing a "sexual revolution" (*xing geming*) with fundamental changes in popular attitudes and behavior. Enjoying a freer atmosphere for sexual expression in which sexual rights are treated as a basic **human right**, everyone in the People's Republic of China (PRC) now has the right to pursue his or her sexual bliss heterosexually, bisexually, or **homosexually**. Characteristics of this revolution include separation of sex from **marriage**, with premarital sex becoming more common, and separation from love and childbearing, with one-night stands and internet sex becoming more prevalent, along with greater socially acceptable display of female sexual desire. A more open display of sexual topics and issues in the public realm has also occurred in the media, with sex studies offered at colleges and **universities**, and sex objects and toys sold in markets, including condom vending machines on school campuses.

Historically, sexual opportunities in the imperial era varied enormously across social **classes**, with **concubinage** practiced by the elite, while the lowest classes competed for **women** in ways that often led to social **violence**. Social decline and the fall of dynasties were often linked to **sexual perversions**, particularly on the part of emperors, with Confucius (551–479 BCE) believing that social disorders took shape at the most intimate level, between man and woman, and spread out into other spheres of society and government. Rigid strictures against sex and sexuality dominated various realms of the traditional culture including by leaders of **rebellions** the likes of the Taipings (1850–1864), who demanded sexual abstinence of their members. Led by intellectuals during the New Culture-May Fourth Movement (1917–1921), a more open and freer attitude toward sex and sexual relations was promoted, including translations of Swedish writings advocating free love. During the period of rule in the PRC by Chinese Communist Party (CCP) chairman **Mao Zedong** (1949–1976), state control of the individual's private life was substantial, with premarital sex described as "hooliganism" (*liumang xingwei*) and subject to prosecution, with sexual impulses widely perceived as fundamentally evil (writings on the topic were strictly forbidden to be published). Subordinating individual sexual behavior to lofty **ideological** and revolutionary goals, especially during the puritanical **Cultural Revolution** (1966–1976), pre-marital and extra-marital affairs were considered immoral and a sign of social degeneracy. Widespread sexual repression made any display of sexuality an enormous threat to the social order. Following the

SEXUAL HARASSMENT, ABUSE, AND ASSAULT • 385

introduction of economic reforms and social liberalization (1978–1979), the move to freer **markets** reduced government control over individual private life with safe-sex products made available in convenience stores and media talk programs addressing a range of sexual issues but with ongoing concerns that taking fear out of sex could result in social **chaos**.

Other factors encouraging more open and frank attitudes and behavior toward sex include the following: the growth of a middle class, estimated to number between 300 and 400 million people; globalization with the spread of an international **youth** sex culture, including to China; the spread of higher **education** and the expansion of cosmopolitan attitudes; the emergence of a **feminist** discourse involving a redefinition of a woman's sex role, along with concomitant **criticism** of the prevailing double standard, expecting **men** to be aggressive and active, with women remaining passive and inactive; and the long-term effects of the **one-child policy**, which drove people to seek sex for pleasure rather than focus on **family** obligations of extending the lineage.

Reigning in aberrant and excessive sexual behavior has been a target of Chinese government policies, with such major actions as the Group Licentious Law (2005) employed against wife-swapping, swinger parties, and virtually any activity involving three or more people in sexual activity. With the actual impact of the law on such activities limited, Chinese sexologist Li Yinhe (1952–) has called for the abolition of the statue, noting that sex between consenting adults is a personal matter that should not be subject to state regulation. **Legal** action was also taken against a proposed Love Land theme park planned for the city of **Chongqing**, with denunciations of the project as vulgar and explicit, leading to its demolition in 2009. At the same time, the internet in China, including popular chat rooms, has become a platform for expressing a rich variety of views on all matters involving sex, while also serving as a means to link up with potential sex partners. Also popular were so-called sex bloggers on the Web such as the popular Mu Zi Mei who, describing her expression of freedom through sex, became the most searched-for name replacing Mao Zedong.

SEXUAL HARASSMENT, ABUSE, AND ASSAULT (*XING SAORAO/ LANYONG/TUJI*). Defined as gender discrimination directed mainly at **women** using various kinds of gender-related provocations, causing physiological and psychological trauma or tension, sexual harassment has become increasingly widespread in the People's Republic of China (PRC), especially in the workplace. In a society still characterized as "patriarchal" (*jiazhang*), with **men** dominating major institutions of government, **entertainment**, academia, and the media, women bringing accusations of sexual impropriety confront **censorship** and even threats of reprisal and retaliation from the Chinese government and employers. Discouraged by police and other official authorities from bringing complaints, especially against popular personalities

386 • SEXUAL HARASSMENT, ABUSE, AND ASSAULT

in the media, women have reverted to sharing their experiences on the internet, modeling their actions on the "Me Too" movement (*Woye Yundong*) in the West, which impacted China beginning in 2018.

Reactions of the Chinese government to the increasing prevalence of sexual harassment and abuse have been mixed, as no uniform antiharassment law exists in the PRC, with prosecutions essentially left to local authorities, many displaying distrust and even contempt for the accuser, usually female, and sympathy for the accused, usually male. Most notable is the defensive reaction of officialdom treating Me Too actions by Chinese women as a form of foreign influence and infiltration of the PRC by hostile Western powers, with claims that the entire movement is aimed at undermining the authority of the Chinese Communist Party (CCP). Efforts by women's groups to post public warnings against sexual abuse have been obstructed, with outright government censorship of Weibo accounts dealing with the issue, crackdowns against activists, and the shuttering of sex **education** centers, while defamation suits have been brought against accusers by the accused.

With one-half of all women reporting cases of sexual harassment, especially on public transportation, moves are afoot to reform the country's civil and criminal laws, as the present **legal** system is ill-equipped to handle sexual harassment cases. Scheduled for consideration in 2020, draft legislation is aimed at encouraging employers to be more proactive in creating a **workplace** environment free of sexual predators against both women and men, granting workers the right to terminate employment and file suits against offenders. The Ministry of Education (ME) has also committed to punishing faculty and staff accused of harassing students, as one of the first serious cases occurred at Peking University in the 1990s, where a student, subject to abuse, ended up committing **suicide**.

Exacerbating the problem is the prevalence of misogynist views among Chinese men who too often dismiss claims of sexual harassment, accusing offended women of being "too drunk to know better," while citing their own **alcohol** abuse as a cheap excuse for their offensive actions. For women wanting to remain polite while turning down advances from aggressive men, subtle hints of rejection can often provoke openly hostile reactions from male partners intent on getting what they want, while accusing women of not being virtuous and crying wolf. With discussion of sex remaining a taboo in most Chinese households, the importance of sexual consent has become a major theme in Chinese media, with an emphasis on the public developing an elevated awareness of **human rights**, notably the right to be free from sexual predators.

SEXUAL PERVERSIONS (*XINGBIANTAI*). An old fashion diagnostic term used as a label for sexual activities considered outside the norm of heterosexual sexual desires, sexual perversion was generally rare in Chinese

SHAMANISM (SAMANJIAO) • 387

history, as the society had a tradition of relatively open humanistic approaches to sex, with a general lack of sadomasochism and degeneration of sexuality. With **Confucianism** emphasizing modesty and Chinese society experiencing a relatively low rate of child abuse, paraphilia, that is, intense sexual arousal to atypical objects, situations, fantasies, and behaviors, generally has been rare throughout Chinese history. Notable exceptions included female **foot-binding**, which involved the sexualized objectification of **women** beginning in the year 950, and continuing until the abolition of the practice in 1912, by the government of the Republic of China (ROC). Perversions also developed with the effort in **traditional Chinese medicine (TCM)** to engage in so-called ultra-orgasmic exercises, which were believed in the long term to improve personal **health** and increase **longevity**. While popular from the Han (202 BCE–220 CE) to the Ming (1368–1644) dynasties, they were considered a threat to political stability and targeted for elimination during the Qing Dynasty (1644–1911).

While **homosexuality** was generally tolerated in imperial China, with some emperors engaged in single-sex relations, during the period of rule by Chinese Communist Party (CCP) chairman **Mao Zedong** (1949–1976), homosexuality was pathologized as a mental illness, with offending males threatened with castration. Following the introduction of economic reforms and social liberalization (1978–1979), same-sex relations were decriminalized in 1997, with homosexuality removed from the list of recognized mental illnesses. Informed Chinese views on the issue of "deviant sexuality" (*yuegui xing xingwei*), primarily involving same-sex relations, were heavily influenced by European works on the topic, for example, *Remembrances of Things Past*, by Marcel Proust (1871–1922), popular in the 1980s. Anecdotal evidence also indicates that Chinese women and **men** experience paraphobia, that is, the fear of sexual perversion in others or oneself, with a spouse unable to engage in normal sexual relations.

SHAMANISM (*SAMANJIAO*). Defined as an agitated or frenzied person engaged in one of the oldest indigenous belief systems, "shamans" (*wu*) mediate between the natural and **spiritual** world, seeking the assistance of spirits and goddesses to help cure diseases, bring good weather, predict the future, and communicate with deceased **ancestors**. Traced in China to the ancient Shang Dynasty (1600–1046 BCE) and influencing major **religious** and social traditions, most notably **Daoism** and **traditional Chinese medicine (TCM)**, shamans engage in mystical performances involving whirling **dances**, incantations, and beating of drums, while appearing to be in trances. Composed of both "male" (*nanwu*) and "female" (*nüwu*) practitioners, the latter prominent in ancient China, shamans act on the belief that discord and sickness result from unhappy and neglected spirits that inflict pain on people, for instance, public displays of insanity, with remediation requiring offerings

388 • SHAME (XIU)

of **food**, shelter, and other amenities. With shamans asserting supernatural qualities, their activities include divination, **dream** interpretation, exorcism, driving out evil spirits, and performing ecstatic rain **dances**. Aimed at controlling spirits in people's bodies, shamans claim unique powers, for example, the ability to levitate objects and escape everyday existence by traveling or flying to other worlds.

Entry into the vocation usually begins with a spiritual journey pursued during a serious, life-threatening illness when a communion is established with spirits and the **gods**, who become the source of the shaman's future powers. Following recovery from the illness, a ceremonial practice of cleansing is performed, with the shaman claiming an ability to navigate along the "spiritual pivot" (*lingshu*), connecting the lower (hell), middle (earth), and upper (heaven) worlds, with overall effectiveness based on the shaman's personal qualities and abilities absent any institutional backing. Composed largely of poor, lower-class individuals, with at least one in every village, shamans were looked down upon with contempt during the imperial era for spouting heterodox ideas at odds with the official doctrine of **Confucianism**, even though the great philosopher had once lauded shamans for their "persistence" (*jianchi buxie*).

Rejected as a "feudal **superstition**" (*fengjian mixiin*) in the People's Republic of China (PRC), shamanism was subject to withering **criticism** and assault during the **Cultural Revolution (1966–1976)**, when known shamans concentrated in **rural areas** were wantonly beaten. Resuscitated as "living gods" (*huo pusa*) following the introduction of economic reforms and social liberalization (1978–1979), newly liberated shamans won popular approval for reconnecting to a fast-disappearing past, an embodiment of timeless order and traditions, with performances following such major disasters as the destructive **Sichuan** earthquake in 2008. Characteristics of shamanism prevalent in other societies but absent in China include notions of soul flight, experiences of **death** and rebirth, **animal** power, and transformers.

SHAME (*XIU*). A major importance in Chinese society involving not only emotions, but also moral and virtuous sensibility, shame is a primary technique of social control and socialization of **children**, especially in collectivist, group-oriented countries like China. Revered in **Confucianism** as one of four major principles of civilized behavior, with significant chapters on the topic in the *Analects* (Lunyu), shame directs people to inward self-examination, motivating individuals to cultivate socially and morally acceptable behavior. While a strong sense of shame provokes forgiveness from others, shameless people are considered beyond moral reach, unpredictable, lacking trust, and beyond any reasonable control. Exhibiting an inflated sense of self, the shameless person lacks "modesty" (*qianxu*), an essential ingredient in the Confucian life-long process toward self-cultivation and self-reflection, both

necessary to achieve "benevolence" (*ren*) and **harmony** in interpersonal relations. Shame is also closely related to a multiplicity of human emotions and sentiments, including "guilt" (*youzui/kui*), "dishonor" (*xiuru*), "disgrace" (*chiru*), "blushing" (*lianhong*), "despising" (*bishi*), "shyness" (*haixu*), "embarrassment" (*ganga*), "**humiliation**" (*ru*), "sense of shame" (*can*), and especially "**face.**"

A common tactic used to oversee social behavior in the People' Republic of China (PRC), public shaming uses facial recognition software and laser pointers aimed at such "uncivilized" (*buwenming*) practices as wearing sleepwear in public and talking on **smartphones** in theaters, with pictures of the offenders often posted on **social media**. Mediating between the Chinese personality and social anxiety, a sense of shame among the population is deeply connected to moral search and considered a major factor in national "civilized city" (*wenming chengshi*) competitions. Public shaming was also employed in limiting the spread of the COVID-19 virus in Wuhan and other threatened localities in 2020. Popular, everyday Chinese sayings regarding shame include the following: "so ashamed that the ancestors of eight generations can even feel it" (*xiusi ba beizi xianren*), "shamed to death" (*xiu siren*), "no sense of shame" (*buzhi xiuchi*), and "blushing down to the bottom of the neck" (*lian hongdao bozi gen*).

SHANGHAI. Located at the eastern end of the Yangzi River Delta, Shanghai, literally "up from the sea," is the second-largest **urban area** in the People's Republic of China (PRC), with a total population of 24.28 million (2019), including 100,000 temporary foreign residents from Asia and the West, along with a large, largely unregistered "floating population" (*liudong renkou*) of migrant workers from interior **regions** of the country. A coastal metropolis more than 6,000 square kilometers in size, Shanghai opened to foreign trade and cultural influences beginning in the middle of the 19th century following the two Opium Wars (1839–1842/1856–1860), a melting pot of peoples with diverse **customs**, **cuisines**, literary and theatrical tastes, and **religions**. Known as *Haipei*, literally "ocean style," this unique cultural blend is characterized by an open-minded and even rebellious spirit distinct from the more traditional *Jingpai*, "**Beijing** style," associated with the country's national capital and illustrative of primarily interior, inward-looking cultural influences. One of the wealthiest municipalities in the PRC with a large middle class, especially of "white collar" (*bailing*) employees, many in large domestic and foreign multinationals, Shanghai is distinguished by the unique *huyu* dialect of the larger Wu **language** group, which shares about 31 percent lexical similarity to the "national language," or *putonghua*.

Historically, Shanghai, prior to the 19th century, was influenced by the surrounding Jiangnan culture in Jiangsu and Zhejiang, referred to as Wu and Yue, considered "delicate and refined" (*xini, jingzhi*), with the evolving *Hai-*

390 • SHANGHAI

pai culture described as a "modern babe" (*xiandai baobei*), in contrast to the "fair lady" (*shünü*) of the Jingpai style. Emerging as a bustling port during the Song Dynasty (960–1279), the city was encompassed by the construction of a high wall, which in the imperial era marked the beginning of an officially recognized urban area. Unlike Beijing or nearby Hangzhou, Shanghai never served as an imperial capital, although the city was the site of traditional **painting** during the Qing Dynasty (1644–1911), while also supplying crucial grain supplies to western areas of the country during the highly destructive Taiping Rebellion (1850–1864).

Dramatic Western influence followed the Treaty of Nanking (1842), which opened the natural port on the Huangpu River bisecting the city between the Pudong and Puxi areas to foreign and domestic trade, the latter up the Yangzi River to the interior city of **Chongqing**. A major industrial and shipping center with substantial commercial links to the West and other Asian nations, Shanghai was the birthplace of Chinese **cinema and** film, and the fount of Western classical **music** in the country, with the creation of the Shanghai Municipal Orchestra (SMO), headed for years by Italian conductor Mario Paci (1878–1946), and the establishment of the Shanghai Conservatory of Music (1927). With their unique **architecture**, **clothing**, and **food**, Shanghainese are considered hospitable and friendly to outsiders, locally referred to as "outlanders" (*waidiren*) and pejoratively as "country bumpkins" (*tubaozi*). Known for excellence, innovation, creativity, and compatibility, several national political figures are associated with the city, including the radical leftist Zhang Chunqiao during the **Cultural Revolution (1966–1976)**, Chinese Communist Party (CCP) general secretary and president Jiang Zemin (1989–2002), Premier Zhu Rongji (1989–1991), and President **Xi Jinping** (2013–).

Opened up by unequal treaties with Great Britain and France, major parts of Shanghai were divided into concession areas reserved for foreign residents and made largely off limits to most Chinese. **Jewish** merchants from Iraq, Syria, and Russia settled in the city during the 1930s, among them prominent families, most notably the Kadoories, Sassoons, and Hardoons, with heavy involvement in real estate and the opium trade. Largely foreign-owned textile and chemical firms were built along Suzhou Creek, meandering through the city, which became a haven for displaced artists and political activists and a center for **drugs**, kidnapping, and **prostitution**, with powerful **gang** leaders the likes of "pock-marked" Huang and Du Yuesheng of the notorious Green Gang, consisting of tens of thousands of members spread throughout the city.

Shanghai had China's first banks (1848), streetlights (1882), running water (1884), telephones (1881), automobiles (1901), and trams (1908). Bombed mercilessly by the Japanese from the air and nearby warships during the Second Sino–Japanese War (1937–1945), Shanghai was occupied by Japanese forces until the end of the war, and during the ensuing Civil War

SHANGHAI • 391

(1946–1949), the city was liberated by Communist armies in May 1949. Largely closed to the outside world during the rule of CCP chairman **Mao Zedong** (1949–1976) and the site of major political and violent conflicts during the Cultural Revolution, following the introduction of economic reforms and social liberalization (1978–1979), Shanghai emerged as one of the largest ports in Northeast Asia, receiving major infusions of foreign investment into the city's Zhangjiang High-Tech Zone and Xinzhuang Industrial Park, with an economy that currently generates 400,000 new jobs annually and large hanging advertising billboards scattered throughout the city.

In 2004, restoration and protection began of the residential area of the Bund, known in Chinese as *waitan*, which was nicknamed "Shanghai's Vienna," for having housed almost 30,000 Jews who had fled Germany and Austria for safe haven in Shanghai, with the Shanghai Jewish Refugee Museum located in a former synagogue and opened in the 1990s. Slated for preservation are the famous "stone gate" (*shikumen*)–style residential row houses, with a stone-framed gate and a carved stone lintel above each entry and an interior courtyard.

Shanghai began publication of the country's first truly English-language newspaper, *Shanghai Daily* in 1999, while in recent years the city has also hosted the Shanghai Open tennis tournament. Among many of Shanghai's cultural contributions that marry Eastern and Western styles is the cheongsam, *qibao*, high-cut, tight-fitting dress, which, first appearing in 1910, was banned during the rule of Mao Zedong but reappeared beginning in the 1980s. While it is said that Beijing residents "can talk about anything," Shanghainese, it is commonly believed, "can do anything."

Major cultural initiatives associated with Shanghai include the writers known as the Mandarin Duck and Butterfly Group (*Yuanyang Hudie Pai*), producers of amusing and light **literature** usually involving **romance** in the early 1900s. Local folk culture also includes "storytelling and ballad singing" (*pingtan*) involving tales of love and exploits of legendary figures, with great appeal to the elderly conveyed in the city's many **tea** houses, parks, and classical **gardens**, like Yuyuan. Prime examples of the city's unique architecture include the art deco buildings in the famous Bund, the mile-long waterfront on the Huangpu River, along with traditional architecture in the Old City inside the ancient wall and **pagodas and temples**, like Jade Buddha, Jing'an, and Longhua. Modern structures include the giant Oriental Pearl Radio and Television Tower and magnificent skyscrapers, most notably the metallic Jin Mao skyscraper, one of the tallest buildings in the world, with the Shanghai Architectural Institute offering new designs. Modern cultural venues include the Shanghai Grand Theater, for orchestra, **dance**, and **theater**; the architecturally iconic China Art Museum (Shanghai), the Great World entertainment center built by the city's powerful criminal gangs with casinos, theaters, and brothels; and the famous Peace Hotel,

392 • SHOPPING (GOUWU)

site of one of the earliest jazz combos in the country. Important annual cultural events include such **festivals** as the folk custom Lantern Festival, the International Tea Culture Festival, the International Film Festival, and the International Arts Festival.

A center of China's ubiquitous **sex** industry during the rule of the Republic of China (ROC) on the mainland (1912–1949), Shanghai saw its many brothels and massage shops dismantled by the puritanical PRC, with as many as 100,000 sex workers from the city subject to "reeducation" (*zai jiaoyu*). Following the introduction of economic reforms (1978–1979), the sex industry made a dramatic comeback, becoming the preferred home for Chinese lesbians ("lala girls"), who can live in the city, enjoying a high degree of **freedom** and anonymity, and avoiding the pressure back home to marry and start a **family**. The first city in the PRC to introduce sex **education** in high schools (1981), also introduced into middle schools (1984), the practice gradually spread throughout the country. On the outskirts of Shanghai, in the small town of Tongli, is China's first sex **museum**, which opened in 1999, featuring exhibits of sex toys, chastity belts, and erotic artwork from ancient times. Inside the city in an unassuming four-story mall is China's most spacious sex emporium, offering sexual remedies and various forms of sexual paraphernalia.

Shanghai was the first city in China to establish a sister-city relationship, with San Francisco, in 1980.

SHOPPING (*GOUWU*). A relatively new phenomenon led by the growing middle class and especially high-spending **youth**, retail shopping in the People's Republic of China (PRC) has grown substantially, spurred by the introduction of economic reforms and social liberalization (1978–1979). Virtually nonexistent during the period of central economic planning (1953–1978), when **food** and minimal **clothing** were subject to rationing, with few retail outlets and even fewer shoppers with disposable income, Chinese cities and towns now offer everything from roadside stalls and street **markets** to large-scale shopping malls and supermarkets, which have become enormously popular. Merchandise of the same kind is often sold on the same street in such notable areas as Wangfujing (**Beijing**), Chunxi Road (Chengdu, **Sichuan**), Shangxiajiu (**Guangzhou**), Central Avenue (Harbin), and Barkhor Street (Lhasa, **Tibet**). Provinces and cities are also known for specializing in certain products. These include cloisonné and freshwater pearls (Beijing); Longjing **tea** and silk (Hangzhou); antique furniture (**Xi'an**); mounted butterflies and batik (**Yunnan**); carpets and **jade** (Xinjiang); and clothing, shoes, toys, and electronic goods (Guangzhou).

Consumer behavior is generally characterized by a need for instant gratification, with little tolerance for later deliveries; omnichannel buying, with new ways constantly sought of interacting with brands; major influence by

powerful **women** controlling **family** finances; solo buyers of unattached young **men** and women; and willingness to pay more for goods if it means saving "**face**." Major differences in shopping habits also exist among the various generations, with people born before 1960, and now retired, exhibiting general frugality and saving a considerable percentage of their income, while at the other extreme, so-called "Generation Z," young people born between 1995 and 2002, and highly Westernized, spend heavily, often beyond their means, particularly on imported products, in line with the latest global trends, with groups in between displaying a variety of shopping and spending habits.

Considered badges of personal success, luxury goods have great appeal to the Chinese shopper, including from some of the most high-end foreign and domestic retailers. Online buyers, especially on live-streaming sales platforms, are also showing symptoms of compulsive buying disorder (CBD), or oniomania, an irresistible and uncontrollable urge to shop, with the buyer sometimes using stolen money to accumulate enormous amounts of goods, lipstick, perfumes, and clothing, beyond any legitimate need. Resulting in expensive and time-consuming activity, as many as several hours a day, CBD is more pronounced among women, with many suffering from deep insecurities and lack of **self-esteem**, and generally in their late teens and early 20s.

SICHUAN. A landlocked province in Western China roughly equal in geographical size and population (87 million) to Germany, Sichuan translates as "four rivers," referring to the Jialing, Jinsha, Min, and Tuo rivers. Consisting of moist and humid plains in the south and east, Sichuan borders on the Qinghai–Tibetan Plateau to the west, with **mountains** and high plateaus, while the southwest is dominated by the Red Basin, drained by the Yangzi River, also surrounded by mountains. Culturally distinct from the dominant Han culture in Northern China with a unique dialect of Mandarin Chinese consisting of several subdialects, for instance, Minjiang, Sichuan traces its ethnic roots to the ancient Wushan and Ziyang peoples.

Several regionally distinct cultures have shaped Sichuan's history, including the excavated Bronze Age Sanxingdui (2050–1250 BCE) and the Ba-Shu state (5th and 4th centuries BCE), the latter conquered by the powerful Qin state in 316 BCE. Incorporated into the Chinese empire and a center of **tea** cultivation, Sichuan was the starting point of the Tea Horse Road (*Chama Gudao*), southern branch of the **Silk Road**, extending from Chengdu, the present-day provincial capital, and transporting both tea and silk to the Middle East and Europe via Burma and India. Among the major historical sites is the giant Leshan Buddha, a red sandstone carving measuring 71 meters (233 feet) high of the Maitreya Buddha, built during the Tang Dynasty (618–907), located at the confluence of the Min and Dadu rivers in the southern city of

Leshan. Sichuan is also the site of Mount Heming, "Singing Crane Mountain," similar in shape to a white crane, hidden inside, and a red crane, perched on top, where basic principles of **Daoism** were formulated by Celestial Master Zhang Daoling, who came to a basic understanding of the doctrine while playing chess, during the Eastern Han Dynasty (25 BCE–220 CE). Known as the home of the giant panda bear, 16 national parks and **nature** reserves have been established by the government of the People's Republic of China (PRC) to protect the once-endangered species, along with the Research Base of Giant Panda Breeding in Chengdu.

Among the major artistic and cultural attributes unique to Sichuan are brocades and embroidery employing brightly colored threads depicting flowers, **animals**, mountains, and rivers, declared a "national intangible cultural heritage," along with similar creations in Guizhou, **Hunan**, and Suzhou. Equally prominent is Sichuan **opera** (*Cuanju*), an old and highly popular musical form most noted for face-changing, multilayered **masks** and stylistic movements with humorous lyrics, fire-breathing **puppetry**, and **acrobatics** adapted from novels, **legends and mythologies**, and **folktales**. Home to many legendary poets, most notably Li Bai of the Tang Dynasty and Su Shi of the Northern Song Dynasty (960–1120), Sichuan was also a center of block printing, which excelled during the Song Dynasty (960–1279).

Internationally renowned for spicy foods known as *mala* ("hot and numbing"), Sichuanese **cuisine** is one of eight culinary traditions in China, especially the popular hot pot, with fresh seafoods and poultry, along with peppercorns and chilies. The establishment of the Sichuan Cuisine Museum in Chengdu, the first devoted to a regional cuisine, testifies to the popular saying that, "All tastes can be tried in Sichuan." Original home to the famous "white liquor" (*baijiu*), Sichuan is also the location of the oldest wine-making workshop in the world at the Shujingfang Museum, featuring such famous brands as Wuliangye. Particularly appealing to the generally slow-moving population of the province are **games** like mahjong, the most popular form of **entertainment** among the population, most evident in tea houses, where drinking is from covered-bowl cups. Sichuan is also the location of many **minority** populations, including large numbers of Tibetans concentrated in autonomous areas and such **urban** centers as Larung Gar in the northwest.

See also CHONGQING.

SILK ROAD (*SICHOU ZHI LU*). A complex network of trade routes connecting imperial China to **markets** in the Middle East, Europe, East Africa, and India, the Silk Road (also known as the "Spice Route") was initiated by the Chinese diplomat and explorer Zhang Qian in the late 2nd century during the Han Dynasty (202 BCE–220 CE) and extended into the 18th century both overland and **maritime**. At 6,400 kilometers (4,000 miles) in length, the

SILK ROAD (SICHOU ZHI LU) • 395

overland route involved lengthy caravans with goods loaded on camels and yaks carrying upward to 500 pounds while more efficient sea routes carrying the bulk of goods were added from the 7th century onward with major ports in India and in the Arabian and Red Seas. Labeled the "Silk Road" in the 19th century by the German geographer and scientist Baron Ferdinand von Richthofen (1833–1905), the term was derived from the large quantities of **silk** initially headed from China to the Roman Empire. There, demand for the fabric was high, especially for **women**, even as Roman authorities considered silk **clothing** decadent and tried to outlaw it. Equally prized by the Byzantines from the 5th to the 15th centuries, Emperor Justinian (527–565) conspired to steal silkworm eggs from China as the market spread throughout the Eurasian steppe, with trade routes branching out through **Sichuan** and **Yunnan** provinces into **Tibet** and India. Other largely luxury products traversing the route out of China included bronzes, **ceramics and porcelain**, dyes, ginger, ivory, **jade**, lacquerware, medicines, perfumes, spices, tea, and paper and gunpowder, the last two having an enormous impact on cultural and social developments in recipient markets. Imports into China along the trade routes ranged from **animal** furs to gold and silver, and even slaves, the highly prized "heavenly horses" (*tianma*) acquired from Greco-Bactrian states and used by Chinese military forces to confront powerful "**barbarian**" tribes, especially the nomadic Xiongnü threatening the empire's northern borders.

Starting points for the Silk Road included the Chinese imperial capitals of Chang'an (today's **Xi'an**) and Luoyang, with major intermediaries along the overland routes, including various empires. Most notable were the Parthians (247 BCE–224 CE) in Persia and the two Islamic Caliphates of Umayad (661–750), and especially Abbasid (750–1250), which spanned the Middle East, North Africa, Persia, and (for a time) Spain. Beginning with expansion into Central Asia during the cosmopolitan Tang Dynasty (618–907), inaugurated under Emperor Taizong (626–649), Chinese and Caliphate forces shared control of the trade routes, especially through the strategic Tarim Basin in today's Xinjiang-Uighur Autonomous Region (XUAR). Periodic military clashes also occurred between the two powers, most notably the Battle of Talas (751) in today's Kyrgyzstan, in which Tang forces suffered a major defeat at the hands of the Arab Abbasid Caliphate in alliance with the expansive Tibetan empire. Trade expanded during the subsequent Mongol-dominated Yuan Dynasty (1279–1368), as the four khanates of the larger Mongol Empire (Golden Horde in the northeast, Ilknanate in Persia, Chagatai in Central Asia, and Great Khanate in China) collaborated with Sogdian and Armenian merchants in managing the many Silk Road routes traversing major cities in Central Asia including Samarkand, Bukhara, Kashen, Tabriz, Aksaray, Edirin, and terminating in Venice, Italy. Notable travelers on these routes included William of Rubruck from France (1253) and the Venetian

396 • SLANG (LIYU)

Marco Polo (1271–1295). Disruptions of the trade routes periodically occurred, from the spread of the bubonic plague in the 14th century to the Turkish **conquest** of the Byzantine imperial capital of Constantinople in 1453. Final closure of the overland routes followed the collapse of the Islamic Safavid empire (Persia and Turkey) in 1736, as China lost the monopoly on the production of silk to competitors in Japan and Europe.

Major cultural influences also traversed the Silk Road, with China incorporating various forms of **arts** and **entertainment**, especially **dance**, and diverse **cuisines** from Inner Asia, along with major **religious** traditions, primarily Islam and Nestorian **Christianity**, the latter in the 7th century. With various tribes and pastoralists along the trade routes integrated into a global trading network and drawn to the riches of great civilizations, substantial intermarriage between Chinese nobility and nomads and families of Turkic origin also occurred. For leaders of the People's Republic of China (PRC), the overland and maritime Silk Road is a model for such international policy initiatives as the One Belt, One Road Initiative (2013), referred to as the "New Silk Road," involving extensive plans for infrastructure projects in regions traversed by the former trade route.

SLANG (*LIYU*). Developed historically through ancient stories passed down through generations, modern-day slang in China has been shaped by the emergence of the internet, with specific words affected by different dialects of the Chinese **language**. With references to such common, everyday needs and social activities as **food**, **family**, and intimate personal **relations**, Chinese slang is very creative, in a society where language is a centerpiece of cultural life. Especially creative are words and phrases with double meanings, the usually prosaic, literal meaning versus the implied and widely understood connotation, usually involving sensitive personal or social matters like **sexual** relations and **marriage**.

Prominent examples, first in Chinese, followed by the literal and then connoted meaning in parenthesis, include the following: *xiaoxian rou*, "small fresh meat" (young handsome guy) versus *laolarou*, "tough cured meat" (old, experienced, and handsome guy); *luohun*, "naked marriage" (failure of the prospective groom to secure an apartment or automobile, considered a requirement for consummating the nuptials); *xinling jitang*, "good chicken soup" (words with useless content) versus *du jitang*, "poisonous chicken soup" (straightforward and frank talk); *bao datui*, "cling to one's lap" (curry favor); *mei mener*, "no door" (No way!); *yanpi dixia*, "under one's eyelids" (right under one's nose); *yeshi zuile*, "being drunk" (Are you kidding me? Do you think I have gone crazy?); and *ni xing ni shang*, "you can, you up" (If you can do it, then do it; if not please shut up).

SLANG (LIYU) • 397

Numbers in ordered sequence also constitute slang based on homonymous similarities, with references to personal behavior and expressions of delight or disappointment. Examples, first in English, then in Chinese, literally, and, in places, the homonymous similarity, with the meaning in parenthesis, are as follows: 666, *liuliuliu, niuniuniu* ("awesome" or "great"); 484, *sibasi, shibushi* ("yes or no"); 233, *ersansan, hehehe* ("hahaha"); 520, *wuerling, woaini* ("I love you," with 520 referencing 20 May, Chinese Valentine's Day); 1314, *yisanyisi, yishengyishi* ("one life, one world"); 995, *jiujiuwu, jiujiuwo* ("Help me!"); 7451/7456, *qisiwuyi/qisiwuliu, qisiwole* ("cheating or fooling me"); 748, *qisiba, qusiba* ("Go to hell"); and 88, *baba* (the Chinese equivalent of "bye, bye"). Numbers and connoted meaning with exactly the same pronunciation but different tones include 555, *wuwuwu, wuwuwu* ("crying"), and 94, *jiusi, jiusi* ("precisely that").

Descriptions of individuals, both complimentary and critical, along with particular situations and conditions, advantageous and disadvantageous, are also captured in slang but with informal provisions for proper use. Examples, first in Chinese and then English, with connoted meaning and informal guidance, include the following: *diaosi*, "loser," used for self-deprecation, generally by young, not very well-off **men**, and especially for unwarranted privileges, not to be directed at others; *gaofushuai*, "tall, rich, and handsome," the opposite of *diaosi*, applied to the guys who get the girls; *baofumei*, "white, rich, and beautiful," the female opposite of *diaosi*, with emphasis on white skin as a sign of purity; *fuerdai*, "rich parents" with good **relations and connections**, helpful for gaining entry into the best schools; *tuhao*, "unsophisticated rich," usually referencing the nouveau riche from the countryside; *zhainan/zhainü*, "geek" or "nerd," referencing young people staying home all day playing video **games** or watching television; *nanshen/nüshen*, "ideal man"/"ideal woman"; *mengmengda*, "cutie pie," with repetition of the first two words used for emphasis, a common practice in China, and *maimeng*, "acting cute"; *doubi*, someone who likes to joke and say stupid things; *amao agou*, nicknames of common people, roughly equivalent to "any Tom, Dick, or Harry"; *choubaguai*, "monster-looking"; *kaopu*, "reliable" or "reasonable"; and *diaobaole*, "very, very cool."

Various personal behaviors with good outcomes but also tragic consequences and expressions of **happiness** but also regret are also embedded in slang, often employing earthy language. Examples in Chinese, with the translation and meaning in English, and further explanations, are as follows: *zhuangbi*, pretending to be something or someone you are not; *chitu*, literally, "eating dirt," referring to spendthrifts, usually young men, blowing all their **money** to impress young ladies, especially on Single's Day (11 November), with nothing left over to spend on **food**; *zuosi*, "seek **death**," meaning to seek trouble, with *buzuo buhsi*, "avoiding trouble by not doing anything silly"; *youqian jiushi renxing*, "having money, can act however I like," and *aishei-*

398 • SMARTPHONE CULTURE (SHOUJI WENHUA)

shei, both phrases speaking to the power of money and greater personal **freedom**, if not political rights, in the contemporary People's Republic of China (PRC), especially since the introduction of economic reforms and social liberalization (1978–1979); *tucao*, "complain, roast, and criticize"; *chunhuo*, a cute way to say something stupid; and *jimodang*, to have oneself a loneliness party. Popular expressions include *niu*, "awesome" or "amazing," and *duang*, a neologism that became a viral meme with unclear meaning, roughly translated as "oops" or "boing," with no written form, although proposals to combine two extant Chinese characters have been made based on the Chinese name for actor Jackie Chan, who first uttered the word in a televised commercial advertisement in 2004.

SMARTPHONE CULTURE (*SHOUJI WENHUA*). A product of the appeal to the Chinese public of advanced technology, smartphones have become ubiquitous in the People's Republic of China (PRC), with an estimated 780 million users (2020), including a reported 80 percent of **children** (ages one to five). Leapfrogging the stage of heavy use of personal computers to access the internet, the cheaper and more easily used smartphones were rapidly adopted, with foreign versions like Samsung and Apple dominating the **market** at first but quickly replaced by more affordable domestic brands, for example, market-leader Huawei, and other brands the likes of Oppo, Vivo, and Xiaomi. Using a wide-variety of "apps" (*yingyong chengshi*) available on such platforms as Tencent's WeChat (launched in 2011), the Chinese consumer relies on the smartphone for not only **communication**, but also important daily functions like paying bills, managing personal wealth, ordering takeout **food**, hailing taxis, arranging bicycle-sharing, reading online newspapers, and socializing. **Entertainment** is also accessible by phone, with popular short videos available via such apps as Kuaishou and Douyin, with TikTok the international version of the latter, as Chinese users spend an average of three hours a day on their phones, second in the world, with offline activities like **sports** and reading replaced by digital devices.

Major issues with smartphones involve concerns about data **privacy** and security, as intrusive policies are promoted by the Chinese government of "weaponizing" (*wuqihua*) the technology, relying on installed malware to trace the movements and contacts by certain groups, for instance, potentially "separatist" (*fenlizhuyi*) Islamic groups among the Uighurs in the Xinjiang-Uighur Autonomous Region (XUAR) and prodemocracy activists in **Hong Kong**. Reflecting the long-standing reliance on technology to maintain social and political control of suspect populations, Chinese government actions range from subjecting individuals to investigation for the mere appearance of certain apps on their private phones to mandating the installation of tracking software on the phones of foreign visitors, with concerns that Chinese-made smartphones are produced with installed tracking software. Referred to by

critics as "algorithms of oppression" (*yapo suanfa*), surveillance platforms package multiple data sources, with such malware as BXAQ and Feng Cai used to scan devices with similar programs, for example, the Alipay Health Code, devised to track COVID-19 cases in 2020.

Negative consequences to human **health** of excessive smartphone use include sleep deprivation, high blood pressure, accelerated heart rate, and **obesity**, especially among **youth**, with ancillary environmental damage coming from piles of abandoned bicycles by poorly designed bike-sharing apps. Widespread fear of missing out on new consumer products, the latest **fashions**, and **celebrity** gossip drives continuing popular demand for the phones, with total users slated to reach 868 million by 2023, which already includes **rural** residents and members of the working class.

SMOKING (*CHOUYAN*). The largest consumer and producer of tobacco products in the world, with an estimated 350 million smokers, overwhelmingly **men**, the People's Republic of China (PRC) has made periodic efforts to reduce smoking, especially among **youth**, but with limited effect, as the habit has become a major social and cultural norm. An ingrained aspect of fraternizing and socializing, particularly among less well-educated men in **rural areas**, with high-priced cigarettes constituting prized **gifts** on special days and during events like the **Spring Festival** and **business banquets**, smoking is highly associated with masculinity, with 52 percent of men (2015) surveyed as smokers, while among **women** the habit is considered a sign of **prostitution** and limited to 2 to 3 percent. A virtual monopoly of the China National Tobacco Company (CNTC), with foreign tobacco sales outlawed in 1953, cigarette sales are a major source of revenue (7 to 10 percent) for the Chinese government, with the industry employing thousands of workers. Most common among the male working class, farmers, factory workers, service people, private employers, and the self-employed, usually with no more than a primary school **education**, and among females, the highest among older retirees, smoking rates have been subject to several national surveys (1984, 1996, 2010), indicating a leveling off and even a decline (2019).

With smoking contributing to the country's high rate of lung cancer diagnoses and costing an estimated 1 million lives a year, China was one of the first countries to ratify the World Health Organization (WHO) Framework Convention for Tobacco Control (FCTC) in 2003, with many cities, including **Beijing** and **Shanghai**, establishing smoking bans in public arenas. Antismoking groups, notably the China Association on Smoking and Health, have been subject to **criticism** for contacts with **foreigners**, while warning labels on cigarette packs appear in English. With most of the 90 or so brands in the country widely available in shops and convenience stores, and still relatively cheap, government plans call for reducing smokers to 20 percent of

400 • SOCIAL ANXIETIES AND PHOBIAS

the population by 2030, while the United States insisted on including American tobacco products in negotiations on promoting trade with the PRC conducted in 2018.

SOCIAL ANXIETIES AND PHOBIAS (*SHEJIAO JIAOLU/SHEJIAO KONGJU ZHENG*). Defined as an unreasonable and excessive **fear** of being closely watched, judged, and criticized by others in certain social situations with negative consequences for physical and psychological **health**, social anxiety disorder (SAD) was not recognized and researched in the People's Republic of China (PRC) until 2000, with relatively low but rising rates, according to recent mental health surveys (2013–2015). A collectivist society with strong orientations and obligations to such groups as the **family**, China is distinguished by an "other-concerned anxiety" (*qita jiaolu*) that derives from an excessive need for social approval from others, with a constant fear of interpersonal rejection and abandonment, along with "emotional discomfort" (*qingxu bushi*) about causing others to feel uneasy. Geographically, SAD rates in the PRC are highest in provinces and cities located on the country's southern coasts, for example, **Guangzhou**, along with northern interior provinces like Hubei and Hebei, and the far western autonomous regions of **Tibet** and Ningxia. Demographically, SAD rates are higher among **women** than **men** but with no significant differences between **rural** and **urban areas**. Major barriers to treatment exist, with significant social stigma still surrounding mental health issues among the population and a national shortage of psychologists and psychiatrists, although self-help programs are available on the internet.

SOCIAL CREDIT SYSTEM (*SHEHUI XINYONG TIXI*). Conceived as a national reputation system for bolstering the overall "trustworthiness" (*kexinlaidu*) of the general population in the People's Republic of China (PRC), the social credit system (SCS) was officially introduced in 2014, based on a grid-style social management system tried out in 2001–2002. Intended as an integrated electronic system for standardizing the evaluation of individuals and **businesses**, with reliance on mass surveillance systems developed throughout the decades, numerical SCS scores are determined by positive (red list) and negative (black list) actions, with rewards and **punishments** handed out accordingly. While the exact standards remain secret, positive actions include donating blood, giving money to **charity**, and volunteering for community service. Negative actions are evidently more numerous and range from minor to serious infractions, including: exercising dangerous **driving habits**; **smoking** in prohibited areas; buying too many video **games** (numbers unknown); posting fake news, especially on **social media**; **eating** on rapid transit systems; playing loud **music**; jaywalking; and failing to sort personal

garbage and waste. Included are negative scores for **pet** owners, especially when failing to clean up after their animal, which in severe cases can lead to confiscation of the pet.

Rewards for high scores are largely economic and include lower bank interest rates, preferred booking on airline and high-speed train travel, and lower **energy** bills, with punishment for those ranked as "untrustworthy." This includes prohibitions on employment in state-owned enterprises (SOEs) and major banks; restricted access to first-class accommodations; and, reminiscent of imperial times, punishment of **family**, for instance, denial of enrollment in the better schools. With the virtual collapse of the previous "**unit**" (*danwei*) system of social control, with highly inefficient, paper-based personal "files" (*dang'an*), SCS is seen as a new, real-time method of shaping behavior, employing such modern technologies as facial-recognition software, artificial intelligence, and bid data. Denounced as a dystopian nightmare of **human rights** abuses and a basic violation of **privacy**, supporters laud the system for "keeping trust" in a society where most people evidently expect to be cheated and personal trust is considered a rarity. While original plans called for full nationwide implementation in 2020, full-scale SCS systems have been limited to piecemeal pilot tryouts in a few **urban areas**.

SOCIAL DESPAIR (*SHEHUI JUEWANG*). Increasingly prevalent among dispossessed and alienated groups in the People's Republic of China (PRC), social despair has grown, exacerbated by such horrific events as the slew of murder-**suicides**, especially of young **children** (2019), with an expanding *sang* culture, influenced by Japan, idealizing "listlessness to the point of despair." Historically, the Chinese penchant for sullenness and despair was directly addressed by **Lu Xun** (1881–1936), who advocated the cultivation of a critical-**thinking** citizenry capable of understanding the social and economic roots of their malaise as the only viable, long-term solution to this national miasma. Similar views were voiced years later by world-renowned physicist Fang Lizhi (1936–2012), who, noting that the failed promotion of socialism by the Chinese Communist Party (CCP) since 1949, had left the Chinese people despondent, called for the introduction of democracy as the key to "resisting despair" in the aftermath of the military crackdown on the prodemocracy movement in June 1989.

High levels of discontent exist among contemporary groups living on the margins, most notably poorly paid migrant laborers working on projects in **urban areas**, along with left-behind **rural youth** confronting even poorer prospects in a dwindling agricultural economy. Similar feelings of hopelessness also beset the more privileged young millennials, born between 1985 and 1995, who despite their college **education** despair about shrinking opportunities in a less robust economy of yesteryear and wallow in poor pros-

pects of **marriage** and a happy home life in expensive housing. Absent a legitimate channel to vent their frustrations in the rigid hierarchies and social norms governing the PRC, many of the young have gathered on **social media** to embrace the attitude of *sang*, a word associated with **funerals**, marked by extreme pessimism and defeatism, and symbolized commercially by the sale of "my-life-is-a-waste green **tea**" and other equally sardonic product lines. A quiet protest against the relentless push for achieving traditional notions of success, *sang* culture has been promoted by prominent international **celebrities**, with a pushback from government propaganda organs and private **companies**, espousing a more positive and optimistic view known as *ran*, roughly translated as "burning."

SOCIAL MEDIA (*SHEJIAO MEITI*). The largest social media market in the world, with as many as 800 million users in a rich and diverse environment, a multitude of websites and applications provide the Chinese public with places for sharing opinions and videos, while also engaging in a variety of commercial and **business** activities. Begun in the form of online forums and communities (1994), followed by the availability of instant messaging (1999), blogging (2004), and social networking (2005), Chinese social media is the most active in the world, with a fiercely competitive but also fragmented and localized social media space. Dominating the **market** are three large-scale domestic Chinese companies, namely "WeChat" (*Weixin*) and "QQ," both owned by Tencent and established in 2013 and 1999, respectively, and Weibo, owned by Sina Corporation, established in 2009, as major Western social media companies the likes of Facebook, Instagram, and Twitter have been banned in the People's Republic of China (PRC).

An all-in-one service provider described as a "super app," WeChat offers access to **games**, **shopping**, financial services, and instant messaging, with 10 million third-party apps and 1 billion monthly active users, 98 percent accessing by mobile devices. Appealing to a younger audience less than 21 years of age, many without access to mobile phones, QQ is a more playful and **entertainment**-oriented site for animated selfie filters, personalized avatars, and photo retouching, supplemented by the Qzone app since 2005, serving as a Facebook-like personal page. Considered the Chinese version of Twitter, Weibo, in a strategic partnership with e-commerce giant Alibaba, is the most popular microblogger, also involved in social commerce and marketing, with users uploading and insta-sharing pictures and videos.

Other prominent platforms and their major service offerings include the following: Douyin, for creating and sharing short videos; Meitu, meaning "beautiful picture," offering photo touch-ups and airbrushing, leading to **criticism** that the site inadvertently created an unrealistic standard of female **beauty**; Meituan-Dianping, meaning "everyone's comments" and considered the Yelp of China, with similarities to Groupon and Other Earth, with re-

SONGS AND SINGING (GEQU/CHANGGE) • 403

views and recommendations of restaurants, gyms, hotels, and bars; Douban, a social networking app for sharing content, including films, television, and books, and compared to Reddit; Zhihu, compared to Quora, where users pose questions, with responses offered; and *Xiaohongshu*, "Little Red Book," a Pinterest-style site geared toward **women** with emphasis on photo-sharing and e-commerce. Industry-specific sites are as follows: Xueqiu, for equity and finance; Keep, for **health** and wellness; Mafengwo, for traveling; and Maiimi, similar to LinkedIn. While relatively open-ended, sites remain subject to state **censorship**, with any politically sensitive material removed immediately.

SONGS AND SINGING (*GEQU/CHANGGE*). Renowned for a vibrant tradition of songs and singing, with the ancients saying, "When words are not enough, one can sing," China has a rich variety of **opera**, dominant in the imperial era, with versions of pop and jazz-influenced singing in the early and late 20th century, separated by the period of revolutionary songs during the rule in the People's Republic of China (PRC) by Chinese Communist Party (CCP) chairman **Mao Zedong** (1949–1976). While influenced by Western song and singing forms since the 19th century, Chinese native singing has distinctive characteristics, including emphasis on the beauty of the melody with subtle and delicate lyrics; "accentuation" (*qiangdiao*) of the last note of a line in a song by prolongation and amplification, and recitation of the lyrics to capture the literary dimension of the song, with a good understanding of **literature** leading to better singing.

Imports from the West began with the introduction of church choirs and chorales by Western missionaries, along with the spread of school songs made popular from Japan. Intertwining the musical with the political, Hong Xiuquan, leader of the pseudo-Christian Taiping Rebellion (1850–1864), mobilized his supporters by singing Christian hymns with the lyrics altered to glorify the rebellion against the ruling Qing Dynasty (1644–1911). With Chinese coastal cities like **Shanghai** undergoing an economic boom from global trade and Western investment, singing troupes arose, notably the so-called "sing-song girls" (*genü*), also known as "flower girls" (*huaji shaonü*), courtesans trained from childhood to entertain wealthy male clients, mainly in sing-song houses, also serving as brothels, with hopes of becoming a "second wife" (*ernai*).

An overlapping singing style also emerged known as "songs of the era" (*shidaiqu*), merging Chinese folk and American jazz, as such prominent singers as Li Jinhui (1891–1967), referred to as the "father of Chinese popular **music**," became known for "Shanghai Night" (Ye Shanghai) and other seductive melodies, along with many female singers, most significantly the "Seven Great Singing Stars," including the iconic Zhou Xuan (1920–1957). The first Chinese pop tune, "The Drizzle" (Maomao Yu), was composed

404 • SONGS AND SINGING (GEQU/CHANGGE)

during this period, which ended with the CCP takeover of the mainland in 1949, as many popular singers fled to **Hong Kong**, while the musical scene in the PRC became dominated by highly politicized and high-spirited revolutionary songs.

Throughout the Maoist era (1949–1976), the most popular songs included "The Internationale" (Guoji Hua) and "March of the Volunteers," the country's national anthem, along with "The East Is Red" (Dong Fang Hong), the last considered the national anthem during the **Cultural Revolution (1966–1976)** and made equally popular by the film of the same name in 1965. "Harvest songs" (*yangge*), literally "rice-sprout songs," with spirited **dances**, garish costumes, and loud music, served as a major CCP propaganda device employed during the Civil War (1946–1949) and continued into the 1950s, to bolster the legitimacy of the new regime, especially during the disruptive and sometimes violent land reform campaign (1947–1953). Songs blurted out by rampaging Red Guards during the Cultural Revolution included such politicized classics as "It Is Right to Rebel" and "Sailing the Seas Depends on the Helmsman," which were primarily aimed at promoting the god-like status of Mao Zedong.

While the introduction of economic reforms and social liberalization (1978–1979) led to a revival of pop songs, known as Mandopop, originating in Taiwan, the so-called "Red Song Movement" (*Hongge Yundong*) was initiated by the one-time CCP leader of **Chongqing**, Bo Xilai, with choirs and collective singing groups organized in local state-owned enterprises (SOEs), schools, and **neighborhood** committees beginning in 2008. With local **children** urged to memorize 10 revolutionary tunes, with such titles as "Protect the Yellow River" (1938), "Ode to the Motherland" (1951), and "Little Ping Pong Ball" (circa 1966), as a way to instill patriotic feelings, extraordinary claims were made that red songs helped cure the mentally ill but with the movement petering out following the purge of Bo Xilai (2012).

Singing competitions now air on China Television, including the likes of *Sing China*, *I Am a Singer*, and *The Voice of China*, as Mandopop has expanded, with such popular singers as Jay Chou and Faye Wong building a following throughout Asia, including the PRC. While songs praising President **Xi Jinping** (2013–) have been released with apparently little popular enthusiasm, periodic political interventions have occurred, as provocative songs from the popular show *Les Misérables* have been blocked on streaming services, along with certain Christian hymns, for example, "Sing Hallelujah to the Lord," replaced in Chinese churches by more politically acceptable lyrics, with hip hop banned in 2018, but with unknown effect.

With a rich tradition of "folk songs" (*minge*) from a variety of **regions**, there is no great gap between orchestral and folk music, as the latter is a basis of prominent symphonies and operas, and the main music taught to children in the PRC. Employing simple melody passed down from previous genera-

SPIRITUALITY (LINGXING) • 405

tions, some notable tunes have been composed in the 20th century, including by prominent composers merging Western and Chinese forms, for instance, He Luting (1903–1999), a defender of Claude Debussy against mindless leftist attacks led by Yao Wenyuan (1931–2005), and Tian Han (1898–1968), who, in 1937, cocomposed "The Wandering Songstress" (Tianya Genü) for a film. Popular folk songs, along with geographical/cultural origin and year of composition, where available, include the following: "Kanding Love Story" (Kanding Qingge), **Sichuan**; "Purple Bamboo Melody" (Zizhu diao), Suzhou, Jiangsu, 1930s; "The Crescent Moon Rises" (Bangeyue Liangpa Shang), Xinjiang; "At a Faraway Place" (Zai na Yaoyuan de Difang), Kazakh, 1939; and "Why Are the Flowers So Red?" (Huaer Weishenma Jeiyang Hong?), Tajik, 1963.

SPIRITUALITY (*LINGXING*). Historically rich in spiritual life, with three major **religious** traditions, **Buddhism**, **Daoism**, and nonsecular elements of **Confucianism** and powerful folk religions, primarily **ancestor worship**, China experienced a spiritual vacuum following the passing of Chinese Communist Party (CCP) chairman **Mao Zedong** in 1976, with a "spiritual reawakening" (*jingshen fuxing*) beginning in the 2000s. According to the ancients, China's rich cultural and artistic traditions, including **calligraphy**, **music**, medicine, and **clothing**, were transmitted to humankind by divine beings from heaven. Despite decades of dominance by a secular Marxist–Maoist ideology, Chinese people still immerse themselves in an alternate world of spirituality shaped by the lunar calendar that continues to underpin how individuals dress, **eat**, worship, and pray. Guided by daily and annual **rituals**, with lessons drawn from poetic stories, spiritual qualities were attributed to stone tablets, believed to gather powerful **energy** and ward off evil spirits, and peach wood swords used in demon exorcism, although overall Chinese have been less obsessed with higher meaning and eternity than worldly concerns and the present.

While the government of the People's Republic of China (PRC), during the culturally iconoclastic rule of Mao Zedong (1949–1976), attempted to stifle the spiritual and religious world, especially during the **Cultural Revolution (1966–1976)**, the administration of **Xi Jinping** (2013–) is trying to co-opt various forms of domestic spiritual and religious traditions, excluding "foreign" **Christianity** and "cults" (*xiejiao*) the likes of Falun Gong, to an agenda stressing the rebirth of a vibrant Chinese culture. The collapse of both the canon of Confucianism in the early 20th century and Marxism–Leninism–Mao Zedong Thought in the late 1970s was followed by a shift to an unbridled and relentless pursuit of wealth that quickly fed a spiritual crisis, with large segments of the population realizing that "money cannot buy happiness" (*qian maibudao xingfu*). Beset by a spiritual vacuum in a society seen as lacking basic shared values, a common belief arose that,

406 • SPORTS (TIYU)

"Anything goes as long as you as don't get caught." Searching for spiritual fulfillment and meaning while regaining the lost moral compass, guidance was pursued from the likes of Qigong masters, Daoist and Buddhist monks, and newly born Christian preachers. Reclaiming values and traditions that historically set China apart from the outside world, pilgrimage associations have grown increasingly popular, offering extended tours to such traditional spiritual sites as the Mount of the Wondrous Peak (*Miaofengshan*) in northwestern **Beijing** to worship the goddess Our Lady of the Azure Clouds.

SPORTS (*TIYU*). Dating to the imperial era, when China developed an independent sports tradition, attraction to modern sports began soon after the humiliating defeat of the country in the First Sino–Japanese War (1894–1895), during a time when sports and physical fitness were considered essential to building national strength and overcoming China's reputation as the "sick man of Asia" (*Yazhou bingren*). Developed primarily as military exercises for imperial armies, major traditional sports included wrestling, chariot and armor racing, and especially ball **games**, with a Chinese version of football (soccer) developed in the Tang Dynasty (618–907) and polo imported from Persia. Spreading to the general population in the Song Dynasty (960–1279), sports expanded, with Taiji and Gongfu boxing becoming popular in the Ming Dynasty (1368–1644).

Endorsed by political leaders, from Republic of China (ROC) president Sun Yat-sen (1912–1925) to a young **Mao Zedong**, and influenced by foreign organizations, particularly the YMCA, and foreign nations, mainly Japan and Germany, China realized that it could only compete in the modern, social Darwinist world by merging progress in sports with the goals of national renewal. Cultivation of a "fighting spirit" (*shangwu*) was especially important for what was seen as the long-moribund and excessively feminized male population. With the first gymnastics school established by a student returning from Japan in 1908, the first national games were held in Nanking (Nanjing) in 1910, as China looked to the Olympics, reestablished in 1896, as an outlet for its newfound interest in sports and a route to international notoriety. The China National Amateur Athletic Federation was set up in 1921, which the International Olympic Committee (IOC) quickly recognized as the Chinese Olympic Committee. China also became an early founder and participant in regional sports events, notably the Far Eastern Championship Games (later the Asian Games), which held its second competition in **Shanghai** in 1915, although the Chinese team was composed exclusively of athletes from **Hong Kong**. The ROC participated in the 1932 Olympics in Los Angeles, where its team was composed of one athlete, a runner by the name of Liu Changchun, who failed to qualify for his event, while at the Berlin Olympics in 1936, China fielded a much larger team of 69 athletes, many again from Hong Kong, although they failed to win any medals.

SPORTS (TIYU) • 407

The lure of modern sports did not diminish following the establishment of the People's Republic of China (PRC), despite the many difficulties faced by the new regime, from consolidating **military** control of the country to its involvement in the Korean War (1950–1953). Assisted by the Soviet Union, China was an official participant in the Summer Olympics in Helsinki, Finland, in 1952, although the Chinese team showed up too late to participate in the competition. That same year, China established a national sports commission, headed by People's Liberation Army (PLA) general He Long, with the high-ranking Deng Xiaoping playing a major promotional role. Domestically, the first Workers' Games were held in 1955, with the first national games in **Beijing** attended by the top Chinese Communist Party (CCP) leaders, including Mao Zedong, Liu Shaoqi, and Zhou Enlai. Participation in the Olympics, however, came to a sudden end concerning a dispute with the IOC involving the participation of a team from Taiwan, whose claim to "represent China" in the Olympics led to a more than 20-year boycott by the PRC.

Little in the way of sports occurred in China during the **Cultural Revolution (1966–1976)**, when some members of the PRC world-class table tennis team committed **suicide** after harassment by marauding Red Guards. Reengaging international sports, the PRC rejoined the Asian Games in 1974, winning the medal count each year since 1982, while also rejoining several international sports federations. Boycotting the 1980 Summer Games in Moscow, along with the United States, due to the Soviet invasion of Afghanistan, the PRC sent teams to the Winter Olympics at Lake Placid, New York, in 1980, and the Summer Games in Los Angeles in 1984, as the issue of Taiwan was effectively resolved.

Under orders to follow a policy of "friendship first, competition second," Chinese teams often lost to inferior teams from such compatriot states as North Korea. But once China rejoined high-level, international competition, especially the Olympics, the emphasis shifted 180 degrees to winning competitions, bolstered by government financial rewards for gold medalists and oftentimes public **humiliation** for lesser performers, even if they won silver or bronze medals. Teams from the PRC have done well in the Winter Games, especially in skating, with a Chinese pair winning the gold in figure skating in 2010, in Vancouver, Canada, and Chinese short-track speed skaters winning three gold medals in 2014, at Sochi, Russia.

In the Summer Games, China has been even more impressive, winning 32 gold medals at Sydney, Australia, in 2004; 51, the most of any nation, in 2008, in Beijing; and 38 in London in 2012, in swimming, diving, track and field, weightlifting, and table tennis. That sprinter Liu Xiang won the gold medal at the Sydney games in the 110-meter hurdles helped dispel the blatantly racist myth that Chinese athletes could never compete with their Western counterparts in such physically demanding events. Beijing has once again been selected as an Olympic venue for the Winter Olympics in 2022, which

408 • SPORTS (TIYU)

will take place at the many winter resorts built north of the city. At the same time, some in China have called for less emphasis on winning medals, which often comes at considerable expense to state coffers and a distortion of the Olympic spirit. Chinese Olympians are subject to various restrictions including highly controlled interactions with the public and press and limitations on **marriage** and other social activities along with accusations of **drug use**.

Modern sports in China have also grown enormously, especially since the introduction of economic reforms and social liberalization (1978–1979), with European football (soccer) by far the most popular sport, followed by basketball, badminton, and table tennis. The popularity of soccer has not been diminished by the failure of the international Chinese **men's** team to qualify for the World Cup, as many Chinese fans became avid supporters of the national team from Germany. On the **women's** side, the soccer team remains internationally competitive, losing to the United States in the semifinals of the 2015 Women's World Cup, eventually won by the Americans. Women have also been successful in international volleyball competition, winning the gold medal in 1984 and 2004, along with five world titles.

Estimates are that 300 million Chinese play basketball, with courts located in such unlikely places as the **Forbidden City** in Beijing and on most military bases. Spurred by the drafting of Yao Ming to the Houston Rockets in 2002, and his successful run with the team, the National Basketball League (NBA) has become enormously popular throughout China, with national broadcasts of NBA games since 1987, and the formation of 18 teams in the Chinese Basketball Association. American-style football has also been introduced, with the establishment of a Chinese League composed of 30 teams, along with baseball, which saw Chinese pitcher Chien-ming Wang from Taiwan rise to fame with the New York Yankees and Toronto Blue Jays. Tennis, while still a rarity among young Chinese athletes, has seen the rise to international prominence of Ms. Li Na, winner of the 2011 French Open, and the up-and-coming Shuai Zhang, with annual international tournaments like the Shanghai Rolex Masters and the China Open in Beijing.

Similar prominence has been achieved in figure skating, where Chinese men and women have emerged as international competitors, with both Beijing and Shanghai hosting major international figure-skating events. Golf, once denounced by Mao Zedong as a "millionaire's game," has witnessed a meteoric rise, with several Chinese players breaking into international competition on the men and women's professional golf tour, with Ms. Feng Shanshan securing a victory in a major tournament event in 2012 and Mr. Li Haoteng becoming a viable contender on the American PGA tour in 2020. With more than 600 golf courses constructed in China since the early 1990s, including Mission Hills Resort outside Shenzhen, the largest facility in the

world, the game has become increasingly popular, as China now has its own professional tour, the China PGA Champions Tour, although in late 2015, the ruling CCP prohibited party members from joining private golf clubs.

After the passage of the Physical Health Law of the PRC (1995) and the promotion of a nationwide program of physical fitness centered on growing numbers of physical fitness centers in many **urban areas**, the physical health of the Chinese people is now a major national concern. Chinese **youth** are a primary target, as rates of **obesity** are increasing from excessive consumption of junk food and spending too much time playing video **games**. Urban sports, especially popular among young men, include skateboarding, rollerblading, bicycle moto cross (BMX), and parkour (*paobu*) imported from France via the internet and involving backflipping and extreme jumping. Sports in China have also served political ends, as when a visit to China by the American table tennis team, at the invitation of Premier Zhou Enlai, laid the groundwork in 1971, for the subsequent visit by U.S. president Richard Nixon to the PRC in February 1972.

SPRING FESTIVAL (*CHUNJIE*). The most important traditional holiday in Chinese society, the Spring Festival, or the Chinese New Year, marks the end of winter and the beginning of spring. Based on the lunar-solar calendar, the holiday lasts for 15 days beginning with the new moon and ends with celebration of the Lantern Festival. Of unknown historical origins, the holiday is traced to **legend and mythology** involving the **conquest** of the mystical beast Nian by a local villager symbolizing peace, who employed red paper and loud noises to drive away the menacing child-eating creature, as the Chinese phrase for "new year's celebration," *guonian*, literally means "survive the Nian." With no fixed date and occurring between 21 January and 20 February, the celebration centers on eating various **foods**, which vary by **region**, with northerners generally preferring "dumplings" (*jiaozi*), symbolizing wealth, reportedly for their similarity in shape to imperial-era gold and silver ingot currency, and southerners eating "sweet rice dumplings" (*tangyuan*), along with special cakes. Other popular foods include chicken; fish; leeks; Mandarin oranges; special puddings; apples, symbolizing peace; and Buddha's Delight, a mixture of vegetables and bean curd, with the eight-ingredient Laba Congee prepared beforehand.

Social obligations include visiting **family** and friends, usually while having special meals and paying homage to **ancestors**, with decorations of hanging red-colored paper cuts and couplets hung over front doors and houses filled with cheerful pictures. Especially prominent is the Chinese character *fu*, meaning "prosperity," and hung upside down to bring good **fortune** and luck arriving from above in heaven. Other activities include sweeping out rooms to drive away evil spirits; settling personal and business debts; pur-

410 • STREET FOODS AND MARKETS (JIETOU SHIPIN/SHICHANG)

chasing new **clothing** and shoes; and burning effigies of such local **gods** as the ubiquitous kitchen god, who reports on the family's behavior during the past year to the Jade Emperor in heaven.

Traditionally, everyone was considered a year older, as individual birthdays were not observed, with traditional holiday greetings in Mandarin of *gongxi facai*, literally meaning to "become wealthy." Performances include the famous dragon and lion **dances**; people walking on "stilts" (*caogaoqiao*); "harvest" (*yangge*) **music** and dances; **temple** fairs in **Beijing**, with plenty of fireworks and drums; and specific days during the holiday devoted to such actions as celebrating the birth of the Jade Emperor. Banned during the **Cultural Revolution (1966–1976)**, with proclamations calling for a "revolutionized and fighting Spring Festival," conventional celebrations were revived after 1978–1979, as the most popular event became the New Year's Eve Gala of **entertainment** presented by China Central Television (CCTV).

STREET FOODS AND MARKETS (*JIETOU SHIPIN/SHICHANG*). Ubiquitous throughout **urban** and **rural areas** in the People's Republic of China (PRC), street foods and street **markets** are a demonstration of the enormous diversity and uniqueness of **cuisines** in Chinese society. Situated in street stalls and small specialized **food** carts, open markets for fresh vegetables, meats, and freshwater fish and seafoods are often located in warehouses concentrated in residential and well-known **neighborhoods** like Wangfujing in **Beijing** and Fangbang Xilu in the Old City of **Shanghai**. Open to retailers with considerable **bargaining** over prices, large markets consist of individual stalls scattered throughout large and often multistoried facilities. Clustered around similar products in designated areas for fresh vegetables and fruits, fish, and butchered meat, making **shopping** easier, street markets in the PRC vary in levels of **hygiene**, with so-called "wet markets" (*shi shichang*) containing live animals, including wildlife, which in the central Chinese city of Wuhan were possibly responsible for the spread of deadly COVID-19 in 2020.

Available in areas known as "snack streets" (*xiaochi jietou*), many offering foods associated with particular **regions** and **religions**, particularly Islam, popular street foods, generally with few ingredients and simple in preparation, include the following: *youtiao*, deep-fried dough sticks; *baozi*, steamed buns, and *jiaozi*, dumplings, with vegetable and/or meat stuffing; *shaokao* and *chuan'r*, barbecue meat sticks and spicy kabobs; *congyoubing*, deep-fried scallion pancakes, and *jianbing guozi*, Beijing street crepes, dating back 2,000 years; *chou doufu*, "stinky" bean curd, from a brine of fermented milk, vegetables, and meat, especially popular in late-night street markets; *cifantuan*, thick rice balls, especially popular in Shanghai; and *tanghulu*, sweet sugar-coated haws of various fruits.

Following the old adage that Chinese "eat anything with four legs, except tables, anything that flies, except airplanes, and anything that swims, except submarines," while also pragmatically avoiding wastage, street foods also feature unusual **animal** parts and exotic creatures, including **insects**. Most notable, and a strain to the Western palette, are the following: deep-fried "tarantula" (*langzhu*); animal, especially sheep, "genitalia" (*longdan*); "pig brains" (*zhunao*), along with other animal brains, for example, monkey brain; tuna fish "eyeballs" (*yanqiu*), considered a delicacy; "bee pupae" (*mifengyong*), especially in **Yunnan**; "thousand-year-old eggs" (*pidan*), preserved duck eggs coated with lime and buried underground for three months; braised rabbit heads, cooked with chili peppers, especially popular in Chengdu, **Sichuan**; skewered "scorpion" (*xie*); "donkey meat" (*lürou*) burger, unique to Beijing; and "goat-head soup" (*shanyang tou*), popular in Kashgar in far Western China.

"STRUGGLE" (*DOUZHENG*). A central concept in the **ideology** of the Chinese Communist Party (CCP), especially during the rule of Chairman **Mao Zedong** (1949–1976), "struggle sessions" (*pidou*) served as a major political tool for shaping public opinion and carrying out periodic mass campaigns. Major targets included landlords, rich peasants, and other designated "**class** enemies" (*jieji diren*) humiliated and persecuted by tough physical treatment and endless **accusations** often concocted out of nowhere, especially during the **Cultural Revolution (1966–1976)**. Believing that people found "boundless joy in struggling against heaven, earth, and other human beings," Mao Zedong considered various struggles the essential goal of the People's Republic of China (PRC) against hostile nations, domestic political enemies, and even the natural world, with the many victims of such campaigns suffering mental breakdowns and resorting to **suicide**. Generally downplayed by the leadership of Jiang Zemin (1989–2002) and Hu Jintao (2003–2012), the latter emphasizing creation of a **harmonious** society, **Xi Jinping** (2013–) has renewed the call for "struggle," especially by CCP members against anyone "jeopardizing our country's sovereignty, security, and development," although stressing that "cooperation should also be sought." The penchant for struggle and conflict is also prevalent in Chinese society, with bickering and name-calling breaking out among individuals and groups, sometimes related to the most minor and insignificant matters.

SUBJECTIVISM (*ZHUGUANZHUYI*). A frequent target of **ideological** scorn and abuse in the history of the Chinese Communist Party (CCP) and the People's Republic of China (PRC), subjectivism was generally associated with literary and artistic styles, especially **calligraphy** and **poetry**, where subjective sensibilities were considered vital to the creative process. At odds

412 • SUICIDE (ZISHA)

with the orthodox Marxist concept of historical materialism based on "objective" (*jiguanzhuyi*) socioeconomic conditions, subjectivism was targeted as unorthodox heresy during the CCP Rectification Campaign (1942–1944), along with other heresies, for instance, "sectarianism" and "liberalism." Similar assaults were launched against poet Hu Feng (1902–1985) for his pursuit of "poetic subjectivity" (*shiye zhuguanzhuyi*) and defense of the "subjective fighting spirit" (*zhuguan zhandou jingshen*) in the 1950s against the orthodox notions of socialist realism.

Following the introduction of economic reforms and social liberalization (1978–1979), the issue of subjectivity arose again as Chinese intellectuals debated the issue of cultural humanism traced back to the May Fourth Movement (1917–1921) in the realms of **history**, **literature**, and **philosophy**, with prominent philosophers like Li Zehou (1930–) and Liu Zaifu (1941–) calling for a revaluation of the place of subjectivity in Marxist cultural theories and a return to traditional Chinese philosophical and aesthetic concerns involving subjectivism. Influenced by the political philosophy of Immanuel Kant, Li Zehou called for a focus on the individual's intellectual, moral, and aesthetic capabilities, with pursuit of social revolution linked to the transformation of individual consciousness, freeing Chinese intellectuals from the confines of orthodox Communist ideology.

SUICIDE (*ZISHA*). Considered an affront to **filial piety**, as the human **body** is seen as a **gift** from parents, suicide in the People's Republic of China (PRC) has varied enormously since the introduction of economic reforms and social liberalization (1978–1979), with internationally high-profile cases at the international electronics firm Foxconn Corporation (2010–2011). While suicide rates reached 22 per 100,000 population in 1991, with 300,000 occurring annually, the number dropped rapidly, reaching 15.4 per 100,000 in 2000, and 9.7 per 100,000 in 2016, the last according to a report of the World Health Organization (WHO), giving the PRC one of the lowest suicide rates in the world. Unique features of suicides in China include the higher rate among **women** than **men**, at 10.3 per 100,000 for the former versus 9.1 for the latter, with higher rates in **rural** versus **urban areas** and among the elderly (65 and older) and the very young (15 to 30) demographics, at odds with suicide patterns in most other countries.

Historically, **Confucianism** accepted the taking of one's life in exceptional circumstances, especially when the "gentleman" (*junzi*) failed to maintain the moral **virtue** of "benevolence" (*ren*), with Mencius (372–289 BCE) declaring that one should not "cling to life at all cost." For **Buddhism**, the belief that all life is sacred inveighed against suicide, while **Daoism** was generally neutral, although emphasis on the importance of persistence in life also frowned upon giving in to self-destructive impulses. Among the figures in Chinese history known for committing suicide is Qu Yuan (340–278

SUPERSTITION AND OMENS (MIXIIN/YUZHAO) • 413

BCE), the poet and government official during the Warring States (475–221 BCE) who, despairing about his own exile and **conquests** of territory by the Qin state, took his own life by drowning, commemorated by the annual Dragon Boat Festival (25 June). More generally, women committing suicide to preserve their chastity in the late Ming Dynasty (1368–1644) and early Qing Dynasty (1644–1911) were considered heroic, as the Qing enacted laws to protect the abuse of women, as female suicides occurred upon hearing lewd comments from male strangers. Suicide was outlawed by the Qing Dynasty but with many exceptions, as individuals declared guilty according to imperial law were often commanded to engage in **ritual** suicides.

Following the establishment of the People's Republic of China (PRC), mass suicides occurred periodically, mainly during mass campaigns, most notably the **Cultural Revolution (1966–1976)**, when individuals, including many **artists** and musicians, subject to harsh persecution by Red Guards, chose to end their lives, for instance, renowned music instructor Fu Lei and his wife, Zhe Meifu, in September 1966. Outside the political realm, suicides resulted primarily from intense **family** disputes, along with poverty and physical and **mental illness**. Regionally highest in the highly competitive environment of the Yangzi River basin, suicides occur by taking poison or overdosing on sleeping pills resulting in less physical dismemberment per prohibitions of filial piety against doing unnecessary harm to the physical body.

Significant declines in suicide rates among rural women, which accounted for a rapid drop in the national rate, came as a result of new employment at higher wages in cities after the introduction of economic reforms from the late 1970s onward. Suffering from low **self-esteem**, rural women, especially among the young, considered migration to urban factory jobs a life-saving opportunity, an escape from the rigid social norms of subordination to father and brothers, and, upon **marriage**, to husbands and tyrannical mothers-in-law, which so often drove them to end their lives of despair and hopelessness. With academic research in China on suicide begun in the 1970s, married women were determined to be more at risk for committing suicide, although such research remains politically sensitive in the PRC. Proposals for physician-assisted suicide for the terminally ill have been shelved, while the PRC continues to recognize World Suicide Day (10 September).

SUPERSTITION AND OMENS (*MIXIIN/YUZHAO*). Embedded in the Chinese **language**, as well as Chinese popular beliefs and daily activities, superstitions help people deal with uncertainty and **social anxiety**, which have increased in the People's Republic of China (PRC), especially since the introduction of economic reforms and social liberalization (1978–1979). While the term "superstition" (*mixin*) is considered an unsavory word associated in the popular mind with **rural** backwardness and ignorance, social

414 • SUPERSTITION AND OMENS (MIXIIN/YUZHAO)

surveys indicate that large segments of the population, including **youth**, are concerned with "destiny, supernatural powers, and mysterious phenomena" (*mingyun, chaoziran liliang, shenmi xianxiang*), as astrology, **fortune-telling**, and horoscopes have flourished, the last based on the Chinese **Zodiac**. Popular targets of superstition, both lucky and "unlucky" (*buxingde*), include, among others, **animals and insects**, **colors**, **foods**, geographical directions, **numbers**, real estate and location, personal behavior, and **shopping** habits, with many superstitions, for example, the buying and selling of stock, sustained by the profit motive. While "lack of a scientific spirit" (*quefa kexue jingshen*) is cited by critics as the basis for the persistence of superstitious beliefs, the same scientific argument is invoked by believers, with anecdotal evidence marshaled as confirmation, often based on **fengshui**.

Examples of superstitions generally unique to Chinese society include the following: keeping turtles as **pets** ruins business; killing bees in a house brings bad luck; wearing the color green provokes marital disputes; **eating** long noodles enhances personal **longevity**; the northwest corners of buildings have bad fengshui; pricing goods using the number 4 should be avoided, as the pronunciation of the number 4 in Chinese (*si*) is similar to the word for **death**; living in a house on a dead-end street blocks the flow of **energy** (*qi*); wearing shabby beards (for **men**) brings bad luck; and bad luck can be inherited from the previous owner when buying "secondhand goods" (*ershou*) from estate or yard sales.

Superstitions, generally harmless, have also accompanied the introduction of the internet and the rapid spread of the new **smartphone culture**. Most notable in the former is the attachment of digital images of the "koi fish" (*jinli*), colored varieties of the prized Amur carp from the "boundless wishing pool" (*wuxian xuyuan chi*), to messages and chats as an expression of good luck to the recipient. In the latter, elaborate phone cases feature lucky **colors**, particularly red, with images of mythical animals associated with good fortune (e.g., the dragon and the phoenix), along with apps for astrology buffs, for instance, Co-Star. Many superstitions are also associated with **marriage** and **pregnancy and childbirth**, namely avoiding marrying someone either three or six years older or younger, as bad luck will follow, and, for new mothers, refraining from taking showers, getting haircuts, or cleaning the house for one month after giving birth and retaining baby teeth in a belief new teeth will grow faster.

Bad omens or portents were considered a threat to the concept of the Mandate of Heaven, which was introduced as a basis of political legitimacy in China during the ancient Zhou Dynasty (1045–256 BCE), as a measure to undermine the previous Shang Dynasty (1600–1046 BCE). The most serious involved such natural disasters as drought, floods, plagues, and especially earthquakes, along with local **rebellions** and **military** defeats, which indicated an emperor was not providing for the good of the people and ruling fairly.

SYMBOLS (FUHAO) • 415

While criticized as an example of "feudal" (*fengjian*) superstition during the 20th century, popular beliefs in the concept evidently persisted in the PRC. Following the massive earthquake in the city of Tangshan in July 1976, preceding the death of Chinese Communist Party (CCP) chairman **Mao Zedong** in September, PRC propaganda organs declared, "An earthquake is only an earthquake," in obvious response to widespread views that Tangshan had been a portent of profound political changes, which, in fact, had transpired.

SYMBOLS (*FUHAO*). Influenced by a rich imperial tradition and a bountiful nature, national symbols in contemporary China also reflect the political principles and interests of the People's Republic of China (PRC) and the national identity of the general population. Most well-known is the mythical "dragon" (*long*), usually portrayed as a snake with four legs in Chinese **legends** and **folktales**. Associated with imperial authority, sculpted images of the creature dot major imperial buildings, with colorful embroidery of dragons with five claws appearing on imperial gowns and in **paintings**, with the Chinese people often referred to as "descendants of the dragon" (*long de houyi*). Equally evocative of Chinese identity in the natural world is the "panda bear" (*xiongmao*), considered one of the country's great natural treasures and projecting a heavy dose of cuteness.

Symbols from the natural world include the national bird, the "red-crowned crane" (*dandinghe*), representing elegance and wisdom; the national flower, the "peony" (*mudan*), a favorite in Chinese painting and invoked in the *Peony Pavilion* **opera**; the national tree, the "gingko" (*yinxing*), symbolizing hope and peace, and introduced from China into Japan; and the national fruit, the fuzzy "kiwi" (*mihoutao*), although many prefer the date-like jujube (*zao*). Political symbols include the "national flag" (*guoqi*), bright red with five gold stars, the largest representing the Chinese Communist Party (CCP), and the Chinese people symbolized by the four smaller stars, designed by Zeng Liansong, a Shanghai economist; the "national emblem" (*guohui*), or coat of arms, also with bright red and gold coloring, and portraying the entrance to the **Forbidden City**, bordered by a machine cog and sheaves of wheat and rice, representing the workers and peasants, designed by Liang Sicheng (1901–1972) and others; and the "national anthem" (*guoge*), "March of the Volunteers" (Zhiyuan Xingjun), composed by Nie Er and Tian Han in 1932. Adopted as the national anthem in March 1949, the piece was banned during the **Cultural Revolution (1966–1976)**, replaced by the more pro-Maoist "The East Is Red" (Dong Fang Hong), but readopted in 1978.

CCP chairman **Mao Zedong** (1949–1976) was also considered a symbol of national unity, denoted by his giant portrait hanging over the entrance to the Forbidden City but with his status somewhat reduced in recent years by revelations of disastrous policies pursued during the Great Leap Forward

416 • SYMBOLS (FUHAO)

(1958–1960) and the Cultural Revolution. Unofficial symbols include the **Great Wall**, **ceramics and porcelain**, the golden pheasant, and the **sport** of table tennis.

T

TEA CULTURE (*CHAI WENHUA*). Also known as the "art of tea" (*chaiyi*), tea culture refers to the methods of preparation of tea, the equipment used to make tea, and the various occasions in which tea is served to **family**, friends, and guests, especially as a sign of respect to elders and people of higher social status, and a means of expressing an **apology**. Considered one of the seven daily necessities, the others being firewood, rice, cooking oil, salt, soy sauce, and vinegar, tea drinking was associated with **literature**, the **arts**, **philosophy**, and the major Chinese **religions** of **Buddhism**, **Confucianism**, and especially **Daoism**. An expression of personal morality, **education**, and social principles, proper tea drinking was essential to self-cultivation, as tea appreciation was treated as a major component of a refined, upstanding lifestyle. White, green, Oolong, and black constitute the four major Chinese tea categories, with the most popular tea varieties being *Long Jing* (Dragon Well), *Bi Luo Chun* (Green Snail Spring), *Tieguan Yin* (Iron Goddess), and *Huang Shan Mao Feng* (Yellow Mountain).

According to **legend**, tea consumption in China can be traced to the mythical second emperor, Shennong, a student of **plants** and herbs, and a strong advocate of personal **hygiene**, who came upon tea in 2734 BCE, when leaves accidently fell into his bowl of boiled water, producing the seductive aroma. Considered a **gift** of the celestial **gods**, green tea, as the first variety, was initially consumed for medicinal purposes, including as an antidote to poisons, and was drunk after a meal as an aid to digestion. Tea leaves compressed into bricks served as a form of currency from 350–600 CE, with tea **banquets** held in the imperial palaces beginning in the Tang Dynasty (618–907). Evolved into a highly cultivated art form, tea is lauded in Tang **poetry** as the preeminent demonstration of greeting guests.

Multiple **virtues** were believed to come from tea consumption, including ridding the **body** and mind of lethargy and depression, breaking up illness, improving personal aspirations, and expressing respect, as tea was viewed as "bringing about the Dao and elegance." Combining philosophy and lifestyle, the elaborate tea ceremony served as a central principle of Daoism, refreshing the mind and clarifying **thinking**, achieving **harmony** and quiescence on

417

418 • TECHNOCRACY AND TECHNOCRATS (JISHU GUANLIAO)

the road to eternal tranquility and peace of mind. Revered for skills in the planting and making of teas, Chinese **customs** of tea drinking, along with attendant **ceramics and porcelains** of teapots and cups, spread to Korea and Japan, and ultimately other parts of the world, including Europe, via the **Silk Road** and the southern Tea Horse Road from **Sichuan** and **Yunnan** into India and South Asia.

A vehicle for enlightening social interaction and conversations, especially among **scholars** and artists, teahouses in **urban areas** and villages became venues for sharing ideas and opinions in an honest and rational fashion without regard for social rank or political allegiance. In an atmosphere of leisurely consumption of tea, conviviality and a civic humanism thrived, especially in centers of high culture like Hangzhou, Nanjing, Shaoxing, Suzhou, Wuxi, Yangzhou, and **Beijing**, the last the site of the famous Lao She teahouse. Outnumbering restaurants and food stalls from the Song Dynasty (960–1279) onward, teahouses were centers of storytelling and aesthetic elaborations, especially among elderly **men**, with offerings of teas ranging from common brews of pu'er and yellow tea to the lavish and expensive "gold ingot" (*Yuanbao*) tea.

Ancient literary works include the long-lost *Classic of Tea* (Chaijing), by Lu Yu (760), with new editions produced during the Ming Dynasty (1368–1644), in which the unity of tea and the universe is explored, along with the *Tea-Picking Opera* (Cai Chai Xi), featuring lengthy tunes sung during the monotonous undertaking of tea-picking in Jiangxi around Mount Jiulong. More recent expressions of the cultural importance of tea include the following: Tea Appreciation Day (early May), the China National Tea Museum and National Tea Expo Fair (Hangzhou), the International Tea Culture Institute (Beijing, **Shanghai**, and Taiwan), and Tenfu Tea Museum (Zhangzhou, Fujian). Tea is often offered at formal state functions in the PRC to indicate the ordinary status of top officials but with none of the participants drinking it.

TECHNOCRACY AND TECHNOCRATS (*JISHU GUANLIAO*). Defined as rule by engineers and scientists who are in power because of their technical expertise, technocracy and politics have been at loggerheads, with the former constituting a major goal of modernization but with the latter often triumphing in the highly politicized atmosphere of public life in modern China. Dominated by a well-educated elite throughout much of the imperial era (221 BCE–1911 CE), with Confucius (551–479 BCE) calling for "exalting the virtuous and the capable," the idea of technocrats wielding special political influence fit with the national mindset and requirements of achieving "wealth and power" (*caifu liliang*) in a highly competitive international system.

TECHNOCRACY AND TECHNOCRATS (JISHU GUANLIAO) • 419

During the period of the Republic of China (ROC) on the mainland (1912–1949), the concept of "expert politics" (*zhuanjia zhengzhi*), promoted by Luo Longji (1896–1965), founder of the China Democratic League, was especially appealing to Chinese intellectuals and political activists with an enormous faith in **science**, or, more accurately, scientism, and who were trained abroad, where the influence of technocratic principles enunciated by the likes of Thorsten Veblen (1857–1929) were particularly strong. Promoting the concept of national economic planning by engineers, Veblen's ideas were put into practice by the government of the People's Republic of China (PRC) with the adoption from the Soviet Union of central economic planning in 1953, in which Chinese technocrats, many trained in the USSR, assumed important decision-making positions, especially with the creation of state-owned enterprises (SOEs). While the reigning political doctrine of Chinese Communist Party (CCP) chairman **Mao Zedong** was government by "red and experts" (*hongse he zhuanjia*), the highly politicized "red" gradually took precedence over the technocratic "expert." Dominated by peasants-turned-revolutionaries, Mao's regime pursued **utopian** political goals of egalitarianism and continuous revolution at the expense of economic and technological development, most notably during the **Cultural Revolution (1966–1976)**.

Following the introduction of economic reforms and social liberalization (1978–1979), technology and technocrats were gradually rehabilitated as paramount leader Deng Xiaoping (1978–1992) promoted "government with scientific methods." While universities and other institutions of technocratic training were reopened and freed from the **ideological** shackles of the Maoist era, major personnel changes were affected, as veteran revolutionary cadres with little or no technical expertise were gradually replaced by highly trained technocrats, especially "engineers" (*gongchengshi*). CCP leaders from Hu Yaobang (1981–1987) to Jiang Zemin (1989–2002) to Hu Jintao (2003–2012) surrounded themselves with technocratic personnel in top **leadership** positions in the CCP and the State Council, with the latter two leaders possessing degrees in technical fields, Jiang in electrical engineering and Hu in hydraulic engineering. During the Jiang–Hu era, 80 percent of officials at the national, provincial, and municipal levels had significant technical backgrounds, with "scientific management" (*kexue guanli*) becoming the reigning doctrine of government operations, as prominent scientists like Qian Xuesen (1911–2009) called for the state to be run like an engineering department.

Drawing on the successful experiences of Asian economic juggernauts the likes of Singapore and Taiwan, the PRC pursued a kind of "technological authoritarianism" (*jishu weiquanzhuyi*), a model of depoliticized and ideologically neutral rule in an antidemocratic framework with emphasis on economic growth and technological modernization. Under President **Xi Jinping** (2013–), trained in chemical engineering at prestigious Tsinghua University,

420 • THEATER (JUYUAN)

two contradictory patterns have emerged, as fewer top leaders in the CCP come from engineering backgrounds, one of seven on the all-important Politburo Standing Committee (PSC), down from seven of eight, but with increased recruitment into general government ranks of technocrats from **military** and space exploration backgrounds, along with individuals from the social sciences, especially economics. While engineering and technical training was often a prerequisite for entry into the top leadership ranks, equally, if not more, important was the ability to endure and survive the brutal political struggles in the CCP and emerge unscathed, as demonstrated by the rise to power by Xi Jinping. Nor are engineering and highly technical fields a guarantee against ideological extremism, as demonstrated by Zhou Yongkang, petroleum engineer and former security chief, who took a tough, uncompromising line toward political dissent and outlawed **religious** groups the likes of Falun Gong.

THEATER (*JUYUAN*). A major feature of the literary and artistic world in imperial and modern China, including the People's Republic of China (PRC), theater is a venue for various types of **entertainment**. This includes **acrobatics**; **dancing**; **music**; singing, especially **opera**; and both domestic and foreign plays, **comedies** and **dramas**. Influenced by political forces and **ideologies** during the 20th century, theater was singled out for **criticism** and even ridicule by radical left-wing elements in the Chinese Communist Party (CCP), notably chairman **Mao Zedong**. With the **Cultural Revolution (1966–1976)** begun by an ideological assault on the play *Hai Rui Dismissed from Office* (Hai Rui Ba Guan), by Wu Han, the vice mayor of **Beijing**, theater went through a dramatic transformation, overseen by Jiang Qing, the radical leftist wife of Mao Zedong, with performances limited to a few ideologically acceptable operas and plays. Largely freed from ideological shackles by the introduction of economic reforms and social liberalization (1978–1979), theater was revived, with a return to a rich variety of shows and performances many in newly built facilities with striking **architecture**, for instance, the National Grand Theater in **Beijing**.

Throughout the course of imperial history Chinese theater involved a rich variety of entertainment, including acrobatics, **puppetry**, shadow plays, and recitals accompanied by music, with actors and actresses trained for as many as eight years in singing, dancing, and role-playing. Originating with **religious** and **shamanistic** performances often involving clowns and even wrestlers in the early dynasties from Shang (1600–1046 BCE) to the Han (202 BCE–220 CE), theater entertainment expanded with a variety of operas (*Canjun*, *Kunqu*, *Xiqu*, and *Jingxi*) and dramas (*Zaju* and *Nanxi*), along with the establishment of private theater troupes and professional theater districts in major **urban areas**, with 50 playhouses in Hangzhou alone. Some of the early plays included *Mask* (Daimian), with the story line of a young prince

THINKING AND THOUGHT REFORM (SIXIANG/SIXIANG GAIZAO) • 421

forced to wear a terrifying **mask** into battle to cover his soft facial features, and *The Dancing Singing Wife* (Tayao Niang), a tale of domestic **violence** about a drunkard husband beating his helpless wife, both produced during the Northern Qi Dynasty (550–577), as well as *Head-to-Head* (Botou), a story of revenge by a young son for the **death** of his father by a wild tiger, produced during the Tang Dynasty (618–907).

Peaking from the 14th to the 16th centuries during the Ming Dynasty (1368–1644), Chinese theatrical arts were available to the imperial court, the social elite, and commoners, especially in the so-called "hundred games" (*baixi*), grand spectacles of jugglers, magicians, mimes, and dancing girls in long-sleeved dresses periodically held to commemorate auspicious events. Political constraints included prohibitions against impersonalizing and satirizing emperors or high-level officials, with public theater dominated by males and performers expected to provide **sexual** services to their private patrons.

Fast forward to the 20th century, when "spoken dramatic plays" (*huaju*), including both imports from the West and Chinese creations, were performed, generally to great fanfare and large, enthusiastic audiences. Included were the provocative *Uncle Tom's Cabin*, by Harriet Beecher Stowe, a highly popular book in China translated into a play by the Spring Willow Society amateur theater troupe and first performed in Tokyo and then **Shanghai** in the early 1900s, and *La dame aux camelias*, by Alexander Dumas, describing an illicit love affair destroyed by social discrimination. Continuing into the period of the PRC, Western plays included well-received performances of *Death of a Salesman*, by Arthur Miller, in 1978–1979, along with such Chinese-authored plays as *The Bus Stop*, by Gao Xingjian, which introduced the Theater of the Absurd into China, and *The Thunderstorm* (Leiyu), *Beijing Man* (Beijingren), and *Curse of the Golden Flower*, by the renowned Cao Yu (1910–1996).

With theater **academies** established in Chinese cities, including Beijing, Shanghai, and **Hong Kong**, state patronage of theatrical troupes ended in 1986–1987, as companies were required to be self-supporting, with revenues coming primarily from ticket sales. Theaters with stunning architecture and innovative performance spaces include the Red Theater, for **martial arts** and *gongfu*, and the Poly Theater, for ballet, opera, and concerts, both in Beijing, with the latter designed by the British, and the Xingtai Grand Theater in Xingtai, Hebei, with a neo-traditional architecture based on the concept of "round sky and square earth" (*tianyuan difang*).

THINKING AND THOUGHT REFORM (*SIXIANG/SIXIANG GAIZAO*). Traditionally dominated by a correlative process grounded in informal and ad hoc analogy with a strong ethical bent strongly influenced by **Confucianism**, the process of thinking in China was integrated with feelings and

422 • THINKING AND THOUGHT REFORM (SIXIANG/SIXIANG GAIZAO)

emotions personified by the word *xin*, which translates as both "mind" and "heart." Lacking the strict dichotomy between subject and object so prevalent in the Western philosophical tradition dating to the ancient Greeks, Chinese thought emerges from a whole bodily sensibility in which rationality and reason are subject to idiosyncratic variation based on social context and absent any "universal" validity. Influenced by a belief in pervasive **energy** fields derived from the concept of *qi*, Chinese thinking generally avoids rigid categories and boundaries treating such frames of thought as permeable and overlapping.

Considered a major factor explaining Chinese backwardness and underdevelopment particularly in the scientific field, individual thinking has been a major target for fundamental transformation in modern China. Among Chinese intellectuals, the strong appeal of liberalism and intellectual and artistic **freedom** made them frequent targets of thought reform efforts involving **interrogations**, writing **confessions** (many of them concocted), incarceration, and even torture. Aimed at remolding the "thoughts" of anyone who did not support the CCP or accept the Marxist–Leninist–Maoist worldview, these efforts especially targeted advocates of "independent thinking" (*duli sikao*) who had spoken out freely during the short-lived Hundred Flowers Campaign (1956–1957). With this Chinese version of an inquisition peaking during the Anti-Rightist Campaign (1957–1959) and more so during the **Cultural Revolution (1966–1976)**, pressure to alter thinking during the latter included "sending down to the countryside" (*xiaxiang*) outspoken critics, included among them professional musicians, to work with peasants, with little or no effect on basic attitudes and beliefs.

Following the introduction of economic reforms and social liberalization (1978–1979), doctrinal constraints were loosened but with periodic assaults for renewed beliefs in liberalism and general artistic and academic freedom. Major campaigns, all ultimately attenuated, included the Anti-Spiritual Pollution Campaign (1983–1984) and the Anti-Bourgeois, Anti-Liberalization Campaign (1989), with renewed **criticism** of liberal thinking but with less intense physical and psychological pressure as in the 1950s and 1960s. Countermoves included major **education** reforms inaugurated in the 1980s promoting "critical thinking" (*pipanxing siwei*) among Chinese students beginning in primary school, involving a capacity to identify assumptions, test hypotheses, and draw correlations between variables. Also pursued was a reconception of Confucianism, challenging conventional notions that the ancient doctrine was antithetical to critical thinking, noting the great philosopher's cultivation of an inner dialogue between multiple voices as a route to enlightened inquiry.

Exemplified by university courses in logic, which were considered highly impractical, curriculum reform and the publication of updated textbooks were pursued for improving critical thinking, especially among Chinese col-

lege students, where studies indicate a weakening of such analytical abilities gained during primary and secondary schools. Concerned with the influx of Western liberal ideas, particularly in the political realm, President **Xi Jinping** (2013–) has called for a reaffirmation of Marxist "dialectical materialism" (*bianzheng weiwuzhuyi*) to guide individual thinking, especially in newly established think tanks, a viewpoint expressly opposed by many Chinese intellectuals for whom academic freedom and open-ended inquiry is the ideal.

TIANXIA **(ALL UNDER HEAVEN).** An ancient concept translated as "all under heaven," or simply "the world," *tianxia* denotes a concept of the entire geographical world and the metaphysical realm of mortals that became associated with the political sovereignty of the Chinese imperial order. Divinely applied to the lands and people subject to the rule of the Chinese emperor, *tianxia* referred to a well-ordered system of domestic and international relations emanating from the "center of the world" in the **Forbidden City** to inner and outer subjects of the realm to the tributary states and finally ending with the **barbarians**, surrounding the empire from all four directions. Included in the China-centered *tianxia* were any ethnic **minorities** and foreign peoples who accepted the mandate of the Chinese imperial order, with foreign leaders ultimately deriving their power from the Chinese emperor.

Originating in the ancient Shang Dynasty (1600–1046 BCE) and becoming a widely accepted political norm in the Zhou Dynasty (1045–256 BCE), *tianxia* became equivalent to the territorial boundaries of the Chinese empire from the Han Dynasty (202 BCE–220 CE) onward and closely associated with civilization itself similar to the Western medieval concept of Christendom in the West. Transforming the world into a home for all peoples, the ultimate goal was a Confucian-inspired notion of reconstituting the world along lines of the **family** with fair and just rule for all peoples and lands. Undermined by the confrontation with the Western theory of **legal** equality among nation-states in the 19th century, the concept of *tianxia* has recently been revived by Chinese international relations theorists to promote a unified world order as a new form of globalism.

TIBET AND TIBETANS (*XIZANG/ZANGREN*). Located in southwestern Central Asia and commonly known as the "roof of the world" with an average elevation of more than 12,000 feet (4,000 meters), historically Tibet was composed of Amdo, Kham, and U-Tsang provinces, with a population of approximately 6 million. Split into the Tibet Autonomous Region (TAR) with the loss of substantial territories and population in Amdo and Kham to neighboring provinces by the People's Republic of China (PRC) in 1965, the TAR is 460,000 square miles (1.2 million square kilometers) in size, less

424 • TIBET AND TIBETANS (XIZANG/ZANGREN)

than half the surface of historical Tibet, with a native population of 2.6 million and 160,000 Han in-migrants. Geographically isolated, with the giant Himalayas on the southern border, including Mount Everest, and generally hostile climatic conditions on the Qinghai–Tibetan Plateau, Tibet developed a distinctive culture dominated by the Tantric school of **Buddhism**, introduced in the 7th century, with broad cultural influences on **literature** and the **arts**, **music**, and numerous annual **festivals**. Subject to outside invasion from Mongols, Manchus, and the PRC, the highly insular culture of Tibet is being gradually transformed by the mass in-migration of Han Chinese, largely into **urban areas**.

Dominated by ancient Bon **religious** traditions of **shamans**, spirits, and exorcism, Tibet was an ethnocentric and warlike, imperialistic culture with an empire extending over a vast territory in Central Asia and South Asia from the 7th to the 8th centuries, including the seizure of the Tang Dynasty (618–907) capital at Chang'an (modern-day **Xi'an**) in 763. Destroyed by incessant civil war in 840, and influenced by Buddhism, Tibet underwent a dramatic transformation during the next several hundred years into a **spiritually** peaceful culture, with the world of prayer and daily obeisance trumping material development and the pursuit of economic prosperity. Dominated by a medieval theocracy, headed by the reincarnated Dalai Lama, ruling from the expansive Potala Palace in Lhasa, Tibetan society was subject to powerful monasteries, once numbering 13,000, with 25 percent of the male population serving as monks. Incorporated into the imperial Chinese empire in the 13th century but with Chinese control limited according to the principle of "rule by custom" to external affairs, Tibetans remained sovereign on domestic matters, an arrangement that lasted until the end of the Qing Dynasty (1644–1911).

Following a British invasion of the territory in 1903–1904, to counter Russian expansionism, along with the collapse of the Qing Dynasty in 1911, Tibet declared its independence from the new Republic of China (ROC), but the territory was quickly carved up by the 1913 Simla Conference, convened in India, which consisted of China, Tibet, and Great Britain. An inner part of Tibet was made into a southwestern province of China, while an outer part was granted full autonomy, although the ROC refused to ratify the treaty, while maintaining little contact with the largely isolated **region**. Foreign visitors to Tibet were prohibited, although Austrian mountaineer Heinrich Harrer made an illegal trek into the isolated territory in 1944.

Invaded by the People's Liberation Army (PLA) in 1950–1951, the PRC terminated the 1911 Tibetan declaration of independence, as ill-equipped Tibetan forces, after some resistance, capitulated. With the signing of a 17-point "Agreement of the Central People's Government and the Local Government of Tibet on Measures for the Liberation of Tibet" (1951), the PRC formally recognized Tibet's autonomy but asserted full sovereign pow-

TIBET AND TIBETANS (XIZANG/ZANGREN) • 425

ers, while the Dalai Lama was appointed chairman of the Preparatory Committee for the Tibetan Autonomous Region in 1952, with power to govern the domestic affairs of the territory. Conflicts broke out once again in 1956, as Tibetans living in the old Kham region in western **Sichuan** rose up against the Chinese, leading to a widespread revolt throughout the TAR, with rumors swirling that the Dalai Lama had been targeted for kidnapping or even assassination. Fleeing the country, the Tibetan spiritual leader sought refuge in Dharamshala, Northern India, in 1959, where he lives with approximately 100,000 Tibetans to this day.

Targeted by Red Guards from outside the TAR during the **Cultural Revolution (1966–1976)**, monasteries and other holy sites were destroyed, notably the 15th-century *dzong* in the city of Shigatse, which was the model for the Potala Palace in Lhasa. With substantial reconstruction occurring in the 1980s, major religious sites, for example, the Jokhang temple in Lhasa and the Drepung monastery, which formerly housed 10,000 monks, are periodically opened by Chinese authorities but often closed down for long periods of time. Continued training of Tibetan lamas (monks) has also been a constant source of tension between Tibet's religious elite and Chinese Communist Party **(CCP)** authorities, as the Chinese government ordered a halt to monastery and temple construction and reconstruction in 1994, with an absolute cap placed on the number of monks and nuns to be trained.

Foreign travel to Tibet has also been periodically restricted in recent years during political flare-ups, although a 15-year program for transforming the economy from its reliance on agriculture began in 2003, with the construction of a rail line, the highest in the world, from Golmud, Qinghai, into Lhasa. **Violence** between Tibetans and Chinese authorities has occurred on numerous occasions (1987, 1989, 2008, 2009), as self-immolations by Buddhist nuns and monks have escalated tensions to the point that the old Tibetan section of Lhasa is patrolled 24 hours a day by armed soldiers in helmets and camouflaged uniforms, while the Dalai Lama is condemned by official Chinese propaganda in even more vitriolic terms as a "jackal in Buddhist monk robes."

Generally unaffected throughout history by Chinese traditions of **Confucianism** and **Daoism** but with some cultural and religious influences from India and Persia, Tibetan culture developed distinctive features in **language**, **handicrafts** and the **arts**, **literature**, **music**, **architecture**, **funeral and burial customs**, and festival life, with Tantric (Mahayana) Buddhism at the core, venerating the Bodhisattva Avalokiteśvara, with her 4,000 arms and eyes in each hand symbolizing **compassion**, and idealizing fierce but protective deities. Worshipping the Living Buddha at stupas and **pagodas**, Tibetans prostrate, which involves devoutly raising their hands together high above their heads, taking one step forward, lowering their hands to the height of their forehead, and taking another step forward, lowering their hands in front

426 • TIBET AND TIBETANS (XIZANG/ZANGREN)

of their chest and taking a third step forward and then kneeling down and stretching themselves out on the ground. After arising, they repeat this process, all the while chanting sacred words, usually. *"Om Mani Padme Hum."* Many pilgrims spend several years traveling from other provinces to Tibet performing prostrations each and every step of the way, with some people dying on the way but never considered a pity, as traveling toward Tibet in this manner is considered a lifelong honor.

Influenced by Sanskrit entirely different from Mandarin Chinese, the Tibetan language is polysyllabic, with a written alphabetic script and terminology borrowed from India, Nepal, Mongolia, and China. An ancient handicraft, colorful Tibetan rugs are hand-made from highland sheep's wool, used by Tibetans for floor coverings and wall hangings, with the city of Gyantse, in the southwest, a center of production. Major art works include the Thangka, **paintings** on cotton and silk in striking **colors** of reds, blues, and yellows depicting Buddhist deities, scenes, and mandalas, the last a dot painting graphically symbolizing the universe with circles enclosing squares. Equally colorful are the sand mandalas portraying an ideal Buddhist world, meticulously created during a period of weeks or months and upon completion quickly swept away, demonstrating the transience of life and illusion of the world.

Tibetan folk **operas** feature several varieties, notably the famous Blue Mask opera, along with a rich variety of **songs** and **dances**, as Tibetan monks are renowned for their playing of horns and chanting ancient sacred texts. Such Tibetan classical music as *Nangma Toshey* is promoted by the Tibetan Institute of Performing Arts, with popularity spreading outside the region to Chinese karaoke bars. A prime Tibetan literary work is *The Epic of King Gesar*, traced to the 12th century, documenting the rich oral traditions of the culture, centered on the heroic actions of the fearless Lord Gesar, with the text containing 1 million verses still sung in folk performances to retain the tradition. Also prominent is *The Tibetan Book of the Dead* (Bardo Thodel), published in the 8th century, providing a guide through the experiences of consciousness after **death** during the interval between death and the next rebirth, along with signs of death and **rituals** to undertake when death is closing in.

Architecture in Tibet is profoundly influenced by the generally harsh climatic conditions, as buildings and houses are built on elevated surfaces, facing south, and with flat roofs to conserve heat, along with multiple windows to let in sunlight. Adorned with images of deer and dragons, along with the ubiquitous prayer wheels, among the prominent building types is the *gompa*, an ecclesiastical fortification and center for meditation and prayer. Most prominent is the world-famous Potala Palace, 13 stories (117 meters) high with 1,000 rooms and 10,000 shrines, and consisting of an inner white and outer red palace, and the traditional home to the Dalai Lama. Limited to

TIME (SHIJIAN) • 427

crops, primarily barley, Tibetan staples include flour (*tsampa*), made into dumplings (*momos*), and bread (*balep*), with yak, mutton, and goat meats often prepared in stews with potatoes, while fish is studiously avoided as one of the Eight Auspicious Symbols of Tibetan Buddhism. Delicacies include *thukpa*, a chicken noodle soup, with butter **tea** (*pocha*) the favorite drink, high in calories and composed of tea leaves, yak butter, water, and salt, along with rice wine (*raksi*).

Marriage in Tibet includes the practice of polyandry, **women** having several husbands, and the opposite, polygamy, with increasing intermarriage between Tibetans and local Han. Both sexes in Tibet traditionally wear long hair and strikingly colorful dress, usually with long sleeves and sporting the traditional ceremonial white scarf (*khata*), often offered as **gift** of greeting. Following Buddhist doctrine on the separation of **body** and soul at death, Tibetans practice so-called sky burials, where corpses are dismembered and taken to a particular place, usually on a cliff or **mountain**, to be fed to vultures and other creatures in what is considered an honorable gift. A culture valuing **sports**, especially horse racing, and mass get-togethers, major Tibetan festivals include the following: Saga Dawa, a month-long celebration of the birthday of Shakyamuni in the fourth month of the Tibetan lunar calendar, usually in April, with a belief that good deeds and prayers are multiplied thousandfold during this period; the Shotun yogurt festival, in which folk operas are sung; and Losar, or the New Year's Festival, originating from the Bon tradition.

TIME (*SHIJIAN*). Shaped by an agrarian past and traditional **philosophy**, time orientation in Chinese society differs substantially from Western culture but with changes occurring as a result of the modernization and industrialization of the country during the period of the People's Republic of China (PRC). In the West, time is generally measured against profit and achievement, traced back in history to ancient Greece and the views of Heraclitus (circa 500 BCE), who described human beings as subject to time, with the regularity, absoluteness, and progress of time fixed in **nature** established during the Renaissance, especially by Isaac Newton (1646–1727). In contrast, time in Chinese tradition is treated as more flexible, relative, and subjective, in tune with the country's agrarian origins of cyclical time, based on daily and seasonal routines dictated by nature.

For Confucius (551–479 BCE), time was valuable and should be put to good use while avoiding inordinate rigidity, with certain tasks and events dealt with at the right moment, no sooner or later than necessary. **Daoism** was even more flexible, considering time (and space) ultimately limitless and thus rejecting any unnatural constraints of time on human consciousness or activity. For **Buddhism**, views on time were even more dismissive, seeing any human experience of time as an illusion and a hindrance to the achieve-

428 • TRADITIONAL CHINESE MEDICINE (TCM, ZHONGYAO)

ment of Nirvana, which included a total liberation from time. Modern Chinese thinkers reinforced these perspectives, with the likes of Lin Yutang (1895–1976), an inventor, philosopher, and novelist, bewailing the impact of highly restrictive modern notions of time on individual **freedom**, while praising the generally easygoing nature of most Chinese and their "divine desire for loafing." For the poetic Lin, "The wisest man is therefore he who loafs most gracefully," a view no different from the musings of the great Daoist Zhuangzi (4th century BCE), who called on humans to freely handle time much like the free-floating "butterfly" (*hudie*), which Zhuangzi fantasized about becoming.

While easygoing attitudes indifferent to time undoubtedly persist among intellectuals and the leisure **class**, the demands of **commercial** and working life in the PRC, especially since the introduction of economic reforms (1978–1979), have brought about substantial transformations more in line with industrial practices in the West and Japan. In the highly competitive world of Chinese **business**, punctuality is considered vital, with lateness, even by a few minutes, considered rude and requiring prior notice, while any "procrastination" (*tuoyan*) by employees on important matters is roundly condemned as a form of "illness" (*zheng*). Adhering to traditional notions that there is a right time for dealing with certain matters, discussion of business is studiously avoided during meals or at social events like the **Spring Festival**. On the other hand, regular and last-minute changes to schedules and locations of meetings is a frequent occurrence in China, especially upsetting to the Japanese with their fanatical approach to strict planning and punctuality.

While Chinese are generally known for revering the past, studies indicate the future is actually their primary concern, particularly involving business and the nation. In the Chinese **language**, the future is sometimes referred to as "back" (*hou*), as in *houtian*, meaning "day after tomorrow," with the "past" as "front" (*qian*), as in *qiantian*, meaning "day before yesterday," although the opposite is true in other renderings. Other notable Chinese-language terms involving time include the following: *chidao*, meaning to "be late"; *xianzai*, meaning "now"; and *mashang*, meaning "right away," literally "on the horse," and originating in the ancient reliance on horses for transportation.

TRADITIONAL CHINESE MEDICINE (TCM, *ZHONGYAO*). A medical system dating back 3,500 years to prevent, diagnose, and treat disease, traditional Chinese medicine (TCM) is based on the belief that vital **energy** (*qi*) flows along certain meridians or "channels" (*jingluo*) in the **body** maintaining a balance in a person's **spiritual**, emotional, mental, and physical **health**. With a holistic emphasis on the dynamic processes and functions of the body such as digestion, diseases are diagnosed in TCM as an imbalance

TRADITIONAL CHINESE MEDICINE (TCM, ZHONGYAO) • 429

in the natural opposing forces of **yin-yang**, which can block *qi* from vital organs and cause the affliction. Restoring balance to the body is the essence of treatment in TCM employing multiple methods including "acupuncture" (*zhenci*), cupping, massage, "moxibustion" (*aijiu*), dried herbs burned near the skin, along with diet, meditation, physical **exercise**, such as *Qigong* and "Tai Chi" (*Taiqiquan*) and herbal therapy. Employed in the last are various plants, such as astragalus, gingko, red yeast rice, cinnamon, ginger, and ginseng, and **animal** parts, many from endangered species, including tiger bone, seahorse, antelope and rhino horn, deer antler, and pangolin scales, the last believed to have carried COVID–19 in 2020. Altogether 13,000 medicinal types exist and 100,000 separate recipes with extensive documentation in the *Handbook of Traditional Drugs* (1941).

Historically, TCM is traced back to several ancient works such as the *The Inner Canon of the Yellow Emperor* (Huangdi Neijing), compiled during the Spring and Autumn Period (770–476 BCE), *Prescriptions from the Golden Cabinet* (Jin Kui Yao), produced during the Eastern Han Dynasty (25 BCE–220 CE), and *Compendium of Mateira Medico* (Bencao Gangmu) issued during the Ming Dynasty (1368–1644) along with many other similar treatises particularly from the Han Dynasty (202 BCE–220 CE). Considered the father of TCM is the mythical emperor Shennong, "Divine Farmer" (28th century BCE) with the *Classic of Shennong's Herbal* (Shennong Ben Cao Jing), also from the Eastern Han, containing detailed descriptions of 365 medicaments derived from a variety of plants, animals, and minerals. Growing interaction with Western countries from the 19th century onward led to the gradual integration of TCM with modern medicine but with hospitals specializing in TCM maintained to this day in the People's Republic of China (PRC). From the 1950s onwards, TCM has retained government support including from Chinese Communist Party (CCP) chairman **Mao Zedong** while during the **Cultural Revolution (1966–1976)** TCM was lauded as an essential element in China's unique national identity receiving substantial state investments as **health** care was expanded, especially into long-neglected **rural areas**. Dismissed by some medical professionals in the West and in the PRC as "fraught with pseudoscience" with an article in the latter calling for its total abandonment in 2006, TCM specialists and drugs, specifically *lianhua qingwen, jinhua qinggan*, and *shufen jiedu*, were sent by the PRC to Italy in the midst of the COVID-19 pandemic in 2020.

U

"UNIT" (***DANWEI***). The name given to place of employment in the People's Republic of China (PRC) beginning in the 1950s, the *danwei* exercised enormous influence on the private lives of the **urban** citizenry, with the term still in use despite significant reduction in power in 2000. Serving as the first step in the multitierd hierarchy linking the individual to the organizational infrastructure of the ruling Chinese Communist Party (CCP), the *danwei* organized and controlled urban areas based on a model developed by the CCP during the Yan'an years (1936–1949) and influenced by organizational experiences of the Soviet Union. Set up in virtually every factory, school, hospital, and government department, the *danwei* exercised control of living arrangements, including the assignment of houses and apartments, and the provision of **food** and medical care in unit clinics, along with shops and services, while also overseeing the implementation of state priorities, for example, the **one-child policy**, and keeping an eye on signs of political waywardness.

Important personal decisions subject to *danwei* approval included **marriage and divorce**, childbirth, and any travel, domestic or foreign, with personal refusal of *danwei* instructions resulting in wage reductions or loss of housing privileges. Long considered a life-long association, a reduction in *danwei* powers, beginning in 2000, has left decisions about marriage and most other personal matters, for instance, international travel and passport application, to the individual, with a right to pursue alternate employment in the increasingly **market**-based economy, as living standards depend on the financial conditions of companies, public and private.

URBAN AREAS AND URBAN LIFE (*SHIQU/SHIQU SHENGHUO***).** An agrarian country throughout much of history, China has undergone rapid growth in urban areas, especially since the 1980s, with estimates that the numbers of people living in urban areas will reach 60 percent of the total population by 2030. Following the establishment of the People's Republic of China (PRC), the urban population, according to the census conducted in 1953, constituted 13 percent of the country's total, with relatively slow over-

432 • UTOPIAS (WUYOUZHIXIANG)

all growth throughout the decades, reaching 21 percent in 1982. Governed by the Chinese Communist Party (CCP) with a **leadership**, headed by Chairman **Mao Zedong**, exhibiting a general antiurban bias, several administrative regulations were adopted for controlling the growth of urban areas, most notably "household registration" (*hukou*) linked to a **food**-rationing system, which effectively blocked **rural** migration into such major cities as **Beijing**, **Chongqing**, **Guangzhou**, and **Shanghai**. Following the passing of Mao in 1976, and the introduction of economic reforms and social liberalization (1978–1979), urbanization accelerated from 1982–1986, reaching 37 percent of the population in the latter year but with some of the growth attributed to administrative changes that arbitrarily doubled the number of urban areas classified as medium and small cities and towns.

In a major government attempt to control unbridled population growth, mainly by rural migrants attracted to the better employment opportunities and improved living standards in cities, a three-pronged policy was promulgated in 1987, with top-tier cities capping their population numbers, while migration was encouraged into medium and small cities, although within limits. With 20 million rural residents moving into cities annually, urbanization accelerated, with the total number of city residents reaching 44 percent in 2007, as the total number of people in urban areas surpassed the rural population in 2012, the first time in Chinese history. Offering consumption levels three times higher than in the countryside, especially in terms of staple products like food and housing, Chinese cities remain a lure for rural residents, especially underemployed **women**, many in estranged **marriages**, who look to urban life as a source of personal liberation.

Of the 100 largest megacities in the world, with 10 million or more people, 25 are in the PRC, as plans exist to build the "smart city" (*zhihui chengshi*) of Xiong'an, spanning several counties in Hebei and south of Beijing. Accompanying rapid urban growth are a host of environmental problems, from air and water pollution to waste disposal, which some cities have addressed with innovative policies, for example, Zhongshan in Guangdong, while others have pursued a "boomtown" approach, leading to serious environmental degradation and an explosion in **health** afflictions. More densely populated with fewer and more remote **family** and **clan** ties than existed in village life, cities provide greater amenities but also more social problems, notably higher **crime** rates, but with lower rates of **suicide**.

UTOPIAS (*WUYOUZHIXIANG*). Defined as the imagining of a spatial construct of human agency exhibiting near-perfect qualities, utopias in China date to **Confucianism** and **Daoism**, with modern revolutionary leaders from President Sun Yat-sen (1912–1925) to Chinese Communist Party (CCP) chairman **Mao Zedong** (1936–1976) inspired by grand utopian visions that generally failed to materialize. Originating as a term in ancient Greece, "uto-

pia" was conceived as a fictional island society by Sir Thomas More (1478–1535), chancellor to King Henry VIII of England, in a book of the same name (1516) intended as a veiled critique of autocratic leaders. Introduced into China in the late 19th century, utopian themes influenced a variety of realms, including **literature**, especially fiction, cultural movements, political ideas, and **ideologies** of revolutionary campaigns, often combining the dual goals of "revolution" (*geming*) and "enlightenment" (*qishi*).

For Confucius (551–479 BCE), writing in the *Book of Rites* (Lijing), the utopian ideal was embodied in the concept of the "great unity" (*datong*), with social and political **harmony** replacing partisan division and conflict, along with "heavenly peace" (*taiping*), the last stage in the pursuit of the ideal society. Revived by the reformer and advocate of constitutional monarchy, Kang Youwei (1858–1927), and published as the *Book of the Great Unity* (Datong Shu), Kang called for the creation of a worldly community and universal brotherhood based on a universal harmony to be achieved by the abolition of private property, disruption of **marriage**, eradication of social differences, and establishment of a world government. Transposed to the political world, utopian visions informed the apocalyptic beliefs of Hong Xiuquan (1814–1864), charismatic leader of the pseudo-Christian Taiping Rebellion (1850–1864), and successors, most notably Mao Zedong, whose embrace of Marxism–Leninism involved the creation of a utopia of material and **spiritual** abundance. Ending in a combination of utopia with despotism most apparent in the chaotic **Cultural Revolution (1966–1976)**, Mao's vision degenerated into pervasive "nihilism" (*xuwuzhuyi*) and "hedonism" (*xianglezhuyi*), which following the introduction of economic reforms and social liberalization (1978–1979) led to a triumph of the **individual** over the collective and the transposition of the utopian impulse from politics to specific programs like the construction of eco-cities and planned communities of new towns.

While dystopian themes have generally dominated the Chinese intellectual and literary world since 1978–1979, utopianism is still evident in the writings of Li Zehou (1930–), who defended the views of Kang Youwei against attacks on the philosopher's purported "conservatism" by orthodox Marxists and in the science fiction writings of Liu Cixin (1963-), describing in works the likes of *Taking Care of God* a utopia based on scientific and technological development. Included was the internet forum "Utopia," established in 2003, to defend the revolutionary principles of Mao Zedong and **Chongqing** CCP chief Bo Xilai, with petitions against critics of the two leaders but which the Chinese government shut down in 2018. Following the lead of President **Xi Jinping** (2013–), international relation theorists have called for the PRC to lead the way in applying the *datong* principle to global politics.

V

VEGETARIANS AND VEGANS (*SUSHIZHE/CHUN SUSHIZHE*). In a society where consumption of meat was traditionally a sign of prosperity, with the People's Republic of China (PRC) the largest importer in the world of meat products, including pork, beef, and poultry, vegetarianism has grown in popularity for both **health** and **religious** reasons, with an estimated 50 million people abstaining from the consumption of meats (vegetarians) and such derivatives of animal products as dairy products, eggs, and cheese (vegans). Associated with the introduction of **Buddhism** in the later years of the Han Dynasty (202 BCE–220 CE), with a sacrosanct view of all life, **plant**-based diets can be traced to earlier periods of Chinese history during the Zhou Dynasty (1045–256 BCE), with Confucius (551–479 BCE) lauding a simple diet of grains and vegetables, a view generally shared with **Daoism**. As Buddhist temples expanded and thrived during the Tang (618–907) and Song (960–1279) dynasties, **food** outlets devoted solely to vegetarian fare appeared, with so-called mock meats, made largely from bean curd to resemble pork and fowl. During ages of general prosperity during the subsequent Ming (1368–1644) and Qing (1644–1911) dynasties, meat consumption increased as vegetarianism became less common, although during the increasingly frequent famines meat in the diet became a rare luxury.

After undergoing widespread food deprivation during the rule of Chinese Communist Party (CCP) chairman **Mao Zedong** (1949–1976), including during the Great Famine (1959–1961), the introduction of economic reforms and social liberalization (1978–1979) led to many Chinese families demonstrating their newfound wealth by increasing the consumption of meat, as gains in agriculture and animal husbandry provided a wider array of culinary choices. Vegetable dishes served at Chinese meals and **banquets** often contained pieces of meat as garnish, with all-meat dishes considered unacceptable and any dearth of vegetables giving rise to complaints. Rising concerns with **obesity**, high blood pressure, and other physical ailments led to a revival of vegetarian sentiments, with growing concern for food safety, **animal** rights, and the environment adding to the appeal and promoted by such organizations as the Shanghai Vegan Society and Veggie Dorm.

436 • VICTIMIZATION (SHOUHAIHUA)

Popular vegetarian and vegan dishes include the following: *disanxian* ("three treasures of the earth"), stir-fried eggplant with chilis and potatoes; *mala xiangguo* ("numbing spicy fragrant pot"), from **Sichuan**, with lotus root, sweet potatoes, broccoli, bean curd, cauliflower, and celtuce; *yuxiang qiezi* ("fish fragrant eggplant"); *lanang yangyu* ("grandma's potato"), with potatoes mashed and fried in oil; *xiangqu qingcai*, green vegetables with mushrooms; and *ganbian sijidou* ("dry fried beans"), salty and spicy long green beans. Like most Chinese dishes, vegetarian food is served with a balance of different **colors** and textures, as well as flavors, with unique ingredients including gluten, fried lettuce, and lily bulbs. Top-rated vegetarian/vegan restaurants in **Beijing** include Tianchu Miaoxiang; Suhe, noted for Sichuan dishes; King's Joy; Blossom Vegetarian, with foreign dishes; The Veggie Table, with European and Middle Eastern fare; Baiyi Shushi Vegetarian Noodles, noted for mock lamb made from mushrooms; Su Yuan Ju; Beijing Vegan Hut; Beijing Zheng Long Zhai; and Lao Qi Yan Su, **Yunnan** vegan.

VICTIMIZATION (*SHOUHAIHUA*). Singling out individuals, groups, or even countries for cruel and unjust treatment or criticism, victimization is an increasing problem in Chinese society, especially among **children**, with the government of the People's Republic of China (PRC) periodically claiming maltreatment by other nations and leaders in the international system. Surveys and studies conducted by domestic and foreign specialists find relatively high rates of victimization by Chinese **youth** consisting of "bullying" (*qifu*), physical and **sexual** assault, and property **crime**, with a strong correlation to problematic interparental relationships, parental absence, and childhood exposure to **family violence**.

The social profile of a self-reported victim is a boy, generally older, with siblings, living in a **rural area**, with parents divorced, separated, or widowed, and father unemployed and chronically absent. A strong association has also been found between various forms of victimization and sexual abuse, more evident among boys than girls (1 in 10, versus 1 in 15, respectively), along with relatively high rates of delinquency and elevated levels of personal depression and **social despair**. Major mitigating factors include strong personal **self-esteem** and parental attachment, while the best coping mechanism for confronting victimization is to seek professional assistance, as self-defense and avoidance, especially the latter, are less effective. Recommendations for dealing with higher incidences of victimization include substantial improvement in child protective services, along with professional child and parental counseling.

At the international level, victimization is a strong narrative, along with national **humiliation**, emphasized by both the Republic of China (ROC) and the PRC, with claims that foreign powers "bullied" China from the 19th

century onward. With analogies of the Chinese nation and people to a raped woman dating back to the 1930s, victimization stands in stark contrast to the "heroic" and "victor" narrative pursued during the rule of Chinese Communist Party (CCP) chairman **Mao Zedong** (1949–1976), when portrayal of China as a raped woman was distinctively unpopular. A major theme of the current victimization narrative focuses on quantifying or, more accurately, requantifying Chinese suffering, especially at the hands of Japan beginning with the Nanking Massacre (1938) and extending into the Second Sino–Japanese War (1937–1945). While the official death toll for the war was set at 9 million in 1949, and maintained throughout the Mao years, that figure has grown to 33 million, starting with the administration of Jiang Zemin (1989–2002). Moving the official starting point of the conflict from the full-scale Japanese invasion of China in 1937, to the Mukden Incident and the subsequent invasion of Manchuria in 1931, the PRC now refers to the "14-year Chinese People's War of Resistance against Japanese Aggression." Expanding the official time period of the war from eight to 14 years incorporates all the Chinese casualties in the intervening years, including victims of bacterial and chemical warfare, begun in 1932, with some Chinese historians calling for extending the origins of the war to the First Sino–Japanese War (1894–1895).

While such stellar events as the reincorporation of **Hong Kong** (1997) and the **Beijing** Summer Olympics (2008) were heralded for "wiping away" the stain of past national humiliations, victimization remains an appealing narrative, especially in Chinese **social media** and periodic statements by President **Xi Jinping** (2013–), although references to the PRC as a "great power" may indicate a return to the "heroic" themes of the Maoist years.

VIOLENCE (*BAOLI*). Touted as a society guided by the pursuit of **harmony** and the resolution of social and political **conflict**s by nonviolent mediation and mitigation, China has a history of massive outbursts of collective violence, including the Taiping Rebellion (1850–1864), at 30 million dead possibly the bloodiest civil war in history, and individual violence, most prominently male-on-female domestic violence. While great dynasties like the Han (202 BCE–220 CE), Ming (1368–1644), and Qing (1644–1911) were generally marked by long and extensive periods of internal peace and social order, a culture of violence often pervaded normal life, with the early and later years of most dynasties marked by major upheavals of distressed peasants often involving horrific losses of human life. Similar circumstances characterize the history of the People's Republic of China (PRC), established after a hard-fought Civil War (1946–1949), as periods of relative calm and social stability were interrupted by paroxysms of collective violence, most

438 • VIOLENCE (BAOLI)

notably during the **Cultural Revolution (1966–1976)**, and enduring problems of domestic and street violence, especially since the introduction of economic reforms and social liberalization (1978–1979).

Historically, by far the greatest loss of human life occurred with peasant **rebellions**, often massive in scale, leading to harsh reprisals and crackdowns by dynastic forces, sometimes wiping out entire villages, cities, and **regions**. Emblematic of this pattern was the uprising led by Zhang Xianzhong (1606–1647), known as the "Yellow Tiger" (*Huanghu*), whose attempt to set up an independent kingdom in **Sichuan** at the close of the Ming Dynasty was crushed by invading Manchu forces, reportedly wiping out half the population of the province. When confronted by uprisings and stubborn defenders, and failing to buy off rebel leaders and their followers, China's dynastic rulers often engaged in extensive "extermination" (*jiao*) campaigns, annihilating with "scorched earth" (*jianbi qingyu*) tactics real and suspected enemies alike, including **family** members. Similarly harsh measures were employed by Chinese rulers against ethnic groups resisting assimilation and Sinicization, as occurred with Emperor Qian Long (1735–1796), who responded to resistant Dzungarians, a Tibetan Buddhist Oirat Mongol nomadic tribe in Mongolia and the western reaches of the empire, with a massive genocide (1755–1758), resulting in as many as 800,000 deaths and total repopulation of the area by Manchu bannermen and Uighurs.

Supplementing state-led **military** campaigns were a variety of social, economic, and cultural forms of violence at the popular level that persisted even in the most prosperous times. On the one hand, the noble **classes** exuded an image of rejecting violence by abandoning blood **sports** like **hunting** and the duel, contributing to the narrative of a peaceful social order, although the same "elite" beat servants and physically abused their wives. On the other hand, conditional acceptance of violence took many forms, including publicly executing **prisoners**, with their severed heads put on display, and the butchering of **animals** in street **markets**, along with animal sacrifices in **religious** ceremonies, as human sacrifice had been abandoned in the Han Dynasty. Even more violent was the wanton extermination of humans thought to have been taken over by evil demons, as occurred in the "soul stealers" (*touhunzhe*) phenomenon in 1768, and the ruthless murder of Christian missionaries and their Chinese converts in the late 19th century, most notably in the Boxer Rebellion (1899–1901), with the acquiescence of the Empress Dowager Ci Xi (1861–1908). Conflicts concerning land and water use, along with differences among ethnic **minorities**, also sometimes erupted in violence, with socially countenanced violent acts, including female infanticide, estimated at 10 percent of births during the Qing Dynasty, and domestic violence, virtually glorified in such traditional sayings as, "A beating shows intimacy, and a scolding shows love."

VIRTUES (MEIDE) • 439

Continuing into the 20th century, wife beating was a regular occurrence deemed to be an acceptable tool to assert male dominance in a "patriarchal" (*jiazhang*) society, with no mention of the phenomenon in the PRC until 1995. With 16 percent of families admitting to experiencing male-on-female violence, more in **rural areas** than in **urban areas**, dealing with the problem is considered high priority, indicated by the enactment of the Domestic Violence Law (2016), but with mixed results, as the law lacks support for victims fleeing abusing homes, while **divorce** cases based on domestic violence claims have proved hard to win in court, as the spread of COVID-19 evidently provoked increases in such incidences. Other forms of violence, including during **gang** and **secret society** confrontations, remain comparatively low, as does the country's murder and violent **crime** rate. Yet, **fears** of violent outbreaks remain strong, with memories still alive and often portrayed in films of the collective and unbridled mayhem that occurred during the Cultural Revolution in both rural and urban areas from 1967–1968.

VIRTUES (*MEIDE*). The centerpiece of the moral code traced to ancient times in Chinese history and articulated primarily by Confucius (551–479 BCE), personal virtues are directed at **women** and **men** with specific admonitions and prescriptions for a variety of activities in **business** and gender **relations**. Designed to maintain social and political hierarchy, and overall **harmony**, the litany of virtues originated in sacrificial rites from ancient times and became a staple of classical works, story lines, and common sayings.

Most prominent are the "Five Constant Virtues" (*wuchang*) of Confucius, namely "benevolence" (*ren*), "righteousness" (*yi*), "propriety" (*li*), "wisdom" (*zhi*), and "fidelity" (*xin*). Considered the most important, *ren* involves cultivation of the inner mind in love and **compassion**, with demands to be amiable, while avoiding envy. Included is the Confucian version of the Golden Rule: "What one does not wish for oneself, one ought not to do for others." *Yi* is a capacity for rational action, abiding by self-restraint to resist all forms of temptation, while *li* constitutes **loyalty** and **filial piety**, a sense of fraternal duty, chastity, and respect, especially for the elderly. Considered innate and necessary for judging right and wrong, and distinguishing good from evil, *zhi* is necessary for the practice of moral norms and is a prerequisite to becoming a person of virtue. Matching deeds with words, *xin* involves high standards of honesty and is key to achieving **perfection**, while also considered inherent to **children**, who can be easily lost to external influences. Idealized in the Chinese **legend** of Ji Bu of the Qin Dynasty (221–206 BCE), a man always true to his word, Ji's promises were considered more valuable than gold, leading to the common saying that, "One promise equals one ton of gold" (*yige nuoyan dengyu yidun huangjin*).

440 • VIRTUES (MEIDE)

Also promulgated were the "Three Obediences and Four Virtues" (*Sancong Side*), which, reflecting Confucian gender bias, outlined the proper and generally submissive role for a woman in her own **family** and as a wife and possible widow. Supporting the "patriarchal" (*jiazhang*) character of the Chinese social order, women, according to the "three obediences," were instructed to obey the father before **marriage**, the husband when married, and the sons in widowhood. Initially appearing in the *Book of Etiquette and Ceremonies* (Yili) and *Rites of Zhou* (Zhou Li), the prescriptions were also followed by Chinese **prostitutes** as a guide to becoming **feminine**, along with imperial eunuchs and **homosexual** men. The "four virtues" also directed at women involved personal ethics, proper speech, manners and comportment, and "works" (*gongfu*), the latter pertaining to chastity, monogamy, and the importance of adhering to the marital bond in **sexual** relations.

Other virtues prominent in **Confucianism** included respect for the elderly, with an obligation to take care of aging parents as a test of honesty and faithfulness, along with being grateful to others and seeking ways to retain kindness. Popular sayings glorifying the golden years include the following: "Born to be like ginger—the older, the spicier" (*layue laoyue, dejiangsheng shu*); "An old horse knows the way" (*tushi malao*); and "Gray hair is the crown of glory" (*baifa shi rongyao de wangguan*). **Education** was equally revered, if not more so, as a great virtue essential to social existence, as affirmed in innumerable story lines, most notably, "When a schedule of one year is covered, we should think about the crops, while making up a 10 years' plan we should take care of trees; however, when it is extended to 100 years, persons of talent are everything." Declaring that, "A teacher for a day is a father for a lifetime," the role of educators is given special attention annually on Teacher's Day (10 September), and teachers are shown respect in the classroom by being addressed as "sir" (*xiansheng*) or "mentor" (*daoshi*).

WAR (*ZHANZHENG*). Dominant views on warfare in Chinese history have gone through three distinct phases: the traditional ideas of Sun Zi (544–496 BCE), laid out in *The Art of War* (Bingfa); the concept of "people's war" (*renmin zhanzheng*), developed by Chinese Communist Party (CCP) chairman **Mao Zedong** (1936–1976); and the concept of modern, technology-based warfare, developed by the People's Republic of China (PRC) since 1978–1979. A military strategist writing during the period of the Eastern Zhou Dynasty (770–221 BCE), Sun Zi, "Master Sun," developed a series of stratagems and tactics based on the principle that warfare is fundamentally evil and should be resorted to only when unavoidable. Peace and welfare should be the priority, with war considered an abhorrence employed only in special circumstances, mainly to eliminate an unjust and inhumane government.

Shared by all the major ancient **philosophies**, notably **Confucianism** and especially **Daoism**, Sun Zi focused on the importance of seeking alternatives to battle, pursuing a strategy of deception and delay, while maintaining alliances, engaging in diplomacy, and submitting, if only temporarily, to a more powerful foe. For Sun Zi, the highest excellence was to subdue an enemy without a fight, with a distaste for war as the most basic principle of the true king. Praising parsimonious behavior as best, Sun Zi praised the "peaceful and passive, favoring silence over speech," as neither "military heroism" nor "glorifying war" had a place in civilized society, where humanness and honesty are supreme. Influential throughout the imperial era and included on the imperial civil service examinations, *The Art of War* governed major dynasties, especially in avoiding aggressive and invasive wars, although major exceptions included assaults by imperial armies on nomadic and tribal groups resistant to "Sinicization" policies of cultural assimilation and the adoption of sedentary agriculture.

From Qin Shihuang (221–210 BCE) to Mao Zedong, Chinese leaders have been influenced by Sun Zi, with the latter invoking the ancient strategist in developing the strategy of guerrilla warfare employed against the Japanese during the Second Sino–Japanese War (1937–1945) and in the Chinese Civil

442 • WOMEN (NÜREN)

War (1946–1949) against the Nationalists (*Kuomintang*). Authoring the concept of "people's war," Mao emphasized the overall importance of maintaining support of the general population, employing such deceptive tactics as drawing an enemy deep into territorial expanse, stretching supply lines, and engaging in both guerrilla and mobile warfare by surrounding isolated enemy units, as occurred in repelling the various encirclement campaigns pursued by the Nationalist armies against the Communist Jiangxi Soviet (1931–1934). While the celebration of **military** valor and "heroic" victories became a staple of the PRC, especially in terms of the Korean War (1950–1953), military action was constantly threatened against the Nationalist regime ensconced on Taiwan, with several crises breaking out concerning the Taiwan Straits (1954, 1955, and 1958), along with border conflicts involving India (1962) and the Soviet Union (1969). Following the less-than-successful Sino–Vietnam War (1979), paramount leader Deng Xiaoping (1978–1992) redefined the concept of "people's war," calling for "people's war under modern conditions," with an emphasis on modern war-making technology, with the PRC, under successive leaders Jiang Zemin (1989–2002), Hu Jintao (2003–2012), and **Xi Jinping** (2013–), advocating peaceful solutions to international conflicts, avoiding, as Sun Zi had proposed, unnecessary and wasteful wars whenever possible.

Major military heroes in imperial and modern Chinese history include Cao Cao (155–220) and Zhuge Liang (181–234), both of the contentious Three Kingdoms (220–280); General Yue Fei (1103–1142) of the Southern Song Dynasty (960–1279), who fended off the invading Jurchen Jin Dynasty (1115–1234) in Northern China; and Yeng Gensi (1922–1950), a People's Liberation Army (PLA) soldier killed in the Korean War.

WOMEN (*NÜREN*). In a "patriarchal" (*jiazhang*) and "patrilineal" (*fuxi*) society stretching from ancient times during the Shang (1600–1046 BCE) and Zhou (1045–256 BCE) dynasties to the 20th century, Chinese women assumed an unequal status in the **family** reinforced by the traditional practice of **concubinage**. Suffering systematic iniquities in the larger social order, the role of women improved during the period of rule by Chinese Communist Party (CCP) chairman **Mao Zedong** (1949–1976) but remains problematic in the People's Republic of China (PRC), especially under the leadership of President **Xi Jinping** (2013–). With the male considered the core of the traditional family, the position of women was closely tied to the kinship system, as the overwhelming preference was for sons in the higher and lower **classes**, with female newborns subject to **infanticide** and surviving women restricted in **freedom** of movement, especially following arranged **marriages**. Assigned a subordinate role in **Confucianism**, women in the **yin-yang** formulation were associated with yin, seen as soft, yielding, receptive, and passive, in comparison to the more assertive and domineering yang

WOMEN (NÜREN) • 443

males. Such gender differentiations were considered part of the "natural" (*ziran*) order, as women were subjected to physical separation from their male counterparts, relegated to the "inner" (*neibu*) areas within the home and declared by the *Book of Poetry* (Shijing) to refrain from involvement in public affairs, instead devoting themselves solely to "tending silkworms and weaving." Women were assigned the limited roles of wife, mother, and mother-in-law.

Also declared by the *Book of Poetry* to refrain from involvement in public affairs, periods in which women, along with eunuchs, assumed political prominence were dominated by disruption and turmoil. Among these women was Wu Zetian (624–705), a well-educated and musically gifted former imperial consort during the Tang Dynasty (618–907) who, through a series of machinations, became a self-proclaimed "emperor" (*huangdi*), the only woman in Chinese history to assume the title (690–705). With her rule marked by a spate of political murders, one of which was that of her own daughter, Wu oversaw the creation of a secret police that would become a common tool of political rulers, including Chiang Kai-shek (1928–1949) and Mao Zedong, although she also instituted progressive reforms, particularly the expansion of the civil service examination system. Equally demonstrative was Empress Dowager Ci Xi (1861–1908), whose name translates as "compassionate joy" and who, by ruling from "behind the curtain" (*muhou*), effectively controlled her nephew, Emperor Guangxu (1875–1908), in the declining years of the Qing Dynasty (1644–1911), with a series of political and military disasters, most notably the Boxer Rebellion (1899–1901).

Subordinate in the dominant Confucian social order, women often emerged as important figures in marginal groups, most notably female **pirate** Ching Shih (1775–1844), also known as Cheng I-Sao, who led the unofficial confederation of Chinese pirates against the Portuguese, British, and Qing Dynasty navies in the early 19th century. Women figures also figured prominently in traditional Chinese **legends and mythology**, for example, Nüwa, the mother goddess, both sister and wife to the emperor-god Fuxi, who together brought order to the world, and Chang'e, goddess of the moon, who lived with the immortal "**jade** rabbit" (*yutu*). Exemplary women in **literature** include Ban Zhao (41–116), an advocate for women's self-education who, in her *Instructions for Women* (Nüje), expanded on the Confucian four virtues for women, and Diaochan, an important fictional character in *Romance of the Three Kingdoms* and considered one of the "Four Beauties of Ancient China," who sacrificed her life to bring down a tyrannical ruler.

Throughout the course of dynastic history beginning with the Han Dynasty (202 BCE–220 CE), men were favored over women in the law, as cultural prejudices were applied to women, especially involving the emerging cult of widow chastity. In the case of **divorce**, men were offered a range of **legal** grounds to terminate a marriage not granted to women, while widows be-

444 • WOMEN (NÜREN)

came head of the family only temporarily until sons became of age. More broadly, women were described in such major works as *The Biographies of Exemplary Women* (Lienü zhuan), by Liu Qiang (79–8 BCE), as offering good advice to husbands but with cautionary tales of female scheming, **jealousy**, and manipulation, with a rich vocabulary in the Chinese **language** settling on a generally prejudicial view of females by the end of the Han.

Status for women in the family and society in general depended on the birth of a son and did not improve dramatically until becoming a mother-in-law or grandmother. While women gradually entered the workforce, especially during the Song Dynasty (960–1279), running inns and serving as midwives, prejudicial views were reaffirmed, especially directed at widows, with philosopher Cheng Yi (1033–1107) declaring that it is "better for a widow to die of starvation than to lose her **virtue** by remarrying." With more women learning how to read and write during the Qing Dynasty (1644–1911), female poets became increasingly prominent, as featured as major characters in *Dream of the Red Chamber* (Hong Lou meng) even as women, usually concubines and mistresses, were offered by prominent men as **gifts** to friends and business associates.

Declaring that women "hold up half the sky" (*chengqi banbiantan*), Mao Zedong oversaw major improvements in the social position of women, including banning female **foot-binding**, outlawing polygamy, promoting literacy programs, and opening up employment in fields like medicine, with divorce made easier for women by the Marriage Law (1950). The expansion of **health** services provided women with better maternal and child care, as the percentage of women in higher **education** grew from 30 percent to more than 50 percent, with the adoption of the **one-child policy** (1979–2005) generally improving the overall position of females in the family and society in general, as women constitute 61 percent of the labor force.

While gender equality was officially declared by President Jiang Zemin in 1995, at the Fourth World Conference on Women, held in **Beijing**, traditional attitudes toward women persisted, with Chinese employers requiring prospective female employees to contractually refrain from getting pregnant and job postings explicitly calling for males. Coerced to return home so as to free up employment for men in 2008, and mandated to retire at age 50, women are also the target of Chinese government efforts to stimulate increases in birth rates to counter the rapid **aging** of the labor force. Encouraged by President Xi Jinping to "shoulder the responsibility of taking care of the old and young," China's position in terms of gender equality ranking, maintained by the World Economic Forum, has dropped substantially, from 57 to 106, out of 153 (2019), despite the achievements of such individuals as female scientist Tu Youyou (1930–), winner of the Nobel Prize in Medicine (2015), along with prominent female Olympic athletes and **celebrities**. There are virtually no female members in the top political leadership in the CCP

WORK HABITS AND WORKPLACE • 445

(2020), including governors of the country's 31 provinces, all of whom are male, as the last prominent woman, Madame Wu Yi (1938–), a vice premier and minister of health appointed in 2003, retired in 2008. At the popular level, state media has been increasingly promoting an image of "middle-class female domesticity," with the emphasis shifted to a woman's "attractiveness" (*you meili*), as opposed to personal achievements.

WORK HABITS AND WORKPLACE (*GONGZUO XIGUAN/GONG-ZUO CHANGSUO*). Generally hardworking and willing to put in overtime, often without compensation, employees in Chinese companies deal with a top-down workplace environment where hierarchy is stressed and punctuality and modesty are expected on the part of staff. Largely group-oriented and collectivist, with little or no room for individual initiative, decision-making in Chinese **companies** is generally dominated by bosses, with little tolerance for being **questioned**, as junior employees craft artful maneuvers to make suggestions without causing any loss of **"face"** by their superiors. With lunches and **banquets**, usually with drinks, serving as a frequent setting for major decisions, often at the exclusion of lower-ranking **women** employees, a prime concern is to avoid upsetting the overall balance and hierarchy of the company culture, with employees refraining from self-promotion, letting their professional CVs speak for themselves.

Negative influences of the top-down hierarchy include lack of transparency across functions, making collaboration challenging as departments operate in stove-pipe fashion, resisting suggestions from "outsiders," a pattern also apparent in the Chinese government. Too often problems get swept under the rug with hopes of them disappearing as time passes or being avoided by employees finding a creative work-around without deviating from overall plans but with the constant prospect of a sudden blowup. Prevailing notions of "good enough" (*chabuduo*) can prevent companies from reaching optimal results, as the details of any operation are often overlooked, to the detriment of larger, macro goals. Frequent interdepartmental and intradepartmental meetings are commonplace, with group consensus in line with the expectations of superiors the standard operating procedure and employees anticipated to "eat bitterness" (*chikui*) by persisting through any hardship without complaint. Codes of conduct, often unofficial, extend to common and generally conservative individual dress, while personal **"privacy rights"** (*yinsiquan*) are often ignored, especially regarding the posting of individual opinions on **social media**, despite national rules and legislation designed to provide protection, for instance, the Tort Liability Law (2009) and Cybersecurity Law (2016).

Chinese employees are also known for maintaining a variety of **superstitions** in the workplace generally aimed at improving company performance and personal prospects, notably promotions, and avoiding dismissal. Among

salespeople, desks and workspaces are often decorated with **sculptures** and pictures of cabbages, as the word in the Chinese **language** for the vegetable, formerly a staple, especially during winter, is *baicai*, a homonym for "making **money**." Money trees and ferns are also popular as **symbols** of good **fortune**, with **fengshui** masters called upon to find the most auspicious site for buildings and offices. Given the long work hours, standards for employees are often open to negotiation, with some habits, for instance, napping after lunch, tolerated in return for extraordinary demands on personal time. Stress is also given to maintaining good **relations** between employees and with other companies, and, where necessary, with government authorities, which in the PRC, unlike in most developed countries, especially the United States, can be frequent and quite interdependent. In the wake of the COVID-19 pandemic, workplaces in China have been dramatically altered with various measures to reduce personal contacts and maximize social distancing as a way to halt the spread of the disease, which originated in Wuhan, Hubei.

Factory work in China is highly regimented, with employees putting in long hours from 9 AM to 8 or 10 PM at night, including valuable overtime, which attracts many workers to companies the likes of Foxconn, a Taiwan electronics firm in Zhengzhou, Henan, known for the production of Apple iPhones. Required to wear uniforms and given meager pay, workers often live in company dormitories and enjoy hourly breaks in air-conditioned facilities, but they are often subjected to high levels of pollution, resulting in vitamin D deficiencies, common in highly polluted industrial areas. Most factory workers perform one repetitive task, lacking the diversity of operations stressed in Japanese management methods, and endure dangerous production processes, for example, the sandblasting of denim, with high rates of on-job injuries but with companies often avoiding accountability, as unions, created by the state, put corporate interests above those of employees.

XENOPHOBIA (*CHOUWAIXINLI*). Historically a society open to outside contacts with periods characterized by a rich cosmopolitanism during the Han (202 BCE–220 CE), Tang (618–907), and Song (960–1279) dynasties, China has also experienced episodes of xenophobia, a **fear** and hatred of **foreigners**, during the imperial era and the People's Republic of China (PRC). Most notable were major xenophobic outbreaks during the Boxer Rebellion (1899–1901), when egged on by Empress Dowager Ci Xi (1861–1908), members of the "boxer" (*yihetuan*) **secret society** wantonly persecuted and murdered foreign missionaries and Chinese converts in paroxysms of unbridled **violence**. Similar levels of xenophobic fervor occurred during the rule of Chinese Communist Party (CCP) chairman **Mao Zedong** (1949–1976), especially during such international conflict as the Korean War (1950–1953) and the multiple crises in the Taiwan Straits (1954, 1955, and 1958). With few foreigners residing in the PRC from the 1950s to the 1970s, xenophobic outbreaks during the **Cultural Revolution (1966–1976)** were launched by marauding Red Guards against foreign embassies in China, with the British consulate set aflame.

On the popular level, xenophobia is strongest among elements of the population less well-educated and having little or no experience of contact with foreigners, dominated by a binary "us-versus-them" mentality fueled by blatantly **racist** attitudes toward blacks from Africa and elsewhere, and **religious** prejudice against Muslims. Driven by a strong "patriarchal" (*jiazhang*) mindset, xenophobic reactions among Chinese **men** are based on a resentment of Chinese **women** "marrying down" to foreign men, based on the belief that the "**body** and sexuality of a nation should not be claimed by foreign men." Seeing **marriage** to foreigners as a "failure of Chinese masculinity," such blatantly sexist attitudes have been reinforced by videos posted on Chinese **social media**, for instance, one of a British national sexually abusing a Chinese woman.

Following the introduction of economic reforms, including the "open-door policy" (*kaifang*) toward the international community (1978–1979), xenophobia ceased as a major narrative in the PRC but with episodic antiforeign

448 • XI JINPING (1953–)

outbreaks occurring on the popular level. Major occurrences included demonstrations and attacks on African students by young Chinese denouncing "black devils" (*heigui*) in Nanjing, Jiangsu, in December 1988, with similar demonstrations and condemnations following the accidental bombing by United Nations forces of the Chinese embassy in Belgrade, Serbia in 1999. Concern about the large numbers of foreign ex-patriots living illegally in the PRC, estimated at 200,000, led to efforts to "clean out" (*zhengli*) such residents, with Chinese citizens urged to report "suspicious foreigners" (*keyi waiguoren*) to authorities, as attacks on Japanese visitors and property escalated during the dispute concerning the Senkaku (*Diaoyu*) Islands in the East China Sea in 2012.

Reinforcing an increasingly xenophobic atmosphere was enactment of the Counterespionage Law (2014), backed by warnings about "Western hostile forces" and offers of financial rewards to Chinese who provide information on suspected foreign spies. With emotion-laded terms like "foreign devils" (*yang guizi*) still heard on Chinese streets and in the countryside, the potential for xenophobic outbursts still exists, as occurred in reaction to the COVID-19 pandemic in 2020, with the focus on "imported" cases, leading to an outbreak of antiforeign sentiments, especially against Africans, although no physical assaults were reported, as was the case in other countries, including the United States.

XI JINPING (1953–). Elected general secretary of the Chinese Communist Party (CCP) and Central Military Commission in 2012, and president of the People's Republic of China (PRC) in 2013, Xi Jinping has been a strong advocate of promoting Chinese culture, both modern and traditional, while warning against undue cultural influence from the West, especially in the realm of political liberalism and opposition to Marxism–Leninism–Mao Zedong Thought. Despite lauding the role of CCP chairman **Mao Zedong** (1936–1976) in the history of the PRC, Xi has avoided any widespread attack on Chinese traditional culture, similar to the Maoist assault on the "**four olds**" (*sijiu*), especially during the **Cultural Revolution (1966–1976)**. Following the purge of his **military** father, Xi Zhongxun, from the top **leadership** by Mao, a young Xi was "sent down to the countryside" (*xiaxiang*) to work, an experience Xi now recalls fondly for his gaining an understanding of the lives of common people. In contrast to the Maoist mindset and the cultural iconoclasm of the New Culture Movement/May Fourth Movement (1917–1921), Xi has promoted the country's "cultural confidence" (*wenhua xinxin*), including a reaffirmation of **Confucianism**, with inspection tours to the great philosopher's birthplace in Shandong in 2014.

While an advocate of economic and scientific-technological development, Xi Jinping believes that a "strong culture" (*nonghou wenhua*) is essential, with the **arts**, **literature**, **philosophy**, and social sciences playing key roles

in achieving the Chinese "dream" of "national rejuvenation" (*minzu fuxing*). Well-read in Chinese **history** and undoubtedly familiar with local folk culture, as his wife, Peng Liyuan, is an accomplished folk singer, Xi Jinping strongly believes that a "nation devoid of soul" provided by culture cannot survive, let along be "rich and prosperous" (*fuyu*). Such cultural traditions as **calligraphy** must be preserved and enhanced, Xi has stressed, along with exhibitions of rare cultural relics to convey the great cultural achievements of Chinese civilization from ancient times to the present. The rise of Xi Jinping to the status of a "great leader" raises the question of the lasting damage done to Chinese **political culture** by the legacy of Mao Zedong.

While periodically tacking on the word "socialist" in front of "culture," Xi's frequent musings in plain, everyday **language** on the importance of culture are generally devoid of **ideological** dogma, although no mention of culture and its importance appears in the 14 principles of "Xin Jinping Thought." Believing that Western "cultural subversion" (*wenhua dianfu*) helped bring down the former Soviet Union, Xi has assigned China's **artists**, writers, and theorists with the tasks of not only providing the people with fine works of culture, but also "guiding the public with high moral standards," countering the widespread moral malaise. For Xi, eroding the destructive effects of Western culture requires widespread **censorship** in the arts, film, and literature, including banning such notorious figures as Winnie the Pooh. Exceptions include Western literary figures admired by Xi, with one example being Ernest Hemingway, whose house in Havana, Cuba, the Chinese president visited during an official visit.

XI'AN. Considered the "birthplace" of Chinese civilization and culture, and the capital of 13 imperial dynasties dating to the Zhou Dynasty (1045–256 BCE), Xi'an, literally "western peace," is one of the oldest cities in China and the second most popular tourist attraction in the People's Republic of China (PRC). Located on the Guanzhong flood plain on the Yellow River in the northwest with a current population of 12 million people, Xi'an is the capital of Shaanxi province and one of the Four Great Ancient Capitals of China, the other three being **Beijing**, Luoyang, and Nanjing. Serving as the base for Emperor Qin Shihuang (221–210 BCE), the great unifier of the Chinese empire, the city, then known as Chang'an ("eternal peace"), was the capital of the Sui (581–618) and Tang (618–907) dynasties, and the most populous **urban area** in the world in the 7th and 8th centuries, estimated at 3 million people, located at the eastern starting point of the **Silk Road**. With tree-lined streets, high walls surrounding more than 100 residential blocks, pleasure parks, and canals, the highly cosmopolitan city was a major center of silk production and included foreign residents, Arabs, Persians, Syrians,

450 • XI'AN

and Sogdian merchants, lured by great wealth, along with Persian princes from the deposed Sassanid Empire (224–651), conquered by Muslim Arab invaders.

Sacked on several occasions, most notedly by rebel Huang Chao in 880, Xi'an retains major **architectural** features and cultural monuments, notably the dramatic city wall, originally constructed during the Tang Dynasty and rebuilt and expanded during the Ming Dynasty (1368–1644). Most impressive is the Terracotta Army, a collection of 8,000 sculptured life-sized soldiers, along with horses and chariots, buried in pits near the unexcavated mausoleum of Emperor Qin Shihuang, located outside the city. Other attractions, many dating to the opulent Tang Dynasty, include the following: the Great and Small Wild Goose **pagodas** (*Da/Xiao Yanta*), built to store translations from Sanskrit of Buddhist sutras; the *Weiyang*, "never ending," Palace, at 4.8 square kilometers the largest in the world, built during the Han Dynasty (202 BCE–220 CE); and the Daming Palace, an imperial complex built during the unofficial reign of Empress Wu Zetian (690–705) of the short-lived Zhou Dynasty, which interrupted the Tang Dynasty, with outer, middle, and inner courts, and "three great halls," situated on a north–south axis.

Other major attractions include the "Bell" (*Zhonglu*) and "Drum" (*Gulou*) towers, with large bronze bells built during the Ming Dynasty; numerous pagodas and temples, including Famen, Wulong, Blue Dragon, and Xingjiao, the last the site of the tomb of Buddhist monk Xuanzang, who returned from India with thousands of sutras, along with temples to the City God and Confucius (551–479 BCE); the Yangling Mausoleum of the Liu Qi emperor and his empress, Wang, from the Han Dynasty, 20 square kilometers in size and the first underground **museum** in China; and the Xi'an and Shaanxi provincial museums, containing hundreds of thousands of cultural relics from the city's long and storied history.

The most notable **religious** relics consist of the stele forest of inscriptions, including those by Nestorian Christians dating to 635, as Xi'an was the site of initial contact between China and **Christianity**, with a Nestorian monastery erected in the city in 781. Substantial interactions also occurred with the Islamic world, especially the Abbasid Caliphate (750–1258), with the erection of the Great Mosque in 742, as 50,000 Hui people live in the Old Muslim Quarter, with vibrant street **markets** and **food** stalls offering fare highly influenced by Arab traditions. Among the most prominent **gardens** is the Tang Cultural Paradise Park, modeled on the exquisite imperial gardens from the Tang Dynasty, with Mount Hua located nearby, one of the five sacred peaks in **Daoism**.

Major artistic traditions and features indigenous to the city include *Qinqiang* **opera**, the earliest operatic form in China, preceding **Peking opera** and other opera types (*Yu*, **Sichuan** and Hebei), with melodies drawn from **rural** Shaanxi and Gansu, and the use of the "woodblock" (*bangzi*) musical

instrument of random pluck, along with ancient Chinese vocal styles. Also notable is the Tang Dynasty Music and Dance Show, a recreation of traditional **entertainment**, with a live classical orchestra performed at the Tang Dynasty Palace (*Tang Yue Gong*).

Other musical forms include Xi'an drum **music**, considered a "living fossil of ancient Chinese music," and the "Eight Oddities of Shaanxi," sung as Shaanxi folk proverbs with a style described as "roaring vigorously." Decorative arts and **handicrafts** include tricolored glazed pottery, traced to the Tang Dynasty, and the Chang'an School of **painting**, also known as Silk Road Art, featuring rural and **mountain** scenery popular in the early 20th century. Prominent foods indigenous to Xi'an include, among others, "dumplings" (*jiaozi*), "spicy cumin lamb noodles" (*biangbiang mian*), "Chinese pork burgers" (*roujiamo*), "steamed stuffed buns" (*guantan baozi*), and kabobs, with many noodle makers engaging in their craft from open street stalls.

YIN-YANG. A concept central to traditional Chinese **cosmology**, yin-yang describes the universe as governed by a cosmic duality between two sets of opposing but also complementary forces and **energy** (*qi*) that can be observed in **nature**. Dating to the 9th century BCE, with first mention in the *Book of Changes* (Yijing) and associated with the School of Naturalists and philosopher Zou Yan (305–240 BCE) during the Warring States (475–221 BCE) period, yin-yang constitutes a kind of logic that views all things in relation to the whole, with major influence on traditional Chinese **philosophy**, including **Confucianism** and especially **Daoism**. Other realms of Chinese **thinking** influenced by yin-yang include **traditional Chinese medicine (TCM)**, along with such **martial arts** as Qigong and Tai Chi (*taijiquan*) **exercise** regimens.

Chinese **sciences** incorporating yin-yang include astronomy, as the coupling represents the observation of the shadow of the Earth on the moon, and the record of the position of the Big Dipper constellation throughout the year. These observations make up the four points of the compass. The sun rises in the east and sets in the west, the direction of the shortest shadow measured is south, and at night, the pole star points north. Originating in early observations of the natural world, yin initially referred to the shady side of a hill and yang to the sunny side, with subsequent applications to natural pairs, like sky and earth, day and night, cold and heat, fire and water, and woman and man.

Characteristics of yin-yang are dualistic, although not mutually exclusive, as yin is considered dark, feminine, cold, wet, and negative, with inward energy, and yang is light, masculine, hot, dry, positive, with outward energy, as the pairs undergo constant change and interaction. With yin seen as receptive and yang as active, the duality is present in all forms of change, including the annual cycle of the seasons (winter and summer), landscapes (north-facing shade and south-facing brightness), and even human history (order and disorder). Virtually everything has a yin-yang aspect, with the coupling constituting a whole greater than its parts and neither considered absolute, as a decline in one is accompanied by an increase in the other. Any imbalance

454 • YOUTH (QINGNIAN)

leads to disruption in **nature**, society, and the human **body**, with too much yin in the body leading to an unhealthy accumulation of fluids and too much yang producing overheating and a fever, with the restoration of *yin-yang* balance as the route to recovery from illness and, at the higher level, stability in politics and society.

The universal yin-yang **symbol** consists of a circle divided into two halves by a curved line, one half black (yin) and one half white (yang), with the two halves intertwining across a spiral-like curve that splits into a semicircle and dots of each in the other indicating both sides carry the seeds of the other. Drawn from an ancient Chinese time-keeping system employing a pole to measure changing lengths of shadows throughout the solar year, the symbol is associated with the *Tai Chi* exercise regimen and has become a virtual national symbol in the Republic of Korea. Everyday phrases invoking the yin-yang concept include "Disaster turns out to be a blessing," "Tragedy turns to comedy," and "Illness is the doorway to **health**."

YOUTH (*QINGNIAN*). Relegated to a generally subordinate status vis-à-vis parents and elderly, who were revered in **Confucianism** throughout imperial Chinese history, youth became the embodiment of revolutionary change, especially by left-wing cultural and political movements, during the 20th century. Exemplified in the popular journal *New Youth* (Xin Qingnian), the mouthpiece of young intellectuals and political activists, mobilized by the New Culture Movement/May Fourth Movement (1917–1921), including the founders of the Chinese Communist Party (CCP) in 1921, youth were seen as major carriers of a vibrant **nationalism** and a vehicle for **cultural change** from the old society, which commentators compared to a decrepit old person. The cultivation of youth was a priority throughout the history of the CCP and the People's Republic of China (PRC), with the creation of the Young Pioneers (*Shaonian Xianfengdui*) for youth ages six to 14, and the Communist Youth League (*Gong Qingtuan*) for ages 14 to 28, a major recruiting route into the CCP.

While youth dominated the ranks of the Red Guards during the early stages of the **Cultural Revolution (1966–1976)**, emboldened by CCP chairman **Mao Zedong**, concern about intense factionalism and lack of true revolutionary zeal among youth led to their being "sent down to the countryside" (*xiaxiang*) beginning in 1968. Residing in the backwaters of **rural** society, sometimes for several years, large segments of Chinese youth became disenchanted with the Communist regime and, upon returning to the cities, became involved in everything from illicit activities to new **businesses**, especially following the introduction of economic reforms and social liberalization (1978–1979).

Constituting the **leadership** and much of the rank and file in the prodemocracy movement in 1989, Chinese youth were alienated from the political world by the crushing of the demonstrations and the arrest and persecution of young leaders like Wang Dan (1969–) and Wu'er Kaixi (1968–). Emerging as a high-spending consumer group throughout the 1980s and 1990s, and the target of aggressive advertising by Chinese retailers, especially via the internet, Chinese youth, with their many promises and anxieties, have become favorite topics in film and the subjects of long-running television serials. Adopting a realistic view of the country's youth at odds with the zealous and uncomplicated portraits of the Mao years, among the most notable films is *Youth* (2017), a coming-of-age drama chronicling the lives of a group of idealistic young people, members of a **military** troupe in the People's Liberation Army (PLA), during the Cultural Revolution and thereafter. Featuring **songs** and **dances**, the film portrays the raw experiences of love, lust, betrayal, and suffering during the Mao era, followed by the inconclusive Sino–Vietnamese War (1979). Going by the same title, *Youth* (2019) is a dramatic television series on life in contemporary China through the growing pains experienced by five college freshmen during their university years, followed by **struggles** in China's increasingly competitive **workplace**.

A bastion of support for Chinese **nationalism**, Chinese youth have willingly participated in periodic anti-American and anti-Japanese demonstrations involving a variety of international issues, for instance, the accidental bombing by United Nations forces of the Chinese embassy in Belgrade in 1999. While generally accepting the status quo of political authoritarianism, combined with plentiful jobs, political stability, and upward mobility, Chinese youth have joined with many journalists and other critics of the current administration of President **Xi Jinping** (2013–), lamenting the slow response to the deadly COVID-19 pandemic in 2020, in Wuhan, Hebei, calling for greater **freedom** of speech and less bureaucratic controls.

YUNNAN. Located in the southwest with subtropical highlands and humid tropical zones, and long isolated from other **regions** in China, Yunnan is home to the largest collection of ethnic **minorities** in the People's Republic of China (PRC), numbering 25 of a national total of 56, and constituting 28 percent of the provincial population. Meaning "south of the clouds," a reference to the geographical location of the province south of the fog-ridden basin in **Sichuan**, Yunnan is split into two distinct areas by the north-to-south Ailao Mountains, with canyons and valleys in the west and the Yunnan–Guizhou Plateau in the east, along with the Three Parallel Rivers Protected Area, constituting the Nu (Salween), Lancang (Mekong), and Jinsha (Yangzi upper reaches).

456 • YUNNAN

Considered the "birthplace" of Chinese **tea culture**, with local production primarily of pu'er tea, and located on the ancient Tea Horse Road into **Tibet** and beyond, Yunnan has frescoes dating to the Jin Dynasty (265–420). The site of two indigenous kingdoms, the Nanzhao (8th and 9th centuries) and the Dali (10th to 13th centuries), Yunnan came under Mongol control during the Yuan Dynasty (1279–1368) and was absorbed into the Chinese empire during the Ming Dynasty (1368–1644). Isolated and difficult to access, the province served as a place of exile for disgraced imperial officials, with tribal life of indigenous minorities remaining basically unchanged up to the 20th century.

With 16 different **languages** and diverse **customs**, the many ethnic groups and tribes in Yunnan are known as *jiaxiang bao*, literally "hometown babies," because of the strong affection for their home province, with individual ethnic groups living together in specific and tight-knit areas, especially in the countryside and in **mountain regions**. The most notable minorities with languages in the Tibeto-Burman group include the following: the Yi, at 4.5 million people, the largest ethnic minority, and known as fierce warriors, serving as onetime rulers of the province, with the annual Torch Festival; the Bai, numbering 2 million people and named for their reverence for the **color** white, living in Dali valley and once leaders of the Dali Kingdom, with the March Fair Festival; the Naxi, concentrated in the city of Lijiang and practitioners of the Dongba **religion**, with their own distinctive dress and written language; and the Mosuo, a small group closely related to the Naxi and constituting the last matrilineal and matriarchal society in China.

The most prominent members of the Tai language group are the Dai, also found in Thailand and Laos, practitioners of Theravada **Buddhism** and famous for the Water Splashing Festival, along with other small groups, including the Bajia, Tai Beng, and Han Tai, mostly concentrated in Xishuangbanna, the southernmost region in China. Yunnan is also home to the **Tibetan** Songzanlin monastery, known as the "Little Potala," in the northwestern city of Shangri-la, a highly touted tourist site. Among other ethnic minorities in Yunnan, many also found in neighboring provinces and countries, are the Aini, Achang, Bailuo, Hani, Kucong, Lahu, Limo, Lisu, Miao, Wa, Yao, Yiche, and Zhuang. Subject to Chinese Communist Party (CCP) rule, state-imposed reforms included terminating slave-owning by the Yi, while the practice of headhunting by the Wa was also ended. Suppressed during the **Cultural Revolution (1966–1976)** by Red Guards, many from outside the province, the ethnic and cultural diversity of Yunnan is now officially celebrated, serving as a major tourist attraction in one of the country's poorest provinces.

With the rich variety of different ethnic groups, Yunnan is known for unique cultural forms, many retained to enhance the lure of the province to domestic and foreign tourists. Included are such oddities as long and elab-

orate bamboo water pipes, often puffed on by wizened elderly men, and the sight of fathers taking over the tasks of childrearing, as Yunnanese **women** spend their time working in the fields and producing **family** income. While both genders generally wear the same clothing year-round in the mild climate, young girls are known for wearing flowers throughout the seasons and colloquially referred to as "old ladies," while Buddhist monks are allowed to engage in love affairs.

Major traditional musical forms include the *baisha xiyue*, reputedly introduced into the province by the invading Kublai Khan (1253), along with *dongjing*, sung by Daoist monks, both associated with the Naxi and considered "living musical fossils." Major temples and mosques, with their locations in parenthesis, are as follows: Xingjiao Temple (Shaxi); Huating Buddhist Temple (Xishan); Guishan Buddhist Temple (Shangri-la); Hall of Golden Daoist Temple (Kunming); Dai Theravada Buddhist Temple (Jinghong, Xishuangbanna); and Tuogu Mosque (Ludian County). To outsiders, the Yunnanese tongue sounds harsh, loud, and sometimes hostile, when in reality the overheard conversation probably involves steep pork prices.

Z

ZHANG YIMOU (1951–). A member of the "fifth generation" (*di wudai*) of filmmakers in the People's Republic of China (PRC), also known as an actor, writer, and **music** director, Zhang Yimou is internationally renowned and the winner of multiple national and international film awards. Born in Shaanxi, Zhang was "sent down to the countryside" (*xiaxiang*) as a **youth** during the **Cultural Revolution (1966–1976)**, working on a farm for three years and in a textile factory for seven years in the city of Xianyang, where he became familiar with the everyday life of the average Chinese, later portrayed in several films. Taking up **painting** and still **photography**, he was admitted to the prestigious Beijing Film Academy (BFA), also attended by such later notable filmmakers as **Chen Kaige**, Tian Zhuangzhuang, and Zhang Junzhou. Assigned to a small regional film studio in Guangxi in the southwest, Zhang debuted with the film *Red Sorghum* (1987), chronicling the life of a woman working in a distillery for sorghum liquor, based on the novel of the same title by prominent author Mo Yan (1955–).

Subsequent films of notoriety by Zhang Yimou, many set in periods of Chinese history, include the following: *Ju Dou* (1990), a tale of a Chinese woman sold into **marriage** to an older man, nominated by the American Academy Awards for Best Foreign Film; *Raise the Red Lantern* (1991), based on the novel *Wives and Concubines*, by Su Tong (1963–), later adapted into a ballet; *To Live* (1994), banned in the PRC for controversial political content; *Shanghai Triad* (1995), set in the criminal world of **Shanghai** in the 1930s; *Keep Cool* (1997), one of the few films set in modern China; *Hero* (2003), a portrayal of an attempted assassination of Lord Zheng, later known as Qin Shihuang (221–210 BCE), first unifier of the Chinese empire; and *Curse of the Golden Flower* (2006), an epic *wuxia* (knight-errant) **drama** set during the opulent Tang Dynasty (618–907), with a story line similar to *King Lear*.

Prominent actresses and actors appearing in films by Zhang Yimou are as follows: Gong Li (1965–), starring in seven films, most notably *Ju Dou*; Zhang Ziyi (1979–), appearing in *The Road Home* (1999) and *House of Flying Daggers* (2004); Jet Li, from **Hong Kong**, in *Hero*; and American

460 • ZODIAC (SHI'ER SHENGXIAO)

Matt Damon in *The Great Wall* (2016), a notorious box-office flop. Other notable work by Zhang Yimou include as an actor appearing in the film *Old Well* (1987), based on a novel by Zheng Yi (1947–), for which Zhang won a best-acting award; as director of the Puccini **opera** *Turandot*, staged in the **Forbidden City** (1996), with the story line set in China; and a similar directing role for the Chinese opera *The First Emperor* (2006).

ZODIAC (*SHI'ER SHENGXIAO*). A repeating cycle of 12 years, with each year represented by an **animal** and its reputed generally positive attributes, the Chinese Zodiac has been used for a variety of functions, including **fortune-telling** and **marriage**, determining the compatibility of two people in a **romantic** relationship. Traced to the **legend** of the mythical "Jade Emperor" (*Yu Huangda Di*), who in search of 12 guards held a Great Race among competing animals, with the "rat" (*shu*) coming in first by cleverly riding on the back of the "ox" (*niu*), followed in order of their position by 10 real and mythical animals. Rooted in the ancient worship of animals important to agricultural livelihood and imperial security, the Zodiac has existed since the Qin Dynasty (221–206 BCE), playing a crucial role in Chinese astrology and divination, and still relied upon in modern times despite its reputation as a **superstition**.

The 12 animals in sequential order, with prominent positive attributes shared by humans indicated in parenthesis, include the following: rat (clever/ charming); ox (direct/knowing what one wants); tiger, *hu* (courageous); rabbit, *tu* (genuine/compatible); dragon, *long* (spirited/lucky); snake, *she* (creative); horse, *ma* (laid-back/benevolent); goat, *yang* (artsy); monkey, *hou* (humorous/optimistic); rooster, *ji* (ethical); dog, *gou* (**loyal**); and pig, *zhu* (forgiving/genial). Each animal is also associated with either yin (ox, rabbit, snake, goat, rooster, pig) or yang (rat, tiger, dragon, horse, monkey, dog), as well as specific months, days of the week, and hours, starting with rat (December/Thursday/11 PM–1 AM) and going to pig (November/Thursday/ 9–11 PM), with the intervening 10 animals following in sequential rank order. In-depth personal analysis and fortune-telling look at all four time periods (year/month/day/hour), with examples of the best romantic matchups as follows: rat/ox/dragon/rabbit, snake/dragon/rooster, monkey/ox/rabbit, and rooster/ox/snake. The "birth signature year" (*benmingnian*) of an individual is traditionally considered an inauspicious time, seen as offending the God of Age and bringing bad luck.

Glossary

baihua	hundred flowers
bianzheng weiwuzhuyi	dialectical materialism
chiku nailiao	"eating bitterness, enduring hardship"
daren buji xiaoren guolu	"a great man does not remember the faults of a petty man"
diao cheng xiaoji	small skills of carving insects
douzheng huiyi; zhengdou huiyi	"struggle sessions"
fazhi	rule of law
feihua wenxue	nonsense writings
fengjianzhuyi	feudalism
fengshui	wind and water
fubai	corruption
fucong	obedience
gaige	reform
gaokao	national college entrance examination
guifei	consort
guocui	national essence
guwei jinyong	"let the past serve the present"
guwei louli ruwei minggao	"commerce for profit and scholarship for personal reputation"
hexie	harmony
hong haiyang	"ocean of red"
hongbao	red envelope
hongse zhuanjia	red and expert
Hongwei Bing	Red Guard
hua er bu shi	"flowering but not bearing fruit," meaning to procrastinate

462 • GLOSSARY

huairou yuanren	"taming people from afar"
jiagu	oracle bones
jiazhang zhidu	patriarchal system
jieji diren	class enemies
jieji douzheng	class struggle
jingshen wuran	spiritual pollution
jinü	prostitute
jitizhuyi	collectivism
junzi	gentleman
kaigang zhengce	open-door policy
laobaixing	old hundred names
laotouzi	old timer
lingchi	"death by a thousand cuts"
liyi zhibang	"land of ritual and righteousness"
maodun	contradiction
mei banfa	"there is no way"
meihua	plum blossoms
meixue	aesthetics
min yi shi wei tian	"people revere food as if it were heaven"
minzu fuxing	national rejuvenation
muxi xianghua	"admire right behavior and turn toward admiration"
putonghua	national language
renlei linghun gongchengshi	"engineers of the human soul"
renzhi	rule by men
rujia	scholar-officials
sanbu yaoyan	rumor mongering
sanjiao heyi	three teachings [Buddhism, Confucianism, Daoism] united as one
shangren wenxue	scar literature
shehuizhuyi xianshizhuyi	socialist realism

GLOSSARY • 463

shibu guanji, gaogao guaqi	"the matter is of no concern to me, hang it up high"
sixiang gongzuo	thought work
tian gao huangdi yuan	"heaven is high, and the emperor is far away"
tianren heyi	unity of humanity and nature
tianxia weigong	"the world is for all"
tiewanfan	iron rice bowl
tuoli qunzhong	"divorced from the masses"
wanshitong	know it all
weiwuzhuyi	materialism
wo yi ai	stability
wending	"me generation"
xianfu qunti	got rich first crowd
xiao gongzhu	little princess
xiao huangdi	little emperor
xiaxiang	"sent down to the countryside"
xing juexing	sexual awakening
xuezhe yaogun	scholars' rocks
yazhou bingfu	"sick man of Asia"
yiku sitian	"recall the bitterness of the past, think of the sweetness of the present"
yingxiong	hero
zhengfeng	rectification
zouzipai	capitalist roader

Bibliography

CONTENTS

I. Introduction	465
II. Books and Articles	466
A. English	466
B. Chinese and Other Languages	490
III. Chinese and International Journals on Culture	493
IV. Films, Videos, and Podcasts	493
A. Films (Post-1978)	493
B. Videos (Available on YouTube and Amazon)	494
V. Websites	495

I. INTRODUCTION

Sources on the multiple topics encompassing Chinese culture are rich and varied, with major primary and secondary works in English, Chinese, and other languages for both the dynastic and modern eras, including the People's Republic of China (1949–). Decorative and fine arts for which China is widely known, including ceramics and porcelains, handicrafts, landscape painting, calligraphy, and jade and seal carvings, have been a subject of major interest to historians and cultural researchers, with considerable sources also available on such traditional forms of entertainment as dancing, opera, and puppetry. Equally substantive are sources on popular customs, including ancestor worship, fortune-telling, weddings and marriage, and religion, along with the beliefs sustaining these practices so vital to China's unique cultural heritage, for instance, fengshui (wind and water) and yinyang. Less attractive practices, like foot-binding of women and infanticide of female babies, have also been the subject of many academic and conventional publications, along with the modern-day campaigns that led to their virtual elimination.

Listed sources are provided, outlining and analyzing major policies pursued by the imperial state and modern political leaders, as well as crucial events, most notably the New Culture Movement/May Fourth Movement (1917–1921) and Cultural Revolution (1966–1976), which shaped the trajectory of Chinese cultural development in the modern era. The impact of the

466 • BIBLIOGRAPHY

economic reforms and social liberalization begun in 1978–1979, in the cultural realm, is also the topic of innumerable works, of which only a small portion are listed here for considerations of space.

II. BOOKS AND ARTICLES

A. English

1. General History

Balazs, Etienne. *Chinese Civilization and Bureaucracy*. New Haven, CT: Yale University Press, 1964.

Barmé, Geremie R. *In the Red: On Contemporary Chinese Culture*. New York: Columbia University Press, 1999.

Beckwith, Christopher I. *Empires of the Silk Road: A History of Central Eurasia from the Bronze Age to the Present*. Princeton: Princeton University Press, 2009.

_____. *Warriors of the Cloisters: The Central Asian Origins of Science in the Medieval World*. Princeton: Princeton University Press, 2012.

Bodde, Derk. *China's Cultural Tradition: What and Wither?* New York: Holt, Rinehart and Winston, 1957.

Brook, Timothy. *The Troubled Empire: China in the Yuan and Ming Dynasties*. Cambridge, MA: The Belknap Press of Harvard University Press, 2010

Carl, Katherine. *With the Dowager Empress of China*. London: KPI, 1986.

Chai, May-lee, and Winberg Chai. *China A to Z: Everything You Need to Know to Understand Chinese Customs and Culture*. New York: Plume, 2014.

Chang, Jung. *Empress Dowager Ci Xi: The Concubine Who Launched Modern China*. New York: Alfred A. Knopf, 2013.

Chow, Tse-tsung. *The May Fourth Movement*. Stanford, CA: Stanford University Press, 1960.

Chu, Godwin C., and Francis L. K. Hsu, eds. *Moving a Mountain: Cultural Change in China*. Honolulu: University Press of Hawaii, 1979.

Clunas, Craig. *Empire of Great Brightness: Visual and Material Cultures of Ming China, 1368–1644*. London: Reaktion, 2012.

Cohen, Paul A. *Between Tradition and Modernity: Wang T'ao and Reform in Late Ch'ing China*. Cambridge, MA: Harvard University Press, 1974.

Dirlik, Arif, and Xudong Zhang, eds. *Post-Modernism and China*. Durham, NC: Duke University Press, 2000.

BIBLIOGRAPHY • 467

Elliot, Mark C. *Emperor Qian Long: Son of Heaven, Man of the World*. New York: Longman and Pearson, 2009.

Ellman, Benjamin A. *A Cultural History of the Civil Examination in Late Imperial China*. Berkeley: University of California Press, 2000.

Elvin, Mark. *The Pattern of the Chinese Past*. Stanford, CA: Stanford University Press, 1973.

Frankopan, Peter. *The Silk Road: A New History of the World*. New York: Vintage, 2017.

Hansen, Valerie. *The Silk Road: A New History with Documents*. Oxford: Oxford University Press, 2016.

Honour, Hugh. *Chinoiserie: The Vision of Cathay*. New York: E. P. Dutton, 1962.

Huang, Ray. *China: A Macro History*. Armonk, NY: M. E. Sharpe, 1988.

Huot, Claire. *China's New Cultural Scene: A Handbook of Changes*. Durham, NC: Duke University Press, 2000.

Johnson, David, Andrew Nathan, and Evelyn Rawski, eds. *Popular Culture in Late Imperial China*. Berkeley: University of California Press, 1985.

Kuhn, Philip. *Rebellion and Its Enemies in Late Imperial China: Militarization and Social Structure, 1796–1864*. Cambridge, MA: Harvard University Press, 1980.

———. *Soul Stealers: The Chinese Sorcery Scare of 1768*. Cambridge, MA: Harvard University Press, 1990.

Lewis, Mark Edward. *China Between Empires: The Northern and Southern Dynasties*. Cambridge, MA: The Belknap Press of Harvard University Press, 2009.

Meisner, Maurice. *Mao's China: A History of the People's Republic*. New York: Free Press, 1977.

Needham, Joseph R. *Clerks and Craftsmen in China and the West*. Cambridge, UK: Cambridge University Press, 1970.

——— et al. *Science and Civilization in China*. 7 vols. Cambridge, UK: Cambridge University Press, 1956– .

Pakula, Hannah. *The Last Empress: Madame Chiang Kai-shek and the Birth of Modern China*. New York: Simon and Schuster, 2010.

Robinson, David M., ed. *Culture, Courtiers, and Competition: The Ming Court (1368–1644)*. Cambridge, MA: Harvard University Press, 2008.

Said, Edward. *Orientalism*. New York: Pantheon, 1978.

Schell, Orville, and John Delury. *Wealth and Power: China's Long March to the 21st Century*. New York: Random House, 2013.

Spence, Jonathan D. *Chinese Roundabout: Essays in History and Culture*. New York: W. W. Norton, 1992.

———. *Emperor of China: Self-Portrait of K'ang-hsi*. New York: Vintage, 1988.

———. *The Memory Palace of Matteo Ricci*. New York: Viking, 1986.

468 • BIBLIOGRAPHY

_____. *The Search for Modern China.* New York: Norton, 1990.

_____. *To Change China: Western Advisors in China, 1620–1960.* New York: Little, Brown and Company, 1969.

Thurston, Anne F. *Enemies of the People.* New York: Alfred A. Knopf, 1987.

Topping, Audrey Ronning. *The Old Silk Road and Me: A Photographic Narrative.* Independently Published, 2020.

Twitchett, Denis et al. *The Cambridge History of China.* 8 vols. Cambridge, UK: Cambridge University Press, 1978–2009.

Wakeman, Frederic, Jr. *The Fall of Imperial China.* New York: Free Press, 1975.

Waley-Cohen, Joanna. *The Culture of War in China: Empire and the Military under the Qing Dynasty.* New York: I. B. Tauris, 2006.

Wang, Jing. *High Culture Fever: Politics, Aesthetics, and Ideology in Deng's China.* Berkeley: University of California Press, 1996.

Wood, Frances. *The Silk Road: Two Thousand Years in the Heart of Asia.* Berkeley: University of California Press, 2004.

Wright, Mary C. *The Last Stand of Chinese Conservatism.* New York: Atheneum, 1967.

Zha, Jianying. *China Pop.* New York: New Press, 1994.

2. Archaeology and Architecture

Barmé, Geremie R. *The Forbidden City.* London: Profile Books, 2008.

Béguin, Gilles, and Dominique Morel. *The Forbidden City: Center of Imperial China.* Trans. Ruth Taylor. New York: Henry N. Abrams, 1997.

Berling, Nancy, ed. *The Emperor's Private Paradise: Treasures from the Forbidden City.* New Haven, CT: Yale University Press, 2010.

Cheng, Wen-chien. *The Forbidden City: Inside the Court of China's Emperors.* Houston, TX: ROM, 2014.

Datz, Christian, and Christof Kullman. *Shanghai: Architecture and Design.* New York: teNeues, 2005.

Hansford, Howard. *A Glossary of Chinese Art and Archaeology.* London: China Society, 1961.

Er Si et al. *Inside Stories from the Forbidden City.* Trans. Zhao Shuhan. Beijing: New World Press, 1986.

Johnston, Tess, and Erh, Deke. *A Last Look: Western Architecture in Old Shanghai.* Hong Kong: Old China Hand Press, 1993.

Knapp, Ronald G. *China's Living Houses: Folk Beliefs, Symbols, and Household Ornamentation.* Honolulu: University of Hawaii Press, 1999.

———. *China's Vernacular Architecture: House Form and Culture.* Honolulu: University of Hawaii Press, 1989.

BIBLIOGRAPHY • 469

Rowe, Peter G., and Seng Kuan. *Architectural Encounters with Essence and Form in Modern China*. Cambridge, MA: MIT Press, 2002.

Steinhardt, Nancy Schatzman. *Chinese Architecture*. New Haven, CT: Yale University Press, 2002.

Waldron, Andrew. *The Great Wall of China: From History to Myth*. Cambridge, UK: Cambridge University Press, 1990.

3. Cuisine, Food, Tea, and Alcohol

Anderson, E. N. *The Food of China*. New Haven, CT: Yale University Press, 1988.

Ang, Audra. *To the People, Food Is Heaven: Stories of Food and Life in a Changing China*. Guilford, CT: Lyons Press, 2012.

Chang, Kwang-chih, ed. *Food in Chinese Culture: Anthropological and Historical Perspectives*. New Haven, CT: Yale University Press, 1977.

David, Percival. *Chinese Connoisseurship*. New York: Faber, 1971.

Evans, John C. *Tea in China: The History of China's National Drink*. New York: Greenwood Press, 1992.

Gang, Yue. *The Mouth That Begs: Hunger, Cannibalism, and the Politics of Eating in Modern China*. Durham, NC: Duke University Press, 1999.

Simoons, Frederick. *Food in China: A Cultural and Historical Inquiry*. Boca Raton, FL: CRC Press, 1991.

Smith, Norman. *Intoxicating Manchuria: Alcohol, Opium, and Culture in China's Northeast*. Vancouver, British Columbia: UBC Press, 2012.

Wang, Di. *The Teahouse: Small Business, Everyday Culture, and Public Politics in Chengdu, 1900–1950*. Stanford, CA: Stanford University Press, 2008.

4. Customs, Habits, Rituals, Punishments, and Superstitions

Ahearn, Emily. *Chinese Ritual and Politics*. Cambridge, UK: Cambridge University Press, 1982.

Allan, Sarah. *The Shape of the Turtle: Myth, Art, and Cosmos in Early China*. Albany: State University of New York Press, 1991.

Anderson, Mary M. *Hidden Power: The Palace Eunuchs of Imperial China*. Buffalo, NY: Prometheus, 1990.

Aylward, Thomas E. *The Complete Guide to Chinese Astrology and Fengshui*. London: Watkins Publishing, 2007.

Barmé, Geremie, and John Binford. *Seeds of Fire*. Hong Kong: Far Eastern Economic Review, 1986.

470 • BIBLIOGRAPHY

Baumler, Alan. *The Chinese and Opium under the Republic: Worse Than Floods and Wild Beasts*. Albany: State University of New York Press, 2007.

Bell, Daniel A. *China's New Confucians: Politics and Everyday Life in a Changing Society*. Princeton, NJ: Princeton University Press, 2008.

Benedict, Carol. *Golden-Silk Smoke: A History of Tobacco in China, 1520–2010*. Berkeley: University of California Press, 2011.

Bogan, M. L. C. *Manchu Customs and Traditions*. Tientsin: China Booksellers, 1928.

Bond, M. H. *Beyond the Chinese Face: Insights from Psychology*. Hong Kong: Oxford University Press, 1991.

Bredon, Juliet, and Igor Mitrophanow. *The Moon Year: A Record of Chinese Customs and Festivals*. Shanghai: Kelly and Walsh, 1927.

Brook, Timothy, Jerome Bourgan, and Gregory Blue. *Death by a Thousand Cuts*. Cambridge, MA: Harvard University Press, 2008.

Burkhardt, V. R. *Chinese Creeds and Customs*. 3 vols. Hong Kong: South China Morning Post, 1953–1958; London: Routledge Curzon, 2004.

Chan, Alan, and Sor-Hoon Tan, eds. *Filial Piety in Chinese Thought and History*. New York: Routledge, 2012.

Chang, Chun-shu, and Shelley Hsueh-lum Chang. *Redefining History: Ghosts, Spirits, and Human Society in P'u Sung-ling's World, 1640–1715*. Ann Arbor: University of Michigan Press, 1999.

Clayton, Matt. *Chinese Mythology: A Captivating Guide to Chinese Folklore Including Fairy Tales, Myths, and Legends from Ancient China*. Middletown, DE: Captivating History, 2018.

Dikötter, Frank, Lars Laamann, and Zhou Xun. *Narcotics in China: A History of Drugs in China*. Chicago: University of Chicago Press, 2004.

Dittmar, Lowell, and Chen Ruoxi. *Ethics and Rhetoric of the Chinese Cultural Revolution*. Berkeley: University of California Press, 1982.

Donald, Stephanie Hemelryk. *Public Secrets, Public Spaces: Cinema and Civility in China*. Lanham, MD: Rowman & Littlefield, 2000.

Eberhard, Wolfram. *A Dictionary of Chinese Symbols*. London: Routledge and Kegan Paul, 1986.

———. *Guilt and Sin in Traditional China*. Berkeley: University of California Press, 1967.

Gunde, Richard. *Culture and Customs of China*. London: Greenwood Press, 2001.

Hearn, Maxwell K. *Splendors of Imperial China: Treasures from the National Palace Museum*. New York: Metropolitan Museum of Art, 1996.

Hinton, William. *Fanshen: A Documentary of Revolution in a Chinese Village*. Harmondsworth, UK: Penguin, 1966.

Hsia, R. Po-chia. *A Jesuit in the Forbidden City: Matteo Ricci, 1552–1610*. New York: Oxford University Press, 2012.

BIBLIOGRAPHY • 471

Huang, Philip C. *Code, Custom, and Legal Practice in China: The Qing and the Republic Compared*. Stanford, CA: Stanford University Press, 2001.

Kutcher, Norman. *Mourning in Late Imperial China: Filial Piety and the State*. Cambridge, UK: Cambridge University Press, 1999.

Leonard, Jane Kate. *Wei Yuan and China's Rediscovery of the Maritime World*. Cambridge, MA: Harvard University Press, 1984.

Levy, Howard S. *Chinese Foot-binding: The History of a Curious Erotic Custom*. New York: Bell Publishing, 1974.

———. *Chinese Sex Jokes in Traditional Times*. Taipei: Chinese Association for Folklore, 1974.

Macgowen, John. *Men and Manners of Modern China*. London: T. F. Unwin, 1912.

Meijer, M. J. *Murder and Adultery in Late Imperial China: A Study of Law and Morality*. Leiden, Netherlands: Brill, 1991.

Mitamura, Taisuke. *Chinese Eunuchs: The Structure of Intimate Politics*. Trans. C. A. Pomeroy. Rutland, VT: Tuttle, 1992.

Mungello, David E. *Drowning Girls in China: Female Infanticide since 1650*. Lanham, MD: Rowman & Littlefield, 2008.

Smith, Richard J. *Fathoming the Cosmos and Ordering the World: The Yijing and Its Evolution in China*. Charlottesville: University of Virginia Press, 2008.

———. *Fortune-Tellers and Philosophers: Divination in Traditional Chinese Society*. Boulder, CO: Westview Press, 1991.

Ting, Joseph Sun-pao. *Children of the Gods: Dress and Symbolism in China*. Hong Kong: Urban Council, 1990.

Tsai, Shih-shan Henry. *The Eunuchs in the Ming Dynasty*. Albany: State University of New York Press, 1995.

Tseng, Yu-ho Ecke. *Chinese Folk Art*. Honolulu: University of Hawaii Press, 1977.

Walshe, Gilbert. *Ways That Are Dark: Some Chapters on Chinese Etiquette and Social Procedure*. Shanghai: Kelly and Walsh, 1906.

Wang, Ping. *Aching for Beauty: Foot-binding in China*. Minneapolis: University of Minnesota Press, 2000.

Watson, James, and Evelyn Rawski, eds. *Death Ritual in Late Imperial and Modern China*. Berkeley: University of California Press, 1988.

Wolf, Arthur, ed. *Religion and Ritual in Chinese Society*. Stanford, CA: Stanford University Press, 1974.

———, and Huang Chieh-shan. *Marriage and Adoption in China, 1843–1945*. Stanford, CA: Stanford University Press, 1980.

Yang, Mayfair Mei-hui. *Gifts, Favors, and Banquets: The Art of Social Relationships in China*. Ithaca, NY: Cornell University Press, 1994.

Zheng, Yangwen. *The Social Life of Opium*. Cambridge, UK: Cambridge University Press, 2005.

472 • BIBLIOGRAPHY

Zheng, Yi. *Scarlet Memorial: Tales of Cannibalism in Modern China*. Trans. T. P. Sym. Boulder, CO: Westview Press, 1996.

Zhou, Yongming. *Anti-Drug Crusades in 20th-Century China: Nationalism, History, and State-Building*. Oxford, UK: Rowman & Littlefield, 1999.

5. Decorative Arts, Gardens, and Fashion

Eitel, Ernest J. *Feng-Shui: The Science of Sacred Landscapes in Old China*. London: Tuber and Company, 1873.

Garrett, Valery M. *Chinese Dress: From the Qing Dynasty to the Present*. Rutland, VT: Charles E. Tuttle, 2007.

Inn, Henry, and S. C. Lee, eds. *Chinese Homes and Gardens*. Honolulu: University of Hawaii Press, 1940.

Johnston, R. Stewart. *Scholar Gardens of China: A Study and Analysis of the Spatial Design of the Chinese Private Garden*. Cambridge, UK: Cambridge University Press, 1991.

Kawayama, George, ed. *New Perspectives on the Arts of Ceramics in China*. Honolulu: University of Hawaii Press, 1992.

Keswick, Maggie. *The Chinese Garden*. New York: Rizzoli International Publications, 1978.

Liu, Tun-chen. *Chinese Classical Gardens of Suzhou*. Trans. Lixian Chen. New York: McGraw-Hill, 1993.

Siu, Victoria M. *Gardens of a Chinese Emperor: Imperial Creations of the Qian Long Era, 1736–1796*. Lanham, MD: Rowman & Littlefield, 2013.

Vainker, Shelagh. *Chinese Pottery and Porcelain*. London: British Museum Press, 2005.

Wong, Young-tsu. *A Paradise Lost: The Imperial Garden Yuanming Yuan*. Honolulu: University of Hawaii Press, 2000.

6. Family, Gender, and Social Life: Rural and Urban

Bai, Limin. *Shaping the Child: Children and Their Primers in Late Imperial China*. Hong Kong: Chinese University Press, 2005.

Baker, Hugh. *Chinese Family and Kinship*. London: Macmillan, 1979.

Baptandier, Brigitte. *The Lady of Linshui: A Chinese Female Cult*. Trans. Kristin Ingrid Fryklund. Stanford, CA: Stanford University Press, 2008.

Barlow, Tani. *The Question of Women in Chinese Feminism*. Durham, NC: Duke University Press, 2004.

Bossler, Beverly. *Courtesans, Concubines, and the Cult of Female Fidelity*. Harvard-Yenching Institute Monograph Series, no. 83. Cambridge, MA: Harvard University Press, 2013.

BIBLIOGRAPHY • 473

Bell, Daniel A. *China's New Confucians: Politics and Everyday Life in a Changing Society*. Princeton, NJ: Princeton University Press, 2008.

Bray, Francesca. *Technology and Gender: Fabric of Power in Late Imperial China*. Berkeley: University of California Press, 1997.

Brokaw, Cynthia. *The Ledgers of Merit and Demerit: Social Change and Moral Order in Late Imperial China*. Princeton, NJ: Princeton University Press, 1991.

Bryson, M. I. *Home Life in China*. New York: American Tract Society, 1886.

Chan, Anita, Richard Madsen, and Jonathan Unger. *Chen Village: The Recent History of a Peasant Community in Mao's China*. Berkeley: University of California Press, 1984.

Chen, Jack W., and David Schaberg, eds. *Gossip and Anecdotes in Traditional China*. Berkeley: University of California Press, 2013.

Chen, Jerome. *China and the West: Society and Culture, 1815–1937*. Bloomington: Indiana University Press, 1979.

Cheng, Nien. *Life and Death in Shanghai*. New York: Grove Press, 1986.

Chesneaux, Jean. *Popular Movements and Secret Societies in China, 1840–1950*. Stanford, CA: Stanford University Press, 1972.

Dong, Stella. *Shanghai: The Rise and Fall of a Decadent City*. New York: Perennial, 2001.

Duara, Prasenjit. *Culture, Power, and the State: Rural North China, 1900–1942*. Stanford, CA: Stanford University Press, 1988.

Eastman, Lloyd. *Family, Fields, and Ancestors: Constancy and Change in China's Social and Economic History, 1550–1949*. Oxford, UK: Oxford University Press, 1988.

Evans, Harriet. *Women and Sexuality in China*. Cambridge, UK: Polity, 1997.

Fei Xiaotong [Fei Hsiao-tung]. *From the Soil: The Foundations of Chinese Society*. Trans. Gary Hamilton and Wang Zheng. Berkeley: University of California Press, 1992.

Feng, Han-yi. *The Chinese Kinship System*. Cambridge, MA: Harvard University Press, 1967.

Gamble, Sidney D., ed. *Chinese Village Plays*. New York: Schram, 1972.

Goodman, Bryan, and Wendy Larson, eds. *Gender in Motion: Divisions of Labor and Cultural Change in Late Imperial and Modern China*. Lanham, MD: Rowman & Littlefield, 2005.

Headland, Isaac Taylor. *The Chinese Boy and Girl*. New York: Fleming H. Revell, 1901.

Heppner, Ernest G. *Shanghai Refuge: A Memoir of the World War II Jewish Ghetto*. Lincoln: University of Nebraska Press, 1993.

Hinsch, Bret. *Passion of the Cut Sleeve: The Male Homosexual Tradition in China*. Berkeley: University of California Press, 1990.

474 • BIBLIOGRAPHY

Hong Kong Museum of History. *Local Traditional Chinese Wedding*. Hong Kong: Hong Kong Museum of History, 1986.

Honig, Emily, and Gail Hershatter. *Personal Voices: Chinese Women in the 1980s*. Stanford, CA: Stanford University Press, 1988.

Hooper, Beverly. *Youth in China*. Ringwood, Victoria: Penguin Books Australia, 1985.

Hsiung, Ping-chen. *A Tender Voyage: Children and Childhood in Late Imperial China*. Stanford, CA: Stanford University Press, 2005.

Huang, Martin W. *Negotiating Masculinities in Late Imperial China*. Honolulu: University of Hawaii Press, 2006.

Jacshok, Maria, and Suzanne Miers, eds. *Women and Chinese Patriarchy: Submission, Servitude, and Escape*. London: Zed, 1994.

Johnson, David. *Spectacle and Sacrifice: The Ritual Foundations of Village Life in North China*. Cambridge, MA: Harvard University Asia Center, 2009.

Jun Jing. *The Temple of Memories: History, Power, and Morality in a Chinese Village*. Stanford, CA: Stanford University Press, 1996.

Kang Zhengguo. *Confessions: An Innocent Life in Communist China*. Translator Susan Wilf. New York: W. W. Norton, 2005.

Kaufman, Jonathan. *The Last Kings of Shanghai: The Rival Jewish Dynasties That Helped Create Modern China*. New York: Viking, 2020.

Kinney, Anne Behnke, ed. *Chinese Views of Childhood*. Honolulu: University of Hawaii Press, 1995.

Ko, Dorothy. *Cinderella's Sisters: A Revisionist History of Foot-Binding*. Berkeley: University of California Press, 2005.

Kutcher, Norman. *Mourning in Late Imperial China: Filial Piety and the State*. Cambridge, UK: Cambridge University Press, 1999.

Lee, Leo Ou-Fan. *Shanghai Modern: The Flowering of a New Urban Culture in China, 1930–1945*. Cambridge, MA: Harvard University Press, 1999.

Lin Yutang. *My Country and My People*. New York: John Day, 1935.

Lipman, Jonathan, and Steven Harrell, eds. *Violence in China: Cultural and Counterculture*. Ithaca, NY: Cornell University Press, 1990.

Louie, Kam. *Theorizing Chinese Masculinity: Society and Gender in China*. Cambridge, UK: Cambridge University Press, 2002.

Lu, Weijing. *True to Her Word: The Faithful Maiden Cult in Late Imperial China*. Stanford, CA: Stanford University Press, 2008.

Mann, Susan L. *Gender and Sexuality in Modern Chinese History*. Cambridge, UK: Cambridge University Press, 2011.

———. *Precious Records: Women in China's Long 18th Century*. Stanford, CA: Stanford University Press, 1997.

McMahon, R. Keith. *Polygamy and Sublime Passion: Sexuality in China on the Verge of Modernity*. Honolulu: University of Hawaii Press, 2009.

BIBLIOGRAPHY • 475

———. *Women Shall Not Rule: Imperial Wives and Concubines in China from Han to Liao*. Lanham, MD: Rowman & Littlefield, 2013.

Min, Jia-yin, ed. *The Chalice and the Blade in Chinese Culture: Gender Relations and Social Models*. Beijing: China Social Sciences Publishing House, 1995.

Murray, Dian H. *The Origins of the Tiandihui: The Chinese Triads in Legend and History*. Stanford, CA: Stanford University Press, 1994.

———. *Pirates of the South China Coast, 1790–1810*. Stanford, CA: Stanford University Press, 1987.

Naquin, Susan. *Millenarian Rebellion in China: The Eight Trigrams Uprising of 1813*. New Haven, CT: Yale University Press, 1976.

Osnos, Evan. *Age of Ambition: Chasing Fortune, Truth and Faith in the New China*. New York: Farrar, Straus, and Giroux, 2014.

Sang Ye. *China Candid: The People on the People's Republic*. Ed. Geremie R. Barmé, with Miriam Lang. Berkeley: University of California Press, 2006.

Shih, Vincent. *The Taiping Ideology*. Seattle: University of Washington Press, 1967.

Smith, Arthur. *Village Life in China*. New York: Fleming H. Revell Company, 1899.

Song, Geng. *The Fragile Scholar: Power and Masculinity in Chinese Culture*. Hong Kong: Hong Kong University Press, 2004.

Song, Ye. *The Year the Dragon Came*. Ed. Linda Javin. Brisbane: Queensland University Press, 1987.

Stacey, Judith. *Patriarchy and Socialist Revolution in China*. Berkeley: University of California Press, 1983.

Stepanchuk, Carol, and Charles Wong. *Mooncakes and Hungry Ghosts: Festivals of China*. San Francisco, CA: China Books and Periodicals, 1991.

Stevenson, Mark, and Wu Cuncun, eds. *Homoeroticism in Imperial China: A Sourcebook*. New York: Routledge, 2013.

Strand, David. *Rickshaw Beijing: City People and Politics in the 1920s*. Berkeley: University of California Press, 1989.

Theiss, Janet M. *Disgraceful Matters: The Politics of Chastity in 18th-Century China*. Berkeley: University of California Press, 2005.

Whyte, Martin King, and William L. Parish. *Urban Life in Contemporary China*. Chicago: University of Chicago Press, 1984.

Yan, Yunxiang. *The Flow of Gifts: Reciprocity and Social Networks in a Chinese Village*. Stanford, CA: Stanford University Press, 1996.

Yue, Daiyun, and Carolyn Wakeman. *To the Storm: The Odyssey of a Revolutionary Chinese Woman*. Berkeley: University of California Press, 1985.

Zhang, Karen. *Golden Orchid: The True Story of an Only Child in Contemporary China*. London: Austin MaCauley Publishers, 2018.

476 • BIBLIOGRAPHY

Zhang, Tiantian. *Red Lights: The Lives of Sex Workers in Post-Socialist China*. Minneapolis: University of Minnesota Press, 2009.

Zhang, Xinxin, and Song Ye. *Chinese Lives: An Oral History of Contemporary China*. Trans. and ed. W. J. F. Jenner and Delia Devin. New York: Pantheon, 1987.

Zhang, Xudong. *Chinese Modernism in the Era of Reforms: Cultural Fever, Avant-Garde Fiction, and the New Chinese Cinema*. Durham, NC: Duke University Press, 1997.

Zurndorfer, Harriet T. *Change and Continuity in Chinese Local History: The Development of Hui-chou Prefecture, 800–1800*. Leiden, Netherlands: Brill, 1997.

7. Fine and Folk Arts: Calligraphy, Carvings, and Paintings

Andrews, Julia F. *Painters and Politics in the People's Republic of China*. Berkeley: University of California Press, 1994.

———. "Traditional Painting in New China: Guohua and the Anti-Rightist Campaign." *Journal of Asian Studies* 49, no. 3 (August 1990): 555–77.

Berliner, Nancy. *Chinese Folk Art: The Small Skills of Carving Insects*. Boston: Little, Brown and Company, 1989.

Beurdeley, Michael et al., eds. *Chinese Erotic Art*. Trans. Diana Imber. Rutland, VT: Charles E. Tuttle, 1969.

Brown, Claudia Ju-hsi Chou. *Transcending Turmoil: Painting at the Close of China's Empire, 1796–1911*. Phoenix, AZ: Phoenix Art Museum, 1992.

Bush, Susan, and Christian Murck, eds. *Theories of the Arts in China*. Princeton, NJ: Princeton University Press, 1983.

Cahill, James. *The Compelling Image: Nature and Style in 17th-Century Chinese Painting*. Cambridge, MA: Harvard University Press, 1982.

———. *The Painter's Practice: How Artists Lived and Worked in Traditional China*. New York: Columbia University Press, 1994.

———. *Pictures for Use and Pleasure: Vernacular Painting in High Qing China*. Berkeley: University of California Press, 2010.

——— et al. *Beauty Revealed: Images of Women in Qing Dynasty Chinese Painting*. Berkeley: University of California Press, 2013.

Chaves, Jonathan. *Singing of the Source: Nature and God in the Poetry of the Chinese Painter Wu Li*. Honolulu: University of Hawaii Press, 1993.

Chiang, Yee. *Chinese Calligraphy*. Cambridge, MA: Harvard University Press, 1973.

Chou Ju-his, and Claudia Brown. *The Elegant Brush: Chinese Painting under the Qian Long Emperor, 1735–1795*. Phoenix, AZ: Phoenix Art Museum, 1985.

Cohen, Joan Lebold. *The New Chinese Painting, 1949–1986.* New York: Harry N. Abrams, 1987.

Guo, Fang, and Li Hongjuan. *Chinese Jade: The Spiritual and Cultural Significance of Jade in China.* Trans. Tony Blishen. Rutland, VT: Charles E. Tuttle, 2012.

Hansford, Howard. *Jade: Essence of Hills and Streams.* New York: American Elsevier, 1969.

Hay, Jonathan S. *Shitao: Painting and Modernity in Early Qing China.* Cambridge, UK: Cambridge University Press, 2001.

Holm, David. *Art and Ideology in Revolutionary China.* Oxford, UK: Clarendon, 1991.

Hsieh, Bao Hua. *Concubinage and Servitude in Late Imperial China.* Lanham, MD: Lexington, 2014.

Jenyns, Soame. *Later Chinese Porcelains.* London: Faber and Faber, 1965.

Kao, Mayching, ed. *20th-Century Chinese Painting.* Hong Kong: Oxford University Press, 1988.

Lin, Yu-tang. *The Chinese Theory of Art.* London: G. P. Putnam's Sons, 1967.

Ng, So Kam. *Styles and Techniques of Chinese Painting.* Seattle: University of Washington Press, 1992.

Rogers, Howard, and Sherman E. Lee. *Masterworks of Ming and Qing Painting from the Forbidden City.* Lansdale, PA: International Arts Council, 1988.

Rowley, George. *Principles of Chinese Painting.* Princeton, NJ: Princeton University Press, 1970.

Silburgeld, Jerome. *Chinese Painting Style.* Seattle: University of Washington Press, 1982.

Sullivan, Michael. *The Arts of China.* Berkeley: University of California Press, 1977.

———. *Symbols of Eternity: The Art of Landscape Painting in China.* Stanford, CA: Stanford University Press, 1979.

Sung, Hou-Mei. *Decoded Messages: The Symbolic Language of Chinese Animal Painting.* New Haven, CT: Yale University Press, 2009.

Sze, Mai-mai. *The Mustard Seed Garden Manual of Painting.* Princeton, NJ: Princeton University Press, 1978.

———. *The Way of Chinese Painting.* New York: Vintage, 1959.

Yang, Xin, and Chengru Zhu. *Secret World of the Forbidden City: Splendors from China's Imperial Palace.* Beijing: National Palace Museum, 1999.

478 • BIBLIOGRAPHY

8. History, Philosophy, Education, and Scholars

Alito, Guy. *The Last Confucian: Liang Shuming and the Chinese Dilemma of Modernity.* Berkeley: University of California Press, 1986.

Allinson, Robert E. *Chuang-Tzu for Spiritual Transformation.* Albany: State University of New York Press, 1989.

Ames, Roger, and David Hall, trans. *The Dao De Jing: A Philosophical Translation.* New York: Ballantine, 2003.

Bonner, Joey. *Wang Kuo-wei: An Intellectual Biography.* Cambridge, MA: Harvard University Press, 1986.

Callahan, William A. *China Dreams: 20 Visions of the Future.* Oxford: Oxford University Press, 2013.

Chan, Wing-tsit. *A Source Book in Chinese Philosophy.* Trans. Wing-tsit Chan. Princeton, NJ: Princeton University Press, 1963.

Chang, Hao. *Chinese Intellectuals in Crisis: Search for Order and Meaning, 1890–1911.* Berkeley: University of California Press, 1987.

———. *Liang Ch'i-ch'ao and Intellectual Transition in China, 1890–1907.* Cambridge, MA: Harvard University Press, 1971.

Chin, Ann-ping. *The Authentic Confucius: A Life of Thought and Politics.* New York: Scribner, 2007.

de Barry, William T. *Learning for One's Self: Essays on the Individual in Neo-Confucian Thought.* New York: Columbia University Press, 1991.

———. *Neo-Confucian Orthodoxy and the Learning of the Mind-and-Heart.* New York: Columbia University Press, 1981.

———, ed. *Self and Society in Ming Thought.* New York: Columbia University Press, 1970.

——— et al., trans. *Sources of Chinese Tradition.* New York: Columbia University Press, 1999, 2000.

Dennerline, Jerry. *Qian Mu and the World of Seven Mansions.* New Haven, CT: Yale University Press, 1988.

Eno, Robert. *The Confucian Creation of Heaven: Philosophy and the Defense of Ritual Mastery.* Albany: State University of New York Press, 1990.

Fairbank, John K., ed. *Chinese Thought and Institutions.* Chicago: University of Chicago Press, 1957.

Graham, A. C. *Yin-Yang and the Nature of Correlative Thinking.* Singapore: Institute of East Asian Philosophies, 1986.

Gu, Mingdong. *Chinese Theories of Reading and Writing: A Route to Hermeneutics and Open Poetics.* Albany: State University of New York Press, 2005.

Guy, R. Kent. *The Emperor's Four Treasuries: Scholars and the State in the Late Ch'ien-lung Era.* Cambridge, MA: Harvard University Press, 1987.

BIBLIOGRAPHY • 479

Han Yu-shan. *Elements of Chinese Historiography*. Hollywood, CA: W. M. Hawley, 1956.

Jami, Catherine. *The Emperor's New Mathematics: Western Learning and Imperial Authority during the Kangxi Reign (1662–1727)*. Oxford, UK: Oxford University Press, 2012.

Legge, James C. C., trans. *The Chinese Classics*. London: Clarendon, 1893–1895.

Li, Chu-tsing, and James C. Y. Watt, eds. *The Chinese Scholar's Studio*. New York: Asia Society Galleries, 1987.

Lin, Yu-sheng. *The Crisis of Chinese Consciousness*. Madison: University of Wisconsin Press, 1979.

Lui, Adam Y. C. *The Hanlin Academy*. Hamden, CT: Archon Books, 1981.

Lynch, Daniel C. *After the Propaganda State: Media, Politics, and "Thought Work" in Reformed China*. Stanford, CT: Stanford University Press, 1999.

Mittler, Barbara. *A Newspaper for China? Power, Identity, and Change in Shanghai's News Media, 1972–1912*. Cambridge, MA: Harvard University Press, 2004.

Miyazaki, Ichisada. *China's Examination Hell*. Trans. Conrad Schirokauer. New York: Weatherhill, 1976.

Mote, Frederick. *Intellectual Foundations of China*. New York: McGraw-Hill, 1989.

Mungello, David E. *Leibniz and Confucianism*. Honolulu: University of Hawaii Press, 1977.

Munro, Don. *The Concept of Man in Early China*. Stanford, CT: Stanford University Press, 1969.

Nivison, David, and Arthur Wright, eds. *Confucianism in Action*. Stanford, CA: Stanford University Press, 1959.

Reed, Christopher. *Gutenberg in Shanghai: Chinese Print Capitalism, 1876–1937*. Honolulu: University of Hawaii Press, 2004.

Rozman, Gilbert, ed. *The East Asian Region: Confucian Heritage and Its Modern Adaptation*. Princeton, NJ: Princeton University Press, 1991.

Schwarcz, Vera. *The Chinese Enlightenment: Intellectuals and the Legacy of the May Fourth Movement of 1919*. Berkeley: University of California Press, 1986.

Schwartz, Benjamin. *In Search of Wealth and Power: Yan Fu and the West*. Cambridge, MA: Harvard University Press, 1964.

Tu, Wei-ming. *Neo-Confucian Thought in Action*. Berkeley: University of California Press, 1976.

Wang, Ban. *The Sublime Figure of History: Aesthetics and Politics in 20th-Century China*. Stanford, CA: Stanford University Press, 1997.

Wang, Y. C. *Chinese Intellectuals and the West, 1872–1949*. Chapel Hill: University of North Carolina Press, 1966.

480 • BIBLIOGRAPHY

Wong, Jade Snow. *Fifth Chinese Daughter*. New York: Harper and Brothers, 1945.

Wright, Arthur, ed. *The Confucian Persuasion*. Stanford, CA: Stanford University Press, 1960.

Wu, Zhongxian, and Karin Taylor Wu. *Heavenly Stems and Earthly Branches (Tian Gan Dizhi): The Heart of Chinese Wisdom Traditions*. London: Singing Dragon, 2014.

Zeitlin, Judith T. *Historian of the Strange: Pu Songling and the Classical Chinese Tale*. Stanford, CA: Stanford University Press, 1993.

9. Languages and Minorities

Dalai Lama. *A Flash of Lightning in the Dark of Night: A Guide to the Bodhisattva's Way of Life*. Boston: Shambhala Dragon Editions, 1994.

De Francis, John. *Nationalism and Language Reform in China*. Princeton, NJ: Princeton University Press, 1950.

Dikötter, Frank. *The Discourse of Race in Modern China*. Stanford, CA: Stanford University Press, 1992.

Gladney, Dru. *Muslim Chinese: Ethnic Nationalism in the People's Republic of China*. Cambridge, MA: Harvard University Press, 1996.

Goldstein, Jonathan, ed. *The Jews of China: Historical and Comparative Perspective*. 2 vols. Armonk, NY: M. E. Sharpe, 1999–2000.

Gunn, Edward. *Rewriting Chinese*. Stanford, CA: Stanford University Press, 1991.

Hansen, Chad. *Language and Logic in Ancient China*. Ann Arbor: University of Michigan Press, 1983.

Ho, Cindy. *Trailing the Written Word: The Art of Writing among China's Ethnic Minorities*. New York: John Jay College, City University of New York, 1997.

Hopkirk, Peter. *Trespassers on the Roof of the World: The Secret Exploration of Tibet*. New York: Kodansha International, 1995.

Israeli, Raphael. *Muslims in China: A Study in Cultural Confrontation*. Atlantic Islands, NJ: Humanities Press, 1980.

Koske, Elisabeth. *The Politics of Language in Chinese Education, 1895–1919*. Leiden, Netherlands: Brill, 2007.

Ramsey, Robert S. *The Languages of China*. Princeton, NJ: Princeton University Press, 1987.

Smith, Arthur. *Proverbs and Common Sayings from the Chinese*. Shanghai: American Presbyterian Mission Press, 1914.

Zhan, Kaidi. *The Strategies of Politeness in the Chinese Language*. Berkeley: University of California Press, 1992.

BIBLIOGRAPHY • 481

10. Literature, Film, Music, Gaming, Sports, and Theater

Ansley, Clive. *The History of Wu Han: His Play "Hai Rui's Dismissal" and Its Role in China's Cultural Revolution.* London and Toronto: Toronto University Press, 1971.

Barmé, Geremie, and Bennet Lee, eds. *The Wonderful New Stories of the Cultural Revolution.* Hong Kong: Joint Publishing Company, 1979.

Barnes, A. C., with Wang Tso-liang, trans. *Thunderstorm*, by Cao Yu. Peking: Foreign Language Press, 1960.

Berg, Daria. *Women Writers and the Literary World in Early Modern China, 1580–1700.* New York: Routledge, 2003.

Berry, Chris, ed. *Perspectives on Chinese Cinema.* London: British Film Institute, 1991.

Birch, Cyril, ed. *Studies of Chinese Literary Genre.* Berkeley: University of California Press, 1974.

Brokaw, Cynthia, and Kai-wing Chow, eds. *Printing and Book Culture in Late Imperial China.* Berkeley: University of California Press, 2005.

Brown, Nick, Paul Pickowicz, Vivian Sobchack, and Ester Yao, eds. *New Chinese Cinema: Forms, Identities, Politics.* New York: Cambridge University Press, 1974.

Brownell, Susan. *Training the Body for China: Sports in the Moral Order of the People's Republic.* Chicago: The University of Chicago Press, 1995.

Chang, Kany-I Sun, and Haun Saussey, eds. *Women Writers of Traditional China: An Anthology of Poetry and Criticism.* Stanford, CA: Stanford University Press, 1999.

Chen, Kaige, and Tony Rayns. *King of the Children and the New Chinese Cinema.* London: Faber and Faber, 1989.

Chen, Shih-hsiung, and Harold Acton, trans. *The Peach Blossom Fan.* Berkeley: University of California Press, 1976.

Chiang Ching. *On the Revolution of Peking Opera.* Peking: Foreign Languages Press, 1968.

Chow, Kai-wing. *Publishing, Culture, and Power in Early Modern China.* Stanford, CA: Stanford University Press, 2004.

Chow, Rey. *Primitive Passions: Visuality, Sexuality, Ethnography, and Contemporary Chinese Cinema.* New York: Columbia University Press, 1995.

Clark, Paul. *Chinese Cinema.* New York: Cambridge University Press, 1987.

Culin, Stewart. *Chinese Games with Dice and Dominoes.* Seattle: Shorey Book Store, 1972.

Cutter, Robert. *The Brush and the Spur: Chinese Culture and the Cockfight.* Hong Kong: Chinese University Press, 1989.

Denton, Kirk A., ed. *Modern Chinese Literary Thought: Writings on Literature, 1893–1945.* Stanford, CA: Stanford University Press, 1996.

482 • BIBLIOGRAPHY

DeWoskin, Kenneth. *A Song for One or Two: Music and the Concept of Art in Early China*. Ann Arbor: University of Michigan Press, 1982.

Dolby, William. *A History of Chinese Drama*. London: Paul Elek, 1976.

Fitzgerald, John. "A New Cultural Revolution: The Commercialization of Culture in China." *Australian Journal of Chinese Affairs* 11 (January 1984): 105–20.

Fokkema, D. W. *Literary Doctrine in China and Soviet Influence, 1956–1960*. The Hague: Mouton, 1965.

Goldblatt, Howard. *Chairman Mao Would Not be Amused: Fiction from Today's China*. New York: Grove Press, 1995.

———. *Chinese Literature for the 1980s: The Fourth Congress of Writers and Artists*. Armonk, NY: M. E. Sharpe, 1982.

Goldman, Andrea S. *Opera and the City: The Politics of Culture in Beijing, 1770–1990*. Stanford, CA: Stanford University Press, 2012.

Goldman, Merle. *Literary Dissent in Communist China*. Cambridge, MA: Harvard University Press, 1967.

———, ed. *Modern Chinese Literature in the May Fourth Era*. Cambridge, MA: Harvard University Press, 1977.

Hegel, Robert. *The Novel in 17th-Century China.* New York: Columbia University Press, 1981.

Hjort, Mette. *Stanley Kwan's Center Stage*. Hong Kong: Hong Kong University Press, 2006.

Hsia, C. T. *The Classic Chinese Novel*. New York: Columbia University Press, 1968.

Hsu, Tao-Ching. *The Chinese Conception of the Theater*. Seattle: University of Washington Press, 1985.

Hu Zhihui, ed. *A Biographical Dictionary of Modern Chinese Writers*. Beijing: New World Press, 1994.

Huters, Theodore, Jr. "Blossoms in the Snow: Lu Xun and the Dilemma of Chinese Literature." *Modern China* 10, no. 1 (January 1984): 49–77.

Idema, Wilt, and Beata Grant, eds. *The Red Brush: Writing Women of Imperial China*. Harvard East Asian Monographs, no. 231. Cambridge, MA: Harvard University Asia Center, 2004.

Jacobs, Katrien. *People's Pornography: Social Surveillance on the Chinese Internet*. Chicago: University of Chicago Press, 2012.

Jones, Andrew F. *Yellow Music: Media Culture and Colonial Modernity in the Chinese Jazz Age*. Durham, NC: Duke University Press, 2001.

Kagan, Alan L. "Music and the Hundred Flowers Movement." *Musical Quarterly* 49, no. 4 (October 1963): 417–30.

Kinkley, Jeffrey. *The Odyssey of Shen Congwen*. Stanford, CA: Stanford University Press, 1987.

Knoerle, Jeanne. *"The Dream of the Red Chamber": A Critical Study*. Bloomington: Indiana University Press, 1972.

BIBLIOGRAPHY · 483

Kraus, Richard Curt. *Brushes with Power: Modern Politics and the Art of Calligraphy*. Berkeley: University of California Press, 1991.

———. *The Party and the Arty in China: The New Politics of Culture*. Lanham, MD: Rowman & Littlefield, 2004.

———. *Pianos and Politics in China: Middle-Class Ambitions and the Struggle over Western Music*. New York: Oxford University Press, 1989.

Kubin, Wolfgang, and Rudolf G. Wagner, eds. *Essay in Modern Chinese Literature and Literary Criticism*. Bochum: Brockmeyer, 1982.

Lai, T. C., and Robert Mok. *Jade Flute: The Story of Chinese Music*. New York: Schocken Books, 1981.

Laing, Ellen Johnston. *The Winking Owl: Art in the People's Republic of China*. Berkeley: University of California Press, 1989.

Lau, Joseph, C. T. Hsia, and Leo Ou-Fan Lee. *Modern Chinese Stories and Novellas, 1919–1949*. New York: Columbia University Press, 1981.

Lee, Leo Ou-Fan. *The Romantic Generation of Modern Chinese Writers*. Cambridge, MA: Harvard University Press, 1973.

———. *Views from the Iron Horse*. Bloomington: Indiana University Press, 1987.

———, ed. *Lu Xun and His Legacy*. Berkeley: University of California Press, 1985.

Levenson, Joseph R. *Revolution and Cosmopolitanism: The Western Stage and the Chinese Stages*. Berkeley: University of California Press, 1971.

Leyda, Jay. *Dianying: An Account of Films and the Film Audience in China*. Cambridge, MA: MIT Press, 1972.

Li, Wai-yee. *Enchantment and Disenchantment: Love and Illusion in Chinese Literature*. Princeton, NJ: Princeton University Press, 1993.

Li, Xiaorong. *Women's Poetry of Late Imperial China: Transforming the Inner Chambers*. Seattle: University of Washington Press, 2012.

Liang, Mingyue. *Music of the Billion: An Introduction to Chinese Musical Culture*. New York: Heinrichschofen, 1985.

Lin, Tai-yi, trans. *Flowers in the Mirror*. Berkeley: University of California Press, 1966.

Link, Perry E., Jr. *Evening Chats in Beijing*. New York: Norton, 1992.

———. *Mandarin Ducks and Butterflies: Popular Fiction in Early 20th-Century Chinese Cities*. Berkeley: University of California Press, 1981.

———. *The Uses of Literature: Life in the Socialist Literary System*. Princeton, NJ: Princeton University Press, 2000.

———, Richard Madsen, and Paul Pickowicz, eds. *Unofficial China: Popular Culture and Thought in the People's Republic of China*. Boulder, CO: Westview Press, 1989.

Liu, Heng. *Black Snow*. Beijing: Panda Books, 1991.

Liu, James J. Y. *The Art of Chinese Poetry*. Chicago: University of Chicago Press, 1966.

484 • BIBLIOGRAPHY

Liu, Jung-en. *Six Yuan Plays*. New York: Penguin, 1972.

Liu, Lydia H. *Translingual Practice: Literature, National Culture, and Translated Modernity—China, 1930–1937*. Stanford, CA: Stanford University Press, 1995.

Liu, Wu-chi, and Irving Yucheng Lo, eds. *Sunflower Splendor: Three Thousand Years of Chinese Poetry*. Bloomington: Indiana University Press, 1975.

Liu, Xinwu et al. *Prize-Winning Stories from China, 1978–1979*. Beijing: Foreign Languages Press, 1981.

Lu, Tonglin. *Misogyny, Cultural Nihilism, and Oppositional Politics: Contemporary Chinese Experimental Fiction*. Stanford, CA: Stanford University Press, 1995.

———. *Rose and Lotus: Narratives of Desire in France and China*. Albany: State University of New York Press, 1991.

Lyell, William A., Jr. *Lu Hsun's Vision of Reality*. Berkeley: University of California Press, 1976.

Ma Qian. *Women in Traditional Chinese Theater: The Heroine's Play*. Lanham, MD: University Press of America, 2005.

Ma Wen-yee. *Snow Glistens on the Great Wall*. Santa Barbara, CA: Erikson Literary Agency, 1986.

Mackerras, Colin P. *Chinese Theater in Modern Times: From 1940 to the Present Day*. Amherst: University of Massachusetts Press, 1975.

———. *Peking Opera*. Hong Kong: Oxford University Press, 1997.

———. *The Performing Arts in Contemporary China*. London: Routledge and Kegan Paul, 1981.

———. *Rise of Peking Opera, 1770–1870*. Oxford, UK: Clarendon, 1972.

March, Benjamin. *Some Technical Terms of Chinese Painting*. Baltimore, MD: Waverly Press, 1935.

Martin, Helmut, and Jeffrey Kinkley, eds. *Modern Chinese Writers: Self-Portrayals*. Armonk, NY: M. E. Sharpe, 1992.

McDougall, Bonnie. *Mao Zedong's "Talks at the Yan'an Conference on Literature and Art": A Translation of the 1943 Text with Commentary*. Ann Arbor: University of Michigan Center for Chinese Studies, 1980.

———, ed. *Popular Chinese Literature and Performing Arts in the People's Republic of China, 1949–1979*. Berkeley: University of California Press, 1984.

Mittler, Barbara. *Dangerous Tunes: The Politics of Chinese Music in Hong Kong, Taiwan, and the People's Republic of China since 1949*. Wiesbaden: Harrassowitz Verlag, 1997.

Mo, Yan. *The Garlic Ballads*. Trans. Howard Goldblatt. London: Penguin, 1996.

Mungello, David E. *Drowning Girls in China: Female Infanticide since 1650*. Lanham, MD: Rowman & Littlefield, 2008.

BIBLIOGRAPHY • 485

Murck, Alfreda, and Wen C. Fong, eds. *Words and Images: Chinese Poetry, Calligraphy, and Painting*. Princeton, NJ: Princeton University Press, 1991.

Nieh, Hualing, ed. *Literature of the Hundred Flowers*. 2 vols. New York: Columbia University Press, 1981.

Nienhauser, William H., Jr., ed. *Critical Essays on Chinese Literature*. Hong Kong: Chinese University of Hong Kong Press, 1976.

Owen, Stephen. *Readings in Chinese Literary Thought*. Cambridge, MA: Harvard University Press, 1992.

———. *Traditional Chinese Poetry and Poetics: Omens of the World*. Madison: University of Wisconsin Press, 1985.

Plaks, Andrew. *The Four Masterworks of the Ming Dynasty*. Princeton, NJ: Princeton University Press, 1987.

Pratt, Leonard, and Su-Hui Chiang, trans. *Six Records of a Floating Life*. New York: Viking, 1983.

Qian, Nanxiu. *Politics, Poetics, and Gender in Late Qing China: Xue Shaohui (1866–1910) and the Era of Reform*. Stanford, CA: Stanford University Press, 2015.

Ragvald, Lars. *Yao Wenyuan as a Literary Critic and Theorist*. Stockholm: University of Stockholm, 1978.

Ropp, Paul S. *Passionate Women: Female Suicide in Late Imperial China*. Leiden, Netherlands: Brill, 2001.

Saussy, Haun. *The Problem of a Chinese Aesthetic*. Stanford, CA: Stanford University Press, 1993.

Scott, A. C. *Actors Are Madmen: Notebook of a Theatergoer in China*. Madison: University of Wisconsin Press, 1982.

———. *Literature and the Arts in 20th-Century China*. London: Allen and Unwin, 1965.

———. *Mei Lan-fang: The Life and Times of a Peking Actor*. Hong Kong: Hong Kong University Press, 1959.

———. *Traditional Chinese Plays*. Madison: University of Wisconsin Press, 1967.

Semsel, George S., Xia Hong, and Hou Jianping, eds. *Chinese Film Theory: A Guide to the New Era*. New York: Praeger, 1990.

Shapiro, Sidney. *Outlaws of the Marsh*. Bloomington: Indiana University Press, 1981.

Silbergeld, Jerome. *Contradictions: Artistic Life, the Socialist State, and the Chinese Painter Li Huasheng*. Seattle: University of Washington Press, 1993.

Snow, Lois Wheeler. *China on Stage*. New York: Vintage, 1972.

Starr, Chloe F. *Red-Light Novels of the Late Qing*. Leiden, Netherlands: Brill, 2007.

486 • BIBLIOGRAPHY

Strassbeanrg, Richard E. *Inscribed Landscapes: Travel Writing from Imperial China*. Berkeley: University of California Press, 1994.

Strickmann, Michael. *Chinese Poetry and Prophecy*. Stanford, CA: Stanford University Press, 2005.

Tsao, Hsueh-chin. *Dream of the Red Chamber* (Honglou Meng). Trans. Chichen Wang. New York: Anchor Books, 1958.

Van Gulik, Robert H. *The Lore of the Chinese Lute: An Essay on the Ideology of the Ch'in*. Bangkok: Orchid Press, 2010.

Vinograd, Richard. *Boundaries of the Self: Chinese Portraits, 1600–1900*. Cambridge, UK: Cambridge University Press, 1992.

Wagner, Rudolf G. *The Contemporary Chinese Historical Drama: Four Studies*. Berkeley: University of California Press, 1990.

Wang, David Der-Wei. *Fictional Realism in 20th-Century China*. New York: Columbia University Press, 1992.

Wang, Meng. *The Butterfly and Other Stories*. Beijing: Panda Books, 1983.

Watson, Burton. *Chinese Lyricism*. New York: Columbia University Press, 1971.

Werner, E. T. C. *A Dictionary of Chinese Mythology*. New York: Julian Press, 1961.

Wichmann, Elizabeth. *Listening to Theatre: The Aural Dimension of Beijing Opera*. Honolulu: University of Hawaii Press, 1991.

Widmer, Ellen. *The Beauty and the Book: Women and Fiction in 19th-Century China*. Cambridge, MA: Harvard University Press, 2006.

Winsatt, Genevieve B. *Chinese Shadow Shows*. Cambridge, MA: Harvard University Press, 1936.

Wylie, Alexander. *Notes on Chinese Literature*. Shanghai: N.p., 1897.

Xiaoxiaosheng, Lanling. *Jin Ping Mei* (The Golden Lotus), vols. 1 and 2. Trans. Clement Egerton. Rutland, VT: Tuttle, 2018.

Yang, Bell, Evelyn Rawski, and Rubie Watson, eds. *Harmony and Counterpoint: Ritual Music in Chinese Context*. Stanford, CA: Stanford University Press, 1996.

Yang, Richard F. S. *Four Plays of the Yuan Drama*. Taipei: N.p., 1972.

Yonge, H. *The Sunrise: A Play in Four Acts by Tsao Yu* [Cao Yu]. Changsha, Hunan: Commercial Press, 1940.

Yu, Pauline. *The Reading of Imagery in the Chinese Poetic Tradition*. Princeton, NJ: Princeton University Press, 1987.

Zeitlin, Judith T. *The Phantom Heroine: Ghosts and Gender in 17th-Century Chinese Literature*. Honolulu: University of Hawaii Press, 2007.

Zhang, Jingyuan. *Psychoanalysis in China: Literary Transformations, 1919–1949*. Ithaca, NY: Cornell University East Asia Program, 1982.

Zhao, Henry Y. H., ed. *The Last Boat: Avant-Garde Fiction from China*. London: Wellsweep, 1993.

BIBLIOGRAPHY • 487

11. Medicine: Traditional and Modern

Chao, Yuan-ling. *Medicine and Society in Late Imperial China: A Study of Physicians in Suzhou, 1600–1850.* New York: Peter Lang, 2009.

Chen, Nancy. *Breathing Space: Qigong, Psychiatry, and Healing in China.* New York: Columbia University Press, 2003.

Cochran, Sherman. *Chinese Medicine Men: Consumer Culture in China and Southeast Asia.* Cambridge, MA: Harvard University Press, 2006.

Furth, Charlotte. *A Flourishing Yin: Gender in China's Medical History, 960–1655.* Berkeley: University of California Press, 1999.

Hsu, Elizabeth. *The Transmission of Chinese Medicine.* Cambridge, UK: Cambridge University Press, 1999.

Hu, Shiu-ying. *An Enumeration of Chinese Materia Medica.* Hong Kong: Chinese University Press, 1999.

Kleinman, Arthur. *Social Origins of Distress and Disease: Depression, Neurasthenia, and Pain in Modern China.* New Haven, CT: Yale University Press, 1986.

Ng, Vivien. *Madness in Late Imperial China: From Illness to Deviance.* Norman: University of Oklahoma Press, 1990.

Schied, Volker. *Currents of Tradition in Chinese Medicine, 1626–2006.* Seattle, WA: Eastland, 2007.

Sivin, Nathan. *Chinese Alchemy: Preliminary Studies.* Cambridge, MA: Harvard University Press, 1968.

———. *Traditional Medicine in Contemporary China.* Ann Arbor: University of Michigan Press, 1987.

Unschuld, Paul U. *Medical Ethics in Imperial China: A Study in Historical Anthropology.* Berkeley: University of California Press, 1979.

———. *Medicine in China: A History of Pharmaceutics.* Berkeley: University of California Press, 1986.

Wu Yi-li. *Reproducing Women: Medicine, Metaphor, and Childbirth in Late Imperial China.* Berkeley: University of California Press, 2010.

Yang, Li. *Book of Changes and Chinese Traditional Medicine.* Beijing: Beijing Science and Technology Press, 1998.

12. Politics and Policy

Cheek, Timothy. *Propaganda and Culture in Mao's China: Deng Tuo and the Intelligentsia.* Oxford, UK: Oxford University Press, 1997.

Dikötter, Frank. *The Cultural Revolution: A People's History, 1962–1976.* New York: Bloomsbury Publishing, 2016.

Garside, Roger. *Coming Alive: China after Mao.* New York: New American Library, 1981.

488 • BIBLIOGRAPHY

Hsiao, Kung-ch'üan. *Compromise in Imperial China*. Seattle: University of Washington Press, 1975.

Hua, Shipping. *Chinese Political Culture*. Armonk, NY: M. E. Sharpe, 1991.

Hucker, Charles C. *The Censorial System of Ming China*. Stanford, CA: Stanford University Press, 1966.

Hung, Chang-tai. *Mao's New World: Political Culture in the Early People's Republic*. Ithaca, NY: Cornell University Press, 2011.

Joseph, William A., Christine P. W. Wong, and David Zweig, eds. *New Perspectives on the Cultural Revolution*. Cambridge, MA: Council on East Asian Studies, Harvard University, 1991.

Khan, Sulmaan Wasif. *Haunted by Chaos: China's Grand Strategy from Mao Zedong to Xi Jinping*. Cambridge, MA: Harvard University Press, 2018.

Landsberger, Stefan. *Chinese Propaganda Posters: From Revolution to Modernization*. Amsterdam: Pepin Press, 1995.

Lee, Hong Yung. *The Politics of the Chinese Cultural Revolution*. Berkeley: University of California Press, 1978.

Liang, Linxia. *Delivering Justice in Qing China: Civil Trials in the Magistrate's Court*. Oxford, UK: Oxford University Press, 2007.

Liu, Bai. *Cultural Policy in the People's Republic of China*. Paris: United Nations Educational, Scientific, and Cultural Organization, 1983.

Liu, Binyan. *A Higher Kind of Loyalty*. New York: Pantheon, 1990.

Metzger, Thomas. *Escape from Predicament: Neo-Confucianism and China's Evolving Political Culture*. New York: Columbia University Press, 1977.

Pye, Lucian. *The Mandarin and the Cadre: China's Political Culture*. Ann Arbor: University of Michigan Press, 1988.

Schoenhals, Michael. *Doing Things with Words in Chinese Politics: Five Studies*. University of California East Asian Studies Research Monograph, no. 41. Berkeley: University of California Press, 1992.

Selden, Mark. *The Yenan Way in Revolutionary China*. Cambridge, MA: Harvard University Press, 1971.

Terrill, Ross. *The White-Boned Demon: A Biography of Madame Mao Zedong*. New York: William Morrow, 1984.

Wassermann, Jeffrey, and Elizabeth Perry, eds. *Popular Protest and Political Culture in Modern China*. Boulder, CO: Westview Press, 1992.

Wilson, Thomas A., ed. *On Sacred Grounds: Culture, Society, Politics, and the Formation of the Cult of Confucius*. Cambridge, MA: Harvard University Press, 2003.

Witke, Roxanne. *Comrade Chiang Ch'ing* [Jiang Qing]. Boston: Little, Brown and Company, 1977.

Xi, Lian. *Blood Letters: The Untold Story of Lin Zhao, a Martyr in Mao's China*. New York: Basic Books, 2018.

BIBLIOGRAPHY • 489

Zhou, Enlai. "Zhou Enlai on Questions Related to Art and Literature." *Chinese Literature* 6 (1979): 83–95.

Zhou, Yang. "On the Hundred Flowers Policy." *China Reconstructs* 29, no. 1 (1980): 8–11.

13. Religion and Cosmology

Bays, Daniel H. *A New History of Christianity in China*. Chichester, UK: Wiley-Blackwell, 2012.

Berger, Patricia Ann. *Empire of Emptiness: Buddhist Art and Political Authority in Qing China*. Honolulu: University of Hawaii Press, 2003.

Busswell, Robert E. *Chinese Buddhist Apocrypha*. Honolulu: University of Hawaii Press, 1990.

Cabezon, Jose, ed. *Buddhism, Sexuality, and Gender*. Albany: State University of New York Press, 1985.

Chang, Chung-yuan. *Creativity and Taoism*. New York: Julian Press, 1963.

Ch'en, Kenneth. *Buddhism in China*. Princeton, NJ: Princeton University Press, 1964.

———. *The Chinese Transformation of Buddhism*. Princeton, NJ: Princeton University Press, 1973.

Covell, Ralph. *Confucius, the Buddha, and Christ: A History of the Gospel in Chinese*. Maryknoll, NY: Orbis, 1986.

Henderson, John B. *The Development and Decline of Chinese Cosmology*. New York: Columbia University Press, 1984.

Jochim, Christian. *Chinese Religions: A Cultural Perspective*. Englewood Cliffs, NJ: Prentice-Hall, 1986.

Johnson, David, ed. *Ritual and Scripture in Chinese Popular Religion: Five Studies*. Berkeley, CA: Institute of East Asian Studies, 1995.

Johnson, Ian. *The Souls of China: The Return of Religion after Mao*. New York: Pantheon, 2017.

Lagerwey, John. *Taoist Ritual in Chinese Society and History*. New York: Macmillan, 1987.

Liao, Yiwu. *God Is Red: The Secret Story of How Christianity Survived and Flourished in Communist China*. New York: HarperOne, 2011.

Lovin, Robin, and Frank Reynolds, eds. *Cosmology and Ethical Order: New Studies in Comparative Ethics*. Chicago: University of Chicago Press, 1985.

Naquin, Susan, and Chün-fang Yü, eds. *Pilgrims and Sacred Sites in China*. Berkeley: University of California Press, 1992.

Nedostup, Rebecca. *Superstitious Regimes: Religion and the Politics of Chinese Modernity*. Cambridge, MA: Harvard University Press, 2010.

490 • BIBLIOGRAPHY

O'Malley, John W., Gauvin Alexander Bailey, Steven J. Harris, and T. Frank Kennedy, eds. *The Jesuits: Cultures, Sciences, and the Arts, 1540–1773.* Toronto: University of Toronto Press, 1999.

Overmyer, Daniel. *Folk Buddhist Religion.* Cambridge, MA: Harvard University Press, 1976.

Plopper, Clifford. *Chinese Religion Seen through the Proverb.* Shanghai: China Press, 1926.

Pollak, Michael. *Mandarins, Jews, and Missionaries: The Jewish Experience in the Chinese Empire.* Philadelphia, PA: Jewish Publication Society of America, 1980.

Reichelt, Karl. *Truth and Tradition in Chinese Buddhism.* Trans. Katrina Bugge. Shanghai: Commercial Press, 1934.

Roman, Charles, and Bonnie B. C. Oh, eds. *East Meets West: The Jesuits in China, 1582–1773.* Chicago: Loyola University Press, 1988.

Rosemont, Henry, Jr. *Explorations in Early Chinese Cosmology.* Chico, CA: Scholars Press, 1984.

Rowbotham, Arnold H. *Missionary and Mandarin: The Jesuits at the Court of China.* Berkeley: University of California Press, 1942.

Smith, Richard J. *China and Managing the World: Cartography and Cosmology in Late Imperial Times.* Oxfordshire, UK: Routledge, 2013.

———. *The Qing Dynasty and Traditional Chinese Culture.* Lanham, MD: Rowman & Littlefield, 2015.

Taylor, Rodney. *The Religious Dimension of Confucianism.* Albany: State University of New York Press, 1990.

Welch, Holmes. *The Practice of Chinese Buddhism, 1930–1950.* Cambridge, MA: Harvard University Press, 2008.

———. *Taoism: The Parting of the Way.* Boston: Beacon, 1957.

B. Chinese and Other Languages

Arrault, Alain. *Shao Yang (1012–1077) Poète et cosmologue* (Shao Yang (1012–1077) Poet and Cosmologist). Paris: Collège de France, 2002.

Ba Jin. *Wu Ti Yi* (Untitled Collection). Beijing: Renmin Wenxue Chubanshe, 1986.

Bao Zhonghao. *Hunsu yu Zhongguo Chuantong Wenhua* (Marriage Customs and China's Traditional Culture). Guilin: Guangxi Shifan Daxue Chubanshe, 2008.

Bergeron, Régis. *Le Cinema Chinois, 1949–1983* (The Chinese Cinema, 1949–1983). 3 vols. Paris: Editions L'Harmattan, 1984.

Cai Dongzhou, ed. *Zhongguo Chuantong Wenhua Yaolue* (Essentials of China's Traditional Culture). Chengdu: Bao Shu Shushe, 2003.

BIBLIOGRAPHY • 491

Cao Xueqin, and Gao E. *Honglou meng* (Dream of the Red Chamber). 3 vols. Beijing: Renmin Wenxue Chubanshe, 1982.

Chang Shouzong, edr. *Shanghai Yinyue Xueyuan Da Shiji Mingren Lu* (A Record of Major Events and Famous People at the Shanghai Conservatory). Shanghai: Shanghai Yinyue Xueyuan, 1997.

Chen Dengyuan. *Zhongguo Wenhua Shi* (History of Chinese Culture). Shanghai: Shanghai Shudian, 1989.

Chen Guofu, and Qiu Peihao. *Tongli Xinbian* (A New Study of Chinese Ritual). Taibei: Zhongzhong Shuju, 1950.

Chen Huangmei, ed. *Dangdai Zhongguo Dianying* (Contemporary Chinese Cinema). 2 vols. Beijing: Zhongguo Shehui Kexue Chubanshe, 1989.

Cheng Jihua et al. *Zhongguo Dianying Fazhanshi* (The History of the Development of Chinese Cinema). 2 vols. Beijing: Zhongguo Dianying Chubanshe, 1981.

Doré, Henri. *Recherches sur les Superstitions en Chine* (Researches into Chinese Superstitions). 6 vols. Shanghai: La Mission Catholique, 1911–1919.

He Luting. *He Luting Quanji* (Complete Works of He Luting). Shanghai: Shanghai Yinyue Chubanshe, 1999.

Hu Xiaoming. *Honglou Meng yu Zhongguo Chuantong Wenhua* (Dream of the Red Chamber and Chinese Traditional Culture). Wuhan: Wuhan Cehui Keji Chubanshe, 1996.

Huang Ziping, and Li Tuo, eds. *Zhongguo Xiaoshuo* (Chinese Fiction). Hong Kong: Sanlian Shudian, 1988.

Ji Yun et al. *Qingding Siku Quanshu* (Imperial Edition of the *Complete Collection of the Four Treasuries*). Taibei: Shangwu Yinshu Guan, 1977.

Li Zehou. *Mei de Licheng* (Stages on the Way to Beauty). Beijing: Renmin Wenxue Chubanshe, 1981.

———. *Zhouguo Jindai Sixiangshi Lun* (Essays on Early Modern Chinese Thought). Beijing: People's Publishing House, 1979.

Liang Qichao. *Yinbing shi Wenji* (Selected Essays from the Ice-Drinker's Hall). Hong Kong: Tianxing Chubanshe, 1958.

Lu Xun. *Lu Xun Quanji* (Complete Works of Lu Xun). 16 vols. Beijing: Renmin Wenxue, 1981.

Ma Ke. *Xian Xinghai Zhuan* (Biography of Xian Xinghai). Beijing: Renmin Wenxue Chubanshe, 1980.

Mao Zedong. *Mao Zedong Xuanji* (Selected Works of Mao Zedong). Beijing: Beijing Publishing Committee of Mao Zedong Works, 1951.

Miao Tianrui, Ji Liankang, and Guo Naian, eds. *Zhongguo Yinyue Cidian* (Dictionary of Chinese Music). Beijing: Renmin Yinyue Chubanshe, 1984.

Ming Yan. *Ershishiji Zhongguo Yinyue Piping Daolun* (A Guide to 20th-Century Music Criticism in China). Beijing: Renmin Yinyue Chubanshe, 2002.

492 • BIBLIOGRAPHY

Nie Chongzheng. *Gongting Yishu de Guanghui: Qingdai Gongting Huihua Luncong* (The Glories of Qing Court Art: Essays on Qing Courtly Painting). Taipei: Dongda Tushu Gongsi, 1996.

Nie Zhenbin. *Zhongguo Jindai Meixue Sixiang Shu* (A History of Modern Chinese Aesthetic Thought). Beijing: Zhongguo Shehui Kexue Chubanshe, 1991.

Ran Yunfei. *Gushu zhi Fei: Daoist Zhuan* (The Lungs of Old Sichuan: The Story of the Temple of Great Charity). Chengdu: Sichuan Wenyi Chubanshe, 2011.

Richir, Marc. *Du Sublime en Politique* (The Sublime in the Political). Paris: Payot, 1991.

Tao Yabing. *Zhong-Xi Yinyue Jiaolu Shigao* (The History of Musical Exchange between China and the Western World). Beijing: Zhongguo Dabaikequanshu Chubanshe, 1994.

Wang Ermin. *Ming-Qing Shidai Shumin Wenhua Shenghuo* (The Cultural Life of Commoners in the Ming and Qing Dynasties). Taipei: Zhongyang Yanjiuyuan Jindaishi Yanjiusuo, 1996.

Wang Yuhe. *Nie Er Pingzhuan* (A Critical Biography of Nie Er). Beijing: Renmin Yinyue Chubanshe, 1987.

———. *Zhongguo Jinxiandai Yinyue Pingzhuan* (Biography and Analysis of Contemporary Chinese Musicians). Beijing: Wenhua Yishu Chubanshe, 1998.

Wang Yungkuan. *Zhongguo Gudai Kuxing* (Torture in Ancient China). Zhengzhou: Zhengzhou Guji Chubanshe, 1991.

Xu Hao. *Shiba Shiji di Zhongguo yu Shijie: Nongmin Juan* (China and the World in the 18th Century: Peasants). Shenyang: Liaohai Chubanshe, 1999.

Yang Zongyuan. *Zhongguo Gudai de Wenzi* (Ancient Chinese Writing). Taibei: Wenjin\Chubanshe, 2001.

Ye Yongli. *Jiang Qing Zhuan* (Biography of Jiang Qing). Ulumuqi: Xinjiang Chubanshe, 2000.

Yinyue Xinshang Shouce (Handbook of Music Appreciation). Shanghai: Shanghai Wenyi Chubanshe, 1981.

Zhang, Ailing (Eileen Chang). *Yangge: Zhang Ailing* (Collected Writings of Zhang Ailing), vol. 1. Taipei: Huangguan Publishing, 1995.

Zheng, Yi. *Hongse Jinianbei* (Red Monument). Taipei: Huashi Wenhua Gongsi, 1993.

———. *Laojing* (Old Well). Tientsin: China Books, 1989.

Zhongguo Yinyue Xiehui. *Shiwu Nienlai de Zhongguo Yinyue* (Fifteen Years of China's Music). Beijing: Zhongguo Yinyue Xiehui, 1964.

BIBLIOGRAPHY • 493

III. CHINESE AND INTERNATIONAL JOURNALS ON CULTURE

Acta Archaeological
China Daily
China Literature, Language, and Culture
China Medicine and Culture
China Poetry Journal
China Reconstructs
Chinese Historical Review
Chinese Literature
Fine Arts
Harvard Journal of Asiatic Studies
International Communication of Chinese Culture
Journal of Chinese Humanities
Journal of Chinese Literature and Culture
Journal of Chinese Religion
Journal of Contemporary Chinese Art
Journal of Modern Chinese Literature
Journal of Song-Yuan Studies
Literature and Art
Modern Chinese Literature and Culture
Peking/Beijing Review
People's Art
Philosophical Studies
Shanghai Daily

IV. FILMS, VIDEOS, AND PODCASTS

A. Films (Post-1978)

After the Nightmare Comes the Dawn (Emeng Xinglai shi Zaochen)
Bamboo (Zhu)
The Child Violinist (Qin Tong)
The Corner Forgotten by Love (Bei aiqing yiwang de Jiaoluo)
The Crystal Heart (Shuijing Xin)
Dance Love (Wu Lian)
Death of the Marshal (Yuanshuai zhi Si)
Emergency (Yanjun de Licheng)
Evening Rain (Bashan Ye Yu)
Fast as Light (Shunjian)
Ghost (Youling)

494 • BIBLIOGRAPHY

Hibiscus Town (Furongzhen)
Home at Last (Guisu)
The Investigator (Jianchaguan)
Jade Butterfly (Yuse Hudie)
A Late Spring (Chidao de Chuntian)
A Loyal Heart (Dan Xin Pu)
Maple (Feng)
Murder in 405 (405 Mosha An)
My Ten Classmates (Wo de Shige Tongxue)
On a Narrow Street (Xiao Jie)
Rays Penetrating the Clouds (Tougou Yunceng de Xiaokuang)
Red Cliff (Chibi)
Reverberations of Life (Shenghuo de Chanyin)
Roar, Yellow River (Nubao ba! Huanghe)
Romance on Lushan Mountain (Lushan Lian)
The Rose That Should Not Wither and Die (Bu gai Diaoxie de Meigui)
Sacred Duty (Shengsheng de Shiming)
Sea Love (Hai zhi Lian)
A Silent Place (Yu Wusheng Qu)
So Near, Yet So Far (a.k.a. Sakura Ying)
Spring Rain (Chunyu xiaoxiao)
Tear Stain (Leihen)
They Are in Love (Tamen zai Xiang'ai)
The Traitor (Pangguozhe)
Troubled Heart (Kunan de xin)
Troubled Laughter (Kunnao ren de Xiao)
Volleyball Star (Paiqiu zhi Hua)
Wedding (Hunli)
Whirlpool Song (Xuanwo li de Ge)
Wind and Waves (Fenglang)
Xu Mao and His Daughters (Xu Mao he tade Nüermen)
Yellow Earth (Huang Tudi)

B. Videos (Available on YouTube and Amazon)

Acrobatic Dance
Ancient Wedding Traditions
Beijing
Business Culture and Ethics
China History Project
China's Forgotten War
Chinese Ethnic Groups

Chinese Religions
Chinese Superstitions and Beliefs
Chongqing
COVID-19
Customs and Traditions
Dos and Don'ts of Chinese Ethics
Epimetheus: Han Dynasty
Festivals in China
Food in China
Guangzhou
Invicta
Kings and Generals
Peking Opera
Puppetry
Real China: Home and Family
Shanghai
Silk Road
Total War: Three Kingdoms
Traditional Chinese Music

V. WEBSITES

About.com
Chinablog.cc
Chinadialogue.org
Chinaorg.cn
Chinapage.com
Chineseculture.org
Culture-China.com: China Discovery
Digital Dunhuang
Flickr.com

About the Authors

Lawrence R. Sullivan is professor emeritus of political science at Adelphi University, Garden City, New York, and research associate at the Weatherhead East Asian Institute, Columbia University, New York City. He received a Ph.D. in political science from the University of Michigan and is author of *Leadership and Authority in China, 1895–1976* and *Historical Dictionary of the Chinese Communist Party*, and coauthor and/or cotranslator of several works on China. These include *The River Dragon Has Come! The Three Gorges Dam and the Fate of China's Yangtze River and Its People*, by Dai Qing; and historical dictionaries on the Chinese economy, Chinese foreign policy, and Chinese science and technology.

Nancy Liu-Sullivan is a member of the faculty in the Biology Department at the College of Staten Island (CSI), City University of New York, with previous work as a senior research scientist at Memorial Sloan Kettering Cancer Center in New York City. Dr. Liu-Sullivan received her Ph.D. in Molecular and Cellular Pharmacology from the Stony Brook University School of Medicine in 2006 and is a member of the Advisory Board of the CSI/NYS Stem Program.